CLASSICAL ART

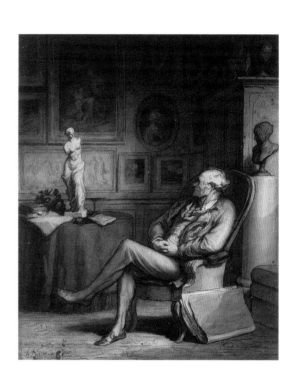

CLASSICAL ART

A Life History from Antiquity to the Present

Caroline Vout

PRINCETON UNIVERSITY PRESS

Princeton & Oxford

For my "collecting" students

Published by Princeton University Press,
41 William Street, Princeton, New Jersey 08540

In the United Kingdom: Princeton University Press,
6 Oxford Street, Woodstock, Oxfordshire OX20 1TR

press.princeton.edu

Frontispiece: Honoré Daumier, *The Connoisseur*,
ca. 1860–65. Pen and ink, wash, watercolor,
lithographic crayon, and gouache over black chalk
on wove paper, 43.8 × 35.5 cm. H. O. Havemeyer
Collection, bequest of Mrs. H. O. Havemeyer,
1929, Metropolitan Museum of Art

Jacket art: Pieter van der Werff, *A Girl Drawing and
a Boy Near a Statue of Venus*, 1715. Oil on panel,
h. 38.5 cm × w. 29 cm. Rijksmuseum, Amsterdam

Library of Congress Cataloging-in-Publication Data

Names: Vout, Caroline, author.

Title: Classical art : a life history / Caroline Vout.

Description: Princeton : Princeton University Press,
2018. | Includes bibliographical references and index.

Identifiers: LCCN 2017023421 | ISBN 9780691177038
(hardcover : alk. paper)

Subjects: LCSH: Art, Classical—Appreciation—
History. | Sculpture, Classical—Appreciation—
History. | Classical antiquities—Appreciation—
History. | Art and society—History.

Classification: LCC N5613 .V68 2018 | DDC 709.38—dc23
LC record available at *https://lccn.loc.gov/2017023421*

British Library Cataloging-in-Publication Data is available

This book has been composed in Gotham and ScalaOT

Printed on acid-free paper. ∞

Printed in China

10 9 8 7 6 5 4 3 2 1

CONTENTS

PREFACE

Every picture tells a story. Hang pictures together, and the conversation between them enriches that story. This book taps one such conversation. It traces the narrative that unfolds as ancient Greek and Roman artifacts are grouped first in sanctuaries, and then in new configurations, as they travel across cultures and time. As they travel—the lucky ones at least—they change the world around them. Symbiotically, they too are changed, accruing values positive and negative. These values, and the ongoing embrace of these values. create "classical art."

Overinvestment in value-laden categories makes them inevitably slippery. But that should not dissuade us from wrestling with them. "Classical art" is sometimes used capaciously to describe the material cultures of the Greeks, Etruscans, and Romans from as early as 1200 BCE to the fall of the Roman empire.[1] But this underrates the values implied by both the "classical" and "art" labels, values that have evolved over centuries. This book is about that evolution, and employs "classical art" for a category comprising "chosen objects," objects that have outgrown their Greek or Roman origins, and often also their intended function, to become part of something bigger—an elite club or canon that dictates taste, and shapes culture and culture's questions. This book also privileges

sculpture. It would be disingenuous to deny the part played by gems, pottery, painting, and architecture, but sculpture is the most eloquent advocate; indeed it is our only advocate, if what we are wanting to track is an available, moveable material that has been in the public domain from its production in Greece or Rome and its discussion in Greek and Latin literature, continuously through to the present—material that offers not just a close-up but a panning shot of classical art's entire trajectory. In as far as this book is concerned with more private narratives, it is less with the biographies of individual enthusiasts than with how these biographies have intersected with (inter)national narratives to dictate classical art's makeup and influence.

As I will show, the "classical art" of today's textbooks and galleries is different from the "classical art" of the nineteenth century, which is different again from the "classical art" of the Renaissance or of antiquity. Not that the terminology "classical art" existed in antiquity or in the Renaissance; it is an observers' category ("classical" derives ultimately from the Latin word "classicus" meaning of the first order), which I apply retrospectively to specimens of Greek and Roman production freighted with normative values. Nor is it a self-standing category: it is always relational. Were one able to ask the

inhabitants of Ptolemaic Alexandria, Seleucid Mesopotamia, or Etruria to pick their "first order" artifacts from the remnants of the past, they may well have pointed to imported Greek artifacts, and they may equally have pointed to pharaonic, near eastern, or Italic styles respectively, creating a capacious and, to us, unfamiliar kind of "classicism." So too the residents of imperial Rome, whose style palette blended Greek, Egyptian, Asian, and Italian motifs. Indeed it is arguably only in the Renaissance and Enlightenment, when Continental powers competed for ownership of the new world and defined the old world in opposition to it, each of them laying claim to an ancestral Greco-Roman-imperial heritage that put them on a surer footing at home, that "classicism" became the Eurocentric model it is today. Even then, the Greek and Roman still interacts with the Indian, the Japanese, the gothic. The Greek and Roman was paradigmatic *before* it became uniquely dominant—had been made so by the reading of Greek and Latin texts. "Classical art" as a discipline comes into its own in the nineteenth century, when the Greco-Roman is prized apart from other ancient cultures in the lecture rooms of universities.[2]

This book follows the Greek and Roman as it reaches these dizzy heights, and "classicism" its hellenocentric bias. When the Parthenon sculptures were making waves in London in the nineteenth century, they were bolstering an already burgeoning hellenism, the ideals of which were tied to the materiality of Greece, real and imaginary.[3] But the Parthenon sculptures were also, inevitably, surprising, bringing many into contact with genuine Greek sculpture for the first time, and accelerating a refinement of the category of "classical art"

to artifacts produced in the fifth and fourth centuries BCE when Athens at least was, for the most part, a democracy. Today, this concept of "classical art" will often be given a capital "C" to put it on an even higher plane than any broader "classical" category. The two definitions coexist. But when it is "classical" style that is being talked about, it is fifth- and fourth-century style that is typically meant, as distinct from the archaic, frontal style of earlier Greek production, or the "baroque" style of works produced after the death of Alexander the Great in 323 BCE. The naturalism of this "Classical art" gives it, and has always given it, a particular kind of potency.

Grappling with these variations on a theme means managing the linguistic problems they generate—not only the different versions of "classical," but also "classicism" and "classicizing." Avoiding "Classical" is not difficult: it is a subgenre as far as this book is concerned; "fifth-century" or "fourth-century" are more precise as adjectives. But the other terms remain tricky: usually in what follows, they imply a debt to the arts of Greece and Rome, as interpreted by a particular period, but occasionally, as in the phrase "Augustan classicism," they infer the narrower nostalgia of our previous paragraph, one that urgently asks us to examine not only modernity's relationship to the classical antique and vice versa but "classicism's" relationship to "hellenism." I rely on the context to clarify, and work hard every time to qualify their different sense of timelessness. Harder is the distinction between "classical" and "classicizing": is an eighteenth-century cast of the Apollo Belvedere one or the other? Find the answer and we pin down the nature of the statue's imitation. But pinning down

is not what "classical art" enables. It has a transcendent quality that defies logic. The best we can do is approximate its appeal, and focus our energies instead on its evolution and impact. If we are occasionally mercurial in our use of these terms, this is as appropriate as it is unavoidable.

All books on the classical have the additional problem of whether to adopt Greek, Latin, or anglicized spellings for Greek names. Because of the massive part played in my story by ancient and Renaissance Rome, I prefer the Latin, except when that is ugly in my eyes: so I call the fifth-century Athenian sculptor "Kritios," as opposed to "Critius," but otherwise prefer "Polyclitus," "Caria," "Doryphorus," and so on. "At best, I hope to have been consistently inconsistent."[4]

CAROLINE VOUT
Cambridge, March 2017

ACKNOWLEDGMENTS

I would like to thank the British Academy for awarding me a midcareer fellowship to write this book and my colleagues in the Faculty of Classics at Cambridge and at Christ's College for their support throughout. I am especially indebted to David Sedley for again stepping in as Director of Studies.

I also thank my colleagues at the Fitzwilliam Museum and Museum of Classical Archaeology in Cambridge, especially Lucilla Burn, for enabling me to curate a preparatory exhibition titled "Following Hercules: The Story of Classical Art" in October to December 2015. Rather than an adjunct to this book, this show was a crucial crucible. I learned a lot. I thank too everyone in the Classics Faculty Library for their practical input, their good humor and their company. My editor Al Bertrand, Hallie Schaeffer, and Terri O'Prey at Princeton University Press, and my copyeditor, Kim Hastings, have made realization possible. Without the support of the Press and funding from the Research Fund Managers of Christ's College, the lavish illustration would have been impossible.

Many people have read sections in draft form. I thank in particular Mary Beard, Robert Coates-Stephens, Viccy Coltman, Robin Cormack, Jas´ Elsner, Maria Loh, Elizabeth Prettejohn, Dorothy Thompson, and Miguel-John Versluys for their detailed feedback on the different periods covered. I also thank Simon Goldhill, Neil Hopkinson, Richard Hunter, Charles Martindale, Paul Millett, Kate Nichols, Gabriele Rota, and Alison Yarrington for their help with various minutiae, and Martina Droth, Jason Edwards, and Michael Hatt for inviting me to contribute to the *Sculpture Victorious* catalog—something formative for my nineteenth-century thinking. Ian Jenkins went well beyond the call of duty in reading and commenting on the content and stylistic foibles of the entire typescript. His deft criticism and kind words enabled me to review the whole with distance and clarity. In the latter stages, Ruth Allen checked the final few references, and Ann Vout and Roeland Decorte the bibliography, each of them with their usual enthusiasm and acumen.

Robin Osborne read, re-read, and held my hand throughout. To do justice in writing to what this means would demand I write another book.

CLASSICAL ART

1

Setting the Agenda, or Putting the Art into Heritage

The thing has a history: it is not simply a passive inertia against which we measure our own activity. It has a "life" of its own, characteristics of its own, which we must incorporate into our activities in order to be effective, rather than simply understand, regulate, and neutralize from the outside. We need to accommodate things more than they accommodate us.—Grosz 2001: 168[1]

What Is Classical Art?

Classical art is a battleground. "Art" is worrying enough for archaeologists. "Classical" is a step too far. Why? Because both terms are value judgments, and the *value(s)* ascribed to artifacts that make the grade so inflationary as to be misleading.[2] "Real knowledge" comes not from antiquities that have been ripped from their original context, cleaned and reconstituted for display in galleries and glass cabinets. "Real knowledge" comes from antiquities that carry their dirt with them. Only if we can trace them back to where the ancients left them— better still, to where they used them—can we appreciate what these artifacts meant and did—give them back their agency.

Everything that is wrong with "classical art" is exemplified by two statues known as the "Tyrannicides" (Tyrant Slayers) in the National Archaeological Museum in Naples (1.1). Indeed everything wrong with classical art could be contained in the following caption: "The tyrannicides Harmodius and Aristogeiton by Kritios

and Nesiotes, 477–76 BCE, marble." For a start, these are not the statues erected in the Athenian agora in the fifth century in honor of the men who killed the tyrant's brother Hipparchus.[3] Those were bronze.[4] Nor are they by Kritios and Nesiotes, but by an unknown copyist working under the Roman empire—if "copyist" is the right word.[5] Without the genuine article, the best we can be is optimistic. And anyway, Kritios and Nesiotes's group was not the genuine article either. It too was a stand-in, after the original group by Antenor was stolen by the Persians in the sack of 480–479 BCE.[6] Not that anyone, even in antiquity, worried that theirs was a replacement, any more than we worry that our Tyrannicides are Roman (although it makes it easier that we do not know enough about their Italian find-spot to reconstruct a rival context)[7] or that they were admired in the Renaissance as "gladiators," and restored as well as relabeled.[8] The replacements stole the show. The caption is a tissue of lies: these Athenian heroes are pretenders.

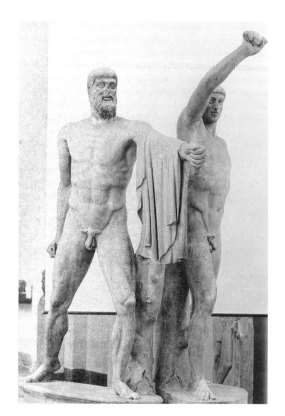

1.1. "The tyrannicides Harmodius and Aristogeiton by Kritios and Nesiotes, 477–76 BCE, marble," or rather a Roman version of that statue group, h 182 cm. National Archaeological Museum, Naples, inv. nos. 6009 and 6010. Photograph: © Hirmer Fotoarchiv, 671.9208.

of Kritios and Nesiotes, as represented by the Naples group, are a "set piece" on the "Greek architecture and sculpture" syllabus of the UK's final-year secondary school examinations and a key mo(nu)ment in textbooks on Greek art by Susan Woodford, John Boardman, and Richard Neer.[9] Although these scholars admit to working with a Roman version,[10] they see its style as emblematic of early fifth-century production, arguing with it as though it actually were the bronze erected in 477–476 BCE, and thus one of the first sculptures, after decades of "kouroi," to break free of the block and the frontal plane. I choose to spotlight Neer as he is a master of close reading and highly influential, in all sorts of respects, on my own thinking:

> They charge forward with swords at the ready, bearing down upon their beholders. Their victim is not depicted but, instead, remains an ever-present absence: the war against tyranny has no end. Stylistically the group is a benchmark in the history of Greek sculpture. No earlier work so convincingly unites the depiction of subdermal musculature with that of vigorous movement. As Stewart puts it, "The Kritian group *literally* marks the birthday of the classical style in Athens."

Just as the Naples group cites the Kritian group that evokes the original dedication, so Neer cites Andrew Stewart, who is paraphrasing Brunilde Ridgway, mutually enforcing their art credentials.[11] He might be said to miss a trick in not mapping the victim's "ever-present absence" onto the "absence" of the group itself, but can be forgiven his confidence: although the Naples statues are far and away the most intact versions to survive in the round,

But before we consign the Naples statues to the storeroom, let us think a bit harder about the nature of this artifice: not what their claims to authenticity obscure about the original groups in their original settings, for none of that is recoverable, but what their posturing reveals about the ways in which the intervening centuries have treated them and material culture more broadly—how it is that we have "classical art" to contend with in the first place. At what point do the Tyrannicides become "art"? And how easy is it to separate the possible answers to that question, and their competing definitions of what "art" is, from questions of "technology," "politics," "archaeology"? As we are about to discover, "classical art" is less a battleground than it is a moving target.

It makes sense to start our target practice in the present. Today, the lost Tyrannicides

images of the Tyrannicides on pottery, coins, and a marble throne, once owned by Thomas Bruce, seventh Earl of Elgin (1766–1841), repeat their poses and confirm their identity (1.2, 1.3, 1.17, and 1.18).[12] Also, a fragmentary inscription, a chronicle or chronology from hellenistic Paros, dates the erection of the Kritian group precisely: the surety of locating it in a fixed time and place makes even an "echo" irresistible.[13]

If it is authenticity we are after, there is plenty here—more real knowledge than can be gleaned from the only actual remains of the group, bits of the statue base to Harmodius and Aristogeiton (usually associated with the Kritian monument but sometimes with its antecedent) found in the Agora in 1936.[14] But there is "authenticity" and "authenticity," and Neer's description, requiring that we see beneath the skin of the Naples versions as if it were bronze, is too bold. Or is it? Is it worse than doing what other art historians do—reduce the group's "vigorous movement" to a pair of static poses, and these poses to symbols of "political freedom" that are then identified in heroes throughout the visual record? This flattens Kritios and Nesiotes's contribution to the history of style, ironing the subtleties of art into straight ideology.[15]

Back in 1956, when Reinhard Lullies and Max Hirmer collaborated on what would become one of the most widely translated and disseminated surveys of Greek sculpture, such was the premium on authenticity that Roman versions did not feature. In fact, the only role for the Tyrannicides was in a catalog entry for the early fifth-century statue from the Athenian Acropolis known as the "Kritios Boy" after purported stylistic similarities between it and the shadowy younger tyrant-slayer, Harmodius—and this despite the fact that

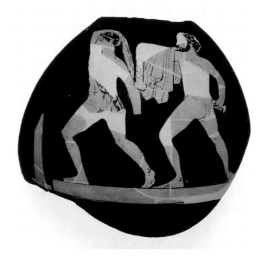

1.2. Pitcher (oinochoe) with the Tyrannicides, from the grave of Dexileos, Athens, c. 400 BCE, ceramic (red figure), 16 × 14 cm. Museum of Fine Arts, Boston, inv. no. 98.936. Photograph: © [2017] Museum of Fine Arts, Boston.

Kritios was famed in antiquity as a bronze-worker (1.4).[16] If anything it is this statue, its torso discovered in 1865 and its head in 1888, and its claims to be the last of the "kouroi"—one of the first sculptures to be more than "man-shaped," but young, alert,

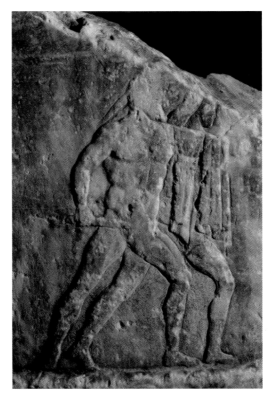

1.3. The Tyrannicides, right side of the Elgin Throne, fourth century BCE, marble, h × w × d: 81.5 × 70 × 66 cm. The J. Paul Getty Museum, inv. no. 74.AA.12. Photograph: The J. Paul Getty Museum, Villa Collection, Malibu, California.

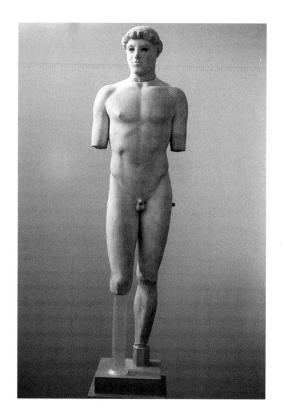

1.4. The Kritios Boy, after 480 BCE, marble, h 117 cm. New Acropolis Museum, Athens, inv. no. 698. Photograph: Jeffrey M. Hurwit.

as though aware of its body—that gives the Tyrannicides their standing.[17] The year before Lullies and Hirmer's publication, and in the wake of Antony Raubitschek's catalog of dedications from the Acropolis, including several statue bases bearing Kritios and Nesiotes's signatures,[18] there was an eagerness to expand the corpus. It was proposed that the Delphi Charioteer too was made by Kritios or his school (2.1).[19] In this climate, his star was rising.

Was this when the Tyrannicides shifted in status from honorific statues to artworks; once the stylistic analysis long practiced by connoisseurs of sculpture, gems, and painting had been theorized in the second half of the nineteenth century to become "attribution studies," supporting archaeology's claims to be a scientific discipline, and, simultaneously, turning Kritios into Canova?[20] This new rigor undoubtedly changed classical antiquity. Indeed without

it, we would *have* to put the Naples statues in the museum-store: they were not recognized as "Tyrannicides" until 1859, by the same scholar who eventually linked the ancient literary testimony about Polyclitus's Doryphorus (Spear Carrier) to the statue type that now bears its name (1.5).[21] Today, the Doryphorus is regularly seen as the maturation of the classical style, as scholars continue to worry about exactly when and why Greek sculptors left abstraction behind in favor of the more naturalistic modes of representation that underpin Renaissance practice.[22] In the future, the gradually swelling number of original bronzes found by fishermen and underwater archaeology may change the parameters of this discussion yet again,[23] but for the moment, the Tyrannicides and Doryphorus rank among classical art's most eloquent proponents. When Neer discusses the bronze found off Cape Artemision in the 1920s (1.6), he writes, "we can be sure that whoever made it had looked at Harmodios and Aristogeiton."[24]

But if post-Enlightenment thinking gave rise to classical art and archaeology as we know it, where does that leave the Renaissance? Before being outed as Tyrannicides in the nineteenth century, the Naples statues were already known, first as part of the antiquities collection in the Palazzo Medici-Madama in Rome, and then, later in the sixteenth century, in the Palazzo Farnese, where they joined a swelling cast of statuary including the Farnese Hercules (1.7 and 1.16).[25] Competition with other Roman collections, such as those of the Borghese and Ludovisi families, not to mention the papacy (the supply of antiquities to the Farnese collection benefiting in 1534 when Alessandro became pope), made this display more important, turning the acquisition of ancient sculpture into a

prerequisite of power.[26] Catalogs and engravings of this sculpture put "classicism" on a stronger footing, with courts throughout Europe commissioning copies and casts of the finest statues, especially those in the Vatican's Belvedere Courtyard (a statue court commissioned by Pope Julius II in 1503), and exchanging them as diplomatic gifts.[27] Classical art was already ideology. And it was already the subject of scholarly inquiry. The "canon" was expanding all the time—and statues were just the tip of the iceberg. The relevant fragments of the hellenistic inscription from Paros were actually acquired early in the seventeenth century in Smyrna (Izmir) by agents working for Thomas Howard, the Earl of Arundel (1585–1646), who was busy amassing his own antiquities for his house on the Strand in London. He had already benefited from a license to excavate in the Roman forum.[28] The inscription was deciphered and published almost immediately in John Selden's catalog of the collection (1628–29), "the first direct study of classical archaeological material by an Englishman."[29]

How did the Naples statues function in this environment? For all of the "rebirth" innate in Renaissance self-fashioning and its fashioning of antiquity, the Tyrannicides were dead, or at least lost in translation, enlisted, along with other versions of Greek works, to reemerge from Rome's soil (the Dying Gaul being another—1.8),[30] to fight a Roman cause as "gladiators."[31] This gave them a nobility of their own, and one that legitimized, almost, the loss of limbs that the passage of time had inflicted. Both had suffered serious injury, "Aristogeiton," as he would become, having lost his head as well as his arms, penis, toes, and part of his mantle, and "Harmodius," his penis, arms, and parts of his legs and base.[32] Prior to

restoration, it was "Aristogeiton" that was more famous, evidence perhaps of the relatively low esteem accorded to Harmodius's expressionless face, features today understood as "archaic" in style.[33] When in 1550 Ulisse Aldrovandi compiled his

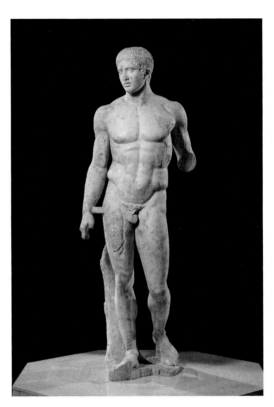

1.5. The Doryphorus, Roman version, second to first century BCE, of a statue made by Polyclitus in 450–440 BCE, marble, h 198.12 cm. Minneapolis Institute of Art, inv. no. 86.6. Photograph: Minneapolis Institute of Art.

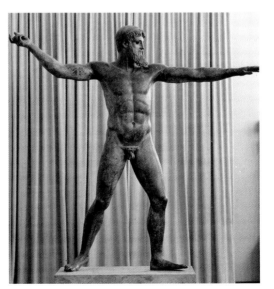

1.6. Zeus or Poseidon, found at the bottom of the sea off Cape Artemision, north Euboea, c. 470–460 BCE, bronze, h 209 cm. National Archaeological Museum, Athens, inv. no. X 15161. Photograph: © Hirmer Fotoarchiv, 561.0429.

1.7. Maarten van Heemskerck, *The Loggia of the Palazzo Medici-Madama with Antique Sculpture*, c. 1532–36, pen and ink, 21.1 × 29 cm. Kupferstichkabinett, Staatliche Museen zu Berlin, inv. no. 79 D 2 a, fol. 48 recto. Photograph: © bpk / Kupferstichkabinett, SMB / Volker-H. Schneider.

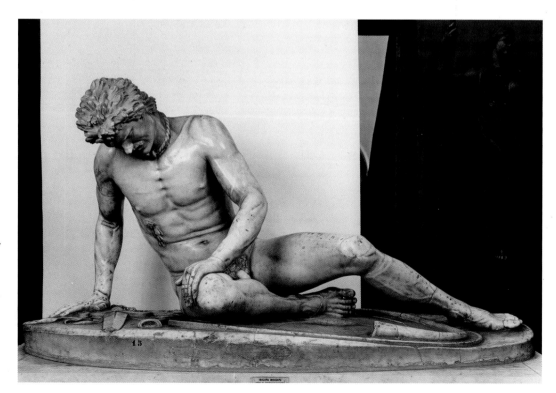

1.8. The Dying Gaul/ Gladiator, from the Gardens of Sallust, Rome, Roman version of a Pergamene original, marble, h 93 cm. Capitoline Museums, Rome, inv. no. MC0747. Photograph: © Hirmer Fotoarchiv, 671.9347.

landmark text of the ancient statues to be seen in more than ninety collections in Rome, he described him, then still in the Palazzo Madama, as "very beautiful," his lack of head and arms notwithstanding.[34] Renaissance draughtsmen sketched him for his strong chest and stance: an exemplary body in an artistic arena (1.9).[35]

Even unknown soldiers could fight classical art's cause. But classical art was a moving target even then. By the time that German art historian Johann Joachim Winckelmann saw "Aristogeiton" in 1756, the statue had long been in the Grand Salon of the Palazzo Farnese, where it and its errant companion were part of a "gladiator" installation known in some of the palace inventories as the Horatii and Curiatii, a reference to Rome's early history that made their Italian indoctrination complete and may well have contributed to French painter Jacques-Louis David's recreation of the encounter on canvas two decades later (1.10).[36] They were mercenaries in a campaign devoted to making Rome the world's cultural capital. They had also been restored: "Aristogeiton" now had a "splendid" head, but a head that, unlike his left arm and cloak, which had originally belonged and been reattached, was alien, thought by Winckelmann to resemble a "young Hercules."[37] He had been literally rejuvenated to suit his new context. Photos taken at the end of the nineteenth century, a century after the move to Naples—post-1859, the "big reveal," and the statues' reunion—show an ancient, alien head (the same head that Winckelmann admired?) still in place (1.11).[38] James G. Frazer's 1898 discussion of the Tyrannicides illustrates them anyway, adding that although Aristogeiton's head is erroneous, "it is a fine head . . . resembling in fact the head of the

1.9. *Aristogeiton*, from *The Cambridge Sketchbook*, Trinity College Library, Cambridge, R.17.3, 1550–62. Photograph: Warburg Institute, London.

Hermes of Praxiteles (1.12), whereas the head of Harmodius is entirely archaic."[39] Even then, the latter's features weigh heavy. His companion's Herculean qualities are more mercurial. He is now similar to a statue excavated at Olympia in 1877, as what counts as a "masterpiece" keeps changing.[40]

Eventually this head is removed and the rightful one put in its place—although this is not the original either, indeed it is not even ancient, but a cast taken from a rather damaged head found in 1922 in the Vatican storeroom.[41] In 1957 this Vatican head was united with its body, a high-quality marble torso discovered in 1937 at the foot of Rome's Campidoglio that confirmed Aristogeiton's identity (1.13).[42] Bit by bit, we muddle toward the Tyrannicides of our textbooks, a patchwork of old, new, and plaster pieces. How does their visual

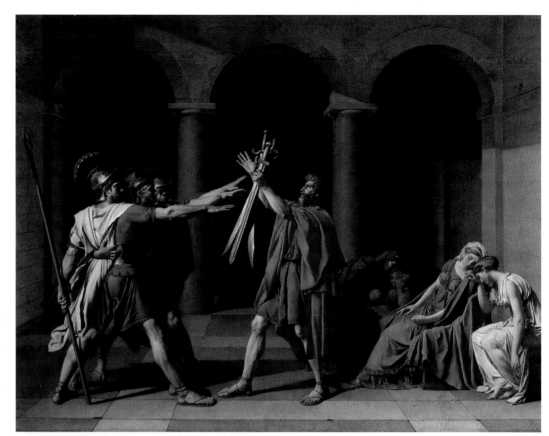

1.10. Jacques-Louis David, *The Oath of the Horatii*, 1784, oil on canvas, 330 × 425 cm. Louvre, Paris, inv. no. 3692. Photograph: © RMN-Grand Palais (musée du Louvre) / Gérard Blot / Christian Jean.

1.11. The Tyrannicide group, Naples, as James Frazer would have seen it late in the nineteenth century. Photograph: akg-images / Fototeca Gilardi.

impact and authority as ancient sculpture compare with the statues studied by Aldrovandi, Winckelmann, and Frazer?

Early in the Renaissance, when the ancient fragments that had contributed to the fabric of Rome throughout the medieval period began to be taken more seriously, broken sculptures were intriguing despite, if not because of, their breakage, the pock-marked Pasquino group and the Belvedere Torso (figs. 5.6 and 9.5) being a case in point.[43] But the more these sculptures influenced contemporary art practice and antiquaries obsessed about their subject matter and their original appearance, the more sculptors saw fit to learn from them by laying hands on them, taking them back to their roots, not by stripping accretions but adding attributes. Even in a museum

context, substitutions continue, those made in the name of knowledge not necessarily more authentic than those made for the sake of gladiatorial spectacle and rivalry between Rome's grand families. Frazer already appreciated the statues as "the finest and most perfect reproduction of the group."[44] What does Aristogeiton's "improved" head add? So clumsy is the join between it and the torso that permanent decapitation might have been preferable.

Where the head is crucial is in making Harmodius and Aristogeiton different ages. For all that the fragments of the statue base support the claims that they were honored for a political act that liberated Athens and led to their martyrdom, some ancient sources give a more personal motive for their actions. According to Thucydides, Harmodius was a boy "in the flower of his youth," Aristogeiton his older male lover, and Hipparchus, the tyrant's brother, a seducer who threatened their union.[45] In other words, Harmodius and Aristogeiton were models of the kind of male-male desire that has been central to the admiration of Athenian cultural production from at least Winckelmann's writings, as well as "splendid specimen(s) of ancient art."[46] Stewart writes, "the group implicitly puts the homoerotic bond at the core of Athenian political freedom and urges us to do the same."[47] But not if we cannot look both figures in the eye and see an older bearded man shoulder to shoulder with his clean-shaven beloved or "eromenos," the paradigm of pederasty familiar from sympotic pottery (1.14) and from Plato. The head discharges the group from its service to Rome and restores a spark that is peculiarly Athenian.

Perhaps it was the group's erotic frisson over and above any militant message that made the ancient patron of the Naples

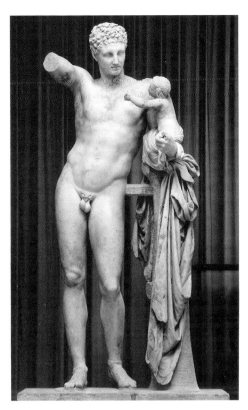

1.12. The Hermes of Praxiteles, c. 340 BCE or a Roman version, found at Olympia, marble, h 215 cm. Archaeological Museum, Olympia. Photograph: © Hirmer Fotoarchiv, 561.0638.

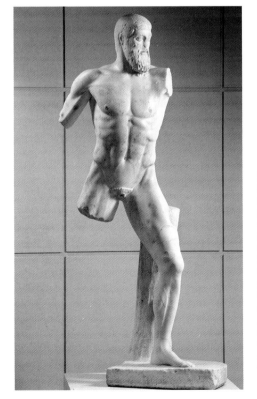

1.13. Aristogeiton, Roman version of figure after the Tyrannicide group by Kritios and Nesiotes, found at the foot of the Capitoline Hill, marble, h 180.5 cm. Musei Capitolini, Centrale Montemartini, Rome, Sala Macchine, inv. no. 2404. Photograph: Archivio Fotografico dei Musei Capitolini, photo Zeno Colantoni, © Roma, Sovrintendenza Capitolina ai Beni Culturali—Musei Capitolini.

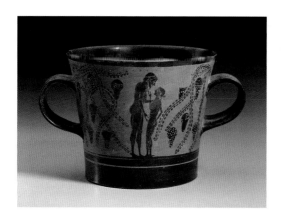

1.14. Side A of a two-handled cup from Boeotia showing a bearded man courting a boy, c. 520 BCE, ceramic (black figure), 11 × 19 × 13.5 cm. Museum of Fine Arts, Boston, inv. no. 08.292. Photograph: © [2017] Museum of Fine Arts, Boston.

statues commission them. Or perhaps this culturally specific erotic frisson limited the type's appeal among Romans. Lucian, writing under Rome in the second century CE, places Kritios and Nesiotes's Tyrannicides in the company of Myron's Discobolus (Discus Thrower) (1.15) and Polyclitus's Diadumenus (Ribbon Binder) (8.23), both of these fifth-century bronzes that are as famous now, through later marble versions, as they were then. But Lucian wrote in Greek, with a lively interest in deconstructing and augmenting the allure of Greece's cultural heritage. His text is also titled *The Lover of Lies*.[48] Although fragments of ancient plaster casts of the Harmodius and Aristogeiton types were found in excavations at Baiae in 1954, suggesting that they were well known in ancient as well as modern Naples, compared to the Diadumenus and Discobolus, relatively few marble versions survive.[49]

The existence of ancient casts of the Tyrannicides and of other famous Greek sculptures in what was presumably a sculptors' workshop at Baiae suggests that they were "art" under the empire already. Under the empire, elites had the time and money to consolidate a relationship with Greek cultural production that began in earnest with Rome's expansion east in the mid-Republic. Statues and paintings

were paraded in triumphal processions, together with exotic trees and captives, and displayed in temples and porticoes.[50] In time, their glamour gilded the private sphere too, upping the demand for hellenic artifacts, real and reproduction, and creating a trade or "market." Processes of selection and deviation led to hierarchies of artifacts and semantics of style that changed Roman, and indeed Greek, painting and sculpture forever. Whatever the Tyrannicides had become, their transfer from the Agora to the Roman villa or bathhouse radically revised their ontology.

This transference also made them objects of intrigue. What were these objects back in their original contexts? Who made them? And how did they fit into a chronology that could then account for, and quantify, Rome's ownership of the world and its contents? What did Rome do to them, and they do to Rome? The elder Pliny's *Natural History*, dedicated to Titus, who became emperor shortly before the author's death, leads the way here, and to explore these questions draws on technical treatises by Greek sculptors and painters, and on the collecting and cataloging practices of hellenistic courts, which were already realizing that knowledge was power.[51] For anyone who thinks that there is no art without art history, the elder Pliny's encyclopedia is a watershed. Even when he makes mistakes, such as ascribing Antenor's Tyrannicides to Praxiteles, he is doing what nineteenth-century specialists were doing, and engaging in attribution.[52]

But Pliny is more than this. He is a mine of information and model for Winckelmann. He is also the reason why Renaissance scholar Aldrovandi, the author of an ambitious "natural history" of his own, exercised his method of direct observation on statues as well as on geological and

biological specimens.[53] Pliny is fundamental for making Rome's treatment of Greek art the paradigm for our treatment of Greek art. Until recently, when Roman "copies" like the Naples group were rebranded "versions," and given a productive part to play in Rome's relationship with Greece, he was also fundamental for making Roman art stale and derivative.[54] When Pliny first mentions them, the Tyrannicides normally attributed to Antenor, "the first portrait-statues erected at Athens" (an accolade that strengthens their claims to authenticity), are said to have gone up in the year the kings were driven out of Rome (510–509 BCE).[55] This is the kind of (mis)appropriation of material culture for personal, national ends that has come to define "the classical."

Classical Art in Context

This book is about this misappropriation, the translocations of Greek and Roman objects that have allowed them to grow, for good or bad, into the classical art we know today; it is a book about the "classical" and about "art," about "classical art" as a collocation. How these words come to be combined into this partly fixed expression is not an easy story to tell. As the Tyrannicides have shown, the life story of classical art, as epitomized in one object, is already a story told by many objects, not to mention lacunae, and is less a straightforward, evolutionary narrative than an oscillating, contested narrative that can shift in meaning within a single place or author. Add more sculpture, or other genres of Greek and Roman material to the mix (paintings, gems . . .), and what classical art is, or does, becomes more fickle. What qualifies for inclusion? When does "classical

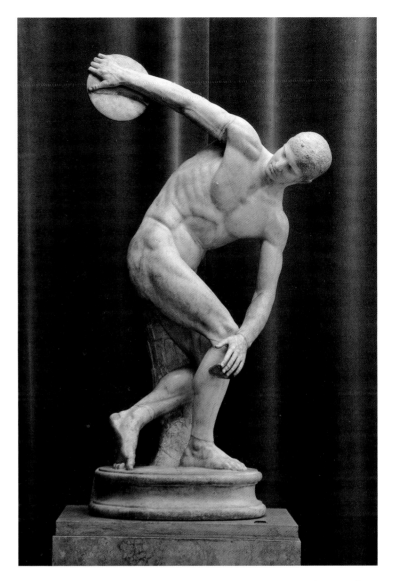

1.15. The Lancellotti Discobolus, Roman version of a statue conceived by Myron, c. 460–450 BCE, found on the Esquiline Hill, marble, h 148 cm. National Museum, Rome, Palazzo Massimo, inv. no. 126371. Photograph: © Hirmer Fotoarchiv, 561.1086.

art" become everyday object or political symbol, natural history, science, evidence? Set it next to antiquities from beyond the Greek and Roman world, and "classical art" comes under greater pressure. It has unique qualities, but what about unique value, virtues, vices? Its consistency depends on the answers. Yet its consistency is hard to fix: it is, as our opening paragraphs acknowledged, undoubtedly a thing of conflict.

The conflict it carries must be met head-on. For sure, the Tyrannicide group

of our textbooks is an imposter, shaped and soiled by centuries of investment. But to turn a blind eye to this build-up is to turn down the opportunity both to understand our scholarship and our museums and to provide crucial commentary on a visual and aesthetic language of art that is too often taken for granted.[56] It is also to miss the birth of what we now call "classicism," and of archaeology as a discipline. Not that "birth" is quite the right word here, any more than it is the right word for the emergence of "art" or even "classical art" as a species or genus. This is not a book about the biography of an "art" born in Rome or in the Renaissance or Enlightenment (whatever its parameters are)[57] because, as the Tyrannicides have also shown us, "art" was not invented, not suddenly and definitively at least. Whenever a statue group is set next to a second statue group, or gem or painting, there is an invitation to engage in the kinds of close, visual analysis that have defined "art history," to rate them in terms of their material, style, and so on. This is not to say that Larry Shiner or Paul Oskar Kristeller are necessarily wrong to identify the "fine arts" as an eighteenth-century phenomenon, although they are not without their critics;[58] it is that we have become unduly obsessed with this "Art" (with a capital) category, and the extent to which ancient terms such as τέχνη and "ars" do or do not map onto it. Philology and academic "systems of the arts" can tell us only so much, as indeed can the social role of the artisan/artist. Whether an object is chiefly of aesthetic or functional value is liable to change overnight dependent on its context.

This is more of a rallying cry than it sounds. The context privileged by specialists of Greek and Roman sculpture today, if not the single stratigraphic event that is (we like to pretend) archaeological context, is the sculptor's workshop where the sculpture was commissioned and made,[59] or the place of this sculpture within the development of an ancient discourse of "art history."[60] Not only does this latter emphasis, itself in part a reaction to Shiner and Kristeller, come with similar problems to those explored above (when was "art history" invented?), but, like art, "art history" is also often something else—not only "religion,"[61] but, in the case of Pliny's *Natural History*, panegyric, moral diatribe, cosmology.[62] More than this, it cannot be reduced to the written word. If there is "art history" in ancient Rome already, it is the sum of the selection processes and display decisions of generals, proud homeowners (some more interested in their acquisitions' authenticity and aesthetics than others), devout temple-goers, and power-crazed politicians, as well as of Pliny and his literary peers. And we must not ignore the selection that comes of serendipity. The Plinian context is but one way of making sense of a series of factors, not all of them edifying or mutually massaging.

By "context," this book primarily means "display contexts," with all of the plurality and emphasis on object over text that that brings with it. It may have started with the fractured statue group that is the Tyrannicides, but its interest from here on is in having its story rub up against other stories, in putting artifacts together, and in understanding how people from antiquity to the present, from ancient "patrons"[63] to Renaissance *pezzi grossi* to English gentlemen, industrialists, and modern curators, put artifacts together, assembling and reassembling them to create meaning. "Classical art" is just one of the categories to come out

of these assemblages and their constituent narratives, but, for our purposes, it is the driver. These acts of assembly are more than chapters in the reception of "classical art," more than instances of "art collecting." "Classical art" was made, not born; it could not exist without them.[64]

It is the weight of this "more than" that made it imperative for this book to open with the Tyrannicides, whose history takes us back to a time before hellenistic court culture. In 1981, Francis Haskell and Nicholas Penny published their influential *Taste and the Antique: The Lure of Classical Sculpture, 1500–1900*, a work that has created a canon of its own, a selection of sculptures, most of them fourth-century or later in style, stars of a narrative that makes Rome the primary focus and collectors its protagonists (1.16).[65] Collecting classical art remains a hot topic, with scholars of all periods raiding the archives to understand how individuals in places as diverse as Rome, Seville, and Los Angeles came to acquire Greek and Roman artifacts, and what these artifacts contributed to their social standing and the societies in which they lived: "collectors and collections, 100 BCE–100CE," "the Palace of Lausus at Constantinople and its collection of ancient statues," "antiquities collections in Renaissance Rome, c. 1350–1527," "sculpture collections in early modern Spain," "why the English collected antique sculpture, 1640–1840," and so on.[66] For all that these studies result in a rather fragmentary picture, there is sometimes a suggestion that if we joined the dots, we could map a single phenomenon.[67]

In bringing some of these fragments together and splicing through them in new ways, this book's longue durée approach will highlight continuities and discrepancies: the value of classical art as a category resides in the realization that it has evolved over two millennia. Whatever combination of erudition, aspiration, and greed characterized the Farnese family's admiration of the antique, they were involved in an activity that elites all over Europe understood as being about the satisfaction of certain symbolic needs, about investing in shared cultural capital. They were "art collectors." But what about the returning war heroes who displayed their swag of Greek artifacts in processions and in temples? Was their "symbolic need" commensurate? Were Roman temples "art collections," or "museums," or neither?[68] Scholars are split on this, with some going as far as to suggest that even prehistoric communities "collected."[69] But to argue over these weak and strong options is again to obsess about genesis, and cannot be done in abstraction. To count the assemblages in Rome's temples as "collections" is trivially true, and trivially false; it is an issue that can only be given the attention it deserves by insertion into wider practices and discourses of display and preservation. "Collecting" of anything, anywhere, can only be given the attention it deserves by insertion into these wider practices and discourses. Starting with the Tyrannicides offers us a useful way into this broader terrain, prior to the narrowing that comes of the Renaissance's investment in ancient Rome, and ancient Rome's investment in hellenistic cities such as Alexandria and Pergamum, as paradigmatic of their own cultural systems. No one would call the Persian theft of the Antenor group in 480–479 BCE an "act of collecting." Yet, as we will discover, its exile in the Persian city of Susa did more than any subsequent episode to give the Tyrannicides the "art" label.

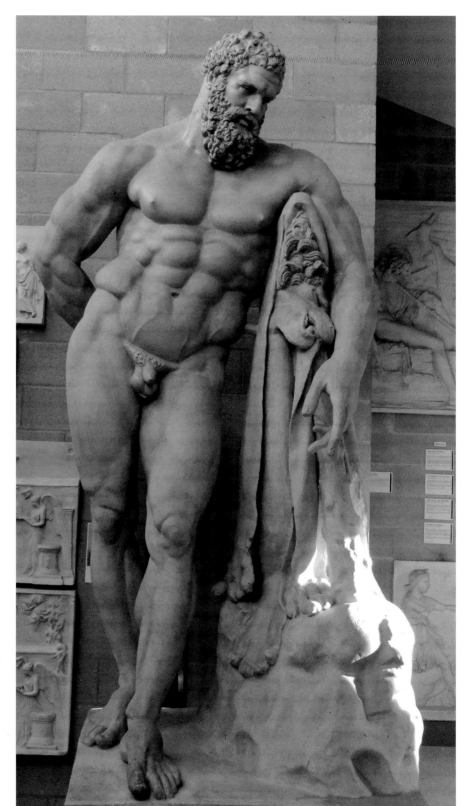

1.16. The Farnese Hercules, cast of a Roman version of a statue conceived by Lysippus in the fourth century BCE, displayed early in the nineteenth century in the sculpture gallery of Sherwood Lodge, Battersea, and from 1850 in the Fitzwilliam Museum, Cambridge, painted plaster, h 315 cm. Museum of Classical Archaeology, Cambridge, inv. no. 277. Photograph: © Museum of Classical Archaeology, University of Cambridge.

Ask what we know about Antenor's Tyrannicides and the answer is, very little: erected somewhere between 510 and 480 BCE,[70] these statues were bronze,[71] and innovatory, renowned for being the first portraits in Athens, in a space, the Agora, that was unaccustomed to statuary. If one wanted to see statues in Athens at this period, one went to the Acropolis or the cemetery.[72] Yet the appearance of these extraordinary statues is something of a mystery:[73] as we have already noted, the images on pottery, coins, and the Elgin Throne pay homage to their successors, which may or may not have resembled the originals; it is the successors that Aristophanes alludes to so graphically.[74] It is not until imperial Rome, centuries after they are rescued in the hellenistic period and restored to the Agora, that Antenor's statues get a look in, and by then, it is as though they are the replicas, not ousting their stand-ins, but striking a pose next to them. When Pausanias sees them side by side, he observes, Antenor made "the old ones," but the τέχνη belongs to Kritios.[75]

The "extraordinary" status of the Antenor group, and of the Tyrannicides in general, owes a lot to its sojourn in Susa. Before its disappearance, it was a bold dedication, an "unclassifiable monument," no less, that commemorated an act that was as much about sex as it was about politics.[76] It was a unique contribution to an area of the city that was only then, at the end of the sixth century, acquiring the buildings to declare it the seat of democracy.[77] But after the theft, the group was an icon, its honorands elevated in status from suitably glamorous spokesmen for the democratic space around them, to freedom fighters, whose blow to tyranny now hit Persia too,

making its message one of nationhood.[78] The Kritian group stepped into the breach, acquiring immediate interest from being a souvenir, which, by virtue of its allusion to something bigger and braver than itself, was given the symbolism to serve as a totem on countless other objects. In Athens itself, Panathenaic prize amphorae, usually thought to have been produced for the festival of 402 BCE, are the most interesting, deploying the statue group on the shield device of Athens's patron deity, Athena (1.17).[79] In the Mysian city of Cyzicus, the group featured on the obverse of coins, with only a tiny tunny fish beneath its feet to confer any local significance (1.18).[80] For Cyzicus, the Tyrannicides were a marker of allegiance as well as appropriation, of membership of the Delian League and of independence against the Persian empire.

The Tyrannicides proved a transferable victory salute to be made, especially, after periods of oppression: 402 BCE, immediately after the fall of the Thirty Tyrants, who briefly controlled Athens after its defeat in the Peloponnesian War, being a case in point. But this transferability, reproducibility, also made them art,[81] liberating them from their site-specific context (for surely no one would see this separation of statue from original context as delimiting of ancient meaning) and enabling them to strut the Mediterranean, not only as ambassadors for Athens, but as advocates of image-making's new interest in action. Perhaps tracing the impact of their poses on the representation of heroes such as Theseus and Hercules is more productive than we first thought, indicative rather of their change in status from "unique contribution," to icons, to iconography, and of an appreciation of style as an instrument of the artist, "a language with an internal order

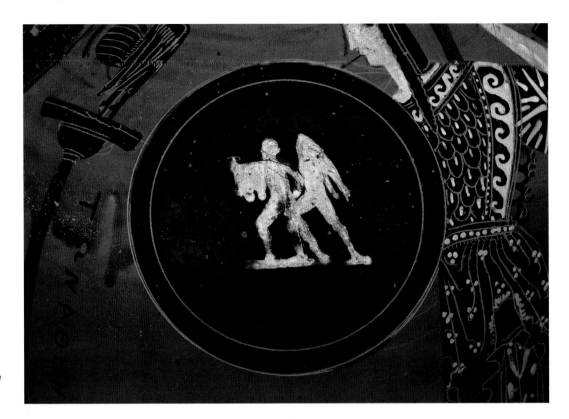

1.17. Close-up of the Tyrannicides on Athena's shield on a Panathenaic amphora, 425–400 BCE, ceramic (black figure). The British Museum, London, inv. no. 1866,0415.246. Photograph: © The Trustees of the British Museum.

and expressiveness."[82] Certainly the longing that results from the theft—its exposure of a gap between experience of the original group and any narrative it might inspire—makes the Tyrannicides possessable and personal in ways that have a lot in common with the desire implicit in art collecting.[83]

Why steal the Tyrannicides? They were not the only statues taken by the Persians: texts tell us that the Persians also took a statue of Artemis and a bronze figure of a female water-carrier dedicated by Themistocles, when he was in charge of the waterworks in Athens.[84] Not only had Themistocles fought at the Battle of Marathon and been instrumental in building Athenian naval power, but he had supposedly paid for the bronze out of fines he had levied for the diversion of public water.[85] It is poetic justice that the Persians should have pilfered a piece

whose raison d'être was theft, erected by Athens's most dangerous politician, just as it is poetic justice that their attraction to the Antenor group should expose them as tyrants. Yet in reality, these "preferences" were presumably more random, or, if not random, then owing to the value of the material.[86] If ransacking the Agora was the game, then the choice of booty was limited.

More important for our story than the question of Persian motivation is the tradition that surrounds the repatriation of the group.[87] According to Pliny and Arrian, Alexander the Great was responsible for sending the statues back to Athens—an attribution that makes sense given the claim that his war against Persia was a revenge campaign for Persian atrocities done in Greece, including "the profanation of the temples."[88] But Seleucus I, who fought with Alexander and founded the

Seleucid dynasty, and his son, Antiochus I, whose administration of the satrapies east of the Euphrates gave him control of Susa, are given the credit elsewhere, neither of them particularly involved in cultivating a relationship with Athens.[89] What is at stake in these divergent traditions, if not the nature of kingship? It is as though "art" has become "heritage," and "heritage" a diplomatic issue.[90] Valerius Maximus is most effusive when he describes how, en route back to Athens on the orders of Seleucus, the statues received special treatment by the Rhodians who set them on sacred couches—not for their aesthetic qualities this time, but for reasons of what they remembered ("memoria"), memory that "possesses so much reverence in such a tiny quantity of metal."[91] Here, the Tyrannicides are not simply "symbolic media," but "physical traces" of the past, "impinging sensuously and physically at a fundamental level."[92] They have the kind of agency and charisma now associated with museum artifacts.

Admittedly, these divergent traditions are in texts written under the Roman empire, a world that was exploring the ethics of its own confiscation of Greek artifacts, and of emperors making some of the most famous of these artifacts more notorious by pocketing them for their private palaces. Such problems of retrospection cannot be ignored: they are an inevitable part of putting material culture next to literary culture, and acquisition and display practices next to descriptions of practice: later, for example, we shall see multiple generals at multiple points in Rome's history being awarded the dubious honor of introducing Greek art into Rome. Arguably, if it is "art collecting" sensu stricto that one wants to find, one needs to find collecting discourse.

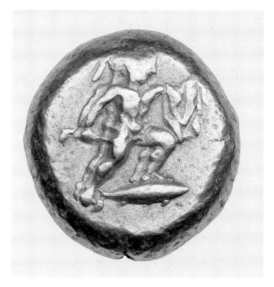

1.18. Stater of Cyzicus with Tyrannicides above tunny fish, c. 400 BCE. Museum of Fine Arts, Boston, inv. no. 04.1343. Photograph: © [2017] Museum of Fine Arts, Boston.

Back in the fifth century, the erection of additional statues in the area around the Kritian group seems to have been severely restricted.[93] It took until 394–393 BCE for public honors in Athens to include the grant of portrait statues, and for bronze statues (those of the Athenian general Conon and his covictor at the naval battle of Knidos, Evagoras, the king of Cypriot Salamis) to be erected in the Agora—Conon said explicitly by Demosthenes to have been "the first man so honored since Harmodius and Aristogeiton" and to have "ended no insignificant tyranny."[94] His honorary decree drew a further link, claiming that Conon had "freed the Athenian allies."[95] Placing this pair of statues together in front of the Stoa of Zeus Eleutherius (the Liberator) worked—by attraction—to make them "like" the Tyrannicides.[96]

Within two decades, other honorific statues have joined the gathering (those of Iphicrates, Chabrias, and Conon's son, Timotheus), radically transforming the cityscape.[97] Yet a public decree from 314–313 BCE grants Asander of Caria a statue anywhere *except* alongside Harmodius and

1.19. Casts of the Peplos Kore, the original of which was found on the Athenian Acropolis, c. 530 BCE, h 118 cm, one of them painted to give an idea of the statue's ancient pigment. Museum of Classical Archaeology, Cambridge, inv. nos. 34 and 34a. Photograph: © Museum of Classical Archaeology, University of Cambridge.

Aristogeiton.[98] What this meant in real topographical terms is difficult to determine, but there was clearly a cordon of sorts around the Tyrannicides, the existence of which makes the erection of two gold statues of foreign rulers Demetrius Poliorcetes and his father, Antigonus I, "directly adjacent" to them in 307 BCE particularly momentous.[99] As with Conon and Evagoras before them, their actions, in this case their expulsion from Athens of Demetrius of Phaleron and their restoration of "democracy," made them tyrant-slayers also, and assured that next time a public decree prevented someone from erecting a statue in that area, it mentioned their statues as well as those of Harmodius and Aristogeiton.[100] By the end of the third century BCE, statues of Alexander, Philip, the Ptolemies, Lysimachus, and Pyrrhus may have infiltrated the circle, all of whom could claim to have helped free the city.[101] Certainly in 43 BCE, Julius Caesar's assassins, Brutus and Cassius, are awarded bronzes next to the Tyrannicides, "as though following in their footsteps."[102]

There are also Antenor's statues to consider, back, competing with their successors to mark out a space reserved for a subset of honorands: liberators(?). Together, these two Tyrannicide groups are the compass, inscribing an arc around themselves that only some individuals can permeate. Did everyone see their relative merits as Pausanias was to see them? How did their bronze bodies look next to the gold of the Antigonids? Did the Antigonids appear more Greek, and all of them more like a single class of objects, once the outliers that are the Roman portraits (with veristic faces?)[103] were added? And how did those that made the cut compare, in collectivity terms, to other manmade assemblages in ancient

Greece, the sixth-century BCE marble maidens or "korai" with their "look-at-me" dresses that had once graced the Acropolis (1.19), the carefully placed dedications along the sacred way in the Sanctuary of Delphic Apollo, or the votives inside Corinth's Sanctuary of Demeter and Kore?[104]

These questions are impossible to answer with any certainty: Pausanias is our main source for this kind of judgment call, and Pausanias is viewing in, and through, a Roman Greece, centuries after the korai have been smashed by the Persians. But they are questions worth asking nonetheless, if only to place later periods' handling of classical artifacts into a new context, out of the straitjacketing that is our classification of their classifications. Seeing what this handling shares with what the Greeks and their enemies were already doing with Greek sculpture in the fifth century is to see that what makes an artifact worthy of special status is never easily delineated. How could it be? For where would that leave longing? The next chapter takes a broader fifth-century landscape as its point of departure to rethink the hellenistic period's contribution to our story.

2

Finding the Classical in Hellenistic Greece

Making Greek Culture Count

More than five hundred years after the Persians snatched the Tyrannicides from Athens, Nero took not two but five hundred bronze statues from Delphi, some of them men and some of them gods.[1] This is quite a haul, and says as much about Greek sanctuaries as it does about Rome's emperors. Whatever the rights and wrongs of his actions (and unsurprisingly, given that it is the tyrannical Nero we are talking about, the snatching of mortal and divine subject matter hints at an incontinence that is hard to sanction),[2] they underline what rich repositories these sanctuaries were—stuffed with statues, big and small, singletons and groups, freestanding, equestrian, fragmentary, metal, stone, wood, clay. . . . And not just statues, but reliefs, weapons, jewelry, utensils, musical instruments, bones, tusks, skins, even sea monsters.[3] All of them were dedications to the gods, and the stories they told or promised, evidence of the power of the immortals. Their "ostentatious deposition" is key, and was a transaction. "Indeed most of what is considered 'art' in standard text books was originally a votive offering."[4]

There are votive offerings and votive offerings. In the case of a statue like the Delphi Charioteer (originally, as other fragments attest, part of a chariot group)

(2.1), its dedication in the fifth century BCE was also a highly competitive act, usually ascribed to a Sicilian tyrant intent on making a name for himself on the mainland.[5] To call it purely transactional would be no more accurate a description than claiming that Nero treated Delphi as a bank, interested only in liquidating its assets so that Rome could rise from the ashes again after the fire of 64 CE.[6] He was more discerning than this, in the sources at least, selecting an Odysseus from Olympia, Praxiteles's marble Eros from Thespiae (a piece given Tyrannicide-type fame by the fact that it had been taken to Rome by Caligula and returned by Claudius), and a statue of Hydna from Delphi, Hydna being a young female swimmer credited with helping to crush the Persian army.[7] The Charioteer's dedicators were discerning too. Every one of his foil eyelashes, combined with the flash of silver between his delicately parted lips and on his headband,[8] asked the visitor to favor it over the dedications on the temple's terraces[9]—to obsess over his horsemanship. The sensory delight of this detail wins him more than the chariot race.[10]

Elsewhere in the fifth-century sanctuary, statue upon statue of the sanctuary's patron deity, Apollo, vied for attention:[11] some of them bronze and contemporary with the Charioteer, another, small and ancient,

another of gold and ivory, another, thirty-five cubits tall, and a further twenty iterations, all part of the same dedication.[12] Each of them was an epiphany of the god, but all of them also a variation on a theme, sent by city-states all over the Greek world to jostle for position in an Apolline army. Which of the Apollos that found itself standing on the east terrace next to the gilded image of Phryne, the famous prostitute and putative model for Praxiteles's Aphrodite of Knidos, in the fourth century BCE was most deserving of her company and the visitor's gaze—the one dedicated from Persian spoils by the Epidaurians, or the one dedicated from Athenian spoils by the Megarians?[13] The replication we see here works differently from that of Kritios and Nesiotes's group, as there is now no original image, except ineffable godhead. The absence of a model, and its replacement by a polyphony of possibilities, prevents any of them from being automatically dismissed as a pale imitation. Each has to want to be innovative, or at least eye-catching, if it is to make its mark and contribute to Apollo's "magic," his aura. It takes more than a patron's finances or a maker's technical expertise to supply this charisma; it calls for craftsmen to become artists.

Certainly Pausanias draws a distinction between statues that are interesting because they are old and statues that are interesting for their τέχνη, for what Alfred Gell famously called "the enchantment of technology"[14]—this second category being represented in Pausanias's account of Athens by Cleoetas's figure of a helmeted man with silver nails (a move that makes the silver teeth of the Delphi Charioteer or the Riace bronzes seem conservative) and by his image of Earth begging Zeus to rain upon her.[15] Even in ancient Greece,

2.1. The Delphi Charioteer, from the sanctuary of Apollo, Delphi, c. 470 BCE, bronze, h 180 cm. Archaeological Museum, Delphi, inv. nos. 3484, 3520, 3540. Photograph: © Hirmer Fotoarchiv, 561.0601.

sculptors are found signing their statues, not in a way that suggests a sudden rise of artistic consciousness in the aftermath of the Persian wars, or at some other point in history, but here and there across the centuries in ways that show that displaying the fabrication of an object was always an option.[16] Nor was this the only way to do it: Phrasikleia (2.2) and other korai pull

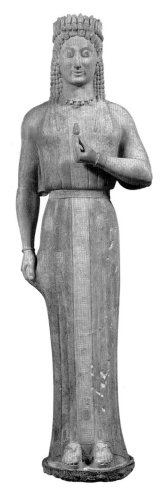

2.2. Funerary statue of the kore Phrasikleia, c. 550–540 BCE, found at Merenda, Attica, marble, h 179 cm without the base. National Archaeological Museum, Athens, inv. no. 4889. Photograph: National Archaeological Museum, Athens. Photographic Archive © Hellenic Ministry of Culture and Sports/Archaeological Receipts Fund.

vision, writing treatises on their practice that would lend it if not artistic merit, then a rationalization and loftiness akin to mathematics.[18] The proportions of his figures were now ideal proportions that could be studied and learned, serving as a counterpoint to the analogies between sculpture and writing/singing conjured by Pindar.[19] If Pindar's victory odes were "agalmata" or offerings pleasing to the gods, ideally "whiter than Parian marble,"[20] then each of the victory statues at Olympia (and not just the epigrams on their bases, but the relative lifelikeness of their bodies and the precision that went into these)[21] asked to be read as "texts." Polyclitus's canon or treatise was a theoretical work and an assertion of his agency.

The more we think about it, the harder it is to see the chaotic crowding of smaller-scale, more modest votives, many of them cheap and "off the peg," as having a similar effect (2.3). So expendable were they that periodically they were cleared from around the cult statue or altar and buried. But on first sight, their sheer number can be dynamite, few of them intrinsically interesting in their own right, but all of them gaining charisma, animacy even, from their company.[22] At the sanctuary of Demeter and Kore at Corinth, the terracottas are of more diverse typology than is often the case, some handmade, some mold-made, many originally finely painted, some from the fifth and fourth centuries resolutely archaic and others more forward looking.[23] Alone they speak to the gods; together they speak to each other, creating a dialogue that turns them from figurines into actors in a soap opera. But even anatomical votives become more expressive when grouped, tempting viewers to "play god," and to unite the scattered body parts.[24] Is it only economics

at their dresses, less to signal movement than the presence of the body beneath,[17] as well as the manufactured nature of its beauty—its fleshiness and artifice. But a signature pinpoints specific authorship, and suggests that there was something to be gained from showing this and knowing this, whether the statue base read "Kritios and Nesiotes," or a sculptor whose name had less recognition. Whatever status a signature conferred, it was a claim to originality.

In addition to signing their statues, from the middle of the fifth century onward, sculptors such as Polyclitus found other means of distinguishing their work and underlining the independence of their

that makes the fragments of painted pottery found on the Acropolis in Athens higher quality than those found in the Agora? For the gods, who cannot use these objects, it is perhaps imperative that they are exquisite.[25]

Add to these sculptures the dresses of the Amazons that Euripides has Hercules dedicate, the tripod won at Patroclus's funerary games and dedicated by Diomedes, or Helen's necklace dedicated by Menelaus, and the buildings at Delphi become protoreliquaries.[26] And they were not unique in this: temples competed to house the sexiest substantiations of Greek myth and thus to make myth history—their history. In the Temple of Apollo Ismenius at Thebes, in the fifth century, a temple with a rival oracle to Delphi, Herodotus claims to have seen three tripods from the time of Laius, Oedipus, and Oedipus's grandson, Laodamas, the first of these dedicated by Hercules's adoptive father, Amphitryon, and inscribed, like the others, in Cadmeian letters.[27] Elsewhere in his histories, he notes that the sixth-century Lydian king Croesus had also dedicated a golden tripod there, contributing, no doubt, to the temple's standing as "the sanctuary of the golden tripods."[28] The site's renown was linked to a particular type of artifact.

What are we to make of this landscape? Bring them into contact with other examples, and the fruits of "ostentatious deposition" are recontextualized as "ostentatious display," all of them turned into something more than memorabilia—into artifacts that are memorable in their own right as artifacts. In "panhellenic" sanctuaries such as Delphi, their sheer physical presence potentially hit harder still, their local style, and sometimes material, offering a stark contrast to other interventions. Which was the *most* memorable, and why? Pausanias and Herodotus's

2.3. Terracotta votive statues in situ around altar at Ayia Irini, Cyprus. Photograph: © Medelhavsmuseet, Stockholm. Photo: Swedish Cyprus Expedition (C01801).

enchantment lies in a tradition of enchantment rooted in Homer and in the craftsmanship of Daedalus, whose labyrinth and flying experiments wowed and terrified by challenging nature. This is how the Charioteer worked too, its eyelashes pushing at what was technically possible.

It would be perverse almost to deny aesthetics a place within this enchantment, or to assume that the sorts of responses now associated with art appreciation were not possible, encouraged even, in the fifth-century sanctuary. One of the first things to tempt visitors to the Acropolis, long before they got to the east end of the Parthenon and prayed that its doors might be open, was the Propylaea or gateway's Pinacotheca or picture gallery.[29] And Xenophon's Socrates is already engaging in art criticism of a sort when he asks the painter Parrhasius whether painting is a representation of things seen, understanding the need for the images to be beautiful.[30] Yet these aesthetics are ancillary to broader philosophical questions in a climate of viewing in which ritual activity dominated, making temples too functional

or mundane to qualify for museum or art gallery status. Not even the wake-up call of the Persian wars, when special measures were taken to protect the sculpture on the Acropolis and when Persian artifacts flooded into Athens, influencing Athenian production, got all Greek sculptors signing.[31] Polyclitus's treatise was an "instruction manual," not a call to subjectivity.

The inventory lists compiled by the Treasurers of Athena in Athens from 434–433 BCE onward, and inscribed on stone for display on the Acropolis, make interesting reading in this regard.[32] Although Pausanias claims that objects "worth talking about" inside the Erechtheum included a chair made by Daedalus, as well as the captured breastplate of the Persian commander at Plataea, Masistius (an example of the enchantment of technology if ever there was one, its gold scales obscuring indestructible iron ones beneath), and the dagger of Persian general Mardonius,[33] the inventories do not mention them,[34] or at least, if they do mention them, they do not draw attention to them, withholding their provenance. This is not unusual at this period: rarely is this kind of detail recorded, and an object only really described to distinguish it from others of its type. Metal objects are normally accompanied by their weight, underscoring that they were expendable.[35] Their value, at least in these lists, lay in the assurance that enough of them were still there—in the knowledge that they could be melted down into cultic equipment, or coinage in times of crisis.[36] These lists were about accountability—not about art, or history.[37]

One man's heritage is another man's income stream even now, and counting culture not the same thing as making culture count. For the statues in sanctuaries and other public spaces really to count as Greek culture in any sustained, significant, deliberate sense, we have, I think, to step outside of the Greek mainland, and out of the fifth and fourth centuries, forward into a world post-Alexander, when the greatest Greek city was Alexandria in North Africa, and the most powerful players, the Antigonids and Seleucids whom we have already met, the Ptolemies in Egypt, and a little later the Attalids in Pergamum, all of them using Greek production as well as other materials, indigenous and alien, to voice their own ambitions. In these worlds, which looked out and away from Greece as enthusiastically as they did toward, there was enough distance for dispassionate assessment. These kings could acquire artifacts from imperial domains that covered not just the Greek world but swathes of western and central Asia;[38] the competition that had given meaning to artifacts in sanctuaries such as Delphi was writ large across a much larger stage—not Sicily against Athens, against Epidaurus, against Megara, but all of them in dialogue with and against the Syrian, Mesopotamian, Egyptian, Persia or India. In choosing which bits of Greek culture to cultivate, these court societies assembled and epitomized these elements, making them more markedly Greek, and (not unlike the fifth century's stray Tyrannicides) more explicitly representational.

Understanding how Greek culture became an exemplary culture, a "classical" culture, with fifth- and fourth-century Athenian production the most exemplary, demands getting to grips with these dynasties' contributions. This involves more than reconstructing which sculptures they acquired and why. As Jas´ Elsner has recently reiterated, the acquisition of statuary needs to be set alongside the acquisition of texts, which are themselves

material artifacts.[39] We shall be getting inside the libraries of Alexandria and Pergamum to explore changes in patronage and changes in classification—how the selections made there and the ordering of knowledge that ensued changed Greek literature and Greece's other cultural forms forever, enabling a sense of ownership and stronger subjectivities. Listing "treasures," negotiating where to place a statue on a temple terrace, or claiming a hero as one's own is all very well, but creating a taxonomy, retrospectively, of how one sits in relation to someone else's statues, inscriptions, or plays, a different matter, and one that removes them from their site-specific locations to represent not author x or patron y but "statuary," "poetry," "stagecraft." By the first century BCE, a sanctuary on Rhodes would compile and display a very different kind of "inventory" that precisely excavates individual votives by putting a premium on antiquarianism and chronology.[40]

We start this phase of our journey, however, not in Alexandria or Pergamum but in fourth-century Caria with a monument that was under construction by a local dynasty nigh in the center of Halicarnassus, modern Bodrum, when Alexander was still an infant.[41] Why? Because already there, within its fabric, Greek bas-reliefs were excerpted from their natural habitat, and reconstituted together with non-Greek elements to serve an alien function (2.4). Although they are but building blocks, they are spotlit nonetheless, purposeful punctuations or citations that turn Greek sculpture into a source text, with all of the possible strands of homage, through to parody, that come with that. Layer on top of this the story that each of its four sides was the commission of a different Greek sculptor, and finally, perhaps, we are closer to the concept of an art competition.

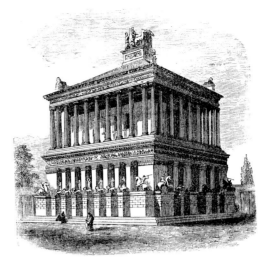

2.4. Reconstruction of the Mausoleum of Halicarnassus, Bodrum, c. 350 BCE by James Fergusson, 1862, J. Trousset, *Nouveau dictionnaire encyclopédique universel illustré* (1885–91). Photograph: Morphart Creation / Shutterstock.

Competitive Culture

The Mausoleum of Halicarnassus is not the only fourth-century monument by a non-Greek dynast to incorporate hellenic elements this knowingly. We might also have looked at Lycian tombs such as the hero shrine of Pericles at Limyra or the Nereid Monument from Xanthus, with their debt to the sculpture of Periclean Athens.[42] But the Mausoleum is the one that impacts most on the western tradition, a building "of such outstanding workmanship"[43] that it was one of the seven wonders of the ancient world and an object of fascination for authors writing under the Roman empire. It is also one of the most explicit in its quotation: its Amazonomachy frieze (2.5), complete with its "heroic diagonals," references the style and the subject matter of the frieze in the Temple of Apollo Epicurius at Bassae in Arcadia (2.6) in a way that the Nereid Monument refuses, and its sculptors are not anonymous but Greeks working at other east Greek and mainland centers.[44] Given that Hercules is depicted in the frieze, and the axe he took from the Amazon queen,

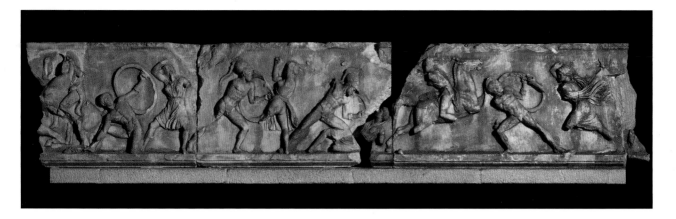

2.5. Section of the Amazonomachy frieze, Mausoleum of Halicarnassus, Bodrum, c. 350 BCE, marble. The British Museum, London, inv. no. 1857,1220.269. Photograph: © The Trustees of the British Museum.

Hippolyte, said to have been housed in the local sanctuary at Labraunda, there is reason to think its content particularly vocal.[45]

But were its merits predominantly aesthetic? Lucian's Mausolus, the ruler of Caria after whom the Mausoleum is named,[46] certainly thinks so, boasting to the cynic Diogenes in the underworld of his tomb's beauty, with its horses and men reproduced so accurately in the most beautiful stone that it would be difficult to find even a temple to match it.[47] Comic this exchange may be, but it underlines the extent to which Amazonomachy and Centauromachy reliefs were standard decoration on religious buildings in Greece, and "matter out of place" on the heroon, where they served a new deity, a dynast

(2.7) commemorated on coins as the demigod Hercules, and now caught mid-apotheosis in the tomb's crowning quadriga.[48] Pliny thinks so too: even after Mausolus's widow had died, the sculptors were determined to finish the project because they judged it "a monument to their own glory and that of their practice."[49]

These were no ordinary sculptors. The building's height (Pliny claims that with its chariot group, it was 140 feet)[50] and its eclectic design clearly contributed to its fame. But it was its sculptors that made it one of the most remarkable structures in the world—the fact that their rivalry was captured forever on four sides of a display cube.[51] Some of them were already well known: we shall be coming back to the most

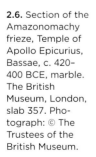

2.6. Section of the Amazonomachy frieze, Temple of Apollo Epicurius, Bassae, c. 420–400 BCE, marble. The British Museum, London, slab 357. Photograph: © The Trustees of the British Museum.

obscure, Bryaxis, sculptor of the north face, later, but Timotheus, who was supposedly responsible for the south face, had made the reliefs and acroteria of the Temple of Asclepius at Epidaurus,[52] and Scopas from Paros, who was responsible for the east, a famous maenad that centuries later the Greek writer Callistratus would praise for being so soft and real, despite being true to the stone, that one was speechless on seeing it.[53] Scopas would go on to oversee the sculpture of the Temple of Athena Alea at Tegea,[54] and the fourth sculptor, Leochares, to make a gold and ivory group of Philip II, Alexander, and other family members, at Olympia (a commission that elevated them by throwing Pheidias's chryselephantine Zeus into relief), as well as a bronze hunting group of Alexander, which his lieutenant, Craterus, dedicated at Delphi.[55] Their involvement at Halicarnassus secured their status among Greek sculpture's leading representatives and led to a further famous fourth-century sculptor, Praxiteles, probably erroneously, joining the party.[56] Even in Pliny's day, they "vied with each other as to whose workmanship was better,"[57] their reputation dependent, to a large extent, on their association with each other.

What came first, this idea of a "competitive hang" or the structure's daring lack of unity? Surprisingly, in a Greek world defined by the competition or "agon," the plastic arts were omitted from the schedule of contests in chariot-racing, athletics, music, dance, and theater that defined public festivals.[58] Although the inscription accompanying the famous Nike of Paeonius at Olympia (c. 420 BCE) makes reference to the sculptor winning the commission to make the temple's acroteria,[59] this could be considered architecture rather than sculpture; other fifth- and fourth-century public sculpture competitions of the

kind that local councils love today are almost certainly anecdotal. The best-known example, the competition or "certamen" to make Amazon statues for the Temple of Artemis at Ephesus, is, as Pliny comes close to admitting when he notes that his "competitors" were born at different times, probably apocryphal, an invention of tradition to account for a gradual grouping of different versions.[60]

Whether causal or explanatory, the celebrated competition between the sculptors of the Mausoleum cements the sense in which its patronage and makeup are new, different from those of the Parthenon. Even the briefest look at the latter's metopes confirms the involvement of a team of sculptors, some of them more capable than others. But they were a team nonetheless, working under the supervision of a master craftsman, Pheidias.[61] As we move toward the hellenistic period, the rhetoric changes,[62]

making landmark buildings and sculptures the buildings and sculptures commissioned by individuals, from individuals, for individual gain. Pheidias may have been renowned for his friendship with Pericles, but it was an intimacy that aroused only jealousy.[63] With Alexander comes the careful orchestration of imagery in dialogue with its maker (2.8): "how great do we think was the respect accorded to 'ars' by king Alexander, who would have himself painted only by Apelles and sculpted only by Lysippus?"[64]

Was it greater than that accorded by Mausolus, and his widow, Artemisia? When the Mausoleum was dedicated, Artemisia (whose identity as a "barbarian and a woman" made the issues of patronage and purpose even more urgent)[65] is said to have held an agon of a more traditional sort,

offering huge rewards to the Greek rhetorician who could deliver the most fitting funerary oration.[66] Perhaps the sculpture worked in a similar way. Although too fragmentary now to attribute to competing authors, the tomb's confection of classicizing friezes, Ionic columns, freestanding sculpture in Greek, local, and Persian dress, colossal sacrificial and hunting groups, plus a group of Greeks fighting Persians, not to mention the lions, and the pyramidal roof with its quadriga, made the Greek elements more Greek than ever, while forcing the sculptors to expand their repertoire. It was as though these sculptors were in exile, where they were no longer craftsmen doing their "day job," if Scopas was ever one of those, but doyens of a mode of expression that could break free of the sanctuary,

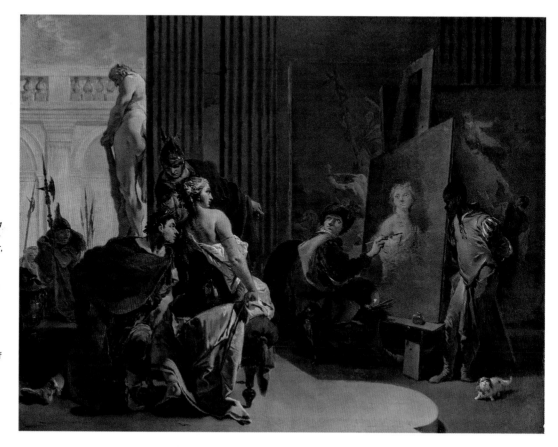

2.8. *Apelles Painting the Portrait of Campaspe*, as Alexander, her lover, looks on, c. 1726, oil on canvas, 57.4 × 73.7 cm. The Montreal Museum of Fine Arts, Adaline Van Horne Bequest, 1945.929. Photograph: The Montreal Museum of Fine Arts, Christine Guest. Note the statue after the Farnese Hercules in the background (see fig. 1.16).

transcend cultural boundaries even. We should not forget that Halicarnassus, where Mausolus had recently moved the capital of his Hecatomnid dynasty, was a Greek coastal city, nor that he used Greek, and the Greek form of decree, in his public communications.[67] The Mausoleum made sculpture a meaningful part of this syntax.

Some two centuries later, with Rome already on the rise and expanding eastward, the Attalid dynasty, benefiting from an alliance with the new superpower and keen to transform their city, Pergamum, into a stage set worthy of their ambition, again made use of this vocabulary, peeling the gigantomachy off temples and treasuries (the metopes of the Parthenon [2.9], the west pediment of the archaic Temple of Apollo at Delphi, and the frieze of the sanctuary's Siphnian Treasury) and pumping it up to give new punch to its elemental impact (2.10).[68] Rather than decorate a tomb, this iteration adorned the exterior of the Great Altar (a monument that was to become a fundamental element in Berlin's imperialist agenda [2.11], rivaling the Parthenon marbles in London as it had once rivaled the Parthenon marbles in Athens),[69] the bodies of its protagonists so exaggerated in their physicality as to burst out from their background, and from the shackles of tradition, onto the steps to the precinct's interior. Any more inflated and they would break from their blocks, and lie in fragments. They could not be more extreme: there was now only one direction for Greek sculpture to go—backward.[70]

Classicism comes of such nostalgia. And it comes with an acknowledgment of inheritance. On the altar, this appreciation is expressed in the inscriptions that name each god and giant as well as the sculptors, complete with their patronymics and cities.[71] Naming the participants makes

the scene more than a shorthand for the triumph of order over chaos, and opposes simply equating the figures' struggle with that of the Attalids versus the Galatians (as though it amounts only to a latter-day appropriation of the Parthenon's gigantomachy and its message of Athenian supremacy over Persia). It makes each of them as much an individual as the next, and asks every viewer where their sympathies lie, while at the same time invoking hellenistic collections of myths or mythographies, perhaps even local mythographies, to invite a more precise, erudite meaning.[72] The proximity of the sculptors' "signatures,"[73] meanwhile, and the fact that some were from Athens and other Greek city-states older than Pergamum, and some from Pergamum itself, maps the frieze's combat onto their interaction, making it too a competition, and asking the viewer to admire a system of patronage that could bring together such an array of talent. Mausolus and Artemisia had nothing on this. Like their tomb, the altar is a monument to excess, but its "labeling" makes nothing otiose— its compilation is a "catalog" of culture.[74]

The altar should not be treated in isolation from Pergamum's longer standing and broader engagement with older Greek cultural production, nor the Attalids from the dynastic competition that shaped the centuries after Mausolus. As a result of the Macedonian wars at the close of the third century BCE, Attalus I (d. 197 BCE) had acquired a wealth of statues from the island of Aegina in particular.[75] And soon his city was adding to these, in a more premeditated way, with versions of Athenian statues of the fifth and fourth centuries BCE, including, in time, a three-meter tall Pentelic marble iteration of the cult statue of Athena Parthenos (2.12),[76] and portraits of Greece's literary stars, among them,

2.9. Metope from the east side of the Parthenon in Athens, showing Hermes defeating a giant, 447–438 BCE, New Acropolis Museum, Athens, inv. no. Acr. 20.000. Photograph: © Acropolis Museum, photo: Socratis Mavrommatis.

Herodotus, Sappho, Alcaeus, and Homer.[77] A base inscribed "Myron" and "Praxiteles" points to the possibility of bronzes by two of Attica's great sculptors, while Pliny mentions a "symplegma" or grappling group by Praxiteles's son, Cephisodotus the younger, that by his time at least was renowned for a sensuous detail ("its fingers that pressed realistically as if into flesh, not marble").[78] And it was not just sculpture: still there in

2.10. Section of the east frieze of the Pergamum altar, showing Athena fighting the giant Alkyoneus, c. 160 BCE, marble. Pergamonmuseum, Berlin. Photograph: bpk / Antikensammlung, SMB / Johannes Laurentius.

2.11. The Pergamum altar installed in the Pergamon-museum, Berlin. Photograph: bpk / Antikensammlung, SMB / Johannes Laurentius.

Pliny's day was a work by the fifth-century Athenian painter Apollodorus.[79] Indeed, such was Attalus II's interest (r. 159–138 BCE) in the fourth-century Theban painter Aristides that he was willing to pay 600,000 denarii for his Dionysus.[80] It appears that he also sent men to Delphi to copy Polygnotus's frescoes in the Knidian Lesche.[81]

One can see why scholars have been keen to call Pergamum an "art collection," or "museum" in the modern sense of the word. Seymour Howard is not untypical when he writes: "The scale and intensity of Pergamene collecting and then imitating masterworks, especially those with learned and self-enhancing references to the virtuous example of Attic classicism, was unprecedented and helped to set a long-lived norm."[82] But as will again become evident with Rome and Constantinople later, bringing home spoils is not (ideally, must not be) the same thing as satisfying a personal love for the finer things in life, and

2.12. Statue after the Athena Parthenos, Pergamum, second century BCE, Pentelic marble, but locally carved, h 310.5 cm without base. Antikensammlung, Staatliche Museen, Berlin, inv. AvP VII 24. Photograph: bpk / Antikensammlung, SMB.

tying pieces to particular "collectors" is a difficult process. More than this, bringing Greek culture home to Pergamum was of a piece with sending Attalid culture out, initiating festivals in their name and erecting and receiving monuments at Delphi,[83] and erecting stoas and sculptural groups in Athens.[84] Of these, the last is most interesting for our purposes, a dedication of giants, Amazons, Persians, and Galatians on a base against the parapet of the south wall of the Acropolis in sight of the Parthenon (2.13).[85] Amazonomachy and gigantomachy were now international currency—so much so that they could be gifted back to Athens, but in a new, improved three-dimensional form, and in a company that made their reference to Persian conflict explicit. Now the Attalids' own enemy was also involved, fighting with the old guard to win the viewers' sympathies, and to rate the relevant victories. Roughly two-thirds life-size, these figures inevitably aroused the viewer's curiosity: they were neither in a parallel universe, like Polyclitus's Doryphorus,[86] nor severed from

reality like the terracottas grouped together in sanctuaries as though in a dollhouse or stage set. Rather, their slight shrinkage made them specimens in a display case.

As already suggested in chapter 1 of this book, collecting is a red herring here. Regardless of the motivations behind all of this, Greek cultural production is being sifted by these processes, elements of it made exportable, tradable, ripe for scrutiny. Howard is not wrong when he claims that the Attalids helped to set a long-lived norm: the Roman general Lucius Mummius, ignorant though he was of such material, blocked Attalus's acquisition of Aristides's painting, realizing there must be "some virtue" in it, and established the "influence" (*auctoritas*) of foreign painting in Rome.[87] Rome would prove particularly enamored of Pergamene sculptors' own "academicism,"[88] the figures from the Acropolis, and the Dying Gaul (1.8), only surviving as Roman versions.[89] But it is not that the Attalids embraced Attic classicism. As with the frieze, they *created* Attic classicism of a kind that would become an indispensable

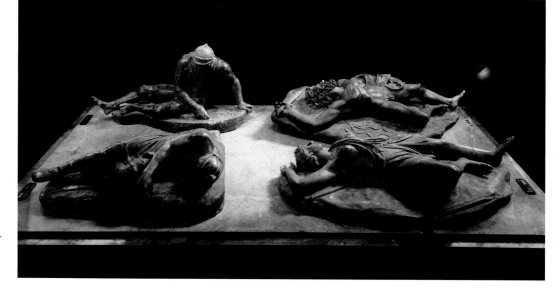

2.13. Dead giant, dead Amazon, dead Persian, and dying Gaul, Roman versions of figures from the lesser Attalid group on the Acropolis, Athens erected in c. 200 BCE, marble. National Archaeological Museum, Naples, inv. no. 6012. Photograph: Brogi 5270, © Alinari.

part of empire's endeavor; [90] and of a kind that was already impacting on the private sphere: a bronze satyr statuette, for example, seen by some as sharing traits with Myron's fifth-century satyr, Marsyas, was found in the rubble of a hellenistic house, southeast of the altar (2.14 and 2.15).[91]

The Attalids did not have it all their own way. South of the Mediterranean, in Egypt, the Ptolemies were in the unique position of bringing their hellenism into contact with the traditions of Egypt's Old to New Kingdom dynasties. Like much of their sculptural production, the statue of their new god, Serapis, was certainly Greek in appearance, later traditions claiming that his cult statue had been physically carried from a temple in the Greek city of Sinope on the Black Sea, and this statue (originally perhaps a Jupiter or a Pluto) made by a certain Bryaxis, whom some scholars have seen as the same sculptor who worked on the north face of the Mausoleum.[92] But their portraits drew on the fluid stylistic idiom of fourth-century Athenian sculptor Praxiteles one moment, and stiff pharaonic idiom the next (2.16 and 2.17).[93] In time, this specifically Alexandrian "sentence structure," with its mix of Greek and Egyptian vocabulary, would also infiltrate Roman culture, asking that "Egyptianizing art" be brought into dialogue with "Attic classicism," or the Pergamene "baroque," and integrated into the "classical art" story. But that is a subsequent chapter. For the moment, it pays to examine some of the other ways in which the Ptolemies engaged with mainland Greek production, using it to vie with other dynasties and to assert themselves as more connected than their competitors.

Unsurprisingly, this connectedness expressed itself as world domination. In the 270s BCE, Ptolemy II Philadelphus had staged a procession in honor of his dead father, Ptolemy Soter, one of the functions of which was to make Alexandria above all

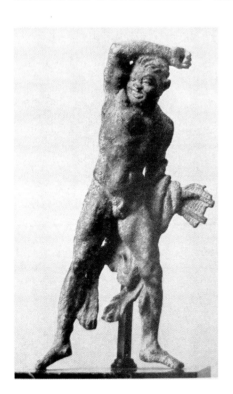 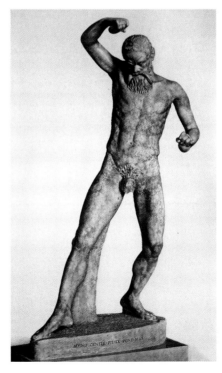

2.14. (Far left) Satyr statuette from Pergamum, from a hellenistic house, southeast of the altar, bronze. Photograph: Winter 1908, vol. 2: no. 469 © Museum of Classical Archaeology, University of Cambridge.

2.15. Marsyas, Roman version found on the Esquiline in Rome of a statue conceived by Myron, c. 440 BCE, marble, h 171 cm with base. Museo Gregoriano Profano, Vatican, inv. no. 9974 (Lateran 225). Photograph: Rayet 1884, vol. 1: plate 33 © Museum of Classical Archaeology, University of Cambridge.

2.16. Ptolemaic statue, identified as Arsinoe II, found in the sea at Canopus, third century BCE, black granite, h 150 cm. Bibliotheca Alexandrina Antiquities Museum, serial 0842, inv. no. M/II/23; (SCA) 208. Photograph: akg-images / Album / M. Flynn / Prisma.

and personifications of Greek cities, trees, exotic animals . . .), but the hospitality tent alone is said to have housed 100 marble statues by "the foremost sculptors," Sicyonian paintings (Sicyon the place where Alexander's portrait-painter, Apelles, trained),[95] fabrics woven with mythological figures, and gold Delphic tripods, not to mention Persian carpets, 100 gold couches with sphinx-shaped feet, and so on. It must have felt like a bazaar: interestingly, when our hellenistic source gets to the cups and other utensils, he prefers cumulative weight to detailed description, not unlike the temple inventories.[96]

This was conspicuous consumption on a scale never seen before. And it was still driving the dynastic agenda a century later when the Seleucid monarch Antiochus IV Epiphanes (r. 175–164 BCE) staged his own procession at Daphne, its explicit intention (at least according to Polybius) to outdo the Macedonian games of the Roman general Aemilius Paullus, its statues "too many to enumerate"—"*all* of the gods or daimones cultivated by humans."[97] How do we get from this desire for world domination to "art appreciation" as Howard would understand it? Not only is a young statesman from Sicyon, Aratus (271–213 BCE), sometimes heralded as "the West's first securely documented art collector,"[98] credited with sending Ptolemy choice fourth-century paintings to solicit his support, but he is persuaded by a friend not to destroy, but merely to adapt, an image of Sicyon's defeated tyrant, because of who made it (Melanthus and pupils, with Apelles's help), and because it was "worth seeing" (ἀξιοθέατον).[99]

The answer lies to a large extent in the intellectual cultures of Alexandria and Pergamum, making it no accident that it

else the new container of everything Greek, and more.[94] Not only did the route of the procession show off the city to best advantage, with a conveyor belt of resources that bore witness to Ptolemaic wealth and control, and would set the standards for the Roman triumph (including 80 silver Delphic tripods and some larger ones also from Delphi, 16 Panathenaic amphorae, gold Spartan mixing bowls, representations

2.17. Head identified as Ptolemy II Philadelphus, c. 280 BCE, gray granite, 28.5 × 22 × 24.2 cm. The Walters Art Museum, Baltimore, inv. no. 22.109. Photograph: The Walters Art Museum, Baltimore.

should be those centers that come, in rather different ways, to dictate Roman modes of classicism. This is not to say that other cities north and east were not as enamored of classic Greek production as they had ever been: at the end of the fifth century already, the court of the then Macedonian king had welcomed the Athenian poets Euripides and Agathon, and commissioned the famed painter Zeuxis to decorate the palace of the new capital in Pella.[100] Mausolus was not the first; autocrats performed their power like this before he was born. Nor is it to suggest that houses in places as diverse as Delos and Priene were not following palace practices and going in for their own displays of statuettes and terracottas.[101] Rather it is to recognize that if collecting depends "in part upon the emergence of a historical perspective about art, in part upon its increasing secularization and privatization,"[102] then it depends upon something more prolonged than the immediate gratification that comes of acquisition and spectacle. It depends on study, discussion, systematization. Without these, there can be no history; nor can the visual arts develop fully as "an autonomous province of meaning"[103] distinct from other cultural forms. When, in the story of autocratic investment in Attic production, did pouring one's resources into sculpture, or into poetry, become different ventures?

The Ptolemies and Attalids were not the first to obsess about scrolls, or to turn their contents into "literature." Indeed in talking about Ptolemy II's acquisition of Aristotle's books, Athenaeus, writing in the second century CE, reminds his readers of the collections of Polycrates of Samos and of Peisistratus of Athens, who is elsewhere credited with editing Hesiod and Homer.[104] Like Antenor's Tyrannicides, the contents

of his library are said to have been snatched by the Persians, only to be returned by Seleucus.[105] But more often, the stories of rivalry and forgery associated with book acquisition leave those involving statues and painting in the shade: Strabo claims that Aristotle's books were buried to prevent the Attalids from securing them.[106] Capturing a culture's written tradition became synonymous with capturing its thinking.[107]

How to turn the tyranny of such endeavor into something more positive? Rome's own bibliophilia and its investment in Alexandria in particular, not to mention the stories of a fire at Alexandria in 48 BCE,[108] fed the mythology about the library's contents, and its competition with Pergamum: the Ptolemies were so rapacious, apparently, that they ordered ships landing at Alexandria to be searched and their books confiscated and copied;[109] they stopped exporting papyrus, forcing the Attalids to invent parchment;[110] and Mark Antony is charged with promising Pergamum's 200,000 volumes to Cleopatra.[111] Even the question of when libraries were first decorated with portrait statues becomes part of these culture wars. Pliny writes, "whether the kings of Alexandria and Pergamum, who established libraries in great competition with each other, began this practice earlier on, I cannot easily comment."[112]

The bottom line is that we have very few facts about either of these library-buildings, and no concrete evidence for the existence of art collections inside either of them.[113] But their reputations dominate the hellenistic skyline, giving their patronage of the arts a far bigger impact than that of the Seleucids, for example, with their sponsorship of Babylonian poet Berossus.[114] Although Alexandria aimed at collecting, if possible, "all the books in the world,"[115] a desire for

totality that chimes with what we have witnessed in Ptolemy II's procession, it was Greek culture that was the main beneficiary. Multiple versions of the Homeric epics were collated and edited into "definitive" versions that made Peisistratid efforts pale in comparison, and editions produced of Aristophanes, Pindar, and Hesiod.[116] Ptolemy III is even said to have borrowed the official copies of Aeschylus, Euripides, and Sophocles from Athens, only to keep the originals in place of the reproductions.[117] In this way, the Ptolemies exerted their "control over the Greek cultural heritage"[118] on a scale that blew their rivals out of the water—transferring this heritage, line by line, page by page, and expanding the corpus by translating key texts into Greek from other languages, the first five books of the Hebrew Bible included (2.18).[119] Small wonder that Athens gained a reputation as a backwater at this time, its reputation resting on past glories. Its culture was valuable because it was old. One hellenistic visitor writes: "because of its antiquity, the lay-out of the streets is chaotic. Most of the houses are shabby, few are better quality. At first sight, a foreigner would find it hard to believe that this was the famous city of Athens. At second glance, however, he would believe it. It is truly the loveliest place in the inhabited world."[120]

For all that Athens was still a place of education with an active peripatetic school of philosophy,[121] its founder Aristotle's legacy now lay in Alexandria (according to Strabo, it was Aristotle who taught the Ptolemies how to organize a library),[122] where library resources were rich enough to attract the cream of the intellectual elite. Associated with it and its accompanying "college" or "Mouseion" are such great names as Callimachus from Cyrene, Theocritus from Syracuse, and Posidippus of Pella, whose poetry we shall look at presently. They were arguably made great by their association, and their ways of seeing artifacts in their poems shaped as much by court culture as by Homeric ecphrasis. In time, Pergamum would try to poach

2.18. Jean-Baptiste de Champaigne, *Ptolemy II Philadelphus Discussing with Jewish Scholars / Ptolemy II Explains the Septuagint Bible in the Library of Alexandria*, c. 1672, 245 × 377 cm. Palace of Versailles. Photograph: © Château de Versailles, Dist. RMN-Grand Palais / Christophe Fouin.

Alexandria's librarian and boast Homeric scholars of its own: for example, Crates of Mallus and Apollodorus of Athens, who moved midcareer from Alexandria to Pergamum.[123] The display of its Greek statues, and style and labeling of its altar, are indivisible from this bookishness.

The reasons for this are twofold: first, because of the classificatory mode of criticism, canonization even, that came with the selection, listing, and correcting of the libraries' contents, and second, because of the attention to detail that this brought with it. Callimachus's *Pinaces* or *Tables* are the best-known example of this practice. Sometimes talked about as though the library's catalog, these were more than this, a systematic and critical inventory of all of Greek "literature," by genre, and then, within each genre, alphabetically by author (together with a few biographical details), then work (the number of lines recorded with each entry, not unlike the weights of gold and silver recorded in the inventories).[124] The fact that works were organized by genre creates categories of production— laws, lyric poetry, epic, history, and so on— that put the focus squarely on form. What about *art* history? Certainly, the siphoning off and distilling of literary production made painting and sculpture distinctive and deserving of similar analysis. It is no surprise perhaps that two of the first writers (both of them sculptors) to take the rationalization of Polyclitus's canon and Plato and Aristotle's aesthetics and turn them into something closer to "the history of art" as we know it, or at least into source material for Pliny, Xenocrates of Athens, and Antigonus of Carystus, worked at Pergamum on sculptural commissions for the Attalids.[125] Their contemporary Duris, whom Pliny also mentions, and who was,

crucially, not himself a sculptor, wrote on tragedy, laws, competitions, Euripides and Sophocles, and Homeric problems, as well as on painting and sculpture.[126] He was also a historian who produced a chronicle of his birthplace, Samos.[127]

This compulsion to catalog anything and everything is of a piece with hellenistic mentalités more broadly, and breathed new life and scope into a Greek literature already given to antiquarian interests and empirical observation (not only Herodotus's *Histories* but the works of local historians of Athens or "Atthidographers," and the "periploi" or itinerary texts). It was at this time that "periegetic" writing came into its own,[128] one of its most productive advocates being Polemon of Ilion (fl. c. 200 BCE), whose interests lay in Greece and other areas inhabited by Greeks, and in Athens in particular.[129] Several of his works were dedicated to Athenian paintings, sculptures, and other monuments; now, finally, the votive offerings on the Acropolis, and at Olympia and Delphi, and the paintings of the Propylaea's Pinacotheca, assumed a more academic, less practical import, removed from their immediate contexts.[130] For example, he describes the contents of the treasury of the Metapontians at Olympia in an inventory-like fashion (132 silver bowls, 3 gilded bowls, 2 silver wine pitchers, and so on).[131] The main difference is that this description is not on stone but on papyrus, its raison d'être accountability not of the temple officials but of Greek culture: through this data collecting, he could explain the greatness of this culture and count himself as "learned" (*pepaideumenos*) or as possessing of that culture in the process.

Polemon was especially famous for stripping inscriptions from their stones,[132]

turning them from personal dedications informed by, and interacting with, their precise setting in the cemetery or sanctuary (their stele, any accompanying statue, other dedications, readers/viewers with local knowledge . . .) into anthologies to be enjoyed anywhere. He was not unique in this: there were collections of epigrams in the fourth century BCE, if not before, and with this act of transference, a growing interest in their authorship as, once separated from their archaeological context, a new kind of authority was called for.[133] Many, like the epigram on the statue base of the Tyrannicides, were ascribed in antiquity to Simonides, the first known specialist.[134]

This activity, like the transference of the Tyrannicides to Persia, the Aegina statues to Pergamum, or the Amazonomachy motif from temple to tomb, changed these works, making their physical appearance more important than their intended function. For all that today's archaeologists worry that few canonical works survive complete with their context,[135] the importance of "context" was queried long ago, and an object's precise, primary locale replaced by a loose definition of origin ("Athenian," "Greek"). It had to be, if said object was to become canonical in the first place, its meaning shaped by a different kind of knowledge, that which comes not of intention or use but of detachment and reassessment, of having the luxury to stop and study. Anachronistic these statuses and interpretations might be, not to mention elitist: the premium put on hellenism by the Ptolemies, and their adoption, to a certain degree, of pharaonic style, might have made the Egyptians, whose land they had taken over, feel excluded.[136] But this is not the same as meaningless. For good or bad, by the end of the hellenistic period, something akin

to our "classical art," and the criticism and history of "classical art," can be labeled as a discrete and state sponsored entity.

Even temples saw power in this kind of knowledge. In 99 BCE, the councillors and people of Lindos on Rhodes erected a stele in their Temple of Athena, detailing dedications made there, starting with that of the eponymous founder of the city back in the dim and distant past, through to Philip V (king of Macedon from 221 to 179 BCE), together with four epiphanies of the goddess.[137] It is not just the list's early cutoff point that is interesting. This is not an inventory so much as an act of reconstruction or of historical research:[138] most of the objects listed were lost long ago, some of them in a fire in 392–391 BCE.[139] In fact, it is not them but their presence in texts that is recorded, the explicit referencing of the authors of these texts bearing witness to the objects' reality, just as it bears witness to Athena's appearances. And it is the bearing witness that is crucial—the witnessing of the sacrality that comes of dedication, and the witnessing of the scholarship of those charged with the list's compilation. No stone is left unturned. Although the following entry is rare in giving as much iconographic detail as it does, evoking the exquisiteness of the workmanship by intimating that Daedalus might be its maker, the cost of an object (its weight in silver or gold) is no longer enough for it to qualify:

Φάλαρις ὁ Ἀκραγαντίνων τυραννεύσας κρατῆρα, οὗ ἐτετόρευτο ἐν μὲν τῶι ἑτέρωι μέρει Τιτανομαχία, ἐν δὲ τῶι ἑτέρωι Κρόνος λαμβάνων παρὰ Ῥέας τὰ τέκνα κ[α]ὶ κ[α]ταπείνων, καὶ ἐπὶ μὲν τοῦ χείλευς ἐπεγέ[γρ]απτο· "Δαίδαλο[ς] ἔδωκε ξείνιόν με Κωκάλωι", [ἐπ]ὶ δὲ τᾶς βάσιος. "Φάλαρις ἐξ Ἀκράγαντος τᾶ[ι Λι]νδ[ί]αι Ἀθάναι", ὡς ἀποφαίνεται Ξεναγόρας ἐν τ[ᾶι] Α τᾶς χρονικᾶς συντάξιος.

Phalaris, the tyrant of the Acragantines: a crater, on one side of which had been embossed a Titanomachy, on the other Cronos taking his children from Rhea and swallowing them. And on the rim had been inscribed, "Daedalus gave me as a *xeinion* or guest-gift to Cocalus," on the foot, "Phalaris from Acragas to Lindian Athena," as Xenagoras displays in the first book of his *Annals*.[140]

The criteria for inclusion have changed. The world has changed. Here a tyrant renowned for his cruelty is recorded dedicating a suitably violent vessel and one with an interesting object biography (claiming to have been given by Daedalus to King Cocalus of the Sicels in return for the hospitality given him after his flight from Crete to Sicily and the loss of Icarus).[141] It is not the only object with an interesting pedigree: the skilled archer Teucer presented the quiver of another of the *Iliad*'s great bowmen, Pandarus.[142] The other dedicants include Cadmus, founder of Thebes, Daedalus's Cretan host, Minos, Hercules, Hercules's son and founder of Pergamum, Telephus, Menelaus, Helen, Alexander, and Ptolemy, in testimony that gobbles up mythology and geography, while the Persian wars are referenced both in the object list and in the first epiphany. Lindos, keen to assert its independence in the face of Rome's ascendance, and fluent in modes of expression and exegesis learned from its contacts with Alexandria, Pergamum, and dynasties beyond, takes refuge in the past, writing an epitome of Greek history that makes all of it, and Athena, theirs, and puts them at the center of the universe. That so many authorities are cited underlines that its

contents are a microcosm, too big by far to have been cataloged first time round by a Callimachus. These contents are now being written up into a "virtual collection" that makes them more than votives.

Learning to Look

Art encourages, if not demands, a certain kind of looking. So far, the "hellenistic gaze" has been cashed out as competitive and clinical, but this is to underestimate the subjectivity involved in any act of classification. As Neer has recently stressed in connection with today's tensions between "archaeological" and "art historical" approaches toward material culture, the "dichotomy of style *versus* substance is at best a half truth." Absolute chronology "*just is* a chronology of styles."[143] So too, in antiquity: the hellenistic period's emphasis on empiricism could be neither lived nor taught without it sliding into "remarkable descriptive intimacy."[144] Once there was competition to take ownership of the cultural record, to "read in," and to display this proficiency to the world, then there was also a greater premium on expressing opinions and feelings.

Perhaps the most intimately descriptive are the epigrams of Macedonian poet Posidippus, who adopts a playful stance toward inventories and the work of "number obsessed, factoid-blind antiquarians,"[145] taking the lead from treatises such as Theophrastus's *On Stones*, to produce his own dazzling λιθικά or poems "on stony things."[146] These are but one group of his poems to be preserved in a papyrus published in 2001, the others including categories already familiar to us from Polemon, "dedications," "epitaphs," as

well as epigrams "on statue making."[147] Based in Alexandria and active earlier than Polemon, from the 270s to the 240s BCE, Posidippus "penned" particularly intricate images, as much about his literary practice as about gems or bronzes. But they are worth examining here nonetheless, not only because the growing distinction between "literature" and "art," each with its own classificatory structure, raised the issue of just how similar they were, but because the poems conjure a novel aesthetic experience, different from the ecphrases of the epic tradition, and the "new epic" of Callimachus.[148]

The opening lines of the first poem in the "statue" collection collapse its readers with statue-makers, urging them to imitate the new, naturalistic statues of Alexander's court sculptor, Lysippus, and to innovate.[149] This is bold stuff—bolder than the instruction that the female poet Nossis issues to her female readers at the start of the third century BCE, to go with her to the temple to see (ἐλθοῖσαι ποτὶ ναὸν ἰδώμεθα) how cleverly crafted its Aphrodite statue is.[150] It asks them not only to put themselves in sculptors' shoes but to imitate (μιμ[ή]σασθε) one particular sculptor, whose own work was famed for its artistry over its "mimesis," for making men not as they were but as they appeared to be.[151] In this way, the art of sculpture is put under the microscope ("you do this" lending the author an authority denied by Nossis's cajoling jussive), and the relationship of art to life is theorized from the outset. With Lysippus as measuring stick, a roll call of fifth-century sculptors, including Polyclitus, Myron, and Cresilas, attests to a canon of sorts, and their weighting to a history of art of the kind that we see played out

retrospectively in the descriptions of the competitions at Halicarnassus and Ephesus.[152] Although Athens's philosophers had been known to express a preference for one sculptor or painter over another, this was in the context of discussing wisdom, beauty, character, and so on; Posidippus's epigrams are revolutionary.[153] Commentaries on his poetic project they may be,[154] but like Nossis's poem, they also inspire us to see objects differently; to look, and look again in detail, and "intently from nearby" (ἐγγύθεν ἄθρει), within a framework of relative value.[155]

Posidippus's *Lithika* pushes this observatory imperative by concentrating its, and its readers', energies on stones, many of them tiny, incised gemstones. Taking a gem per poem, the anthology works a bit like the Lindian Chronicle to create a collection of written objects from as far afield as India, Persia, Greece, myth and history—an imaginary jewelry cabinet or "daktyliotheke" of the kind that the Ptolemies probably owned for real, structured in such a way as to celebrate their dominion.[156] One by one, Posidippus "treats the stones he describes with the loving connoisseurial caress of the expert gem-handler,"[157] delighting in their materiality, shine, and surfaces with a sensuousness normally reserved for epiphanies of the immortals. We see, we touch, we almost taste:

ἐξ Ἀράβων τὰ ξάνθ᾽ ὀ[ρέων κατέρ]υτα κυλίων,
εἰς ἅλα χειμάρρους ὦκ᾽[ἐφόρει ποτα]μὸς
τὸν μέλιτι χροιὴν λίθ[ον εἴκελον, ὃ]ν Κρονίο[υ] χεὶρ
ἔγλυψε. χρυσῶι σφιγκτ[ὸς ὅδε γλυκερ]ῆι
Νικονόηι κάθεμα τρη[τὸν φλέγει, ἧ]ς ἐπὶ μαστῶι
συλλάμπει λευκῶι χρωτὶ μελιχρὰ φάη.

Rolling yellow [rubble] from the
 Arabian [mountains],

the winter-flowing [river] quickly
[carried] to the sea
the honey-coloured gem engraved
by the hand of Cronius.
Mounted in gold [it lights
up sweet] Niconoe's
inlaid necklace, as on her breast
the hue of honey glows with the
whiteness of her skin.[158]

As we read, we see the gem literally take shape before us, from earth, to engraver, to metalworker, to its home on the human body, where its primary function is to turn a girl into a goddess. The name of the artist is also supplied, a name that means "of Cronus," a Titan born of Earth and Sky, and one that, therefore, puts more emphasis still on the act of creation.[159] But not in an overly technical sense as we get in anecdotes about the processes and perception of painters Zeuxis, Parrhasius, Apelles, and Protogenes.[160] The gem is heavenly, and its impact its color and luster. We are a million miles from this chapter's starting point: were the Charioteer's accompanying epigram written in this climate, his eyelashes would not go uncelebrated.

How far down the social ladder did this aesthetic consciousness extend? Certainly sumptuary legislation attempted to define the limits, protecting people from luxury while maintaining, if not increasing, its cachet.[161] By the time we get to the Roman empire, such was the allure of luxury items that nonelite aspiration for these objects did more than almost anything else to turn a love of painting and sculpture into an art market. But what about the world outside the walls of the hellenistic palaces? As far as the silent majority was concerned, was visiting a sanctuary really any different in the third century BCE from in the fifth century BCE? Theocritus and Herodas suggest that it was, each of

them staging an encounter between a pair of female friends, and artifacts in a sacred setting.[162] For all of the artifice of these scenarios, and the humor generated by putting the latest "realism" debates into unschooled, or "naïve,"[163] mouths, their interactions help us realize the implications of the changes.

For the women in the Sanctuary of Asclepius in Herodas's fourth *Mimiamb*, the most important "critical term," if we can call it that, is the statues' beauty.[164] "Oh what beautiful statues," cries Phile to her friend, as though the delight or pleasure at the very root of the word for statue (ἄγαλμα) is not enough.[165] She hopes that the sculptors are blessed for their "beautiful work" and later exclaims, "you would say that Athena carved such beautiful things."[166] When her companion, Cynno, offers to show her something else, it too is "beautiful," this beauty residing, to a large extent, in its novelty.[167] Innovation is key even here, and exegesis. Oohing and aahing is not enough—or perhaps it is too much: in admiring the tapestries in the Ptolemaic palace at Alexandria, Theocritus's women are told to shut up.[168] When Phile asks about the sculptor and the dedicator of a statue, she is instructed to look at the base, or to "read the label."[169] Its makers are none other than Praxiteles's son, Cephisodotus the younger, and his brother.[170] Apelles is the only other maker to be name-checked.[171]

What these women see, and how they see, is indicative of the disembedding identified in this chapter. Worrying about just how crude their responses are both is and is not worth our while: *everyone's* subjectivity and taste began to be questioned in the hellenistic period, or rather the subjectivity of viewing and the question of how statues and paintings affected (where religious viewing stopped and other

kinds of viewing started) were put on the agenda in a way they had not been before, making it increasingly difficult to look at anything without expressing an opinion and an opinion informed, consciously or not, by a live discourse. Just how much appreciation is too much appreciation remains a live issue as we head into Rome.

What is worth pausing over for a moment, however, is what attracts the women's attention: first, a statue of a girl, then that of an old man, and then that of a child strangling a goose, versions of which were popular in the Roman period (2.19).[172] Subjects of these kinds, subjects that, like Herodas's portraits of Phile and Cynno, privilege "being human" over "being perfect," are emblematic of sculpture conceived in the hellenistic period, to be explained less by Alexander's conquests and the court societies that followed in his wake than by the kinds of theorization of sculpture's relationship to real bodies (writ large in Posidippus's picture of the tiny gem against female flesh) that the intellectual communities bolstering these societies

encouraged. The popularity of these subjects, and their gritty appearance that left even Lysippus in the shade, further contributed to making fifth- and fourth-century Greek sculpture classical, and this classical sculpture "art"ful, giving the Romans more options than Mausolus, or even the patrons of the Pergamene altar, could have dreamed of, and making style speak more loudly than ever.[173] As the Romans blended from these palettes, and made this chapter's material, and debates about this material, their own, they put their gloss on Greece's cultural production—a gloss that is impossible to remove. That said, the sorts of scholarly objection that maintain that booty was just that—booty, a temple's contents simply "gifts to the gods," and Polyclitus a better sculptor than his fourth-century successors—do not go away.[174] Rome's contribution to the story of classical art is more multifarious than we imagine.

2.19. Child strangling a goose, Roman version of a statue of the third or second century BCE, found in the Villa of the Quintilii, Via Appia, Rome, marble, h 92.7 cm. Louvre, Paris, inv. no. Ma 40. The sculpture was formerly in the Braschi collection in Rome and came to Paris under Napoleon. Photograph: © RMN-Grand Palais (musée du Louvre) / Hervé Lewandowski.

3

Making Greek Culture Roman Culture

The Beginning of the End?

"We are all Greeks. Our laws, our literature, our religion, our arts, have their root in Greece," trumpeted Shelley in the preface to his *Hellas* written in 1821. "The human form and the human mind attained to a perfection in Greece which has impressed its image on those faultless productions whose very fragments are the despair of modern art."[1] Like so many hellenophiles of his generation, Shelley had never been to Greece; the validity of his claims relied on his seeing not like a Greek but like a Roman—on appreciating what Greece stood for, and what had come to stand for Greece, through a largely Roman lens. Thomas Howard's Paros inscription was rare in being bought in Asia Minor;[2] until the nineteenth century, when the Parthenon sculptures and Bassae frieze, and then later the Mausoleum's sculpture, went on display in London, and excavations were carried out on the Athenian Acropolis and at Olympia, Pergamum, and Delphi, most of the excellent marbles that bore witness to Greece's greatness had been acquired in Italy. The "father of archaeology," Winckelmann (1717–68), never reached Greece either. We have already glimpsed him amid the then unknown "Tyrannicides" in the Palazzo Farnese; his formative *Geschichte der Kunst des Alterthums* or *History of the Art*

of Antiquity, first published in 1764, with its historicization of Greek art's perfection, was written and revised in Italian collections, with pieces like the Belvedere Torso as its primary data set.[3] Greek sculpture was Roman sculpture and vice versa.

How did this convergence come about? Eventually, and increasingly with its translation into French and Italian, the impact of Winckelmann's historicism would demand that Greek and Roman sculpture be more strongly separated. This is not to say that there had not always been a space for Roman sculpture: the Tyrannicides' spell as gladiators confirms that.[4] Rather it is to admit that for centuries, many of the finest ancient statues in Italian collections had been identified as the products of Greece and that this would come to an end,[5] condemning Rome's imitation of Greek culture as bad, and its own nonclassicizing style (in particular the late antique, the frontality and schematic nature of which shares a lot with sixth-century BCE, "archaic" style) as less admirable still. The first question for this chapter is, when did Rome's absorption of Greek visual culture begin? And second, what did this do to Roman culture, and to Rome? When did it become possible for Greek sculpture to be Roman and Roman sculpture Greek?

These questions differ from anything we have asked thus far: whereas Attalid

and Ptolemaic investment in Greek culture found its legitimation in Alexander the Great's legacy, Rome was an outlier, which, for all of its debt to Troy, defined itself *against* Greece. In fact, Rome's appropriation of the Trojan prince Aeneas happened relatively late and intensified with the broader appropriation of Greek cultural forms that came of its expansionist drive eastward in the third century BCE.[6] It was driven by suspicion as much as anything else, and this suspicion did not fade overnight. Far from it. As Rome won military success, the attraction of the spoils that came with it threatened traditional *grauitas* and self-control, tempting Romans to express their wealth and discernment in ways that challenged their identity as Romans. In light of these challenges, the question of "when" was inevitably loaded.

In one sense, of course, it is a nonquestion. Greek visual culture, the image of Aeneas included, had long been part of the Italian landscape; many of the artifacts from Latium and Etruria made in or before the third century BCE would not exist were it not for contact with the mythology and iconographies of the Greek mainland and southern Italy's Greek colonies; many of our most impressive sixth- and fifth-century Athenian pots were discovered in Etruscan tombs and, until the third quarter of the eighteenth century, were thought to be Etruscan-made.[7] Etruscan elites too found that there was prestige to be won in displaying an affinity with hellenic forms, just as there was advantage to be gained from sending delegations to, and making dedications at, Delphi.[8] As far as Roman elites are concerned, their wrinkled, "veristic" portraits might make them appear distinctively serious (3.1), defining them as a hardworking group, whose cursus honorum

or civic career structure privileged age and experience and set them apart from Greek heroism with its "live fast, die young" ethos, but the character of these portraits was as dependent on hellenistic style as it was divergent from Alexander's youthful idealism. It would have been inconceivable had Rome not been a hellenistic superpower.[9]

But it is a giant leap from any "anxiety of influence" that this might cause, the oddity, for example, of seeing a Roman general playing at dressing up, his veristic head perched indecorously on a princely hellenistic torso,[10] to the Principate. There, the Roman ruler and moral exemplar, Augustus, can be given smooth, ageless features that blend, imperceptibly almost, with the body of Polyclitus's Doryphorus (1.5 and 3.2),[11] a statue now able to represent Roman soldiers as well as Greek athletes,[12] and reproduced in Italy for its own sake. There too, the Senate can honor Augustus with the Ara Pacis or Altar of Peace, the design and frieze of which pay a debt to the Altar of the Twelve Gods in the northwest corner of the Athenian agora and to the Parthenon (9.1).[13] How did the classical language of art come to be this natural?[14]

Fast-forward a century or so and many a would-be Virgil is writing in Greek, and Augustus's imperial successor Hadrian, now renowned for being a hellenophile, decorating his Tivoli villa east of Rome with versions of Praxiteles's Aphrodite of Knidos (4.11), Myron's Discobolus (1.15), the Amazons from Ephesus,[15] the "caryatids" from the Erechtheum in Athens (4.6), not to mention portraits of his young Greek lover, Antinous, whose features are exaggeratedly classical and clothes sometimes stereotypically Egyptian (3.3). This exoticism, and the statues of Egyptian priests and gods that accompanied him, remind us that Ptolemaic

culture, if not the visual culture of Egypt more broadly, asks to be integrated into this classicism palette.[16] Bar an interlude in the late third century CE, when the division of the empire into four created a need for a new language of power, classicism remained the dominant language, surviving the more "abstract," "symbolic" tendencies of the medieval and Byzantine periods.[17]

The ethical implications of this journey, its corruption of Roman mores and of what it meant to be a good Roman man (not slugging it out on the battlefield or in the law court so much as displaying one's artistic credentials in a cultivation of leisure or "otium"), mean that Rome's intellectuals constantly revisited it in their writing, attempting to pinpoint a precise *terminus post quem*, and turn the steady drip of external inspiration into something more cataclysmic—east meets west, a finger-wagging moment. The triumphal processions of the past (3.4), which had ostentatiously brought artifacts from Sicily and the eastern Mediterranean to Rome and then distributed them in public venues throughout the city, were an easy target, as generals such as Mummius and Marcus Claudius Marcellus competed with each other, retrospectively, for the accolade of introducing Rome to unimagined luxuries, of creating Roman taste, and, with it, connoisseurship, and of polluting, as well as prettifying, city, home, and garden.[18] If today's classical archaeologists are obsessed with when "art," and its problems, were invented, it is, in part, due to this moralizing discourse.

It is this moralizing as much as it is any ancient art-writing proper that puts classical art on the map as classical "art." The elder Pliny, as we shall see later, combines both. His *Natural History* and other Roman literature has been more influential than

3.1. The Tivoli General, first century BCE, found in the Sanctuary of Hercules Victor, Tivoli, marble, h 186.5 cm without base. National Museum, Palazzo Massimo, Rome, inv. no. 10653. Photograph: C. Faraglia, Neg. D-DAI-ROM-32.412.

3.2. Statue of Augustus, of contested date (perhaps c. 15 CE, after a model of c. 19 BCE), ascribed to the Villa of Livia at Prima Porta, marble, h 203 cm. Vatican Museums, inv. no. 2290. Photograph: akg / Bildarchiv Steffens.

3.3. Antinous from Hadrian's Villa at Tivoli, traditionally dated 130–38 CE, marble, h 241 cm. Museo Gregoriano Egizio, Vatican, inv. no. 22795. Photograph: akg-images / Album / Oronoz.

For Plutarch, writing toward the end of the first century CE, it was Marcellus's return to Rome after his capture of Syracuse in 212–211 BCE, and his lesser triumph or "ovation," that marked this turning point. Before this, "Rome neither possessed, nor knew about, refined or extravagant things, nor loved sophistication or elegance."[19] If anything, the city looked like a battlefield. But afterward, it was "ordered," adorned "with spectacles pleasurable to look at, things that had Greek grace and naturalism."[20] Not that this was universally positive. The masses liked it, but the senators thought that he should have left the statues of gods where they were; that their transportation to Rome made it a city ἐπίφθονον or "prone to jealousy."[21] While Marcellus boasted that he had "educated the Romans to revere and marvel at the beautiful and wonderful productions of the Greeks,"[22] the establishment bridled at people prattling about art and artists, wasting their days on "pretentious babble."[23] Livy too had seen Syracuse as the start of Rome's admiration for Greek art and an invitation to despoil "everything, sacred and profane."[24] Bringing beautiful things to Rome was a double-edged sword even, if not especially, in Livy's day, when Greek pedimental sculpture and Egyptian obelisks were being uprooted from their temples and shipped across the Mediterranean to be the scaffolding for Augustus's stage set (3.5).[25] For these to be "art," not building blocks, their appeal had to be infectious.

Infections breed paranoia. Elsewhere, Livy points the finger at Cnaeus Manlius Vulso's Asian victories of 187 BCE for being the "source of foreign luxury," introducing bronze couches, and other luxurious furniture and fabrics, and, thus, sowing the "seeds (*semina*) of future luxury":

any material culture, even the sculptural assemblage from Hadrian's Villa, in dictating what Greek artifacts meant to the Romans and what Greek and Roman artifacts mean to us. After the "watershed" moment somewhere in the Republic, Romans, and anyone following in their footsteps, are not simply interacting with Greek culture. They, and they alone, own, and are owned by, Greek culture and its competing "classicisms," gradually fashioning it into merchandise. From then on, the sculpture and painting of the past are more than mimetic, expressive, emotive, or political. They are "property of Rome," to be used for competitive gain internally, and externally, as part of a discourse of empire that, at its height, embraces Greece, Asia Minor, Syria, Egypt, Northern Europe, and Britain; a process that hones the classical in dialogue with the provincial.

3.4. Andrea Mantegna, *The Triumphs of Caesar: The Bearers of Standards and Siege Equipment*, c. 1484–92, tempera on canvas, 266 × 278 cm. Lower Orangery, Hampton Court Palace, London, inv. no. RCIN 403959. Photograph: Royal Collection Trust / © Her Majesty Queen Elizabeth II 2016.

luxuriae enim peregrinae origo ab exercitu Asiatico inuecta in urbem est. ii primum lectos aeratos, uestem stragulam pretiosam, plagulas et alia textilia, et quae tum magnificae supellectilis habebantur, monopodia et abacos Romam aduexerunt . . . tum coquus, uilissimum antiquis mancipium et aestimatione et usu, in pretio esse, et quod ministerium fuerat, ars haberi coepta. uix tamen illa, quae tum conspiciebantur, semina erant futurae luxuriae.

For the origins of foreign luxury were brought into the city by the army from Asia. Those men, for the first time, carried into Rome bronze couches, expensive throws, curtains and other textiles, and what then was regarded as great furniture, one-legged tables and sideboards. At this time, cooks, whom the ancients had considered the basest of slaves, both in terms of what they thought of them and how they treated them, gained in value, and what had been labour began to be considered art. Yet those things that were then looked at with admiration were barely even the seeds of future luxury.[26]

3.5. Greek Amazonomachy figures, fifth century BCE, marble, resituated in the Augustan period in the pediment of the Apollo temple of C. Sosianus, Rome. Musei Capitolini, Centrale Montemartini, Rome, Sala Macchine. Photograph: Archivio Fotografico dei Musei Capitolini, photo Zeno Colantoni, © Roma, Sovrintendenza Capitolina ai Beni Culturali—Musei Capitolini.

Luxury "invades" like a foreign foe, bringing mutant tables with it, as these and other everyday items, cooks included, are converted from objects necessary to live to markers of an affluent lifestyle. Who is to say where this madness will end, except in the dissolution of empire? Livy is as scientific as he is inflammatory—all of this was but the *semina* of an engorged aesthetic.

Pliny agrees about the dining couches but attributes Rome's penchant for other kinds of bronze and fine paintings to Mummius.[27] Mummius himself had been immune to this contagion, still so "rudis" or uncultivated when he captured Corinth in 146 BCE that he had reputedly told his men that if they lost any of the sculptures or paintings, by "the greatest artisans" no less, they would have to replace them with new ones! Again the Augustan author who tells us this, Velleius Paterculus, cannot resist a sideways swipe at what he sees as his contemporaries' excessive interest in Greek production: perhaps Mummius had it right after all—it would be better if everyone were ignorant ("rudis" again)

of Corinthian art. Lack of foresight was more beneficial to the public than what currently passed for "intelligence."[28]

Velleius raises a laugh from his readers, only for the joke to be on them; it is his readers whose pretentions need puncturing. Like Livy and Plutarch, his account is less about the origins of art than about where Rome in the first century CE had gotten; and enables a reassessment of how it is that the modern man was obsessed with sculpture and Velleius's emperor, Tiberius, so enamored of Lysippus's Apoxyomenos (the Scraper), a statue of an athlete cleaning himself after exercise, as to try snaffling it from public view into his bedroom (3.6).[29] What constitutes good practice? Marcellus is less admirable than Fabius Maximus, who is credited with hesitating, as he hesitated in everything else, in taking statues from Tarentum when he recaptured it in 209 BCE.[30] But Marcellus, Mummius, Scipio Asiaticus, and other Republican generals are paragons of virtue compared to Sicily's corrupt Roman governor Gaius Verres, who was prosecuted by Cicero in 70 BCE and

harried into exile: anything they took from these very beautiful and highly embellished cities, they redisplayed publicly for all to appreciate.[31] And not only in Rome: Mummius dedicated Aristides's painting of Dionysus, which he had held onto in the face of King Attalus's interest, in the Temple of Ceres on the Aventine, but other spoils in Italy and the western provinces and in the Greek East.[32] Pausanias claims that Mummius kept the most admired artifacts for the Romans, but gave those with less of a reputation to Attalus's general, and that there were still Corinthian "spoils" to see at Pergamum in his day.[33]

Back in the Republic, as Pausanias's vocabulary underlines, these spoils were simply that—"spoils" (λάφυρα)—and generals operating within parameters "refined" over decades of sacking cities such as Veii, and distributing booty to soldiers, state, and gods.[34] As Cicero emphasizes in attacking Verres, Publius Servilius Vatia Isauricus (c. 122–44 BCE) captured the Lycian city of Olympus, and then entered the statues and other trappings that he had taken "in accordance with the rights of war and his powers as general" in the public accounts of the Treasury.[35] But this had long since stopped being the full story, if it had ever been the full story. In 168 BCE, after his victory at Pydna, Roman general Aemilius Paullus had embarked on a tour of Greece, taking in the centers of Delphi, Athens, and Olympia, with the brother of Attalid king Eumenes II (r. 197–159 BCE) as his guide.[36] Although Livy's emphasis is largely on Paullus's piety, he does highlight the antiquity of Athens with its statues of gods and mortals, "extraordinary for their varied materials and artistry," and bases his account on that of Paullus's contemporary Polybius, who had also

3.6. The Apoxyomenos, Roman statue found in Trastevere, Rome, after a work by Lysippus c. 320 BCE, marble, h 205 cm. Museo Pio-Clementino, Vatican, inv. no. 1185. Photograph: © Hirmer Fotoarchiv, 671.9292.

stressed the act of viewing.[37] Paullus's tour is, and always was, as much about the power of Greek heritage as about the power of empire. By the time we get to Plutarch, in a passage we have already met, he can pun on how λάφυρα (spoils) have become something γλαφυρόν (elegant).[38]

This discourse demands the category of "heritage" and is itself spurred by the need for atonement: cultural heritage is here the flipside of "art," a counter-acknowledgement of the value of material inheritance. In Polybius's eyes, what the Romans did in despoiling Syracuse was, on balance, a mistake; in the eyes of Livy's Cato, the irresistible allure of its artifacts brought disease (*pestes*) in its wake,

undermining the terracotta antefixes of Roman gods, and making people greedy.[39] Corruption of this magnitude risked the health of the empire, yet made it what it was; it stripped Greece bare, yet clothed it in glory. We saw nothing on this scale in the classical or hellenistic world: inventiveness or genius is now prodigal,[40] and the challenges to nature offered by sculpture and painting not just obfuscating of truth and corrosive of reason[41] but threatening of humanity. Take Vitruvius on the wall painting of the Augustan period, the grotesquerie of which he sees as indicative of a culture that was now pernicious.[42] Once the floodgates were opened, all artifacts were potentially as polluting as each other: according to Pliny, the worst crime against mankind was committed by the person who first wore gold on his fingers.[43] Herodas's women are naïve in comparison. Despite its politics, his and Posidippus's poetry is rarefied, overly concerned with its status as literature.

If hellenistic poetry establishes a model of art history as ecphrasis (by which I mean the art of conjuring objects in words), and Pliny's *Natural History*, via Renaissance writer Giorgio Vasari, a model for periodization and artist-centered study, then Livy and his fellow historians give us something closer to a social history of art, one that redirects the "what is good art?" question to position authorship and aesthetic responses within a more pervasive web of value that asks "what is art good for?"[44] A closer look at their descriptions of triumphal processions sees them put further distance between early Republican and modern Roman perspectives by favoring quantitative accounting over qualitative description, and of a kind familiar to us from temple inventories. Livy's report of

Titus Quinctius Flamininus's three-day triumph after victory over Macedon in 194 BCE is a case in point.[45] On day one, there were arms, weapons, and unidentified statues of bronze and marble; on day two, gold and silver, the unwrought silver alone amounting to 43,270 pounds in weight and the wrought silver including vases of "outstanding workmanship," bronze vases, ten shields of silver and one of gold, more gold (3,714 pounds of it to be precise), and piles of coins (84,000 silver Attic coins and 14,514 gold coins); and on the final day, 114 gold crowns, captives, soldiers, and prisoners. Even in descriptions of Marcellus's ovation, the statues are merely "renowned" (nobilia)—perhaps so renowned that any more information was otiose. The Syracusan and Spaniard who aided the Roman cause were, if anything, a bigger spectacle.[46]

We are a long way, rhetorically, from the crates that will carry tens of the most iconic classical sculptures, with an already elaborate art history, from the Vatican collection in Rome to Paris in 1797–98 under the conditions of Napoleon's Treaty of Tolentino (4.1), each wagon loudly labeled with its artworks—the "Dying Gladiator," "Laocoon," and so on.[47] If there was an iconic artwork in Pompey's triumph over Mithradates in 61 BCE, perhaps even more iconic than the solid gold colossus of the defeated dynast, then it was the portrait of Pompey made out of pearls.[48] Most of the artifacts in these processions are said to have been brought in χύδην, to use Josephus's word, "promiscuously or indiscriminately heaped up" or "poured forth in floods," as one would expect of a contagion.[49] They were commodities on a conveyor belt of countless wagons.[50] And when there is archaeological evidence to support their

display in Republican Italy, their inscriptions are simple—"L. Mummius, son of Lucius, consul," or "M. Fulvius, son of Marcus, grandson of Servius, consul, took [this] from Aetolia"—different in emphasis from the statue bases of the spolia at Pergamum that named the statues' makers.[51]

This is not to say that there were not famous statues by famous makers among them—not least the bronze Granicus group of Alexander and his twenty-five companions made by Lysippus, brought to Rome by Quintus Caecilius Metellus in 146 BCE, and installed opposite the temples in the Porticus Metelli.[52] But it takes some special pleading to assign him and his fellow generals similar motivation to Renaissance collectors, or museum curators.[53] Pliny notes simply that the group was transferred to Rome by Metellus, but is silent about why, or about where he placed it. Although keen to convey the location of other famous works, when he organizes these by category, it is by material, and after that, more often by artist than by display space or patron.[54] The closest he comes to crediting anyone with a unified, aesthetic vision is in his description of the statues in the library and art gallery of the Atrium Libertatis, where their benefactor, Gaius Asinius Pollio (76 BCE—4 CE) is an "ardent enthusiast" (fuit acris uehementiae) who wants his "monuments looked at" (spectari monumenta sua uoluit).[55] In sum, Pliny produces an "inventory of Rome's possessions,"[56] not an inventory of collections.

Pliny's "inventory," however, is itself a watershed, distilling thousands of facts into a schema, the overarching principal of which is nature[57]—hence the discussion of sculpture and painting under the headings of "bronze," "pigments," and "stones." His is not a work about "seeds," but about avowedly "sterile matter," a reappraisal no less of the raw materials that make up life itself: "my subject is a barren one, the nature of things; this is life."[58] In this reappraisal, any objects that have made their way to Rome are no longer an amorphous haul but a "survival of the fittest," great for intrinsic qualities that they owe to their fabric and their skilled fabrication—so Asinius Pollio's sculptural group of Dirce by second-century BCE Apollonius and Tauriscus (the same type, if not the same sculpture, as the Farnese Bull, found in the Baths of Caracalla in the sixteenth century [3.7]) is said to be carved from a single block of marble, like the Laocoon (6.1), which is itself "to be preferred to any bronze or painting."[59] These manufacturing details give the visual arts a sense of natural progression.

Pliny is not the first to show an interest in artists. As he himself notes just a few

3.7. The Farnese Bull, as captured by Dutch printmaker Antoni Zürker (1765–1837), etching on paper, 192 × 111 cm. Rijksmuseum, Amsterdam, inv. no. RP-P-1907–4954. Photograph: Rijksmuseum, Amsterdam.

sentences later, the Greek sculptor and metalworker Pasiteles, whose own classicizing work was highly praised in Rome, had, toward the close of the Republic, produced a five-volume treatise on the world's "nobilia opera" or masterpieces.[60] And there was also Xenocrates and his hellenistic contemporaries, not to mention the anonymous papyrus known as the *Laterculi Alexandrini*, dated to the second century BCE, and listing representatives of various fields including "law givers," "cult-statue makers," and "statue-makers."[61] Only Pheidias, Praxiteles, and Scopas make the grade in the second of these categories, and Myron and Polyclitus in the third. But, unlike Pasiteles and Xenocrates, Pliny was neither art-critic nor practitioner, but a physician almost, whose "elevated" and "laborious" task it was to heal, or impose order on, chaos, deploying Latin criteria such as "diligentia" or "carefulness,"[62] and bringing "novelty to antiquities, authority to novelty, brilliance to the mundane, light to the obscure, refinement to things now vilified, and credibility to things in doubt"; and all in service to the Flavian empire.[63]

If it is Roman artists one is after, Pliny's *Natural History* disappoints. But even if his sources are partly responsible for the bias, the fact that the history of sculpture and painting is a history of Greek sculpture and painting is now inscribed forever, with fifth- and fourth-century exponents such as Apelles immortalized as the best at what they did, not only because of their outstanding work and their influential position at Alexander's court, but because of their contribution to art theory. As Pliny is quick to point out, Apelles too had published volumes on "doctrina," rated himself vis-à-vis his chief competitors, honed his skills by actively soliciting criticism, and engaged

fellow painter Protogenes in a competition of a kind that rarely happened in public.[64] In other words, he had perfected art— hence perhaps Pliny's notorious claim that "ars" "came to an end" or "reached its full potential" at the start of the third century BCE.[65] There was nowhere for it to go but downhill, to be rediscovered by Pasiteles and pupils in the centuries following Marcellus and Mummius's triumphs. As this was happening, however, the pressures of civic duties and business dealings meant that art-historical knowledge was too readily lost and the makers of sculptures (even makers as important as Apelles) forgotten: was the Niobid group in the Temple of Apollo Sosianus by Scopas or Praxiteles?[66] Rather than call a stop to art, Pliny legitimizes connoisseurship. Without him, Napoleon's men would not have labeled the crates nor Laocoon received so much attention.[67]

Managing the Legacy

As we proceed through this book, we shall witness these dual ideas of connoisseurship and corruption repeatedly reinforcing each other. But for the moment, it is important to step, if not outside rhetoric, for that is impossible, then onto terra firma so as to think a bit more about what Rome's engagement with Greek sculpture and painting looked like "on the ground." For all that victorious generals had a responsibility to put their booty on public display in porticoes, temples, and public gardens (Marcellus supposedly keeping but one celestial globe for himself),[68] and any booty pinned as a trophy to the facade of Rome's atrium-houses remained with the house if the owner moved,[69] Verres and Tiberius were not the only ones to pilfer Greek

artifacts for their private spaces and personal gratification. In the second century BCE already, the elder Cato had complained about Romans displaying cult images in their homes and treating them as part of the furniture.[70] Short of all-out rejection, this adoption was an inevitable response to "the shock of the new," or at least a necessary response, if conditions were to be ripe for Augustan classicism. And it was a corollary of a climate in which, as we have seen, makers such as Polyclitus and Scopas already had special status. Although he talks about them in the most general terms, Livy tells us that such was the superiority ("excellentia") of the various works dedicated by Marcellus in the restored Temple of Honos with its new shrine to Virtus outside the Porta Capena that foreign visitors stopped to admire them. So few of them were visible in Livy's day that the implication is that most had been stolen.[71]

Centuries later, US oil magnate J. Paul Getty (1892–1976) imagines that one of the star attractions of his antiquities collection in Malibu, the Roman Lansdowne Hercules (3.8), is an original Greek statue, bought on the ancient Roman market after Mummius's sack of Corinth and displayed in the Villa of the Papyri in Herculaneum before being sold to Nero, and passed on, eventually, to Hadrian, at whose villa it was actually discovered. It is a nice story that attests to the premium of Greek art over Roman art even in the 1950s.[72] Yet the amount of fifth- and fourth-century Greek sculpture found in Rome or in Roman towns is not huge, even admitting of the fact that much of it will have been in bronze and, therefore, ripe for melting down in later periods.[73] For definite domestic contexts, this amounts to a few marble votive plaques and small sculptures in the round, often

of an architectural nature (for example, the fifth- or fourth-century BCE nereids riding on sea monsters, probably from the roof of a Greek temple, found around a pool in a villa complex at Formia [3.9]).[74] There are no large-scale statues that are undisputedly of this date from Vesuvian sites.[75] Even the Villa of the Papyri, where bronze figures have been found in abundance, and Hadrian's Villa at Tivoli eschew fifth- and fourth-century originals: "Hadrian, who in his exalted position might have accumulated originals without incurring the reproach of vandalism contented himself with the acquisition of copies."[76] Did "copies" make better souvenirs? Had the exceptions in Rome's houses arrived on Italy's shores as booty, like the fifth-century figures that from the 30s BCE graced the pediment of the Temple of Apollo Sosianus (3.5)?[77]

The dearth of such statues in Herculaneum and Pompeii is fairly unremarkable: loss and problems of dating the sculpture notwithstanding, these were moderately affluent towns, and the pieces brought back by Mummius, and, later, Sulla, after his sack of Athens in 86 BCE, not an unlimited resource. But the Villa of the Papyri and Hadrian's Villa seem at first sight more surprising,[78] especially given the growth of a thriving art market, and the presence of the Antikythera Ephebe (3.10) and of fourth-century BCE marble votives in cargoes destined for wealthy Roman patrons at the end of the Republic already.[79] Even then, the amount of ancient sculpture on board is swamped by more recent material, made, or so it would seem, specifically for foreign buyers.[80] Some of this recent material copied well-known fourth-century statuary, Lysippus's Weary Hercules included (1.16), but most was more freely classicizing, or later in style.[81] When Cicero wrote to his

3.8. Statue of Hercules (the Lansdowne Hercules), found at Hadrian's Villa at Tivoli, c. 125 CE, marble, h 193.5 cm. Formerly in the collection of the Earl of Shelburne, London, and now in the J. Paul Getty Museum, inv. no. 70.AA.109.1. Photograph: Digital image courtesy of the Getty's Open Content Program.

3.9. Nereid sculpture found at Formia, Italy. Greek, probably fifth or fourth century BCE, marble, h. 119 cm. National Archaeological Museum, Naples, inv. no. 145080. Photograph: H. Schwanke, D-DAI-Rom-66.1807.

friend Atticus in Athens in the 60s BCE about acquiring Greek sculpture for his villa, he was partaking in this trade, and had no problems in distinguishing its ethics from Verres's kleptomania. His impatience is palpable and the outlay considerable: he

pays over 20,000 sesterces for statues. But he too wants herms, bas-reliefs, and puteals of the kind that dominate the wrecks, and not antiques by master craftsmen.[82] He is avowedly not after "pretty little things," but into creating decorous spaces.[83]

Not that Cicero's sense of seemliness is devoid of pleasure, as his use of words such as "delectare" (to seduce) and "uoluptas" (sensual delight) reveals.[84] If this desire to decorate his library is rooted in Aristotelian ideals and Ptolemaic precedent, then its blossoming came in the eighteenth century when aristocrats such as Charles Townley (1737–1805) (7.13) built on his example to adorn their personal libraries with "Greek" sculpture and make them each a "repository for the antique" in the most overarching sense.[85] And as Viccy Coltman in particular has explored, lust and learning were still productive bedfellows then.[86] But the surprise, such as it is, is that Greek sculpture could and should be so decorous in the first place, indicative not of dissolution but of education and sophistication. In the same passage in which Cicero praises Marcellus, Mummius, and Scipio, and damns Verres, he draws attention to the negative pleasure ("uoluptas" again) that comes of "wantonness and desire" (ex libidine et cupiditate).[87] How did the Romans efficiently manage the legacy hard-won from the Greeks?

The answer does not lie in private individuals wrestling each other for ancient "originals," not primarily at least—although, as we shall see presently, Rome was not without an interest in authenticity. Rather it lies in them aping and adapting the Greek sculpture and painting that they saw in public so as to commission "hellenizing" artifacts, the very suffix of which—"-ize"— casts the Romans as creators of their own destiny, while at the same time condemning

the Greeks who worked for them to play to a new tune. The "Greek" in "Greek" sculpture and painting was now no longer a given. It was an accent or a flavor, the intensity of which could be turned up or down depending on the context. From the second century BCE onward, Roman wall painting borrowed elements from hellenistic palace architecture before growing bored with the illusion of marble-clad walls, deploying it instead to open up the space as if onto hellenistic vistas (3.11).[88] And it was not only the most opulent villas that reveled in such whimsy. In Pompeii's House of the Golden Bracelet, a lush garden is depicted populated by a marble-looking birdbath and herms balancing plaques decorated with reclining female figures (3.12). Here, the East and its artifacts are fully integrated, attenuated even to be the "pretty little things" that made Cicero so anxious.[89] The inclusion of theater masks in each painting celebrates the unreality of the scene, and hands its patron the stage management.

"Nilotic" landscapes and other Egyptianizing motifs were part of this importation (or, perhaps better, part of this expanded and expanding hellenistic koine[90]), the former designed to transport viewers out of their everyday Roman world into an Alexandrian idyll,[91] and the latter transplanted from a setting in which they had stood for monumentality and immortality to function as decorative borders, or within fantastical architectural frames of the kind despised by Vitruvius.[92] In a Republican house under the Domus Flavia on Rome's Palatine (3.13), misleadingly now known as the "Aula Isiaca," we find both of these features—a hippopotamus swimming as though in a fish tank, and "situlae" (water jugs), rearing snakes, and other cultic devices replicated to the point of

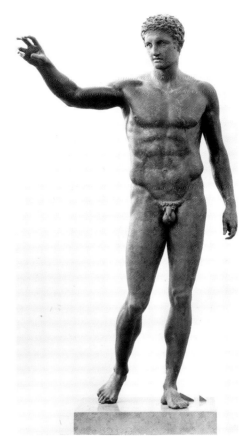

3.10. The Antikythera Ephebe, c. 340–330 BCE, bronze, h 196 cm. National Archaeological Museum, Athens, inv. no. X 133396. Photograph: © Hirmer Fotoarchiv, 654.1896.

redundancy.[93] So too in the Villa della Farnesina in Trastevere, which may have belonged to Augustus's friend and son-in-law Marcus Agrippa. In the wake of Actium, when these scenes were probably painted, the "monstrous gods" had lost their bark.[94]

Did the reproduction of Greek material have a similarly taming effect? In some senses, yes: if the House of the Faun's Alexander mosaic is based on a Greek painting of the third century BCE as many scholars believe (3.14), then its homage turns that masterpiece into a jigsaw made up of more than a million tiny tesserae that attest to the skill and audacity of a new maker and the wealth of a new patron. Set into the floor of an exedra that opened off the first peristyle, the entrance of which was marked

3.11. Cubiculum m of the Villa of P. Fannius Synistor at Boscoreale, 50–40 BCE, as reconstructed in the Metropolitan Museum of Art, New York. Photograph: The Metropolitan Museum of Art, Rogers Fund, 1903, www.metmuseum.org.

by its own Nilotic frame of hippopotamus, crocodile, and other nonnative species (3.15), the mosaic challenges the visitor to cross into its exotic world and to assume the role of victorious general, trampling it underfoot, as some of the men and horses in it are about to be trampled underfoot.[95] Alexander's victories that had so shored up Ptolemaic culture were now shoring up a Roman empire, demanding to be seen from a new perspective. In this process of repackaging, Greek painting is domesticated.

And yet at the same time, the representation of Alexander's battle against Darius is turned from ephemeral hang to monument, and a monument worthy of its own space at

3.12. Section of the garden fresco from the north wall of Oecus 32 of the House of the Golden Bracelet, Pompeii, VI,17.42, mid-first century CE, Antiquarium, Pompeii, inv. no. 40690. Photograph: Sites & Photos / akg-images / Samuel Magal.

3.13. Detail of wall painting in the "Aula Isiaca," Rome. Photograph: akg-images / Album / Oronoz.

that. It is made the "main event" in the same way that in the Villa della Farnesina the major panel paintings in the relevant spaces portray *Greek* myth.[96] In part, Greece's primacy in the villa stems from the fact that Egyptian myth lacked the currency of Greek myth, but it is also because works borrowed from the Greek world came with a kind of kudos that works referencing the Egyptian world could not muster. "References" to Egypt were just that—symbolic elements—whereas references to Greece had a literature. For this reason, few classicists have worried about whether Rome's "Egyptianizing" artifacts are copies.[97] Unlike Alexandrian writers like Callimachus, who were active in the Ptolemaic court and admired by Catullus and his fellow neoterics, there seems not to have been a similar canon of Ptolemaic artists; no Ptolemaic sculptor to equal Pliny's Scopas or Lysippus, hence perhaps the story that Bryaxis made the statue of Serapis.[98] As far as Alexandrian

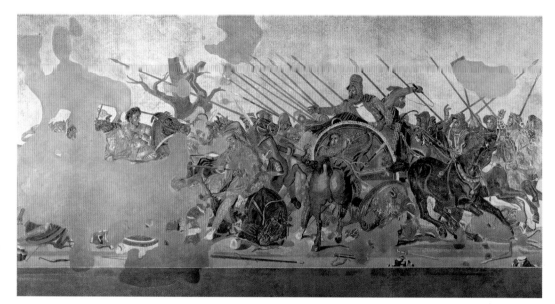

3.14. Battle of Alexander and Darius, House of the Faun, Pompeii, VI,12.2, late second or early first century BCE, 272 cm × 513 cm. National Archaeological Museum, Naples, inv. no. 10020. Photograph: akg-images.

painting is concerned, the Egyptian-born Antiphilus is as good as it gets, and he as much a client of Philip and Alexander as of the Ptolemies.[99] Prior to Ptolemaic rule, the situation was more desperate: in Winckelmann's words, Egyptian art "did not advance much beyond its earliest style, and it could not easily have attained the heights that it did among the Greeks."[100] Plato may have viewed this intransience more positively, but still Egypt lacked a tradition of first-rate practitioners.[101] When an "Egyptianizing"

baboon is carved in the second century CE, probably for the Temple of Isis and Serapis on Rome's Campus Martius, its makers place it not in an Egyptian tradition of craftsmanship, but in august Athenian company by signing it "Phidias and Ammo(nios), [sons] of Phidias made [it]."[102]

It makes sense that in contexts beyond the strictly cultic, Egyptian elements were often "subsidiary focal points," framing devices, or part of Vitruvius's "grotesque."[103] Alexandria was curator of

3.15. Nilotic scene, House of the Faun, Pompeii, late second or early first century BCE, National Archaeological Museum, Naples, inv. no. 10323. Photograph: akg-images / Album / Prisma.

Greek culture, and Rome a rival repository. Alexandria was also, peculiarly, as we saw in the previous chapter, curator of pharaonic culture—something that the Romans would also adapt to their own imperial ends, but which the renown of Greek art and the naturalism associated with it would inevitably keep on the margins. It was one thing for Egypt to be part of a cultural koine, another for it to be part of a visual koine—for a hellenistic koine to be a "classical koine." Chances are that the Greek pedimental figures on the Temple of Apollo Sosianus blended into Rome's visual landscape in a way that obelisks with hieroglyphs, flat figures in pharaonic headdresses and kilts, or indeed any Egyptian element that was not sufficiently hellenic in content or style, did not—that the latter remained productively alien.[104] Hadrian's sculptors used this to Antinous's advantage (fig. 3.3) respelling exoticism as eroticism.

The complementary case of "Egyptianizing art" serves to make the "-ize" in "hellenizing," and the affinity or "becoming" it implies, all the stronger. It matters little that Cicero privileges, or claims to privilege, a sculpture's subject matter over

its authorship or antiquity, that the cargoes of ships wrecked en route to Rome contain few fifth- or fourth-century statues, or that many Roman versions of Greek works are only loosely tied to a source text. That there was a long-standing roll call of ancient Greek artists meant that there was inevitably a "copybook."

Even Latin author Petronius's caricature, the grossly ignorant freedman Trimalchio, has heard of Myron and Lysippus; he expects enough of his readership to recognize that Trimalchio's account of their contribution to sculpture is ridiculous.[105] And Martial can parody a certain Mamurra for criticizing statues by the widely acclaimed Polyclitus.[106] Greek art was "something" in the way that Egyptian was not, and "having a handle on it," as opposed, simply, to owning it, fundamental to a claim to be cultured because of previous investment. Presumably the statues that Martial's Mamurra sees when browsing in the shops of the Saepta Julia are not the genuine article,[107] but they are "Polyclitan" all the same, on the same scale as the Prima Porta statue of Augustus. Each iteration increases the value of the other, making it logical that Romans everywhere should want to work

with this "language." Only some did this by copying exactly: so Pliny tells us how the Neronian artist Zenodorus copies two cups by the fourth-century BCE silversmith Calamis so skillfully that there was scarcely any difference between them.[108] But where was Rome's contribution, or Greece's genius in a case such as this? Other artists preferred to "wander from the originals for the better" so as to showcase their talent and their patron's knowledge.[109] This momentum meant that anyone might give pride of place to a nubile Venus, or a fresco of Medea, whether or not familiar with Praxiteles or the celebrated painter, active somewhere from the third to first centuries BCE, Timomachus of Byzantium.[110]

Configured like this, the preference for "copies," or perhaps better, creative reworkings, of Greek painting and statuary is less remarkable. "Copying" meant "bottling" the essence of hellenic greatness; taking Praxiteles's controversial cult statue from its shrine at Knidos in Asia Minor and reproducing her over and over so as to turn her from deity to celebrity (4.11). Nor is it remarkable that stories about sex with this statue, or about its likeness to the courtesan Phryne, proliferate in the Roman period:[111] these stories do more than meditate on mimesis and the relationship of marble to flesh; they recognize that her availability makes her a prostitute. What *is* remarkable is that Hadrian liked close copies so much as to put his own Knidia in a designated monopterus so as to activate the viewing in the round for which the original was famous.[112] At the Villa of the Papyri at Herculaneum, by contrast, most probably owned by Lucius Calpurnius Piso Caesonius,[113] few of its freestanding sculptures appear to be reproductions of famous Greek statues, the most knowing of these, and the

only one to be signed by its "copyist," in this case "Apollonios" (3.16), a bronze herm of Polyclitus's Doryphorus that castrates it of its contrapposto.[114] What kind of a spear-carrier is this, if not a postmodern one, the presence of the sculptor's name, emblazoned across its chest, pushing the viewer's powers of recognition to breaking point. Without the perfectly proportioned body for which it is famed, Polyclitus's Doryphorus becomes a Roman portrait. Elsewhere in the villa, there were other portraits, some of which scholarship still cannot identify, and children, animals, and deities, including the now notorious Pan having sex with a goat (3.17).[115] Almost all of these are generic pieces, some of them with piping inside so as to function as fountain sculpture. They are less about emulation than imagination, and about creating fantasy spaces and spaces for fantasy.

Homeowners, rich and less rich, deployed different means of controlling the legacy that is Greek sculpture and of asserting their independence (both in relation to it and to contemporary Roman society). Take the Hadrianic townhouse found beneath the Via Cavour in Rome in 1940 where four freestanding marble sculptures were discovered in situ close to their bases, two on either side of two doorways on an important public axis.[116] Three of these sculptures (3.18–20) are immediately recognizable, and presumably would have been in antiquity: a satyr of Praxiteles's Resting Satyr type, and two statues of Pothos (Longing), a type attributed to Scopas. The fourth (3.21), now headless like the first Pothos statue, is a military figure, a later relative of the Tivoli General that we looked at earlier, with a cloak or paludamentum draped from its shoulder. It completes the set of fourth-century body types.[117]

Not that they are a "set" in any strong sense of the word. Perhaps the pair of Pothos statues alludes to the story that Scopas made two versions of the daimon, one for Samothrace and one for Megara, and invites the viewers to flex their optical muscles so as to spot the subtle differences between them in terms of pose, surface, and drapery:[118] postantiquity too, scholars have been divided as to whether both are second-century "copies," or whether the more complete version is Julio-Claudian.[119] Yet the pairing also alleviates the status of either as "masterpiece": their impact is as an ensemble, the exaggerated swing of their hips establishing a replica series that itches to embrace the leaning satyr also. As the eye moves from Scopas's production to Praxitelean production and back again, the unique contributions of the original Greek artists, not to mention the relative merits of their copyists, are subsumed by something more abstract, by shape: no longer is Pothos a personification, and the satyr a Dionysiac creature, but all of them are examples of the young, male, languorous body. The figure of

3.16. Doryphorus herm from the Villa of the Papyri, Herculaneum, bronze. National Archaeological Museum, Naples, inv. no. 4885. Photograph: Koppermann, Neg. D-DAI-Rom-1964.1804.

the general shares in this accolade, his nude torso less the torso of a Marcellus, Mummius, or Aemilius Paulus than a specimen of manhood that begs comparison with the other specimens, his contrapposto with their leanings. And we thought we knew what "pothos," "longing," or "desire" looked like! To think that Scopas had had the last word is to miss the point. Instead, the owner of this house casts the viewer as Paris by

3.17. Pan and goat, Villa of the Papyri, Herculaneum, marble, h 44.2 cm. National Archaeological Museum, Naples, inv. no. 27709. Photograph: akg-images / MPortfolio / Electa.

3.18. Satyr of Praxiteles's Resting Satyr type, from the Via Cavour, second century CE. Musei Capitolini, Centrale Montemartini, Rome, Sala Caldaie, inv. no. 2419. Photograph: Archivio Fotografico dei Musei Capitolini, photo Zeno Colantoni, © Roma, Sovrintendenza Capitolina ai Beni Culturali— Musei Capitolini.

3.19. (Top right) Statue of Pothos, from the Via Cavour, second century CE. Musei Capitolini, Centrale Montemartini, Rome, Sala Caldaie, inv. no. 2416. Photograph: Archivio Fotografico dei Musei Capitolini, photo Zeno Colantoni, © Roma, Sovrintendenza Capitolina ai Beni Culturali—Musei Capitolini.

3.20. Statue of Pothos, from the Via Cavour, probably second century CE. Musei Capitolini, Centrale Montemartini, Rome, Sala Caldaie, inv. no. 2417. Photograph: Archivio Fotografico dei Musei Capitolini, photo Zeno Colantoni, © Roma, Sovrintendenza Capitolina ai Beni Culturali—Musei Capitolini.

3.21. (Bottom right) Statue of a Roman general, from the Via Cavour, second century CE. Musei Capitolini, Centrale Montemartini, Rome, Sala Caldaie, inv. no. 2418. Photograph: Archivio Fotografico dei Musei Capitolini, photo Zeno Colantoni, © Roma, Sovrintendenza Capitolina ai Beni Culturali— Musei Capitolini.

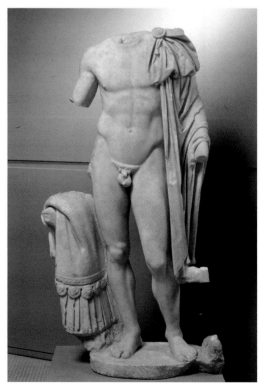

turning the display of Greek sculpture into a beauty contest. He also offers him or her alternative modes of configuring the desire that Greek art represents—as the conquest or ownership embodied by a general, or the "otium" or escapism of the satyr.

When not using pairs of sculptures to frame and tame Greek art and to elicit the kinds of dialogues that inspired Pliny to go back to first principles in his *Natural History*, Roman patrons favored miniaturization as a means of advertising their ownership of Greek sculpture, turning statues after the Aphrodite of Knidos into table-top trinkets (3.22) or, different again, precious objects of devotion akin to the statuettes that populated their household shrines, the *Lares*.[120] Delighting in their gilding or delicate alabaster finish, these miniatures were fascinating for their materials as much as their subject matter, asking to be possessed by the gaze in a way denied to a life-size or colossal statue; to be picked up, caressed, pocketed. As noted in the last chapter, miniatures were already a feature of hellenistic houses. But in Rome, their smallness was made more of a virtue, and for reasons that again leave Posidippus's poems on gemstones, with their investment in exotic materials and in intricacy, delicacy, and radiance, looking a little too polished. Although Martial's and Statius's poems about a bronze statuette of Hercules made by Lysippus, owned in their own time by the obscure Novius Vindex, inevitably engage with the hellenistic tradition and thus speak, in competition with each other, of their own literary project,[121] their premium on the object's biography, on its treatment, and on the majesty of its tiny form are new, and exemplary of a way of seeing that can be deemed "connoisseurial." They recognize what literary critic Susan Stewart recognizes:

"There are no miniatures in nature; the miniature is a cultural product."[122]

Statius's version casts Vindex as someone whose "eye" is unrivaled, an expert able to spot a work by Myron, Praxiteles, Polyclitus, Pheidias, or Apelles at forty paces. In the elite, art-educated world of the Flavians, the issue of who made what is now imperative. Perhaps it always was, and Cicero's nonchalance about his sculpture's makers as exaggerated as his attack on Verres, whom he criticizes for forcing a local businessman to sell him statues by the first three of our sculptors at ludicrously low prices.[123] How his Sicilian victim had come by them and whether they were *by* or *after* Myron, Praxiteles, or Polyclitus is another matter.[124] The Hercules that snares Statius (with "multo amore" no less)[125] is an image of godhead, which, though small, massively moves him, actively encouraging his gaze to range over and across his tiny limbs

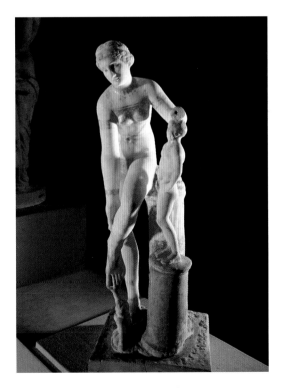

3.22. Gilded statuette of Venus (Aphrodite) removing a sandal, from the House of Venus in a Bikini, Pompeii, I, 11.6–7, first century CE, marble, h 62 cm. National Archaeological Museum, Naples, Secret Cabinet, inv. no. 152798. Photograph: akg-images / Erich Lessing.

and to get the measure of the hero and of Lysippus's artistry.[126] And it is not just his gaze that is marshaled; this is an artwork that grows in stature as it is felt ("sentiri").[127] The statuette had belonged to Sulla, and, before him, to Hannibal and to Alexander, who carried it around with him, handling it with pleasure (the verb used for "handling," "prensare," also meaning "to try to cling on to" or "to solicit the support of"), and treating it as interlocutor and talisman.[128] All of this pales in contrast to Vindex's approval,[129] at a time when statuettes like it captivated owners across the empire.

Mastery takes many forms. But Rome's knowing treatment of Greek material culture and its exploration, in poetry and in practice, of the ways in which "copying" meant control puts this material culture in its place, creating a space for it to become something more than itself, to become art as we know it. It is not chance that in the early Renaissance, powerful patrons such as Isabella d'Este wanted the most exquisite modern miniatures of the statues in Rome's collections (5.21), or that in the eighteenth century, one of the wealthiest homeowners in England, Nathaniel Curzon (1726–1804), bodied forth his relationship with the antique not with original Roman statues but with casts.[130] This preference for reproduction is not only about what Curzon could manage on a truncated Grand Tour;[131] it betrays as much of an understanding of ancient Roman modes of production and display as the eighteenth century's penchant for pairing copies of sculptural groups such as Cupid and Psyche with Bacchus and Ariadne.[132] It attests to Rome being the model for what one does with Greek art, to the Romans making imitation the sincerest form of flattery and Greekness a visual language of power not just in

the hellenistic kingdoms but throughout the western hemisphere. Indeed it is hard to think that today Abu Dhabi would be collaborating with the Louvre in establishing a "universal museum" for the Arab world were it not for Rome.[133] Although there was appropriation and art criticism in Pergamum and Alexandria, Rome adds the ethics as well as a global perspective to "theoria" (the theorization of looking).

With Rome holding all the cards and worrying away at the effects, positive and negative, of dealing them in different ways, Greek art became Roman (it *had* to if it were not to remain dangerous), and Roman art something shaped in dialogue with it. As we shall explore in the next chapter, this relationship shifted as the empire evolved and expanded, accommodating not only new territories but, later, foreign emperors. But by the reign of Augustus, the kinds of hellenism that we see in the Prima Porta statue or in the Ara Pacis were trickling down through sub-elites and bubbling up from the bottom, where they were spontaneously generated by a culture of competition that had long embraced Greek style. Greek style was *theirs* to use as they wanted; had been for some time; eclectically, discerningly, practically—sometimes in reverence of early fifth-century sculptures such as the Tyrannicides, and sometimes more subversively even than the copies of the Knidia, as beautiful, male bodies were converted from canon to kitsch and incorporated into lampstands. Augustan dominance consolidated the empire under a unifying brand, upping the need for provincials everywhere to praise the princeps and his regime. What better way to do that than visually, and in what was now the official language of classicism, an investment that further

honed what this classicism was and what it stood for? The more that local families in places such as Aphrodisias in Asia Minor were willing and able to configure Roman conquest in their own Greek language, casting characters such as Nero and the personified kingdom of Armenia (3.23) as Achilles and the Amazon Penthesileia, the more classicism was strengthened.[134]

It is not only baboon-makers who have gone the extra mile to share in this classicism. Classical art historians have struggled, and still struggle, to see the sculptural production of Roman Gaul and Britain, and the art of nonelites as part of this picture. In the 1960s, Ranuccio Bianchi Bandinelli coined the phrase "arte plebea" or "plebeian art" for the latter, a term that defined the paintings on the walls of inns and fulleries at Pompeii and the reliefs on tombs at Isola Sacra as distinctly "anticlassical."[135] Those working on Romano-British art, meanwhile, could not fail to find it "artless": if Roman art had suffered for being imitative of Greek art, then the material culture of Roman Britain was condemned as the worst possible imitation.[136] Provincial art was bad art (3.24).[137] Even now, much attention is given to extricating "Roman" and "Celtic" influence, the best that can be said of the local being that it is not just "anticlassical" but aggressively, ideologically "anti-Roman." Provincial art becomes, quite wrongly, an art of resistance.[138] Such a view enforces the elitism inbred in classical art's life history.

Back in the eighteenth century, Winckelmann's thesis about the greatness of Greek art vis-à-vis the art of other cultures, especially the Egyptian, did not have it all his own way.[139] In addition to predictable artifacts (e.g., a Discobolus from Hadrian's Villa, a statue type recently attributed to the fifth-century Athenian sculptor Myron),[140]

3.23. Panel showing Nero suppressing Armenia, south portico of the Sebasteion, Aphrodisias, first century CE, marble. Photograph: New York University Excavations at Aphrodisias: Guido Petruccioli.

Charles Townley acquired Etruscan, Indian, Egyptian, and Romano-British material, most famously a helmet found with other metal objects at Ribchester in Lancashire in 1796;[141] Camden's *Britannia*, which had first appeared as early as 1586, was greatly expanded, and the Society of Antiquaries founded, speeding the recovery of Roman material in Britain and making this recovery a fundamental part of Britain's investment in Rome as a model for its own imperialist ambitions.[142] But antiquarian and aesthetic imperatives clashed even then: in 1792, an "Attick" column base from Bath was said to be "of so very bad a design, that it was quite disgusting to put it on paper."[143] And as Winckelmann's influence grew, nourished by the fifth- and fourth-century Greek sculpture on show in London, what constituted "classical art" narrowed.[144] The *Handbook to the Antiquities in the British Museum* (1851),

3.24. Roman Venus figurine, 43–200 CE, pipe clay, h 15.5 cm. Museum of London, inv. no. 80.333. Photograph: © Museum of London.

"thought best to begin with the Greek Collection, as that directly tending to form and elevate the Public Taste: the work, therefore, commences with a brief outline of the progress of Greek art. . . . The only collections omitted are those known by the names of British or Anglo-Roman Antiquities, together with the ancient coins . . . the former being as yet too insufficiently arranged to admit of classification and description."[145] Material unearthed during the construction of the railways made this classification more urgent. But still today, "Roman Britain" is a gallery apart from the museum's majestic "Greek and Roman."

Must it be ostracized? If we focus not on what it looks like but on what it knows,[146] it gains an access denied to the Egyptian. The pipe-clay figurines of Venus that were so widely distributed throughout the northern provinces are no longer crude renditions of the goddesses conceived by Praxiteles and Apelles, but coy, their status as pocketable playthings exacerbated by the warmth of their sometimes molded clay and the exaggerated curve of their hips.[147] Seen like this, even the mosaic from the Rudston villa in Yorkshire (3.25), a piece that is both British and late antique, can be embraced with open arms, its central roundel showing not a deformed goddess of desire but a voluptuous Venus who is asking to be seen from the front and the back simultaneously, a Venus whose "lack of proportions" are enabling, inviting the viewer to imagine her in the round, and to walk around her as viewers did at Tivoli and in the ancient literature.[148] With a mirror on one side of her and a male spectator in the monstrous merman on the other, her allure is ramped up rather than reduced, further stressed by the emphasis on her sex organs. It does not matter that the mosaicist's technical ability is not his greatest skill. His creation boasts a classical birthright.[149]

So too the "plebeian" figures from Isola Sacra and Pompeii, their blockiness and frontality less a limitation than a direct result of wanting to advertise a trade, or epitomize a life (3.26).[150] They share with archaic Greek sculpture the desire to hit viewers between the eyes rather than engage them in a seductive story, offering them something closer to straight description than the subtle narratives or ways of seeing suggested by fifth- or fourth-century production.[151] There is no "what kind of man

or woman am I?" about these figures. The answer is obvious: a baker, fuller, or vegetable seller. Not that they are ignorant of Polyclitan or Lysippan form any more than late antique art is ignorant: the emperor Constantine the Great's image (3.27) turns out to be as dependent on Augustus and Alexander's portraiture as on the squat, samey, popular shapes of the Tetrarchy that preceded it, when the division of the empire into four, under two Augusti and two Caesars, demanded a new vocabulary of power that stressed the rule of four over and above any singleton's charisma. No, knowing what the classical stood for meant knowing that there were certain things it could not do. Recognizing this now means understanding what it is that gives it its continued currency—why it is that (although the Christians favored symbolism and orant figures in uninterrupted communion with the divine) Christ and Old Testament protagonists such as Daniel fostered contemplation by continuing to be classicizing.[152]

The Cult of Authenticity

Before thinking harder about art and empire in the next chapter, a coda on authenticity. As we are already discovering, the relationship between original and copy is more complicated than we might imagine, and Rome, as it is in most areas of our inquiry, instrumental in establishing a paradigm. All the time that the workshop at Baiae is making casts of famous Greek sculptures such as the Tyrannicides,[153] and the owner of the Villa of the Papyri and, later, Hadrian, using reproductions in art installations to decorate their gardens and come to grips with Greece's legacy, the growing reputations of a small

3.25. The Venus Mosaic, central panel found at Rudston, East Yorkshire, c. 350 CE (mosaic) / © Hull and East Riding Museum, Humberside, UK / Bridgeman Images.

group of ancient painters and sculptors, and the increasing value of displaying an awareness of this hierarchy, inevitably led to questions of authenticity. Vindex was not the only one to claim to distinguish a genuine Polyclitus from a statue by a sub-Polyclitus, from a fake.[154] Pliny the younger writes to the otherwise obscure Annius Severus to tell him about a statuette of an old man he has bought with a legacy he has just received, admitting that "as far as he can tell" (quantum ego sapio), although his knowledge is limited, it is a genuine, antique Corinthian bronze, and pretty.[155] He describes it with an attention to detail worthy of the best art historian.

It is unsurprising that it should be a work of Corinthian bronze that excites Pliny. According to his uncle in his *Natural History*, it was a material that was invented by chance when Mummius set fire to Corinth[156]—a material that, like a number of cult statues in antiquity that were reputed to have fallen from the sky, was worth more due to being spawned organically, rather than conceived of by human vision.[157] So

3.26. Funerary relief of a vegetable seller, Isola Sacra Necropolis, Ostia, second half of the second century CE, Museo Ostiense, Ostia. Photograph: Fototeca Unione, American Academy in Rome, FU 2383.

intensifies the spotlight put on authenticity; the anxiety creates a need for the expert.[159]

Expertise could be faked as easily as any artwork. As Pliny the elder is all too aware, the majority do as Trimalchio does, and "*pretend* to have this expertise" (ac mihi maior pars eorum simulare eam scientiam uidetur) so as to seem better than their peers.[160] And Martial's Mamurra thinks it worth playing at being a connoisseur even though, in the end, he cannot afford more than a couple of paltry cups.[161] By the close of the first century CE, art appreciation is able to make one upwardly mobile. Perhaps it is aspiration of this kind that leads to the owner of a house at Pompeii normally associated with Gaius Julius Polybius possessing a bronze water jar from the fifth century BCE engraved with an inscription that shows it to be from the Argive Heraion.[162] Had he inherited it from a booty-bringing ancestor or bought it at a premium, its virtue lying less in its beauty than it its provenience? Lucian, in typical parodying fashion, mocks the man who pays 3,000 drachmas for a terracotta lamp of Epictetus, a Greek Stoic philosopher, renowned for his simple life and lack of possessions.[163]

Art appreciation, antiquarianism, and excessive posturing merge even here, paving the way for men like Townley to use art acquisition and study as a means of prestige when their Catholicism denied them entry to politics; and for caricaturists like James Gillray to poke fun at the cognoscenti's overinvestment in the antique.[164] Crucially, however, even Pliny the younger intends to erect his Corinthian statue in public, preferably in the Temple of Jupiter:[165] as far as domestic displays were concerned, it seems that there was one rule for major Greek statuary, where

celebrated was it, continues Pliny the elder, that Mark Antony proscribed Verres, and Cicero along with him, because they had refused to give him some of their pieces. Material this valuable makes criminals of both of them. Suetonius attributes to Augustus the same overzealousness as Antony, Martial's Mamurra is seen sniffing the stuff on the stalls in the Saepta to determine whether or not it is genuine, and Petronius's Trimalchio claims to be the only one to own "uera Corinthea"—"true Corinthian ware."[158] Predictably, given that this is Trimalchio we are talking about, his justification is ridiculous, but everyone's cultural pretensions are pilloried in the process. It is not just that "copying"

imitation was the game, and another for lesser Greek artifacts; that there was, despite the lack of ancient vocabulary for it, a distinction akin to that that the eighteenth century would make between "old masters," "precious metals," and "curiosities." When did they converge? Was it ever acceptable to have a genuine Lysippus in one's bedroom? The statues purloined by Tiberius and Nero were an exception: bona fide "old masters" remain on public display even, if not especially, at the height of empire, when the power of putting a version of Timomachus's Medea, which Julius Caesar had dedicated in Rome's Temple of Venus Genetrix, on one's wall came from both advertising one's hellenic pretensions and engaging with the Urbs and its emperor.[166] In light of this, it is unlikely that the archaizing bronzes found in Pompeian houses (one of them, from the Villa of the Papyri, deliberately cast to look damaged [3.28]) were forgeries bought by hoodwinked Romans.[167] More probably, they are installations that query what Greek art is. The more that (some) Greek art could now be Roman art, the more appealing the idea of its antiquity became.

Perhaps it is not until Christianity becomes the empire's official state religion in 380 CE, and sacrifices are prohibited, temples closed or converted, and pagan statues sometimes destroyed,[168] that anyone other than the emperor can put together a private collection of genuine Pheidian and Praxitelean statuary without censure—although, even then, statues in domestic contexts disappoint.[169] The next chapter takes us into this world, a world which sees "Greco-Roman" sculpture, as it now is, play a fundamental role in the transference of capital from Rome to Constantinople and then in securing

3.27. Colossal head of Emperor Constantine I, c. 313–24 CE, from the Basilica of Maxentius, Rome, marble, h 260 cm. Courtyard, Capitoline Museums, inv. no. MC0757. Photograph: R. Sansaini, Neg. D-DAI-Rom- 57.998.

3.28. Archaizing Apollo/kouros, Villa of the Papyri, Herculaneum, first century BCE, bronze, h 43 cm. National Archaeological Museum, Naples, inv. no. 5608. Photograph: Rayet 1884, vol. 1: plate 26 © Museum of Classical Archaeology, University of Cambridge.

Venice's place within the Latin empire after the sack of Constantinople in 1204. At that time, the confiscation of choice pieces— some of them, like the bronze horses now in the Basilica of San Marco, fifth- or fourth-century in style; others, like the "Tetrarch" group, blunter symbols of power (4.19)—gave Venice a past and advertised its aspirations. Gradually, awareness and appropriation of these objects, of Greek and Latin poetry, and of authorities such as Pliny would bridge to the Renaissance.

Before this, we will examine how an emperor's attitudes to art were indicative of his fitness to rule; how from the Julio-Claudians through to Hadrian, and beyond into late antiquity, when Rome's imperial building becomes parasitic on its own material culture, these attitudes create discourses that authorize Constantinople's acquisition and display of pagan artifacts in the first place. Why is this important to classical art's life history? Because after the foundation of Constantinople, these Greco-Roman artifacts are the building blocks of empires. Napoleon's procession into Paris is but one example. This link between art collecting and empire building gives the moral dimension of much of this chapter new reach, enabling the Roman language that is classical art to become an international language of diplomacy.

4

Roman Art, the Building Blocks of Empire

Translatio Imperii

When the Laocoon group, Dying Gaul, Apollo Belvedere, and other "Monuments of Antique Sculpture" were paraded into Paris in July 1798, an accompanying banner issued an irresistible challenge: "Greece let them go, Rome has lost them; their destiny has changed twice; it will not change again!" (4.1).[1] Not even Napoleon, however, could keep hold of classical art nor fix its meaning forever; and by 1815, the statues were en route back to Italy. Rome remained the past master, and the one to beat; Rome had been the owner of Greek sculpture, and, by extension, the arbiter of artistic taste for centuries. In the intervening seventeen years, the first director of the Louvre, Dominique Vivant Denon, had accompanied Napoleon's troops across Europe, requisitioning artworks from royal collections, long established to rival each other by rivaling Rome, ancient and modern (4.2).[2] And in publishing his *Voyage dans la Basse et la Haute Égypte pendant les campagnes du général Bonaparte* (Travels in Lower and Upper Egypt during the campaigns of General Bonaparte), he had tapped Augustus's legacy after his defeat of Antony and Cleopatra by reinvigorating Egypt's stake in a story of increasingly competitive classicisms.[3] Why this course of action? This chapter traces how the Rome of our last chapter gradually shifted in status from repository of culture to cultural exemplar. It sets the scene for classical art to become European currency.

The material culture of the fifth and fourth centuries BCE did not congeal as "the art of classical Greece" until viewed with hindsight from the hellenistic courts. Neither were Rome's absorption of Greek art, or the political and ethical implications of this absorption, sealed as "Greco-Roman" until this art was redeployed in the foundation mythology of Constantinople. The marble bodies beneath Rome's topsoil made its Renaissance different from that of Venice or Florence, but so too did Constantinople's investment in Rome—the growing realization that for a "new Rome" to hold sway on a world stage, in addition to its strategic position on the Bosporus, it needed Greco-Roman artifacts. Not least among these was the image of Athena known as the Palladion: its supposed transfer from Troy to Rome, and then to Byzantium, made it the most obvious baton or imperial insignium for a city close to the Hellespont.[4] In time, if the literary record can be trusted, Praxiteles's Aphrodite of Knidos and Pheidias's statue of Olympian Zeus joined it.[5] With the sack of Constantinople in 1204, some of these artifacts, most notably the horses of San Marco (4.14), which would also be kidnapped by Napoleon,[6] were already being moved to serve

4.1. Antoine Béranger (1785–1867), *The Entrance into Paris of Works of Art Destined for the Musée Napoléon (Louvre)*, section of a vase of Etruscan shape, ceramic, showing the statue known as the Apollo Belvedere. Sèvres, Cité de la céramique, inv. no. MNC1823. Photograph: © RMN-Grand Palais (Sèvres, Cité de la céramique) / Martine Beck-Coppola.

as the security blanket of Venice's ambitions. By this point, the language of Roman imperialism, and the classical antiquity that gave substance to that language, had cemented Carolingian claims on Europe.

Religious change is an important driver here. Christianity created a fissure with the "pagan" past, making its idolatrous remains recyclable. Yet Rome had always been a recycling culture, reusing materials from Greece and Egypt, and recutting its own portrait statues—not just in aggressive acts of the kind inflicted on Nero and Domitian's images,[7] but as a legitimate means of saving money and time and of achieving a sense of continuity.[8] By the third century CE, the city of Rome had gone further still, becoming so parasitic on its own cultural production as to break up imperial monuments and reset elements of them into new structures, less as statements of seamlessness than as "survivals" or quotations, which preserved

4.2. Denon examining a tray of gems in Benjamin Zix's *Monsieur Denon Visiting the Cabinet des Antiques Berlin*, 1807, paper, 22.4 × 29.2 cm. The British Museum, London, Department of Prints and Drawings, inv. no. 2001,0519.32. Photograph: © The Trustees of the British Museum.

the past, and asked their viewers to see the present differently. The Arch of Constantine, erected by the Senate and people in the shadows of the Colosseum between 312 and 315 CE, is the best-known example of this phenomenon, its mix of contemporary and classicizing sculpture, the latter in honor, originally, of three second-century emperors (4.3), channeling "classicism" from the glory that was Greece to the political powerhouse that was Rome. Whether there because of exigency or ideology, this sculpture is no longer biographical of Trajan, Hadrian, and Marcus Aurelius but a badge of quality or imperial virtue.[9]

Christianity was not the cause of Rome's dismantling, but part of an enveloping sense of its belatedness. As we have already hinted,[10] the splitting of the Roman empire into four under Diocletian called for a new language of power that risked Augustan classicism becoming a defunct category that could do little but demand revival. Once Rome's own classicizing production was destabilized like this, and its marble made the building blocks of the third-century city, it was a small step for Constantinople, and indeed for churches everywhere, to engage in similar acts of spoliation (or should that be "salvage archaeology"?) and integration so as to rise from the ashes of Rome's fracturing empire. From this point on, success meant being a second Roman empire with all of the fixtures and fittings that came with that—although, as we are about to discover, establishing exactly what these were, and whether Pheidian Zeus and the Aphrodite of Knidos

4.3. Section of the Arch of Constantine, showing two of the recut Hadrianic roundels above the late antique frieze, marble. Photograph: Sam Keen / Wikimedia Commons https://commons.wikimedia.org/wiki/File:Arco_di_Costantino_(Roma)_-_tondo_lato_settentrionale_destro.jpg (last accessed 28 December 2016).

did end up in Constantinople, is more difficult than most scholarship acknowledges. In reconstructing Constantinople's contents, we rely largely on late or self-consciously literary texts that have better uses than the "straight" documentary.

The most important fixture of all, of course, was the emperor himself, an officeholder whose own power—that delicate balance between the excess and exemplarity expected of a leader—was regularly, since Suetonius's *Lives of the Caesars* early in the second century at least, measured in terms of his attitude to ancient painting and sculpture. Before we get to Constantinople, this chapter will look at how this index of power worked, for it is this, as much as it is the adornment of any city, that makes collecting classical sculpture a courtly pursuit, and a means whereby states, and aristocrats in and beyond the court, perform their authority.

Suetonius is referenced in Einhard's biography of Charlemagne, written in the early ninth century, while Pliny's *Natural History*, already consulted and epitomized in late antiquity and the Middle Ages, is generously mined from Petrarch onward.[11] The reading of these texts by early humanists further inscribes art as a building block of empire, establishing parameters of good and bad practice that endure at least into the nineteenth century and ensure that Hadrian's Villa at Tivoli becomes a model for imperial architecture far and wide, from Louis XIV's Versailles to Catherine the Great's palace at Tsarskoye Selo.[12] According to ancient authors, Hadrian had been exceptionally skilled at painting and fluent in Attic Greek.[13] But Hadrian was only one of the Roman emperors to offer later dynasts a potential model of how to behave. Britain's George IV (r. 1820–30), for example, who had, as prince regent, supported the

transcription of some two hundred scrolls from the Villa of the Papyri, the acquisition of the Parthenon sculptures, and the dissemination of casts of them to academies in Rome and Venice,[14] is depicted as Nero, playing his cello on Brighton Pavilion as the Peterloo Massacre blazes in the background (4.4).[15] And although J. Paul Getty likes to think himself "a reincarnation" of Hadrian's spirit, emulating him as closely as possible, he writes defensively of Nero's taste in art and feels "no qualms or reticence about likening Getty Oil Company to an 'Empire'" and himself to a generic "Caesar."[16] What separates the Neronian and Hadrianic paradigms, and where does this leave Augustus and his immediate successor Tiberius, who, in so many other respects, write the script for what imperium should look like? Patronage of the arts had been a mark of tyranny since archaic Athens and the Peisistratids.[17] But it becomes an imperative of all rulers, incumbent and aspirational, and of Renaissance Rome's popes and cardinals.

4.4. *Nero Vindicated*, satirical print of George IV, title page, pamphlet, London, 1820. The British Museum, London, inv. no. 1865,1111.722. Photograph: © The Trustees of the British Museum.

Collecting Like Caesar

The stakes involved in decorating a palace were high, and negative exempla abounded. In our previous chapter we met Martial's Mamurra. It is hard to follow him around the Saepta Julia without remembering his decadent namesake, the "dick" of Catullus's poems.[18] And it is similarly hard to extricate one Caesar's art appreciation from another's. The effects are cumulative, and the precedents unpromising. Excessive appreciation of the kind displayed by Catullus's Mamurra, whose house on the Caelian Hill was supposedly the first in Rome to boast marble columns and thin-cut veneer, was part of a general incontinence,

a looseness of morals that also defined him as a serial adulterer.[19] Such precedents are why critics mention Augustus's weakness for Corinthian bronze in the same breath as his penchant for gambling.[20]

For Augustus at least, these proved excusable vices: whatever he was up to in his weaker moments, the rhetoric that was written after his death placed him in a modest house on the Palatine, its locally sourced colonnades and lack of marble the antithesis of Mamurra's mammon.[21] Augustus was "disdainful of large and sumptuous palaces," preferring to fill his villas with objects notable for their "antiquity" and "rarity," such as animal bones and heroes' weapons, rather than with paintings and statues.[22] Of all the ancient artworks he could have chosen for his palace, he picked the panel on which Apelles and Protogenes had drawn a series of almost invisible lines, a painting that resembled a blank canvas, dedicating other sculptures and paintings publicly in the adjoining temple and porticoes, and elsewhere in the city, and returning some

statues to their sanctuaries.[23] Julius Caesar had been less politically correct than this: he too had played the part of the "humane general" in preventing the looting of the Temple of Artemis at Ephesus.[24] But he was enthusiastic in his collecting of ancient statues, paintings, and gems, going so far as to take mosaic floors with him on campaign and to invade Britain in the hope of finding pearls, which he would weigh for size in his hand.[25] Even his euergetistic inclinations were too much, seeking as they did to make Rome as monumental as Alexandria. Model behavior maybe—but Julius Caesar was assassinated.

Cicero's critique of Verres in the 70s BCE, and, earlier than that, of Sulla's freedman Chrysogonus, whose Palatine residence, stuffed with paintings, statues, Corinthian bronze, and slaves, was so extravagant as to be deemed less a "house" than a "showcase of moral turpitude and a den of every kind of iniquity," makes the suspicion of Caesar predictable.[26] Such were Chrysogonus's pretensions that he thought "no one human except himself."[27] In due course, Nero too would be charged with turning the heartland of Rome into a pleasure palace so as to "start living like a human being."[28] He had to live like this, if he was to be bigger than his Julio-Claudian predecessors, a dynasty descended from Venus, goddess of desire; if a life lived to excess was going to redefine humanity. As gods in training, emperors had the power to make desire literal (hence Tiberius's ill-judged abduction of Lysippus's Apoxyomenos [3.6], and his decision to decorate other bedrooms with paintings by Parrhasius, one showing the athletic heroine Atalanta pleasuring Meleager, and the other the castrated high-priest of the goddess Cybele).[29] In their new setting, these masterpieces are turned to sex aids, of a piece with erotic writings that he also kept there "so that illustration of the required position would always be available."[30] An eighteenth-century illustration in Baron d'Hancarville's *Monumens [Monuments] de la vie privée des douzes Césars*, an infamous publication falsely claiming to be based on a previously unknown collection of gems and cameos, titillates its readers by showing a laurel-wreathed Tiberius, surrounded by courtiers, admiring the Atalanta painting.[31] As they look at him looking, they are voyeurs; he is pornographer, not a model of statecraft.

Caligula's contribution to the story is similarly desperate: his kleptomania stretches as Nero's does to confiscating statues from Greece, and further still, to swiping Alexander's breastplate from his sarcophagus, and trying and failing to shift Pheidias's Zeus from Olympia.[32] Claudius, meanwhile, follows Augustus by sending Greek statues back again.[33] Yet he cuts Alexander's head out of paintings by Apelles and replaces it with Augustus's features.[34] Despite these emperors' exemplarity, and what recent work on collecting might have us believe, it is not until Nero that art appreciation becomes part of a Caesar's job description. The aesthetic attitudes that encouraged this activity were seeded in Augustan classicism, but took time to mature, creating, under Nero's immediate successors, a need for a Pliny to unpack the relationship of art and empire.[35] The Athenians had added a Temple of Augustus and Rome to the Acropolis, but by the Neronian period were writing Nero's name in bronze letters across the east architrave of the Parthenon. The young Cornell student Eugene Andrews, who in 1896 deciphered the inscription from holes left behind after the letters' removal, was appalled: expecting, no doubt, to find further evidence of

Greece's fifth-century greatness, he discovered instead that a "proud people" had "grown servile."[36] Athens's most iconic building had been put at Rome's disposal, a turn of events prompted by an emperor whose enthusiasm for Greek language, literature, and art had become his *public* persona. In liberating Hellas from taxation and Roman administration in 67 CE, his primary concern was perhaps "not with promoting the well-being of Greece, but with bolstering his own reputation."[37]

Nero paints and sculpts and is the first ruler since Alexander to be seen in intimate dialogue with named artists.[38] He commissions the sculptor Zenodorus to make a colossal statue for the vestibule of his Golden House, and Famulus to paint the frescoes.[39] He also amasses a wealth of ancient Greek bronzes, including an Alexander by Lysippus, an Amazon by the late fifth- or early fourth-century BCE sculptor Strongylion (a statue that used to accompany him everywhere as Lysippus's Hercules statuette had Alexander), a child strangling a goose (2.19) by Boëthus, and perhaps the original Dying Gaul (1.8).[40] Was Praxiteles's Eros also on display in his sitting room?[41] After Vespasian comes to power in 69 CE, these sculptures are rededicated in his Temple of Peace and other public buildings,[42] sealing Nero's fate as a Caesar sensitive to art and beauty.[43] When, in the nineteenth century, Oscar Wilde seeks a paradigm for his own "living Greek art," he styles his hair after Nero's portraiture.[44]

However provocative Wilde's self-posturing, Nero is, and always was, an aesthete, his art-filled palace so large as to stand as a metonym for the city, which was a metonym of the world.[45] Gradually, in the course of the sixteenth and seventeenth centuries, the glorious "grotesques"

that had first been discovered beneath the Esquiline's Baths of Titus at the end of the previous century, immediately influencing the ceilings and walls of Italy's pontifical and other palaces, became associated with Nero's Golden House, forcing the Renaissance to embrace his legacy.[46] Sites such as Sperlonga, a coastal villa tenuously linked to Tiberius, and Claudius's summer palace on the Bay of Naples, each with a dining grotto adorned with spectacular sculptural assemblages, would not be discovered for centuries.[47] Of the Julio-Claudians, it was Nero who set the pace. Indeed one of the most famous ancient gems in Renaissance Italy, a cornelian showing Apollo and Marsyas, was mounted into a modern setting bearing his name. Bought by Lorenzo de' Medici in 1487, and valued at an eye-watering 1,000 florins, it was then inscribed LAV.R.MED., merging his and Nero's identities.[48]

At roughly the same time as artists were exploring the underbelly of the Esquiline, Hadrian's Villa at Tivoli, the ruins of which were first described and measured a century earlier, was emerging as *the* ancient site par excellence, and by the 1550s was being systematically studied by architect Pirro Ligorio.[49] Its statuary would take longer to impact on Europe's aristocracy than its pavements and vaults, although under Pope Leo X already (1513–21) eight of its marble muses were displayed at the Villa Madama on Rome's Monte Mario (4.5), where they remained until the late seventeenth century when they were acquired by Queen Christina of Sweden, winding up in the Prado.[50] Few statues were as valuable as those from Hadrian's Villa: there was a chance that they had been caressed by the emperor.[51]

By the eighteenth century, other rural villas were also yielding statuary, some of them dug by the same excavators who would

4.3. Maarten van Heemskerck, *Two Muses from Villa Madama, Kalliope and Terpsichore*, c. 1532–36, pen and ink, 13.6 × 21 cm. Kupferstichkabinett, Staatliche Museen zu Berlin, inv. no. Römisches Skizzenbuch I Inventar-Nr.: 79 D 2, fol. 34 recto. Photograph: bpk / Kupferstichkabinett, SMB / Jörg P. Anders.

further mine Tivoli's marble stocks.[52] Hadrian's Villa, however, was in a league of its own as far as taste was concerned. Perhaps it always had been. Writing in the fourth century CE, heavily influenced by Suetonius, Aurelius Victor claims that Hadrian "curated feasts, statues and paintings" there and "ultimately provided everything luxurious and wanton, albeit a little anxiously"—sufficiently anxiously to sanction later rulers to follow in his footsteps.[53] In the earlier *Augustan History*, he is described as building "in remarkable fashion," naming the sectors of his villa after emotive Greek and Alexandrian sites, the Lycaeum, Academy, Prytany, Canopus, Poecile, Tempe, even the Underworld.[54] Hadrian offers a positive microcosm of empire to ape, encouraging an academic hellenism.

What did this "hellenism" look like? We have already noted his preference for replicas over and above Greek originals.[55] But we have yet to do justice to the wit of the villa's display, a wit that we shall see informing the endeavors of postantique patrons. Inevitably, the premium put on Greek culture in the second century CE—so much of a premium that Hadrian could pose as a pseudo-Aristogeiton with his young lover, Antinous, and make the performance of masculinity that came of being an ideal Athenian citizen a Roman imperial virtue[56]—gave the "caryatids" at his villa a different relationship with their models in Athens from those in the Augustan forum or at the Augustan Pantheon (4.6).[57] Inevitably, Antinous's premature death in the Nile in 130 CE made the incorporation of Egypt at Tivoli more elegiac, if not also more sensual, than that in the House of the Faun or the Campus Martius. Indeed, any love or learning on display here was potentially as suggestive as the love and learning promoted by the novels of the period, with their playful intertextuality and scopophiliac fantasies.[58] If the canal across which Hadrian's "caryatids" stare is indeed the Canopus of the *Augustan History*, then we must remember that the Egyptian coastal town of Canopus was, at least according to Seneca, a "den of vice" ("den" or "deuersorium" the word Cicero uses of Chrysogonus's den of iniquity).[59] Positioning them here, between two silenoi, the pot-bellied followers of Dionysus, ventured

4.6. Caryatids and silenoi, marble, by the "Canopus" of Hadrian's Villa at Tivoli. Photograph: Wikimedia Commons, Carole Raddato.

making these "priestesses" maenads with tambourines in lieu of offering bowls.[60]

Perhaps Hadrian's "hellenism" is overstated,[61] his sculpture park at Tivoli less a paean to Greek culture than a promiscuous mix of famous reproductions, satyrs and centaurs, Roman portraits, and Egyptianizing figures (not just Antinous, but Isis, Ptah, the River Nile, a crocodile [4.7], sphinxes, and so on).[62] These Egyptianizing figures unsettle the Erechtheum maidens' point of reference and vice versa. Ask where this is, and it is not Athens, Alexandria, or Antinoopolis, but "empire," or a mythologized version thereof, setting the agenda for centuries of bringing "the classical" into dialogue with the artifacts of other cultures, and having their "sum" speak not of Greece and Greek politics, as they will for Winckelmann, Byron, and Shelley, but of world politics, without ethnic affiliation. Almost immediately the villa inspired

imitators: as well as engaging in extraordinary acts of benefaction, fabulously wealthy sophist and senator Herodes Atticus (ca. 101–77 CE) constructed "a Greek parallel for Hadrian's villa at Tivoli" at Loukou in the Peloponnese,[63] complete with its own Antinous portraits,[64] and a Canopus complex at Marathon, using his Athenian descent and his properties' position to acquire an unusual number of genuine Greek antiquities.[65] At his estate on Rome's Via Appia, he too had "caryatids."[66] From this moment on, acting like an emperor was tied to having the right kind of residence with the right kind of sculpture collection, as well as to euergetism.[67] As this "rightness" was reenacted in centuries of imperial competition, every "Hadrian," not just George IV, risked being seen as "Nero": so Louis XIV's detractors compare his Louvre to the Golden House, and call him "Nero Gallicanus."[68] But Hadrian and his villa

remained the benchmark. A nineteenth-century British traveler captures this nicely:

> We strolled to the ruins of the Villa of Hadrian, the architect emperor; who, though but a sort of royal dandy in the art, certainly produced, by his patronage, some finer things than the Pavilion at Brighton, or the Palace at Buckingham Gate. But the incongruous assemblage of Grecian, Egyptian, and Roman amalgamations at Tibur, the productions of his own fancy, have, I cannot but imagine, a much finer effect in the ruins, than in all their splendour as the autumnal *delizia* of the emperor. It is but fair, however, to allow that by his encouragement, the arts, already upon the decline, were again raised to a pitch nearly equal to that of their zenith, as is still testified by the works which he left to the design of great architects whom he drew to Rome from every corner of his vast dominions.[69]

From Backdrop to Bricks and Mortar

Edward Gibbon's influence makes post-Hadrianic "decline" a hard concept to shake. But whatever was happening to Rome's

4.7. Crocodile, marble, "Canopus," Hadrian's Villa at Tivoli, inv. no. 2326. Photograph: H. Koppermann, Neg. D-DAI-Rom-82.1358.

economy between the second century and the end of the third, the reuse of relief sculpture from its own monuments in increasingly obvious ways freed this sculpture up to function as an assurance of imperial power, whatever the reality—a more marked claim to power perhaps than could be made there and then by reusing imported Greek sculpture. Inscriptions erected in the Republic and early empire already asked that Roman monuments not fall into ruin, but by Hadrian's time a senatorial decree specified that any "ornamenta" (decorations, embellishments, or insignia) be preserved, and by the mid-third century, Hadrianic panels were being integrated into Rome's Arco di Portogallo, and perhaps recut to bear the portrait features of Gallienus (joint ruler with his father from 253 and then alone from 260 to 268 CE).[70] Tetrarchic-period monuments would follow suit, first- and second-century reliefs being incorporated into the Arcus Novus, probably dedicated to Diocletian and Maximian in 293 CE, and an Augustan cornice, Flavian molding and column capitals, and Severan bronze doors into Maxentius's "Temple of Romulus" in the Forum (4.8).[71] Enough survives of the latter to show that these elements were designed to be noticed, part of the same "Hadrianic revival" that saw Maxentius (declared emperor in 306 CE and defeated by Constantine near the Milvian Bridge in 312 CE) rebuild Hadrian's Temple of Venus and Roma after the fire of 307, undertake repairs at his villa at Tivoli, and recast his colossal statue in his image.[72] What remains of this statue, in the courtyard of Rome's Palazzo dei Conservatori (3.27), now has the features of Constantine, whose image-makers also saw "classicism" as a conduit of continuity, and regularly recycled portraits of previous emperors.[73] His arch is but the most famous

incarnation of this recycling process, and of "classicism" as "Romanitas." Although erected roughly a decade before he reunites the west and east of the empire, its assemblage gives ballast to the role of sole ruler.[74]

Constantinople achieves in three dimensions what the Arch of Constantine does in two. If Augustus "found Rome a city of brick and left it a city of marble,"[75] then by the time we get to 324 CE, this marble is en route to becoming the raw material for new Romes—not "mini-Romes" as provincial cities were sometimes known, with their temples, bathhouses, and fora,[76] but an alternative Rome, composed of older statuary from the breadth of the empire. "Constantinople was dedicated by denuding virtually all the cities in the Greek east of their antique statues."[77] And it was not the only one: an imperial decree of 365 CE makes it clear that many provincial governors were transferring statues, slabs of marble, and columns to "adorn" their cities.[78] The verb "adorn" ("ornare") is interesting here, and accords with what we find in Christian sources more generally, where, whatever their problems, pagan statues are prized for their beauty. Indeed if they can no longer be treated seriously as gods, then what they have left is aesthetic value.[79] Prudentius, whose poetry is published at the start of the fifth century, instructs Rome's leaders to "wash" these statues and enable them "to stand pure" to be "the most beautiful adornments" of the city. For him, they are more beautiful now that they are not defiled by religious observance—real "works of art," "works of great craftsmen."[80]

Cleansed of their ritual specificity, these marbles are ripe for reinterpretation in a way that allows their artistry to shine; either that, or allows for their absorption into the

4.8. The entrance of the "Temple of Romulus," Forum Romanum, Rome. Photograph: Zoran Karapancev / Shutterstock.

architectural fabric of the empire's early churches. Rome had been compiling inventories of its public artworks since the Republic, going as far as to mark statues and their bases with lettering so as to signal their status as moveable commodities.[81] But by the fourth century CE, there was a "curator of statues" to join the offices of "curators of sacred buildings and public works" established by Augustus, and an emphasis, in inscriptions, on moving statues from "squalid" or "hidden" places to "a particularly renowned or frequented place."[82] Bases of statues redisplayed near Rome's Basilica Julia celebrate being thrown into the spotlight like this: they are much closer to those from hellenistic Pergamum than any bearing the spoils of Mummius had been, advertising that they carried works by Polyclitus, Praxiteles, and Timarchus.[83] There are also, of course, the Horse Tamers on the Quirinal with their late antique inscriptions, renewed in the

sixteenth century, attributing them to Praxiteles and Pheidias (4.9).[84] And the Mausoleum of Constantine's daughter, and the Basilica of San Paolo fuori le mura, each of them also from the fourth century CE, delight in incorporating older columns and column capitals, fueling a fashion for spolia in churches that takes us into the medieval period.[85] Rather than destroy pagan art, late antiquity arguably creates pagan art, making its visual properties more important than any original content, and putting more of a premium on adaptation as preservation than almost anything we encountered in the previous chapter.[86] It is not simply that this art is of another world, as it was when it first came into Rome in the middle of the Republic; it is that, like Christ, marbles are being reborn or "resurrected" ("rediuiua saxa").[87] At the same time, Christianity needs the antiquity of "pagan art" to sponsor its ambitious imperial narrative.

4.9. Giovanni Maggi, *The Dioscuri [Horse Tamers] on the Quirinal*, 1576–1618, etching on paper, 21.5 × 15.6 cm. Rijksmuseum, Amsterdam, inv. no. BI-1891-3063-48-1. Photograph: Rijksmuseum, Amsterdam.

Constantinople's foundation mythology is part of these phenomena. For all that Constantine's biographer Eusebius would like his readers to think that the Greco-Roman statues in the new capital were held up for ridicule and displayed so that non-Christians could see the error of their ways, a second source claims that they were for the express purpose of "decorating the city."[88] The word used, διακόσμησιν, is stronger than this sounds, stressing a bringing of order as well as of beauty, a "world order" of the kind that the Stoics sought to see established after the periodic destruction of the cosmos.[89] Rome's *Regionary Catalogues* (lists of monuments and sites in topographical order derived ultimately from Diocletianic documents but concretized in the mid-fourth century) set the standard here, their appendix listing 2 colossi, 23 equestrian statues, 80 gilded gods, and 74 ivory statues.[90] As rival capital, Constantinople had to compete. What did it have on its "wish list"? Constantinople's orators and poets continued to privilege the artists who had been deployed by Quintilian and contemporaries (Pheidias, Myron, Praxiteles, Zeuxis, Apelles . . .), artists as important for their contribution to debates about the relationship between art and life as for their actual oeuvre.[91] How do their literary preferences fit with what is known to have traveled to Constantinople?

Vasari claims that it was "Constantine's departure from Rome to establish the seat of his Empire at Byzantium" that "brought to Greece . . . an infinity of statues and other examples of the most beautiful sculpture."[92] But it is not always easy to distinguish his contribution from that of later emperors. Eusebius is our only contemporary source, and he, as we have seen already, powered by proselytism. Two centuries later, chronicler

John Malalas credits Constantine with "a large and beautiful palace," a hippodrome with "bronze statues and with ornamentation of every kind," colonnades "decorated with statues and different kinds of marble," and "a public bath, known as the Zeuxippon," "with columns and marbles of many colours and bronze statues," but without qualification of what these statues were.[93] Investing in such material is enough (whatever it is) to make his capital like Rome, and himself Caesar Augustus.[94]

Ask for more detail, and what there is takes us in a different direction from the superstars that are Praxiteles's Aphrodite or Pheidias's Zeus (we have to wait for later in Constantinople's history, and a private collection, for those), the most famous statues his agents acquire with any certainty being muses from the Sanctuary of the Muses on Mount Helicon in Boeotia, perhaps those by one of Praxiteles's relatives, the younger or elder Cephisodotus, mentioned by Pausanias.[95] Leaving them languishing in the shadows is the Serpent Column from the Sanctuary of Apollo at Delphi, which is usually assumed to be one of the "Delphic tripods" that several sources claim he secured for the Hippodrome, and which is one of the very few antiquities to survive the Crusader sack, albeit in fragmentary form (4.10).[96] Dedicated by the Greek allies after their victory over the Persians at Plataea in 479 BCE, the tripod is recorded by Herodotus and then by Pausanias, already without its golden bowl, and inscribed with the names of the thirty-one cities and the simple assertion, "These fought the war."[97] In its new position, on the *spina*, it speaks not only of new kinds of competition, but of Constantinople as the new "omphalos" and center of civilization. It is a text or archive as much as it is an object, and one

that betrays the complexity of Byzantium's repudiation of non-Christian "hellenismos." By the tenth century, Constantine Porphyrogenitus (independent or coruler of the Byzantine empire from 908 to 959) would clearly and consciously distinguish hellenic from pagan culture, stimulating a first wave of humanism.[98] And when Vasari has Constantine bring art to the East, he is simultaneously bemoaning the collapse of a Rome that only he and the Renaissance can revive. As classical art becomes both the language of empire and an antiquarian obsession, the balance between its Greek- and Roman-ness ebbs and flows.

It is safer to see Constantinople's "collection" of classical art as a deposit or buildup, rather than as the work of a single visionary—and not only because the sources, such as they are, give the acquisition of some of the most memorable sculptures, for example, the horses now in San Marco in Venice, over to later rulers (in their case, Theodosius II).[99] The argument is more "chicken and egg" than this: for the securer Constantinople's footing as a capital, the greater its need for an armory of appropriate artworks, and for a live artistic tradition that could give these artworks continued charisma. Just as Constantine's porphyry column in the city's Forum attracted objects like a magnet (so that by the time we get to the writings of ninth-century monk George Hamartolus [the "Sinner"], the twelve baskets of loaves and fish blessed by Christ, fragments of the Holy Cross, and other undefined holy relics have joined the Palladion at its base),[100] so too Constantinople attracted sculpture and stories about sculpture, Greek and Roman, real and imaginary (including portraits of Augustus, Tiberius, and Hadrian, and a bronze she-wolf).[101] An extant red granite

4.10. Ottoman miniature of the Hippodrome at Constantinople with the Serpent Column in the foreground from the sixteenth-century *Surname-i hümayun (Book of Imperial Festivals)* fol. 367a. Photograph: akg-images.

obelisk brought from Egypt and inscribed in honor of Theodosius I this time, attests to the presence of artifacts other than the Greco-Roman, as we would expect of a "new Rome," establishing a pattern that would impact on nineteenth-century New York, London, and Paris.[102] Yet even this is but part of a transfer of culture that is less important in its individual elements than for its cumulative weight—less a studied selection of classical artworks than a wholesale, and sometimes hostile, takeover. Zosimus, writing early in the sixth century from an aggressively pagan perspective, claims that one of the other statues moved by Constantine, a cult image of Rhea/Cybele, had first been dedicated on Mount Dindymus by Jason's Argonauts. Even here, millennia of myth-history trump both Constantine and the author's interest in artists. Zosimus's Constantine goes as far as to "damage" the statue out of disregard for its subject matter.[103]

If the arts were maintained at the "pitch" to which they had been raised by Hadrian, then this was in large part owing not to Constantine, but to the responses of men such as Christodorus of Coptos, whose Homeric hexameters are the main source for the sculptures in the Baths of Zeuxippus, and Constantine of Rhodes, whose verse most probably lies behind George Cedrenus's account of the fifth-century sculpture collection of the imperial chamberlain Lausus.[104] Christodorus's poem, published as book 2 of the *Greek Anthology*, could not be further from a "catalog" of Constantine's bronzes (if indeed these bronzes were all acquired by Constantine);[105] its "descriptions" of the eighty bronzes, if we can call them that, are an exercise in "reading in," breathing in even, that stresses the limitations of the metal and poetry's power to animate it.[106] There is only one statue Christodorus claims to be unable to identify,[107] his confidence serving as a

mark of his intellect, and of an overwhelming desire to dramatize the others and their relationships to one another, a drama that takes the listener back, via Athens and its oratory, philosophy, and stage plays, and back through Greece's literary canon, to a world that has all of us direct our eyes, as the statue of Achilles's son, Pyrrhus (Neoptolemus), directs its eyes, to Ilion.[108] Almost thirty of the statues pertain to Troy, and that is before adding the gods and the portraits of Virgil and of Homer,[109] who is captured, like the other literary figures represented, in the act of composition: "he looked like one in thought . . . weaving some war-themed work."[110] The emphasis is on the intricacies of Christodorus's composition, and on his claim to be an epic successor. Constantine had hoped to found his city at Troy.[111] Here, finally, under Anastasius I (emperor from 491 to 518), who is name-checked in the poem and compared to Pompey the Great for his conquest of the Isaurians of Asia Minor, the two cities converge.[112] Not content with this allusion, Christodorus writes an entire epic on the subject (his now lost *Isaurica*). But more important for our story is that Constantinople's gathering of statuary had achieved its aims: the dialogue between Christodorus's ecphrases of individual subjects serves the city's imperial and cultural agenda.

The only artist mentioned in Christodorus's poem is the goddess Athena:[113] if there is a canon to be found in his poetry, it is a literary rather than a visual one. The Constantinopolitan dossiers of documents that are the eighth-century *Parastaseis Syntomoi Chronikai* and tenth-century *Patria* are similarly reticent about the statues they feature, eschewing artists and aesthetic criticism in favor of an emphasis on their agency (their capacity to kill people,

stimulate natural disasters, conjure spectacles, and predict the future).[114] These statues are the stuff of history in a very active sense (as one modern commentator puts it, these "statues have seen a lot, and they are reluctant to let go"),[115] taking the connection between artworks and empire that was already live in Suetonius to lay claim to the past and, in so doing, to map the imperial city. It is not simply that the emperors' treatment of statues is revelatory of their reign; statues themselves speak of the emperors' character. So, for example, a sculpture in the Hippodrome of a woman giving birth to a monster "reveals the story of the godless Justinian" (Justinian II, emperor twice, 685–95 and again 705–11).[116] If it is artists and great "art," as opposed to "gossip" or prophecy, one is after, almost all the cards belong to Lausus.[117]

The Christian eunuch Lausus is the Herodes Atticus of his period, but with a collection of statues that leaves even Herodes's antiquities in the shade. Whereas Pheidias's cult statue of Zeus at Olympia was supposed to have laughed aloud, when Caligula attempted to take it Rome-ward,[118] if the eleventh-century chronicler Cedrenus is anything to go by, it capitulated under Theodosian legislation, spending its final years in Lausus's palace, probably close to the Forum of Constantine.[119] There it joined Praxiteles's Knidia (4.11), "naked, shielding with her hand only her pudenda"[120] (a qualification that suggests that she might feel more shame there than in her shrine in Asia Minor), and the Athena of Lindos, attributed to Skyllis and Dipoenus (whom Pliny reports were the first to make a name for themselves as sculptors in marble), and given as a gift to the Greek temple by the pharaoh Amasis, who features in the Lindian Chronicle as the dedicant of a

4.11. Roman statue after the Aphrodite of Knidos made by Praxiteles in c. 340 BCE, marble. Museo Pio-Clementino, Vatican, inv. no. 812. Photograph: © Hirmer Fotoarchiv, 671.9289.

Christian meaning in its arrangement.[124] But they need not be this demanding: its statues, as presented by Cedrenus, are already the ultimate acclamation of classical culture's arrival in Constantinople, showing (off) that what Hadrian did with copies might now be done with originals, and that reproductions of the Knidia in Roman villas and bathhouses referenced a new Heimat. Whether Praxiteles's Aphrodite and the other "superstars" really were in Constantinople is as irrelevant as whether it is Myron's actual heifer and originals by Pheidias and Lysippus that Procopius sees in sixth-century Rome.[125] Their literary life histories in hellenistic epigram and rhetorical handbooks make them present: Pheidias's Zeus, for example, by then one of the seven wonders of the ancient world, had long been a locus classicus for debates about god and image.[126] Preservation takes many forms.

What is clear is that artistic capital, and the issues raised by this capital, including what constitutes the "canon," were on the move, enabling Greece and Rome's share of this capital to be triangulated, and opening the door for Venice and Florence to stake counterclaims to this heritage. "Rome, of all cities under the sun," was agreed to be "the greatest and the most noteworthy . . . bringing together in that city all other things from all the whole world."[127] Rome's demise only made it and its contents more charismatic, generating the kinds of competition, aspiration, and ethical debate that will define the Renaissance. With the Ostrogoths threatening to raze Rome to the ground, Procopius has the Byzantine general, Belisarius, send an envoy to their king. The letter he carries reads: "While the creation of beauty in a city which has not been beautiful before could only proceed from prudent men who understand mankind,

linen corselet.[121] Also in attendance were a statue of Hera by the archaic sculptor Bupalus, whose Graces were supposedly one of the sculptural groups redisplayed by the Attalids at Pergamum, an Eros and a Kairos (Opportunity) by Lysippus, the last of these the subject of an influential poem by Posidippus, exotic animal figures, pans, and centaurs.[122] At Tivoli, centaurs, crocodiles, and silenoi had complicated Hadrian's emulation of hellenic culture. Here they turn the penning of pagan divinities into a zoological experiment.

Lausus's palace was destroyed by fire later in the fifth century.[123] Scholars have tried hard to reconstruct its display and find

the destruction of beauty that already exists would be naturally expected only of men who lack understanding and are unashamed to leave posterity this token of their character."[128] Preserving the splendors of the classical past had become a mark of civilization.

Lausus's collection, and the competition it activates, not only with the sculptural assemblages of the Roman empire, but with Constantinople's imperial statuary proper, both in and outside the palace complex,[129] stands as a precursor to the courtly collections of sixteenth- and seventeenth-century Europe. And it was not the only private collection to do so. Although late antique villas more generally support what we found in the previous chapter, favoring sculptures that suit their setting over and above antiques or "famous faces" by famous artists, a house in Corinth, extensively renovated in the late third or early fourth century CE, contains statuettes after Lysippus's Weary Hercules, the chryselephantine statue of Asclepius made by Thrasymedes for the sanctuary at Epidaurus, and the so-called Aspasia type attributed by some modern scholars to Calamis.[130] In Roman France, meanwhile, the villa of Chiragan near Toulouse, a site so exceptional in the volume of its sculpture as to be widely regarded as second only to Hadrian's Villa at Tivoli, mixed versions of statues such as the Weary Hercules again, the Knidia, and Myron's Athena, with freer classicizing pieces (4.12 and 4.13), and about twenty imperial portraits dating from the Augustan to Tetrarchic period.[131] Whether these add up to a late antique collection, or represent the prolonged purchasing power of a property inhabited from the first to the fourth century CE, the mix is paradigmatic of the kinds of assemblages that one finds in early modern Europe. In the second

4.12. Roman statue of the Farnese Hercules type from the Roman villa of Chiragan (Martres-Tolosane, Haute-Garonne), second or third century CE, marble, h 62 cm. Musée Saint-Raymond, France, inv. no. Ra 115. Photograph: JF_Peiré, Musée Saint-Raymond, musée des Antiques de Toulouse.

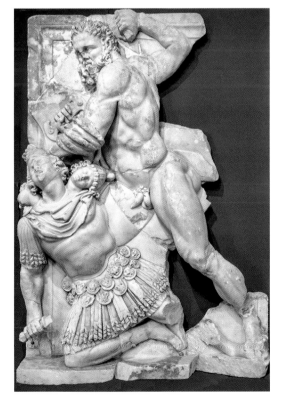

4.13. Relief sculpture showing Hercules battling the giant Geryon from the Roman villa of Chiragan (Martres-Tolosane, Haute-Garonne), end of third century, marble. Musée Saint-Raymond, France, inv. no. Ra 281. Photograph: JF_Peiré, Musée Saint-Raymond, musée des Antiques de Toulouse.

half of the fifteenth century, in Florence, Naples, Milan, and Ferrara, busts and profiles of Suetonius's twelve Caesars were prominently placed in, or on, the facades of Renaissance palaces.[132] In the eighteenth century, collectors were as keen on these as on ideal sculpture and sarcophagi.[133]

But if we forget about imperial portraits for a moment, and ask instead which statues were most commonly copied in eighteenth- and early nineteenth-century Europe, the teleology becomes less obvious. Take the collection of casts bought from Rome and Florence by the Danish consul in London, Jens Wolff, for his house, Sherwood Lodge, in Battersea and its sculpture gallery, built in 1807–8. We will come back to galleries like this in chapter 7, but pause now to note its statues and statue groups: the Farnese Hercules, "Dying Gladiator," Capitoline Antinous and Capitoline Venus, Borghese Gladiator, Apollo Belvedere, Belvedere Torso, Arrotino, torso of Bacchus, torso of Venus, Meleager, the Medici Venus, the Venus of Troas, Cupid and Psyche, the Wrestlers, the Townley Venus, Venus dipping her hair from the Louvre, the Vatican's standing Discobolus, Niobe and her daughter, the Dancing Faun, Barberini Faun, Laocoon, and Borghese Hermaphrodite.[134] The selection criteria are obvious: the "originals," themselves Roman "copies," were the "greatest hits" of the greatest collections in Italy and France, and of the collection of Charles Townley, their greatest British rival. But their fame is still peculiar: how did these come to be the choice specimens? We have already touched on the popularity of the Antinous type. Many of the others are bulkier of body than he is, more "hellenistic" in style than almost anything encountered or imagined in Constantinople, with the exception of the Hercules, whose brawn

is counterbalanced by centuries of royal investment.[135] Whether this difference is due to Renaissance taste, or to ancient Roman taste (and we remember Nero and the sculptures in his Golden House, his successor Titus, in whose palace the Laocoon is said to have been displayed,[136] and the statue groups found in the "Tiberian" grotto at Sperlonga), it is a very different prospect from Byzantine classicism.

"Almost another Byzantium"

Between these poles lie the Middle Ages. One of the most economical ways for us to chart this terrain is to end this chapter in Venice, a lagoon that shaped itself as a cosmopolitan city by cultivating the Roman heritage it lacked through the intermediary that was Constantinople. In the fifteenth century, Domenico Selvo, doge four centuries earlier, was credited with sending men out all over the world to find "the most magnificent columns" with which to adorn the Basilica of San Marco.[137] And in 1309, captains of boats sailing to the eastern Mediterranean were still under instruction to find the Church fine marbles.[138] But it was Venice's part in the fourth crusade of 1202 to 1204 and in the foundation of the Latin empire as intended heir to the Byzantine empire that really fueled this economy, supplying boatloads of bronze and stone with which to decorate the interior and exterior of the building, and making Selvo's thirteenth-century successor "Lord of a quarter and one eighth of all the Roman empire," and equal to any Caesar.[139] Increasingly the sorts of mythology that had surrounded Constantinople's foundation surrounded and supported this moment: "It is said that [San Marco's bronze horses]

were brought from Constantinople, as were almost all the precious marbles on the temple" (4.14).[140] The Palladion had passed to new owners.[141] In time, the collapse of the Latin empire, and the recapture of Constantinople by the Byzantines in 1261 served only to increase Venice's claim on the classical past. Soon, the city's material inheritance was underwritten by stories of its own foundation by Trojan Antenor.[142] A poem, penned in local dialect in 1420, chimes: "I speak the truth, I speak of what I love, that Troy was never so powerful nor Rome in ancient times, as Venice, and now it is clearly shown."[143]

Working out exactly what in and on San Marco arrived in Venice in 1204 is no easier than working out Constantine's share of his capital's sculptural collateral, and is made all the more difficult by a fire that is said to have destroyed almost all of the treasury's contents in January 1231, and by looting by Napoleon's troops in 1797.[144] For our purposes, however, a full inventory is less important than an understanding of Venice's impact on our story, and of the impact *on* Venice of such an influx of marbles, mosaics, and other precious materials. After the fourth crusade, Venice was an emerging colonial power,[145] which leaned on the authority embodied by the display of sculpture to legitimize its imperial ambitions. With the rise of the Ottoman empire and its eventual conquest of Constantinople

4.14. Canaletto's reimagining of the horses in the square (as opposed to high up in the Basilica of San Marco's loggia where they were actually placed), *Capriccio: The Horses of San Marco in the Piazzetta*, 1743, oil on canvas, 108 × 129.9 cm. Royal Collection, inv. no. RCIN 404414. Photograph: Royal Collection Trust / © Her Majesty Queen Elizabeth II 2016.

in 1453, the city put more of its energies westward into an Italian Renaissance, cashing in the benefits of bringing classical art back to Italy.[146] Venice bridges the worlds of antiquity and of medieval chroniclers, with the worlds of the d'Este, the Medici, and their post-Enlightenment imitators.

As with Constantinople, so with Venice, we have to put the reuse of sculpture and other artifacts into a broader context if we are fully to understand it. Complementary, but running counter, to Constantine Porphyrogenitus's classicism in the East was Carolingian classicism in the West, led by the pope's designated Roman emperor and "second Constantine," Charlemagne (800–814), whose accomplishments, according to Einhard, included being able to read and speak Latin fluently, and whose official seal bore the phrase RENOVATIO IMPERII ROMANI (Renewal of the Roman Empire).[147] Whatever Charlemagne's motives in moving the equestrian statue of Theodoric, the Ostrogothic king of Rome, from Ravenna to his palace at Aachen, this move was more marked an activity than Byzantium's recycling of its own art to build new churches[148]—recognition, whether explicit or not, of the imperial power innate in a stock Roman type hymned to the heavens by Statius, and most famously represented by the statue of Marcus Aurelius (4.15 and 4.16).[149] And it was not only statues that partook of such power: from early in the fourteenth century, on a column in front the Porta di San Ranieri on the steps of the Duomo in Pisa, a neo-Attic krater or vase (4.17), decorated with the sorts of satyrs, maenads, and silenoi that would have been at home in Hadrian's Villa, joined other antiquities, mainly sarcophagi, in making a similar statement.[150] An inscription, added at the same time, referenced the relationship between ancient Pisa and Rome: "This is the unit of measurement that imperator Caesar gave to Pisa with which to weigh the tribute money that was given to him."[151] As one of Venice's main maritime rivals, but one that in the fourteenth century was in decline, the Republic of Pisa was another of the states to use artifacts to link to Rome, and reassert the strength of its waning hegemony.[152]

Pisa's display of antiquities, and those on, and in front of, San Marco have a lot in common with what was then the main papal palace in Rome, the Lateran, where, in the eighth century, several bronze statues (a she-wolf, a ram, the equestrian statue of Marcus, then often identified as Constantine, a seated boy removing a thorn from his foot or Spinario [4.18], and a colossal Constantine, which came to be known as Absalom and Samson respectively, and probably the Lex Imperio and Capitoline Camillus) were placed in the adjacent piazza as an assurance of papal judicial authority.[153] In other words, the Rome being respected and supplanted was both pagan and Christian. On San Marco's west facade, one of a series of mosaics showing the transferal of the eponymous saint's relics to Venice from Alexandria in 828–29 CE[154] points to the sculptural spolia on the facade, turning them into relics too, and collapsing time so as to have all of them empower church and state.[155] To quote Nagel and Wood, "With their temporal flexibility, artworks and other 'structural objects' were the perfect instruments of the myths and rituals that knit present to past." "The ability of the work of art to hold incompatible models in suspension without deciding is the key to art's anachronic quality, its ability really to 'fetch' a past, create a past, perhaps even fetch the future."[156] The bronze horses were

set not as Canaletto imagines them (4.14) but above the central portal of this frontage, a rare use of the three-dimensional in an architectural setting that would normally require relief sculpture.[157] Surveying the square below them, they embodied four times the force of Charlemagne's statue—like Pegasoi in the service of a Christian god, ciphers perhaps of the Evangelists.[158]

Elsewhere on the exterior, on the Treasury's southwest corner, two porphyry reliefs, the so-called Tetrarchs (or should that be Constantine's sons?), originally from the area of Constantinople known as the Philadelphion, stood watch over a key entrance to the church, the Porta da Mar, blocked up in 1503, and over the arch into the forecourt of the Doge's Palace, their purple material enough to advertise regal pretensions (4.19).[159] Like the krater in Pisa, they too were accompanied by a modern motto: "Man may do and say as he thinks, but in thinking, let him consider that which may befall him."[160] They, and the Roman and Byzantine empires they embody, are now subservient. Huddled together in their new setting in conspiratorial embrace, they mark out Venice's religious and governmental territory.

They also, by virtue of their blunt and blocky appearance, throw a further piece of late antique spolia, a marble panel of Hercules delivering the Erymanthian boar to Eurystheus, into relief. Set into the spandrels of the west facade of the basilica together with a thirteenth-century Venetian version of Hercules, with the Ceryneian hind and Hydra, its iconography and style owe a lot to fifth- and fourth-century BCE production, the strength of the hero's body, with its bulging biceps, made to seem more Greco-Roman next to the spikiness of its modern counterpart

4.15. Equestrian statuette of Charlemagne or Charles the Bald, ninth century CE, formerly in the treasury of Metz Cathedral, bronze, once gilded, h 25 cm. Louvre, Paris, inv. no. OA 8260. Photograph: © RMN-Grand Palais (musée du Louvre) / Droits reserves.

4.16. Print of the equestrian statue of Marcus Aurelius, 161–80 CE, Capitolino Museums, Rome, inv. MC3247, c. 1538–55, engraving, 36.3 × 25.2 cm. Rijksmuseum, Amsterdam, inv. no. RP-P-BI-2768. Photograph: Rijksmuseum, Amsterdam.

4.17. Giovanni Antonio Dosio, *The Bacchic Krater from the Cathedral in Pisa*, 1560–69, pen and ink, 33.2 × 22.7 cm. Kupferstich-kabinett, Staatliche Museen zu Berlin, Codex Berolinensis, inv. no. 79 D 1. fol. 17 recto, nr. 43. Photograph: bpk / Kupferstichkabinett, SMB / Volker-H. Schneider.

(4.20 and 4.21).[161] Such continuum and disconnect inevitably raises questions of style. Inside San Marco's treasury, smaller Greco-Roman artifacts were put to religious use—some of them, for example, Greek or Roman sardonyx cups, already integrated into more elaborate artifacts to function as ornate chalices.[162] These, and other productions of Byzantine workmanship, such as a gilded and glass bowl with roundels derived from Greco-Roman gems (4.22),[163] again shaped Venetian representation,

including the mosaics of the basilica itself.[164] They would also, over the ensuing centuries, attract visiting dignitaries.[165]

Renaissance "classicism" comes of such contacts and contrasts, and is markedly different from Rome's classicism, not least because of Byzantium's filter, and because much was lost in translation.[166] The Venetians had to learn how to look, and understand what it was they were looking at. Loot had to become beauty and, in time, beauty become scholarship.

Public display, and the civic ambition that came with it, had to prompt private ownership and contemplation. In the thirteenth and fourteenth centuries, Greek and Roman material culture, and the status associated with its admiration, was often undifferentiated from late antique, Byzantine, and medieval material culture, and the pagan from the Christian.[167] Even recently made eastern icons were venerated as antiquities.[168] Across in Paris, the largest surviving classical cameo, the Roman imperial carved gem known as the Grand Camée de France (brought from Constantinople in the middle of the thirteenth century during the rule of Louis IX and kept for much of its new life in the treasury of the Sainte-Chapelle) was thought until early in the seventeenth century to illustrate the biblical story of Joseph at the Court of Pharaoh (4.23).[169]

By the fifteenth century more viewers are attuned to the specific virtues of the Greco-Roman. But what remains insurmountable is Venice's dislocation—the fact that the city was twice removed (both temporally and topographically) from the classical past it craved. In Rome, an inscription in the spolia-studded facade of a house in Piazza Giudia can boast:

> In the city of Rome, now being reborn in its former beauty, Lorenzo Manlio, with esteem for the homeland of his family, built this house, bearing the Manlian name, from the ground up, in proportion to his modest circumstances, on the Jewish Forum, for himself and his descendant, 2229 years, 3 months, and two days after the foundation of the city, on the 11th day before the Kalends of August [22 July, 1476].[170]

4.18. The Spinario, painted cast of a bronze original of the first century BCE (Capitoline Museums, inv. no. MC 1186), h 73 cm. Museum of Classical Archaeology, Cambridge, inv. no. 417. Photograph: © Museum of Classical Archaeology, University of Cambridge.

4.19. The "Tetrarchs," c. 300 CE, porphyry, corner of the facade of San Marco, Venice. Photograph: Cortyn / Shutterstock.

4.20. Hercules and the Erymanthian boar, marble, fifth century? CE, west facade of San Marco, Venice. Photograph: hipproductions / Shutterstock.

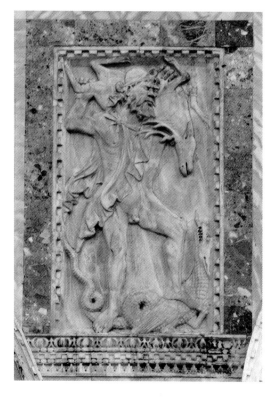

4.21. Hercules with the Ceryneian Hind and the Lernean Hydra, marble, thirteenth century, west facade of San Marco, Venice. Photograph: © 2016. Photo Scala, Florence.

There, spolia, which had been a feature of Rome's urban landscape from at least the third century CE, bolster a claim to continuum that takes us back to the city's foundation and grounds the antique ancestry assumed by a self-made, ambitious apothecary.[171] But in Venice, especially after Constantinople's recapture in 1261 and then its fall to the Ottomans in 1453, there could be no continuum; the Venetians were not direct heirs, but "appropriators or conservators,"[172] "almost another Byzantium."[173] Venice looked to the Ottoman world too: there are Islamic objects in San Marco's treasury.[174] If the city facilitates competing dynasties' claims to the classical antique, this antique is productively decentered.

As we move into the next two chapters, we will see how "cabinets of curiosity," studies or "studioli," and Greek and Roman statue courts give states and elites new opportunities for responding to the antique and for forms of private devotion other than the narrowly religious. If Kunstkammern or cabinets of curiosities kept the Greek and Roman in dialogue with other geographies and categories of object, manmade and (super)natural, then the study and statue court excerpted it and refined what it was, leading eventually to the canon we see in the casts at Battersea. This selection process did not happen overnight, and there were always outliers. There were also differences of emphasis as one moved from place to place. Venice became a center of gem production, trade, and collection, the famous Gemma Augustea surfacing there early in the seventeenth century, only to be bought for the Kunstkammer of the then Holy Roman emperor, Rudolf II (r. 1576–1612), whose interest in stones was as scientific as it was aesthetic.[175] Imperial ambition

and personal erudition, quantity and quality, mirabilia (wonders) and notabilia (things of note) stayed in tension.[176]

As more antiquities were unearthed and set side by side, there was more comparative data, and thus a greater incentive to analyze. From Petrarch (1304–74) onward, there was also an increase in the knowledge gained from ancient literature, and a growing sense from this literature of how much had been lost—of the classical world as ripe for revival.[177] With these sensibilities came a desire to classify, contextualize, and attribute broken marbles to named artists. So Cyriac of Ancona (1391–1452), one of the first to bring mainland Greece into Italy's study of the classical past, traveled through Italy and the Aegean armed with texts of Pliny and Strabo, copying inscriptions with an intensity that matched that of Polemon.[178] On arrival in Venice in 1436, he wrote to his patron, Gabriele Condulmer, by then Pope Eugene

IV: "we finally made our way to the holy and highly decorated temple of St. Mark, where first we were allowed to inspect— not once, but as long as we liked—those four bronze chariot horses which are so

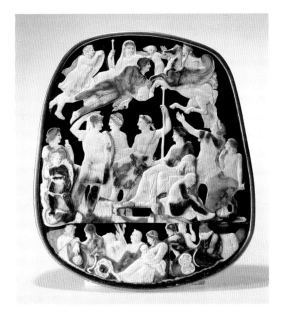

splendid a work of art and most elegant design, the noble work indeed of Pheidias, and once the glory of the temple of warlike Janus in Rome."[179] Looking, and looking for the sculptors celebrated by ancient authors, made bronze and stone speak in new ways. Constantinople was a placeholder; Rome the nucleus; and Renaissance Venice a chief competitor.[180]

5

Reviving Antiquity in Renaissance Italy

Anyone interested in Greek and Roman art today looks at it through a Renaissance lens. The Renaissance teaches them how to look. This chapter and the next ask how the Renaissance view of classical art crystallized, and how it came to color Europe's understanding of Greek and Roman culture, and its emulation of this culture, until at least the mid-eighteenth century. If the relationship of fifth-century Greece, the hellenistic world, and Rome, or Rome, Constantinople, and Venice is hard to handle, the volume of data available for Renaissance Rome, never mind Renaissance Italy, or early modern Europe, makes it more daunting still. The Gonzaga family and Lorenzo de' Medici (1449–92) have multiple publications dedicated to their collections and these collections' "inventories":[1] "the lure of classical sculpture" is in evidence well before 1500, when Haskell and Penny's trailblazing narrative begins.[2]

For this reason, and because our interest lies less in individual ambition than in how the civic displays of centers such as Venice led to more contemplative engagement with Greek and Roman artifacts as Greek and Roman, we will attempt to navigate the detail and capture the landscape. It is not an even terrain: in pursuing trends, we will discover variations in practice, and evolving, even unstable, attitudes to collecting, exhibition, and restoration, many of these

(e.g., how much admiration for the antique is too much admiration?) rooted in ancient Roman literature.[3] This literary investment is hardly surprising: the first printed edition of Pliny's *Natural History* was produced in Venice in 1469, and a vernacular edition in 1476.[4] Scholarship can overestimate the extent to which the collections of the Quattrocento and Cinquecento were governed by aesthetic considerations alien to anything at work in the assemblages on San Marco or at the Lateran.[5] Even figures such as Henry of Blois, bishop of Winchester (1129–71) and brother of King Stephen, is supposed to have brought "ancient statues" from Rome to England, while our source for this activity, John of Salisbury (d. 1180), was well versed in authors as diverse as Cicero and Frontinus.[6] But there is no denying that the wider reading and circulation of classical texts in the fifteenth and sixteenth centuries, not just Latin, but Greek, and the discussions that result— between humanists, between word and image, between painting and sculpture, and between sculpture, ancient and modern— make a difference.[7] They change the status of a statue like the Spinario (4.18) from a relic of the past into a more responsive creature, with a life beyond Rome and the Old Testament.[8] If it is "classical art" we are looking for, we would do well to remember that it is less a canon than a

conversation, and that this conversation was arguably scripted between 1300 and 1600.

From Ecphrasis to Art Appreciation

By the time that merchant and diplomat Cyriac of Ancona was traveling around Italy, Greece, the Mediterranean islands, and Asia Minor in the first half of the fifteenth century, there was no shortage of men, keen to share their love of antiquity with him, accompanying him to a range of classical sites (from the supposed Tomb of Priam's son Polydorus to the marble quarries of Paros) and showing off their most valuable possessions, many of these ancient.[9] The majority were small-scale artifacts (coins, medals, gems, and fragments). Cyriac writes:

> when Giovanni Delfino, that diligent and most industrious fleet commander, had displayed numerous coins and precious gems to me as I lingered by night with him on his flagship, he showed me among other items of the same sort, a splendid crystalline signet seal the size of a thumb that is engraved in deep relief with a bust of helmeted Alexander of Macedon, the marvelous workmanship of the artisan Eutyches.[10]

He then describes the seal's decoration in detail (5.1), down to the Molossian hounds "of extraordinary artistic beauty" (eximia artis pulchritudine) on "Alexander's" helmet, and speaks of how holding it up to the light makes the figure's "breathing limbs . . . gleam with wondrous beauty" and reveals the name of the carver.[11] Cyriac is antiquary and art lover, with a finely tuned sensitivity to the material and aesthetics of the gem as well as a historical interest

in its subject matter and maker. Its owner, Delfino, is as august as his prized possession, credited both with a sense of drama as he shares his treasure in the darkness and with an ancient work ethic to offset any charge of "luxuria." He is as "diligens" as sculptors of the best artworks—"diligentia" a quality that Pliny attributes to artists able to make the most convincing likenesses and to people who study phenomena so closely as to rate as authorities.[12] Cyriac has no formal training in Latin, but his vocabulary is Plinian; more than this, it is suffused with an appreciation of the object as object, and the beauty of the object, different from anything we encountered in our late antique or Byzantine texts, different also from Petrarch. Petrarch too appeals to the visual, and is himself formative of humanist art criticism, drawing attention to painting and statues, and turning this attention into discourse.[13] "While Petrarch had looked at ruins to illuminate the text, Cyriacus read the texts to illuminate the ruins."[14]

This self-consciousness, and importance of the intimacy of viewing, rival and reposition the literary consciousness of a hellenistic tradition of ecphrastic writing.[15] At some point between 1143 and 1327, the Latin text that is the *Narracio de Mirabilibus Urbis Romae* or *Marvels of Rome* by the otherwise unknown Master Gregory, perhaps "the first medieval writer to look at classical statuary with a critical eye," shows its knowledge of this tradition, citing, for example, a line from Ovid's *Ars amatoria* about the judgment of Paris as the stimulus for an encounter with a marble statue of Venus that is as Virgilian as it is Ovidian: this Venus was "more like a living creature than a statue; indeed she seems to blush in her nakedness, a reddish tinge colouring her face, and it

5.1. Roman gem with a helmeted figure, now correctly identified as Athena, signed "Eutyches, Son of Dioscurides," last quarter of first century BCE, 3.72 × 2.9 cm. Berlin, Antikensammlung, Staatliche Museen zu Berlin. Photograph: bpk / Antikensammlung, SMB.

appears to those who take a close look that blood flows in her snowy complexion."[16]

Such sensibilities swell with a new wave of private collecting on the part of Italian elites, influenced both by what they saw in the public sphere and by archaeological discoveries brought to light by urban expansion. One such collector was Oliviero Forzetta, a moneylender from Treviso, who in 1335 compiled a list of artifacts he hoped to acquire on the Venetian market: manuscripts of texts by classical authors and the Church fathers, Roman gems, coins, statues, and relief sculpture.[17] Some of this sculpture, depicting putti struggling beneath the weight of a scythe and scepter, came from the Church of San Vitale in Ravenna, but found its way to Venice, and, by 1532, had been

set above an arch connecting Piazza San Marco with the Frezzeria. There it influenced artists as great as Titian (5.2).[18]

Forzetta and Venice are less precocious than we might imagine. According to Poggio Bracciolini (1380–1459), a scholar renowned for his rediscovery of classical texts, Florentine humanist Niccolò Niccoli (1364–1437) was another to take "much delight" ("delectabatur," from the Latin for "to seduce" or "amuse") in paintings and statues. Meanwhile, Poggio himself was "delighted beyond expression" (from "delectare" again, "supra modum," "excessively") by sculpture, writing to Francesco da Pistoia, who was then in Greece seeking antiquities for him, that if he could secure "a complete figure," he would certainly have triumphed.[19]

5.2. Relief with putti from the Throne of Saturn, first or second century CE, marble. Archaeological Museum, Venice, inv. no. 9. Photograph: Su concessione del Ministero dei beni e delle attività culturali e del turismo.

An emphasis on exemplarity, and anxieties about idolatry, delayed the display of scantily clad, mythological statues in more public areas of the house and garden, especially in Rome.[20] But this did not make figurative sculpture a category apart. St. Vitale's putti were commended by coming from a church, while even sober artifacts could elicit "amore": in his *La composizione del mondo*, completed in 1282, Ristoro d'Arezzo had used the ancient pottery or "Arretine ware" produced in his hometown to enhance the city's antiquity, noting the "greatest delight" that it inspired in connoisseurs ("diletto" a word also used of a "darling" or "beloved"), causing them almost to lose their senses, and treat it like a holy relic.[21] By the close of the fifteenth century, San Marco's mosaics showing the lynching of pagan statues coexisted in Venice with a painting of a former doge and his wife praying in a loggia decorated with classical fragments (5.3).[22] The

dogaressa turns her back on the male torso in the niche, but it is a protecting presence nonetheless, blurring the boundaries between "art" and "cult," pagan and Christian.[23] It works in synergy with the sarcophagus and with the act of prayer—a meditation perhaps on the devotional image that was the "Man of Sorrows."[24]

Long before Aldrovandi first published his inventory of ancient statues in 1556, before even Pliny's *Natural History* was circulating in print, classical art had gained a symbolism beyond the polytheistic or the political. The posturing of men like Poggio was as influential on this as their knowledge, more influential perhaps than technical treatises on painting, sculpture, and architecture.[25] Poggio's letter to Pistoia is as crafted as the artifacts he desires, a Ciceronian confection that casts himself as Cicero and his agent as Atticus: it is not only its vocabulary (e.g., "delectare") that echoes the orator, but the admission

5.3. School of Giovanni Bellini, *The Doge Pietro Orseolo I and Dogaressa Felicita Malipiero*, c. 1490, oil on wood, 19.5 × 38.2 cm. Museo Correr, Venice. Photo: Cameraphoto Arte, Venice / Art Resource, NY. Photograph: akg-images / Cameraphoto.

that Poggio is *overly* devoted to antiquities: "many people labour under various diseases (*morbis*); that which principally affects me is an admiration of outstanding sculptors, to which I am perhaps more devoted than becomes a learned man."[26] When Pistoia replies to say that he has found three marble heads (of Juno, Minerva, and Bacchus) by Polyclitus and Praxiteles, Poggio is as skeptical as he is thrilled: "as for the names of the sculptors—I just don't know. Greeks, as you know, are rather too talkative and perhaps they have invented these names to sell them at a higher price."[27] The word for "Greeks," "Graeculi," is an interesting choice: in a Ciceronian context, it is used disparagingly for those who favor argument over truth, but in the late antique *Augustan History*, it refers to Hadrian and his deep devotion to Greek culture.[28] Who is the better "Graeculus"? The seller of statues, or the scholar, with his latter-day Hadrian's Villa? Less than a century later, we have an answer: Blosio Palladio will credit the Luxemburg-born humanist Johann Goritz with bringing "the centre of Athens and an

academic emporium" into the gardens of his villa in Rome, and with "transferring the Muses of Helicon and Parnassus to the Tarpeian Rock and the Quirinal."[29]

Not that everyone steered a course between avarice and accomplishment, any more than they had done in ancient Rome. And after the end of the Avignon papacy in 1417, the confidence of Rome's cardinals was sufficiently high to see some of them riding for a fall. Venetian cardinal Pietro Barbo (1417–71) ranks among the flashiest, an inventory of his collection begun in 1457 recording roughly 3,300 objects (made up of more than 1,000 Roman coins, 500 engraved gems, and 200 cameos, including the Seal of Nero and the Tazza Farnese, 50 bronze statuettes, hard-stone objects like the chalices of our last chapter, icons, mosaics, ivory diptychs, and liturgical vestments). Housed in the huge Palazzo San Marco in Rome, these objects constituted a "treasury" to rival that of its Venetian namesake.[30]

When Barbo became pope in 1464, his opportunities for acquiring antiquities, especially large-scale antiquities, increased,

and he was soon moving statuary, a massive granite basin, and a porphyry sarcophagus (the last two of these from churches in Rome) to the piazza outside his new palace.[31] Rumor had it that he also wanted the Horse Tamers from the Quirinal and the equestrian statue of Marcus Aurelius from the Lateran (4.9 and 4.16), the latter the ultimate rival perhaps to the horses in Venice.[32] Rumor and retrospection combine here to tar Barbo, or Paul II as he became, with the same brush as Nero. If Paul had acted like Nero in confiscating statues for his palace, then his successor, Sixtus IV, was acting like Vespasian in giving them back to the people.[33] Not only did Sixtus restore the porphyry sarcophagus to Santa Costanza, as Claudius had restored Praxiteles's Eros to Thespiae after it had been stolen by Caligula.[34] He also transferred some of the Lateran bronzes (e.g., the wolf, Spinario, and fragments of the colossal Constantine) to the Capitoline in 1471 in an act of reappropriation that celebrated public beneficence, and condemned Barbo's behavior as deviant.[35] Just as Vespasian had "dedicated in the Temple of Peace and his other buildings" works "violently brought to the city by Nero and arranged in the sitting rooms of his Golden House,"[36] so Sixtus's act was branded an act of liberation. An accompanying inscription read: "Pope Sixtus IV, on account of his immense benevolence, decreed that these outstanding bronze statues must be re-instated and presented as a monument of ancient excellence and virtue to the Roman people from where they had originated."[37]

In this way, Barbo's claims to be descended from the same family as Nero backfired.[38] The pope was Rome's new emperor, and Paul II a tyrant. Papal librarian Platina (Bartolomeo Sacchi) (1421–81)

is most Suetonian in his critique: "it was difficult to approach the man during the day since he slept then; and at night for though he was awake he was busy fingering his gems and pearls."[39] We can almost hear Suetonius on Julius Caesar's lust for pearls.[40] Platina goes on to imply that the weight of wearing these gems may even have caused Barbo's death; they certainly made him effeminate—like "a certain Cybele—Phrygian, and in a turret-crown" (and, less explicitly, perhaps, like Caesar again, the "Queen of Bithynia").[41] There was a lot at stake. The paradigms of best practice were found in ancient literature.

Familiarity with ancient literature made the search for masterpieces more desperate. Martial, Quintilian, Lucian, and Pliny agreed on a top-tier of sculptors, whose names piqued interest and spurred attribution: in 1446–47, for example, the Florentine poet Cristoforo Landino's elegiacs *On Rome Almost Destroyed* lament the shame of seeing broken statues and herms by Scopas, Praxiteles, and Pheidias, artists who had long attested to Rome's grandeur as well as Greece's greatness.[42] And the putti that Forzetta was so keen on are, like one of the Horse Tamers and Poggio's perspective purchases, erroneously ascribed to Praxiteles and Polyclitus.[43] More than this, Cyriac and Poggio's studies of inscriptions,[44] and the fashion for displaying antique and pseudo-antique inscriptions in private gardens, generate an interest in the sculpture that had once graced funerary monuments and statue bases. Ecphrastic epigrams are a key part of this display, swelling enthusiasm for authors such as Philostratus the elder and Ausonius, and for the relationship between text and image.[45] They beg that statues like Eros, the subject of several hellenistic epigrams, reappear in glorious epiphany.[46]

The "earliest known collection of antique statuary in Renaissance Rome,"[47] that formed by Cardinal Prospero Colonna in the 1430s and 1440s on the slopes of the Quirinal Hill, was born of this literary climate and of a community of writers who rivaled the poets who once worked in the court of the Ptolemies. Although Cyriac tells us that the Belvedere Torso was then part of this collection,[48] it was a group of the Three Graces (5.4) that was the pièce de résistance, each of them a budding Aphrodite of Knidos (4.11), who had starred with her son in numerous ecphrastic epigrams.[49] The goddesses' Praxitelean bodies (positioned so as to offer a front view next to the rear view for which the Knidia was famed), combined with the allegorical import of the three graces in the work of the younger Seneca and other Roman writers, made this group an obvious, if daring, choice, which invited viewers to pick their preferred angle.[50] In dwelling on their beauty, the relationship of marble and flesh at its core, and the ways in which ancient authors had configured this relationship, viewers were inspired to write new poetry—not only the epigram on the base of the group that drew attention to, and clothed, the figures' nudity,[51] but additional verses, which responded to them and their

5.4. Colonna's Three Graces, Roman statue group of hellenistic conception, second century CE, marble. Libreria Piccolomini, Duomo, Sienna. Photograph: akg-images / De Agostini Picture Lib. / A. De Gregorio.

inscription. "They are equally nude, but one stands turned towards the other two: she looks out at us," wrote Martino Filetico, whose scholarly work included commentaries on Cicero's letters and the *De senectute*, and a translation of Theocritus's *Idylls*.[52] In these exchanges, ways of seeing and an exchange of gazes were honed to become visual analysis.

Elsewhere in Rome, and in the court of Alfonso V (d. 1458) in Naples, other female figures, often reclining this time, motivated the production of epigrams, and these epigrams the display of further "sleeping nymphs," the most famous of them the Ariadne/Cleopatra, which would grace the Vatican's Belvedere Courtyard (5.5).[53] It was a process that made all of them muses, and statuary a stimulus for reflection, as well as an object of study and a marker of status—not only in public spaces of the house, but in the private retreat or studiolo, a setting participating both in the history of things and in the history of ideas.[54] It also gave the ownership of antiquities a greater social dimension, until all serious "patrons of the arts" cultivated a Greek and Roman art collection. Colonna's reputation as a latter-day Maecenas relied as much on the

sculpture in his gardens, then associated with the Tower of Maecenas from which Nero is said to have watched the fire of Rome, as it did on his literary clients.[55]

Sculpture as Subject

None of this is unconnected with what was happening in the artist's studio. In Florence, Lorenzo Ghiberti (1378–1455) and Donatello (c. 1386–1466) both owned classical sculpture; in the Veneto, painters Francesco Squarcione (c. 1395–1468), whose pupils included Andrea Mantegna, and Jacopo Bellini (1400–1470) possessed antiquities and plaster casts; and in Rome, in his house on the Quirinal, sculptor Andrea Bregno (1418–1503) had an impressive collection of ancient marbles—among them, a large marble vase, a Venus and Adonis sarcophagus, now, due to the Gonzagas, in the Ducal Palace in Mantua, and probably (post-Colonna, and prior to its move to the Vatican in the 1530s) the Belvedere Torso (5.6).[56]

As each of these artists learned and taught from the antique, rivaling one another to be the Polyclitus or Apelles of his day,[57] ancient sculpture became subject matter in its own right, and the template for modern figurative art—a relationship that we will see collectors Isabella d'Este and Andrea Odoni exploring by displaying ancient and modern pieces side by side. This competition between old and new came with a stronger imperative to compare and contrast. But close analysis was already sanctioned by detailed studies on paper, some of them wittier than others. Take the sheet attributed to Bologna-born Amico Aspertini (c. 1474–1552), in which a Venus nestles between the thighs of the Belvedere Torso, while the Naples Dying

5.5. Ariadne/Cleopatra, Vatican Museums, inv. no. 548 as captured by James Anderson, 1845–55, albumen silver print, 25.4 × 33 cm. The J. Paul Getty Museum, Los Angeles, inv. no. 84.XM.635.10. Photograph: Digital image courtesy of the Getty's Open Content Program.

5.6. Ancient marbles including the Belvedere Torso in *Studies after Antique Statuary (Fragments)*, sixteenth century, black chalk, pen and ink, bistre-brown wash, heightened with white (partly oxidized) on blue-green paper, 29.4 × 21.2 cm. Roman School. Formerly attributed to Amico Aspertini. The Fitzwilliam Museum, Cambridge, inv. no. 2978. Photograph: © The Fitzwilliam Museum, Cambridge.

Gaul (2.13), unearthed in Rome in 1514, "plays footsie" from the sidelines. The final fragment is perhaps Hercules in the snood of the Lydian queen Omphale.[58] But whatever its identity, its presence, and downward glance, add introspection to the orgy, making the composition as sexy as its elements are accurate, and the "classical nude" more suggestive. Sketches of the Spinario (4.18), meanwhile, and of models posed like the Spinario, gave new meaning to the thorn-puller's absorption: his self-examination either shows off the artist's own obsession with feet (5.7) or turns the subject's imitator into an object of desire, akin to the pretty boy, Narcissus (5.8).[59] "We may say, then, that . . . artists had taken the lead in developing a new way of looking at antiquities. It was the artists' gaze, their expert judgment and aesthetic

emotion, their rush to renew their own style and workshop practice out of careful inquiry into antiquity . . . that endowed collected items with a new value."[60]

Nowhere was this new value more obvious than in Renaissance portraiture. Early in the sixteenth century in Venice, and, then, elsewhere in Italy, sitters began to be captured with ancient and classicizing sculpture—not simply in the same space as this sculpture, as in the canvas of the doge and dogaressa, but in a more challenging way that put it in the spotlight and queried the sitter's piety. A portrait of an unidentified man by Venetian painter Domenico Capriolo is one of the earliest

examples (c. 1512), his name signaled by the roebuck or "capreolus" in the medallion, bottom right (5.9). In this canvas, Christian devotion, as represented by the church in the background, and the devotion to the antique embodied by the mutilated Venus appear, at first glance, to be in balance. But it is the Venus that has the advantage, nudging, almost, the man's shoulder, and daring us to read the contents of the folder in his hands, and of his mind, more imaginatively. Is this a self-portrait and the folder a portfolio of drawings? Forty years later, Giovanni Battista Moroni (1520/24–79) will immortalize Venetian sculptor Alessandro Vittoria, with a fragmentary male

5.7. Jan Gossaert, *Study after the Spinario*, recto, c. 1509, Rijkuniversiteit, Prentenkabinett, collezione Welcker, Leiden, inv. no. PK-T-AW-1041. Photograph: Rijkuniversiteit, Leiden.

torso in his hands, the whiteness of its marble body and its missing head and arms throwing the sculptor's strong arms and keen gaze—his craft—into relief (5.10).[61] These paintings are not about the virtue that comes of ownership, but about making artworks, and making artworks speak.

Florentine painter Bronzino (1503–72), court artist of Cosimo I de' Medici, is the best-known proponent of this fashion, revealing just how voluble classical statuary had become by the 1550s, and how sophisticated the understanding of its subject matter.[62] The Bacchic group peeping from the pink curtain in his portrait of a young man, currently in the National Gallery in London, is suggestive of sublimations beneath the sitter's public persona, and the notebook in front of him an invitation for him and his audience to respond in writing. An association with the antique has become revelatory of character.[63] But it is not just iconography that these artists put on the agenda. It is an altogether heightened sensibility, and a keener awareness of sculpture's sculptural qualities. In 1524 already, Bernardino Licinio had painted a family portrait of his brother, also an artist, in which a miniature version of the Belvedere Torso is held up for approval, competing with a newborn baby in its mother's lap for care and attention (5.11).[64] In a second Bronzino painting, the sitter caresses a statuette, inspired by contemporary engravings of a classical crouching Venus, and in so doing, gestures to the competition between drawing and sculpture, and to the feel of sculpture (5.12).[65] We remember Alexander and Nero carrying Greek statues around with them, consumed and comforted by their every contour, perhaps even their smell.[66] Geraldine Johnson puts it very nicely when she explains, "In early modern Italy, a secular

counterpart to the devotional touch began to emerge when elite collectors such as Venetian merchant Andrea Odoni and the art dealer Jacopo da Strada were depicted holding, grasping, even fondling works of art."[67] It is a world in which "essentially ocularcentric models of reception" are being supplemented and examined.[68]

Both Lorenzo Lotto's portrait of Venetian merchant Andrea Odoni (1488–1545) and Titian's portrait of polymath, collector, and art dealer Jacopo Strada (1507–88) deploy a similar handling device (5.13 and 5.14). Here, however, it verges on manhandling, as each of them offers up, rather than simply shows off, the female figure in his grasp in a manner that is explicitly transactional. Strada's statue of Venus appears almost

5.8. The workshop of Benozzo Gozzoli, *A Nude Young Man Seated on a Block, His Right Foot Crossed over His Left Leg*, c. 1460, paper, 22.6 × 15 cm. The British Museum, London, Department of Prints and Drawings, inv. no. Pp. 1.7. Photograph: © The Trustees of the British Museum.

5.9. Domenico Capriolo, *Portrait of a Man*, 1512, oil on canvas, 117 × 85 cm. The State Hermitage Museum, Moscow, inv. ГЭ-21. Photograph: akg-images.

added late in the composition, will win the day and serve as a paradigm for his love of classical antiquity.[70] Unlike many of his collecting contemporaries, Odoni was not from a patrician family, but a "cittadino" (i.e., from a social group between the common people and patriciate) of Milanese extraction, keen to use artifacts, ancient and modern, to increase his prestige, and, as Townley would do in eighteenth-century England, to create an alternative—more contemplative—means of sharing in elite status to that found only in politics.[71] Pietro Aretino describes Odoni's residence, where the line between contemplation and conspicuous consumption was delicate: "I don't know what prince has such richly adorned beds, such rare pictures, and such regal decor. Of the sculptures I will not speak: Greece would have the best of ancient form [art] had she not let herself be deprived of her [these] relics and sculptures."[72]

Even, if not especially, then, in the years following the sack of Rome by the mutinous forces of the Holy Roman emperor, Charles V, Venice could still mount a challenge to Rome as the center of Renaissance revival. Aretino continues: "when I was at court I lived in Rome and not in Venice; but now that I am here, I am in Venice and in Rome. When I leave here where I do not see marbles or bronzes, no sooner have I arrived there [at your house] than my soul enjoys that pleasure it used to feel when it visited Belvedere on Monte Cavallo [the Quirinal] or another of those places where such torsos of colossi and statues are seen."[73] Odoni's sculpture collection in the public spaces on the lower level of the house was unusual: few collectors in Venice at that time so obviously mixed ancient and classicizing pieces.[74] But, as we are about to discover, different

shocked at the affront to her modesty, reanimated by the attention lavished upon her, yet also prostituted (the coins at her feet shining more brightly than the bronze statuette of Diana, goddess of chastity, on the table behind her). This is Strada doing business, in his official role as "imperial antiquarian" or "Antiquarius Caesareus" to the Habsburg court.[69] Lotto's painting is more enigmatic, and more urgent in its asking "what kind of man is this?" With a sculpture of the hero Hercules at each shoulder, a smaller, drunken Hercules to the far right, and a doll-like symbol of the female, a fragmented Diana of Ephesus figurine, in his right hand, Odoni opens himself up to the audience, hoping perhaps that the bust of Hadrian in the foreground,

collectors put the emphasis on different aspects as they competed to tap classical art's potential and to edit its agenda. The tensions between these collections were as powerful as any single individual display in securing classical art's legacy.

For all that our sitters have been male, women were not exempt from sharing in these assets. Perhaps more renowned for her collection of paintings than her antiquities, Charles V's aunt Archduchess Margaret of Austria (1480–1530) is also known to have had sculpture and gems in the private quarters of her palace at Mechelen in Belgium, among them a white Spinario, which passed to her niece, Mary of Hungary (1505–58).[75] Mary's collection, at Binche and then in Valladolid in Spain, also included the Jüngling [Youth] from Magdalensberg, a life-size bronze statue discovered in 1502 near the ancient settlement of Virunum in the eastern Alps

5.10. Giovanni Battista Moroni, *The Sculptor Alessandro Vittoria*, 1552, oil on canvas, 875 × 700 cm. Kunsthistorisches Museum, Vienna, inv. no. GG 78. Photograph: KHM-Museumsverband.

5.11. Bernardino Licinio, *Portrait of Arrigo Licinio and His Family*, c. 1532, oil on canvas, Borghese Gallery, Rome, inv. no. 115. Photograph: akg-images / Pirozzi.

5.12. Bronzino, *Portrait of a Man Holding a Statuette*, 1545–55, wood transferred onto canvas, 99 × 79 cm. Louvre, Paris, inv. no. 131. Photograph: © RMN-Grand Palais (musée du Louvre) / Michel Urtado.

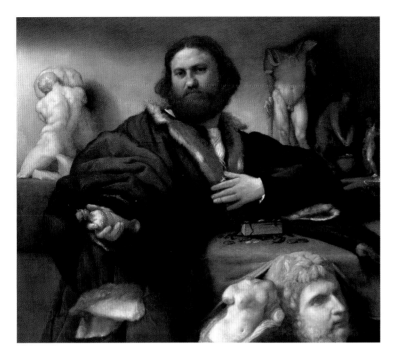

5.13. Lorenzo Lotto, *Andrea Odoni*, 1527, oil on canvas, 104 × 116 cm. Windsor Castle, inv. no. RCIN 405776. Photograph: Royal Collection Trust / © Her Majesty Queen Elizabeth II 2016.

(5.15).[76] And Barbara Gonzaga Sanseverino, Countess of Caiazzo (c. 1482–1558), owned an important gem collection, which, when widowed, she was perhaps overly eager to convert to disposable income.[77] In Rome, meanwhile, the Palazzo Medici-Madama, as it would become (after Margaret "Madama" of Parma),[78] was from 1509 to 1520 in the hands of Alfonsina Orsini de' Medici, who in 1514 acquired "around five" of "the most beautiful sculptures ever seen in Rome," one of them the Gaul in Aspertini's drawing. These are now identified as Roman "copies" of figures from the Attalid dedication on the Athenian Acropolis.[79]

Outperforming all of them, even without a Roman residence, was Barbara's cousin, Isabella d'Este (1474–1539), whose "insatiable desire for all things antique" was legendary, and who will, therefore, feature heavily in the latter stages of this chapter.[80] Her tenure as acting regent of Mantua, in the absence of her husband, Francesco II Gonzaga, goes some way to explaining why Greek and Roman art and literature were so important to her: they gave her a vocabulary for communing with her male counterparts.[81] But they did more than this: by the end of the fifteenth century, serious interest in Greek and Roman gems, coins, and sculpture had transcended poetic and artistic emulation, regional and gender boundaries, to be about something bigger, not just about curiosity, ambition, or even politics or nationhood, but—in the space between the expert and the amateur, the objective and the subjective, the collective and the individual, and the personal, public, and epistolary self—about "habitus."[82] The reflexivity and rivalry involved in appreciating these artworks made it a matter of taste.

Taste and the Antique

How did this taste manifest itself? Decades later, in 1638, French artist François Perrier would publish an anthology of engravings

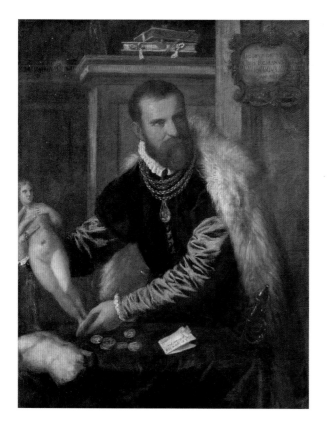

5.14. Titian, *Jacopo Strada*, 1567–68, oil on canvas, 125 × 95 cm. Kunsthistorisches Museum, Vienna, inv. no. GG-81. Photograph: KHM-Museumsverband.

"antiquarians" such as Petrarch and Giulio Pomponio Leto (1428–98) preferring coins and inscriptions.[84] Both Barbo's inventory and the will of Cardinal Francesco Gonzaga omit marble statuary;[85] poets active in Leto's Academy in Rome produce the most famous of the "sleeping nymph" epigrams.[86] Nor is it a simple story of change over time, from small-scale artifacts to statues, and from fragments to whole sculptures, nor indeed of the increasing separation of classical artifacts from other "collectibles." Study spaces or studioli and—evolving from these and from church treasuries—Kunstkammern or cabinets of curiosity (5.23) continue to privilege the genius or "ingenium" of myriad intricate objects.[87] Francesco Gonzaga followed Barbo in displaying his ancient cameos on gilt trays, a decision that made them look more like Byzantine devotional objects than part of the plastic arts of Greece and Rome.[88] And in the sixteenth century, Cosimo I de' Medici kept bronzes by sculptors Andrea Sansovino (1467–1529) and Baccio Bandinelli (1493–1560), whose works include a marble copy of the Laocoon, now in the Uffizi (6.1), and a large-scale Hercules and Cacus in Florence's Piazza della Signoria, in the same cabinet in the Palazzo Vecchio as "Indian" masks from the new world.[89]

Beyond these intimate spaces, Renaissance drawings still give an impression of random discoveries, heaped up haphazardly. Haarlem artist Maarten van Heemskerck's Roman views of 1532–c. 1537 are a case in point: his representations of the house of the Maffei brothers and garden of the Galli family (5.17), both of these collections formed in the second half of the fifteenth century, not to mention the courtyard of the Palazzo Medici-Madama, with "Aristogeiton," as he will become, striding purposefully across the foreground (1.7), revel

of statues in the Vatican and other major collections in Rome, all of them ancient, except Michelangelo's *Moses*.[83] But what was setting the pace before this "canon" of statues, the majority of which were unearthed post-1500 (the Laocoon on the Esquiline in 1506, the Farnese Hercules in 1545–46, and the Medici Venus seemingly later still), was widely disseminated? With what else were the graces, nymphs, and "gladiators" displayed, and in what state of preservation? All of the statues in Perrier's catalog have heads, and few any compromising damage: perhaps it is the Belvedere Torso's loss of head and limbs that relegates (or elevates?) it from the plates proper to the frontispiece (5.16). What did classical art look like in the fifteenth and sixteenth centuries?

This is not a simple story of cardinals and dukes preferring sculpture, and

in a mess of mutilated sculpture.[90] After the sack of 1527, these fragmented statues take on new poignancy: Heemskerck's landscapes look less like "collection environment(s)"[91] than they do temporary injury tents. But for all their "mannerism," these drawings have a broader message about classical sculpture in the Quattrocento and Cinquecento, and not just how much of it was unearthed in the *vigne* of Rome's wealthy landowners. They prove that incompleteness was no barrier to aesthetic enjoyment: "There are many who would happily give many living horses for one made out of stone by the hand of Phidias or Praxiteles, even if it were not whole, or some part were damaged."[92] More than this, they prove that it could be productive: "If the fragments of sacred antiquity, the ruins and debris . . . fill us with stupefied admiration and give us such delight in viewing them, what would they do if they were whole?"[93] An attraction of broken marbles was that they kept everyone imagining.

Artists exercised this imagination in the figures that populated their paintings, restoring missing limbs and faded color to instill classical form with new life. But they also, whatever Heemskerck's elegiac vision might lead us to believe, exercised it on the ancient statues themselves, fashioning their missing sections in concrete form, and turning them from forsaken stones into more graceful mannequins.[94] Vasari famously claimed that Lorenzetto's work for Cardinal della Valle in the 1520s led to "all of Rome" preferring complete statues.[95] But in the 1460s, in Florence, Tuscan sculptor Mino da Fiesole was already restoring Cosimo il Vecchio de' Medici's (1389–1464) Hanging Marsyas. His grandson, Lorenzo de' Medici (1449–92), added a second Marsyas to the

5.15. Cast of the Jüngling from Magdalensberg, sixteenth century, bronze, h 185 cm. Kunsthistorisches Museum, Vienna, inv. no. VI 1. Photograph: KHM-Museumsverband.

5.16. Frontispiece, Perrier's *Segmenta nobilium signorum et statuarum*, 1638. Photograph: Reproduced by kind permission of the Syndics of Cambridge University Library.

collection, the legs, thighs, and arms of which were restored by Andrea del Verrochio.[96] And back in Rome, an inventory of Gabriele de' Rossi's antiquities of 1517 mentions several broken sculptures, pieced together with iron clamps or restored with additions in gesso.[97] Interventions of these kinds can today be undetectable.

In the sixteenth century, restoration became a more routine phenomenon. The Farnese Hercules was given new legs by sculptor Guglielmo della Porta (legs that were not replaced, despite the discovery of the originals, until the second half of the eighteenth century).[98] And marbles sent to France in the 1540s, courtesy of François I's agents, and to Spain in the 1560s by Per Afán de Ribera for his house in Seville, were also cleaned and "completed."[99] Restoration tested whether the workmanship of modern sculptors could stand comparison with that of the ancients.[100]

And for this reason, and other aesthetic ends, restoration remained a live issue. Despite what Vasari tells us, the innovative garden in Cardinal della Valle's new palace, still unfinished at his death in 1534, accommodated restored and unrestored pieces (5.18).[101] A contemporary inscription, displayed prominently on the east wall of the sculpture court, drew attention to the "restoration of collapsing statues," but there was more than one way to "renew" them even then. A second inscription, on the west wall, prescribed that the ensemble function as "an aid to poets and painters."[102] Were this aim to be realized, then better a mix of "before" and "after" images so that artists could learn by example and see what they might do to revive antiquity. Art and text are again in dialogue, as are antiquity and modernity. The dialogue turns a hang designed to make a statement into something more didactic.[103]

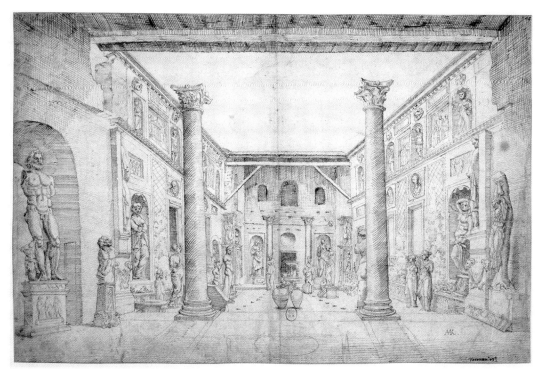

The "openness" of broken statues means that restoring them was always a leap of faith. It is true that artists were becoming better versed in classical iconography, and even if they got the restoration right, were still at the mercy of an audience who might misidentify the finished product.[104] But, as far as buyers were concerned, well-preserved figures were deemed a safer investment. We have already noted Poggio's desire for a complete figure.[105] In 1489, Lorenzo was notified about the discovery of the Apollo Belvedere (4.1 and 8.20) in the following terms: "a large complete figure . . . which is thought to be an exceptional object."[106] Not that Isabella d'Este was not delighted to receive an ancient bronze arm, and this at roughly the same time as she was sending a statue of a sleeping Cupid and several heads to the restorer. In part, this is about the rarity of bronze over marble, and in part, about display context and different modes of viewing: the arm was for her private space of "Studiolo" and "Grotta" (grotto) and some of the heads, presumably, for more public axes above doorways (5.19). But, the Cupid too was for her study space, across from a second sleeping Cupid by Michelangelo.[107] And in 1523, a Roman relief of dancing satyrs, still in its fragmentary state, was set into a chimney breast in the Camera Depinta.[108] To describe the arm as a "purely archaeological piece,"[109] or attempt to sketch an overarching scenography of fragmentation or wholeness is to flatten the picture: when Isabella was offered it, it was described as "a thing of beauty—not only in Rome, but in the whole world."[110] There were inconsistencies, even within individual practice.

Inconsistencies notwithstanding, some classical artifacts were immediately more desirable than others—the Torso for its incompleteness, the Apollo for its antithesis. The Laocoon group's link to Virgil

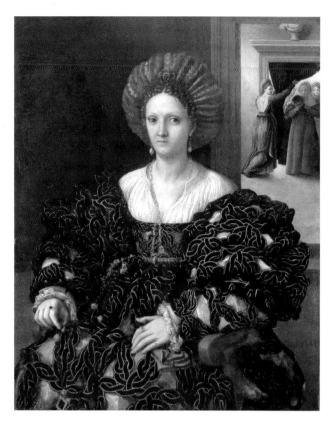

5.19. A bust displayed above a Mantuan doorway in Giulio Romano, *Portrait of Margherita Paleologo*, Isabella's daughter-in-law, c. 1531, oil on panel, 115.5 × 90 cm. King's Closet, Windsor Castle. Royal Collection, inv. no. RCIN 405777. Photograph: Royal Collection Trust / © Her Majesty Queen Elizabeth II 2016.

and Pliny saw several patrons compete for its ownership.[111] Once these statues were acquired by the pope and exhibited in the Vatican's Belvedere Courtyard, their canonical status was cemented for centuries. Other collectors, especially, one might think, those outside of Rome, had to make the best of what was available, casting the net wide, or capitalizing on local resources. Isabella acquired some pieces from Rhodes, Delos, Halicarnassus, and the Levant.[112] Neopolitan noble Diomede I Carafa (c. 1406–87) found sculpture and inscriptions on the sites of his properties in Naples and Pozzuoli and ordered excavations in other parts of the kingdom.[113] But networks were such that for elites at least, there were "universal standards." A seventeenth-century woodcut of the Palazzo Carafa's courtyard, with its mix of marbles

in niches and on high bases (5.20), gives some sense of what one early visitor meant when he claimed that it resembled the Palazzo delle Valle (or, strictly speaking, that the later Palazzo delle Valle resembled it).[114] As well as marble statues of Hercules, the three graces, and so on, there were also bronzes, the best-known of them a colossal horse's head given to Carafa by Lorenzo in 1471, pictured on the right of the engraving.[115] Gift exchange further influenced the appearance of sculptural assemblages.[116]

These influences were not confined to Italy. Several of the Carafas' antiquities will eventually end up, after the death in 1746 of Francesco Carafa, and via dealer Thomas Jenkins, in "the best antiquities collections in England," including those of the second Earl of Shelburne (later first Marquess of Lansdowne), Lyde Browne, and Charles

Townley.[117] But in the sixteenth century already, the palazzo's combination of statues, heads (not only emperors but an antique "Antinous" and "Cicero"), urns, inscriptions, and the kind of column drums and capitals often glossed as spolia, made it a popular destination for travelers such as the English diplomat Thomas Hoby (1530–66).[118]

Access of this kind had grown in importance after 1471 and Sixtus IV's donation of the Lateran bronzes to the Roman people, and their transferral to the Capitol, site of municipal government.[119] A couple of decades later, in 1493, citizens in Reggio Emilia were petitioning Isabella's father, Ercole I d'Este, Duke of Ferrara, to display some recently discovered sarcophagi in a "public place so as to be seen by all."[120] And by 1500, an inscription outside the sculpture garden of Cardinal Cesarini in Rome insisted that any "decorous pleasure" or "honesta uoluptas" derived from his statues was that of his fellow countrymen.[121] As the century drew to a close, Cosimo I's sons had moved some of the Medicis' most precious pieces into a wing of the Uffizi, a structure built, as its name suggests, to house the offices of Florence's magistrates (the most famous element of this new setup, the octagonal Tribuna), and the collections of Cardinal Domenico Grimani (1461–1523) and his nephew Giovanni (1500–1593) had been installed in a "Statuario Pubblico" in Venice's Marcian Library.[122] The intention was "that foreigners, after they have seen the Arsenal and the other marvellous sights of the city, could see another notable thing in these antiquities transformed in a public place."[123]

This pressure to display large-scale sculpture in courtyards, loggias, and gardens, and the educational imperatives that followed in its wake—imperatives

5.20. Print showing Palazzo Diomede Carafa, 1659–1707, Naples, paper, 12.7 × 6.4 cm. Rijksmuseum, Amsterdam, inv. no. RP-P-1957-653-102-4. Purchased with the support of the F. G. Waller-Fonds, 1957. Photograph: Rijksmuseum, Amsterdam.

that gave birth to the modern museum— were offset by a more concentrated, personal engagement with the antique, in the studiolo (which spawned the Tribuna [7.5]),[124] and Kunstkammer. The existence of over three hundred letters covering the period from 1490 to 1539, and a posthumous inventory drawn up within three years of her death, make Isabella d'Este an excellent case study here. On coming to Mantua in 1490, she secured a suite of rooms, first in the Ducal Palace's Castello di San Giorgio and then, in 1519, on her husband's death, on the ground floor of the Corte Vecchia.[125] In both locations, gilded ceilings, cabinets, and mythological paintings by artists Lorenzo Costa, Andrea Mantegna, and Pietro Perugino made her Studiolo and Grotta a luxury space, in which the relationship of art and

text, sculpture and painting, and antiquity and modernity gained in intensity.[126] Like the paintings, the Cupids that took center stage were informed by ancient ecphrastic literature: "when we entered the deep-shadowed wood, we found within it the son of Venus, like two rosy apples . . . and he lay among the rose-blossoms smiling, bound fast by sleep."[127] Contemporary sculptor Antico's bronze miniature *Hercules and Antaeus* (5.21) was also enlivened by this literature, and a Greek text that Isabella had had translated into Italian: "you see them engaged in wrestling, or rather at the conclusion of their bout, and Hercules at the moment of victory."[128] In these exchanges, and in the interactions of the Cupids with Mantegna and Perugino's painted putti, responding to the antique was dramatized. Isabella's artworks did not passively stimulate ideas; they cried out to be read.

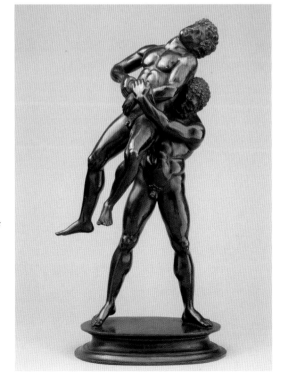

5.21. Antico (Pier Jacopo Alari Bonacolsi), *Hercules and Antaeus*, model created by 1511, cast 1519, bronze, h 39.6 cm, and engraved with Isabella's name. Kunstkammer, Kunsthistorisches Museum, Vienna, inv. no. 5767. Photograph: KHM-Museumsverband.

Studioli and Kunstkammern

We can perceive this demand most clearly by zooming in on the Grotta of the Corte Vecchia, where Isabella's most prized possessions were displayed.[129] It is hard to imagine a more concentrated experience, the journey of discovery made all the more magical by virtue of the clutter. Cupboards lining the walls were full with bronze and marble, complete and fragmentary, vases, cameos, engraved gems and coins, not to mention "naturalia" such as fossilized snails and pieces of coral. Above them, a "unicorn" horn and fish tooth hung from walls that accommodated portrait busts, heads of putti, and statuettes in portals and on cornices.[130] Access to any of these items was made deliberately difficult, all of them vying for space and attention,[131] but all of them gaining from their groupings. Even the freshly discovered Laocoon, which Mantuan diplomat Ludovico Canossa lamented should have been taken to Isabella's Grotta in the Castillo rather than the "fairly public place" that was the Belvedere Courtyard, was represented not once, but twice, in two modern reductions, at least one of these in bronze.[132] This was not just about referencing a new masterpiece and sharing in the cachet of papal ownership, nor even about the group's relationship with text; if anything, the presence of not one but two Laocoon sculptures destabilized these relationships, inviting visitors to compare them and to meditate on the act of reproduction.[133] What were Isabella and her confidantes admiring when admiring the antique? What was "antique" and, different again, what was "beautiful" about it? Such was the Laocoon's standing that only a few years after its discovery, Bramante organized a contest that saw artists compete to have their wax

replica of it cast in bronze.[134] Isabella's two versions participate in this kind of competition. The winning bronze, by Andrea Sansovino's pupil Jacopo Sansovino, was given to Domenico Grimani, who valued it more than his antiquities as a "very rare thing" (come cose rarissima).[135] It was probably through this miniature version that the Laocoon became famous in Venice.[136]

Elsewhere in the Grotta, Michelangelo's Cupid sculpture, in a cabinet on the right of the window, balanced the antique version in a cabinet on the left and shared its confines with a version of the Vatican's Ariadne, which was then known as "Cleopatra" (5.5). Above them on a cornice, a head of Mark Antony was framed on one side by Antico's *Cupid and Bow*, and on the other, by a seated Pan and a Silenus.[137] The Pan was again modern, and bronze, and the Silenus, marble and ancient, but this was about more than the mix of ages and materials. It prompted its audience to weave more nuanced narratives and play at being budding Shakespeares, reenacting Antony's love affair and his acclamation as the new Dionysus.[138]

This buying of old and new pieces is itself unremarkable. Indeed, as the inclusion of his *Moses* in Perrier's book of engravings later underlines, Michelangelo for one was in a different category from other contemporary sculptors: his statue of Bacchus and the first version of his *Risen Christ* (unfinished because of a disfiguring vein in the marble on the left cheek) were displayed with, and effectively *as*, antiquities in the courtyards of Jacopo Galli and the Porcari respectively (5.17).[139] But by balancing Michelangelo's *Cupid*, carved of Carrara marble and acquired in 1502, with an ancient equivalent attributed to Praxiteles,[140] which was finally in 1506, after

nine years of bidding, secured in exchange for a benefice for the family of its previous owner, Isabella was setting a precedent for Odoni in Venice, as well as suggesting that the differences between modern sculpture and its models be carefully considered by patrons as well as artists; that patrons become critics. This invitation gains complexity when we consider that Michelangelo's version, itself a copy of a piece belonging to Lorenzo de' Medici, had been widely considered an antique, and was first described to Isabella in 1496 as "ancient or modern."[141] By the time it arrived in Mantua, gifted by Cesare Borgia, its modernity had been revealed (although whether Isabella knew who its artist was must remain open).[142] There, in an honest and open fight, it competed for the spotlight.

Certainly by 1542, three years after Isabella's death, Michelangelo's name was in the frame, and comparison of the Cupids, which remained in situ, a popular literary topos. French statesman and scholar Jacques-Auguste de Thou (1573) was one of the most imaginative.

> There was a sleeping Cupid, made by Michelangelo from a rich Carrara marble (. . .). When they had been left to admire it for some time, they were shown another Cupid that had been wrapped in silk fabric. This ancient monument, such as is represented to us in so many of the ingenious epigrams that Greece once dedicated to its praise, was still soiled with the dirt from which it had been dragged. In comparing them to one another, all of the company were ashamed of having been so generous in judging the first and agreed that the ancient one appeared animated, and the new

one an expressionless block of marble. Several people from the house assured us that Michelangelo (. . .) had immediately asked Countess Isabella, after he had presented her with the Cupid and had seen the other, that they only show the ancient one second so that connoisseurs could judge on seeing them how much in these sorts of work the ancients outweigh the moderns.[143]

It is as though the ancient piece is being reexcavated in front of de Thou's readers, while the modern piece is yet to be carved, or is interesting only as raw material for highlighting Praxiteles's comparative brilliance. Even Michelangelo is made complicit, just as he was in the discovery of the Laocoon.[144] When Lorenzo was collecting, in the second half of the fifteenth century, ancient sculptures, even large ones, had proven inexpensive compared to hard stones and gems, but by the end of the century and into the next, their prices skyrocketed.[145] The benefice that Isabella acquired in exchange for the Cupid brought the family 100 ducats a year; not even 1,000 ducats could secure the Laocoon.[146] As in de Thou's text, so in Isabella's Studiolo and Grotta: contemporary art's increasingly explicit debt made ancient art invaluable.

All of this increased the chances that excessive love of the antique would slide into fetishism. The studiolo offered seemingly endless possibilities for new encounters. So Antonio di Pietro Averlino or "Filarete" on Lorenzo's father, Piero di Cosimo de' Medici (1416–69):

> Another day he looks at his jewels and precious stones. He has a marvelous quantity of them of great value and cut in different ways. He takes pleasure

and delight in looking at them and in talking about the virtue and value of those he has. Another day [he looks] at vases of gold, silver, and other materials made nobly and at great expense and brought from different places . . . I was told that he had so many different things that if he looked at [each] one of them for a day it would take a month to see them all.[147]

There were multiple pathways, unlocked by the repeated enjoyment of the object in the hand, in the eye, and in lines of literature, pathways that transported people across oceans and millennia, out of their palaces and out of themselves. The letters read and written in these spaces took this experience into the open so that even the most celebrated statues, male and female, were subject to more fervent devotion, one on one, like Pygmalion and his Venus. We tend today to associate rhapsodic appreciation of the Apollo Belvedere as a sublime, yet erotically charged being with Winckelmann and the eighteenth century.[148] But it was there in 1517 already—part of a studied self-consciousness about what statues did to their viewers, and viewers to classical statues.[149] Mantuan nobleman Nicola Maffei confides in Isabella:

> I have fallen in love, in the Belvedere, with an extremely beautiful youth named Apollo, in such a way I cannot refrain from going to contemplate his celestial beauties at least twice a day on average. If your Ladyship were to see me I'm sure you would laugh a good deal . . . [my] Apollo is going to drive me out of my mind, no more than right now, since it's time for me to go and see him again.[150]

At least Maffei has a sense of humor: he is rendered a Hyacinthus or a Daphne by his obsession with (the god of) culture. But everyone was at risk. A painting of an unknown youth by Moretto da Brescia dated to 1540–45 confronts this risk head-on (5.22): the sitter leans languorously, lugubriously even, on silk cushions, the coins and a bronze foot no longer the object of his attention nor ours, but strewn carelessly across the table. Man is the artifact, complete with label. On his cap-badge is the motto ιού λίαν ποθῶ, "Alas, I desire too much."[151]

If assiduousness were not one's métier, then there was always curiosity and wonder.[152] As well as classical art, architectural fragments, icons, and so on, Lorenzo de' Medici owned an arrow, bronze nails, a terracotta urn, and lead water conduits, hardly objects that obviously competed on aesthetic grounds. In contrast to Isabella's bronze arm, these really were "purely archaeological piece(s)," of more interest for their age and ancient efficacy than for their beauty, and evocative of a different "wow factor," and power, from that that comes of scrutiny and poesy.[153] Like Isabella, Lorenzo also owned "naturalia": he kept three fish heads in his study together with small paintings, miniature bronzes, and other minor artworks.[154]

The combination of objects is worthy of comment. Thus far, we have tended to treat classical art, and its Greek and Roman world of reference, as a separate entity, when in many scenarios, it shared the space with materials that we might today think of as being of another place and genre. The late sixteenth-century studiolo of Francesco I de' Medici (1541–87) in Florence's Palazzo Vecchio privileged a different category again, "scientifica," or instruments that attest to man's domination of nature,

mechanical gadgets and clocks, as well as pharmaceutical and animal exhibits, carved and uncarved stones, ivory, agate, and ebony vessels and medals.[155] We remember his father Cosimo's mix of classicizing bronzes and "Indian" masks. But Cosimo's storeroom on the floor above Francesco's studiolo was more comprehensive in its decoration than its contents. Designed by Vasari, the "Sala delle Carte Geografiche," as it is now called, comprised a series of walnut cupboards decorated with maps. Above them were portraits of princes, emperors, and popes; there were also to be terrestrial and celestial globes.[156] It is a context that placed his collection in a world enlarged by astronomy and Columbian exchange, and the Medici at the center of the universe. When they moved some of their collection to the Tribuna in 1584, an iron and gold nail reputedly made in an alchemical experiment and a "unicorn" horn competed with the artworks.[157]

Elsewhere in Florence, the Casino di San Marco built for Francesco in 1574 was a complex of workshops housing glassworks, gem-carvers, statue-restorers, not to mention alchemists, in a collision of interests already obvious in his studiolo, where the walls were devoted to the four elements and to paintings of classical mythology and the chemical arts.[158] According to Aldrovandi, the Casino was a veritable "casa di natura," in an area of the city associated with Lorenzo de' Medici's sculpture garden, and one that produced "porcelain" vases, the beauty and value of which exceeded the myrrhine-ware owned by Nero.[159] The Medicis' patronage of natural history and technology went hand in hand with their patronage of the arts, bringing the practical knowledge fostered by the guilds beyond the court, into elite

5.22. Moretto da Brescia, *Portrait of a Young Man*, probably Fortunato Martinengo Cesaresco, 1540–45, oil on canvas, 114 × 94.4 cm. National Gallery, London, inv. no. NG299. Photograph: © The National Gallery, London.

service.[160] Nowhere, perhaps, was the link between art and science stronger than in Florence.[161] But all over Europe, Pliny and the imperial agenda of his *Natural History* enjoyed an expanded remit.

Aldrovandi's museum of nature in Bologna (established in 1547), and similar "natural history" ventures by sixteenth-century apothecaries such as Francesco Calzolari (1554) and Ferrante Imperato (1573–75) in Verona and Naples respectively, cannot have escaped being influenced by the arts in return.[162] Francesco and his brother were patrons of Aldrovandi, who used Medici painters to provide illustrations of key specimens. And although Imperato, whose own *Natural History* was published in Italian in 1599, would claim in a letter

to own "nothing but natural things, such as minerals, animals and plants,"[163] a few "artificialia" were included (not only paintings but clocks, mirrors, sculpture, paintings, plaster models of statuettes) as part of an increasingly encyclopedic exercise.[164] An engraving of Calzolari's museum or "theater" as it was also known,[165] published in the second catalog of the collection in 1622 (5.23), reveals equestrian figurines, statues of Atlas and an imperator-figure, and various pots among the books, shells, stuffed animals, and drawers of biological specimens. By now, its discussions had been expanded to appeal not just to students of medicine, but to virtuosi.[166]

This amalgam of art, science, and nature—"naturae atque artis, tot rerum

millia in una"[167]—would come to define the Kunstkammern of northern Europe. Not that this in any way diluted the increasingly nuanced appreciation of classical and classicizing works witnessed earlier in this chapter. If anything, it had the opposite effect, giving what was already a growing interest in "reading" images a scientific grounding, and turning description into observation. Indeed, for anyone wishing to use collecting as a sign of elite, especially regal, standing, paintings, antiques, medals, and cameos were preferable.[168] This was writ large in one of the biggest courtly collections north of the Alps, in Munich, where some six thousand objects made the Kunstkammer of Albrecht V, Duke of Bavaria from 1550 until his death in 1579, "the first truly encyclopedic princely collection in Central Europe."[169] Among the organic and inorganic specimens, some of them reputed to have prodigious properties, and

documentary images, there was an amazing array of ancient sculpture, some of it gifted by Rome's cardinals. Four pieces were sent in 1569 by Pope Pius V from the Vatican's Belvedere.[170] In the same year Albrecht also received 91 busts, 43 statues and torsos, 33 reliefs, and 120 small bronzes, brokered by Jacopo Strada from the Venetian collection of Andrea Loredan.[171] Under Strada's supervision, a designated "Antiquarium," or Hall of Antiquities, was added, modeled on sculpture displays in Italy.[172]

Not that classical sculpture needed this kind of separation to shine, even in the king's Kunstkammer, where the overriding message was that of self-representation as a dynast.[173] As well as the Gemma Augustea, Rudolf II had other important antiquities in his collection, including a kneeling male figure known as "Ilioneus", made circa 300 BCE, and previously passed from collection to collection in Renaissance Rome.[174] Like

5.23. Engraving by G. Viscardi from B. Ceruti and A. Chiocco, *Musaeum Francisci Calceolari*, Verona: 1622. Photograph: Reproduced by kind permission of the Syndics of Cambridge University Library.

our first chapter, given temporary glory as "gladiators." Only gradually was something of a visual canon created, shaped organically almost, by the serendipities of patronage, competition, emulation, and study—not by definition, but by dialogue—and embracing portrait heads as well as ideal statuary, whole and fragmentary, not only emperors, but more enigmatic figures such as Antinous.[176] In the next chapter, we examine how this "canon" was refined, and disseminated across Europe. We also examine the role played in this refinement by Spain, France, and Britain. Responding to the antique is now about being human, with a capacity to express both the cognitive and the emotional aspects of this. We remember Maffei and his feelings for the Apollo. The statues of the papal collections bear the brunt of this infatuation, but are always vulnerable to being jilted for newer discoveries.

Isabella, he also owned two Laocoon groups, one bronze, the other alabaster, which he displayed next to a version of Giambologna's *Rape of the Sabine Women* (5.24) and a set of antlers.[175] All were part of a "natural history," but joined by their twisting form. The antlers may even have hinted at the myth of Actaeon, and metamorphosis. Certainly, the Laocoon was made more dynamic.

The Laocoon emerges as one of the most influential classical artworks ever found, but from a field cultivated in Italy since at least the fourteenth century. Back then, the only canon that existed was a set of artists' names (e.g., Praxiteles and Polyclitus) to which sculptures such as Isabella's Cupid were matched, often erroneously. Statues of nymphs were the order of the day; either that or toned male bodies, some of them, like the Dying Gaul and Tyrannicides of

6

European Court Society and the Shaping of the Canon

Rome and the Rest of Europe

Within two decades of the Laocoon being discovered and installed in the Belvedere Courtyard, ambassadors of the French king, François I (r. 1515–47), were visiting the Vatican in the hope of securing the sculptural group and others like it for France. Unwilling to part with it, Pope Leo X, as aware as François that classical statuary was now important diplomatic currency, commissioned Bandinelli to make the king a marble replica. Unfortunately, François never received the gift (although in 1540 he was gifted a bronze copy of the Spinario by Cardinal Ippolito II d'Este): Medici pope Clement VII (1523 34), under whose papacy the group was finished, took such a shine to it as to claim it for his family in Florence (6.1).[1]

François had to find new ways of satisfying his desire for the antique, sending agents to Italy in search of antiquities, and charging his court artist, Italian painter Francesco Primaticcio, to copy the "medals, pictures, triumphal arches and other exquisite antiquities that we desire to see, and to choose and advise us on those that we will be able to obtain or buy."[2] Chief among this commission was the securing of molds of classical sculpture, the Laocoon included, most of which were cast in bronze for his palace at Fontainebleau. Like the Laocoon, the majority came from the Vatican (the

Nile and Tiber, Belvedere "Antinous" [6.2], Ariadne/Cleopatra, Commodus/Hercules, Apollo Belvedere, "Aphrodite of Knidos" as she will become, twin sphinxes), although molds were also made of the equestrian statue of Marcus Aurelius, of Trajan's column, and of two Pans/satyrs from the della Valle collection, the discovery of which had been hailed in poetry in the 1470s.[3] These constituted a sculptural canon, and confirmed Fontainebleau's ambition to be a new Rome (quasi una nuova Roma).[4]

After the king's death, his successor Henri II eventually agreed to give Mary of Hungary, Regent of the Netherlands, access to some of Primaticcio's molds, and the Vatican Nile and Ariadne were cast, in plaster this time, for her garden at Binche, and a Laocoon planned as their companion.[5] The use of plaster is interesting here—evidence that the subject matter of these pieces was more important than the nobility or endurance of their material.[6] At about the same time, Henri's mistress, Diane de Poitiers, was busy sourcing antique marble statues for her château, including a larger than life-size head of Venus that Italian dealers agreed was by Pheidias;[7] and gifts continued to be gratefully received, most famously, and perhaps allusive of his relationship with Diane, the Roman statue of Diana and doe (6.3), given to Henri by Pope Paul IV.[8] In time,

6.1. Baccio Bandinelli, *Laocoon*, 1520–25, marble, h 213 cm. Uffizi, Florence, inv. no. (Inventario Sculture) 284 (1914). Photograph: © 2016. Photo Scala, Florence.

this too would be cast in bronze and copied in marble, rivaling the Spinario, Marcus Aurelius, and the Vatican's exhibits, which were also popular as bronze miniatures. When Charles I of England (r. 1625–49) commissioned Hubert Le Sueur to "make moulds and patterns of certain figures and antiques," the bronzes cast included the Spinario, Belvedere Antinous, more recent finds such as the Medici Venus and Borghese Gladiator, and the Diana (by then in the Hall of Antiquities at the Louvre), as what constituted the "best pieces" shifted.[9]

Diana's intrusion into the canon from a position of power in France is less peculiar than we might imagine, symptomatic no less of the two-way, or, perhaps better, multidirectional process that dictates what classical art is and how it should be shown. Although Rome remains central, it is perhaps less the nucleus from which

the influence of Greek and Roman art, and indeed the model of empire, radiates, than a mirror that reflects an already distorted image, refracted through Constantinople and the Republic of Venice, back, more strongly, upon itself. When Charles I and, before him, Henry VIII want classical artifacts for their palaces, it is arguably Fontainebleau as much as it is Rome or Vatican City that they are trying to rival.[10]

And it is not only wandering antiquities such as Diana that exert an impact on the center, if indeed Rome was "the center." Poggio Bracciolini came to England in 1418, while in 1494–96 Florentine architect Giuliano da Sangallo accompanied Cardinal Giuliano della Rovere to France, where he encountered at Arles "a most beautiful Colosseum."[11] These were not countries devoid of classical culture prior to their monarchs' emulation of Rome's collections. They had

themselves been part of the Roman empire and had Roman artifacts of their own to accommodate into a story of classical art. François I is given a copper statue of Julius Caesar, for example, found at Saint-Quentin in Picardy, and, like Suetonius's Caesar, who was said to have carried mosaics with him on campaign, removes a Roman mosaic from Saint-Gilles, and crawls around excavations in Dauphiné, carting off anything remarkable.[12] Some of these are then stored with Egyptian artifacts, mummies' feet included, in a cabinet in Fontainebleau's Pavillon des Armes, the main entrance of which is flanked by a pair of Egyptianizing figures inspired by two telamons found at Hadrian's Villa in the fifteenth century and drawn in 1504–7 by Sangallo.[13] These make Egypt the primary frame, but of objects that constitute a different microcosm of empire from that at Tivoli, one where the provincial is core. France threatened to supplant Rome, surpassing "not only the Italians, but even the Dorians and Ionians, who taught the Italians."[14] The Greeks were the instigators of the tradition in which both operated. For humanist Geoffroy Tory (1480–1533), the Romans "destroyed"—as much as preserved—Greek "laws, customs, practices, epitaphs and tombs."[15]

Such declarations of decadence and decline, declarations more usually associated if not with Vasari and the second edition of his *Lives of the Most Eminent Painters, Sculptors and Architects* of 1568, then with Winckelmann, and the second half of the eighteenth century, coexisted in Europe with the imperial ambition expressed in collecting like a pope or Caesar. They ensured that the story of classical art was not a simple story of a canon imposed from the outside, but one of negotiation between the center and the periphery, Rome and

6.2. Pieter Perret, print of the Belvedere "Antinous," 1580, engraving on paper, 42.7 × 24.7 cm. Rijksmuseum, Amsterdam, inv. no. RP-P-H-H-1216. On loan from the Rijksakademie van Beeldende Kunsten. Photograph: Rijksmuseum, Amsterdam.

Greece.[16] Soon after acquiring Hampton Court Palace in 1514, Cardinal Wolsey commissioned Florentine sculptor Giovanni da Maiano to make gilded, terracotta roundels of cuirassed figures in classical style; and when Henry VIII began Nonsuch Palace in Surrey in 1538, he hired Italian artists who had worked for François to contribute works "seeming to contend with Romane antiquities."[17] Within fifty years, Nonsuch's sculptures would include classical busts, scenes of Hercules's labors, marble obelisks, and a grove and fountain of Diana, complete with inscriptions and statues.[18] But Italy ancient and modern remained but one point of reference: as antiquary André Thevet observed of the famous

6.3. Hubert Le Sueur, bronze cast of the Diana of Versailles (now missing its stag), h 202 cm, now at Windsor Castle. Royal Collection, inv. no. RCIN 71444. Photograph: Royal Collection Trust / © Her Majesty Queen Elizabeth II 2016.

sculpture-filled grotto of Cardinal de Guisse (1524–74) at Meudon, southwest of Paris, "there is no need to go to Greece or Egypt, and still less to Rome, to satisfy the eyes and spirit of those who are lovers of antiquity."[19]

For those few who did make it to Greece and Asia Minor, like the agents of Isabella d'Este and of the Earl of Arundel, Thomas Howard, "the most interesting and idiosyncratic of a group of collectors who resided at the early Stuart court of Charles I,"[20] "the treasure . . . of the Kings and Archons of Athens" was beyond compare.[21] The publication of Arundel's inscriptions, the *Marmora Arundelliana, siue, Saxa Graecè incisa ex venerandis priscae Orientis gloriae ruderibus . . .* (or *The Arundel Marbles or Stones inscribed in Greek, from the Venerable Remains of the Ancient Glory of the East . . .*),

a "decisive influence in the rise of Hellenism," was consulted throughout Europe.[22] Arundel's greatest agent, William Petty (1587–1639), was, like Geoffroy Tory, closer to Cyriac of Ancona than to an art dealer: perhaps his most impressive acquisition, after the Parian Chronicle, was a bronze head of the second century BCE, reputedly from Smyrna (6.4).[23] In 1632, a visitor to Arundel House in London wrote: "Everyone is agreed in praising . . . the head of a certain Macedonian King, cast in bronze. . . . The English sculptors almost to a man model their own works most accurately on this. . . . The Earl of Pembroke offered three thousand florins for this head, even allowing for its damaged state."[24] The head influenced English and Netherlandish painters of the period, and appears in the

6.4. The Arundel Head, second century BCE, bronze, h 29.21 cm. The British Museum, London, inv. no. 1760,0919.1. Photograph: © The Trustees of the British Museum.

background right of Anthony van Dyck's portrait of Arundel and his wife Aletheia, herself a patron of the arts, their ambition set on the conquest of Madagascar on the globe between them (6.5).[25] Its presence glosses this ambition not as acting like a Caesar, but like a hellenistic dynast.

This was not the only sculpture in Arundel's collection to capture artists' attention: a marble statue, from the second or third century BCE, known as the "Arundel Homer," had been sketched by Peter Paul Rubens when still in Italy, and was included with other marbles from the collection in Jan de Bisschop's book of engravings, the *Signorum ueterum icones* (6.6), a series largely confined to statues in Florence and Rome.[26] Perrier's anthology would not have it all its own way; nor would Italy. The author of *Britannia*, William Camden penned an inscription for Arundel's sculpture gallery, celebrating the removal of antiquities from Rome's ruins. But Henry Peacham's *The Compleat*

Gentleman, dedicated to Arundel's son, puts the emphasis rather differently—on him "transplant[ing] old Greece into England."[27]

The publication of Camden's *Britannia*, first in six Latin editions, and then in English in 1610, made Roman history British history, and surveyed the evidence with an antiquarian eye that embraced coins and inscriptions.[28] It was not alone in its obsession with protonumismatics. Peacham's attempt to define gentlemanly behavior was the first courtesy book to discuss antiquities, incorporating detailed discussion of coins, inscriptions, and statues into its second edition.[29] "It is not enough for an ingenuous Gentleman to behold these with a vulgar eye: but he must be able to distinguish them, and tell who and what they be," advised Peacham, advocating four ways of ensuring this—first, general instruction in history and poetry; second, comparative evidence from coinage; third, consultation of *icones statuarum* or sets of

6.5. Workshop of Anthony van Dyck, *Lord and Lady Arundel: The Madagascar Portrait*, 1639. Kunsthistorisches Museum, Vienna, inv. no. GG 6404. Photograph: KHM-Museumsverband.

prints of the kind executed in the studios of Lafreri and Cavalieri prior to Perrier's *Segmenta*; and fourth, asking an expert.[30] From then on, admiration and careful consideration of ancient artwork was to be a British virtue. Peacham demonstrates: in his view, the "Farnese Toro" or Bull (3.7) was the best sculpture to survive from antiquity: it "out-strippeth all other Statues in the world for greatnesse and workmanship."[31] The center of expertise was also shifting.

Contributing to this shift was the *De pictura ueterum* by Arundel's Dutch secretary Francis Junius (1591–1677), first published in 1637 and dedicated to Charles I, and then in English a year later as *The Painting of the Ancients*, dedicated to Arundel's wife. More than a miscellany of ancient sources on the art and origins of painting, these texts are defenses of their dedicatees' activities as collectors and patrons, casting art appreciation as a positive alternative to the loose living, sex, and gambling with which it was long associated, and imbuing it with a dignity, morality even, that makes it equal, if not superior, to poetry.[32] With Alberti's treatise on painting, and Philip Sidney's *Defence of Poesy*, published posthumously in 1595, very much in mind,[33] it takes a different course, making Ovid an art critic almost, and asking that everyone hone his artistic judgment by reading ancient literature. In this way, the king's patronage of the arts has the capacity to reform society.[34] As far as this book's thesis is concerned, *The Painting of the Ancients* has been seen as marking "the beginning of the systematic study of classical art," a work that would be heavily mined by Winckelmann, and responded to by Gotthold Ephraim Lessing.[35] In 1694, nearly two decades after his death, Junius's *Catalogus artificium* or catalog of artists and architects, and their works, was

6.6. The so-called "Arundel Homer," Jan de Bisschop, *Signorum ueterum icones*, 1668–88, plate 72. Harvard Art Museums/Fogg Museum, Gift of Belinda L. Randall from the collection of John Witt Randall, inv. no. R5943. Photograph: Imaging Department © President and Fellows of Harvard College.

also published, a forerunner of Johannes Overbeck's collected ancient sources on Greek art (Leipzig, 1868, updated 2014). If art, as we know it, was invented in Italy, then art history may be said to have been invented elsewhere. Certainly there is a need, when examining European court society, and the formation of the canon, to pay due diligence to local input.

With these kinds of variables in view, this chapter starts in the same period as the previous to highlight how humanists, artists, princes, and publishers in France, Spain, and England do not simply follow in Italy's footsteps, but walk apace. This shared journey starts early. We have already encountered the bishop of Winchester's penchant for ancient Roman statues. In the

fourteenth century, Jean, Duke of Berry, brother of Charles V of France, owns some fifteen hundred cameos and intaglios, many of them sourced in Italy, as well as ancient coins and large gold medallions based on classical models, and, in 1448, Cyriac of Ancona is offering to send René of Anjou, who also has ancient cameos in his collection, copies of Latin inscriptions.[36] René was Count of Provence and of Piedmont and, from 1435 to 1442, titular king of Naples. Under his patronage, artists from Dalmatia, Provence, and Spain put something of a Catalan stamp on that city.[37] And he is not the only protagonist in this chapter to have held an official appointment there, reminding us that Italy was not an island, and that prior to Italy's unification, the Kingdom of Naples had been the battleground of France, Spain, and Austria.

Not that kings, princes, and courtiers like Arundel are this chapter's only collectors. As in Rome, Venice, and Florence, court artists such as Jacopo Nizzola da Trezzo (1514–89), Pompeo Leoni (c. 1533–1608), both of whom worked for Spanish monarchs, and Rubens (1577–1640) had antiquities collections of their own, not just studio props but objects of considerable prestige. Nizzola's collection includes a full-length marble "Antinous," which he displayed on a marble pedestal.[38] Rubens acquired a large part of his collection—more than ninety sculptures in total—from the British ambassador to the States General at The Hague, Dudley Carleton, in 1618, after Arundel turned them down, most of these acquired during Carleton's time in Venice. Although it is hard to think that they lived up to Carleton's hype ("the like of which has neither prince nor private citizen on this side of the mountains"), they proved the perfect contents for the Pantheonesque gallery that

Rubens added to his house in Antwerp and comprised portrait heads (6.7), urns, and a fourth-century BCE Attic grave stele, today in the Dutch National Museum of Antiquities in Leiden.[39] Again we are reminded how copies of canonic pieces coexisted with other influential groups of Greek and Roman artifacts (6.8). Some of Rubens's pieces, the stele included, are sold in 1626 to George Villiers, first Duke of Buckingham (1592–1628), infamous "favourite" of James I and Arundel's archrival.[40]

As we travel from the fifteenth century to the eighteenth and meet figures as important as Charles I of England, Philip IV of Spain, Naples, and Sicily, and Louis XIV, we shall try to juggle some of the competing instantiations of classical art in early modern Europe. Inevitably, our view is colored by how the eighteenth century configured classical art when the study of objects in a historical manner led to the History of Art (Geschichte der Kunst). But looking in more detail at what was happening before the historicizing work of men like Winckelmann and the Comte de Caylus began directing the activities of collectors such as Townley helps us understand the need for art history in the first place. It explains why Caylus's *Recueil d'antiquités égyptiennes, étruscanes, grècques, romaines et gauloises* (1752–67) embraces minor, and Gallo-Roman, works as well as Greco-Roman masterpieces.

Iconic Pieces in Context

We have already noted the Spinario statues of François and Charles I, and miniatures of this sculptural type owned by Isabella d'Este and Margaret of Austria. These were just the tip of the iceberg:[41] in fifteenth-century France, Florimond Robertet (?–c. 1527), an

influential administrator of bourgeois origin and treasurer to François I, had "a man drawing a thorn from his foot" among his clutch of bronze and marble statues.[42] And today, museums such as the Metropolitan have several Spinarios from this period, beyond that by Antico (6.9).[43] Robertet's town house in Blois, built between 1498 and 1508, was a mix of the gothic and classical, with medallions of the twelve Caesars supplemented by a portrait of his patron, Cardinal Georges d'Amboise, placed above the arcades of the courtyard against a band of white stone.[44] Did installations like these inspire Hampton Court's terracottas?[45] Such series would become more fashionable with the publication of Andrea Fulvio's *Illustrium Imagines* in 1517, the first extensive set of "images of the famous" ostensibly based on ancient medals.[46]

The popularity of Fulvio's pocket book also had implications for ancient coinage. In around 1538, antiquary Guillaume du Choul, himself a prodigious coin collector, would model the structure of his unfinished study of ancient Rome, his *Antiquités romaines*, on Fulvio's volume and intend for its frontispiece a medal design showing François I in the guise of a Roman emperor in cuirass and radial diadem.[47] Around the medal's border were the words RESTITVTORI BONARVM LITERARVM (the restorer of belles-lettres): coins were now historical documents as well as intricate examples of metalwork, and patrons of the arts people who fostered knowledge of the past as well as the acquisition and production of sculpture, painting, and literature. This growing awareness of one's place in history expanded "universal standards" into systems of value, creating inevitable hierarchies of objects that put statues like the Spinario and Laocoon, and, rather differently,

6.7. Peter Paul Rubens, *Head of Nero Caesar Augustus*, from an antique head in Rubens's collection, c. 1638, brown ink, black chalk, scratchwork at the proper left eye and nose, on cream antique laid paper, mounted down, two brown ink framing lines, 27.7 × 19.8 cm. Harvard Art Museums/Fogg Museum, Bequest of Charles A. Loeser, 1932.360. Photograph: Imaging Department © President and Fellows of Harvard College.

the twelve Caesars, at the top of the pile. But, reproduced across Europe in different media, at different scales, and with differing degrees of intimacy and access, these types were changed by their company, potentially cheapened and dehistoricized as well as elevated and interrogated. The premium put on knowledge led to a need for new objects, and standardization to a need for diversity.

The story of standardization across Europe through emulation and substitution has been well told. It was as important for Arundel to acquire the gems of the Gonzaga Dukes of Mantua (especially, perhaps, in light of Charles I's acquisition nigh on a decade earlier, and through the same dealer, of their paintings and antiquities, including Mantegna's *Triumphs of Caesar* [3.4], Titian's *Twelve Caesars*, now lost, a crouching Venus of the second century CE, and Isabella's sleeping Cupids), some of them

formerly in Barbo's collection, as it was for later English collectors to be hailed as Arundel's successor.[48] And it is no surprise that Spanish king Philip IV (r. 1621–65) should have followed what was quickly becoming royal precedent in sending artist

6.8. Peter Paul Rubens, *The Council of the Gods*, from the Marie de' Medici cycle, 1624, oil on canvas, 394 × 702 cm. Louvre, Paris, inv. no. 1780, with figures based on the Apollo Belvedere, and, in the background, left of center (Chronos with his scythe), on the "Arundel Homer." Photograph: © RMN-Grand Palais (musée du Louvre) / Christian Jean / Hervé Lewandowski.

6.9. Antico (Pier Jacopo Alari Bonacolsi), *Spinario*, probably modeled by 1496, cast c. 1501, bronze, partially gilt (hair) and silvered (eyes), h 19.7 cm. Metropolitan Museum of Art, New York, inv. no. 2012.157. Photograph: The Metropolitan Museum of Art, Gift of Mrs. Charles Wrightsman, 2012, www.metmuseum.org.

Diego Velázquez to Italy to acquire Greek and Roman sculpture, originals, bronze copies, and casts. Most prized among these was an exquisite bronze version of the Borghese sleeping Hermaphrodite (6.10), and plasters of the Farnese Hercules and Flora, all of them valued more highly in the 1666 inventory than almost any of the royal paintings.[49] They, and others—casts of the Laocoon, Nile, Ariadne/Cleopatra, Dying Gaul (then part of Rome's Ludovisi collection), Wrestlers (in the Villa Medici), and, more surprisingly, bronzes of "Germanicus" from the Villa Montalto (6.13), the Palazzo Giustiniani's resting Faun, and a standing Discobolus—joined several busts, and a Spinario, probably cast from a version presented to Philip II by Cardinal Ricci in 1561, in Madrid's Alcázar Palace.[50]

Nor is it a surprise that under Louis XIV (r. 1643–1715, from 1661 without a chief minister) a French Academy should have been established in Rome, one of its principal purposes being to provide casts and copies after the antique for his gardens at Versailles.[51] Most of the full-size sculptures were of marble, but a few, the Apollo Belvedere, Belvedere "Antinous," and Crouching Venus included, were also cast in bronze by the Keller brothers.[52] Some of these were less faithful to their models than others (6.11).[53] In the gap between version and original, a contemporary artist could make his name as, paradoxically perhaps, increased devotion to now familiar forms took the visual arts in new directions. Under François I already, sculptor Benvenuto Cellini's involvement in securing Ippolito II d'Este's Spinario may have helped him pin down the commission to decorate the main entrance of Fontainebleau—for which he made his first large-scale bronze, a vast semicircular relief of a reclining nymph (6.12).[54] Had this nymph been installed, she would have joined a series of sleeping nymphs, and thus equated François's patronage with that of Italian humanists from Pomponio Leto to Angelo Colocci (d. 1549) to the popes.[55] But her style was different from that of the Belvedere's Ariadne/Cleopatra (5.5), her body not languorous, voluptuous, and draped, but nude, alert, and elongated toward abstraction. She and Cellini's

6.10. Matteo Bonuccelli, *Hermaphrodite*, 1652, bronze cast, h 61 cm. Museo Nacional del Prado, Madrid, inv. no. E00223 (previously in the Royal Collection, Royal Alcázar Palace, Madrid). Photograph: © Museo Nacional del Prado.

6.11. Antoine Coysevox, *Crouching Venus*, 1686, marble, h 132 cm, inscribed with the false signature "Phidias." Louvre, Paris, inv. no. MR1826 (in the park of Versailles from 1692 to 1871). Photograph: © RMN-Grand Palais (musée du Louvre) / René-Gabriel Ojéda.

saltcellar, again for François, put the king at the vanguard of mannerism as much as the naturalism that comes of classicism.[56]

Louis's desire to shine brightly leaves François in the shade. Not content with buying into a courtly copying culture, or with encouraging contemporary artists to spread their wings and surpass the Greeks and Romans, Louis still sought exemplary antiquities of his own and set his sights on bringing "the genuine article," the Farnese Bull, and the Meleager from the Palazzo Fusconi-Pighini to Paris, and on purchasing the Ludovisi collection wholesale.[57] Money cannot buy everything, and he failed both times, having to make do with the "Germanicus" and a statue of Hermes, then identified as "Cincinnatus," from the Villa Montalto (6.13 and 6.17).[58] Other important purchases included two dancing fauns from the collection of his deceased chief

minister, Cardinal Jules Raymond Mazarin, whose antiquities might then qualify as the most important in France, and, via a Dutch merchant, statues recently found at Smyrna.[59] Unlike Arundel, Isabella, and the Venetians, the French had as yet little access to antiquities in Greece and the Levant.[60] Rome was the main target and the grant of export licenses difficult.

Balancing these purchases were ongoing diplomatic gifts (e.g., a veiled female figure found at Benghazi in Libya in 1693 at the latest and given to Louis by Consul Dusault [6.14] and a centaur gifted by Alessandro Albani in 1712) and Roman antiquities found on French soil (e.g., a togate statue from Langres and the Venus of Arles [6.15]).[61] The latter two statues had been given by representatives of the towns themselves, "to affirm to Versailles the importance of a sort of Gallic antiquity" and were eventually displayed with the others and the Diana and doe in the palace's grand apartments (Diana, Venus, "Germanicus," and the Benghazi statue were all at one stage in the central Grande Galerie).[62] Together, they affirmed Versailles's identity as a rival Pantheon,[63] but the Diana and Venus of Arles (a statue previously displayed in its hometown, where it was often identified as a Diana) threatened those from the Villa Montalto. Soon after Venus's discovery in the theater in 1651, and prior to her removal to Versailles, when her identity was confirmed by sculptor François Girardon, who restored her broken arms to hold a mirror and apple with a skill that again put the modern artist in the spotlight, monographs were published, and prints circulated.[64] She remained a local celebrity, able to speak of regional as well as national, royal pride (6.16). "The most beautiful woman

in the kingdom of France," she prepared the ground for the Venus de Milo (8.2).[65]

The Benghazi statue also had its admirers, not least because of its exceptional state of preservation. Thought by some to be superior to the Venus of Arles,[66] it was its marble quality and the slight crimson across its cheeks that were particularly striking, evidence, at least according to Jean-Aymar Piganiol de la Force in his description of Versailles, that color had been applied to them in antiquity.[67] Nearly fifty years later, Caylus would make a similar observation about the statue in the third volume of his *Recueil*, stirring a debate on polychromy that would germinate early in the nineteenth century with the publication in 1814 of Antoine-Chrysostôme Quatremère de Quincy's *Le Jupiter Olympien* and give birth to creatures such as John Gibson's

Tinted Venus.[68] Winckelmann too made passing mention of "the Vestal" as she was then known, as a good Greek work made under Rome.[69] Today, she is studied as part of a replica series, a female body type now known as the "Large Herculaneum Woman."[70] Then, she single-handedly pushed art history to ask new questions.

If the beautiful Benghazi priestess is now but a "Herculaneum woman," "Germanicus" and "Cincinnatus" are almost entirely neglected. Back in the seventeenth century, Louis had presumably wanted the former, in part, to outdo Philip. Missing from Perrier's anthology of the most admired statues in Rome (perhaps because it was still in the ground), it does—some twenty years after its arrival in France—make it into Domenico de Rossi's volume of plates of statues ancient and modern, with its text by Paolo

6.12. Benvenuto Cellini, *The Nymph of Fontainebleau*, 1542–45, bronze, h 205 cm. Louvre, Paris, inv. no. MR1706. Photograph: © Musée du Louvre, Dist. RMN-Grand Palais / Pierre Philibert.

6.13. The so-called "Germanicus," now identified as Marcellus, c. 20 BCE, marble, 180 cm. Louvre, Paris, inv. no. MR 315 (Ma 1207). Photograph: © RMN-Grand Palais (musée du Louvre) / Hervé Lewandowski.

Alessandro Maffei (1704).[71] Admittedly, most of the draughtsmen and engravers involved in this project were French,[72] but the plates otherwise of works in Italian collections, the first of them, the Laocoon, Apollo Belvedere, and so on, in the Vatican. Renaissance pieces by Michelangelo, Giambologna (5.24), Bernini, and others were also included, as the repertoire of modern Italian masters expanded. It is noteworthy, as far as developing tastes and hierarchies are concerned, that Lorenzetto's *Jonah*

from the Chigi Chapel of Rome's Church of Santa Maria del Popolo is one of these: its head, based on a drawing by Raphael (c. 1513), has the features of Antinous.[73]

The statue of "Cincinnatus," which had featured in one of Cavalieri's prints in 1594 already, joins "Germanicus" in de Rossi's volume, even though it too had been omitted from Perrier. The departure of each of the statues for France, replaced by casts in Rome's French Academy, is underlined by legends that say that they *had been* in Villa Montalto but were now in Versailles.[74] By contrast, a statue group identified as "two geniuses of Nature," and now usually referred to as the San Ildefonso group, is recorded as formerly in the possession of Queen Christina of Sweden but "today" (oggi) with Duke Odescalchi. Its return to Italian ownership, however, was short-lived. Soon it would be sold to Philip V of Spain and, in 1839, taken to the Prado.[75]

As Haskell and Penny note,

> Perhaps the most significant single point about de Rossi's choice of plates is that, although it was much more extensive than that published by Perrier, only three of the four additional works included in it which were acknowledged to be of the highest quality had actually been excavated since Perrier's day. The appearance of de Rossi's sumptuous volume amounts almost to a recognition of the fact that the situation had now stabilized. Indeed, for about a century there was very little increase in the number of antique statues which earned universal acceptance as masterpieces of the first order.[76]

Their final sentence overestimates the importance of the print tradition, or a certain kind of print tradition on the formation

of taste, underplaying the extent to which "Cincinnatus" was a superstar in France, where it influenced French artists drawing from the antique (6.17). It also elides the agenda and influence of other collections of prints such as Simon Thomassin's *Recueil des statues, groupes, fontaines, termes, vases et autres magnifiques ornemens du chateau et parc de Versailles* with its text in French, Latin, Italian, and Dutch: there, the Venus of Arles is immediately before "Germanicus," which precedes the Diana and doe, and then "Cincinnatus" several plates further on, after the Benghazi "Vestal."[77]

Not that a statue had to leave Italy in order that France or England might have a positive effect on its reception and ranking. The Borghese Gladiator, for example, remained in Rome until 1807, when it was bought by Napoleon and sent to Paris. But bronzes of it were cast for the Earl of Pembroke's residence Wilton House, as well as for Charles I, and engravings made to rival the multiple views of it in Perrier by resituating it in a British built-environment (6.18).[78] British travelers to Italy a century later would still note of the marble there, "the copy whereof is in brass at St. James's park in London," or "the original to that at Hampton-Court," as though Rome were the satellite and London the center.[79] In time, other English sites including Whitby Abbey House, Knole, and Woburn Abbey would have their own versions, the last of these, erected in 1827, spurred perhaps by the original's move to Paris.[80] Joseph Wright of Derby (1734–97) featured a reduction of the work in one of his experiments with painting light and shadow, *Three Persons Viewing the Gladiator by Candlelight*.[81] It was one of the most famous sculptures (not) in England; England helped give it canonical status.

6.14. Unknown woman of the large Herculaneum type, found at Benghazi, second century CE, marble, h 94 cm. Versailles, châteaux de Versailles et de Trianon, inv. no. MV9049, MR 245. Photograph: © RMN-Grand Palais (Château de Versailles) / Gérard Blot.

The proliferation of travel writing in the long eighteenth century itself impacted on the way that Greek and Roman art was perceived, opening up humanist culture to the kinds of thinking that underpins the Enlightenment, and ushering in popularist approaches to material culture more commonly associated with the nineteenth century. Through travel writing, the imperial gaze and the subjective gaze merge, changing the relationship of the observer and

6.15. The Venus of Arles, end of first century BCE, marble, h 194 cm. Louvre, Paris, inv. no. MR 365 (Ma 439). Photograph: © irmer Fotoarchiv, 681.3024.

the urn to highlight the king's elaborately adorned and upright masculinity. In her self-portrait, a broken marble lies in the foreground, its subject matter resonant both of the bond between mother and child and of female sensuality. Far from "holding the baby," Anne clasps a sheet of paper, presumably her poetry. In the illumination of her neck and hands, she is herself the most compelling fragment.

"Local" displays, print anthologies, and travel writing aside, the French and English embarked on new kinds of publishing projects that would leave Junius looking decidedly old-fashioned. Take Bernard de Montfaucon's *L'antiquité expliquée et représentée en figures* (1719–24), a five-folio work, each folio of two parts, plus five volumes of "supplément," which copied from the plates of Perrier, de Rossi, and others to collect 30,000 to 40,000 images on 1,200 plates. Flagging its debt to French scholars in particular, and written in Latin and French so that even the young could understand, this project was more than a catalog: it was an illustration of "all of antiquity," which, if read for two years (!), promised to provide the reader with everything he or she needed to know about the Greek, Roman, and sometimes Gaulish past up to Theodosius II.[85] Divided not by place or chronology but by theme (gods, cult practice, then things secular), its images were in hock to ancient texts as evidence for the ancient world.

In 1728, a revised, corrected, and expanded edition of Jonathan Richardson Sr. and Jr.'s *Account of Some of the Statues, Bas-Reliefs, Drawings, and Pictures in Italy* was translated into French (a text first published in London in 1722 just as *L'antiquité expliquée* was rendered in English). Compared to Montfaucon's rather frenetic mélange of objects, ancient and

observed once again, and pressing authors to find safe distances, sometimes ventriloquizing their views through a third party.[82] An argument can be made that it is then, and not post-Lacan, that the art historian's friend, "the viewer," is born. An argument can also be made that through travel writing, responses to classical antiquity become more explicitly gendered, enabling women to enact the cultural pursuits of the court lady as scripted in Baldassare Castiglione's influential *Book of the Courtier* (*Il libro del cortegiano*), first published in 1528.[83] English poet and painter Anne Killigrew (1660–85), whose father was a court chaplain, is one such early protagonist (6.19), painting herself against a similar landscape of marbles to that against which she painted James II.[84] In the royal portrait, a female figure, not unlike the crouching nude in Bronzino's canvas (5.12), peels itself from

6.16. Augustin Dumas, *Arlésienne à la Vénus d'Arles*, c. 1860, oil on wood, 99 × 81 cm. Collection of the Museon Arlatan, musée départmental d'ethnologie, Arles, inv. no. 2002.0.1493. Photograph: Coll. Museon Arlaten, musée départmental d'ethnologie, cliché S. Normand.

reproduction, and his emphasis on totality and text, the Richardsons—in dialogue with him and with other French authors such as Jean-Baptiste Dubos (1670–1742)—stressed their project's selectivity, drawing attention to the difficulty of judging the sculpture of the ancients, and to the small proportion of statues that had been lucky enough to survive the ravages of time. Linked to this, they realized that the mismatch of the signatures inscribed on statues such as the Borghese Gladiator and Farnese Hercules and the names of the Greek masters celebrated by Pliny, not to mention the similarities between statues, meant that many great works endured only as copies.[86] To the Richardsons, who were painters,

the Farnese Bull was "grand and vast," but there was "something hard about it," "a lack of delicateness." The animals were "of mediocre taste," and the cord "very poor."[87] As "the viewer" of travel writing morphed into "the viewer" of art history, sensibilities were further sharpened.

The epigraph to the French edition, an extract from a letter written on 1 August 1637 by Rubens to Junius on receipt of *De pictura ueterum*, underlines the firsthand visual analysis of Richardson Jr. on which their work (both on ancient art and Renaissance canvases) is based, setting it apart from that of Junius, who barely mentions extant artworks and had never been to Italy:[88] "Yet, since we can pursue those

6.17. Jean-Antoine Watteau (1684–1721), *Study of an Antique Statue— Jason or Cincinnatus*, today identified as Hermes tying his sandal, Louvre, Paris, inv. no. MR 238, chalk (red, black, and white) on paper (buff), 10.2 × 17.2 cm. Courtauld Institute of Art, London, inv. no. D. 1952.RW.1084. Photograph: The Samuel Courtauld Trust, The Courtauld Gallery, London.

edition not as a work of history but one of harmonious proportions, an experiment in aesthetics that, in debt to Frenchmen Roland Fréart, Sieur de Chambray (1607–76), Roger de Piles (1635–1709), and André Félibien (1619–95),[90] will contribute to William Hogarth (1697–1764) and Winckelmann's theories of beauty. All of this was a product of the dialogue between antiquarianism and theory of the arts, and French, Dutch, and English scholarship.

Before we put the classical sculptures of our kings and courtiers into a broader context of European collecting and display, a little bit more about artists' signatures. It is not only the Borghese Gladiator and Farnese Hercules that are signed by their sculptors (their inscriptions read "Agasias of Ephesus, son of Dositheus made [me]" and "Glykon, the Athenian made [me]" respectively). Often overlooked is the fact that "Germanicus," the Belvedere Torso, and the Medici Venus are also signed, as are the Orestes and Electra group, in the Ludovisi collection from at least 1623 (7.7), and the Furietti Centaurs, said to have been found at Hadrian's Villa at Tivoli in 1736 and soon copied in various media.[91] Given the rarity of such signatures, this is extraordinary, recognition perhaps that their Greek lettering and onomastics were of interest, even if, as the Richardsons note, Pliny makes no mention of Agasias or Glykon.[92] For Winckelmann, their clearly late letter forms will cause a problem, threatening the premium that he and others before him had put on artists of the fifth and fourth centuries BCE.[93] But they were proof of the objects' Greek manufacture, and, from the sixteenth through to the eighteenth century, a fairly uncontroversial stamp of quality. There was more than one way

examples of ancient painters only more or less in our imagination and according to our capacity, I would indeed wish that one day, with the same carefulness, a similar treatise could be made on the paintings of the Italians, whose examples or originals still openly exist today and can be pointed at with a finger and be said, 'This is it.' "[89] A preliminary discourse by Amsterdam-born philologist, historian, and art collector Lambert ten Kate (1674–1731) on "le beau idéal," or ideal beauty in art, framed the

for text to underwrite image even then. Pliny was never the be-all and end-all.

Competing Assemblages

Around 1618, Dutch portrait painter Daniel Mytens, who would later paint James I and Charles I, completed two life-size canvases, one showing the Earl of Arundel gesturing toward the sculpture gallery of his house on the Strand in London, and the second, a companion piece, with his wife Aletheia in front of their painting gallery on the floor below (6.20 and 6.21). This was before William Petty returned from the East, where he "raked together 200 pieces," "all broken or few entyre," and lost others in a shipwreck, and before the acquisition of the Gonzaga gem cabinet.[94] Arundel's sculptures had thus far been bought in Italy, where in 1613–14, he and his wife had been seeing, collecting, even excavating antiquities, and they were, with the possible exception of the "Arundel Homer," individually unremarkable—at least compared to the Diana and doe, Louis XIV's ancient marbles, or the bronze head that Arundel would acquire later. An inventory of objects exported from Rome in 1626 lists frieze- and bas-relief fragments, heavily restored busts and statues, modern pieces after the antique, and plaster heads, busts, legs, torsos, and a lone plaster statue.[95]

Collectively and retrospectively, however, they amounted to a collection "equal in Number, Value and Antiquity to those in the Houses of most Princes."[96] One estimate claimed that, in addition to the inscriptions, there were 37 statues, 128 busts, several bas-reliefs, and some miscellaneous pieces, "All whole and in good preservation, many of them as white and beautiful as when they

6.18. The Borghese Gladiator, at Wilton House from de Caus 1645: plate 20, 21.2 × 17 cm. The British Museum, London, Department of Prints and Drawings, inv. no. 1978,U.774. Photograph: © The Trustees of the British Museum.

came from the Sculptor's hand."[97] But from 1618 already, the assemblage had ambition: it was neither a simple distraction from the exigencies of daily life nor "try hard" (for as Louis would, Arundel had desired antiquities he could not secure, the most important of them the Fusconi-Pighini Meleager, and the obelisk, then in Rome's Circus of Maxentius),[98] but exemplary of "practices of distinction as a constitutive aspect of court-culture itself that worked as a continuous impulse for the re-negotiation of established values, their maintenance or demise, and the creation of new criteria of discrimination or assimilation."[99] "There are every where in our age," observed Junius, "a great many of noble descent and eminent places, who having made an end of their urgent affaires, doe after the example of . . . Vindex recreate themselves in the contemplation

6.19. Anne Killigrew (1660–85), *Self-portrait*, the Private Apartment, Berkeley Castle. Photograph: Berkeley Castle.

marbles than by his erudition, as he points didactically toward them, as though giving a lecture. As he does so, he becomes both subject and viewer, willing his audience to enter his world, a barrel-vaulted space that looks more like an Italian palazzo than it does his London residence; to be transported into a representational realm that acts as a portal from England out across the sea to the rest of the world. Animated by this attention, the statues, the "Arundel Homer" included, stare back. But it is the Venus Pudica figure that receives special attention.[101] This is what respectable desire for the antique should look like.

In contrast, Aletheia is studied rather than studious, guarding the entrance to a room of portraits that appear, from a distance, to look like her. If his picture was about the reproduction of knowledge, "her domain is the reproduction of lineage."[102] It matters little here that the couple were putting together one of the best collections of drawings and painting in the world. The gallery behind her is less about the qualities of this developing collection than it is about her qualities, her constructedness. Yet the same can be said about Arundel and his painted gallery. In contemplating his wife's relationship with the artifacts, what they do for her, and she for them, we think similarly of the sculpture. Even Venus plays a bit part; the ensemble is where it is at, and this ensemble about fine-tuning "habitus" into "virtuosity."[103]

In this sense, these paintings have something in common with the "pictures of collections" genre that grew out the buoyancy of the art market in early seventeenth-century Antwerp but became increasingly inventive and self-reflexive, reveling in clusters of cognoscenti discussing crowded hangs of artifacts. In an example, now in

of the divine works of excellent Artificers, . . . weighing and examining by a secret estimation what treasures of delight and contentment there are hidden in them."[100] This might well have been Arundel's epitaph.

Few bits of evidence show this "self-recreation" better than Mytens's portraits. Arundel and his wife sit in the foreground of their respective canvases, acting as the interface between the viewer and the galleries behind them. Unlike most of the paintings in the last chapter, which saw sitters such as Odoni and Strada almost toying with the antique as though a puppet or plaything, Arundel and the ancient sculpture are in balance, his power expressed less by commodification of the

the National Gallery in London, classicizing miniatures, paintings, and prints compete for attention as one figure, a man to the foreground left of the picture, holds a scientific object out to the viewer to encourage his or her scrutiny (6.22).[104] Unlike artist Giovanni Paolo Panini (1691–1765), whose *Ancient Rome* canvas will offer an object lesson (6.23), each of its paintings showing a famous ancient monument and each sculpture an iconic object (e.g., the Laocoon and Farnese Hercules), the artifacts in these pictures are more interesting for their agglomeration than their object histories. It is the scene that is crucial, and the capacity, amid such choice, for discrimination. Mytens's canvases talk directly to the viewer, and in the evacuation of scientific instruments, and the splitting of sculpture and painting, leave the Kunstkammer behind them. Their relationship to the courts of Europe lies in this split: not in canonic pieces, but in its debt to discrete displays of ancient marbles from the Belvedere Courtyard to the Munich Antiquarium.

If Arundel had unparalleled holdings, it was his Holbein portraits that together with works by more recent painters such as Adam Elsheimer (1578–1610), and his patronage of Mytens and Van Dyck, positioned his artistic activities in a distinctly northern climate, revisioning the Italian Renaissance by having it speak to a German and Netherlandish Renaissance and tracing a genealogy that absorbed the Tudors as well as the Caesars.[105] But he expanded the perimeters of possibility eastward also, beyond Asia Minor, influencing Charles I as the courts of Europe had influenced him. In 1637, on Arundel's recommendation, Charles sent the painter Nicholas Wilford to Persia, one of the aims, after diplomacy, and before trade, being to

6.20. Daniel Mytens, *Thomas Howard, 14th Earl of Arundel, 4th Earl of Surrey and 1st Earl of Norfolk*, c. 1618, oil on canvas, 207 × 127 cm. National Portrait Gallery, London, inv. no. NPG 5292. Photograph: © National Portrait Gallery, London.

acquire "Antique statuaes . . . , subscriptions or such like in Marble or brasse, any great or small Vessels of Aggats, Brasse or Marble any Antique Coins or gravings in any kind of Aggat or any Mettall any Instruments for . . . or such like As also any excellent auntient Bookes in ye Persian Arabian or Greeke Language."[106]

Arundel no more followed in the king's footsteps when it came to classical art any more than France, Spain, and England trailed blindly behind Italy. In France too, the interventions, and extensive collections of Bishop of Paris Jean Du Bellay (c. 1493–1560), in Rome and in Saint-Maur-des-Fossés, are crucial to our story, even if his Roman residence on the Campus Martius has but two sculptures worthy of inclusion in Aldrovandi's

6.21. Daniel Mytens, *Aletheia (née Tal-bot), Countess of Arundel and Surrey*, c. 1618, oil on canvas, 207 × 127 cm. National Portrait Gallery, inv. no. NPG 5293. Photograph: National Portrait Gallery, London.

inventory, and his later collection, within the ruins of the Baths of Diocletian, is more renowned for fake inscriptions than fine statues.[107] François I stayed at Saint-Maur in the summer of 1544, his existing enthusiasm for the antique fed not only by its innovative design, with its debt to the Palazzo Farnese, its display of classical statues and the verses that those of Apollo, Mercury, Diana, the Muses and Graces inspired, but by Du Bellay's enviable address book, compiled during his shuttling back and forth to the eternal city.[108] It was Du Bellay who supplied Diane de Poitiers with the head of Venus (which he had restored on a modern bust and base of the rarest stone), admitting to being torn between affection for it and for her, before finally giving way.[109] Agents and ambassadors could only go so far in equaling the "Houses of . . . Princes."

In Spain, one of the most illustrious collections of classical sculpture belonged to Per Afán de Ribera, Duke of Alcalá (d. 1571). Until serving as Viceroy of Naples from 1558, the duke seems to have had little interest in antiquities.[110] Perhaps such an interest was already a deal-breaker for diplomatic office, enabling the incumbent to cross cultural and political boundaries by desiring the same thing as his non-compatriots. From that point on, the duke acquired ancient inscriptions, reliefs, statues, heads, and other artifacts, some of them, including an urn said to contain the ashes of the Roman emperor Trajan, gifted to him by Pope Pius V. Twenty-four restored busts were set into niches off the courtyard of his house in Seville and a sleeping nymph sculpture in its garden. Many of these heads were optimistically identified, and some of fairly mediocre quality; but beginning with Rome's

founder, Romulus, and continuing through Rome's Republican statesmen and emperors so as to culminate with Charles V, they succeeded in giving the history of Rome a suitably Spanish ending.[111]

When the third Duke of Alcalá (1583–1637) became ambassador in Rome and then, like his great-uncle, Viceroy of Naples, he added busts, casts, bronzes ancient and modern, books, and paintings (including a copy of an early Augustan fresco found on the Esquiline in 1601 and named the "Aldobrandini Wedding" after its first owner, Cardinal Cinzio Aldobrandini).[112] He also opened a remodeled Casa de Pilatos to intellectuals and artists.[113] As inspired by his ancestor as by Philip IV and Philip II, the duke brought something of Madrid's courtly culture to Seville, and was praised, like Colonna, as "another Maecenas."[114] In the eighteenth century, drawings of historical reliefs in the house would feature in Montfaucon's *L'antiquité*.[115]

Classical art in Spain, France, and England was not confined to king, courtiers, or capital cities. It was to be found in diverse spaces, only some of which would see their contents published. It accrued value as it moved from collection to collection (whether from Carleton to Rubens to the Duke of Buckingham, or from a king to his successors) until eventually it populated the Greek, Roman, and Renaissance departments of museums such as the Prado and Oxford's Ashmolean. Oxford was given its share of Arundel's ancient marbles in two gifts, in 1667 and 1755, and set about advertising the erudition it gained from them, and they from the University, by republishing them as the *Marmora Oxoniensia*.[116] The Ashmolean Museum's "starter-pack," a cabinet of curiosities

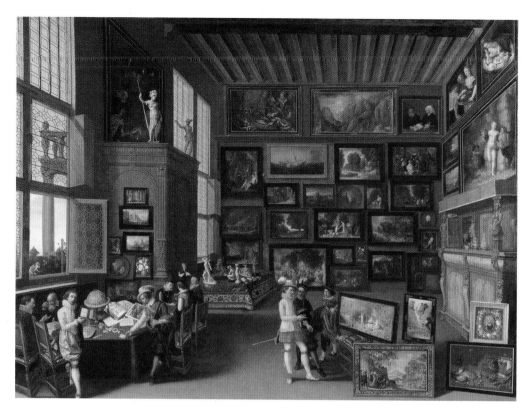

6.22. Flemish school, *Cognoscenti in a Room Hung with Pictures*, 1620s, oil on oak, 95.9 × 123.5 cm. National Gallery, London, inv. no. 1287. Photograph © The National Gallery, London. Bequeathed by John Staniforth Beckett, 1889.

bequeathed by Elias Ashmole in 1677, and collected by gardener and naturalist John Tradescant (c. 1570–1638), client of Buckingham and Charles I, and his son, in their house in Lambeth, also contained gems given to them by Aletheia.[117]

The Tradescants remind us yet again that collections of classical art coexisted in England with collections of curiosities.[118] Somewhere between them were collections of Romano-British altars and inscriptions of the kind assembled by Sir Robert Cotton and Lord William Howard, Arundel's uncle, a decade or so before the Arundels' visit to Rome.[119] Actively contributing to the expansion of Camden's *Britannia*, the first edition of which (1586) contained only 12 stone inscriptions and the first English edition (1610) more than 110,[120] these collections are sometimes seen as having little to do with Arundel's

ambitions: they are "resolutely provincial and cannot directly compare with the finest from the Imperial City."[121] They are also, in the case of Cotton at least, who favored coins, manuscripts, and printed books to sculpture, less about the visual than the written word.[122] There was more than one way to perform virtuosity.

Yet to draw a distinction here is to forget that not only Howard but Camden and Cotton were close associates of, and influences on, Arundel, the latter supposedly the first to see the unpacked Parian Chronicle.[123] It is also to forget that much of what we have encountered in this chapter, François's portrait of Julius Caesar, Louis's priestess from Benghazi, the Venus of Arles, and many of Arundel's own marbles were "resolutely provincial" in provenance, and these better quality than many of the sculptures sent from

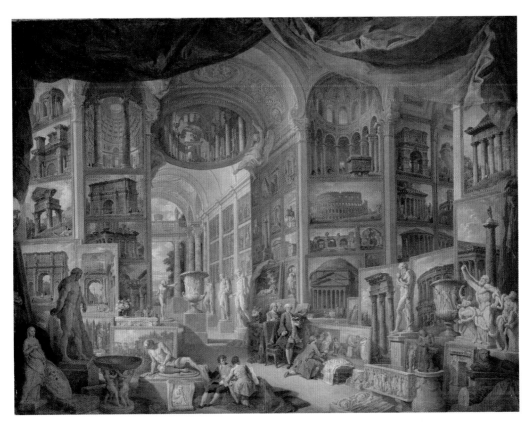

6.23. Giovanni Paolo Panini, *Ancient Rome*, 1757, oil on canvas, 172.1 × 229.9 cm. Metropolitan Museum of Art, New York, inv. no. 52.63.1. Photograph: The Metropolitan Museum of Art, Gwynne Andrews Fund, 1952, www.metmuseum.org.

Italy to the Casa de Pilatos. Even expensive and exquisitely crafted versions could degrade the original: take the busts of the twelve Caesars, with their porphyry heads, marble busts, and elaborate gilded drapery, that François Girardon executed for Versailles, or Antico's Spinario with its shock of flaxen hair (6.9).[124] Today they appear parodic almost of "the finest from the Imperial City," but the comparison they crave always allowed room for failure as well as for surpassing the antique. Classical art was not unassailable as a category. It maintained its status by being a universal measure.

Soon this measuring stick would extend across the Atlantic. By the end of the 1720s, Scots artist John Smibert had taken a cast collection, a Medici Venus and bust of Homer among them, to Boston and,

with it, "improve[d] the cultural climate of New England."[125] And in 1771, future president Thomas Jefferson, whom we know to have owned a copy of Perrier, was making a list of the casts he would like to have in his house, Monticello (the Medici Venus, Farnese Hercules, Apollo Belvedere, Dancing Faun, Wrestlers, Spinario . . .).[126] As we move into the next chapter and concentrate on the eighteenth century proper, we will see this slate of iconic images crystallize further. We will also see the virtue or probity associated with the antique challenged by a flood of new artifacts from the more domestic settings of Herculaneum and Pompeii, and by the diverse audiences that come of the emergence of the public museum. Classical art is historicized for the first time, sorted into places and periods that will eventually

separate Greek style from Roman, keying it as much into democracy and homosociality as into court society. Such is the legacy of "neoclassicism" (as the eighteenth century's revival of Greek and Roman style is now known) and the premium put on Greece as a guide to lifestyle as well as art style that at the end of the nineteenth century aesthetes will still claim to be "living Greek art," even as "neoclassicism" is being criticized for its coldness.[127]

7

"Neoclassicisms" and the English Country House

Classical Consciousness

By the 1750s, many of the most discerning international travelers to Italy, especially discerning British travelers, were having their portraits painted by Pompeo Batoni (1708–87). Batoni was not the first artist to paint the British leaning on classical antiquities for affirmation. We have already noted Anne Killigrew's portrait of James II (1685). Italian painter Carlo Maratta had captured Robert Spencer, second Earl of Sunderland, posing for a Raphael-like portrait in toga-like drapery and Roman sandals against an ancient altar (probably 1661).[1] And, in an image not unrelated to Mytens's pictures of the Earl of Arundel and Aletheia, Francesco Trevisani (1656–1746) immortalized a young Thomas Coke, whose Norfolk house, Holkham Hall, would go on to rank "first among English private collections of ancient sculpture," in front of an architectural vista starring the Medici Venus and Farnese Hercules (7.1).[2]

Batoni built on these experiments, and on portraits by Titian and Van Dyck, to make the genre his own. He specialized in outdoor settings and on the texture of cloth against stone, and enhanced not only the landscape's color and light, but the self-consciousness of the sitter. Occasionally, this landscape conjures a famous setting: so Thomas Dundas, later first Baron Dundas,

is about to dip his toe into the Vatican's Ariadne/Cleopatra fountain, by then reinstalled in a room adjoining the Belvedere Courtyard, as the Apollo, "Antinous," and Laocoon look on.[3] But typically, the statues that populate Batoni's landscapes are even less natural than those in Trevisani's canvas. Take his portrait of lawyer and antiquarian Charles Crowle of Fryston Hall in Yorkshire (7.2): a miniature Ariadne/Cleopatra (5.5) competes for the accolade of "most weary" with the Farnese Hercules (1.16), whose pose is echoed by Crowle himself. Despite Crowle's posturing, it is perhaps languor we see, the crossed legs shared by him and both statuettes as compelling as the plans of St. Peter's Square and Basilica that risk sliding from the table. Study of the antique enabled eighteenth-century aristocrats to evade the boredom or ennui that a life of luxury brought with it.[4] But the line between worldliness and weariness, active and passive masculinity, is made, if anything, to seem overly delicate.

This sense of affiliation as affectation is not unique to this painting. A few years earlier, Batoni painted Sir Wyndham Knatchbull-Wyndham gesturing toward the "Temple of the Sibyl" at Tivoli, a canvas that Winckelmann regarded as "one of the best portraits in the world" (7.3).[5] This enthusiasm is predictable: Sir Wyndham assumes the position of Winckelmann's

7.1. Francesco Trevisani, *Portrait of Thomas Coke (b. 1697), 1st Earl of Leicester*, 1717, oil on canvas. Holkham Hall. Photograph: By kind permission of Lord Leicester and the Trustees of Holkham Estate, Norfolk/Bridgeman Images.

favorite statue, the Apollo Belvedere (8.20), his calves and cloak shining with a bright, white, crisp intensity that is suggestive of marble. Just as Winckelmann's ecphrasis of Apollo transports him to Delos and the Lycian groves, and enables him to identify with, and submit to, the statue, so Wyndham's embodiment of Apollo places him in an ideal landscape and makes him "elevated above the human," but also vulnerable, inviting viewers to appreciate not only "the fullness of his grandeur" and his "sublime gaze" but the "lofty structure of his limbs" beneath his golden exterior.[6] Winckelmann's encounter with the statue is a "homoerotic encounter," and encourages us to feel similarly about meeting Batoni's aristocrat.[7] The presence of the greyhound increases this possibility: it is a mirror image of the dog in a Roman relief showing the sleeping shepherd boy Endymion, awaiting his lover, Selene (7.8).[8]

There is something peculiarly mid- to late eighteenth century about this particular embrace of classical art, an embrace that is of a piece with the intimate collaborations

7.2. Pompeo Batoni, *Charles Joseph Crowle*, 1761–62, oil on canvas, 248 × 172 cm. Louvre, Paris, inv. no. R. F. 1981–37. Photograph: © RMN-Grand Palais (musée du Louvre) / Stéphane Maréchalle.

between men that define the Grand Tour, and the studios of painters like David (7.4).[9] Scholars have shown how classical bodies like those of Endymion and the Apollo Belvedere grew in popularity at this period, in part, because of their capacity to conjure an array of masculinities. Compared to the Belvedere "Antinous" (6.2), the Apollo was strong and virile:[10] such distinctions "figure[d] sexual difference in a same-sex system—sexual difference without women,"[11] and offered up paradigms,

or, perhaps better, attitudes, that made all encounters with these paradigms more obviously performative, or more performative of manhood, than in the Renaissance. Not that women's bodies were neglected: the rococo works of François Boucher (1703–70), for example, still luxuriated in the female flesh of Greek and Roman myth. But if it was classical form, or "neoclassicism," one was after, investment in the male nude won out until into the nineteenth century. When in 1772 Queen Charlotte,

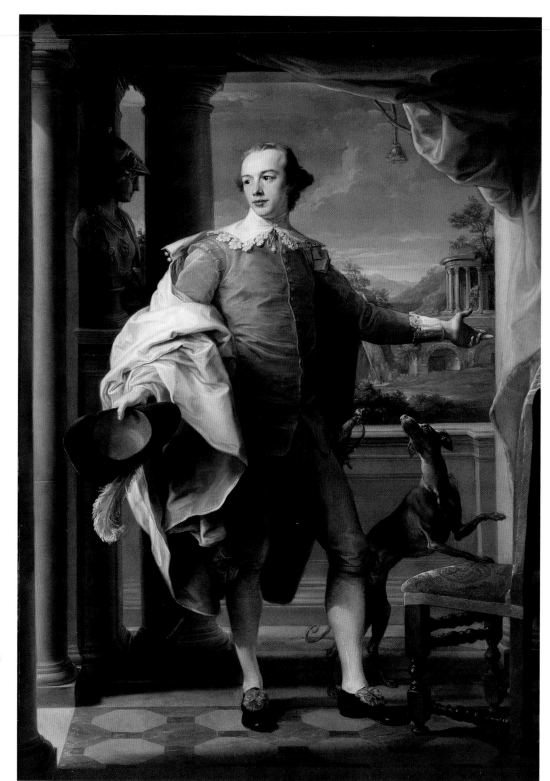

7.3. Pompeo Batoni, *Sir Wyndham Knatchbull-Wyndham*, 1758–59, oil on canvas, 233.05 × 161.29 cm. Los Angeles County Museum of Art, Gift of The Ahmanson Foundation (AC1994.128.1). Photograph: © Museum Associates / LACMA, www.lacma.org.

7.4. Léon-Mathieu Cochereau, *The Studio of Jacques-Louis David*, 1814, oil on canvas, 91.12 × 102.87 cm. Los Angeles County Museum of Art, Gift of the 1993 Collectors Committee (AC1993.19.1). Photograph © Museum Associates / LACMA, www.lacma.org.

wife of Britain's George III, commissioned German painter Johan Zoffany to paint one of Italy's most celebrated Renaissance spaces, the Uffizi Tribuna (7.5), she could scarcely have intended that she, a collector in her own right, would be so "boxed out of the connoisseurial world" it portrays.[12] Although the Medici Venus attracts more attention than the other ancient marbles, more than Titian's *Venus of Urbino*, it is the only artwork being ogled through a monocle. "Boys will be boys." Seen like this, classical art, especially sculpture, is the glue of ideal, male solidarity.

But the eroticism of classical art, as explored by Winckelmann, is not only about homosociality in all of its shades and intensities. It is about beauty in its purest form, a beauty that was not "locked in the past," but accessible in the "direct encounter with a particular object," an encounter that understood, more acutely than ever, "what a new attentiveness to ancient sculpture might mean for modern art" and for the modern gentleman.[13] Every time another of Winckelmann's favorites, the Ludovisi Mars (a statue known in Rome since the first half of the seventeenth century, when it was first identified as Adonis), is included in a Batoni canvas, or a marble krater resurrected from Montfaucon's "archaeological" exegesis to dominate a Batoni landscape and vie with its human subject for attention, it shines again, as a measure against which to evaluate the aristocrat, the painter, and the concept of beauty itself—beauty as debated in the eighteenth century, as (meta)physical, sublime, free, subjective.[14]

Few of Batoni's pictures are more "attentive" than his portrait of Francis Basset, Later Baron de Dunstanville (7.6), in which the famous statue group now

7.5. Johan Joseph Zoffany, *The Tribuna of the Uffizi*, 1772–77, oil on canvas, 123.5 × 155 cm. Royal Collection, London, inv. no. 406983. Photograph: Royal Collection Trust / © Her Majesty Queen Elizabeth II 2016.

usually referred to as "Orestes and Electra" (7.7), again from the Ludovisi collection, is turned from three dimensions into two and reversed as in Perrier's *Segmenta* and de Rossi's *Raccolta*.[15] In Perrier, the taller figure is identified as male, and the action as "fraternal greeting"; in de Rossi, they are the Roman boy Papirius and his mother, after a story in Latin author Aulus Gellius.[16] Batoni adopts the angle favored by the first of de Rossi's plates, but makes the direction of the maternal gaze more ambiguous: it is as though she stares out from the bas-relief that now encases her, imploring us to look kindly on the young Basset as he embarks on his tour of Rome, a copy of Giambattista Nolli's important map of the city in his hand, and on Batoni's ingenuity as a painter.[17] Batoni's pictures are thick with references to antiquity, or, as they became in his manipulation of them, "turns of phrase," and his sitters rendered stooges,

whose role it is to draw attention to the beauty that comes of firsthand observation. Confronted with familiar artworks, buildings, maps, and books, viewers of these paintings are confronted with Rome's rich reception history. Had Batoni read Thomas Nugent's English translation (1748) of Dubos's *Critical Reflections on Poetry, Painting and Music*, a book that endeavours "to explain what the beauty of a picture or poem chiefly consists in"?[18] Its first chapter warns about the dangers of ennui, while, later, of the Ludovisi group, it notes, "Never was there a sentiment better expressed than the curiosity of the mother. . . . The soul of this woman seems to be entirely seated in her eyes, which pierce through her son while she caresses him." Is the "adventure of young Papirius" projected onto Basset?[19] Batoni's clients certainly knew Nugent's work, traveling the Continent with his multivolume guidebook, *The Grand Tour*, in their luggage.[20]

Batoni's status as the leading portrait painter in Rome and his close connection with Cardinal Alessandro Albani (1692–1779), who secured him many of his commissions, make him well placed to introduce this chapter.[21] Albani was the leading antiquities collector and dealer of his day and Winckelmann's patron, a man whose villa on the Via Salaria was as formative a site for some visitors to Rome as the Colosseum or Vatican. Batoni had sketched many of Albani's earliest acquisitions, the relief of Endymion included (7.8), pieces that were sold, prior to the building of the villa and of a second collection, to Pope Clement XII, who added them to the Capitoline's antiquities, the equestrian statue of Marcus Aurelius and the other Lateran bronzes included, and inaugurated a new public museum.[22] The Capitoline Museum opened in 1734 and continued to grow, quickly supplementing its stocks with statues such as the Dying Gaul and Capitoline Venus.[23] Together, they would rival the Vatican sculptures, which, by 1784, had been incorporated, together with hundreds of new acquisitions, into the ambitious rebuilding works that constituted its new complex, the Museo Pio-Clementino.[24]

These early art museums have a profound effect on classical art. Not only do they open it up to wider constituencies, but they also lead the way in what today might be called "research," "presentation," and "conservation." Large, multivolume publications by Giovanni Bottari at the Capitoline and Ennio Quirino Visconti at the Vatican are paradigmatic of the genre that is the scholarly catalog, while the layout of the latter leads the owners of private collections across Europe to make their displays more programmatic.[25] By this point, however, closure of the sea routes because of war

7.6. Pompeo Batoni, *Francis Basset, Later Baron de Dunstanville (1757–1835)*, 1778, oil on canvas, 221 × 157 cm. Museo Nacional del Prado, Madrid, inv. no. P00049. Photograph: © Museo Nacional del Prado.

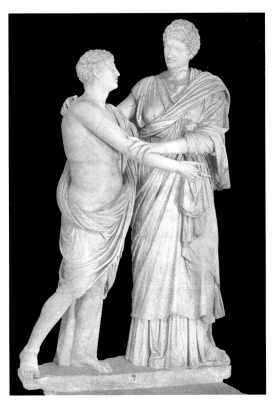

7.7. Orestes and Electra, first century BCE–first century CE, marble. National Museum, Rome, Palazzo Altemps, Rome, inv. no. 8604. Photograph: Brügner, Neg. D-DAI-Rom-34.190.

7.8. Pompeo Batoni, *Endymion Relief* (second-century marble relief, Capitoline Museums), c. 1730, red chalk on white paper, 47 × 36 cm. Eton College, Windsor. Photograph: Reproduced by permission of the Provost and Fellows of Eton College.

context that takes account not just of education and ambition, but also of shifting definitions of spectatorship, authenticity, public and private. We last met Baron d'Hancarville preparing his pornographic *Monumens [Monuments] de la vie privée des douzes Césars*.[29] But d'Hancarville was also responsible for the publication of the ancient vases of William Hamilton, British envoy to the court of Naples from 1764 to 1800, a series of volumes to rival the lavish publication of the king of Naples's antiquities collection, *Le antichità di Ercolano esposte* (*Antiquities of Herculaneum Displayed*) (1757–92). Although that publication too hoped to "reward public expectation," its circulation was initially limited to presentation copies.[30] D'Hancarville's first volume opens with the riposte "It is to Mr. Hamilton that the Public is indebted," and continues its French and English preface as follows:

> the Artists of every country will have these fine forms under their eyes, almost as well as if they were in the very Cabinet which contains the originals, and had the liberty of disposing of them at pleasure. We hope that the Artists thus enlightened in the true principles of their Art, will soon annihilate those Gothick forms which habit alone renders supportable; and we shall have gained our end if at the same time that we make our book agreeable, we can render it useful, by engaging those who work for the Public to serve it better, without any additional expense.[31]

There is an explicitly didactic edge to this utilitarian project and one that will come to fruition when, in 1772, Hamilton offers his first collection for sale to the British Parliament and it enters the British Museum,

with France meant that English travelers to Italy were waning.[26] France would soon be carrying Rome's classical statuary (the Dying Gaul, Capitoline Venus, Laocoon, Apollo . . .) to Paris to furnish the Louvre, which had in 1793 itself become a public state museum, and would in 1803 be renamed the Musée Napoléon.[27]

Batoni's Englishmen are the focus of this chapter. Not only were these men particularly successful in acquiring antiquities from new digs and existing collections in Italy, but the fruits of this success have been extensively studied of late,[28] often collection by collection, house by house. Bringing some of these houses together enables us to explore emerging trends, some of them peculiarly English and others shared with comparative Continental endeavors. All of them benefit from being set in a wider

7.9. South Italian and Attic pottery, some of it from the collections of Sir William Hamilton and Thomas Hope, on display in artist Adam Buck's self-portrait *The Artist and His Family*, 1813, watercolor, 44.6 × 42.4 cm. Yale Center for British Art, Paul Mellon Collection, inv. no. B1977.14.6109. Photograph: Yale Center for British Art.

founded less than twenty years earlier. Part of this zeal comes from the collection's contents—pots were less accessible and memorable than sculpture, which had long circulated in engravings, and through casts and copies; if they were noticed, they were regarded as curiosities, the "wonder of ancient art" in the same way that "the smallest, most negligible insects are a wonder of nature" (7.9).[32] But part of it stems from the shifts identified in Jürgen Habermas's *The Structural Transformation of the Public Sphere: An Inquiry into a Category of Bourgeois Society*, first published in German in 1962. In this book, Habermas

identifies first the emergence in the eighteenth century of a "literary public sphere," in which letters, novels, and coffeehouse culture emphasized "subjectivity, as the innermost core of the private, [which] was always already oriented to an audience,"[33] and then a "bourgeois public sphere," between civil society and state. In this space, the kinds of royal and courtly performances familiar from our previous three chapters were appropriated and critiqued.[34]

Whatever one thinks about the socio-economic factors driving Habermas's excerpting of the eighteenth century,[35] his model helps bring the self-reflexivity

7.10. Christopher Hewetson, *Thomas Mansel Talbot of Margam Park and Penrice Castle*, 1770–75, marble, h 61.5 cm. Victoria and Albert Museum, London, inv. no. A.41–1953. Photograph: © Victoria and Albert Museum, London.

such busts had left their niche to become *the* mode of self-representation, giving even sitters "of the middling sort" a means of expressing their status as individuals—stakeholders in a brave new world where what was paramount was reason.[37] Several of Batoni's sitters are also captured in three dimensions, their propensity for rational thought visible in their faces.[38] The ancient form of these busts maintains the fictiveness of the pose, while their features make a claim to a new sensibility.

Portrait busts are part of this chapter's engagements with the antique and remind us from the outset how capacious even British eighteenth-century "classicism" is as a term, embracing practitioners as diverse in style and period as Michael Rysbrack (1694–1770), a Dutch sculptor active in England, British brothers Henry and John Cheere (1702–81 and 1709–87 respectively), Christopher Hewetson (1737–98) (7.10), and Joseph Wilton (1722–1803). Compared to Antonio Canova (born in the Venetian Republic in 1757) and Rome-based Bertel Thorvaldsen (born in Copenhagen in 1770), who would work for British patrons later in the century and into the next, all of these sculptors are responsible for distinctly animated works. The doughy faces of Joseph Nollekens (1737–1823) are again another species (7.11). Preferring to sit for one over the others was not only about patronage networks; it was also about a patron's aesthetic sensitivity, the range and subtlety of which is sometimes lost on us today—the same aesthetic sensitivity that directed which ideal sculptures he desired, ancient and modern. As we look for patterns, we should not forget these distinctions, nor imagine that "neoclassical" is an adequate definition for the subtly different ways

of Batoni's canvases, eighteenth-century discourses on beauty, and the gendered beauty that psychology and elevated feeling bring with them, into dialogue with the empowerment of a more socially diverse constituency.[36] It also, perhaps, explains the phenomenon that is the "neoclassical" portrait bust. Before the 1720s, it was rare for British patrons "to commission a bust as an independent work to be placed within a domestic interior," but by 1770,

7.11. Joseph Nollekens, bust of writer Laurence Sterne, modeled 1765–66, marble, h 55.2 cm. Metropolitan Museum of Art, New York, inv. no. 1979.275.2. Photograph: The Metropolitan Museum of Art, Purchase, John T. Dorrance Jr. Gift, in memory of Elinor Dorrance Ingersoll, 1979, www.met museum.org.

in which our eighteenth-century protagonists stage their encounter with Greece and Rome.[39] Before we enter these "stage sets," we would do well to give more thought to this "classicism's" parameters.

Locating the "Classical"

No matter what d'Hancarville would like to achieve, "Gothick forms" do not dissipate, but continue to harry the classical as they had done since the Renaissance, lending picturesque color to the sublime and making "Gothic Revival" and its turn to medieval forms one of the most influential styles of the nineteenth century. In 1772, Charles Townley, whose library on Park Street we have already encountered, was bringing fragments of a fourteenth-century fresco as well as Roman statues from Italy to England. Not the least interesting thing about these fragments, from the Church of Santa Maria del Carmine in Florence, was their attribution (wrongly) to Giotto (d. 1337), whom Vasari had thought unparalleled among artists of "so gross and incompetent an age."[40] They represented a break with Byzantine "abstraction" and a return to naturalism, a "primitive" classicism that would later enable painter Benjamin Robert Haydon (1786–1846) to compare them to the Parthenon frieze and imagine their maker schooled by "poor Grecian artists who had fled to Italy during the invasion of their country, and carried with them what they had seen at Athens."[41] Not that the sculptures of the Parthenon were "classical" in the way that Roman marbles were "classical." As we shall discover in our next chapter, they were as iconoclastic as they were affirming, offering a new kind of "classical" for

a new, industrial age: "vital" with a "chiaroscuro" to counter "insipid mediocrity."[42]

The fresco was but one element in Townley's gothic vision. In addition to his house on Park Street, with its neoclassical interiors, he inherited a medieval seat in Lancashire, for which he commissioned Gothic Revival lodges, and acquired the twelfth-century chalice of Abbot Suger (1081–1151), part of the treasury of the royal Abbey of Saint-Denis near Paris. Like some of the chalices in San Marco's treasury in Venice, its core is an ancient sardonyx cup, probably carved in Alexandria in the first or second century BCE, and its filigree metalwork, twelfth century. We do not know how Suger came by the cup; perhaps its most classical feature is that it was smuggled out of France in 1804 inside a plaster bust of the Laocoon.[43]

Townley is unexceptional in this regard: many of the Englishmen who spent most money cultivating Greek and Roman sculpture and sculpture after the antique were also drawn to other territories. The first Duke of Northumberland, for example, Hugh Percy (d. 1786), a surname he assumed on marriage, made up for his relatively unremarkable ancestry by commissioning architect Robert Adam, and garden designer Lancelot Brown, to create "a palace of Graeco-Roman splendour" at Syon in Middlesex and to "Gothicise" Alnwick Castle.[44] Whig politician and antiquary Horace Walpole (1717–97), to whom Hamilton made several generous gifts, displayed these, and other antiquities, including sculptures from major Roman collections, in his Gothic Revival villa in Twickenham, a tourist attraction in his own lifetime.[45] Richard Payne Knight (1750–1824), author of the *Specimens of Antient Sculpture, Aegyptian, Etruscan, Greek and Roman*, much of

its contents from his own and Townley's collections, built a neomedieval castle with a dining room based on the Pantheon in a picturesque landscape in Herefordshire, criticizing Brown's "classical" gardens for being "smooth, unvaried," and his lakes "motionless, and dead"—terms that will one day define modernism's denigration of "neoclassicism."[46] And, most notoriously of all, Hamilton's distant cousin, novelist and art collector William Beckford (1760–1844), swapped his newly built gothic abbey in Wiltshire for a neoclassical property in Bath, complete with Grecian and Etruscan libraries, Greek vases, and Roman sculpture from the sale of Walpole's collection.[47] Japanese lacquerware and Hindu "idols" swell these scenographies. The founding of colonies and trade networks in the Americas and Asia, and the strengthening of the East India Company, brought a stream of exotica in their wake, all of it pressing for reappraisal of the Greek and Roman; for reassertion of its hegemony.

The classical and the colonial, the classical and the gothic, and the princely and the public realm jostle for supremacy in this period. Antiquarianism mounts a further challenge. Like Townley, Walpole was a member of the Society of Antiquaries in London, a group established in protoform in 1707 to promote the study of "Bryttish antiquitys," not only medieval and Romano-British but pre-Roman and Anglo-Saxon.[48] But in 1772 he resigned his membership, in part because of a growing anxiety that the Society's study of northern and eastern artifacts, artifacts that stood for "deformity and absurdity," was threatening the Greek and the Roman and the "genuine principles of all beauty and all taste" that they brought with them.[49] Further to this threat was the fact that members were interested

in the kind of comparative approaches to the past that would come to be epitomized by d'Hancarville's *Recherches sur l'origine, l'esprit et les progrès des arts* (1785–86) with its recourse to India, Persia, Asia, and Egypt, and indeed Payne Knight's *Discourse on the Worship of Priapus* (1786–87), which dared whisper world religion.[50] There was more than one way to ease the antagonism. As the eighteenth century drew to a close, German philologist Friedrich August Wolf (1759–1824), whose aim it was to reclaim antiquity from the antiquarians, would spearhead "the scientific study of antiquity" or "Altertumswissenschaft," helping to make it "the first modern humanistic discipline."[51] This involved sidelining the Egyptian, Persian, and Hebraic: "There were in ancient times only two nations that attained a higher intellectual culture—the Greeks and Romans."[52]

Even Greek and nonprovincial Roman production risked becoming dissolute. Offsetting the ongoing interest in casts, and the faithfulness of bronze miniatures that rendered famous sculptures more accurately than their Renaissance counterparts had done, the candelabra and vases of Giovanni Battista Piranesi (1720–78) assembled ancient fragments, many of them found at Hadrian's Villa, into fanciful forms, or new "antiquities" (7.28).[53] Walpole was enthusiastic about the "sublime dreams of Piranesi," admiring the way in which the artist "imagined scenes that would startle geometry, and exhaust the Indies to realize," precisely because they elicited flights of fancy toward antiquity's lost splendor.[54] But not everyone was convinced. For British painter James Barry, Piranesi's fame was assured, "in spite of his Egyptian or other whimsies, and his gusto of architecture flowing out of the same cloacus with Borromini's, and other hair-brained

moderns."[55] For Polish prince Stanislas Poniatowski, his candelabra were "made up of beautiful pieces of sculpture assembled quite tastelessly and not even set up at a perpendicular."[56] Where were the limits? As noted in the preface already, it is only really in the nineteenth century, after decades of testing what was "classic" about the Greek and Roman, that the word "classical" is used of material culture, and of the material in this book. Familiarity with the Greek and Roman had led to ease of translation and to a handling that strained its integrity.

Productions like those of Piranesi increase the pressure to delineate what Greek and Roman art is, and what it does. But they are also born of delineation, and of efforts to pin down the nature of the relationship between antiquity and modernity. Winckelmann's historicization of style, most famously represented by his *Geschichte der Kunst des Alterthums*, comes in time to be most influential here.[57] But it is his *Gedanken über die Nachahmung der griechischen Werke in der Malerei und Bildhauerkunst* of 1755, translated as *Reflections on the Painting and Sculpture of the Greeks* by Britain-based painter and art critic Henry Fuseli ten years later, that is more relevant for this chapter. This sense of artists going beyond nature in search of an ideal was there already in the sixteenth century, when Venetian humanist Ludovico Dolce went against the advice of Leonardo and others to advise that artists should only partly imitate nature, and in part also "imitate the lovely marble or bronze works by the ancient masters. Indeed, the man who savors their incredible perfection and makes it his own will confidently be able to correct many defects in nature itself. . . . For antique objects embody complete artistic perfection."[58] How could imitation not have been a live issue,

when it was live in Aristotle, Quintilian, and Cicero? Yet the eighteenth-century version is more obviously political-—made so by the appropriation of the previous chapters: "No Nation under Heaven so nearly resembles the ancient *Greeks*, and *Romans* as we. There is a Haughty Courage, an Elevation of Thought, a Greatness of Taste, a Love of Liberty, a Simplicity, and Honesty amongst us, which we inherit from our Ancestors, and which belongs to us as Englishmen," wrote Jonathan Richardson Sr. in his *Essay on the Theory of Painting*.[59] Winckelmann's development of a causal link between art and life, *Kunst und Leben*, cements this sense, conjuring images of gymnasia and bright blue skies where emulation warms to identification.[60]

Winckelmann's ancients are avowedly Greeks, a clarification that will turn the distinction between Greek and Roman production (a distinction that is there already in the Richardsons' recognition of Roman copies, and in the gradual decay that Vasari sees in Roman art) into a mantra that will demand the acquisition of genuine fifth-century BCE sculpture from Aegina, the Parthenon, and Bassae.[61] It is also a clarification that leads, in the second half of the eighteenth century, to a new austerity of taste, as exemplified by the Greek Revival of James "Athenian" Stuart (1713–88).[62] Piranesi's candelabra are an early assault on "the essence of Greek art" that Winckelmann sought to isolate, and on academic, "summary classicism."[63] Hewetson was criticized for chiseling his subjects "in the form of an Antinous, a Fawn, or some such Classical figure for the sake of elegance" (7.10).[64] Piranesi echoes the sentiment:

> The law which some people would
> impose upon us of doing nothing

but what is Grecian, is indeed very unjust. Must the Genius of our artists be so basely enslaved to the Grecian manners, as not to dare to take what is beautiful elsewhere . . . ? But let us at last shake off this shameful yoak [*sic*], and if the Egyptians, and Tuscans present to us, in their monuments, beauty, grace, and elegance, let us borrow from their stock. . . . No, an artist, who would do himself honour, and acquire a name, must not content himself with copying faithfully the ancients, but studying their works he ought to shew himself of an inventive, and, I had almost said, of a creating Genius; And by prudently combining the Grecian, the Tuscan, and the Egyptian together, he ought to open himself a road to the finding out of new ornaments and new manners.[65]

For Piranesi, creative adaptation was key to learning from the antique, and this exemplified less by "Greek" sculpture, which was simply beautiful, than by "Tuscan" or Italian design. Particularly noteworthy was that of the Roman empire, whose architects had themselves "assimilated and improved ideas derived from other cultures" to become boldly experimental.[66]

Rome was still, as it had been in the Renaissance and Baroque periods, the main source of the antiquities, as well as the backdrop for Batoni's sitters. The second half of the eighteenth century witnessed an unprecedented flow of marbles into English country houses, fueled by the expansion of semiprofessional digging in Italy, and by the "virtù news" (archaeological reports and drawings) of excavated artifacts that British painter and dealer Thomas Jenkins (1722–98) sent home to the Antiquaries.[67]

Although the popes still had first refusal on choice pieces, enough of them leaked out to make "getting one over" on the Vatican a worthwhile endeavor in itself, proof no less of a patron's prowess.[68] "Damned Englishmen" were well placed to play the market, and dealers like Jenkins enterprising, and pandering, sweet-talking their clients about the need to find each statue a home "where its merit" might be "Properly understood."[69] Thomas Coke was not the only one to have the "means and audacity" to go "well beyond the bland aesthetic ideals of his time."[70] "Going beyond" was what it was about.

Experiencing the "Classical"

Today, the sculpture galleries of England's grand houses can feel lifeless and uninviting. Their replicas appear predictable and their antiquities second-rate—a "motley" crew of statues, many of them chosen for their dimensions, rather than for their subject matter.[71] They anesthetize their modern viewers, fading Winckelmann's investment in the stillness and purity of Greek sculpture to blandness.[72] But in the eighteenth century, it was a different story. An antique head of Athena that would wind up, via Jenkins, in the Wimbledon collection of antiquary and banker Lyde Browne (d. 1787) impressed Winckelmann so much that he thought it more beautiful than "everything witnessed by man": "I became deaf and dumb, and am deprived of my senses looking at this statue."[73] Being anesthetized could be a positive.

Put pieces in dialogue with each other and they starred in performances of a more dynamic nature than we encountered with Arundel or Isabella: one visitor to Newby Hall in North Yorkshire describes how the

light from the alabaster vases in the dining room enhanced "the magic effect with which the mind is impressed" when one looked through to the adjacent sculpture gallery.[74] Enchantment of this kind came from juxtapositions of material, scale, and subject matter, and the dance of light and shadow produced by candlelight and revolving statue bases. These absorbed the viewer, and turned the patron into circus-master, making his show a show of personality and personhood. Johann Wolfgang von Goethe (1749–1832), whose work was to prove so fundamental for Winckelmann's reputation, and for classicism, again puts the emphasis on consciousness, not on its loss, but on its awakening: "Surrounded by ancient statues, we feel ourselves in the midst of a vigorous natural life, we become aware of the diverseness of human forms and are led directly back to the human being in its purest state, with the result that the observer himself becomes alive and purely human."[75] We are not far from Lacan's theory of the mirror stage and "the statue in which man projects himself."[76]

We are also not far from William Hamilton's young wife Emma, who entertained his guests in Naples by assuming the poses of famous statues in a tableau vivant that brought together "all the antiquities, all the profiles of Sicilian coins, even the Apollo Belvedere" (7.12).[77] Walpole was skeptical about the idea of exhibiting one's wife "in pantomime to the public."[78] But like it or not, Emma's "attitudes" were symptomatic of a dramatization and eye to popularization that were changing Greek and Roman sculpture at this period, uniting classical and contemporary femininities in a surprising stream of altered states or transformations.[79] Emma's object-hood would soon be turned on its head

as nineteenth-century fashion magazines advised women everywhere that dressing like an Egyptian Cleopatra, a Grecian Helen, a Roman Cornelia, or an amalgam of them all, was liberating.[80] For classical art to retain its cachet, it would have to be credited with "material transiency," or adaptability, over and above "eternal verity."[81]

At the same time as Greek and Roman statuary was being dramatized like this, publications resulting from the Spanish-Bourbon excavations on the Bay of Naples, most importantly the *Le antichità di Ercolano esposte* volumes, were disseminating a different kind of lived antiquity in the objects found at Pompeii and Herculaneum. This dissemination influenced contemporary pottery production and wall and ceiling painting across Europe, adding color to modern domestic settings.[82] Meanwhile, the difficulties of seeing the real thing in the Royal Palace at Portici enhanced the cities' mystique and the mystique of objects unspoiled by centuries of restoration.[83] In 1828, François René de Chateaubriand, a man now known as the founder of Romanticism in French literature, published a letter that claimed that Herculaneum and Pompeii were "objects so important for the history of antiquity that in order to study them well, one must live there, stay there," and that Rome "was but a vast museum," Pompeii "a living antiquity."[84] Pompeii offered a new, more immediate, measure against which to judge classical sculpture: in Zoffany's painting of the Park Street library (7.13), volume 6 of the *Antichità* lies open at an engraving of a bronze drunken faun, and asks us to compare Townley's marble version next to it.[85]

Drunkenness was the least of the "sins" showcased by this material. Many of the remains at Portici—everything from the bronze "tintinnabula" or mobiles that once

7.12. Satirical print made by Thomas Rowlandson, entitled *Lady H******* [Hamilton's] Attitudes*, c. 1800, 23.7 × 17 cm. The British Museum, London, inv. no. 1981,U.258. Photograph: © The Trustees of the British Museum.

hung from doorways, complete with bells and phallic figurines, to highly crafted sculptures, such as Pan having sex with a goat from Herculaneum's Villa of the Papyri (3.17)—were so different from the ideal sculpture that had so dominated the discourse that they threatened that discourse, and the virtue associated with it. One reviewer of volume 6 of the *Antichità* decried it as "abominably indecent . . . obscene trash."[86] Others (and not just d'Hancarville, who sits at the table in Zoffany's canvas) found stimulation in the material's sexually explicit nature. In a second painting, by portrait painter Richard Cosway,

Townley and his fellow connoisseurs are pictured, two of them with their hands in their breeches, admiring a statue of Venus, which is shown from front and back, in debt to Pseudo-Lucian.[87] As was the case in Zoffany's *Tribuna*, the fact that one of these gentlemen spies her through an eyeglass dramatizes the act of looking, and looking hard. None of this was theater as Kunstkammern were theater. This was spectacle.

Even modest displays could speak suggestively. Take Zoffany's painting of Thomas Dundas's father, Sir Lawrence Dundas, at 19 Arlington Street, London (7.14). Sir Lawrence sits in front of an ornate

7.13. Johann Zoffany, *Charles Townley and Friends in His Library at Park Street, Westminster*, 1781–90 and 1798 (when the newly acquired Discobolus was added in the foreground), oil on canvas, 127 × 102 cm. Towneley Hall Art Gallery & Museum, Burnley. Photograph: akg-images / De Agostini Picture Library.

fire-surround, the mantle of which presents a curtain call of Rome's finest classical specimens, bronze miniatures of the Borghese Gladiator, the Apollo Belvedere, the Capitoline "Antinous," which had, before its move to the Capitoline Museum, belonged to Alessandro Albani, the Furietti Centaurs and rosso antico faun that, like it, had been found at Hadrian's Villa, and, in their midst, a Renaissance statue type, Giambologna's Mercury.[88] In one sense, these bronzes have a status akin to wallpaper; in another, they function as a pediment, turning the fireplace into a temple, and man and boy (his grandson) into cult statues. Such is the centrality of Mercury, and the way in which his elongated shape and his legendary link to trade and travel interact with the Dutch

seascape on the wall behind him, that one almost misses the larger bronze on the table in the foreground, between mirror and curtain. A beardless Bacchus, grapes in hand—it is this statue that is the gatekeeper of the scene. What is going on beneath the painting's formal exterior? Dundas's status as a member of the Society of Dilettanti, an English association of gentlemen formed for the purpose of enjoying life and the art of Greece and Rome, and sponsor of James Stuart and Nicholas Revett's expedition to Athens to measure and accurately describe its buildings,[89] depended not only on his promotion of the study of Greek and Roman antiquity, but on his hospitality. We note that two of the chairs are empty.[90] Drinking had been at the heart of the Society,

7.14. Johan Zoffany, *Sir Lawrence Dundas and His Grandson in the Pillar Room at 19 Arlington Street, London*, 1769, oil on canvas, 102 × 127 cm. Aske Hall, North Yorkshire. Photograph: The Zetland Collection.

since its foundation in 1732.[91] Suddenly the faun and centaurs appear less decorous.

Yet at Holkham, where the display of sculpture has changed little since its arrangement in the 1750s, art historians have taken a different approach—less spectacle than Sudoku (7.15). "In its general message, then, the Sculpture Gallery provides an abridged edition of Virgil's 'Georgics', an agrarian treatise dealing with the tillage of crops, the growing of fruit-trees, especially the vine, husbandry and bee-keeping."[92] As a description of the poem, this assessment overlooks the philosophy and politics; as a solving of the space, it privileges the parallelism of art and poetry that we find in Junius's *The Painting of the Ancients*, and in Joseph Spence's

Polymetis, first published in 1747. Although this kind of interpretation was open to Coke's contemporaries (*Polymetis* was popular, and in Nicholas Tindal's abridged edition, "necessary, not only for classical instruction, [b]ut for all those who wish to have a true taste for the beauties of poetry, sculpture and painting"), it is as overly determined as Spence's links between genres.[93] What about the gallery's invitation to glance excitedly as well as to gaze like a connoisseur or scholar, registering "the volumes, depths, and surfaces of the visual field" *and* "reading the image"?[94] As others have shown, this oscillation of the eye between gazing and glancing is fine-tuned in the 1760s, both by public art exhibitions and by "showhouses" that implicate their

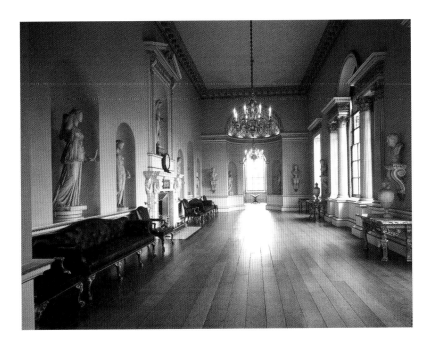

7.15. The Sculpture Gallery, Holkham Hall, Norfolk. Photograph: © Holkham Estate.

audiences by making them, their seeing and being seen, part of the show. In this way, Habermas's "public sphere" is redefined as a visual revolution, creating a "culture of visuality" that empowers viewers to recognize themselves "in the look."[95]

Not only are Newby Hall, Syon House, and Wentworth Woodhouse in South Yorkshire extensively altered in this period to make them better suited to the "presentation of culture," and Holkham Hall (begun in 1734 but not completed until the 1760s), Kedleston Hall in Derbyshire, Walpole's Strawberry Hill, and Townley's Park Street residence purpose built. Many of them also admitted tours, and compiled (often multiple) catalogs of their contents, some of these penned by the owner.[96] When in 1776 a visitor signed the visitors' book at Wilton House near Salisbury, one of the most established antiquities collections in the country, she noted that 2,324 people had preceded her that year alone; less than a decade later, close to 700 visitors were calling at Park

Street.[97] Comparison of two early publications of the same collection is enlightening of the challenges. In 1803, Henry Blundell's privately printed catalog of his antiquities at Ince near Liverpool opened with the words, "The following Descriptive Catalogue was written with the sole view of its serving as a kind of interpreter, in order to obviate the daily questions of those visitors who are not much versed in history, or heathen mythology, and was by no means intended to meet the eye of the learned antiquarian, much less that of the public, on account of the many errors and mistakes in it."[98] Just six years later, and the introduction to the first volume of his *Engravings and Etchings of the Principal Statues etc* admitted that such large parties, many of them "improper people," were visiting that admission had to be limited.[99]

At a time when "propriety" could be claimed "the key stylistic concept, along with a host of related terms and formulations," such prescriptions are hardly surprising.[100] Beauty was no longer restricted

to the cognoscenti but was "an organising term for a variety of discourses" and "a means of distinguishing between proper and improper behavior."[101] The cognoscenti controlled access, luring a swelling crowd to join them, while simultaneously protecting the credentials of a coterie of gentlemen that now included newly landed families like the Weddells of Newby Hall, and banking stock like Lyde Browne and Thomas Hope, as well as established aristocracy and those close to the king. Although the British Museum opened, free, in 1759, to satisfy "the desire of the curious, as for the improvement, knowledge and information of all persons," visitor numbers were tiny until the end of the 1830s.[102] This is not surprising either: the British Museum was an ensemble of collections without classification or identity.[103] It was the owners of England's grand houses who made Greek and Roman antiquities central to visual culture, directing the show with such aplomb that when Townley's collection was eventually bought for the museum in 1805, it lacked, according to one recent critic, "its essential element, the presence of the collector, who restored a certain sense to the compositions by his own 'antico-mania', his interpretation, his individual mythology."[104] Contrary to the Virgilian reading of Holkham, the "mûthos" was more important than the "logos" of the "mytho-logy"; as indeed it was at Kedleston and in our other spaces. Kedleston "does not strive for the accuracy of the copy or slavishly follow so-called academic reconstructions of the past as it was—merely, of course, another fantasy—but aggressively makes its own image in its fantasized version of the antique. In so doing it stakes a claim for the utmost sophistication, proclaims itself as standing at the summit of cultured progress."[105]

Staging the Antique

How does Kedleston's "fantasized version of the antique" compare to its closest competitors? In the 1710s already, on the cusp of the phenomena that are the focus of this chapter, Thomas Herbert was adding to his collection at Wilton with purchases from the Giustiniani in Rome, the Mazarin collection,[106] and the Valetta collection in Naples, and rebuilding parts of his Elizabethan house to accommodate neo-Palladian galleries. There are obvious overlaps between his endeavors and what happens later: Townley's residence was "the Wilton House of London," just as Wilton House drew repeated attention to its inheritance of Arundel's legacy.[107] But it is also the case that in the 1720s Wilton House was in a league of its own in England, and unable, in isolation, to turn antiquities collecting into something with enough of a public consciousness to stimulate the sorts of sensibilities already outlined. If it is these we are looking for, we have to wait until the 1750s and the publication of Richard Cowdry's printed catalog of the collection, with its dedication to Sir Andrew Fountain, himself a collector. This publication makes its absorption of collections at home and abroad explicit.[108]

It is also in the 1750s that a journal writer in *The London Chronicle* notes that "This Palace, for so we may call it, contains a Collection of the richest Statues, Busts, Antiques and Relievos, of any Nobleman in England, or perhaps of any Man in the World." He continues, "Indeed it is a grand repository of Curiosities. The lower apartments are so crowded, that they appear like so many Shops or Magazines of Marble Merchandise. But amidst the profusion of Grandeur, the Arrangement seems to be as elegant as the number will permit."[109]

"Curiosities" is a word also found in the title of Cowdry's catalog, and one suggestive of a miscellany of extraordinary objects, prior to the emergence of natural history and art history—outside, one might think, the world of Batoni, in which classical marbles elicit identification and aesthetic pleasure.[110] But there is grandeur here nonetheless—a "profusion" that Arundel would dare have dreamed of. Come 1757, chaos can speak of abundance, and stockpiling of elegance.

By the end of the eighteenth century, the Giustiniani, Valetta, and Mazarin collections were not the only ones to furnish English houses. Pieces from the Palazzo Barberini and Mattei, the Villa Negroni and Albani's first collection, and from the Carafa family in Naples had also made the journey.[111] In the same year that the Barberini collection began to be dispersed (1740), Walpole wrote to his friend Richard West, "I am persuaded that in an hundred years, Rome will not be worth seeing . . . the statues and private collections must be sold, from the great poverty of the families. There are now selling no less than three of the principal collections, the Barberini, the Sacchetti, and Ottoboni."[112] The growth of the Vatican and Capitoline museums depended, in part, on this dismantling, which also fed England's aristocracy and gentry, whose proclivity for imaging themselves as Romans had grown more intense since the Glorious Revolution.[113] This imaging could bolster Whig and Tory ambition and increase the authority of men like the Catholic Townley, who were barred from participating in political institutions. When, less than fifty years later, Catherine the Great wanted ancient sculpture for Tsarskoye Selo, she turned to agents in England, securing Lyde Browne's collection (d. 1787) (much of it from the collections above) for £23,000.[114]

England's counties were a major repository, and the houses referenced in this chapter but the most ostentatious containers: there was, for example, a vase from the Villa Mattei in the small collection of George Strickland at Boynton in Yorkshire.[115] Two of the statues that Coke acquires from Italian collections, Diana and "Lucius Antonius," had been illustrated a dozen years earlier in de Rossi's *Raccolta*, a copy of which he owned.[116] And one of Lyde Browne's pieces, identified as Paris (7.16), was to feature in Winckelmann's *Monumenti Antichi Inediti* (his *Unpublished Ancient Monuments*).[117]

Early in the eighteenth century, casts of classical sculpture were still quite rare in England. Quickly, however, they too became part of the landscape—so much so that in 1737, John Cheere took over sculpture yards at Hyde Park Corner, London, to produce lead and plaster casts for gardens and libraries.[118] A print issued with William Hogarth's *The Analysis of Beauty* in 1753 "with a view of fixing the fluctuating ideas of taste" perhaps shows Cheere's yard, where versions of the Farnese Hercules, Belvedere "Antinous," Laocoon, Medici Venus, Belvedere Apollo, and Belvedere Torso vie for the viewer's affection (7.17). It was at this time that architect Matthew Brettingham the younger (1725–1803) supplied Coke with his first casts (a Capitoline Antinous, Albani Apollo, Apollino, Medici Bacchus, and, in a different category, François Duquesnoy's Saint Susanna, a statue of a Christian martyr made for a church close to Trajan's column), having already begun to order molds of sculpture in the Albani and Capitoline collections with a view to establishing an Academy of Design.[119] Soon he was supplying Kedleston Hall and the Duke of Richmond, whose gallery in his Whitehall Palace was to fulfill the teaching function, sponsoring

7.16. Statue of Paris, unknown maker, Roman, and unknown maker, Italian, probably 100–200 CE; and before 1767, marble, h 133 cm. The J. Paul Getty Museum, Los Angeles, inv. no. 87.SA.109. Photograph: Digital image courtesy of the Getty's Open Content Program.

artists to draw from the antique, and presaging the foundation of the Royal Academy in 1768.[120] Immediately it too began building its collection (7.18), although not without censure. One critic lamented that casts sent from Rome to George, the prince regent in 1816, "should be destined to the smoky, dingy rooms of the Royal Academy, liable to the carelessness of housekeepers, porters, and idle boys. . . . The Farnese Hercules was once scoured with a scrubbing brush!" They would be better off in the British Museum with the newly acquired sculpture from the Parthenon, "where the public could rely on the preservation of those beautiful productions for themselves and their children."[121]

The cleaning of the Parthenon sculpture in the 1930s will open the museum to similar charges, and to the accusation that "the lustre and the gentleness have

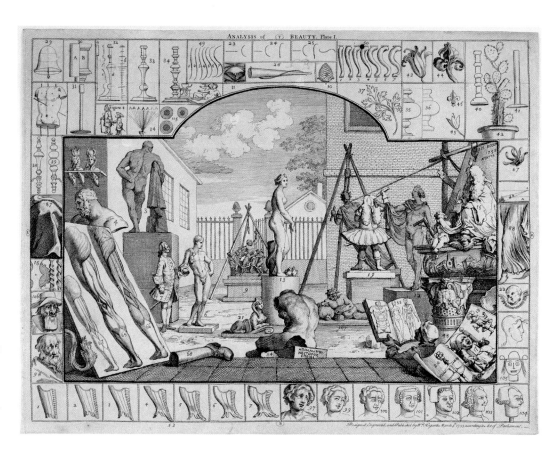

7.17. Hogarth, *The Analysis of Beauty*, 1753: plate 1, etching and engraving, 38.9 × 50.2 cm. Harvard Art Museums/Fogg Museum, Gift of William Gray from the collection of Francis Calley Gray, inv. no. G1841. Photograph: Imaging Department: © President and Fellows of Harvard College.

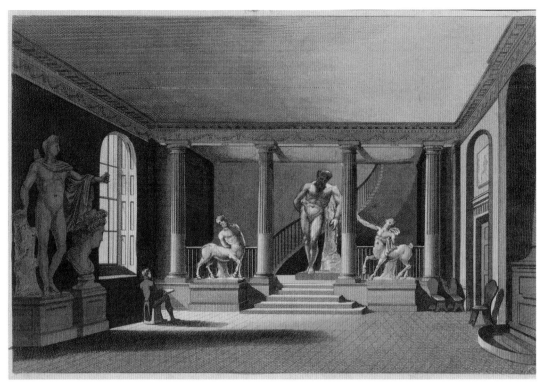

7.18. *The Hall at the Royal Academy, Somerset House*, 1810, etching ink on paper, hand-colored with watercolor, 12.5 × 17.5 cm. Victoria and Albert Museum, London, inv. no. E.601–1903. Photograph: © Victoria and Albert Museum, London.

vanished. The lumps of stone remain, robbed of life, dead as casts."[122] But until the 1930s and the subsequent two decades, when cast collections were regularly put into storage or smashed to pieces, casts were far from lifeless. They were "objects of the highest beauty and of inestimable value toward the formation of sound taste in Art"; their flexibility and canonicity were crucial in turning admiration of ancient statuary into a classical style that integrated sculpture and architecture.[123] At Kedleston, casts were preferred to antique marbles—and a different set from those in the Marble Hall at Holkham.[124] At Wentworth Woodhouse, for which Lord Malton, later the second Marquis of Rockingham (1730–82), was already buying casts in Florence in 1749, plasters of the Medici Venus, Medici Mercury, Idolino, and Dancing Faun would eventually be joined by not one but two

casts of the Dying Gaul, and a roundel of a relief of Antinous.[125] The Antinous was one of at least two similar casts in England, the other at Spencer House in London, and the relief on which it was based widely regarded as the most exquisite sculpture in the Villa Albani, in large part because of Winckelmann's praise of it and of other Antinous portraits (7.19). At Wentworth, it was joined by an ancient Antinous bust, acquired at the sale of physician Richard Mead's collection in 1755 but initially installed in Rockingham's London residence, a copy of a bust of Hadrian bought in 1777, and pastes of Antinous gems, their company increasing the relief's allure and its homosocial signaling.[126]

The Antinous relief was not the only copy to reference a recent discovery. Rockingham was the first Englishman to own a version of the Capitoline Flora (in marble

7.19. Robert MacPherson, *Antinous—bas relief, Villa Albani*, 1860s, albumen silver print, 27.5 × 24.4 cm. The J. Paul Getty Museum, Los Angeles, inv. no. 84.XM.502.32. Photograph: Digital image courtesy of the Getty's Open Content Program.

this time), a statue unearthed in 1744 and known by some as Hadrian's wife, Sabina.[127] And Thomas Anson of Shugborough Hall in Shropshire secured casts of the Furietti Centaurs in the year that they entered the Capitoline Museum.[128] All of these sculptures were from Hadrian's Villa, and Hadrian, as we have repeatedly witnessed, the model collector. In an entry on a bust of Hadrian from his own collection, Blundell notes, "He [Hadrian] was two years in Greece, where he collected many Grecian statues, and other sculpture, to ornament his villa at Tivoli; a wonderful place both for extent and curiosities." He continues, "Adrian came over to England, which he conquered."[129] So too the statues

themselves, creating new cultures of viewing in the process. Was Holkham's plaster of Flora a nod to Hadrian and the pope, who had bought the original, or a response to Wentworth Woodhouse?[130] Rockingham also owned a cast of a portrait bust bought by Townley in Naples in 1772 (7.13 and 7.20). Known as "Clytie" after the nymph who was transformed into a flower, the marble bust appears to have been extensively reworked, if not "faked" completely, and was Townley's favorite sculpture.[131] Her inclusion underlines how English this had become, as much about the performance of the self and of the national prompted by the growth of the British empire and debated in the work of David Hume, Adam Smith, and Samuel

Johnson, as about international rivalries. National identity "was performed through group and individual interactions in the matrix of everyday relations, where the public and the domestic, the personal and the historical intersected." But it "depended upon the ability of individuals to insert themselves into the weft of collective narratives, and to identify themselves with experiences that are shared through representation." For this "phantasmatic staging,"[132] Greco-Roman statuary was fundamental.

Shaping these stage plays, and people's participation in them, was the architecture and décor of the spaces themselves. So innovative were these that Adam's sculpture gallery at Newby Hall is thought by some scholars to have influenced the Pio-Clementino.[133] At Holkham, although the octagonal rooms to the north and south of the sculpture gallery take the form of the Tribuna (7.5), they eschew its contents, relegating casts of pieces from the Uffizi (the Medici Venus, Dancing Faun, Cupid and Psyche) to other parts of the house in favor of originals.[134] Not that Coke's own ancient satyr, which had been restored to play the cymbals in homage to the Dancing Faun, or his ancient statue of a draped Venus, were placed there either.[135] Instead, in the northern octagon, the togate statue of "Lucius Antonius" set the tone,[136] separated from the collection's other superstar, Diana, which stood with the "faun" and other mythological figures in the main gallery. Far from following a script, Holkham too was avant-garde, marshaling experimentation, if not also disorientation, to reinvent "the classical."

Unlike houses in Italy, where sculptures were incorporated into interiors decorated with wall and ceiling painting (so the Antinous relief is above a fireplace on the

7.20. Clytie/Antonia, 40–50 CE or eighteenth century, marble, h 57.15 cm. The British Museum, London, inv. no. 1805,0703.79. Photograph: © The Trustees of the British Museum.

piano nobile of the Villa Albani immediately adjacent to a section of eighteenth-century fresco that captures Hadrian and Antinous at Tivoli), Newby Hall and Holkham let the statues do the talking. All emphasis is on them, their "diverseness of human forms," and their conversations with each other, and with the viewer.[137] At Holkham, the ceiling was "plain, with only a single Palladian Corinthian cornice under it," the walls a "dead white," and the stucco work and gilding, discrete.[138] The curtains too were white, and the seating mahogany with blue upholstery to offset the marble: in the words of its architect, Matthew Brettingham, it was "the completest [gallery] in this kingdom, for the manner and stile of furnishing."[139] Newby's architect, Adam, preferred a "pale strawberry" to compliment "the brightness of the Parian and Pentelican [*sic*] marbles."[140] Whereas marble might need toning down for its properties to be appreciated, casts needed light, hence the locally sourced alabaster used in the Marble Hall

at Holkham. The grandeur of the hall's proportions and the glassiness of its surfaces make the eyes swim and the spirits soar (7.21).[141] In their attempts to focus, Coke's visitors find subjectivity in transcendence.

At the start of the nineteenth century, Amsterdam-born collector and designer Thomas Hope (1769–1831) will take a similar approach to the statue gallery of his London home on Duchess Street:

> As this room is destined solely for the reception of ancient marbles, the walls are left perfectly plain, in order that the back-ground against which are placed the statues, might offer no inferior ornaments, or breaks, capable of interfering, through

their outline, with the contour of more important works of art.[142]

Hope's mention of "contour" reminds us that this is not just about exploiting the dramatic potential of the statues, or about aligning them aesthetically with his display of vases, the core of which he had acquired in 1801 from Hamilton's second collection and "placed in recesses, imitating the ancient Columbaria" (7.9).[143] It is about eliciting, by enhanced modes of display and lighting, ways of seeing that stimulate the suppression of superfluous detail that Winckelmann had advocated in his *Reflections*, with its emphasis on "noble Contour," and, with it, the "sublimity of thoughts" of Greek artists[144]—that same emphasis on

7.21. The Marble Hall, Holkham Hall, Norfolk. Photograph: © Holkham Estate.

outline that characterizes John Flaxman's drawing (1755–1826) and engravings of Thorvaldsen's statuary (7.22).[145] It is also why when Fuseli visits Wolff's sculpture gallery at Sherwood Lodge in Battersea, he is moved to tears: "No man shall persuade me, that these emotions which I now feel are not immortal." Dramatically turned to face the wall, Wolff's cast of the Farnese Hercules (1.16) was "a vast mass of shadow, defined only by its grand outline and the strength of the light behind it."[146]

This privileging of outline over surface "was a form of representation that came to have a remarkable influence not simply on reproduction, however, but on the creation of original work," affirming the "distilled immutable ideal" that drives nineteenth-century neoclassicism.[147] Work by neoclassical sculptors such as Canova and Thorvaldsen is the final part of our country houses' sculptural jigsaw, jostling with antiquities and with copies in ways that bring out the Englishness of English patronage networks, and the perfections and imperfections of ancient marbles. When British writer Anna Jameson visited the Munich Glyptothek soon after its opening in 1830, she wrote, "Thorvaldsen's statue reminded me of the Antinous; Canova's recalled the young Apollo. I hardly know which to prefer as a conception." Although the marble of the former had "a coarse gritty grain, and glitters disagreeably in certain lights, as if it were spar or lump-sugar," "in both, the feeling is classically and beautifully true."[148] Such responses threw the originals further into relief, transfiguring them from models (as they had been since the Renaissance) to "types," to a style system that spoke of, and through, affinity.

7.22. John Flaxman, *Study of Two Women Grieving*, before 1787, pen and gray ink, brush and gray wash, 34 × 24 cm. The Metropolitan Museum of Art, New York, inv. no. 2007.275. Photograph: The Metropolitan Museum of Art, Purchase, Catherine G. Curran, Jeffrey L. Berenson, PECO Foundation, and Susan H. Seidel Gifts, 2007, www.metmuseum.org.

The Classical and Contemporary

What did work by Canova, Thorvaldsen, and their British counterparts contribute to our houses? Lyde Browne's statue of Paris had been sold in the 1760s, prior to Catherine the Great's interest in the collection, to Rockingham, and by the time of Rockingham's death had become part of a tableau, together with statues of Venus, Minerva, and Juno, in a ground-floor room in his house at Grosvenor Square in London (7.16, 7.23, 7.24 and 7.25).[149] All were on mahogany bases, which would probably, like that on which Coke's Diana was placed, have turned, exploiting the goddesses' poses, which ask to be viewed from multiple angles.[150] Compared to them with their satiny "skin" and flowing drapery, the patched, lesser-than-life-size Paris (shorter, in fact, than Minerva or Juno), "in

a shepherd's dress,"[151] with clear fractures across the ankles and neck, appears stolid. But then they are the work of Nollekens and closer in style to miniature bronzes, some of which also decorated the space. In 1778, the sculptor finished a fourth goddess for Rockingham, a dynamic figure of Diana in the act of shooting (7.26). Shortly after Rockingham's death, all were moved to the sculpture gallery or "museum" at Wentworth Woodhouse, where they were set amid other classical artifacts.[152]

In this way, the judgment of Paris is staged and restaged (far more explicitly than it had been back in Rome in the house beneath what is now the Via Cavour), inviting every viewer to be an arbiter of taste by identifying with a protagonist who is made more human by virtue of his flaws. The relative modernity of the goddesses makes each of them an "Emma Hamilton," until Diana intrudes, destabilizing the familiar

7.23. Joseph Nollekens, *Venus*, 1773, marble, h 124 cm. The J. Paul Getty Museum, Los Angeles, inv. no. 87. SA.106. Photograph: Digital image courtesy of the Getty's Open Content Program.

story. Her running introduces elements of uncertainty and flux, as does her shooting, which might work as it does in Greek and Roman epic to signal a radical redirection of the narrative.[153] Perhaps we have reached an impasse; perhaps such sculpture already seems monotonous and overly mechanical, as it will for many nineteenth-century critics, especially in contrast to painting. In 1881, British essayist Vernon Lee's "child in the Vatican" will find the statues in its "desolate" corridors "vague, white things, with their rounded white cheek, and clotted white hair, with their fold of white drapery about them . . . in their vagueness, their unfamiliarity, they seem also to be all alike." For Lee, domestication means distortion of meaning: the Vatican is "a place of exile; or worse, of captivity, for all this people of marble."[154] None of them possesses inherent qualities that determine its value; the act of reception is key, and form more important than subject matter.

Lee's position would be impossible were it not for the immediacy of response invited by an evolving mix of contemporary and classical sculpture in the second half of the eighteenth and first half of the nineteenth centuries. Neoclassical sculpture had been integral to Wentworth from the start, and not only in the Flora and other marble versions of famous originals that graced the Marble Saloon, but also in Vincenzo Foggini's *Samson and the Philistines*, which nodded to Michelangelo and Giambologna, a group perhaps also destined for the Marble Saloon but consigned because of its weight to the Pillared Hall on the ground floor.[155] Blundell displayed Canova's *Psyche* among antiquities in his main gallery at Ince, and John Russell, sixth Duke of Bedford, made Canova's *Three Graces* the focal point of a "temple" in his sculpture gallery at Woburn

Abbey.[156] Indeed for Hope, as for many collectors at home and overseas, it was neoclassical sculpture that sparked the acquisition of antiquities.[157] The first statues in the sculpture hall of Sweden's Gustav III (1746–92) were an Apollino and a Venus Callipyge by Johan Tobias Sergel, who would later advise the king on buying his first substantial set of ancient sculptures and depict him in the pose of the Apollo Belvedere (7.27).[158] An ancient Endymion, supposedly found at Hadrian's Villa, was considered the jewel in Gustav's collection (7.28): "To see Endymion and especially the play of shadows in the light is an experience. . . . We could have stayed there all night," wrote a visitor in 1787.[159] But by 1840, long after the collection had been reinstalled in Stockholm's Royal Museum, views had shifted: "The most remarkable part of the collection to a foreigner are the works of Sergel."[160]

Hope preferred antiquities for his Duchess Street sculpture gallery.[161] But elsewhere in the house, Flaxman's marble *Aurora Abducting Cephalus* was the star of an opulently mirrored room, amid glass showcases containing a marble arm, believed to be from a Parthenon metope, and a stalactite from the Cave of Antiparos, one of many taken during the Russian occupation of the island from 1770 to 1774.[162] The ensemble amounted to a modern take on the studiolo or Wunderkammer, and vied for attention with rooms of Egyptian, Chinese, and Hindu objects, turning the eclecticism of the eighteenth century into a series of themed utopias.[163] It also vied with other classical installations. In the dining room, Flaxman's portrait-herm of Hope's brother Henry Philip, inscribed Φίλιππος (Philippos), which means "horse-lover" in Greek, was positioned on the mantelpiece between two antique-type equine heads.[164]

7.24. Joseph Nollekens, *Minerva*, 1775, marble, h 144 cm. The J. Paul Getty Museum, Los Angeles, inv. no. 87.SA.107. Photograph: Digital image courtesy of the Getty's Open Content Program.

7.25. Joseph Nollekens, *Juno*, 1776, marble, h 139.1 cm. The J. Paul Getty Museum, Los Angeles, inv. no. 87.SA.108. Photograph: Digital image courtesy of the Getty's Open Content Program.

7.26. Joseph Nollekens, *Diana*, 1778, marble, h 124 cm. Victoria and Albert Museum, London, inv. no. A.5–1986. Photograph: © Victoria and Albert Museum, London.

7.27. Johan Tobias Sergel, *King Gustav III of Sweden*, plaster, h 96 cm. National Museum, Stockholm, inv. no. NMSk 464. Photograph: Photo: Erik Cornelius / Nationalmuseum.

It is not antiquity but "the spirit of the Antique" that Hope masters,[165] the same "spirit" that will see William Spencer Cavendish, the sixth Duke of Devonshire (1790–1858), include but one major ancient sculpture, a colossal head of Alexander, in his sculpture gallery at Chatsworth—and this despite the fact that he can still get his hands on ancient examples from British collections and abroad, not only marbles but the fifth-century BCE bronze head known as the "Chatsworth Apollo" (9.11).[166] Instead, its contemporary angle is a memorial to Canova, who died in 1822.[167] In 1834, when the duke's gallery was finished, the best way to capture the essence of the Vatican's Pio-Clementino and Braccio Nuovo galleries (the latter opened in 1822 after the return of spoils seized by Napoleon, its display overseen by a committee chaired by Canova) was with modern sculpture.[168] Classicism's nostalgia now lay in the new.

This same "spirit of the antique" goes some way to explaining the "architectural kaleidoscope" of casts and original fragments that clutter the house of architect Sir John Soane (1753–1837) at Lincoln's Inn Fields in London, a house that was more or less as it is now in the 1820s, before being bequeathed to the nation (7.29).[169] At first sight, its crowded aesthetic, with its emphasis on incompleteness, separates it from our earlier "showhouses." But in another sense, it is the apogee of what we have encountered: the subject of its classicism is the space itself, and this, a conception of space that "centered on individual experience" over and above "stable representation."[170] Building on the vision of Piranesi, whom he had met in Italy in 1778, and re-presenting this vision with such three-dimensional dynamism that it seems to threaten the solidity of the walls, Soane's

7.28. Endymion, second century CE, marble, length 213.5 cm, with composite works by Piranesi in the background, also marble. Gustav III's Museum of Antiquities, Royal Palace, Stockholm, inv. no. NMSk 1. Photograph: Åsa Lundén / Nationalmuseum.

museum exceeds "what is generally understood to define British neoclassicism."[171] Rather than channel Canova's perfection, Soane prefers the "ruin lust" of painter Charles-Louis Clérisseau (1721–1820) (7.30) and his teacher Panini, and imagination to classification, reaching out to more popular forms of entertainment such as the panorama and diorama. It is no accident that the most famous fragment of them all, the Venus de Milo (8.2), was discovered at this time, and admired in a post-Napoleonic world that saw the restored Apollo Belvedere and friends return to Italy.[172] For Soane, as for Venus, beauty lies in the "union between antiquity and modernity."[173]

The celebration of the fragment accords with a growing anxiety about restoring ancient statuary. These anxieties were not without precedent: the sculptor Orfeo Boselli (1597–1667) wrote the first treatise on the subject in 1650.[174] Indeed restoration's controversial nature had long contributed to debates about what made ancient art inimitable, and ancient artists exemplary. But from the 1770s on, with Italian sculptor Carlo Albacini assuming Bartolomeo Cavaceppi's place as the leading restorer of the day (responsible, for example, for the Townley Venus and Discobolus), what was wanted from a restored sculpture changed, from an obviously rescued production of the kind that populates Holkham's sculpture gallery, to a more unified, refined artwork, with a polish that rivaled Nollekens and Canova.[175] The issue of whether or not to restore was compounded by the question, to what effect?[176] Turn-of-the-century classicism changed Greek and Roman sculpture by airbrushing what it looked like.

The more seamless the transition between ancient and modern, the more

7.29. Interior of Sir John Soane's Museum, London. Photograph: © Nigel Dickinson.

pressing the question of what was classical about classical art. When in 1803 Elgin asks Canova to restore the Parthenon sculptures, he refuses, saying that if this really had to happen, he might use Flaxman, who would do least damage.[177] "To Flaxman," claimed an art critic of the period, "our obligations are very great, since, as far as our acquaintance with his works extends, they served nobly to elevate from a certain monotonous lethargy and to create afresh that taste for the severe and golden style of antiquity which he applied to his own inventions."[178] But even this "creation" could be damaging. In a book designed to supply artists with accurate ancient material with which to work, Hope explains how he has taken pains to distinguish "from the genuine antique stock remaining, the spurious and often modern restorations grafted upon it; and had lamented that these indifferent additions should so seldom be pointed

out as such in the engravings executed from the originals in question, and should consequently render these latter so much more frequently calculated to mislead than to instruct the youthful student."[179]

One of the most interesting manifestations of this concern is the Society of Dilettanti's two-volume *Specimens of Antient Sculpture, Aegyptian, Etruscan, Greek and Roman: Selected from Different Collections in Great Britain*, eventually published in 1809 and 1835. The brainchild of Payne Knight and Townley, who from the 1770s had begun making inventories and compiling drawings, its engravings were a nationalist endeavor to put the choicest pieces in British collections, some of them known in Rome circa 1500 already, onto a world stage and to rival compendia like those of de Rossi and Perrier.[180] But these engravings and their accompanying text were also an experiment in scholarly method, excluding,

7.30. Charles-Louis Clérisseau (1721–1820), *Architectural Fantasy with Roman Ruins*, pen and brown ink and brush and brown and green wash, 25.3 × 35.6 cm. The Metropolitan Museum of Art, New York, inv. no. 1975.131.98. Photograph: The Metropolitan Museum of Art, Bequest of Harry G. Sperling, 1971, www.metmuseum.org.

or such was the claim, "all heterogeneous compositions of parts, not originally belonging to each other," bracketing off restored elements by the deployment of dotted lines, and drawing attention to antique surface-finish.[181] In an exception, like the Townley Discobolus, which was deemed too important to omit, attention was drawn to the rogue head,[182] and notice given throughout of the limitations of illustration. So, the entry on a statue of Apollo with his lyre opens, "Our duty to the public obliges us to acknowledge that justice has not been done in the print either to the truth of the proportions, the elegance of the limbs, or the grace of the action," and a head from the Townley collection (7.31) is deemed "very accurately represented in the print; though the artist has introduced too much of the painter's beauties of play or light and shadow, and glitter of effect."[183] The "magic" of this chapter's houses is all very well, but cannot dispense with the antiquarian gaze. If anything, the "magic" of their ensembles increases the need for empiricism and for

a sharper focus back on individual statues. Townley led the way here. Of his dining room, d'Hancarville writes, "The aim in the decoration of this room was principally to recal[l] the eye in particular upon each of the marbles which it contains."[184]

Townley's privileging of old over new, and original over casts, is of a piece with a more general curiosity that marks him out from some of our other eighteenth-century protagonists (although we must also remember Cosway's painting, which realigns him with Rockingham, who kept a "grand antique group" of a "satyr and satyress in amorous conjunction" in the "closet" of his London residence).[185] But if his curiosity anticipates the archaeological approaches of the nineteenth century, his collection risks seeming old-fashioned already—an Italian collection in a changing world in which Greece was becoming the utopia of choice, a place for which Byron fights in the Greek War of Independence of 1821–32. Payne Knight's "Preliminary Dissertation" in the *Specimens* on the "The Rise,

7.31. "Head of the Didymaean or Androgynous Apollo," *Specimens of Antient Sculpture,* 1809, plate 64. Photograph: © Museum of Classical Archaeology, University of Cambridge.

Impelled by a love of the Fine Arts, and anxious to view the celebrated remains of sculpture, when it was carried to the highest perfection by the most elegant nation in the universe, the Greeks, I determined to visit Athens. . . . After having employed two years in visiting the antiquities of Greece, her islands, colonies in Asia Minor, Egypt, Constantinople, and Lesser Tartary, I returned to Rome, where listening to the earnest solicitations of some literary friends with whom I lived in the habits of the closest friendship, engravings were made by the best artists of a considerable number of antique monuments, collected in the course of my extensive tour.[190]

Progress, and Decline of Antient Sculpture" is Winckelmannian through and through;[186] and the stock of Roman marbles that shaped engagement with the antique since the story of classical art began, downgraded as "plunder of the Greek cities, or copies made from the masterpieces which still continued."[187]

Challenging Townley's collecting and publishing projects were catalogs like that of Sir Richard Worsley (1751–1805), a two-volume folio privately circulated among "chosen friends" including Townley, Payne Knight, William Hamilton, and the prime minister, William Pitt, in 1798 and 1802.[188] This *Museum Worsleyanum; or Collection of Antique Basso-Relievos, Bustos, Statues, and Gems; With Views of Places in the Levant* combined the virtues of "Kunstkammer"-catalogs like those of the Tradescants and Danish physician Ole Worm,[189] the publications of the Capitoline and Vatican collections, and Stuart and Revett's magnum opus to set its antiquities, many of which came from Athens itself, in a revised framework:

Rome was still the hub of activity and dissemination (a status stressed by Worsley's collaboration with Visconti and the rendering of the text in Italian as well as English), but was now recognized as the processing center as much as the source, a space that signaled mediation and homecoming. An engraving of a cameo of the fifth-century BCE Athenian politician Pericles seals volume 1's English "Introduction," and an engraving of a coin of the emperor Hadrian, Rome's most famous "philhellene," the introduction's Italian version.[191]

As we move into the next chapter of our story and through the nineteenth century, new arrivals—not just the sculptures of the Parthenon and Bassae, but the Aegina pediments in Munich and, by the close of the century, the finds from Olympia (1875–81), "the first of the 'big digs' in Greece,"[192] from the Athenian Acropolis and Delphi—make fifth-century Greek art ever more ideal, and Roman art

lacking. Inspired by Napoleonic activity in Rome and Egypt, and powered by the Germans, whose Romantic hellenism proves particularly passionate so passionate that its desire for Greece fosters the sciences of philology and state-sponsored archaeology—excavation assumes a louder nationalist agenda, leaving the classical art of England's country houses seeming lackluster. "Spectacle" increasingly belongs to public exhibitions, and world fairs, and the "classical" as much to sculpture in the urban landscape (in parks, in cemeteries, and on the facades of commercial buildings) as in private galleries.

Not that wealthy individuals stop buying classical sculpture, any more than they can afford to ditch the Roman for what is emerging from Greece's soil. English painters Charles Ricketts (1863–1937) and Charles Shannon (1866–1931) are a prime example, indulging their love of Greek style by buying a restored bust of Antinous, found at Hadrian's Villa in the eighteenth century, and consequently bought by the Earl of Shelburne in London, and an early Roman version of a torso of Praxiteles's Apollo Sauroktonos (Lizard-Slayer) (9.9) as well as Greek terracottas and pots—and this despite the symbolism of their own artistic production and the rejection of naturalism that this entails.[193] When the Museum of Classical and General Archaeology opens in Cambridge in 1884 as a "laboratory" for students and an aesthete's paradise, its "touch of Greece"[194] still comes from casts of the Laocoon, Apollo Belvedere, Farnese Hercules, and so on (many of these given to the university in 1850 upon the sale of the contents of Sherwood Lodge) as well as from casts of the Parthenon sculptures and of other more recent finds.[195] The museum's utility and beauty lie, in part, in

centuries of response—in turning a history of art appreciation into the foundations of an academic discipline with its own professorships.[196] As visual data increase, so too do the antiquities that can be identified and dated. Classification changes classical art: will it puncture its charisma?

8

Seeing Anew in the Nineteenth Century

In 1898, London-based publisher J. M. Dent and Co. issued British writer Albinia Wherry's *Greek Sculpture, with Story and Song.* Today, this book is largely forgotten, but at the time, its reception was positive: "This is a very pleasant, readable book, not too technical for the ordinary reader, but not wanting in solidity."[1] It was an explicitly didactic work that set out "to awaken in boys and girls an interest in Greek Sculpture, and to provide for older people possessing some superficial knowledge, and desiring to widen it, a convenient companion when examining Galleries of Casts."[2] Although Wherry included "110 illustrations," she "wisely limited her list of statues and works of art described to those that are to be found in the British Museum, or of which casts are accessible to the English reader."[3] In other words, the "illustrations" are, as the word suggests, subservient to a text that hopes to give its users the tools to see the originals for themselves. What kind of vision is this? Wherry was, by her own admission, no archaeologist, but was wedded to a chronology and a Winckelmannian vision of "Rise and Decline."[4] Her key chapters, on the fifth and fourth centuries BCE, are entitled "The Golden Age" and "The Apotheosis of Beauty," and open with verses from Shelley.[5]

Surprisingly, the line drawings that frame Wherry's preface are not of fifth- or fourth-century artifacts, nor even of artifacts

fifth- or fourth-century in style, but of earlier, "archaic" artifacts, the first a relief from Chrysapha in Laconia in southern Greece (8.1), found in 1877 and dated to circa 550 BCE, and the second a bronze head of a statuette of Zeus from Olympia, again from the sixth century.[6] Competing with the line drawings are three photographs, the first of them (a cast of a head of the Athena Lemnia in Bologna) serving as the frontispiece of the book. Like the pieces in the other photographs, there is a sense in which this head is also a nineteenth-century discovery, only identified as that of Pheidias's Lemnia a few years earlier, and controversially at that.[7] The final photo, the Venus de Milo (8.2), is there despite disagreement over its maker, date, and subject matter: it was still among the most famous antiquities in Europe, so famous as to have been numbered one in the catalog of the Greek court at Sydenham's Crystal Palace.[8] Between them, a detail of the Hermes, unearthed in excavations at Olympia in 1877 and feted as a fourth-century original by Praxiteles (1.12), clarifies the essence of Praxitelean style, and makes the Venus appear resolutely hellenistic.[9]

As Wherry herself acknowledges, it was not simply that tastes were changing and the canon shifting at this period. It was that anyone interested in classical art was looking at a radically expanded terrain. In

Rome, the first half of the nineteenth century witnessed the discovery of the Odyssey Landscapes (a first-century BCE fresco cycle showing scenes from Odysseus's legendary travels), and in Pompeii, the Houses of the Faun and the Tragic Poet. By the 1870s, once Rome had been wrested from papal control to become capital of a unified Italy, building activity brought unprecedented antiquities to the surface, including the statue of the Esquiline Venus (8.25) and the Augustan paintings found in the grounds of the Villa Farnesina.[10] Rome-based "agents" such as Wolfgang Helbig (1839–1915) capitalized on this *embarras de richesse*, supplying a new breed of collector, men such as Danish brewer and philanthropist Carl Jacobsen (1842–1914), with choice pieces.[11] Even the Villa Albani and its contents were sold to a banking family, its Antinous relief still a "strangely beautiful and impressive thing" (7.19).[12] Or at least this was how it seemed to American novelist Henry James, who otherwise found Roman villas, "in spite of statues, ideas and atmosphere," "to offer the writer 'a scanter human and social *portée*, a shorter, thinner reverberation, than an old English country-house, round which experience seems piled so thick.'"[13] European and American patrons flocked to the Rome-based studios of Canova and Thorvaldsen's neoclassical successors, sculptors like John Gibson (1790–1866), William Wetmore Story (1819–95), Harriet Hosmer (1830–1908), and Edmonia Lewis (1844–1907).[14] Conversing with them was promoted, through guidebooks and fiction, as a key element of foreign travel.[15]

The Rome that they encountered was not just a different city, but a different crucible for a different kind of "classical" from anything understood in the eighteenth century. Unlike the dealers of our last chapter

8.1. Relief from Chrysapha, c. 550 BCE, Pergamum Museum, Berlin, inv. no. 731 as represented in Wherry 1898. Photograph: © Museum of Classical Archaeology, University of Cambridge.

8.2. The Venus de Milo, from the island of Melos, Greece, c. 100 BCE, marble, h 202 cm. Louvre, Paris, Gift of the Marquis de Rivière to Louis XVIII, 1821, N° d'entrée LL 299 (usual number Ma 399). Photograph: © Hirmer Fotoarchiv, 561.1039.

(men like Thomas Jenkins who were painters and antiquaries), Helbig was agent and archaeologist, a scholar at the Instituto di Corrispondenza, the first international association of classical archaeologists and precursor of the German Archaeological Institute, and then its "second secretary" or deputy director.[16] He published foundational works on Pompeian painting, on Homer and Bronze Age Mycenae, as well as on Rome's public collections of classical antiquities, a work last revised in 1963–72.[17] Gibson, meanwhile, was inspired less by those antiquities than by casts of the sculptures of the Parthenon in Rome's Accademia di San Luca.[18] Finally, Rome's residents had "a true idea of the works of that most renowned prince of the Greek sculptors [Pheidias]," by which to assure themselves "also of the merit of the works of the Greek chisel, of which we have in Rome several undoubted masterpieces, although in another style."[19] If there were to be another Renaissance, its grass roots would be in Greek territory. In 1905, the world's first International Congress of Classical Archaeology was held in Athens, its inaugural session in the Parthenon.[20]

Athens was now the driver, itself the capital of a newly independent Greek state that outstripped Italy in its supply of influential antiquities. Wherry writes, "Within the last ten years many famous sites have been systematically investigated—Mycenae, Tiryns, Eleusis, Epidauros, Argos, Olympia, Delphi, and the Acropolis at Athens,—and as the results of these excavations are given to the world, the knowledge of archaeology increases daily."[21] As well as the finds from these sites, newly popular categories of sculpture such as Tanagra figurines, the molded terracottas made in the third century BCE and looted from

graves in Boeotia (8.3), bolstered classical art markets.[22] Wherry continues,

All these things are revelations, and the Englishman of last century who completed his education by making the grand tour, which always included Rome and sometimes Athens, would be aghast could he return and see what changes have been wrought in received opinions. Another great revolution in the standard idea of taste accepted by our parents has been brought about by the discovery during the last twenty years of original works, belonging to every period of Greek artistic activity. For even the earliest of these statues, where the artist endeavours ineffectually to express ideas too complicated for his unpractised hand, still bear the unmistakable stamp of genius . . . which is absent from the Roman copies. It is a terrible heresy in the eyes of those brought up to regard the Apollo Belvedere, the Medicean Aphrodite, and the Laocoon as the most perfect expression of Greek art, to learn that the first two are Romanized, and therefore debased copies of famous originals, and are not to be compared with the Hermes of Praxiteles . . . while the Laocoon is characterized by an exaggerated realism that would never have been tolerated at the best period of Greek art.

Where would the narrative go next? The Laocoon had long been beyond compare. Perhaps "the time is coming when all things not strictly utilitarian will be voted rubbish, when, in a world governed by steam power and moved by machinery, even the shadows of the old gods will be consigned

8.3. Draped woman with traces of polychromy, third century BCE, terracotta, h 19.6 cm. Boeotian, The Metropolitan Museum of Art, New York, inv. no. 07.286.2. Photograph: The Metropolitan Museum of Art, Rogers Fund, 1907, www.metmuseum.org.

to that limbo where they themselves have long since been banished."[23]

The Hermes of Praxiteles and the Parthenon frieze might have posed the biggest challenge to the Vatican's holdings—the latter, together with the relief sculpture from Bassae and Halicarnassus, threatening to leave statuary standing. But as Wherry's illustrations underscore, the nineteenth century also put archaic sculpture on the map, replacing the Roman archaizing reliefs admired by eighteenth-century trendsetters such as Alessandro Albani (8.4) and imitated by Thorvaldsen in his statue *Hope* of 1817,[24] with the less

fluid lines and uncompromising frontality of the genuine article. Figures from the pediments of the Temple of Aphaia, found on the Greek island of Aegina in 1811 (8.5), broke new ground here, and were predictably judged aesthetically inferior to their equivalents from the Parthenon.[25] But by 1865, the "Apollo" of Tenea (8.6), "Apollo" of the Naxians, and the Moscophoros (Calf Bearer) from the Athenian Acropolis (all of them made in the first half of the sixth century BCE) had joined them, and, by the time that Wherry was writing, had been further contextualized by the Acropolis korai and the Kritios Boy (figs. 1.19

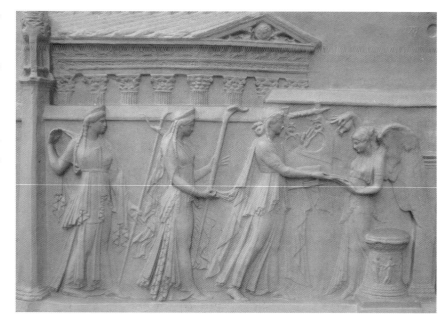

8.4. Archaizing relief showing Artemis, Leto, Apollo, and Nike at an altar, cast of a marble relief, 66 × 100 cm, probably first century BCE, Villa Albani, inv. no. 522. Museum of Classical Archaeology, Cambridge, inv. no. 455. Photograph: © Museum of Classical Archaeology, Cambridge.

8.5. (Below) Athena and section of fallen warrior, west pediment of Temple of Aphaia, Aegina, as restored by Thorvaldsen. Brunn and Bruckmann, 1888–1947, plate 23. Photograph: © Museum of Classical Archaeology, University of Cambridge.

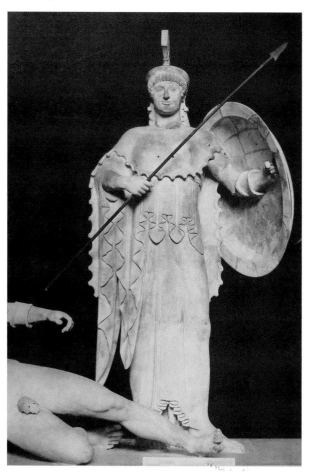

and 1.4).[26] When Boston's Museum of Fine Arts published the catalog of its cast collection in 1891, these early artifacts were still seen as "less attractive than those in the rooms that follow,"[27] but would not have been there at all had they not been partially integrated into the story: in writing his *Histoire de l'art grec avant Périclès* (*History of Greek Art Prior to Pericles*) in 1868, Charles Ernest Beulé was already making this architecture and sculpture—sculpture that Winckelmann himself had acknowledged "prepared the way for the high style of art and guided it to strict accuracy and high expression"—his subject, and its conservatism a virtue: "Greek sculpture advanced slowly because it was not after novelty; it was after progress."[28]

This integration was made easier by modernism, and modernism motored by finds like the statues from Naxos and Tenea that by the end of the nineteenth century were no longer regarded as representations of the god Apollo as they had been earlier in the century, but of a purer,

more abstract form: "Just as the *korai* are the impersonal representations of Woman, so are these impersonal representations of Man."[29] Tanagra figurincs too suitcd modernism's cause, their sassy or "urban" style speaking not of the idealism of neo-classicism but of the realism shaping the British "New Sculpture" movement of the 1870s to 1890s (8.3). "Always elegant, but never affected, always in motion, but never in a hurry, the Tanagra lady is truly the Parisienne of antiquity."[30] She was also, at least in some manifestations, gilded, and the question of whether classical sculpture was painted, though live in the eighteenth century, a decidedly "modern question."[31] The reemergence of the Tanagras and korai made it so.[32] Of the latter, Wherry writes: "Until this discovery, although it was known that the Greeks were in the habit of painting their stone figures, we had no idea of what they really looked like. . . . Unfortunately no casts can be taken of them, for fear of destroying the delicate colour, which is already fading from exposure to the light after two thousand years of darkness."[33]

Wherry wrote her book in Cambridge, and in dialogue with Charles Waldstein (1856–1927), the university's first reader in classical archaeology, a scholar instrumental in the foundation of the Museum of Classical and General Archaeology, with its growing collection of casts, a teaching collection no less.[34] She was a beneficiary of the "scientific work of Archaeology" that was pushing philology into "second place."[35] In the opening essay of the inaugural volume of the academic journal *Revue Archéologique* in 1844, Charles Lenormant, a professor at the Sorbonne, had attempted to define this emerging field by extricating the knowledge demanded of an archaeologist from the job description of the anti-

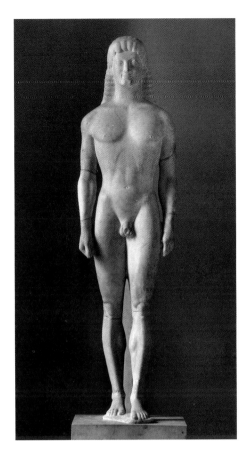

8.6. The so-called "Apollo" from Tenea, 560–550 BCE, marble, h. 168 cm. Glyptothek, Munich, inv. no. 168. Photograph: © Hirmer Fotoarchiv, 561.1003.

quary: "the first condition for becoming an archaeologist is to get to know the monuments; history of art is the basis of all archaeology" (8.7).[36] Wherry's book rolled these lessons out to "the ordinary student,"[37] while also understanding that the factors that facilitated their learning of them—widening access to classical collections, ease of reproduction, cheaper publishing, travel by rail and steamship—made for a fast-moving, forward-thinking world that risked the classical becoming obsolete. In this way, it nicely captures the tensions at the heart of this chapter—snowballing tensions between expertise and mass education, tradition and innovation, subjectivity and empiricism.

Five years before the publication of Lenormant's review, in the same city, members of the Académie des Sciences

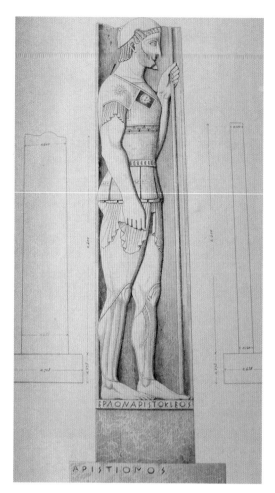

8.7. The inaugural volume of the *Révue Archéologique*, 1844, plate 1, showing the marble grave stele of Aristion, c. 510 BCE, National Archaeological Museum, Athens, inv. no. 29. Photograph: © Museum of Classical Archaeology, University of Cambridge.

and inexpensive reproduction."[39] The act of weighing monument against monument, often monuments from disparate places, and thus "Meisterforschung" (the quest for the reconstruction of the works and style of great Greek sculptors), attribution studies, and "Kopienkritik" (copy criticism) are nourished by this technology, which leads, in time, to dual slide projection and to a revision of the art historian's discourse.[40] Ecphrasis cedes to scientific description cedes to an awareness that comparison is the best way to give works without provenance an ancient visual context. It is not only access and excavation that change classical art in the nineteenth century. Wherry's readers see differently due to the invention of scientific scholarly method.

What follows traces how this happens, and what happens to the category and import of classical art as a result. Not all of this is positive, as we shall explore in our last chapter, on the twentieth and twenty-first centuries. Today, as we hinted at in chapter 1, the privileging of a piece's find-spot over and above anything else is sometimes at odds with art historical approaches that work with objects without such a context and derive contextual data by other visual means. Indeed we could go so far as to say that it is the nineteenth century that is to blame for this unhelpful division, and for making "art" the enemy. On the one hand, art was cheapened by being made mass entertainment: "In contrast to the old world of art, dominated by the connoisseur and the artist, the commercial art world encouraged mass consumption, vigorous publicity and artistic experiences based on spectacle and open to anyone with modest resources, all factors in the phenomenon of the universal exhibition."[41] On the other hand, this contrast is overstated. As we have already

and Académie des Beaux Arts had been shown an invention that changes visual culture forever: detailed photographic images produced by painter Louis Daguerre (1787–1851) on highly polished, silver-plated sheets of copper, many of these images of classical casts (8.8). Photography helps classical archaeology mature, giving it the means to turn to "stylistic analysis and appreciation."[38] Perhaps no single agency does more "to facilitate archaeological work in the field, the publication of new discoveries, the intensive study of monuments already known, and the giving of systematic instruction than the development of photography and the allied methods of accurate

8.8. François Gouraud, *Still Life of Plaster Casts*, 1840, photograph, daguerreotype in original frame. Museum of Fine Arts, Boston, inv. no. 1972.234. Photograph: © [2017] Museum of Fine Arts, Boston.

noted, the "science" that saw scholars attribute works to named artists was giving a greater number of examples a status akin to masterpieces—often anachronistically. Connoisseurship too thrived in this climate, inflating value and making sculpture, pots, and gems more expensive and more elitist.

Within a couple of decades, moreover, some of the contemporary artists who were embracing archaic and Etruscan styles were using the frontality and faceted planes that the former promoted to cut through the figurative tradition that neoclassicism had fostered. Even Auguste Rodin's (1840–1917) disavowal of conventional academic postures was not enough—or too much—the surface modeling of his pieces and their twisted, melting torsos, a trumpeting of psychology over form (8.9). "I hated the work of Rodin who was then *à la mode*," wrote Ukranian-born sculptor Alexander Archipenko (1887–1964). "His sculpture reminded me of chewed bread spat on a pedestal, or of the wretched cadavers of Pompeii. My true school was the Louvre,

which I attended for several years every day. There I studied mainly archaic art and the great dead styles."[42] For form to reestablish itself, abstraction would often win out.[43] It is debatable whether figurative classicism ever recovered its cachet.

The reverberations of the word "dead" should not be ignored. For all of the light and life that Wherry sees in the nineteenth century, its investment in the classical was often heavy-handed, and capable of being as stultifying as electrifying. British novelist Samuel Butler's painting *Mr Heatherley's Holiday: An Incident in Studio Life* of 1874 exemplifies this nicely (8.10): a cast of the reclining river god from the Parthenon's west pediment poses next to familiar characters (the Farnese Hercules and Townley Discobolus), but the effect is neither that of an art school, with students drawing from the antique, nor of a "picture of collections" with all of the "curiosité" that that genre entails (6.22).[44] All attention is on the adjustments being made to the knee of a skeleton, which is

8.9. Auguste Rodin, *The Kiss*, 1901–4, marble, h 182.2 cm. The Tate, London, inv. no. NO6228 (previously owned by E. P. Warren). Photograph: © Tate, London [2016].

hung as though hanged, and stares out, as does the bust of the athlete next to it, to confront viewers with their own academic pretensions. This is the clutter out of which Victorian classicism was created, and it reminds us that the Roman icons of the Renaissance and Enlightenment do not go away. Are their bodies moribund? No more so, it would seem, than that of the Greek god next to them (Butler was photographed with a miniature Farnese Hercules in his rooms at Clifford's Inn, London).[45] The painting is less a memento mori than an admission of futility that makes the ennui of Batoni's aristocrats inconsequential in comparison: "it was South Kensington and Heatherley's that set me wrong," complained Butler. "I listened to the nonsense about how I ought to study before beginning to paint, and about never painting without nature, and the result was

that I learned to study but not to paint."[46] Too much academicism could be stifling.

From Art to Archaeology

Butler's (1835–1902) distrust of academicism is well known,[47] and the century in which he lived defined by increasing institutional organization of education, art display, and art practice. But when the eighteenth century first ceded to the nineteenth, Britain still had no national gallery of art, and nothing to rival the public holdings of the Louvre (although the British Museum would soon have the Egyptian sculpture, the Rosetta Stone included, confiscated from the French on the Capitulation of Alexandria, the Townley collection, and the Parthenon sculptures). "I could but ill judge what has been done in Art," confessed

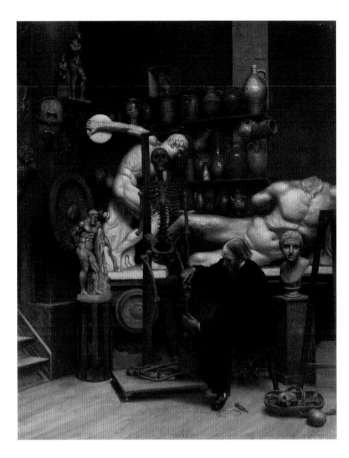

8.10. Samuel Butler, *Mr Heatherley's Holiday: An Incident in Studio Life*, 1874, oil on canvas, 92.1 × 70.8 cm. The Tate, London, inv. no. N02761. Photograph: © Tate, London [2016].

Lancashire-born landscape painter Joseph Farington (1747–1821) before his visit to Paris in 1802.[48] From 1793, the Louvre had been a state-controlled museum, distinct from the Vatican, Uffizi, and National Museum in Stockholm in being beyond princely control; distinct too from the Munich Glyptothek and the other public museums that would later be founded by princes in Germany. Indeed, it opened on the anniversary of the deposition of Louis XVI, and soon showcased the finest artworks, many of these taken by Napoleon's men as they ranged across Europe (4.1 and 4.2).

There was a need to salvage Greece and Rome from the neoclassicism of the ancien régime, and a new sense of time and history born of the rupture that followed years of political and social upheaval.[49] But there

was nothing revolutionary about the Louvre's display of ancient sculpture. Unsurprisingly, given that its administrator and professor of archaeology was Visconti, the arrangement was similar to that in the Vatican's Pio-Clementino with an emphasis on superstars and subject groupings (8.11)— and this despite the fame of Winckelmann's *Geschichte,* which had been translated into French in 1766, and the opening of the Musée des Monuments français in 1795, where French sculpture from the Middle Ages to the modern day was arranged more or less chronologically.[50] For all that sculptures like the Apollo Belvedere were now acknowledged to be Roman, difficulties of dating them precisely made chronology difficult, especially for the Louvre, which had inherited the highlights of the traditional

8.11. Étienne Neurdein, *Sculptures in the Louvre*, with Marcellus (fig. 6.13) in the foreground, 1880–1910, paper, 27.9 × 20.6 cm. Rijksmuseum, Amsterdam, inv. no. RP-F-F16590. Photograph: Rijksmuseum, Amsterdam.

canon. Once these statues were returned to Italy in 1815, the Nike of Samothrace and Venus de Milo would take their place, neither of them fifth- or fourth-century in style or workmanship. The latter stood in front of red drapes, a stand-in for her Medici sister; from 1884, some twenty years after the bulk of the figure's fragments came to Paris, the Nike was installed for maximum dramatic effect on the landing of the Daru staircase.[51]

Museums and galleries inevitably worked with, and around, what they had. Even now, there are relatively few sixth-century BCE Greek statues in Paris—fewer in London, or Cambridge. As Percy Gardner, the first Lincoln and Merton Professor of Classical Archaeology at Oxford (from 1887), noted in his preface to the English edition of Adolf Michaelis's *Die archäologischen Entdeckungen des neunzehnten Jahrhunderts* (*A Century of Archaeological Discoveries*), from the

Olympia excavations on, "Nothing since discovered in Greece, in the great excavations of the Athenian Acropolis, of Delphi, Delos and other sites, has left the country. Turkey and Crete are copying the laws of Greece in such matters. All that the western nations are now allowed to gain by work in the East is knowledge. We have reached the scientific stage of discovery. . . . We must learn to work for science, not for reward."[52]

The dealing activities of figures such as Helbig ensured that that last line, between academic altruism and lining one's pockets, would remain blurred, often so dangerously as to threaten, rather than advance, the field.[53] Issues of preservation and destruction raised by the French Revolution—intense anxieties about Napoleon's transfer of artworks—caused all countries to rethink their relationship to the past, their own and that of other countries. The Capitoline Museum even opened a special gallery for the sculptures returned in 1815, anticipating the Palazzo del Quirinale's "Nostoi: Recovered Masterpieces" show of 2007–8 (a celebration of the repatriation of nearly seventy looted artifacts from US collections),[54] and the emotional attachment to heritage that the Homeric word "nostos," or "homecoming," brings with it.[55] Heritage was part of the same national pride that underpinned the nineteenth century's international exhibitions.[56] As countries became keener to hold onto their heritage, demand outstripped supply, making the illicit trade in antiquities, and their forgery, more lucrative.[57]

"The Musée Napoléon was the last magnificent example of a museum exhibiting a Roman character. It marked the end of the old system of conducting museums. . . . Simultaneously with the Roman Musée Napoléon the British Museum in

London was developing as the most illustrious centre of Greek art."[58] This was not due just to the presence of the Parthenon sculptures, "pre-eminently national monuments and historical documents" (8.12),[59] and those from Bassae and the Mausoleum of Halicarnassus. The Nereid Monument and Harpy Tomb (both removed from Xanthus in Anatolia by the archaeologist Charles Fellows in the 1840s), not to mention the Assyrian sculptures brought back by Austen Henry Layard a decade later—sculptures that "throw a new and unlooked-for light on the question which has occupied archaeology for more than a century—the origin of Greek art"[60]—upped the museum's ante as abode of the Muses.

Even in the British Museum curators struggled with chronology, rearranging the Townley sculpture by subject as late as 1850.[61] If this sculpture had found a place in this chronology, it would have been one of decadence. But it was not just notions of decline that discouraged a more historical hang. The beauty on which the "classical" was predicated was shaken every time another example of genuine Greek

sculpture begged integration. So architect Karl Friedrich Schinkel's Royal Museum, now the Altes Museum, inaugurated in Berlin in 1830, opened with a display that privileged aesthetics over history.[62] When the historian of art and culture Jacob Burckhardt saw sections of the Pergamum altar (2.10) in the same city in 1882, they "shattered the systems of the archaeologists and tumbled an entire pseudo-aesthetics [die halbe Ästhetik] to the ground. . . . Since we have come into possession of these terrifyingly glorious spectacles [événements] everything that has been written about the emotional power [Pathos] of the Laocoon is for the wastebasket."[63]

Luckily for Lessing, the Laocoon proved more resilient than Burckhardt imagined:[64] its advocacy for the relationship of art and text louder than its raw emotion. "Beauty" has been less fortunate, and in the twentieth century lost out to science, only now to be reemerging as a productive art historical and museological category.[65] We need think only of Rome's Palazzo Altemps, which opened to the public in 1997, where sculptures from the Ludovisi collection

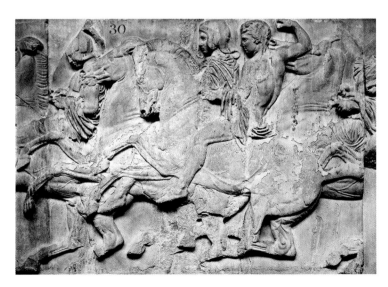

8.12. Detail of the Parthenon frieze, photographic print by Bernieri, Caldesi & Co., London, 1857–59, h 26.5 × 37.7 cm. Rijksmuseum, Amsterdam, inv. no. RP-F-00–59. Gift of the heirs of C.J.J.G. Vosmaer, Leiden, 1989. Photograph: Rijksmuseum, Amsterdam.

are positioned in airy galleries as though art installations. But as the nineteenth century galloped to a close, science was winning. In 1889, with his home already open to the public and plans for a new museum, the Ny Carlsberg Glyptotek, on the table, Jacobsen wrote to Helbig, "In the beginning I placed my sculptures after their artistic value because there were too few to create a chronology. But now I have begun to plan a chronological setting. The lantern hall is entirely occupied by Greek works. This also constitutes a new era for a new principle. Previously the hallmark of the collection was artistic—to achieve the most beautiful—now it is also about bringing the historical side to the fore."[66]

His inspiration was most probably the Munich Glyptothek, which, when it opened in 1830, was "the first major European museum in which ancient sculpture was organized chronologically," clockwise, from Egypt to Greece to ancient Rome, through the Renaissance to neoclassicism, with sculptures by Canova, and by Thorvaldsen, who had restored the Aegina pediments.[67] Unlike museums in Italy, where there was "hardly any attempt at classification beyond the separation of Roman and other portraits from the general mass, or an occasional selection made on some partial unessential principle, such as that of Coloured marbles in the Museo Borbonico, or Animals in the Vatican," Munich embodied "the true method of arrangement."[68] Although even here, "a compromise is found necessary in the case of those numerous works which, being evidently Roman copies of great Greek originals, cannot be assigned with certainty to any particular date or school, but must be grouped round some one central object of kindred subject and of more decided style."[69] And there was more than

one agenda at work. The Glyptothek was a royal collection of objects, the core of them acquired by Crown Prince Ludwig on his grand tour of Italy in 1804–5, and from the sale of those pieces of the Albani collection not to make it back from Paris; it was a key element in the prince's ambitions to transform Munich into a city to rival the French capital.[70] It had to look the part. Hungarian émigré Ferenc Pulszky (1814–97) put it nicely in an art lecture he gave at University Hall, London, in 1852: "the predilection for architectural effect and for the display of royal grandeur, forbade gaps in the monumental history of art being filled up with plaster casts, though these would have transformed the Museum into a school of arts and into an authentic archive of history. They are noble proofs of princely display, but they lack that civilizing influence on the people, which, if duly arranged, they might easily impart."[71]

"Due arrangement" was slow in coming. In the Louvre, the museum of sculpture inaugurated by Napoleon was not dismantled and chronological classification established until 1934.[72] Part of this was obviously practical: galleries of painting were easier to rearrange, a factor that might account for painting's increasing prominence over sculpture in art historical debates. Yet such difficulties were not insurmountable, nor beauty and history necessarily in opposition to one another, any more than they had been for Winckelmann. As Pulszky notes:

> The education of the people is a question of the most vital consequence to our age. . . . But, when we speak of education, we too commonly understand the term as implying merely the training of the understanding and the

development of the moral feelings; and we bestow too little attention on the improvement of taste, and on the guidance and direction of the imagination. The sentiment of the Beautiful, therefore, remains undeveloped in the mind of the public.[73]

This lack of attention extended to gallery display:

> Even museums are far from answering the purposes for which they were erected. They are thrown open, it is true, to the people; but their arrangement is defective: so far from assisting the student, they augment the difficulties he feels in understanding their contents. . . . These inestimable heirlooms of antiquity, so immeasurably superior to all modern productions of art, do not give us that satisfaction we might expect; for the mind is oppressed by the confusion which reigns, and wearied in finding neither connexion nor meaning in their arrangement.[74]

Pulszky ends his lecture with a call for an evolutionary and expansive vision that takes account of the "feeling of the beautiful" "in all ages and countries" and the "noble offspring of human genius, whether in Japan or Athens, whether on the Nile or the Arno, on the Euphrates or the Tiber."[75] It is a call that is of the moment, resonating with the breadth of cultures on display in the Great Exhibition the previous year, and with the "totalizing aims" of the plaster casts and scaled-down architectural reproductions exhibited from 1854 in the Egyptian, Greek, Roman, Alhambra, Nineveh, Byzantine, Mediaeval, Renaissance, and Italian courts at the Crystal Palace.[76] This eclecticism is

not matched in universities until the second half of the twentieth century when global art history, or, more multidisciplinary, "world art studies" will aim to see art as a world-wide phenomenon. Although the British Museum acquires an important body of Gandharan sculpture in 1879, it makes little of this, the cultural production of the Indian subcontinent, or of other non-classical peoples until well into the 1930s; indeed one could argue that its Greek and Roman collection is still overly dominant.[77]

As the Crystal Palace attests, casts make Pulszky's vision a concrete possibility. Casts come into their own in this period by being the driver of empirical analysis, neither serving only as tools of artistic craft nor speaking primarily of their originals in the Vatican or Villa Albani and thus of the value of the classical in the modern world, but of antiquity, and of Greek and Roman art's intrinsic development. According to some, they were "preferable to the originals because they cast a purer and more direct shadow, whereas in a fragment of ancient sculpture you can hardly distinguish the dirt, as it were, from the shadow."[78] To others, the utility of beauty question could be redirected: in a report for the Trustees of the British Museum compiled after visiting Italian museums and the Munich Glyptothek in 1848, Charles Newton (1816–94), who would go on to be the museum's first keeper of Greek and Roman antiquities, writes: "The great task of Archaeology—comparison—though much promoted by the facilities of modern travelling, is still greatly hindered by the inability of the memory. . . . Nothing would so much supply this deficiency in the natural powers of the mind as a well-selected Museum of casts of sculpture, not disposed, as is too often the case merely to please the eye, but so as to

develop, by a series of transition specimens, the chief features of successive styles."[79]

The importation of casts from houses and palaces to academies and universities was already underway in the eighteenth century. But maintaining a distinction between the museum and the art school meant that the Royal Museum in Berlin initially excluded them.[80] The antiquities department of the British Museum, meanwhile, although admitting casts of the Aegina pediments (8.13), the metopes from Selinus in Sicily (both of these the fruits of recent excavation), and of the missing sections of the Parthenon frieze, which would remain on display until the late 1920s, had a policy in 1840 not to include casts of sculptures in European galleries.[81] Nationalism trumped the sophistication to be siphoned from a shared heritage, and, as one irate correspondent (author of a book on the merits of the

German education system) would put it in a letter to the The Spectator in 1877, the claim "to possess the finest collection of original Greek marbles in the world" trumped Bloomsbury's ambition to be the "best place for the study of Greek art."[82] By then, that accolade might be said to be Sydenham's—a precedent that the British Museum likely viewed as suspiciously as the Royal Museum had Berlin's art schools.[83] What would it mean for its Parthenon frieze to take second place to a plaster replica of a statue in France or Italy? In the 1880s, the popularity of painters such as Edward Poynter (1836–1919) and Lawrence Alma-Tadema (1836–1912) made more visitors wish to draw from the antique (8.14), with the result that casts of the Venus de Milo, Venus de Medici, and Praxiteles's Hermes were introduced, but for reasons of art, not art history.[84]

8.13. The Phigaleian Room of the British Museum, with casts of the Aegina pediments, looking west into the Elgin Room, c. 1875, by F. York, The British Museum, London, Department of Greek and Roman Antiquities. Photograph: courtesy of Ian Jenkins.

PERILS OF ÆSTHETIC CULTURE.

Uncle John (suddenly bursting on newly-wedded pair). "HULLO, MY TURTLE-DOVES! WHAT'S THE ROW? NOT QUARRELLED YET, I TRUST?"

Edwin. "OH DEAR NO. WE'VE BEEN GOING IN FOR HIGH ART, THAT'S ALL."

Angelina. "AND DRAWING FROM CASTS OF THE ANTIQUE."

Edwin. "AND ANGY'S NOSE TURNS UP SO AT THE END, AND SHE'S GOT SUCH A SKIMPY WAIST, AND SUCH A BIG HEAD, AND SUCH TINY LITTLE HANDS AND FEET! HANG IT ALL, I THOUGHT HER PERFECTION!"

Angelina. "YES, UNCLE JOHN; AND EDWIN'S GOT A LONG UPPER LIP, AND A RUNAWAY CHIN, AND HE C-C-CAN'T GROW A BEARD AND MOUSTACHE! OH DEAR! OH DEAR!" [*With difficulty restrains her sobs.*

8.14. George du Maurier, "Perils of Aesthetic Culture," *Punch* 10 May 1879, p. 210. Photograph: courtesy of Paul Millett.

The British Museum would have to wait until the end of the nineteenth century before it had a representative cast collection like those in Germany, or elsewhere in England.[85] Casts were controversial, delicately balanced between art, science, and redundancy.[86] When those from Sherwood Lodge were first offered to the University of Cambridge in 1850, they were certainly seen as useful "to the course of Art" and for making the university greater than its rival, Oxford.[87] Like the Eleusis caryatid, and the other originals that were given to Cambridge by mineralogist Edward Daniel Clarke at the start of the century and initially installed in the vestibule of the University Library, they prevented the university from "blush[ing] for her poverty in documents so materially affecting the utility and dignity of her establishment."[88] They were also "a means of acquiring a knowledge of some of the noblest works of human imagination and skill" and displayed, with the gifts of Clarke and other benefactors, in the sculpture galleries of the recently completed Fitzwilliam Museum.[89] From the 1870s on, in tandem with the teaching of Greek art in the university, the cast collection grew rapidly (for example, it quickly acquired casts of the sculpture found in the Olympia excavations), until in 1884, it was relocated to a separate building and reordered in a "rigorously historical sequence"[90] (albeit one in which Roman copies stood, as they still do today, for their Greek prototypes) (8.15).[91] Only then, in response to the space that the relocation generated, did the Fitzwilliam's display also move toward a revised classification by style and origin.[92]

8.15. Casts in the Museum of Classical Archaeology or "Ark" in Little St. Mary's Lane, Cambridge. Photograph: © Museum of Classical Archaeology, University of Cambridge (MCA 2290_201506_kly25_mas).

Casts remained both artworks and "specimens." But it is that second ontology that interests me here—extracted from the mélange of originals and copies that had defined the "classical antique" since at least the 1500s to create panoramic vistas otherwise impossible even in the Louvre and Vatican. In this way, they not only were able to plot a history of art that gave a "quick and accurate appreciation"[93] inaccessible to Winckelmann, but enabled "attempts to reproduce the effect of color employed by the Greeks in their marble sculpture" in experiments of paint on plaster (1.19), putting the ideals underpinning the "classical" under the microscope. In the process, the measure of excellence that was the Medici Venus or Apollo Belvedere was tested by a finer gauge, and qualitative discourse by scientific analysis.

It is no surprise that by 1842 plaster had already infiltrated Berlin's Altes Museum as it would become, nor that when the collection of casts, organized chronologically and amplified by an appropriate fresco cycle, was opened in the Neues Museum in 1856, it was Carl Friederichs, the man who identifies the Tyrannicides and Doryphorus, who cataloged them.[94] This catalog, which is conceived less as a hand list than as a study of ancient sculpture and which is revised in 1885 (collapsing, as the first guidebooks to the Fitzwilliam collapse, the distinction between cast and original, and encouraging Waldstein to produce his 1889 *Catalogue of Casts* in the ensuing Museum of Classical Archaeology), celebrates these identifications, and their acceptance by the academy.[95] The 1850s and 1860s saw a number of these identifications, the Apoxyomenos by Lysippos (3.6) and Marsyas by Myron included (2.15), in a blooming of Meisterforschung, an area of expertise rooted in the second half of the eighteenth century when Myron's Discobolus and Praxiteles's

Knidia had been recognized.[96] Although numismatic skills and pottery studies had a crucial role to play here (the work on the Marsyas type by Heinrich Brunn, who would go on to be the first holder of Munich's Chair in Classical Archaeology, was, for example, as dependent on Karl Otfried Müller's research on the iconography of Greek pots as Friederich's work on the Tyrannicides was on Otto Magnus von Stackelberg's work on the minor arts),[97] the desire to see casts in historical sequence stimulated this methodology, and this methodology historical sequencing.

In Berlin, mythology would soon reassert itself over history as the casts were redisplayed thematically.[98] But elsewhere, chronology continued to gain ground, as casts enabled museums like the Boston Museum of Fine Arts and the Metropolitan to put works by the same sculptor, or different versions of the same statue type, side by side so as to reap the fruits of new methodologies: so at Boston, Myron's Discobolus and Marsyas were grouped together, as were two versions of Polyclitus's Diadumenus (8.23), both in the British Museum, a cast of the Naples Doryphorus, and of an Argive relief in the National Museum in Athens, showing the Doryphorus as horse-leader, and, in the corridor, statues after Praxiteles.[99] Although the accompanying catalog cannot resist the national pride that comes of quoting novelist Nathaniel Hawthorne's description of his eponymous Marble Faun, based on the Praxitelean Resting Satyr in the Capitoline Museum, it also encourages periodization (8.16) and the comparisons that constitute Kopienkritik.[100] Not only does it cross-reference Brunn and Friederichs-Wolters; it takes the scholarship we were discussing in chapter 1 out to its visitors, drawing their attention

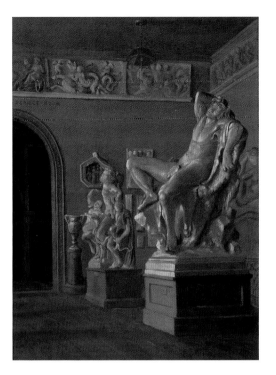

8.16. Enrico Meneghelli, *The Hall of the Maidens in the Museum of Fine Arts, Copley Square, with Casts from the Athenaeum Collection*, 1899, oil on canvas, 35.9 × 23.5 cm. The Athenaeum, Boston, inv. no. UR292. Photograph: Boston Athenaeum.

to the "fact" that "in treatment" the Kritios Boy "is very much like the Harmodius, next which it stands. As in that figure, the modelling of the body shows a considerable advance over that of the head, but both are handled with much delicacy, and form an interesting example of the resemblance, in spirit and feeling, between the Greek artists of the semi-archaic period and the Italians of the *cinque cento*."[101] In 1891 and 1892, the museum exhibited casts of the heads of the Hermes by Praxiteles and Medici Venus colored by Pittsburgh-born painter Charles E. Mills, and then full-size casts of the Hermes and the Louvre's Venus Genetrix, colored by Joseph Lindon Smith, best known for his paintings of Egyptian tomb reliefs. The catalog notes: "The steadfastness of Mr. Smith's desire to carry his archaeological data to their logical conclusion, irrespective of modern ideas of color, has, combined with his taste, produced a result in the highest degree educational."[102]

8.17. James Tassie, cast of the Portland Vase, c. 1782, plaster, h 26.67 cm. The Athenaeum, Boston. Gift of Francis Calley Gray, 1831. Photograph: Boston Athenaeum.

In this way, a collection of casts, which had its roots in the Boston Athenaeum, a member-supported private library founded in 1807 (including obvious examples like the Apollo Belvedere and more unusual bequests such as James Tassie's "unprepossessing" cast of the Portland Vase given by Francis Calley Gray in 1831 [8.17]), becomes educational of art's "development and decline" and of the skills needed to measure these.[103] Although too dull to have been shown in any of the Athenaeum's annual exhibitions, in the context of the Boston Museum of Fine Arts, the cast of the Portland Vase was a didactic gem of "especial value and rarity": "a mould was made . . . whilst it was in the possession of the Barberini family, and from this, on its first arrival in England, a certain number of copies were taken in plaster of Paris by Tassie, who afterwards destroyed the mould."[104] Coverage was crucial. Like Cambridge, Boston was quick to acquire

casts from Olympia, where the agreement between the Germans and the Greeks ensured that molds were made within five years of an object's discovery, and, thus, that the pediments and Hermes statue were just as impactful as (if not more impactful than) they would have been in London, Paris, or on Museumsinsel.[105] The "whole of civilised Europe," and beyond, was "eagerly watching their proceedings in expectation of great results."[106]

The Olympia pediments caused controversy, as the Aegina pediments had done some sixty years earlier (8.18).[107] But their dissemination in casts, newspapers, and new academic journals such as *The American Art Review*, which carried a multipart essay on "Olympia as it was and as it is," turned this controversy into productive debate, at the same time as it transcended the contents of individual collections to create an international databank. *The American Art Review* reproduced a line drawing of the Apollo from the west pediment, confirming its identity as such by arguing that it "corresponds in type of face and arrangement of hair with an archaic head of the same god in the British Museum, and in these particulars as well as in general appearance recalls a bronze statue of Apollo in the Louvre."[108] The academic language we know today developed in this climate, but so too did more sensual modes of critique that ramped up the homosocial self-consciousness of our last chapter's investment in the classical, experimenting with it to explore a less heteronormative sense of self (artistic, political, sexual).[109] In the same year that the *Art Review*'s essay appeared, Waldstein published an article in *Transactions of the Royal Society of Literature*, in which he argued that only Praxiteles, whose temperament was akin to that of "Shelley,

Heine, De Musset, Chopin," could have conceived of the Hermes (1.12).[110] Hermes not only confirmed what was Praxitelean about Praxitelean style. The statue's melancholy spoke to the "modern romantic period" and its aftermath, a world in which art style and lifestyle were interwoven. Until Ezra Pound (1885–1972) used the Hermes to argue against classical idealism and the artistic training provided by state-sanctioned cultural establishments such as the Royal Academy, the statue was an icon of the aesthetic movement—something that Oscar Wilde exploited when he presented Harvard University with a cast for its gymnasium.[111]

As already established in the introduction to this chapter, the availability of Greek and Roman art owed as much to photography as it did to casts and print culture.[112] The first commercially successful photographic process, the daguerreotype, named after its inventor, Daguerre, was linked to archaeology from the outset. From the 1850s onward, stereoscopic daguerreotypes were being taken of the cast courts at the Crystal Palace, and technologies invented for mass-producing stereographs and stereograph cards (8.19). Meanwhile, British photographers Roger Fenton and Robert MacPherson were taking more exclusive images of "the genuine article" in the British Museum and Vatican respectively.[113] MacPherson (1814–72) moved in the same circles in Rome as Jameson, Hosmer, Story, and Gibson, whose sculptures he also photographed, and was soon able to boast the definitive view of statues such as the Apollo Belvedere, which had long lent themselves to engraving (8.20). His large albumen print (the first commercially exploitable method of producing a print on a paper base from a negative) of the Apollo was exhibited in 1855 at a show organized

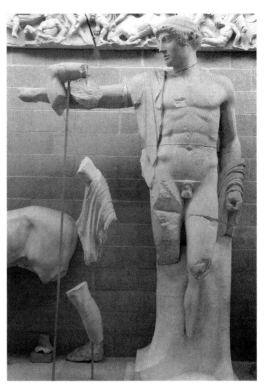

8.18. Apollo, cast of the central figure from the west pediment of the Temple of Zeus at Olympia, c. 460 BCE, h 329 cm. Museum of Classical Archaeology, Cambridge, inv. no. 99a (acquired 1884). Photograph: © Museum of Classical Archaeology, University of Cambridge.

by the Glasgow Photographic Society, and an album of more than 120 statues and 6 interiors of the Vatican produced (with new finds, the Prima Porta Augustus included, added to a second edition).[114]

In 1863, spurred by the expense and size of Visconti's Vatican catalogs, and by an expanding readership, MacPherson also produced a pocket guide to the Vatican statues, "in the order in which they are found in the galleries."[115] Although this used woodcuts rather than photographs, and was sparing in its descriptions,[116] it sold itself as part of this same technological march, its illustrations "carefully traced from the photographs" and the "outlines, photographically reduced to their present size . . . subsequently traced on wood, and carefully re-drawn in outline with the original photograph at hand."[117] A quote from Goethe on the title page epitomizes where it is coming from: "To speak suitably,

8.19. Stereoview of the Greek Court, Crystal Palace: Negretti and Zambra, no. 66, Niobe and Family, with a section of the painted Parthenon Frieze behind. Photograph: courtesy of Kate Nichols.

and with real advantage to one's self and others, of works of art, can properly be done only in their presence. *All* depends on the sight of the object. On this it depends whether the words by which we hope to elucidate the Work produce the clearest impression, or none at all."[118] As well as satisfying tourists and inspiring those who could to buy his photos, the book was "equally useful to art students who cannot visit Rome, and as a protection against a short memory to those who have left it."[119]

At the same time as MacPherson was showing his work in Glasgow, the brothers Alinari in Florence were producing the first catalogs of their photographs of Italy (although none of these initially of Rome), and exhibiting in European expositions.[120] Their stocks (2.13 and 9.1) are still invaluable to art historians today. In 1875, the results of the German excavations at Samothrace were published in the first major archaeological work to include mounted photographs (8.21) and by 1888, Brunn was collaborating with publisher Friedrich Bruckmann on the

monumental photographical archive, the *Denkmäler griechischer und römischer Skulptur*, which aimed to illustrate all major works of classical sculpture.[121] One need only glance at the first sixty of its plates, each of them labeled in German, French, and English, to understand how the corpus had shifted, the Barberini Faun a rare intrusion in a selection that favors archaic and fifth-century Greek subjects (8.22).[122] If casts enabled statues from different countries to be grouped "in the same gallery, and, if possible, in the same room," then these plates went one further, allowing their users to shuffle them as they chose, and thus to enjoy a more direct, personal engagement (even in two dimensions) than that offered in the museum or country house, where, as we saw in the last chapter, viewers played their part in the performance. "Photographs of paintings and sculpture helped to convert connoisseurs into art historians,"[123] not only by affording them the leisure to look closely, but, in the case of unbound images, to act as curator, and create new narratives.

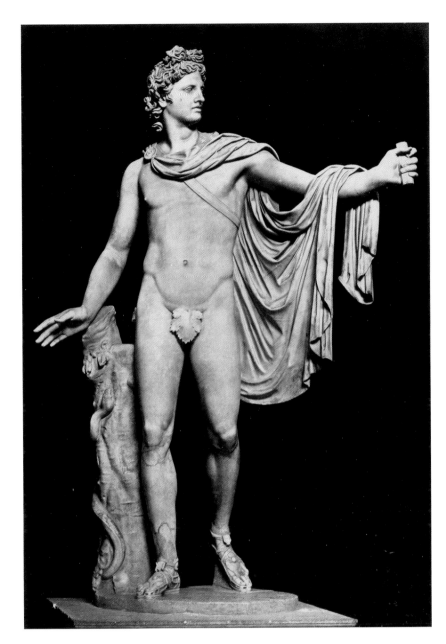

8.20. Robert MacPherson, *Apollo Belvedere, in the Vatican*, 1860–63, albumen silver print, 37 × 24.1 cm. The J. Paul Getty Museum, Los Angeles, inv. no. 84.XP.921.3. Photograph: The J. Paul Getty Museum, Los Angeles.

Photographs also made paintings and sculpture timeless, and, unless combined in the stereoscope to produce an apparently three-dimensional image,[124] sculpture in the round "painterly"—something that by the end of the century would have Swiss art historian Heinrich Wölfflin (1864–1945) query their accuracy and worry about how to produce images that would be most useful for his purposes: "one almost always avoids the normal frontal view and believes one does the figure the greatest favour when one gives it a 'painterly appeal,' that is, takes the viewpoint slightly from the side. Few know that, by doing so, in most cases the best quality [of the sculpture] is lost."[125] Photographs are artworks in their own right, and art something that has many markets. From

8.21. Photograph of "Nike" (Victory) from Conze's Samothrace volume, 1875: plate 48. Photograph: © The Museum of Classical Archaeology, University of Cambridge.

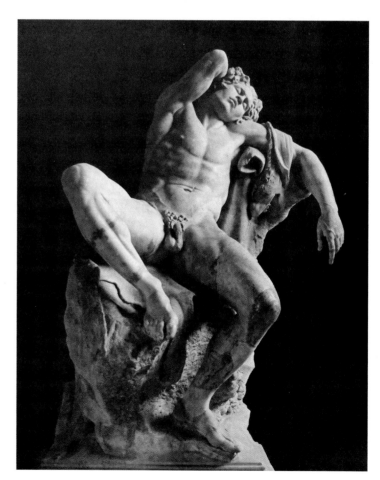

8.22. The Barberini Faun. Brunn and Bruckmann, 1888–1947, plate 4. Photograph: © Museum of Classical Archaeology, University of Cambridge.

1881 to 1884, a precursor to the *Denkmäler*, Olivier Rayet's *Monuments de l'art antique*, which was itself anxious about photographic quality, claimed that unlike earlier publications, which were targeted at archaeologists and filled with objects chosen for their scientific or historical merit, its interest was in beautiful photographs of beautiful objects (2.15 and 3.28): "Our work is, on the contrary, especially targeted at artists curious to know what route their predecessors followed, at men of taste (more of them every day), who appreciate simple beauty—the charm penetrating the Antique. We want to have pass beneath their eyes, without compelling ourselves to a methodological order, without taking chronology into account, without worrying about previous publications, the works of those happy times, where one sought to copy nature with a zeal so honest."[126] Several of the accompanying articles still impress in scholarly terms,[127] but often aim at bringing interested amateurs into dialogue with scholars and museums. Rayet prints the letters exchanged by one such "amateur," Eugène Raspail, and the authorities of the Louvre and the British Museum about a version of Polyclitus's Diadumenus found at Vaison in southeastern France (8.23), only to bemoan the inefficiency of his countrymen in losing the statue to London.[128]

Faced with an expanding pool of amateur enthusiasts, "scholars" relied on photographs to hone their own expertise, and on cheaper photomechanical reproduction processes that allowed them to incorporate photos into their academic publications. The inclusion of such images in works such as Adolf Furtwängler's *Meisterwerke der griechischen Plastik: Kunstgeschichtliche Untersuchungen* or *Masterpieces of Greek Sculpture* helped "show and tell" the new

analytical techniques, turning expertise into a discipline and Furtwängler into a proto-"text book."[129] "As the botanist lives among his fresh or dried plants, the mineralogist among his stones, the geologist among his fossils, so the art-connoisseur ought to live among his photographs, and if his finances permit, among his pictures and statues," claimed Giovanni Morelli (1816–91), whose name is now synonymous with identifying painters' hands through sustained scrutiny of diagnostic minutiae.[130] Without photography, his and the progress of John Beazley (1885–1970) (classical archaeology's main exponent of Morellian method, and a man renowned for drawing details of pots so as to recognize the identifying features of their painters) would have been slower.[131] The 1890s saw the publication of Edmond Pottier's albums of the Louvre's vase collection, with circa fifty photographic plates per volume.[132] These were the precursor of the *Corpus vasorum antiquorum* (*Corpus of Ancient Vases*), also initially edited by Pottier—an international project to document Greek vases.

"Thus with the help of photography, we have learned to see anew," wrote Michaelis.[133] This is not quite the same as saying that photography "set the study of ancient art and architecture on a fresh course,"[134] for it was ancillary to changes already underway in the academy, facilitated by Michaelis himself, and by Brunn, whose *Geschichte der Griechischen Künstler* (*History of the Greek Artists*) (1853–59) had, with Johannes Overbeck's *Die Antiken Schriftquellen zur Geschichte der bildenen Künste bei den Griechen* (*The Ancient Sources on the History of Greek Art*) (1868), been so influential on their pupil Furtwängler. These were the results of philological training: "The *catalogue raisonné* of the works of each

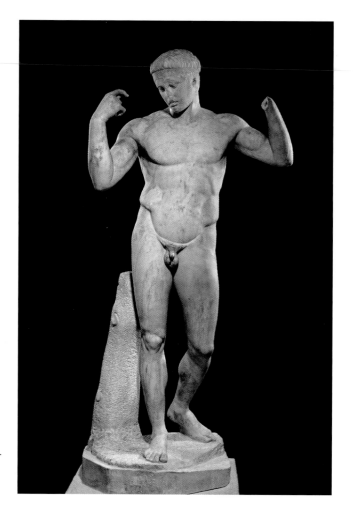

8.23. The Vaison Diadumenus, Roman version of Polyclitus's famous statue from around 440 BCE, marble, h 189 cm. The British Museum, London, inv. no. 1870,0712.1. Photograph: © Trustees of the British Museum.

artist was the masterpiece of the philological history of art."[135] And as the success of Overbeck's publication, with its clear layout of ancient passages on the biography, oeuvre, and technique of each artist, attests, they were to be of long-lasting importance: not only was there a 1959 reprint, but it has been recently revised in a 4,000-page *Neue Overbeck* or "New Overbeck" for the twenty-first century.[136] They supplanted books that had emphasized subject matter and mythology.[137] Meanwhile, Wilhelm Klein, who became professor of archaeology at the German University in Prague, published a monograph on Attic potter and pot painter Euphronios (1879, second edition 1886),

with line drawings of scenes lifted from their vessels.[138] If, as we suggested in chapter 6, there emerged in the travel writing of the long eighteenth century a subjectivity that made visitors to galleries feel like "viewers," then the nineteenth century's obsession with attribution turned viewing into something different again, something that needed to be taught. It is the "learning" in Michaelis's statement that is crucial.

Not that all of this learning put the emphasis on individual artists. August Mau, for example, encouraged by the framework offered in antiquity by Vitruvius, used similar methodology to come up with his four styles of Pompeian painting (1882), and

Wölfflin and Alois Riegl (1858–1905) would, in different ways, make style characteristic of epochs.[139] Building on psychologies of vision popular in the nineteenth century, their work begins to theorize viewing, thinking hard about ways of seeing, and about the options with which artists at any given time were working. "Seeing as such has its own history, and uncovering these 'optical strata' has to be considered the most elementary task of art history," argued Wölfflin in his *Kunstgeschichtliche Grundbegriffe* (*Principles of Art History*), published in 1915, opening up the issue of how the "eye" and the world relate and inspiring, often in strong disagreement with him, many of the great art historians of the twentieth century, Erwin Panofsky, Ernst Gombrich, Michael Baxandall, Ernst Kitzinger, Richard Krautheimer, and John Berger.[140] Classical style (as distinct from the "mannerist," "baroque," or "rococo") becomes more concrete as a result of this "formalism"; and Roman art, potentially at least, less decadent. Of late antique Roman art, Riegl writes: "judged by the limited criterion of modern criticism, it appears to be a decay which historically did not exist; indeed modern art, with all its advantages, would never have been possible if late Roman art with its unclassical tendencies had not prepared the way."[141]

Riegl's desire to "destroy this prejudice" against late Roman art,[142] a prejudice that had existed since at least Vasari, is, as we shall see in the ensuing chapter, slow in its fulfillment, and the art historian arguably still today better on detail than the "bigger picture." That said, before we move into more recent territory, a little bit more about the place of Greek and Roman art beyond the museum and university in the nineteenth century. If popularization

and "art for art's sake" were the antithesis of "art as archaeology," they were also its corollaries. Collectors such as E. P. Warren (1860–1928), who lived with his aesthetic brotherhood in Lewes House in Sussex and penned, under a pseudonym, *A Defence of Uranian Love*, was in close contact with Helbig, Beazley, and Bernard Berenson, the American art historian whose specialism in Renaissance art and art criticism would bring the decline of late antique art so forcefully back again. He was also fundamental in expanding Boston's collection of classical antiquities.[143] Their treatments of art are perhaps best understood against a sliding scale of the sensory. Because of the formidable choice of material available for discussion, and because of my emphasis on British collectors and artists in the previous chapter, I again focus on England.

Archaeology as Art

"In the 1880s and 1890s, the art galleries of London flared with a burst of painting on classical subjects"—and this, contemporaneous with the radical redefinition of the classical that was happening in sculpture.[144] If these classical subjects borrowed bodies from Greek and Roman statuary, they did so not (only) as Rubens had done with the Apollo Belvedere and Arundel Homer, or David with the Tyrannicides (6.8 and 1.10), but with an archaeological gaze, using this archaeology, as well as classical form, to walk an attenuated line between the sensuous and the sensual.[145] Drawing from the antique was now a critical comment on the antique, as well as on beauty, nature, gender. An obvious example of this is Poynter's *Diadumenè* (8.24), first exhibited at the Royal Academy in 1885.[146]

Compared to the bodies in Charles William Mitchell's *Hypatia* and John William Waterhouse's *St. Eululiu*, displayed the same year, the first of them athletic and androgynous, the second, sexless and foreshortened, Poynter's figure is reassuringly classical, old-fashioned even.[147] Not that that made her any less scandalous. Bereft of any ancient (and, in Hypatia's case, also contemporary) literature to give narrative drive to her disarray,[148] and of a Christian message (the amount of church building and religious art produced in Britain in the Victorian period being another factor in the redefinition of the classical), Poynter's nude was shocking—so shocking that to sell it, he had to clothe it. He writes, "After the figure came back from the Manchester Exhibition I painted a drapery over the figure, for which I am now very sorry."[149]

8.24. Original undraped version of Edward Poynter's *Diadumenè, The Magazine of Art* 8 (1885): 349. Photograph reproduced by kind permission of the Syndics of Cambridge University Library.

When the scandal first broke, Poynter was less apologetic.

> Those who have visited the new museum of the Capitol will have noticed a nude statue which goes by the name of the Esquiline Venus (8.25), discovered with many other fine works about 10 years ago in digging the foundations of some houses on the Esquiline hill. The arms are wanting. . . . The attitude is nearly the same as that of the well-known Diadumenos of Polycletus, of which there are two copies in the British Museum; hence I have ventured to coin the name Diadumene for the figure. . . . Now, such an attempt at restoration appears to me to be a perfectly legitimate aim for a painter. . . . I had hoped that by my attempt at realizing the sculptor's motive, combining with it such a surrounding that should not only enrich the picture . . . but give some idea of what the bath-room of a lovely Greek or Roman girl might be."[150]

His was an act of archaeological and historical reconstruction for a museum-going audience, and, in a world in which "the solitude and quiet so central to the enjoyment of the sublime were threatened" by tourism and growing visitor numbers (many of these visitors without a classical education),[151] what constituted a discerning audience was in dire need of definition. Thirty-four million entry tickets to the Crystal Palace were sold in its first twenty years, its aim being to attract people of all classes for an archaeological and entertaining experience; 89,110 visitors were recorded at the 1878 Liverpool exhibition in which Alma-Tadema's *A Sculptor's Model* was displayed, a painting which itself claimed to capture the young

Roman woman on whom the Esquiline Venus had been based, and would "be more appreciated by the critics than by the public at large."[152] These painters were keener than museum displays on themes of ancient everyday life, and as fixated as Brunn and Furtwängler on attribution and artists.[153]

Back in 1877, the year before Alma-Tadema's painting was making waves in Liverpool, Charles Lenormant's son, François, had published an article in the *Gazette archéologique* entitled "La Vénus de l'Esquilin et le Diadumène de Polyclète." It is a long piece, which tries to make sense of a statue "insufficiently ideal and godlike" to be an Aphrodite, but "too chaste" to be a courtesan in the mold of Phryne—a figure who resembles "a simple woman adjusting her hair as she gets out of the bath," but ultimately one with "too much gravitas to be a straightforward representation drawn from real life."[154] Is she a mythological or historical heroine? The snake winding itself around the water pot next to her leads Lenormant toward Egypt, and Rhodopis, the courtesan who, in some versions of the story, became a queen,[155] but not before he acknowledges that in its configuration the statue is "une figure d'étude," a study by an eclectic ancient sculptor, working in Rome, to be a "female counterpart" to Polyclitus's Diadumenus.[156] Already, there is justification for the earthier aspects of both Victorian nudes, and possible inspiration for Poynter, whose French was excellent.[157]

By the time that the Boston catalog of casts is published in 1891, the entry reads, "The Esquiline Venus is an anomalous work, for while the body is modelled with voluptuousness that almost oversteps the line dividing the nude from the naked, the head is treated with archaic severity."[158] By then, the figure's fame in contemporary

8.25. The Esquiline Venus, early imperial period, marble. Capitoline Museums, inv. no. MC 1141. Photograph: Hirmer Fotoarchiv, 671.9361.

painting may well have been dictating the pace, and perhaps explains why Boston dispensed with the torso altogether and made do with a bust of the statue. But the statue had always almost overstepped the mark.[159] In contrast to Scopas's oeuvre, with which it was compared when it was first discovered,[160] it was now seen as an experimental, Roman work that could underwrite the modernity and sensuality of late nineteenth-century practice, and the status of these paintings as academic studies. Poynter's *Diadumenè* would be hard-pressed to be more knowing of its place in a replica series and in a debate about nudity and propriety. In the background of the picture, behind the font, a second "Diadumenè" is depicted, this time a statuette, left undraped during the overpainting (as indeed are other female

miniatures that decorate the vaulting of the painted interior). This has educated viewers think not only of the statue, and of Alma-Tadema and Poynter's earlier versions, but of debates live in the scholarship, as the responses of artist and archaeologist massage each other, making ancient sculpture sexier, and more serious. Both painters were present at the opening of Cambridge's Museum of Classical Archaeology.[161] It took another two years for that gallery to acquire its own plaster replica.[162]

I am by no means the first person to draw attention to the porousness of these boundaries, nor indeed to see in the "care" "expended upon the details of the picture," "a mine of archaeological knowledge."[163] Alma-Tadema's work in particular was (and still is) widely praised for such accuracy— more so even than that of Poynter, Leighton,

and Albert Moore[164]—even if some thought it contravened "the calling of art" because there was "no soul in it, though the whole antique mish-mash be exhibited with undisputable knowledge."[165] Widely reproduced in prints of different prices (8.26), in art journals across Europe, periodicals in Europe and the United States, and in *The Illustrated London News* and the weekly British newspaper *The Graphic*, Alma-Tadema's paintings made him "a valuable teacher, and in a manner more attractive and 'readable' than any writer, for pictures are more generally intelligible and more elaborate than the most elaborate verbal description."[166] These paintings and their reproduction stood, in a sense, in place of art historical description, offering a more intense and proliferating way of seeing, experiencing even, antiquities long renowned and recently excavated,

8.26. Engraving of Alma-Tadema's *The Sculpture Gallery*, 1874, by Auguste Blanchard, c. 1877. Photograph: Library of Congress Prints and Photographs Division Washington, D.C., reproduction no. LC-DIG-pga-03409.

than that offered by a museum or cast gallery. In Alma-Tadema's *The Sculpture Gallery*, the seated "Roman" man signaling with outstretched arm toward the highly restored basin in the center has the artist's own facial features: what is dramatized is not simply the act of looking,[167] but, as in any ecphrastic text, "the moment of looking *as* a practice of interpreting, of reading—a way of seeing meaning."[168]

What proportion of the readers of *The Illustrated London News* shared this interpretative capacity? Engravings of Greek and Roman sculpture had been included in the popular press for years, including in the *Penny Magazine of the Society for the Diffusion of Useful Knowledge*, first published in 1832 with the aim of mass education. And in the late 1840s Swansea industrialist Lewis Llewelyn Dillwyn began producing inexpensive ceramics on ancient Greek models (a sort of diffusion line of Wedgwood, sold for between two and four shillings) in the hope of "carrying into the more humble homesteads of England forms of beauty in combination with useful ends, and in placing in the

hands of all, ornaments of a high character at a cheap rate" (8.27).[169] Success was short-lived: it seems as though classicism as an end in itself was of limited application. Print media may have flattened antiquity, but, in contrast, they gave it, if not the eternal beauty of Rayet's *Monuments*, then a different kind of timelessness that dimmed its luster and rendered it universally applicable. On the cover of the *Penny Magazine* of 12 January 1833 is the "Dying Gladiator" (1.8), a "celebrated statue," which

> "represents a man of toil, who has lived a laborious life, as we see from the countenance, from one of the hands, which is genuine, and the soles of the feet. He has a cord around his neck, which is knotted under the chin; he is lying on an oval buckler, on which we see a kind of broken horn." The rest of Winckelmann's remarks are little to the purpose.

The ensuing discussion focuses less on the sculpture as artwork than on its identity as a gladiator, the degradation of the Romans who enjoyed such spectacle,

8.27. Bowl in imitation of a Greek kylix, made in Swansea, mid-nineteenth century, and inscribed DILLWYN'S ETRUSCAN WARE, earthenware, transfer-printed in black outline, 9.2 × 26.9 cm. Victoria and Albert Museum, London, inv. no. 3503–1901. Photograph: © Victoria and Albert Museum, London.

and the dangers of looking at this suffering.[170] In this way, a Renaissance icon is recast as a working-class hero.

At the same time, the "tableaux vivants" performed by Emma Hamilton, themselves linked to the growing popularity of history painting, expanded into extravaganzas that packed circuses and music halls.[171] In the 1820s, a certain Andrew Ducrow of Astley's Amphitheatre in London, a man with "no education, but great natural quickness of intellect," gave performances that were "at once picturesque and classical,"[172] posing in a white body stocking, first on a horse and then on a pedestal.

> He appeared first as the Hercules Farnese. With the greatest skill and precision he then gradually quitted his attitude from one gradation to another, of display of strength; but at the moment in which he presented a perfect copy of the most celebrated statues of antiquity, he suddenly became fixed as if changed to marble . . . his form is faultless.[173]

The Discobolus and Dying Gaul/Gladiator were also in his repertoire. "In fact, Ducrow's person was precisely that of the Dying Gladiator," claimed *The New Monthly Magazine and Humorist*, while his face was *"very like that of a horse*—or rather THE horse—the *ideal* of all horses—the Phidian horse from the pediment of the Parthenon" (8.28).[174] A true elision of man and machine, or art criticism gone bonkers. By the 1890s, strongmen such as Eugen Sandow starred in sell-out shows on both sides of the Atlantic, posing again as the Gaul and Farnese Hercules (8.29).[175] One frequently reproduced poem is wonderfully forthright about their attractions:

> For nearly one hour they sat and they gazed
> At Sandow's nude figure and
> gushingly praised
> His form and his muscles, his
> curls and his face,
> His curves and his outlines,
> his ease and his grace,
> And vowed it was, oh!, such an artistic sight,
> They could linger with pleasure
> there night after night,
> And so when the "horrid old
> curtain" came down
> Each lady declared with a very deep frown
> She thought the performance
> was really too short
> They did not see half the "art
> pictures" they ought![176]

The popularization of Greek and Roman sculpture that social reform and the drive for self-improvement enabled endangered the special standing of that sculpture. In the twentieth century, its new universality, if we can call it that, would see it used in more propagandist modes than ever before, by Hitler and Mussolini (and to a lesser extent, Franco and Stalin). It would also—as a riposte to National Socialism's appropriation of the classical and to Leni Riefenstahl's *Olympia* film of 1938—see promoters of postwar Olympic Games embrace the Discobolus (8.30).[177] Even without Fascism, demystification had a price: whatever else was happening to the classical, casts become fixtures of cinemas, casinos, and hotel lobbies.[178]

But what of private collecting in the late nineteenth and early twentieth century? Mid-nineteenth century, the fourth Duke of Northumberland (d. 1865) is ripping out most of Adam's gothic interiors from the state rooms at Alnwick Castle and replacing them with Victorian classicism

(for example, marble chimney pieces with caryatids or statues of Dacian captives based on those reused on the Arch of Constantine), by Rome-based sculptor Giuseppe Nucci.[179] And at Wentworth Woodhouse, Charles William Wentworth Fitzwilliam (d. 1857) is commissioning two marble reliefs by Gibson, both of them with a debt to the Parthenon frieze, to add to the Marble Saloon.[180] Warren, meanwhile, cast the net as wide as possible to find Greek and Roman artifacts, most of them small-scale enough to lend themselves to intimate viewing, and several of them sexually explicit, and in 1900 commissioned Rodin

8.28. Eugène Delacroix, *Head of Horse, after the Parthenon*, c. 1825, pen and brown ink, over a little black chalk on laid paper, 8.3 × 11.3 cm. The Metropolitan Museum of Art, New York, inv. no. 1980.21.4. Photograph: The Metropolitan Museum of Art, Bequest of Gregoire Tarnopol, 1979, www.metmuseum.org.

to make a version of his *Kiss* sculpture on the stipulation that the genital organ of the man was completed (8.9).[181] When Warren's Rodin sculpture was loaned to Lewes

8.29. Napoleon Sarony, *Eugen Sandow as the Farnese Hercules*, c. 1890–95. Photograph: TCS1, Houghton Library, Harvard University.

8.30. Stamp, printed in Italy to celebrate the Olympic Games of 1960, showing a statue after Myron's Discobolus. Photograph: neftali / Shutterstock.com.

Town Hall in 1913, the outrage at its public display was still enough to call for a railing and a sheet.[182] However, in a world in which homosexuality was illegal, and women's rights, not only to vote, but to feel, and to feel pleasure, seriously debated, classical art could be as liberating as it was illicit.

It was this power to liberate that industrialist William Hesketh Lever (1851–1925) exploited when in the 1910s he made Greek pottery and Roman sculpture part of the art gallery in his model village on the Wirral.[183] Born in Bolton in the same year as the Great Exhibition, Lever had long collected objets d'art and paintings, many of them for his private residences and some for potential use as advertisements for his company's brand of Sunlight Soap. But in the twentieth century, motivated by American philanthropists, and by the desire to provide his employees with housing, infrastructure, and culture, this collecting became more serious, including in 1917 the acquisition of fourteen sculptures and thirty-five vases

from the sale of Thomas Hope's collection, ten of the latter originally owned by William Hamilton.[184] "The beautiful in art . . . led me gently and joyously nearer the truth and the right, and has always taken me without humiliation further from error and wrong," claimed Lever.[185] As he "arranged the whole collection himself, devoting many long and happy hours to the task," he must have hoped to instill similar joy in his workforce: "It is within the reach of all of us, however humble we may be" (not least because "the genius of printers' reproductions" had put the finest works of art "within the reach of all").[186] According to Lever's son, "it was my father's wish that it should be not merely an art gallery or museum in the formal sense, but also a 'home' to which people might come for inspiration and, on appropriate occasions, for recreation and entertainment."[187]

When the gallery opened in 1922 (free of charge on weekdays and on Sunday afternoons), the establishment's reaction is easier to gauge than that of the target audience. The *Observer*'s special correspondent bridled, "The scale is that of a national museum rather than that of a provincial gallery. The parallel must not be carried too far. There is neither the severity of choice nor the strict orderliness of arrangement that is expected in a national collection."[188] What was Lever's vision, and the place of classical art within it? When his son details the three occasions "of any importance" on which his father bought whole collections, the Hope collection does not get a look in.[189] And in the lavish catalog of the paintings, drawings, and sculpture published after Lever's death, on the model of those produced by European museums and English country house owners, we are reminded, "Nothing of particular

importance in ancient sculpture seems to have come Lord Leverhulme's way."[190]

The presence of an Antinous statue from the Hope collection (8.31) optimistically said to have been found at Hadrian's Villa, and a funerary altar that was once in the Cesi collection, would make this a peculiar admission—except that Lever's son's only comment on them is that "the north rotunda is devoted to sculpture of earlier periods."[191] Classical antiquities were no longer "the main event," and this despite the fact that the gallery's "Adam" and "Napoleon" rooms, and the acquisition of Lord Tweedmouth's Wedgwood collection, not to mention portraits of Emma Hamilton, and paintings by Poynter and Alma-Tadema, made the reception of classical art through the ages an important part of its story.[192] Part of this is about the standing of sculpture more generally: the explosively erotic *Salammbo* statue by Maurice Ferrary (1852–1904), which Lever probably bought at the Universal Exhibition in Paris in 1900 and exhibited in the south rotunda, its writhing, white body shockingly offset by the use of materials other than marble, barely rates a mention in the catalog either.[193] And part of it is about Lever's desire to have his collection celebrate the merits of British art vis-à-vis its European counterparts.[194] But much of it is that classicism has outgrown its ancient origins to become domesticated. Even the "Adam" room is as much about the polychromy of the painted furniture as it is about neoclassicism per se.[195] Perhaps the attraction of Hope's antiquities was that their prior owner was the author of *Household Furniture and Interior Decoration*.[196]

The Lady Lever gallery serves as a good stopping point, caught as it is between educational reform and aesthetic pleasure, and stuffed with representations of the human

8.31. The Hope Antinous, 130–38 CE with late eighteenth-century additions, including a jug that also makes the statue a Ganymede, marble, h 232.5 cm. The Lady Lever Art Gallery, Liverpool, inv. no. LL208. Photograph: National Museums Liverpool.

body, some of them, like Antinous, pointing back to the eighteenth century, and others, like Salammbo, speaking to the contemporary's abandonment of classical restraint. If anything binds the protagonists of our chapter together, it is that, "[t]he idealism associated with classicism was for many at the turn of the nineteenth century a clarion-call to change the world."[197] But by 1922, calls to arms had turned to cataclysm. Try giving Wherry's *Greek Sculpture, with Story and Song* to the siblings of those who had set off to the trenches with their copies of the *Iliad* in their knapsacks.[198] As we begin our march through the twentieth century into the world in which I first learned, and now teach, classical art, anxieties about artists, audience, and what constitutes an appropriate response are trumped by a more pressing concern—relevance.

9

The Death of Classical Art?

Competing Values

This, the last chapter of our story, might be anticipated to be a nightmare. Antiquities collections were bundled up to protect them from bombing, cast galleries put into store or smashed up, and stately homes, which had become objects of shared heritage, neglected by a populace who preferred the seaside to the countryside and cottages to castles.[1] Worse than destruction and neglect, Fascist leaders in Italy and Germany made classical sculpture and casts of classical sculpture central to their political ambitions. We need only think of Mussolini's "Mostra Augustea della Romanità" (Augustan Exhibition of Romanness), which opened in Rome's Palazzo delle Esposizioni in 1937, Hitler's state visit to the city the following year (9.1), and his gift to the Glyptothek in Munich, the "Hauptstadt der Bewegung" or "Capital of the Movement," of the Lancellotti Discobolus, found on the Esquiline in 1781 (1.15) and secured for five million lire before tax. On show for a year before the museum had to close, the statue symbolized the Aryan body at the heart of the Nazi master race, while modernist works by Archipenko and peers were branded "degenerate."[2]

As the twentieth century regrouped and rattled on, the superiority of western culture, and the classical art and literature underpinning it, was no longer a given. Of course, challenges to the permanent value attached to the vestiges of Greece and Rome and to their exemplary status had been mounted as soon as humanism was stratified as "wissenschaftliche Bildung" (scientific education) at the turn of the nineteenth century.[3] But the status of classics as but "one noble subject" among many became more explicit with the popularity, in England at least, of new university syllabuses, the demise of Greek teaching, and of first Greek, and then Latin, as general entry requirements for Oxbridge.[4] For Latin to remain embedded in high schools, emphasis was put on its disciplinary value, with such a premium on grammatical training that its cultural content was often evacuated—either that or eventually hived off into the distinct qualifications of ancient history and classical civilization.[5] This was still my experience of the schoolroom in the 1980s and 1990s, when I learned Latin using *Bradley's Arnold Latin Prose Composition* (1884, revised in 1938)[6] and knew little about Rome beyond the level of the sentence. And it is often marshaled as an argument in the retention of Latin in schools today:

> [B]ecause Latin is a dead language, because it is taught to be read, not spoken, because it is taught entirely through its grammatical rules not

through its demotic use, as you learn it you gain an understanding of the mechanics and structure of language streets ahead of any you will gain from the study of a modern tongue. Any other language—not just Spanish, Italian, Portuguese, but German, Russian, Arabic—becomes easier for a child with a grounding in Latin. A student can use Latin to grasp the bones and sinews of any language.[7]

The author has a point. But where does utility leave antiquity, and the beauty of the classical?

In the 1970s and 1980s, the whole concept of the canon, classical or otherwise, came under threat, the perceived "ethnocentricity" of its aesthetic standards, if not the very idea of aesthetic standards, attacked by multiculturalism, feminism, deconstructionism. If there was hegemony now, it was diversity that ruled.[8] In 1996, one of the contributions to an *Art Bulletin* feature, on "Rethinking the Canon," was a piece on world art studies and the need for a new natural history of art. "Homo sapiens" put the Greeks and Romans in their place, and substituted the workings of eye and hand for genius.[9] But the same author is also responsible for *Classical Art and the Cultures of Greece and Rome*, the preface of which concludes:

> Those Europeans who for two and a half thousand years imitated the Greeks in their rigorous education and in their mineral self-representation came to share both that secret and its benefits, regardless of the costs. Today those same benefits are now available to people anywhere in the world, with similar, albeit lower,

costs. To some of these benefits and costs of so-called western civilisation this book might eventually serve as a brief accountant's guide. Such is the importance claimed here for an understanding of Classical art and the cultures of Greece and Rome.[10]

Before we sound classical art's death knell, it is important to stir the countercurrents. In 1949, less than twenty-five years after it opened to the public, the Metropolitan Museum's "Roman Court" and surrounding galleries were turned into an eatery and administrative offices, and entire categories of classical object consigned to the storerooms.[11] But by 2007, after a fifteen-year, $220 million project to recommandeer the space, the Greek and Roman collection is back, brighter than ever, the aim, at least in the central hall, less the education that comes of chronology than the self-discovery that comes of leisure activities. "I don't believe in itineraries; I believe in wanderings," claimed its then director.[12] In London, the 2013 exhibition "Life and Death in Pompeii and Herculaneum" proved the British Museum's third most popular show of all time and the first to be streamed to cinemagoers in 281 venues.[13] Although the human-interest angle was a large part of its success (its plaster casts of Vesuvius's victims, carbonized bread, "pornographizing" of the Villa of the Papyri's Pan and Goat sculpture [3.17] by the deployment of a "parental guidance" notice), we remember the ongoing controversy that is the restitution of the Parthenon sculptures and the impact of redisplaying some of them in the State Hermitage Museum, St. Petersburg, and in the British Museum's own 2015 "Defining Beauty" exhibition.[14]

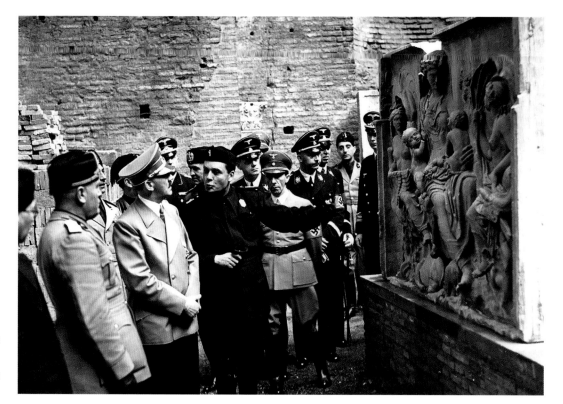

9.1. Bianchi Bandinelli showing Hitler and Mussolini the Tellus (Mother Earth) relief of the Ara Pacis, then in the Baths of Diocletian, prior to permanent installation in the pavilion opposite Augustus's Mausoleum, May 1938. Photograph: akg-images / Alinari Archives, Florence.

Addressing the Oxford Union in 1986, Greek actress and activist Melina Mercouri (1920–94) claimed, "They are the essence of Greekness."[15] For *Guardian* critic Jonathan Jones, that essence still makes them "the world's most beautiful art."[16]

Greek and Roman art is big business even now, and its beauty not something confined to the auction room where private collectors push prices higher and higher,[17] especially for pieces with provenance. It is not only that luxury companies such as Fendi continue to use classical statuary to give their perfumes old school glamour and eroticism (9.2) or that the Fondazione Prada, an institution dedicated to contemporary art and culture, should have recently collaborated with classicist Salvatore Settis to stage two classical art shows, which put the emphasis less on

antiquity than on reproduction or "seriality," and on exposing the ongoing influence and power of a "hidden category of our contemporary culture."[18] It is that contemporary artists on both sides of the Atlantic have not stopped playing similar games to Settis, reproducing figures such as the Farnese Hercules in polystyrene (9.3) or having a cast of the statue carry not the earth, but a glass gazing ball or "yard globe," on its shoulder.[19]

Although these renditions risk removing the classical from its pedestal (one puff and Matthew Darbyshire's polystyrene giant topples; while in Jeff Koons's piece, the Hercules is but a stand for a bauble better suited to gardens and patios), they also reaffirm it. For Darbyshire, as for Koons, the Hercules statue is "kitsch":

9.2. Photograph by Sheila Metzner for Fendi (story 72681), exploiting the enduring eroticism of Antinous. Photograph: Sheila Metzner / Trunk Archive.

I like that Greek and Roman sculpture is virtually ingrained in our minds and, therefore, devoid of novelty. This enables people to register the symbolism of my work quickly, get over it, and explore the more intrinsic attributes of form, physicality, material, process and patina. My work uses easily recognisable symbols (Hercules as the ultimate symbol of power; Venus [the Venus de Milo] as the ultimate symbol of beauty; the Doryphoros as the ultimate symbol of vigour etc) and I use them much the same way as I might a water cooler to epitomise or represent cleanliness and vitality; a cat, domesticity; or a Dyson vacuum-cleaner, technology (9.4).[20]

Not that any of this makes Darbyshire's Hercules less beautiful. Up close, the hand-cut polystyrene sheets from which it is made prove as pixelated as the computer-generated model from which they derive, but from a distance, they shine like fine-grained Parian marble.

Koons's Hercules is part of a series of *Gazing Ball* sculptures, several of them classical, including the Belvedere Torso

9.3. Matthew Darbyshire, *Hercules*, 2014, polystyrene, h 315 cm. Photograph: Caroline Vout with the permission of the artist and Robert Tucker and Jonathan Wilmot, Restoration House, Rochester, Kent.

9.4. Matthew Darbyshire, *CAPTCHA No. 11—Doryphoros*, 2014, multiwall polycarbonate, silicone, and steel armature, h 224 cm. Photograph: © the artist and Herald St, London.

(9.5), Barberini Faun, Ariadne/Cleopatra, Esquiline Venus, Crouching Venus, Silenus with Baby Dionysus (a statue group famous in Rome since the sixteenth century and frequently copied), Antinous Braschi (discovered at the end of the eighteenth century), and centaur grappling with a Lapith woman from the west pediment of the Temple of Zeus at Olympia. Interesting for our purposes is how many of these have been stars since the Renaissance.[21] In the art world at least it seems that the canon lives on as the "baroque" dilutes, if not dominates, the narrowing definition of the "classical" as fifth- or fourth-century BCE in style that comes of Meisterforschung and the preeminence of the Parthenon.

This is in stark contrast to what has happened in schools, where a quick scan of the UK's Classical Civilisation syllabuses for the final-year examinations reveals only Olympia in common with Koons, and preference, as far as freestanding sculpture is concerned, for kouroi, and statues after Polyclitus and Praxiteles.[22] Copies aside, Roman art is bundled into history modules, or made practical in an option entitled "Roman architecture and town planning." Classical art is Greek art, and much of this, work associated with artists whose names have topped the "hit parade" since at least the hellenistic period. Until the nineteenth century, these were, in effect, "great masters" without portfolio, coexisting with the alternative, Renaissance canon that is the Barberini Torso and Faun, Ariadne/Cleopatra, Silenus with Baby Dionysus, the Apollo Belvedere, and so on. But once linked, convincingly, to extant figurative types, they threatened the competing canon's academic credentials. Also included in these syllabuses are a good many bronzes (the Delphi Charioteer, Artemision Zeus, Antikythera Ephebe, Riace

Bronzes, and Marathon Boy), all, bar one, found in the sea in the twentieth century.[23] All new finds struggle to be integrated into an existing narrative, but that narrative is no longer driven by the Winckelmannian measure that made Apollo and Antinous the yardstick: just as Chamoux wanted the Charioteer to be by Kritios,[24] so the Riaces are ascribed to Pheidias, Myron, or Polyclitus, the Zeus to Myron, and the Marathon Boy to the school of Praxiteles.[25]

Not that contemporary artists are not invested in this narrative also. How could they not be when from the fifteenth century on, trailblazers such as Raphael, Bregno, and Fra Angelico had been compared to Apelles, Parrhasius, Zeuxis, and Polyclitus?[26] We have already encountered Darbyshire's "Doryphoroi";[27] in 2012, in conjunction with the London Olympics, the British Museum exhibited Chinese sculptor Sui Jianguo's (b. 1956) *Drapery Folds—the Discobolus*, a version of the Discobolus in a Mao suit, inspired by a cast that had been in Beijing since before the Cultural Revolution, brought from Paris by the painter Xu Beihong (1895–1953) as part of a wider influx of western models that would inspire sculptures such as the People's Heroes Monument in Tiananmen Square.[28] As well as embodying "the intellectual and artistic constraints of communist China,"[29] Sui Jianguo's version questions the applicability of classical art, highlighting how hard it is to reconcile this book's material with the artistic production of nonwestern cultures unable to be reduced (as the production of Assyria is sometimes, unabashedly, reduced) to a footnote of our story, and reminding us of the politics of all acts of appropriation. Hitler and the Munich Glyptothek loom large in this remembrance, a museum that, in the 1960s, recognized

9.5. Jeff Koons, *Gazing Ball (Belvedere Torso)*, 2013, plaster and glass, 181.6 ×75.9 × 89.2 cm © Jeff Koons. Photograph: Tom Powel Imaging.

new knowledge and the "way to the liberation of the Aegina pediments from their neoclassical bonds," when they removed Thorvaldsen's restorations.[30] Welcomed by the archaeological community as a victory of accuracy over aesthetics, this decision too was political, "cleansing" the sculptures of a neoclassicism sullied by National Socialism: in a piece in *Die Kunst im Deutschen Reich* in 1944, Thorvaldsen had been praised as a prime example of "the contact, so fruitful for our intellectual life, of the Germanic-Nordic character with the south, with antiquity."[31] Whatever Darbyshire, Koons, and Sui Jianguo are doing, it perhaps cannot afford to be "classicism."

Greek and Roman art itself continues to be hit by a series of controversies that have seen museums like the Getty pay vast amounts of money for examples, like the Getty Kouros, which are now thought to be fake (9.6), and become embroiled in charges of looted antiquities.[32] The UNESCO convention of 1970 on the "Means of Prohibiting and Preventing the Illicit Import, Export and Transfer of Ownership of Cultural Property" has worked to ill as well as positive effect, constraining a market that relies on a ready supply of artifacts and, far from halting it, driving its activity underground. In this climate, antiquities are still ripped from their archaeological

context without proper record, provenances fudged or invented, and damage inflicted. If and when any of this comes to light, legal wrangles can mean that objects are marooned in bank vaults or warehouses, where scholars are also deprived of them.[33]

Only a tiny fraction of looted antiquities are returned to their country of origin: for example, the late sixth-century Athenian red-figure pot known as the "Euphronios Krater" after the signature of its painter (9.7), which was relinquished by the Metropolitan Museum of Art in 2008 and first displayed in the National Etruscan Museum in the Villa Giulia in Rome, and later in the Archaeological Museum in Cerveteri, close to its Etruscan find-spot, or the ten antiquities that in the same year were returned to Italy from the collection of Leon Levy and Shelby White, who give their name to the "Roman Court" at the center of the museum's revamp.[34] Private collectors and museum curators massage each other: when the Getty Villa, which has itself had to return tens of antiquities, was closed for restoration in 1997, it published the glossy *Masterpieces of the J. Paul Getty Museum: Antiquities* with a foreword celebrating not only Getty's own collecting activities, but the acquisition of the Molly and Walter Bareiss and Lawrence and Barbara Fleischman collections.[35] In Cerveteri, in contrast to other local museums (for example, in Mazara del Vallo, Sicily, where the bronze satyr found off the coast is displayed in glorious isolation),[36] the krater is still in dialogue with other works of its kind: although found in Etruria, these were made in Athens, and attest to a thriving *ancient* market.

If only the effects of the repatriation drive were as clear-cut as the ethics that underpin it. At one extreme, some museum directors are outspoken about what they see as a privileging of archaeological context (where an object admittedly ended, rather than "lived," its life) over and above other contexts, and of the claims of modern nation-states over and above the idea of the "universal museum" and world heritage. "True art is cosmopolitan. It knows no country. It knows no age. Homer sang not for the Greeks alone but for all nations, and for all time."[37] At the other extreme are scholars who argue that (only) the most fully contextualized objects should hold pride of place in scholarship and in the gallery and classroom, and not only because it might stem looting. Too much of what we think with is, dangerously, "ungrounded."

> Very few of those canonical works of Roman art—the ones that serve as the bedrock and baseline of the entire discipline—have come down to us with a known findspot. The oft-repeated platitudes about . . . works' meanings . . . are not the product of any real knowledge about those particular objects' ancient patrons or users. They are derived, rather, from literary texts . . . , which have been used to fill in the historical gaps left by these artworks' missing ancient contexts. Their fame is due not to the richness of their historical documentation, but to their beauty, exceptional state of preservation, and prominence in the best-known collections.[38]

It is impossible to argue with this, but to embrace its implications as a modus operandi risks rendering this book and its contents separate, if not obsolete, depriving archaeology of its origins. It drives a wedge between archaeology and art, empiricism and aesthetic judgment.[39] Few of us would deny the importance of

9.6. The Getty Kouros, c. 530 BCE or modern forgery, marble, h 206.1 cm. The J. Paul Getty Museum, Los Angeles, inv. no. 85. AA.40. Photograph: Digital image courtesy of the Getty's Open Content Program.

The dating of sculptures, pottery, and other ancient objects, meanwhile, is often based on stylistic criteria, which not only bring art historical approaches and the educated subjectivity of the art historian's "eye" back in again, but rely on bodies of material, which have, through centuries of comparison and contrast, provided data to mitigate loss.[40] Archaeologists cannot avoid "art" (indeed the word is helpful here, as anyone willing to use these bodies of evidence is inevitably mixed up in the value systems that have commodified them) any more than art historians can dispense with archaeology. Ultimately what we must do is work responsibly, and to do that, we could do worse than understand the choices, good and bad, that have got us to this point—rather than rewrite history. We must also continue to teach our students how to look. "Real knowledge" comes in many forms, not least the data acquisition needed to classify, and to appreciate the problems of classification and the possibility of alternative categories. It is easy to denounce connoisseurship as an outmoded, elitist exercise that inflates the value of ancient artifacts by turning their makers into Berninis of Titians, or, now that the production of Polyclitus and Euphronios is duly recognized, to see its work as done;[41] even the "new art history" of the 1980s, with its embrace of postcolonial discourse and microhistories, is now passé. But dispensing with connoisseurship's tool kit is another matter. By learning about past ways of seeing, we see how our own are culturally contingent.

But is what we are looking at still *classical* art? Literary texts and collection histories are such an important part of what gives Greek and Roman production its "classical" status. Recognize this, and this production becomes, in some eyes,

archaeological context: ideally we would know with what else a sculpture was displayed, and at different times in its ancient history, on how high a base, in what kind of space, light and viewing conditions, for what kind of audience. We would also like to know what its surface originally looked like and how thickly the paint was applied (something that eludes pigment specialists even now). But, as this "wish list" implies, context is always, also, to a greater or lesser degree, a picture of the excavator's making, the most plausible picture, based on the stratigraphy of the particular site and on a host of long-held, evolving assumptions. It can never be the same picture as that inhabited in "real time" by an ancient with the oral tradition that we call "Homer" at his, or—differently—her, fingertips.

9.7. Sarpedon's body carried by Hypnos and Thanatos (Sleep and Death), while Hermes watches. Side A of the so-called "Euphronios Krater," Attic red-figure calyx-krater signed by Euxitheos (potter) and Euphronios (painter), c. 515 BCE, h 45.7 cm. Formerly in the Metropolitan Museum of Art, New York (L.2006.10); returned to Italy in 2008. Photograph: Jaime Ardiles-Arce, https://commons.wikimedia.org/wiki/File:Euphronios_krater_side_A_MET_L.2006.10.jpg.

no more authoritative than the material culture of any other society. More than this, the academy has been slow to incorporate into its teaching major finds from recent excavations such as those at Perge and Sagalassos in Turkey.[42] Were it to do this, Greek and Roman art as we know it would be unrecognizable. The fact that Roman art is being used to debate these issues ("Very few of those canonical works of Roman art—the ones that serve as the bedrock and baseline of the entire discipline—have come down to us with a known findspot") is again a departure—so much so, that if we were wanting to celebrate a development in the academic strand of our story, one might say that it is the birth of Roman art as independent of Greek art. The seeds of this independence were sown late in the nineteenth, start of the twentieth, century, when art historians such as Riegl and Franz Wickhoff (1853–1909) put imperial, late antique, and early medieval art on the map.[43] Approaching Roman sculpture from the medieval end gave it a more active role than preservation of the classical. Roman art could be an originator, and had a brighter future.

The next section explores the place of Rome in more detail, for it is arguably in Roman art that the most methodologically interesting work of the last thirty years or so has been done, work which understands that the "classical art" that Rome inherits is less a burden than it is a language,[44] and the visual culture of the empire as polyglot as its peoples. Recognizing this diversity (whether in Romano-British or "plebeian" art)[45] is in step with "world art" initiatives, and celebrating the inventiveness of those examples that explicitly play with Greek culture (through seriality, size, material, bricolage), with postmodernism. How do these approaches, and the liberated, sophisticated art they engender, sit next to the Doryphorus and Tyrannicides of the exam boards and Greek art textbooks, where they still serve as ciphers for lost masterpieces, or next to the museum, the art market, or contemporary art practice?

In the final section of this chapter, we tentatively return to modern collecting, both that of private individuals and public museums. Before we pronounce that classical art is dead, dissected into its constituent parts (Attic, Lycian, Italic, Gallic . . .), subsumed,

or superseded, we visit the Mougins Museum of Classical Art, established in the south of France in 2011 to house over seven hundred artworks, ancient, neoclassical, and modern, collected by British investment manager Christian Levett (b. 1970). Its embeddedness in the local region, "which is renouned [*sic*] for its ancient Greek colonies and Roman remains,"[46] could not be more different from that experienced by the Roman Museum in Canterbury, England, or the National Museum of Roman Art at Mérida in Spain. This is not just because the only provenance that many of its pieces have is that given to them by scholarship, but because of the (dis)continuities it celebrates between ancient works and pieces by Pablo Picasso, who spent his last years in the town, Paul Cézanne, Antony Gormley, and Damien Hirst. Can we resolve this first section's "conflicting values," and secure classical art's future as "good to think with"?

A Place for Roman Art

"Of the innumerable learned men who have worked at Classical Archaeology, almost all have hitherto devoted themselves exclusively to Greek art," explains Wickhoff in the preface to the English edition of an essay, first published in German in 1895, not as a self-standing thesis on the character of Roman art but as an intrinsic part of explaining the pictures in an edition of a sixth-century CE illuminated manuscript of the Book of Genesis in Vienna.[47] Moving from its illustration backward, Wickhoff is keen to shake Pheidias and Praxiteles from "that solitary height where the first has been placed by the sentimental pedants of to-day, and the latter by those of antiquity" and to put the art back into all periods

of cultural production.[48] For Rome, this means tracing a trajectory from the early empire when Roman and Greek elements (the latter learned through copying) "met and mingled" to give "Augustan style," which led in time to art making "the step from Greek to Latin," to greater illusionism, and "Latin art" like historic relief.[49]

The agency that this gave Roman production was inevitably controversial: in a lengthy, catty, and anti-German review, Percy Gardner responded,

> There is a confusion of mind which has gravely misled Wickhoff and his adherents; writers are apt to confuse two very different things, art in the Roman age and Roman art. Through the whole Roman empire, as in all the ancient world, art persisted and had important functions. But all in it that was really artistic, that is, which showed poetry, imagination, love of beauty, belongs to Hellas, whether the original Hellas or the greater Hellas after the days after Alexander.[50]

For Gardner, Wickhoff had let theory lead: the "style and execution" of the reliefs of the Arch of Trajan at Beneventum were "purely Greek" (9.8) and the idea that Roman portraits were better than those made by hellenistic artists "astounding": "The contrast is simply one between death and life, between sheer dullness and brilliant imagination."[51] In case anyone were in doubt, he evokes romance: "'A thing of beauty is a joy for ever.' That sentiment is quite in accordance with the Greek spirit. But to the Romans a thing of beauty was the sensation of an hour."[52] Fortunately, despite criticism from Gardner and from scholars on the Continent, Wickhoff's views had a longer shelf life, in

9.8. Section of "historical relief" from the "country" facade of the Arch of Trajan at Beneventum, dedicated 114 CE, showing the Roman emperor Trajan with his familiar portrait features, presenting children to Italia and Mars. Photograph: Camster2, https://commons.wikimedia.org/wiki/File:Benevento_arco_di_Traiano.JPG.

part due to his translator Eugénie Strong, née Sellers, and her own book, *Roman Sculpture: From Augustus to Constantine*, which Gardner regarded more highly.[53] Published in 1907, two years before she moved to Rome to take up the position of assistant director and librarian of the British School at Rome, and based on a series of lectures, "mainly in the form of a running commentary on the aesthetic ideas put forward by Wickhoff,"[54] Strong's book is spurred also by what she sees as the narrow curriculum of Oxford and Cambridge, "where the word 'classical' is restricted to a tithe of the remains of classical antiquity, and subjects of study are called dangerous or unprofitable which have not yet been included among the 'subjects of examination.'"[55] Starting further back than Wickhoff, so as to include the republican "Altar" of Domitius Ahenobarbus, and explicit in its assessment

of the Ara Pacis as "embryonic" in its experimentation with its hellenic inheritance, she explains, "The Augustan artists are neither academics nor decadents, still less are they servile imitators. They are pioneers treading new paths which it will take their successors nearly a hundred years fully to explore."[56] Rather than a coda to the story of "classical art," Rome was now a new chapter. Although the constraints of her book restrict Augustan sculpture "to the Hellenic or Hellenistic art, which was transformed under Augustus into Roman Imperial art," she admits to the variety that is "Roman Art of the Augustan period in the Provinces."[57]

By 1953, the study of Roman art was established enough as a field for Otto Brendel to write its historiography.[58] "In its most general aspect the re-evaluation of Roman art by Wickhoff and Riegl implies a positive interpretation of modernism."[59]

And it was not only modernism that dared Roman art to assert its individuality. It was that the life history of Greek art had recently been extrapolated backward, centuries further back than Aegina or the kouroi, to embrace a prehistory devoid of classical texts, revealed in Heinrich Schliemann's (1822–90) finds from Troy (exhibited at the South Kensington Museum in London for four years from 1877), Tiryns and Mycenae, and Arthur Evans's (1851–1941) discovery of the Bronze Age palace at Knossos, the restoration and reception of which became part of modernism's project.[60] However disappointing Schliemann's exhibits might have proven to "the student of Homer,"[61] they questioned orthodoxies by challenging the values of later Greek aesthetics.

Born in Germany in 1901, Brendel ended up, via the Ny Carlsberg Glyptotek in Copenhagen, where he served as curator, and Rome, in America, teaching first at Washington University in St. Louis, Missouri, and, after another stint in Rome, this time at the American Academy, as professor at Columbia. Reissued in expanded form in 1979, his *Prolegomena to the Study of Roman Art* offers a critical assessment of the key questions. Most burning among these was what made Roman art "Roman": was it where it was made and displayed, the ethnicity of the artist, or its style? For, unlike Greek art (at least as honed over centuries) or Egyptian, the unity of Roman art was "not obvious as a style or approach to artistic representation," but "oscillating between a 'neo-classic' acceptance of Greek standards and an often crude 'popular' realism, and eventually issuing in the seemingly 'anti-classic,' formal rigidity of the late Roman style."[62] It was also, by and large, an art without artists. In its freedom to pick from a palette of

possibilities, "Roman art may well be considered the first 'modern' art in history."[63]

As should already be obvious from Brendel's focus on diversity and freedom of choice, a lot had happened in the world and in the world of Roman art since Wickhoff's identification of it as a national phenomenon—not least the rise and fall of Hitler and Mussolini and, at exactly the time that Brendel was writing version one, nationalism in a different form, McCarthyite Americanism.[64] As far as Rome's art was concerned, debate had shifted from the issue of its independence to how to gauge originality, and from Greek versus Roman to classical versus nonclassical.[65] Informed by cultural history, Marxist art historian Bianchi Bandinelli (9.1) wrote of Rome's artistic expression as something "bound up with the specific historical phenomenon of a certain society and culture"[66] and in defining Roman art as "eclectic," contributed to a paradigm shift from "how Greek" to "how classical" by adding class-based diversity to the mix and highlighting how Augustan "neo-Atticism" was limited to the urban elites. Hence the term "plebeian art," and the opening up of the field to sociohistorical analysis.[67] Paul Zanker's book, *Augustus und die Macht der Bilder*, published in 1987, and as *The Power of Images in the Age of Augustus* in 1988, is particularly important, attempting as it does to move beyond the classicism question to examine "the social and political context out of which it arises and which it so greatly illuminates."[68] In so doing, it is less interested in artistic traditions and techniques than in visual communication, and the relationship between emperor, images, and consumers. Zanker is no less coy about evoking Fascist history than he is about rejecting the idea that there was a master plan to, or propaganda

machine behind, Augustan building.[69] His subtle integration of ancient literature, and his emphasis on dialogue, still colors Roman art history: without Zanker, Elsner's work on the interrelations of art and text in the empire and on the Roman viewer would surely have looked very different.[70]

In his preface, Zanker (b. 1937) notes the "powerful orientation toward Greek art" that persisted in Germany even after the Second World War.[71] The emergence of Roman style as a subject did not mean the death of Greek art then, any more than it did in 1917 when Gardner reviewed Wickhoff. In 1948, Cambridge classicist Charles Seltman was just as adamant: "there was no truly Roman art."[72] And in 1941—perhaps in response to what he perceived as an erosion of post-Renaissance humanism with the rise of Fascism—Renaissance art specialist Bernard Berenson (1865–1959) was busy reversing Riegl's idea of progress, and reasserting the "decline of form" represented by the Arch of Constantine (4.3), a "decline" akin to the lamentable abstraction of modern art.[73]

During and immediately after the war, Seltman put on a series of exhibitions of Greek art in London, Scotland, Cambridge, and Norwich, the final one, at the Royal Academy in 1946, receiving in excess of 72,000 visitors.[74] The torso of the Apollo Sauroktonos after Praxiteles, a statue previously owned by Ricketts and Shannon,[75] and acquired by the Fitzwilliam in 1937 (9.9), was one of the key pieces in an exhibition "set up for a memorial to men of Greece, Britain, and the Dominions who fought and died for the cause of liberty in Greece and the Greek seas."[76] Independence meant many things—especially then. The poster for the Cambridge show claimed, "All modern civilisation in Europe and America is an offshoot from that of the Greeks who were the authors of its philosophy and science as well as its poetry and art. It was the ancient Greek genius which devised these ideas of democracy and freedom for which the Greeks of our day continue to strive."[77] Press coverage drove home the message: "It might be asked why such an exhibition should be held at these times, and the answer was that Greek art was the symbol of everything good we stood for, and everything we were fighting for, and everything the Nazis and Fascism were seeking to crush."[78]

Greek art had a special, consolatory power ingrained in its humanist history. If there was a precedent for this kind of exhibition, it was, as the "Prefaces" to the catalog point out, the "Exhibition of Ancient Greek Art," arranged by the Burlington

9.9. Statue of the Apollo Sauroktonos type, c. 100 BCE, marble, h 94 cm. The Fitzwilliam Museum, Cambridge, inv. no. GR.94.193 (formerly in the collection of Ricketts and Shannon). Photograph: © The Fitzwilliam Museum, Cambridge.

Fine Arts Club in 1903, which had included works as august as the Chatsworth Apollo (9.11).[79] The cataclysm of war made stability as important as independence, something underlined by the inclusion of the Chatsworth head in Seltman's show, illustrated in four separate plates.[80] Compared to this catalog, Eugénie Strong's illustrated catalog of the 1903 exhibition had been a lavish production, which rejoiced in representing the collections of Chatsworth, Lansdowne House, Petworth, and so on, and regretted the exclusion of loans from Woburn Abbey, Ince Blundell, Wilton, Holkham, and Hope's country residence, The Deepdene.[81] Despite its fashionable framing (Strong's preface name-checks Wickhoff, and questions whether beauty is what makes Greek art Greek),[82] its list of lenders (from Gardner and his wine jugs, and Evans and his coins, gems, a head from Portici, and casts of the decoration at the Palace of Knossos, to the Duke of Devonshire, Marquess of Lansdowne, Lord Leconfield, and H.R.H. the Duchess of Connaught) drew a line back to the collecting culture of the eighteenth and nineteenth centuries, underscoring that objects like these had made not only Greece, but Britain, great.[83]

Where did all of this leave Roman copies of great Greek sculptures and, connected to this, the conviction that a Greek work by a known artist lay behind almost every work of Roman ideal sculpture? Scholarship eventually liberated these sculptures also, making them worthy of study in their own right as eloquent "versions" or reactions, which—due to a developing understanding of how they functioned within the context for which they were carved—bore further witness to Roman art's eclecticism. Without this work, the approach I took in chapter 3 of this book would have been

impossible.[84] Not that this has ejected them from books on Greek art—not from many of them at least. Unsurprisingly, Seltman's *Approach to Greek Art* is happy to speculate about whether a famous bronze statue, the Idolino, found in Pesaro in 1530, is a Polyclitan original but balks at admitting any obviously Roman statues.[85] But Gisela Richter's *The Sculpture and Sculptors of the Greeks* (1929; fourth edition, 1970) has no such qualms, following books like the two-volume *Handbook of Greek Sculpture*, by Percy Gardner's younger brother, Ernest (1862–1939), which had built on the work of Brunn, and Overbeck to include lengthy discussions of Myron and Polyclitus tentatively based, in part, on the Lancellotti Discobolus and the Naples Doryphorus.[86] She writes:

> For our estimation of Polykleitos there is no original statue extant; but several of his famous works have been recognized in Roman copies and from them we can derive a glimpse of this great personality. . . . The best copy in the round was found in Pompeii and is now in the Naples' Museum.[87]

It is this search for "personality" that pushes Lullies and Hirmer, whose textbook on Greek sculpture, first published in German in 1956, we referenced in our opening chapter, in the opposite direction, even as it acknowledges that in neglecting "copies," "much had to be omitted that would be indispensable for a complete survey of the historical development of Greek art." Originals allow us "to feel across the intervening centuries the direct impact of the Greek sculptor's artistic personality . . . to feel the undiluted power of his creative genius."[88]

Since the 1950s, specialists in Greek art have been divided—both in what they do and in how explicitly they do it. In

their books on Greek sculpture, Brunilde Sismondo Ridgway and John Boardman make original pieces their priority, grouping Roman "copies" together in discrete sections.[89] Robin Osborne's *Archaic and Classical Greek Art* is less open about its guiding principles, but lets Attic pottery do some of its heaviest lifting, introducing statues after the Doryphorus and Knidia (only) to illustrate ways of seeing in Polyclitus's Canon, Pliny, and Lucian.[90] And Richard Neer's *Art and Archaeology of the Greek World* "avoids Roman versions wherever possible."[91] Roman art's increased independence makes these decisions understandable: "We cannot know in advance whether a Roman statue is or is not a useful guide to a Greek original."[92] Yet the image of Greek art produced is, by necessity, more two-dimensional than anything we have considered thus far, grounded, for the most part, in the study of temple sculpture, stelai, and pot painting. It is different again from the canon of works associated with artists, who have had name recognition since at least the hellenistic period.

How to move forward? Perhaps more productive, and appreciative of the advances made in the study of Roman visual culture, is to accept the interdependence of the Greek and the Roman. Indeed one could argue that if it is Greek *art* and its history, as opposed to Greek artifacts and their ancient usage, that we are after, then one has to accept this:[93] as Mary Beard and John Henderson explain in a book in the same series as Osborne's, "in Classical art Greece is always mediated through Rome."[94] In other words, it is the *journey* that confers value, and hellen-ism (i.e., the adoption of Greek production and style) as much as Greek workmanship that makes sculptures, gems, or pottery, created in Athens, Argos, or

Sicyon, "Greek" in an ideological, transferable sense. Beard and Henderson's admission that almost all of the "art treasures" found in Renaissance Rome or in later excavations at Pompeii and Herculaneum "belonged to the period between Alexander and Hadrian" is another way of recognizing Rome's lens-like nature.[95] Learning to look at Roman art helps us understand what Greek art is. "All art is material culture, though not all material culture is art," writes James Whitley. But his conclusion ("Classical art history therefore is archaeology or it is nothing") does not, or need not, follow.[96] Art has an allure that transcends its archaeological context. Classical art history exists whether we like it or not, and has for centuries. Without classical art history, even the Riace Bronzes or Antikythera Ephebe (3.10) might be consigned to the scrap heap.

Classical Art and the Modern Museum

Ancient Greece was not just consoling of a war-torn Britain; it offered collectors a spiritual salve with which to justify their buying. And it still offers them this. "I was looking for God, for the truth and for the absolute. In 1949 I went to Greece and I found my answer," explains Parisian born George Ortiz, who died in 2013 having gained a reputation as one of the greatest collectors of the period.[97] In 1950, while still in his early twenties, he had begun to collect, using his inherited wealth to amass, over a fifty-year period, a spectacular, if spectacularly controversial, collection (the majority of objects "allegedly from" x or y, others, "provenance: no indication"), exhibited in the 1990s in St. Petersburg, Moscow, London, and Berlin. Encompassing antiquities from as far afield as

Africa, Assyria, China, and the Pacific, its core is Greek, and the lion's share of its Roman artifacts assessed within a Greek frame: so one feels that the first of the Roman objects, a bronze statuette of Ajax, "Allegedly from Asia Minor," is there because of Sophocles, who is referenced in the catalog. It continues:

> "On account of its close parallel to the Belvedere Torso, its best comparison, its classical spirit and yet its Roman characteristics (such as the treatment of certain details . . .), we perceive between its classical inspiration and its execution reminiscences of baroque Pergamene art with eastern influences expressed in the muscles and thorax. I feel that we should place him in the second half of the 1st century B.C. and probably in the early reign of Augustus." The 1st century B.C. is a very eclectic period, but in spirit it is classicizing: Greek artists worked for Augustus.[98]

Even a very Italian object, like a phallic "tintinnabulum" from Herculaneum, which is rare in this company in having a place and date of discovery (its record of ownership including the Bourbon kings and Napoleon), comprises a multiphallic figure, whose "physiognomy is more in keeping with the Alexandrian models of the Late Hellenistic period, possibly indicating an Alexandrian origin, though the object may well have been made in the Pompeian region."[99]

First impressions of the part of Levett's collection on display in the Mougins Museum of Classical Art suggest that its emphasis, in contrast, is less on Greece and Greek origins than on what happens to this inheritance under the Roman empire:

Over 2500 years ago the Romans were inspired by the art and literature of the Greeks when they conquered Greece. These classical influences continued to inspire artists over the centuries; in this Museum familiar myths are presented showing how they have been reinterpreted over the past 2000 years.[100]

Perhaps the most interesting antiquity, as far as this book is concerned, is a larger than life-size marble statue of Hadrian bought for more than its estimate at Christie's New York in 2008 (albeit at a fraction of what provenanced pieces are fetching today) (9.10). First recorded in the collection of the Villa Montalto in Rome, then, from late in the eighteenth century in Cobham Hall in Kent, home of the Earls of Darnley, and finally in New Iberia, Louisiana, in the United States, latterly on a pedestal in a glass atrium outside a bank, the statue is a heavily restored pastiche, only the head of which is definitely ancient.[101] But the catalog is quick to bundle Greek origins back in again: under Hadrian, "there was a return to a form of Augustan classicism in portraiture. . . . Probably reflecting his philhellenism, or love of all things Greek, Hadrian introduced the wearing of a beard."[102] Levett is also funding further investigation of the Pantanello or "little bog" of Hadrian's Villa, a site Gavin Hamilton had mined in the eighteenth century, and, together with the Leverhulme Trust and the Shelby White–Leon Levy Program for Archaeological Publications, the British Museum's project on the Greek trading post of Naucratis, Egypt.[103] The catalog's opening essay observes:

> It is a curious irony that the concept of philanthropy, as expressed in the

classical art of the Levett Collection in Mougins, derived from ancient Greece. Writing in the Classical Greek period some 2500 years ago, the Greek playwright Aeschylus—whose portrait is displayed on the ground floor—mentioned '*philanthropos*' in *Prometheus Bound* and the term was subsequently adapted by the ancient Greeks as the essence of civilisation—of benefit to humanity according to Plato.[104]

Ironic or not, there is nothing surprising about this statement. It is anticipated by Ortiz:

> Most of the politicians in the West have forgotten their mission and consider politics a career; their ego projections, self-interest and power more important than their call to serve humanity.[105]

It is also anticipated by the rhetoric of the "Greek Miracle" exhibition, held at the National Gallery of Art in Washington and at the Metropolitan Museum in 1992–93, and the opening statements of the prime minister of Greece and the president of the United States, each of whom hymned "the value of the individual" and "shared democratic heritage."[106] There, thirty-four original Greek works, twenty-two of them lent by Greece, displayed "the development of the Greek classical style" and "the birth of democratic ideals."[107] Style is always political, and admiration of Greek art something that was seen as transcending race and class to bind people together. The Chatsworth Apollo, by then in the British Museum, was again a key exhibit and the emphasis this time (in the text and six images) on the enchantment of its technology (9.11): "The

9.10. Hadrian, marble, h 208.2 cm. Mougins Museum of Classical Art, inv. no. MMoCA.214. Photograph: courtesy of the Museum.

eyes were once inlaid with colored glass or stone, the right eye retaining the metal casing that was cut to represent the lashes. The reddish hue of the original copper lips would have contrasted with the golden sheen of the bronze."[108] In that initial encounter, everyone should feel humble.

In Mougins, everyone should also feel better equipped to appreciate the postantique and contemporary art that jostles the ancient exhibits. On the first floor, for example, a marble cinerary urn of the first century CE that the catalog tells us was illustrated in a Piranesi volume, and a marble double-headed herm of Bacchus and Ariadne, frame a bronze figure by Rodin, one of the "Shades" that overlook the tormented souls on his *Gates of Hell* (9.12).[109] In doing this, they supply the figure with an alternative funerary context: Bacchus, who appears more than once in the gallery,

was a god of mysteries who conveyed hope of rebirth.[110] They also prepare the visitor for the abstract and figurative forms in the case beyond. Here (9.13), Yves Klein's *Blue Venus* sculpture, conceived in 1962, if not cast until later, shares the space with four Roman statuettes of the goddess in bronze and marble, and with Salvador Dali's *Venus as a Giraffe* of 1973, and, added since the photograph was taken, Paul Cézanne's drawing of the Venus de Milo (1872–73). Behind them, Andy Warhol's screen print of the *Birth of Venus* drives the reproduction and fragmentation points home, highlighting, in its reverence of Botticelli's famous painting, one of the statuettes in particular, that of the type that is the "Anadyomene" (rising from the sea).[111] As we follow her gaze out of the cabinet toward the plinths, the darkness of Warhol's *Venus* takes us first to Beth Carter's bronze *Minotaur*, made in 2013 and now seated between the case and the base of the herm, and then to Rodin's *The Shade*, the patina of which shines amid the marble. There is no longer anything

funereal about him or the urn to its left, if there ever was in this company.[112] The latter is as curvaceous as Klein's *Venus*, its foliage picking up the ivy-clad Bacchus and his consort. We remember Piranesi—Venus is not the only antiquity to have inspired artists.

Juxtaposing objects magnifies their aesthetic qualities.[113] But at Mougins, these juxtapositions afford more than detailed description or new angles; they plot the inextricable interrelatedness of Greek and Roman art, ancient art and modern art—not as a linear narrative, but as a web of suggestiveness. "Influence" is too weak a gloss for the relationship between Klein's Venus and the marble torso next to it—and also overly exclusive. The power of each of them, and with it, the ongoing "relevance" of the classical, is not so much bolstered by the existence of the other as it is proven. Not just Picasso (1881–1973) but Francis Picabia (1879–1953) and Jean Cocteau (1889–1963) spent time in the village, and are represented in the collection.[114] And thus far the venture is a success. In 2013, the Musée d'Art Classique de Mougins was the only French institution to be nominated for the European Museum of the Year.[115]

"Classical art," as defined by Levett, is alive and well, but then Mougins's proximity to the French Riviera and its popularity during the Cannes Film Festival make it a peculiarly moneyed and arty kind of place (there are even yacht and real estate advertisements in the back of the catalog). That said, ask what my local museum, the Fitzwilliam, has done to its collection recently, and one gets a complementary picture. The only recent acquisition of note to have made it into the Greek and Roman gallery is a relief of dark gray limestone, punctuated with niches and decorated with scenes from Greek mythology including

9.12. View of the first floor of the Mougins Museum of Classical Art. Photograph: courtesy of the Museum.

9.13. Further view of the first floor of the Mougins Museum of Classical Art. Photograph: courtesy of the Museum.

Dionysus and Odysseus and the Sirens (9.14). Found in the Pantanello of Hadrian's Villa by Hamilton in 1769 and then shipped to the Earl of Shelburne, where it was installed as the mantelshelf of a chimney piece in the main gallery of Lansdowne House, it was first loaned to the Fitzwilliam before being bought with the help of the Heritage Lottery Fund in 2012.[116] There it joins three other artifacts from Hadrian's Villa: the bust of Antinous, which Hamilton had also acquired for the Lansdowne collection but which, latterly, was owned by Ricketts and Shannon, and two pilaster capitals, formerly in the collection of barrister and art collector John Disney (1779–1857).[117] When the Fitzwilliam's Greek and Roman collection was redisplayed in 2010, the division of the museum into departments meant that introducing postantique works, such as Titian's *Rape of Lucretia*, Batoni's portrait of the fourth Earl of Northampton, Renaissance bronzes, or Wedgwood pottery was a step too far. But an emphasis on the collectors as well as the markers of artifacts, and on multiple contexts, ancient and modern, meant that these kinds of object histories were told, stressing continuities.

This display too is a success: the Greek and Roman cases are among the most popular in the building and issues of ancient craftsmanship, materials, polychromy, and function given as much airtime as issues of collecting, restoration, forgery, and conservation.

> In terms of the way the objects are organised and the narratives constructed by the displays there is a clear engagement with new scholarship . . . the redisplay attempts to construct a biography of each object or group by highlighting the role of people in the creation of meaning. The redisplay also focuses on making the processes of the museum transparent.[118]

The display is an object lesson in museology as well as in classical art and classical antiquity.

Classical art and Greek and Roman antiquity need not be at odds with one another. Yes, there must be an acknowledgment that there are those artifacts that "classical art" does not reach, as well as an acknowledgment that those it reaches, it warps. But we might also acknowledge that "warping" is concomitant with admiration, collecting, excavation, and studying, and that in fixating on some artifacts and downplaying, or downright rejecting, others, societies, or sections of society, from Ptolemaic Alexandria and Attalid Pergamum to Renaissance Italy to Enlightenment Europe and on into Victorian England, turned themselves from peoples to "culture(s)," and honed, and handed on, the image of Greece and Rome that we are working with today. Divisive this may have been; inflated most certainly, but it is also fortuitous. Without it, there would be no "heritage" to handle knowingly, or conscientiously.

We can keep Greece and Rome separate if we want to. But to define Greek "art," "artifacts," or whatever we want to call them, as those objects found on what is now Greek soil is to tell but a partial story and one that still creates false homogeneity. From the vantage point of Republican Rome, vast swathes of material culture produced across the Mediterranean, not to mention as close to home as Pompeii and Herculaneum, looked "Greek," but on the ground at Olympia or Delphi, Athenian dedications looked Athenian and Naxian dedications Naxian; the latter were even

made of Naxian marble. "Greek" meant something different in Rome from in the Byzantine or early modern world, different again after Greek independence.

Restricting the "Greek" content of books on Roman art to "Augustan Classicism" or "Classicism in the Second Sophistic" is similarly reductive. The copies found at Hadrian's Villa are but the tip of the iceberg; copies are more than totems of a "distinctive archaism" or "revival of Greek culture" seeded in Roman oratory and literature.[119] They were raw material *and* finished product, as Roman as they were Greek, and instrumental in shaping the "imperial" imagery and "freedmen art" with which they were in dialogue, just as they then shaped late antique art and, through ongoing display and increasingly explicit investment, western, even Chinese, sculpture and painting. If the hellenistic period had already made Greek sculpture and painting "art," then in Rome, this art increased in popularity and prestige, attracting Roman production (altars, columns, portraits, gems, coins) into its orbit. "When Romans discuss art in their literature, as they quite often do, 'art' for them means *Greek art.*"[120] Although few, if any, collectors today attempt to collect only Greek art,[121] they are driven by its Keatsian cachet.

Collectors are not the enemy, any more than art is the enemy. Private collectors and the patronage and collecting activities evidenced throughout this book are but part of a broader canvas of appropriation, repudiation, and response that witnessed sculpture being carted from Greek sanctuaries to Republican temples, from Rome to Paris, and from Athens, Bassae, and Bodrum to London. It saw artists restore and sketch this sculpture, making it the basis of their own creations, some of them truer to their models than others, a few so close as to trick their buyers and pass as originals. There is less of a gap than we might think between smoothing down surfaces and adding attributes so as to turn ancient marbles into a Hercules or Ganymede (8.31), and smashing or sawing up looted antiquities so as to send them, undetected by customs, across the Atlantic. Rendering them in polystyrene, or with a gazing ball or Mao suit, as Darbyshire, Koons, and Sui Jianguo have done, is reverential in comparison.

The admiration and acquisition of Greek and Roman antiquities have always been ethically problematic and explicitly debated, and these debates formative of

9.14. The Lansdowne Relief, found at Hadrian's Villa at Tivoli, c. 100–150 CE, marble; h 56 cm. The Fitzwilliam Museum, Cambridge, inv. no. GR.1.2012 (formerly in the collection of the Earl of Shelburne). Photograph: © The Fitzwilliam Museum, Cambridge.

"classical art's" status. We can hive collectors off, if we want to, cull many of the works that have made the "classical art" grade from our syllabuses, or leave them to those interested in the reception of antiquity and of classics as a discipline. But this is to sideline two thousand years of investment; and it would be disingenuous, given that the galleries of the Fitzwilliam and Metropolitan Museum, which "reveal classical art in all its complexity and resonance,"[122] are well visited, and that the British Museum's Greek and Roman Life display, now thirty years old, in contrast, feels a little jaded.[123] "Classical art" is still with us; and still evolving, contributing to culture, and to discussions of what constitutes culture, as it does so. Understanding what is classical and artful about classical art has led us across millennia, back to the fifth century BCE. Far from producing a nostalgic narrative, the lessons learned from looking back ensure that we keep traveling.

10

And the Moral of the Story . . .

This is, and was only ever destined to be, *a* life history of classical art. Other narrators would have emphasized different parts of the life, making it less British, more obviously political, with a greater emphasis on medieval Rome, or imperial Russia, or a wider reach into Gandhara or Mughal India. Inevitably, one has to make choices, and often, as in the chapter on the English country house, I have privileged areas where much work has been done, so as to experiment with what happens when one puts that work into a longer history. It was never my intention to write a synthesis or survey, but a biography or travelogue—a mapping not of facts, but of the ways in which Greek and Roman artifacts experience history. As these artifacts interact with different peoples and places, a shifting subset—or canon—emerges with a distinct personality, and it is this personality that has been our subject. In identifying the distinctive character and charisma of classical art, we can better assess its paradigmatic status.

The longue durée approach of this book is what marks its contribution. Classical art existed before it was christened as such, and survived Christianity and the fall of Rome and Byzantium, the French Revolution, the rise of modernism and fascism, to live on in galleries and auction rooms and make the heart soar, and the blood boil, today. The continuum of classical art offers an accumulation of values that invites us to measure our subjective and scientific categories against those of other periods. Winckelmann's "homoerotic encounter" with the Apollo Belvedere, "surely one of the most inspired and often-quoted texts in the entire history of artful writing about art,"[1] turns out to be a more studied form of Nicola Maffei's epistolary enthusiasm for the statue, which taps the Pygmalion myth that had already dictated how Master Gregory described a marble Venus. This "way of seeing" was live, and gendered, in the third century BCE, when Theocritus's female viewers of tapestries were struck by "how realistically" the figures stand, "and even dance, as if alive, not woven."[2] And it became art historical discourse as the "lifelikeness of the poetically evoked image"[3] was excavated from its ecphrastic context, and applied to greater numbers of actual artifacts.

Alongside continuities, we have witnessed discontinuities. The Vatican of the eighteenth century was a different place from the Vatican of Maffei's day, and in a different world, in which being a man, never mind an art-loving man, was unlike what it had been. What counts as classical art had changed. For every Apollo Belvedere, which hangs on to its status, attracting tourists with their camera-phones, even as it has fallen out of favor with the exam

boards, there are other seventeenth- and eighteenth-century favorites (Louis XIV's "Vestal" from Benghazi, for example), which have the lifespan of drosophila. The arrival of the Parthenon sculptures in London causes more ripples than most; the discovery of Tanagra figurines, archaic statuary, and Bronze Age artifacts from Mycenae and Knossos expanded and distorted Greek art's remit; the freeing of Roman art from hellenism's shackles purified it. The Apollo Belvedere preserves some prestige, not because of what it is, or where it was carved or found, but because of what it was, what it inspired, and what the exemplarity it accrued has made it: we remember Rubens's *Council of the Gods*, Batoni's portrait of Sir Wyndham Knatchbull-Wyndham, Sergel's statue of Gustav III, and MacPherson's albumen print. It is not simply that each period finds new heroes from an expanded set of artifacts. In engaging with the artworks canonic in the previous generation, each period starts from a distinct position.

What are we to make of this nexus of change and continuity? Currently, one of the most productive ways that scholarship has of working with Greek and Roman artifacts is to use the language of "material agency" and talk about the "affordances" of objects (i.e., the properties that they have in relation to their environment, but independent of the needs of the observer). Arguably, it is a language that rescues them from value judgments and gives them control over their own destiny. Yet this book too is about agency and affordances. In the same way that affordances are not absolute, so the "agency" of objects depends not only on their formal characteristics (shape, design, iconography, workmanship) and on their materiality, but also on their freedom to

act. As far as classical art is concerned, this freedom is granted by the society, or the privileged few in society, that controls the selection process, and the access.

In this way, the meaning of style ("classical" or otherwise) is not a given. Any select group of artifacts, and the antique it mourns or conjures up, is bound by communal concerns, whether practical constraints, forward-thinking ambition, or backward-looking cultural memory.[4] We need only weigh Rome's embrace of Praxiteles's sculpture against that of Pergamum, or of Constantinople, with the spread of Christianity, and the denigration of polytheism that that brought with it, or think about Napoleon transferring the Apollo Belvedere and Laocoon to a city in which, if classicism spelled anything, it spelled Louis and the ancien régime. The saving grace was that they joined a palace, the Louvre, that was now a public museum. But even then, plaster arms after those made a century earlier by Girardon, restorer of the Venus of Arles, were added, and a national competition was planned to find an artist to restore the sculpture definitively in marble.[5] These were complex negotiations, recognition of which also restores classical art's dynamism by seeing it always in conversation with its former self. To claim that each period gets the classical art it deserves is too passive. It inherits centuries of baggage and repackages classical art by restricting or developing its affordances or avenues.

Only by being immersed in this idiom can we appreciate what classical art has to offer us. When the curators at the Munich Glyptothek removed Thorvaldsen's restorations from the Aegina pediments, they did not so much take them back to a pristine state as out of the feedback loop, rendering them damaged goods. It was

not a restriction of avenues or a change of direction that was being enacted here, but a refusal to speak the language, or rather an insistence that the only language worth speaking was an academic one. Where did this leave historical imagination, popular imagination? The lack that the Aegina pediments embody is a different lack from that of the Venus de Milo, which asks always to be completed, not opportunity but deprivation. In 2011, the Glyptothek marked the two hundredth year of the pediments' discovery by putting new versions of Thorvaldsen's restored figures on display.[6] They had relearned the lingo. For art to be "classical," it has to know its place in the discourse.

What does a work of art know?[7] The past life of classical art has been so eventful, its experiences so life-changing and its impact so momentous, that it knows a formidable amount. Knowledge is power. It is also dangerous. In the hands of Renaissance dynasts, classical art was as powerful a weapon as Christian imagery. Today, classical remains like those at Palmyra are fiercely fought over. In consumerist culture, the battle is between those who make classical art a language of globalization in perfume and clothing advertisements and those who want to keep it on its pedestal. But, as this book has repeatedly shown, classical art knows too much to be tied down. Indeed, when anyone thinks they have succeeded (and we need only think of "neoclassicism"), it wriggles free to mount a challenge.

Often, the most iconoclastic experiments in classical art are the most invigorating, and I think here not only of the sculptures of Rodin and Archipenko but of Sui Jianguo and Koons's contemporary artworks, through which the classical speaks of a vaster universe—of Communist repression and of sensory perception more generally.

Of a companion set of old master paintings with gazing balls, Koons writes, "These paintings are stronger for being together with the gazing ball—if you removed the gazing ball they don't have the same power, they don't have the same phenomenology." Koons's revised canon foregrounds the structures of consciousness that looking enables, and connects him with the canons of the past, in the case of his sculpture series, a canon shaped by centuries of artists, worshippers, dynasts, scholars, collectors, diggers, dealers; by politics, local and national; and by questions of competition, access, morality, beauty—but with daring additions (e.g., *Gazing Ball [Stool]* and *Gazing Ball [Snowman]*). He continues, "I enjoy participating in the dialogue."[8] So has this book. In tapping classical art's life story, it throws down its own challenges. Classical art has plenty left to say. Let us not let our search for certainties stifle it.

NOTES

Preface

1. As discussed by Settis 2006: 18.
2. For detailed and nuanced accounts of the "classical" and "classicism" in their manifold and shifting meanings, for the place of Greece, Roman, and other cultures therein, and for the notion of the "classical" and "classicism" in antiquity already, see Settis 2006, 2010, and 2015 and Porter 2006.
3. See, e.g., Güthenke 2008.
4. I. Jenkins 2006: 8.

Chapter 1: Setting the Agenda, or Putting the Art into Heritage

1. A favorite passage with archaeologists: see, e.g., Hodder 2012: 58 citing a version from Grosz 2005: 132.
2. See, e.g., Chippindale and Gill 1993, Vickers and Gill 1994, Shanks 1996: 59–65, S. Scott 2006, and Whitley 2001 and 2013. For critique of this position, Squire 2010a and 2012, and Vout 2012a.
3. For a full account of Harmodius and Aristogeiton's killing of the Athenian tyrant's brother, Hipparchus, in 514 BCE, and the statues erected in their honor, see Brunnsåker 1955, republished with postscript and bibliographical addenda 1971, and Azoulay 2014.
4. Mattusch 1988: 119–21. Note that the earliest extant source to ascribe them to Kritios and Nesiotes dates from the second century CE (Luc. *Philops.* 18) and that the first author to give the name of either—Pausanias (1.8.5)—credits only the former.
5. Roman "copies" and their makers have been rehabilitated of late to be taken seriously in their own terms rather than dismissed as slavish, or interesting (only) for what they remember of the Greek statues on which they are based: see Marvin 1989, 1993, 1997, and 2008, Bartman 1988 and 1992, Gazda 1995a, 1995b, and 2002, E. E. Perry 2005, Trimble and Elsner 2006, Tanner 2006: 277–301, Kousser 2008, Junker and Stähli 2008, and Anguissola 2012.
6. Paus. 1.8.5. For a full list of sources on Antenor's Tyrannicides, see *DNO* 382–88.
7. The group is sometimes said to have been found at Hadrian's Villa at Tivoli but this is a result of confusion (Gasparri 2009: 181; Schuchhardt and Landwehr 1986: 86), and its continued propagation part of a wider tendency to associate early sculptural finds with Hadrian, the ultimate "philhellene." We shall return to Hadrian later.
8. See below, n. 31.
9. *AQA GCE, AS and A Level Specification, Classical Civilisation, for Exams from June 2014 Onwards*: 6. Woodford 1986: 80–83 and fig. 111 with most caution, Boardman 1993: 92, fig. 81, and Neer 2010: 78–79, fig. 38, and 2012: 199, fig. 8.3. Also W. Fuchs 1969: 337–41, figs. 374–75, Pedley 1993: 216, fig. 7.20, Spivey 2013: 136–39, fig. 5.9, Barringer 2014: 184, 203–4, and fig. 3.50, and Stansbury-O'Donnell 2015: 109, 238, and fig. 5.9. A. Stewart 2008: 70–75, fig. 34 reproduces a reconstructed plaster cast of the Tyrannicides from the Museo dei Gessi in Rome as well as the Naples group (fig. 5).
10. The Naples group is probably of the Hadrianic-Antonine period: Schuchhardt and Landwehr 1986.
11. Neer 2010: 78 citing A. Stewart 1997: 245, alluding to Ridgway 1970: 12, who describes 477 BCE as "the legal birthday of the Severe style."
12. For the other sculptural fragments, see Brunnsåker 1955: 47–83, and Schuchhardt and Landwehr 1986. Landwehr (1985: 43–47) preferred to see ancient plaster casts found at Baiae (below, n. 49) as from the Antenor group (and for criticism of this view and its implications for the Roman marble versions, Krumeich 2007: 8–

14, esp. n. 28, although who knows how similar the Antenor group was?). For the versions in the minor arts, Brunnsåker 1955: 99–125 and Schmidt 2009. These versions show that in the Naples group, Harmodius's right arm has been wrongly restored and should bend backward over his head, hence, why A. Stewart (n. 9) illustrates the cast in his 2008 publication. The fourth-century BCE Elgin Throne is now in the Getty Villa in Malibu, inv. no. 74.AA.12: for the problems of establishing its provenience, see Frischer 1982: 250–61 and, for Elgin's collection, A. H. Smith 1916.

13. *Marmor Parium*, *FgrH* 239 A 54, without names of the sculptors (standard edition, Jacoby 1904 and now, Chaniotis 1988: 87–89), although it also conflates (*FgrH* 239 A 45) their assassination of Hipparchus with the expulsion of the tyrants from Athens, pushing its date from 514/13 BCE to 511/10 BCE.

14. IG I³ 502: Brunnsåker 1955: 84–98, Thompson and Wycherley 1972: 155–60, and *DNO* 561.

15. See, e.g., W. R. Connor 1970, J. P. Barron 1972: 39–40, Harrison 1972, M. W. Taylor 1981: 111–58, T. Carpenter 1997, and Tanner 2006: 184–87. Shefton 1960 is also important here, not least for noting that Harmodius's famous pose, the so-called "Harmodius blow," predates Harmodius.

16. Lullies 1957: 49. Although this is not a straightforward story of evolution either. The revised and expanded German edition of Lullies (1979) does include Roman versions and the Tyrannicides (pp. 67–68), though it privileges Aristogeiton, and not the Naples version, but one discovered in Rome (fig. 1.13). For more on twentieth-century's scholarship's embrace/rejection of Roman versions, see below, ch. 9, and for the christening of the Kritios Boy, Furtwängler 1880a: 34.

17. See Hurwit 1989.

18. The bases with both signatures are Raubitschek 1949: nos. 120–23 and 160–61. See now *DNO* 564–69.

19. Chamoux 1955: 78–82, and criticism by Ridgway 1970: 33.

20. Helpful on attribution studies are Shanks 1996: 59–65, Palagia 2010a, Snodgrass 2012: 13–23. Overbeck's *Die antiken Schriftquellen zur Geschichte der bildenden Künste bei den Griechen* (1868), of which *DNO* is an expansion and revision, is exemplary of these studies.

21. Friederichs 1859, after von Stackelberg 1837: 33–35, who had already identified the Tyrannicides in the minor arts, and, for the Doryphorus, Friederichs 1863.

22. The influence of Ernst Gombrich 1959 is important here: see Vout 2014.

23. See also the Riace Bronzes, of similar date, which were found off the coast of Riace in 1972 (National Museum of Magna Grecia, Reggio Calabria, inv. nos. 12801 and 12802): Arias 1984, although note the objection with regard to their date of Ridgway 2002b. Also interesting here are the Apoxyomenos recovered from the sea off Croatia and restored in 1999 (probably c. 300 BCE in date): I. Jenkins 2015: 66–67, and the hellenistic or Roman dancing satyr found by fishermen off the southwestern coast of Sicily in the 1990s, and now in the Museo del Satiro, Mazara del Vallo, Sicily: Moreno 2003 and Andreae 2009.

24. Neer 2012: 236, because its clay core reveals Attic manufacture.

25. The statues became part of the Farnese collection upon the second marriage of Margaret "Madama" of Parma (1522–86) (whose first husband was Alessandro de' Medici) to Ottavio Farnese. See Gasparri 2009: cat. nos. 84 and 85 and Riebesell 1989: 41–58, esp. cat. nos. 5 and 10. On the Farnese Hercules (National Archaeological Museum, Naples, inv. no. 6001), see Moreno 1995: 416–94 and Gasparri 2015.

26. Bartman 2015: 15–20.

27. For an overview, Haskell and Penny 1981, and for an introduction to, and overview of, the ancient statuary in the Vatican's Belvedere Courtyard, Winner, Andreae, and Pietrangeli 1998.

28. Stoneman 2010: esp. 47–49 and Grafton 2010: 168. For the marbles more generally, Haynes 1975 and below, ch. 6, and, for Arundel's excavations in Rome, Hervey 1921: 84–85 and 132, and White 1995: 15–18.

29. Parry 1989: 120. Selden's catalog, the *Marmora Arundelliana*, was written in Latin. Note, however, how the display of the inscription was far from exemplary: first, the fragments were in the garden of Arundel House and the upper half soon made into a hearthstone and lost. Then, in 1667, the remaining fragment was moved to the "Garden of Antiquities," again outside, in Oxford, where it suffered more damage (Bodel 2014: 440 and Liddel 2014: 388–90).

30. The Dying Gaul was also known in the Renaissance as a "gladiator": Haskell and Penny 1981, cat. no. 44.

31. Barkan 1999: 174–75 and inventories from 1566 onward (Gasparri 2009: 180–81).

32. Gasparri 2009: 180–81.

33. For the "discovery of archaic sculpture," see Prettejohn 2012: esp. 181–256.

34. First published 1556, then 1558 and as an appendix to Mauro 1562: 182: "una bellissima statua . . . ma le mancano le braccia e la testa."

35. See Brunnsåker 1955: 48–51 and Gasparri 2009: 181.

36. Winckelmann 2003: 69, lines 7 10 (and rather less effusively on "Harmodius": 68, line 19) refers to each of them as "ein Fechter," a fencer. On the Horatii and Curiatii identifications, see the inventory of 1697 (Fiorelli 1878–80, vol. 2: 380) and Rausa 2007: 21. On the link to the painting, see A. Stewart 2001.

37. See previous note: "Der Kopf ist herrlich und einem jungen Herkules ähnlich."

38. Gasparri 2009: cat. no. 73, where it is today identified as "Meleager." Also A. Stewart 2001: 216. The Farnese collection began to be moved to Naples in 1787 where it was again restored.

39. Frazer 1898, vol. 2: 96.

40. Treu 1897: 194–206, pls. 49–52. The fact that Pausanias (5.17.3) mentions seeing a Hermes at Olympia by Praxiteles has led many scholars to think it an original fourth-century marble. See Borbein 2007.

41. Amelung 1922. This head is added in 1929.

42. Settis, Anguissola, and Gasparotto 2015: cat. no. SC 44, and Germini 2008: 27–42. For the discovery of the torso, see Colini 1938; also Schuchhardt and Landwehr 1986: 111–26; and for what it might have been doing on the Capitol, Azoulay 2014: 189–95.

43. Barkan 1999: 119–231.

44. Frazer 1898, vol. 2: 96.

45. Thuc. 6.54–59. See A. Stewart 1997: 70–75.

46. Frazer 1898, vol. 2: 96.

47. A. Stewart 2008: 73.

48. Luc. *Philops.* 18. Also Luc. *De parasito* 48.

49. Landwehr 1982: nos. 7–19 and above, n. 12. These were among hundreds of fragments found in the fill of a cellar room in Baiae's Sosandra Baths. On the Discobolus, see Anguissola 2005 and I. Jenkins 2012, and for the Diadumenus, Kreikenbom 1990.

50. See below, ch. 3.

51. Tanner 2006: 212–46.

52. Plin. *HN* 34.70 when Praxiteles's accepted *floruit* is 375 to 330 BCE. Also 34.86, which attributes a Tyrannicide group to Antignotus, though this may be an error introduced in the manuscript tradition. On the productivity of reading Pliny through the lens of "error" and "errare," see Vout 2018 and for an alternative solution, concerning the Antenor group's restoration and copying, Brunnsåker 1971: 185.

53. Ashworth 1996: 33–35.

54. See above, n. 5.

55. Plin. *HN* 34.17, and on the Tyrannicides as portraits, Tanner 2006: 136.

56. Shanks 1996: 59.

57. On the impossibility of writing about "*the* Enlightenment" as a unified and universal movement, see, e.g., Pocock 1999 and the response by J. Robertson 2001 and 2005.

58. Kristeller 1951 and Shiner 2001, and in response, Porter 2009a and 2009b and, with a specifically "classical art" emphasis, Squire 2010a.

59. See, e.g., part 2 of Friedland and Sobocinski, with Gazda 2015, Kristensen and Poulsen 2012, and Heilmeyer 2004.

60. Squire 2010a and Tanner 2006.

61. Tanner 2006 and Platt 2010 and 2011.

62. See, e.g., Beagon 1992, Carey 2003, Gibson and Morello 2011.

63. On the problems of applying the word "patron" and its Renaissance baggage to antiquity, see W. V. Harris 2015: 402–4.

64. As Squire acknowledges (2012: 471), "Classical art is 'Classical' because it is not simply done and dusted, rooted in the past, but rather part of an ongoing western tradition."

65. Haskell and Penny 1981. This book is currently being revised and expanded for republication soon.

66. Bounia 2004, Mango, Vickers, and Francis 1992, Christian 2010a, Di Dio and Coppel 2013, Guilding 2014. Also relevant are Higbie 2017, Rutledge 2012, Bassett 2000, Cavallaro 2007, and Coltman 2006 and 2009.

67. See, e.g., E. L. Thompson 2016a and the review by T. Jenkins 2016a.

68. Compare, e.g., D. E. Strong 1973, Beaujeu 1982, Rouveret 1987, and Rutledge 2012 with Hölscher 2006a: 41–42.

69. Bounia 2004: 1 and Elsner 2014a: 156. Important here on defining "art collecting" as opposed to patronage of the arts and on arguing for the former as well as the latter in only a handful of cultures in history including hellenistic Greece and Rome is Alsop 1982. For Alsop (p. 37), "'Art-as-an-end-in-itself' has always characterized the rare way of thinking about art that gives rise to art collecting" and (p. 93) "The potential usefulness of a work of art is never a serious consideration for a true art collector, as compared to the work's inherent qualities."

70. Scholars still disagree about when after the tyrants' expulsion from Athens, usually set at 510 BCE, the group was erected. Azoulay

2014: 43–48 prefers a very late date, in the context of the Median War post-Marathon.

71. Val. Max. 2.10. ext. 1.1, Arr. *Anab.* 3.16.7–8 and 7.19.2, and Mattusch 1988: 88.

72. See, e.g., Keesling 2003 and Arrington 2015.

73. Although note Landwehr, above, n. 12.

74. Ar. *Lys.* 630, first performed in 411 BCE.

75. Paus. 1.8.5.

76. Azoulay 2014: 41.

77. See T. L. Shear 1994.

78. Azoulay 2014: 40: "Les rares fois où les statues sont évoquées, c'est moins pour leur intérêt intrinsèque qu'en raison de leur destin ultérieur—leur capture par les Perses."

79. See Schmidt 2009 and J. L. Shear 2012a: 109–11.

80. Brunnsåker 1955: 99–100.

81. Lissarrague 2004 and 2009.

82. Schapiro 1953: 291.

83. My thinking here is heavily influenced by S. Stewart 1984.

84. Arr. *Anab.* 7.19.2 and Palagia 2008. Palagia's article raises the additional issue of the Greek marble statue of Penelope, found at Persepolis in 1945, and now in the National Museum of Iran, Tehran, inv. no. 1538. This statue, however, is too late in date (c. 450 BCE) to have been part of the same booty and was more probably a gift. Now see also Hölscher 2015.

85. Plut. *Them.* 31.1.

86. We do not know whether the statue of Artemis (above, n. 84) was bronze, but the statue of Apollo that the Persians took from Miletos was: Paus. 1.16.3, 2.10.5, 8.46.3, and 9.10.2. Also interesting on the question of why is Gruen 2011: 51–52.

87. Note Moggi 1973, who thinks the story of the Persian theft a hellenistic invention of tradition.

88. Plin. *HN* 34.70 and Arr. *Anab.* 3.16.7–8 and 7.19.2. On Alexander's philhellenic cause, see, e.g., Diod Sic. 16.89.2.

89. Val. Max. 2.10. ext. 1 and Paus. 1.8.5. Although note Seleucus's gift of a tiger or tigers to the Athenians: see Habicht 2006: 155–56.

90. Note too the Ptolemaic recovery of Egyptian statues stolen by the Persians, their return celebrated in Egyptian honorific decrees: Winnicki 1994.

91. Val. Max 2.10. ext. 1: nihil hac memoria felicius, quae tantum uenerationis in tam paruulo aere possidet.

92. A. Jones 2007: 19.

93. There is some disagreement about where in the Agora the Tyrannicides stood: see Keesling's 2015 review of Azoulay, and on their isolation

and their setting as "representational space," Ma 2013: 104–21.

94. Dem. 20.70: ὥσπερ Ἁρμοδίου καὶ Ἀριστογείτονος, ἔστησαν πρώτου· ἡγοῦντο γὰρ οὐ μικρὰν τυραννίδα καὶ τοῦτον, τὴν Λακεδαιμονίων ἀρχὴν καταλύσαντα, πεπαυκέναι.

95. Dem. 20.69 and on the possible placement of this inscription next to the statues, J. L. Shear 2007: 107. Also important here is the language used by Isocrates to describe their joint achievement: Isoc. *Evag.* 56.

96. How "like" depends on whether the Tyrannicides were in the northern sector of the Agora near the "crossroads enclosure" (Keesling 2015) or farther south, some 100 meters away from Conon and Evagoras: compare J. L. Shear 2007: 107–8 and 2012b: fig. 2 and Azoulay 2014: 126–29 and figs. 19 and 23. Also relevant here is Ajootian 1998: 3–7.

97. See Dillon 2006: 101–2 and A. Stewart 1979: 121–24.

98. *IG* II² 450, 25–34. See also Bayliss 2011: 121.

99. Diod. Sic. 20.46.2, Bayliss 2011: 120–21, and M. W. Taylor 1981: 26.

100. *IG* II² 646, 40–42 in 295/94 BCE.

101. See Azoulay 2014: 170–75, although again note Keesling's warnings above about the exact position of the Kritian group.

102. Dio Cass. 47.20.4: ὡς καὶ ζηλωταῖς αὐτῶν γενομένοις, ἐψηφίσαντο.

103. The seemingly harsh realism or "verism" of Roman Republican portraiture is at odds with the idealism associated with archaic and classical Greek sculpture: see below, ch. 3, n. 9.

104. On the Acropolis korai, see Stieber 2004 and Keesling 2003, and on Delphi, M. C. Scott: 2010: 29–145.

Chapter 2: Finding the Classical in Hellenistic Greece

1. Paus. 10.7.1.

2. See Pausanias's explicitly negative statement at 9.27.3–4.

3. On the range of dedications, see Boardman 2004, and for mirabilia such as sea monsters, A. Mayor 2000.

4. Whitley 2001: 136; also, 146.

5. The Delphi Charioteer is traditionally, though not universally, thought to have been damaged by the earthquake of 373 BCE and buried, hence not being on display when Nero was on his mission: for detailed discussion of the piece

and bibliography, see Mattusch 1988: 127–34. A statue base (Delphi Museum, inv. no. 3517) inscribed with the name of Polyzalos of Gela, whose wife was the widow of Gelon, who had refused to help the Greeks resist the Persian attack in 480 BCE unless he was put in charge (Hdt. 7.158), is associated with the statue, and its dedicatory formula written over the rasura of a previous inscription now thought by some to be in honor of Polyzalos's brother and predecessor, Hieron. For the inscription, *FD* III 4 452, and for the most skeptical recent reading of the "ensemble," Adornato 2008. See also Rolley 1990, M. C. Scott 2014: 123, and K. Morgan 2015: 75–80.

6. Duncan-Jones 1994: 9, n. 66.

7. Odysseus: Paus. 5.25.8, Eros: Paus. 9.27.3 and Varner 2015a: 164, and Hydna: Paus. 10.19.2.

8. Chamoux 1955: 52–53, Homolle 1897: 195, n. 4, Houser 1987 (abstract of paper), and Rolley 1990: 287–89.

9. The group was positioned in a relatively unpopulated part of the sanctuary, somewhere on the slope north of the temple, opening up a whole new section for dedications: M. C. Scott 2010: 89–90.

10. It is usually assumed (e.g., Neer 2012: 233) that the chariot group celebrated a chariot victory in the Pythian games, but as with almost everything else about the statue, this is not certain.

11. On this "war of monuments," see Mylonopoulos 2006 and S. Hansen 1996 and on the "aesthetics of crowding," Vout (forthcoming).

12. Bronze Apollo: Hdt. 8.121 and Paus. 10.14.5 (M. C. Scott 2010: 321, ref. 103); small, earliest Apollo dedication: Paus. 10.16.8 (M. C. Scott 2010: 310, ref. 1); colossal Apollo: Paus. 10.15.2 and Diod. Sic. 16.33.1 (M. C. Scott 2010: 328, ref. 166); chryselephantine Apollo, buried after 420 BCE: Lapatin 2001: 57–60; and multiple marble Apollo dedication commemorating the Liparean victory over the Etruscans: Jacquemin 1999: 121–22 and M. C. Scott 2010: 92 and 322, ref. 116.

13. Paus. 10.15.1.

14. Gell 1992.

15. Paus. 1.24.3. For Riace statues A and B, see ch. 1, n. 23.

16. R. Osborne 2010 and Alsop 1982: 181–83.

17. See Stieber 2004: 141–78, and on the "skirt-tugging" gesture, Sourvinou-Inwood 1995: 241–42.

18. Tanner 2006: 161–70.

19. Steiner 1998: 137: "No different from the sculptor, Pindar presents us with victors who are the epitome of loveliness and other idealized accounts of the human form" and p. 142: "these homologous physiques in verse and stone, and the engaged or 'cathected' spectatorship that poetic and artistic conventions and motifs seem deliberately to prompt." Although note too the response to this by O'Sullivan 2005.

20. Pind. *Nem.* 4.81.

21. Pind. *Ol.* 7.50–53.

22. For the c. two thousand terracotta figurines from the seventh and sixth centuries, found around a stone altar at the Sanctuary of Ayia Irini in northwest Cyprus, and now divided between the Cyprus Museum and the Medelhavsmuseet, Stockholm, see Gjerstad, Lindros, Sjöqvist, and Westholm 1935: 777–91, esp. 777: "they are not of an artistic, but only a sacred nature; not produced with artistic intentions, but only for religious purposes to be used as votive offerings."

23. Merker 2000.

24. On anatomical votives, fragmentation, and physical reconstitution and redemption, Hughes 2008.

25. For the pottery from the Acropolis, see Graef and Langlotz 1925–33.

26. Eur. *Ion* 1141–62, Ath. 232c–d (Phaenias, fourth century BCE, *fr.* 11 Wehrli) and 232e (Ephorus, fourth century BCE, *FgrH* 70 F 96). The same passage claims that Delphi had Eriphyle's necklace too, an object that temples at Amathus (Paus. 9.41.2–5 and Duffy 2013) and Delos (*IG* XI 2 161 B42) also claimed. In addition to these, Hdt. 1.14 places Midas's throne in Delphi's Corinthian treasury.

27. Hdt. 5.59–61.

28. Hdt. 1.92 and for the "golden tripod" nomenclature, Pind. *Pyth.* 11. Note that this tripod too (and a solid gold shield and spear, 1.52) are said to have been extant in his time. See Bassi 2014 for Croesus's dedications here and at Delphi, and, on the shield, Papazarkadas 2014.

29. Paus. 1.22.6–7.

30. Xen. *Mem.* 3.10.1–2: γραφική ἐστιν εἰκασία τῶν ὁρωμένων; and his similar discussions with the sculptor Cleiton and the armorer Pistias (3.10.6–15) before the famous Theodote passage (3.11). All of these are about beauty. Hunter 2009: 119–20.

31. On the special measures taken on the Acropolis, see D. Harris 1995: 18–19. Compare Delphi where the god tells them not to take special measures to protect the treasures since he will do it himself and does: Hdt. 8.36–39. On the influx of Persian goods into Athens, some even before the wars, Miller 1997, and on the Persian wars not

providing a turning point in terms of sculptors' signatures, R. Osborne 2010: 241.

32. *IG* I³ 292–416 (fifth century); *IG* II² 1370–1552 (fourth century and later).

33. Paus. 1.27.1, and for the earlier fame of the breastplate, Hdt. 9.22. Also Dem. 24.129, who reports the theft of the dagger, and a silver throne of Xerxes.

34. Although note D. B. Thompson 1956: 284–86, Miller 1997: 47, and Kosmetatou 2004: 147–48.

35. D. Harris 1995: 23.

36. D. Harris 1995: 28–29 and 31–38.

37. Obviously the artifacts listed in the inventories of different temples of the period vary, dependent on the nature of the site and its deity: e.g., the Brauron inventories (349/48 to 336/35 BCE) are largely lists of clothing and dedicated by women (Cleland 2005 and Linders 1972—one of these stelai [*IG* II² 1514] having been brought to London by Lord Elgin), artifacts that are, like gold and silver, more obviously amenable to an aesthetic reading than the anatomical votives listed on inventories from the Athenian Asclepeion (Aleshire 1989). That said, these broad principles apply across the spectrum: see Dignas 2002: 235 and Linders 1988: 40–41 and 44. It is presumably because of accountability too that inventories note damage or breakages: see, e.g., D. Harris 1995: 56, nos. 63 and 64.

38. See Lightfoot 2016, and, with specific reference to the Seleucids, Kosmin 2014.

39. Elsner 2014a.

40. See the section on "Competitive Culture" later in ch. 2.

41. Work on the Mausoleum takes place between the 360s and the start of the 340s BCE: Ashmole 1972: 147–91, Waywell 1978, 1988, and 1989, and I. Jenkins 2006: 203–35. After standing intact throughout antiquity, the Mausoleum was damaged in an earthquake and some of its material used by the Knights of St. John. Thirteen slabs from its friezes, which were built into the walls of their castle, were gifted to the British ambassador by the sultan of Turkey and ended up in the British Museum. From 1856 to 1858 excavations carried out by Charles Newton led to a fuller picture to put next to the literary evidence and more sculpture to join the friezes.

42. The hero shrine of Pericles, c. 370–360 BCE, with its caryatids and "frieze with clear echoes of that of the Parthenon" (Jenkins 2006: 159) and the Nereid Monument, c. 390–380 BCE (now partially reconstructed in the British Museum): I. Jenkins 2006: 153–60 and 186–202, and Bruns-Özgan 1987.

43. Vit. 2.8.11: Mausoleum ita egregiis operibus est factum, ut in septem spectaculis nominetur.

44. Despite some similarities between the compositions of figures on the Nereid Monument and at Bassae, "Unusually, for battle friezes of this type in Greek art, [in the former] the participants are all male and not pitched against Amazons, such as we find in the podium frieze of the Mausoleum at Halikarnassos and other monuments, including the Parthenon west metopes and Bassai frieze. Nor are these male warriors shown as distinct, opposed races" (Jenkins 2006: 191). For the artists, see A. Stewart 1990: 180–81 and 182: "In its novelty, its splendor, its fusion of disparate traditions, its employment of first-rate artists outside Greek territory proper, and its strident exaltation of a mortal ruler, the Mausoleum heralds the Hellenistic age."

45. Plut. *Quaest. Graec.* 302a.

46. On Mausolus, see Hornblower 1982.

47. Luc. *Dial. mort.* 430.

48. For this interpretation of these Coan coins (Head 1897: pl. XXX 6–8), see Walbank 1984: 86.

49. Plin. *HN* 36.31: iam id gloriae ipsorum artisque monimentum iudicantes.

50. Plin. *HN* 36.30.

51. Or at least this is the claim of Pliny (*HN* 36.30): opus id ut esset inter septem miracula, hi maxime fecere artifices. Note too that just before this in the text, he refers to them as "aemulos," rivals.

52. *IG* IV² 1 no. 102, lines 34–35: See A. Stewart 1990: 273–74.

53. On Scopas, see A. F. Stewart 1977 and Calcani 2009, and on the maenad, usually thought to be the original behind the "reduced" Roman "version" in the Staatliche Kunstsammlungen und Albertinum Dresden, Skulpturensammlung (inv. Hm 133), Barr-Sharrar 2013 and Callistratus, *Imag.* 2.2.

54. Paus. 8.45–47. On Scopas and the temple, dated, not uncontroversially, to 345–335 BCE, see Stewart and Calcani, above, n. 53, A. Stewart 1990: 182–84, and Norman 1984: 191–94.

55. Olympia: Paus. 5.20.9 and Delphi (together with Lysippus): Plut. *Alex.* 40.4.

56. Vitr. *De arch.* 7. praef. 12–13. Plin. *HN* 36.31 claims that a fifth artist, Pythis/Pytheus, was responsible for the marble quadriga on top of the pyramid.

57. Plin. *HN* 36.31: hodieque certant manus.

58. Finley 1985: xviii.

59. Loewy 1885: no. 49 and Rhodes and Osborne 2017: no. 164.

60. See Ridgway 1974 and Plin. *HN* 34.53. Another exception, if we can call it that, is Plin. *HN* 36.17, which tells how two of Pheidias's pupils, Alcamenes and Agoracritus, go head to head in the making of a Venus statue, Alcamenes winning "not on account of his workmanship" but because he won the votes of his fellow citizens who supported him as the local boy. Not unrelated to this is the story about Lysippus being without competition: he was instead inspired by the painter Eupompus, who, when asked which of his predecessors he followed, claimed to use only nature as his model (Plin. *HN* 34.61).

61. See Plut. *Per.* 13.9 and *FgrH* 328 F 121 Philochorus quoted by the scholiast on Ar. *Peace* 605.

62. I say "rhetoric" because, as Ashmole asserts (1972: 159), the Mausoleum's lions alone were too many to be done by one sculptor and as diverse in style as the Parthenon metopes.

63. Plut. *Per.* 13.9 and 31.2–5.

64. Val. Max. 8.11. ext. 2: quantum porro dignitatis a rege Alexandro tributum arti existimamus, qui se et pingi ab uno Apelle et fingi a Lysippo tantummodo uoluit?

65. Dem. *Rhod.* 23. See too Vitr. *De arch.* 2.8.15 on her patronage of sculpture on Rhodes.

66. Gell. *NA* 10.18.6.

67. Vlassopoulos 2013: 258–60.

68. For a useful introduction to Pergamum as a site, see Grüssinger, Kästner, and Scholl 2011 and Pirson and Scholl 2014.

69. On the reconstruction of the altar and its politics after its arrival in Berlin from 1871, see Gossman 2006 and Bilsel 2012. It is usually dated to c. 160 BCE and the reign of Eumenes II.

70. A. Stewart 1990: 212: "All of this looks like a self-conscious attempt to constitute the Altar as the climax of the Greek sculptural tradition, just as the Attalid kings regarded themselves as the true standard bearers of Greek culture, and their citadel as rightful repository of its riches."

71. Queyrel 2005: 109–11, A. Stewart 1993: 159, who notes that despite the inscriptions on the sixth-century Sicyonian and Siphnian friezes at Delphi and on the architrave below the metopes in the Temple of Athena Alea at Tegea, "the programmatic nature of the Pergamene inscriptions is essentially unprecedented in the genre. Here, they serve as signs (*semeia*) that replicate the representational content of the monument, and signal the choral nature of the undertaking," and Platt 2011: 139. Also important here on the "careful balance of art and text" in another hellenistic relief, the Archelaus relief, is Newby 2007: esp. 177–78.

72. Simon 1975 has pushed for the most precision here, arguing that the gigantomachy is based on the genealogies presented in Hesiod's *Theogony* and tied to the influence of Stoic philosophy at the Pergamene court, in particular that of Crates of Mallus. Other scholars (e.g., Pollitt 1986: 109) have preferred to relate the frieze to the Stoic Cleanthes of Assus's lost epic, *On Giants*. See Webb 1996: 36–37, A. Stewart 1993, for a measured reassessment, and Platt 2011: 139–40. More recently, Scholl 2014: 485 stresses the importance of Homer and suggests that we see the altar as a "visualization in stone of the mythical palace of Zeus as the ancient Greeks imagined it on Mount Olympus in Thessaly—assembled, here at Pergamon, from the repertory of forms and types of classical and Hellenistic architecture." Also Scholl 2016: 50.

73. A. Stewart 2014: 107: "Since the script is uniform, these were not true signatures. Instead, they showcased Eumenes' success in assembling this heterogeneous crew (native Pergamenes, Rhodians, Trallians, Athenians, and others) and in welding them into a unified team."

74. Howard 1986: 27: "Eumenes II's Great Altar of Zeus, a wonder of the ancient world and an encyclopedic compendium of references to visual and literary old-master works, animated by the passionate new style of synthesis and sentiment."

75. For Attalus's acquisition of Aegina for 30 talents, as a result of his alliance with Rome, who captured the island in 210 BCE, and Attalid rule of it with the presence of a military garrison, *IPerg* 47–49, Polyb. 22.8.10 and Allen 1971. For the statues, see E. V. Hansen 1971: 316, Tanner 2006: 222–34, and Kuttner 2014: 49, who stresses the studied nature of their display. She continues, "Though these images from Aigina are normally referred to as booty, *spolia* qua spoils, they quite possibly were not." Kuttner gives a fuller list of the sculpture found at Pergamum, not all of it classical or classicizing—some of it archaic.

76. See Ridgway 2000: 162, Niemeier 1985: 114–20, Platt 2010: 201–3, and Picón and Hemingway 2016: cat. no. 39. The statue was discovered in a large room behind the north stoa of the Pergamene sanctuary of Athena Nicephorus, which has traditionally been identified as the reading room of the famous library (Höpfner 1996). A. Stewart 1990: 213–14 is not untypical when he writes: "the Athena is powerful testimony to Eumenes' desire to constitute his city as a sec-

ond Athens, outshining the first. Her updated style directly registers these concerns, as did her placement exactly opposite the library door and flanked by the shelves containing Eumenes' vast manuscript collection. Declarative and programmatic, she is a monument to culture, not cult." That said, the evidence for identifying the room as a reading room is thin: see L. L. Johnson 1984, Mielsch 1995, and Strocka 2000, who argues that the podium running around it did not support bookshelves but a bench, making the space a ritual dining room or *hestiatorion*, and for a useful survey of scholarship's current position, Coqueugniot 2013. Other statues, e.g., two goddesses, and a marble head of Athena found in the debris of the stoa, are also versions of Attic works: Winter 1908, vol. 1: 13–33, nos. 22–23, and 46–47, no. 25, and Ridgway 2000: 161–63. Note too Winter 1908, vol. 1: 9–10, who sees a Tyrannicide group (not in Brunnsåker 1955 or 1971).

77. The others are the lyric poet Timotheus and the historians Balacrus, son of Meleager, and Apollonius, son of Philotus. It is interesting to note that like Sappho, Alcaeus, Homer, and Herodotus, the first of these at least was from the eastern Aegean, making this potentially a rather regional "canon"—if a canon at all. The coherence of this "group" is threatened by the fact that the bases were found in secondary locations, not in their original contexts, and use different scripts and materials, Coqueugniot 2013: 121. Did the Sappho come from capture of the Euboean town of Oreus (E. V. Hansen 1971: 316–17)?

78. E. V. Hansen 1971: 317 and Kuttner 2014: 51, although whether the inscription refers to the fifth-century Myron is in doubt: another base was inscribed with the name of the third-century sculptor and critic Xenocrates, more on whom below. For Cephisodotus's symplegma, Plin. *HN* 36.24: nobile digitis corpori uerius quam marmori inpressis. Also important here is the replica of Leda and the Swan, the original of which is attributed to Timotheus of Mausoleum fame: Rieche 2010: 123–24.

79. Plin. *HN* 35.60.

80. Plin. *HN* 35.24.

81. *SIG*³ 682. The verb ἀπογράψασθαι has also been translated as "to restore."

82. Howard 1986: 26. Also E. V. Hansen 1971: 316, Alsop 1982: 190–94, Miles 2014: 43–44, Parsons 1952: 22, who compares the Attalids to the Medici, Schalles 1990, and Kuttner 2014: 45: "The court collecting practices of Attalid Pergamum are the 'museum' behaviours best doc-

umented for us among the Hellenistic courts, which all amassed art and luxury artifacts."

83. M. C. Scott 2013: 198. Also relevant here is the way in which the Attalids give the Rhodians in effect a capital sum which the Rhodians can then invest to fund their education system: Polyb. 31.31 and *SIG*³ 672.4.

84. Habicht 1990.

85. A. Stewart 2004 and R. Osborne 2017. It is uncertain whether the dedication was erected by Attalus I or Attalus II.

86. On the way in which classical statuary glances rather than gazes, so absorbed in its own experience as to sever archaic sculpture's frontality and "hotline" to the viewer and stand in a parallel universe, see Elsner 2006a.

87. Above, n. 80: Tabulis autem externis auctoritatem Romae publice fecit primus omnium L. Mummius . . . suspicatusque aliquid in ea uirtutis, quod ipse nesciret, revocauit tabulam.

88. Howard 1983: 487 and Kuttner 1995.

89. See also ch. 5, "Sculpture as Subject."

90. See Niemeier 1985 and Ridgway's response, 1987, which rightly points out that classicizing forms are present as early as the third century BCE. Niemeier's problem is to claim that Klassizismus is *born* at a particular moment. As the introduction to this book has already suggested, it is safer to think in terms of classicisms and to give Pergamene classicism special purchase because of its influence.

91. E. V. Hansen 1971: 318. For the similarity of its composition to that of Myron's Marsyas, Furtwängler 1880b: 9 and Winter 1908, vol. 2: no. 469.

92. Tac. *Hist.* 4.83–84, and Clem. Al. *Protr.* 4.48.1–3, quoting an earlier historian (*FgrH* 746 F 3). See Bevan 1927: 43–44, Charbonneaux 1961, and for queries over which Bryaxis this is, raised already by the Athenodorus whom Clement cites (the sculptor of the Mausoleum, his son or grandson), A. Stewart 1990: 300–301, who follows Bieber 1961: 83–84 in preferring the last of these. A useful overview is provided by Ashton 1999: 147–81, who makes the point that important elements of the Serapeum statue, which survives only in later Greco-Roman versions, the kalathos included, are Roman. Also useful is Goddio and Masson-Berghoff 2016.

93. Goddio and Masson 2016: 92–93. Compare too the sculptures in Stanwick 2002 and, e.g., Savvopoulos and Bianchi 2012: 78, cat. no. 22, Ptolemaic queen Berenice II. See also the Ptolemaic section of Beck, Bol, and Bückling 2005 and Savvopoulos 2010. On the ways

94. Rice 1983 and D. J. Thompson 2000.

95. Athen. 5.196a–203d, quoting the hellenistic source, Callixeinus of Rhodes. For the status of Sicyon's painting, see Plut. *Arat.* 13 and Plin. *HN* 35.75–77.

96. Athen. 5.197c.

97. Polyb. 30.25–27, esp. 30.25.13: τὸ δὲ τῶν ἀγαλμάτων πλῆθος οὐ δυνατὸν ἐξηγήσασθαι. πάντων γὰρ τῶν παρ᾽ ἀνθρώποις λεγομένων ἢ νομιζομένων θεῶν ἢ δαιμόνων. And Strootman 2007: 309–13.

98. A. Stewart 2006: 180.

99. Plut. *Arat.* 12–13. Note that there is some confusion about which Ptolemy this is, Ptolemy II Philadelphus or Ptolemy III Euergetes. See also the "Letter from Plato," probably a hellenistic forgery, to Dionysius II of Syracuse about buying two sculptures by Leochares (see the discussion of the Mausoleum, above) for the tyrant and his wife ([Plat.] *Ep.*13.361a).

100. Hornblower 1983: 79. On the existence of a library in Antioch, at least in the reign of Antiochus III (224/23–188/87), see Pfeiffer 1968: 122 and Casson 2001: 48: "apparently it never acquired much of a reputation."

101. Burn 2004: 106: "In one house [in Priene] were found the remains of ten marble statuettes and thirty-five figured terracottas, suggesting that the owner could choose his materials and had put together his collection with some care." See also Rumscheid 2006.

102. A. Stewart 1990: 58.

103. Tanner 2006: 220.

104. Athen. 1.3a. Note that Strabo 13.1.54 favors a genealogy, which sees Aristotle's books, which come via Theophrastus to Neleus, wind up in Rome under Sulla. On Peisitratus and Homer, see Too 2010: 20–24, Davison 1955, and Pfeiffer 1968: 6–8, who notes that "Not only in the later embroideries, but in the whole conception of a powerful statesman as collector of literary texts, as the earliest founder of a Greek 'library', as head of a committee of scholars, we seem to have a projection of events of the Ptolemaic age into the sixth century." [Plat.] *Hipp.* 228b–c credits Harmodius and Aristogeiton's victim Hipparchus with introducing the Homeric poems to Athens and forcing the rhapsodes to perform them in a fixed sequence.

105. Gell. *NA* 7.17.1–2.

106. Strabo 13.1.54. On book forgery, see, e.g., Dio Chrys. *Or.* 21.12.

107. Useful here in thinking about "possession" is Nagy 1998: 206–12.

108. The best introduction to the library is Bagnall 2002. See also El-Abbadi 1990, Blum 1991: 95–123, and Fraser 1972, vol. 1: 305–35. Note that it was part of a complex that embraced not only the Mouseion, from where we get our word "museum," but the royal tombs (Strabo 17.1.8), including, most importantly, the tomb of Alexander the Great, which would become a pilgrimage site for the Julio-Claudians (e.g., Suet. *Aug.* 18.1). For the fire, see Hatzimichali 2013, and on Rome's privileging of Alexandria's collection, e.g., Suet. *Dom.* 20.

109. Gal. *Comm. in Hippocratis librum iii epidem.* (as cited in Fraser 1972, vol. 2: 480, n. 147). For Galen and the library at Alexandria, see Handis 2013.

110. Varro as cited in Plin. *HN* 13.70. See R. R. Johnson 1970.

111. Plut. *Ant.* 58.5. Ancient estimates about the size of the library at Alexandria's holdings vary immensely.

112. Plin. *HN* 35.10: an priores coeperint Alexandreae et Pergami reges, qui bibliothecas magno certamine instituere, non facile dixerim.

113. Bagnall 2002 and, on art collections, Coqueugniot 2013: 119.

114. See the review of Haubold et al. (2013) *The World of Berossos* by Heller 2014: "Nearly every contribution in this volume strives to underscore the importance of Berossus' work for the Greek understanding of Near Eastern history. Some stress his close relations with the Seleucid court and detect, in the third book, tendencies to legitimise Seleucid rule in Syria or to create Nebuchadnezzar II as role model for Seleucid kings. Notwithstanding the enthusiasm of the contributors, there are good reasons to doubt the impact on Greek historiography and Berossus' importance."

115. *Letter of Aristeas* (pseudoepigraphical and probably second century BCE) 9. See edition by B. G. Wright 2015: 118–19.

116. Pfeiffer 1968: 105–209.

117. Galen, above, n. 109, as discussed in Fraser 1972, vol. 1: 82 and Matusova 2015: 87.

118. Erskine 1995: 45.

119. See *Letter of Aristeas*, above, n. 115.

120. Herakleides Kritikos, visiting the city in the third century BCE: edition and translation, Brill's New Jacoby, 369A F 1 (http://referenceworks .brillonline.com/entries/brill-s-new-jacoby /herakleides-kritikos-369a-a369A?s.num=23&s

121. Sharples 2010.
122. Strabo 13.1.54.
123. Erskine 1995: 46, Nagy 1998: 213–30 and, on Apollodorus, Montanari 2002.
124. See, e.g., Pfeiffer 1968: 123–34 and Blum 1991: 124–27, 150–60, and 182–84, both of them including the rival *pinaces* from Pergamum, Witty 1958, and, putting Callimachus's *pinaces* into the context of his other work, Krevans 2004.
125. Albeit before the foundation of the library? Antigonus the writer is usually now assumed to be the same Antigonus as the sculptor (Plin. *HN* 35.67–68)—A. Stewart 1990: 303. See Tanner 2006, Platt 2010: 199, Alsop 1982: 187–89, and Pollitt 1974.
126. For a fuller list of Duris's work, see Tanner 2006: 214.
127. Meister 2004.
128. On Polemon (Preller 1964), periegetic writing, and their predecessors, see Angelucci 2011 and Engels 2014: 73–92.
129. For the relationship of Polemon and Pausanias, see Frazer 1898, vol. 1: lxxxii–xc.
130. Angelucci 2011. Also note the mention of Polemon by Plutarch as evidence for Apelles's hand in the painting of Sicyon's tyrant (above, n. 99).
131. Preller 1964: Fr. 22, cited in Athen. *Deip.* 11.479f–480a.
132. He was nicknamed στηλοκόπας (tablet-glutton): Preller 1964: Fr. 78 with commentary.
133. And not just in epigrams: see, e.g., Craterus of Macedon's (*FgrH* 342) late fourth-century collection of Athenian decrees, and Lendle 1992: 275, and Higbie 1999. For possible collections of epigrams earlier than the fourth century, see Baumbach, Petrovic, and Petrovic 2010: 7–8.
134. Cameron 1993: 1–2, and, on the Tyrannicides' epigram specifically (as attributed in Heph. *Enchiridion* 4), Friedländer 1938: 92 and 1948: 141–42, no .150, and Brunnsåker 1955: 85–88.
135. See ch. 9.
136. Erskine 1995: 43. Although note that there was no revolt before 246 BCE and earlier, good evidence for Egyptians at court, including the historian Manetho.
137. *SIG*³ 725 (*FgrH* 532, Blinkenberg 1915 and 1941, no. 2, Chaniotis 1988: 52–57). The stele was later used as a paving stone in a Byzantine church and thus its original position in the sanctuary is unknown. See the edition by Higbie 2003, and discussions by Shaya 2005 and 2014, Dignas 2002: 240–41, and Platt 2010: 208–12.
138. For comparanda, including the *Marmor Parium* (above, ch. 1, n. 13), see Higbie 2003: esp. 258–73.
139. On the loss of objects, see Higbie 2003: 256–57 and Bresson 2006: 543–44.
140. Translation adapted from Higbie 2003: 33. Particularly interesting is the word for "displays," ἀποφαίνεται, which is very demonstrative, implying a sort of "show and tell."
141. Diod. Sic. 4.77.5–78, Hygin. *Fab.* 44, and Paus. 7.4.6.
142. Higbie 2003: 26–27, B XIV.
143. Neer 2010: 6 and 7.
144. Elsner 2014b: 153.
145. Kuttner 2005: 145. For Posidippus, see di Nino 2010.
146. For Theophrastus, see Gutzwiller 2005a: 301 and edition by Caley and Richards 1956.
147. *P. Mil. Vogl.* VIII 309: there is still some contention over whether all of the poems in the papyrus are by Posidippus. See editions by Bastianini and Gallazzi 2001, Austin and Bastianini 2002, and Stähli and Wessels 2015, and the volumes of essays by Gutzwiller 2005b and Acosta-Hughes, Kosmetatou, and Baumbach 2004.
148. Elsner 2014b: 167–68: "It is not that *lithic leptotes* is less subtle than the woven kind [of Callimachus], but it reflects a different vision of poetics, more monumental though miniature, perhaps more enduring, perhaps more sublime. . . . Effectively, the *lithika* function as emblems, material symbols of relationships, and not as ecphrases of naturalistic imitations of persons . . . or animals . . . or objects." Also important here, as Elsner acknowledges, is Porter 2010: 453–90.
149. Posidippus 62.1 (using the numbering system established by Austin and Bastianini 2002); μιμ[ή]σασθε τάδ᾽ ἔργα. See Gutzwiller 2002: 44–46 and Angiò 2004.
150. *Greek Anthology* (edn. by Paton) 9.332.
151. Plin. *HN* 34.65. Helpful here is Barkan 1999: 86.
152. See A. Stewart 2005.
153. A. Stewart 2005: 185.
154. See, e.g., Sens 2005 and Prioux 2008: 173–77.
155. Posidippus 67.1, a poem with a proliferation of looking imperatives. This is in keeping with what we find in epigram more broadly where epigrams celebrating the individual represented in the sculpture die out and are replaced by those that praise famous artists and their works. See Gutzwiller 2002: 41–42 and on these epigrams as a history of art, Prioux 2008: 200–252.

156. The best known example here would be Mithridates's gem cabinet, which Pompey the Great dedicated in the Temple of Jupiter Capitolinus in Rome: Plin. *HN* 37.11. See Kuttner 2005, Prioux 2008: 159–252, and Prioux 2014.

157. Elsner 2014b: 156.

158. Posidippus 7 (translation Austin in Austin and Bastianini 2002). For nature and culture in this poem, see Elsner 2014b: 157–58.

159. Prioux 2008: 167. And on a gem-carver of this name, mentioned by Pliny, *HN* 37.8.

160. See, e.g., the later stories in Plin. *HN* 35.65–66 and 35.81–83.

161. On sumptuary legislation, see Hunt 1996 and, for Rome, Wallace-Hadrill 2008: 315–55.

162. On the self-consciousness of viewing in these poems, see Goldhill 1994, Burton 1995: 97–108, and Hunter 1996: 116–20, and for the addition of a gendered dimension, Skinner 2001.

163. G. Zanker 2004: 85 and Skinner 2001: 220–21: "If the language of artistic verisimilitude in *Mimiamb* 4 replicates the discourse of fourth-century academic art criticism, it does so only to benchmark the perceptual shortcomings of its female users." Compare Hutchinson 1988: 246.

164. The lack of part attributions means that scholars are split as to whether Cynno's companion is called Coccale or whether Coccale is a slave and Cynno's companion called Phile: see Cunningham 1966, G. Zanker 2009: 104, and Skinner 2001: 218, n. 65. I here use Cunningham's text and conventions (Rusten and Cunningham 2002).

165. Herod. 4.20–21: ἆ, καλῶν, φίλη Κυννοῖ, / ἀγαλμάτων.

166. Herod. 4.26: καλῶν ἔργων and 57–58: ταῦτ᾽ ἐρεῖς Ἀθηναίην/γλύψαι τὰ καλά.

167. Herod. 4.39–40: ἕπευ, Φίλη, μοι καὶ καλόν τί σοι δείξω/πρῆγμ᾽ οἷον οὐχ ὥρηκας ἐξ ὅτευ ζώεις.

168. Theoc. *Id.* 15.78–88. Not that, overall, Theocritus's female viewer is not, "among other things, a surrogate for the *trained* reader" and affirmation of "the feminine ekphrastic tradition" Nossis embodies (Skinner 2001: 211–16).

169. Herod. 4.21–24.

170. Herod. 4.23.

171. Herod. 4.73.

172. Herod. 4.27–34 and G. Zanker 2009: 112–13. For the child strangling a goose motif, Ridgway 2006.

173. Hölscher 1987, translated into English in 2004.

174. How could they go away, if Greek art was to become good to think with? Take, for example, the problems posed by the perfection of Polyclitus's statues in Longinus's *On the Sublime* 36.3

(de Jonge 2013) and on the productiveness of error in Roman writing about art more broadly, Vout 2018. Even in Rome and into late antiquity, inventories and synopses of sculptures and other "artworks" are still listed as though "the data useful for a careful asset management." "The bare minimum is a short and simple name or definition that allows us to recognize the object, but we also encounter a serial number, eventually registered on the object itself, specific notations concerning valuable parts, size or weight when useful" (Liverani 2014: 77).

Chapter 3: Making Greek Culture Roman Culture

1. *Hellas: A Lyrical Drama*, published in 1822 (edn. by Reiman and Fraistat 2002: 431).

2. See ch. 1.

3. On Winckelmann's problems in dating the Belvedere Torso, see Marvin 2008: 118. On Winckelmann, his influence, and "Greek" art, see Potts 1980 and 1994, Marvin 2008, Harloe 2013, and Siapkas and Sjögren 2014: esp. 38–45.

4. See ch. 1, "What Is Classical Art?"

5. Marvin 2008: 103–20.

6. When exactly Aeneas arrived in Rome is much debated; here I follow Galinsky 1999: 198.

7. See, e.g., Spivey 1991, Sparkes 1996: 47–55, and Burn 1997.

8. Hdt. 1.167 and Strabo 5.2.3 on the Agyllaeans (from modern Cerveteri) and Strabo 5.1.7 on the town of Spina.

9. On the style of portraiture known by modern scholarship as "verism" or "truthfulness," see Schweitzer 1948, R. R. R. Smith 1981, Giuliani 1986, Jackson 1987, Gruen 1992: 152–82, Nodelmann 1993, Tanner 2000, Croz 2002, Fejfer 2008: 262–70, Pollini 2012: 13–68, and Papini 2004 and 2011.

10. This kind of statue lives on into the Principate: compare the Tiberius from Utica, Tunisia, now in the Rijksmuseum van Oudheden, Leiden.

11. Scholars have argued about the extent of the Polyclitan paradigm here: compare, e.g., P. Zanker 1974: 43 and 1988: 245–52 with R. R. R. Smith 1996: 41–45. For a more measured take on this issue, see Squire 2013a: esp. 265–66, who stresses that although "conversations" between "Greek" and "Roman" bodies were not new (cf. the Tivoli General), Augustus's image-makers managed a more self-conscious, yet still negotiating dialogue that made his

Polyclitan frame part of the costume of the princeps.

12. Quint. *Inst.* 5.12.21.

13. On the Ara Pacis and Altar of the Twelve Gods, see H. A. Thompson 1952, and on the altar's hellenism and influences more broadly, including the Greekness of its sculptors, Borbein 1975, Charbonneaux 1948: 74, Toynbee 1953, and Bonanno 1976: 24, and, in response, Conlin 1997. Also relevant here is my discussion of Strong and Wickhoff (ch. 9, "A Place for Roman Art"). More recently, emphasis has been put on the Egyptian nature of the altar's design and decoration: P. J. E. Davies 2011: 360–63, Trimble 2007, and van Aerde 2015: 211–21.

14. Crucial on Augustan classicism in the visual arts is P. Zanker 1988 (which translates his *Augustus und die Macht der Bilder*, Munich, 1987), Hölscher 2004a (which translates his *Römische Bildsprache als semantisches System*, Heidelberg, 1987): 47–57, and Hölscher 2006b.

15. See ch. 2, "Making Greek Culture Count."

16. On Hadrian's hellenism, see Calandra 1996, Vout 2006a, and on hellenism and his villa, Calandra and Adembri 2014. Still classic on Hadrianic classicism is Toynbee 1934. For more detailed discussion of, and bibliography on, the sculpture at Hadrian's Villa, see ch. 4, "Collecting Like Caesar." On the integration of Antinous's "Egyptianizing" statues into Hadrian's classicism palette, see Elsner 2006b and Versluys 2012.

17. On the Middle Ages as inheritor of Roman art, as deserving of distinction from Greek art, see Riegl 1901 and below, ch. 8, "From Art to Archaeology." Recently, more emphasis has been put on the endurance of classicism into Byzantium in particular: see, e.g., the recent Royal Academy exhibition "Byzantium, 330–1453" and its accompanying catalog edited by Cormack and Vassilaki 2008, Maguire and Maguire 2007, and A. Walker 2008. Note, however, that just as Hadrianic classicism is different from Augustan classicism, so late antique and postantique classicisms are different again. Though the Romans were adept at using "hellenistic" and "fifth- and fourth-century" styles to say different things, their concept of "classicism," such as it was without a word for it, embraced both. On "classicism" in late antiquity, Elsner 2006b: 293–97.

18. Particularly good on the material aspects of the triumph are Pollitt 1978, Gruen 1992: 84–130,

C. Edwards 2003: 49–57, Welch 2006, Beard 2007, Miles 2008, Holz 2009, Östenberg 2009, Russell 2016: 127–52, and Popkin 2016.

19. Plut. *Marc.* 21.1: οὐδὲν γὰρ εἶχεν οὐδ᾽ ἐγίνωσκε πρότερον τῶν κομψῶν καὶ περιττῶν, οὐδὲ ἦν ἐν αὐτῇ τὸ χάριεν τοῦτο καὶ γλαφυρὸν ἀγαπώμενον. See McDonnell 2006 and Russell 2016: 130–39. In a passage of Florus (a near contemporary of Plutarch), *Epit.* 1.13 [1.18.27], the surrender of the Greek colony of Tarentum in the 270s BCE had already led to an influx of gold, purple, statues, paintings, and curiosities or "deliciae" (a pleasure-soaked word, if ever there was one) of an unprecedented, yet still unremarkable kind, when compared to the elephants in the procession. See Gruen 1992: 98–99 and Beard 2007: 148–50.

20. Plut. *Marc.* 21.3: διὸ καὶ μᾶλλον εὐδοκίμησε παρὰ μὲν τῷ δήμῳ Μάρκελλος ἡδονὴν ἐχούσαις καὶ χάριν Ἑλληνικὴν καὶ πιθανότητα διαποικίλας ὄψεσι τὴν πόλιν.

21. Plut. *Marc.* 21.4.

22. Plut. *Marc.* 21.5: ὡς τὰ καλὰ καὶ θαυμαστὰ τῆς Ἑλλάδος οὐκ ἐπισταμένους τιμᾶν καὶ θαυμάζειν Ῥωμαίους διδάξας.

23. Plut. *Marc.* 21.5: σχολῆς ἐνέπλησε καὶ λαλιᾶς, περὶ τεχνῶν καὶ τεχνιτῶν ἀστεϊζόμενον.

24. Livy 25.40.2. Also 34.4.4 and Polyb. 9.10.1–13.

25. On obelisks, see Iverson 1968, and, on other Egyptian antiquities in Rome, Lollio Barberi, Parola, and Toti 1995. On the fifth-century BCE Greek Amazonomachy figures, perhaps from Eretria, that came to grace the Temple of Apollo Sosianus, rededicated by G. Sosius in the 30s BCE, La Rocca 1985 and 1988, and querying whether they were in the pediment, Hafner 1992: 21–22 and, with regard to Hafner, Cirucci 2010: n. 88.

26. Livy 39.6.7–9. See Beard 2007: 68, 78–79, where she notes the important point that this same triumph was, according to Florus (*Epit.* 1.27 [2.11.3]) refused, and 161–62.

27. Plin. *HN* 37.12, also implicating Lucius Scipio Asiaticus and his triumphal procession of 189 BCE, a triumph which he elsewhere claims (33.148) first brought luxury to Italy.

28. Vell. Pat. 1.13.4–5. See Gruen 1992: 123–29, Yarrow 2006, and Miles 2008: 73–76.

29. Plin. *HN* 34.62. For a precedent or rather retrospective attribution, see Paus. 9.35.6 on Attalus having the Graces by Bupalus in his "thalamos," one possible meaning of which is "bed-chamber." And on the possibly fictional Bupalus, below, ch. 4, n.122.

30. Plut. *Marc.* 21.3.

31. Cic. *Verr.* 2.1.55: the fact that Syracuse and Corinth are each "ornatissimam" in this passage hints that they were overly full and had statues to spare, but that still these generals' houses were empty. There is considerable bibliography on Verres: e.g., Paoletti 2003, Miles 2008: esp. 105–217, and Lazzeretti 2014.

32. See above, ch. 2, "Competitive Culture," and for his wider dissemination of spolia, Strabo 8.6.23, Frontin. *Strat.* 4.3.14, and Yarrow 2006.

33. Paus. 7.16.8.

34. Miles 2008. Although note reviews by Beard 2009 and Vout 2009.

35. Cic. *Verr.* 2.1.57: P. Seruilius, quae signa atque ornamenta ex urbe hostium, ui et uirtute capta, belli lege atque imperatorio iure sustulit.

36. Livy 45.27.5–28.5. Also Plut. *Aem.* 28.

37. Livy 45.27.11: simulacra deorum hominumque, omni genere et materiae et atrium insignia. The Polybius passage is 30.10. Very useful here is Russell 2012.

38. Plut. *Marc.* 21.1–2: οὐδὲν γὰρ εἶχεν οὐδ᾽ ἐγίνωσκε πρότερον τῶν κομψῶν καὶ περιττῶν, οὐδὲ ἦν ἐν αὐτῇ τὸ χάριεν τοῦτο καὶ γλαφυρὸν ἀγαπώμενον, ὅπλων δὲ βαρβαρικῶν καὶ λαφύρων ἐναίμων ἀνάπλεως οὖσα, καὶ περιεστεφανωμένη θριάμβων ὑπομνήμασι καὶ τροπαίοις, οὐχ ἱλαρὸν οὐδ᾽ ἄφοβον οὐδὲ δειλῶν ἦν θέαμα καὶ τρυφώντων θεατῶν. I owe this point to Mary Beard.

39. Livy 34.4.2: auaritia et luxuria . . . quae pestes omnia magna imperia euerterunt; and 34.4.4: iam nimis multos audio Corinthi et Athenarum ornamenta laudantes mirantesque et antefixa fixtilia deorum Romanorum ridentes.

40. Plin. *HN* 33.4: heu prodiga ingenia.

41. On art's challenge to truth and reason, Tanner 2006: 191–96.

42. Vitr. *De arch.* 7.5.3.

43. Plin. *HN* 33.8.

44. Helpful here is Burke's review article on "the social history of art," 1990.

45. Livy 34.52.4–12. See also Plut. *Flam.* 14 and Beard 2007: 172 on problems with Livy's text.

46. Livy 26.21.8: multa nobilia signa; and 26.21.9–10: et non minimum fuere spectaculum cum coronis aureis praecedentes Sosis Syracusanus et Moericus Hispanus. See Östenberg 2009: 79–91.

47. See below, ch. 4. That said, official announcements puffed Aemilius Paullus's triumph into Rome as the paradigm for Napoleon's procession: Miles 2011: 32 and Rowell 2012: 142. And the *Journal of Paris* (26 July 1798: 1289–91) detailed the antiquities.

48. Plin. *HN* 37.14–16, App. *Mith.* 116–17, Hölscher 2004b: 95–96, and Beard 2007: 7–14 and 36–41.

49. Joseph. *BJ* 7.148 and Beard 2003.

50. App. *Mith.* 116.

51. For the Oscan inscription from Pompeii recording a possible Mummius donative, see [partial publication] Conway 1897: no. 86, and Martelli 2002 and *Imagines Italicae* 2: 615, and for Fulvius Nobilior (Tusculum) (*M. Fuluius M.f. Ser. n. co(n)s(ul) Aetolia cepit*): ILLRP 322.

52. Vell. Pat. 1.11.3 and Calcani 1989, with review by Ridgway 1991, and for the placing of Greek art in public places on semantic grounds, with an emphasis on artistic form in service to function, Bravi 2012.

53. Contra, most recently, Bounia 2004, Rutledge 2012, and E. L. Thompson 2016a. See also Kuttner 1999 on "Pompey's Museum" on the Campus Martius, pieced together from trace elements in a wide range of source material.

54. See Jex-Blake and Sellers 1968: xci–xciv. For Pliny's comparative interest in artists and in motivations for bringing pieces to precise locations in Rome at particular times, compare appendixes A and D in Gualandi 1982, and for Pliny on Metellus, *HN* 34.64.

55. Plin. *HN* 36.23–25, 36.33–34, and on the portraits in the library, 35.10. For the location of the Atrium Libertatis, see Purcell 1993 and for other nods to its collection's difference, Bounia 2004: 188, Rutledge 2012: 224, and Bravi 2012: 82–93 and 2014: 95–110. The classic study is still Becatti 1956. Also Rouveret 1987: 128–30.

56. Carey 2003: 80.

57. Plin. *HN*, praef. 15: omnibus uero naturam et naturae sua omnia. For bibliography on Pliny, see above, ch. 1, n. 62 and also, because of its emphasis on his encyclopedism and influence, Doody 2010.

58. Plin. *HN*, praef. 13: sterilis materia, rerum natura, hoc est uita, narrator.

59. Plin. *HN* 36.34 and 36.37, and on the phrase "ex eodem lapide / ex uno lapide," Kunze 1991: 17 and 1998: 42 and, on its Renaissance import, Lavin 1998. For the Farnese Bull, National Archaeological Museum, Naples, inv. no. 6002, see De Caro 1996: 334 and Haskell and Penny 1981: 165–67.

60. Plin. *HN* 36.39. On Pasiteles, Borda 1953, Ajootian 1996: 121, Tanner 2006: 215, 242, 289, Ridgway 2002a: 189–92, Anguissola 2015: 245–47, and Touchette 2015.

61. See above, ch. 2, "Competitive Culture," and Fraser 1972, vol. 1: 456.

62. On "diligentia," see Pollitt 1974: 351–57 and E. E. Perry 2000.

63. Plin. *HN*, praef. 15: res ardua uetustis nouitatem dare, nouis auctoritatem, obsoletis nitorem, obscuris lucem, fastiditis gratiam, dubiis fidem.

64. Plin. *HN* 35.79–83.

65. Plin. *HN* 34.52: cessauit deinde ars ac rursus olympiade CLVI reuixit. See Tanner 2006: 242–43.

66. Plin. *HN* 36.27–28.

67. The Laocoon has spawned a formidable bibliography: for an overview of its reception, see, e.g., Haskell and Penny 1981: 243–47, Barkan 1999: passim, Settis 1999, Brilliant 2000a, and Buranelli, Liverani, and Nesselrath 2006, and on the impact of Pliny on the Laocoon, and the sculpture's inverse influence on the reception of the *Natural History*, McHam 2013: 215–23.

68. Cic. *Rep.* 1.21–22: one of a pair, the second of which he dedicated in the double Temple of Honos and Virtus. See also on Aemilius Paullus, Plut. *Mor.* 198C and *Aem.* 28.6–7, and on Augustus, Suet. *Aug.* 71.1.

69. Plin. *HN* 35.7.

70. *ORF*, Cato, fr. 98: miror audere atque religionem non tenere, statuas deorum, exempla earum facierum, signa domi pro supellectile statuere, and Gruen 1990: 136. Also Polyb. 9.10.13.

71. Livy 25.40.3, and on this shrine and its decoration, Bravi 2012: 29–32.

72. Getty 1955. See True and Silvetti 2005: 16, Beard 2008: 83, and Lapatin 2011: 275–78.

73. Although growing all the time (and although most of it dates from between the second half of the fifth century and the beginning of the fourth century BCE, there are also archaic examples): see Le Brunn and Lullies 1955 and Paribeni 1969, and, on the state of play now, Cirucci 2010. On specific bodies of this material from Rome, Pompeii, and elsewhere in Campania, Bell 1998 (Esquiline), Comella 2008a and 2008b (Pompeii and Campania), Settis and Catoni 2008: nos. 42–45 and Cirucci 2009 (Pompeii). Much of this sculpture, some of it Greek grave stelai, comes from the ancient grand gardens on the Esquiline and Quirinal. These parklands were also used for public entertaining, business, and so on and most became imperial property. Also important are five statue bases found in the Templum Pacis region of Rome, dated to the Severan period, and inscribed in Greek with the names of Praxiteles, Leochares, Cephisodotus, Parthenocles, and Pythocles, son of Polyclitus (La Rocca 2001: 196–201, Noreña 2003: 28–29, and Coates-Stephens 2016: 143). Whether these supported originals or later imitations remains up for grabs.

74. Although note the comments on domestic contexts by Comella 2008b: 148 and Cirucci 2010: 13. On the nereids, Bielefeld 1969 and Marzano 2007: 377, and putting them in the context of other under-life-size Greek statues, Delivorrias 1990. On reliefs, see, e.g., the Attic relief from V, 3.10 (National Archaeological Museum, Naples, inv. no. 126174) and the small votive relief to Aphrodite and Eros (Pompeii, inv. no. 20469), probably from the last quarter of the fourth century BCE, from the House of the Gilded Cupids (VI, 16.7): Seiler 1992: 123–24 and fig. 614, Cirucci 2009, and Neudecker 2014: 135–36. Also note the fifth-century bronze water jar (below, n. 162).

75. Beard 2008: 74.

76. Seltman 1948: 111. For more on Seltman, see below, ch. 9.

77. On this pedimental sculpture, see earlier in this chapter, n. 25. Fifth-century Niobid sculptures from the Gardens of Sallust are very similar in style to the figures of the Apollo Sosianus "pediment": are they the same niobids mentioned by Pliny (above, n. 66)? See Hartswick 2004: 102 and Talamo 1998:146–48.

78. On the sculpture from the Villa of the Papyri, see Mattusch 2005: 142–337. Note that R. Carpenter 1960: 184–85 believed, wrongly, that the Villa's bronze Seated Hermes (National Archaeological Museum, Naples, inv. no. 5625) was produced early in the third century BCE by the School of Lysippus. On the sculpture from Hadrian's Villa, Aurigemma 1961: 100–133, Raeder 1983, MacDonald and Pinto 1995: 139–51, and Slavazzi 2002.

79. On the ephebe, Vlachogianni 2012 and Bol 1972. Also four marble votive reliefs from fourth-century Athens found in the roughly contemporary Mahdia shipwreck: Bauchhenss 1994, Kuntz 1994, and for the wreck and its cargo, Hellenkemper Salies 1994 and Ridgway 1995. For the differences in their cargoes, Himmelmann 1994. There are other sculptures found in the sea, which may also have been en route to Italy—most famously, the Riace Bronzes (see above, ch. 1, n. 23). Helpful on bringing this long-submerged material together are Arata 2005 and Hemingway 2016.

80. Wallace-Hadrill 2008: 361–71 and W. V. Harris 2015: 400.

81. National Museum, Athens, inv. no. 5742: Vlachogianni 2012: 64–65, fig. 1.

82. Cic. *Att.* 1.8, 1.10. Mattusch 1997: 53–60 and Rutledge 2012: 59–64.

83. Cic. *Fam.* 7.23 to Marcus Fabius Gallus criticizing Gallus's acquisition of Bacchantes for his library. These are not fit for purpose: at pulchellae sunt. *Att.* 1.4.3, 1.8, 1.9.2, 1.10 stress the need for "decor."

84. Cic. *Att.* 1.8: Hermae tui Pentelici cum capitibus aeneis, de quibus ad me scripsisti, iam nunc me admodum delectant, and *Att.* 1.9: genus hoc (i.e., buying sculpture) est uoluptatis meae.

85. Coltman 2006: 17–37.

86. Coltman 2009: 159–280.

87. Cic. *Verr.* 2.1. 57.

88. See M. Anderson 1987–88 and Bergmann, de Caro, Mertens, and Meyer 2010.

89. See above, n. 83.

90. I owe this formulation to Versluys 2015, who seeks to blur the boundary between "Egyptian" and "Egyptianizing" artifacts and integrate them into Roman culture by replacing models of acculturation or "transfer studies" with one of "globalization." He writes (164): "From around 200 BC onwards Hellenistic culture, in itself already 'global' in nature, was brought to dramatic time—space compression through the Roman conquest of the oikumene and its institutionalisations." Also emphasizing integration over alienation are Elsner, above, n. 16, Versluys 2007, P. J. E. Davies 2011, Osborne and Vout 2010: 240–42, Swetnam-Burland 2015, and Versluys's students, Van Aerde 2015 and Mol 2015. Further useful material can be found in Beck, Bol, and Bückling 2005.

91. On Nilotic mosaics, Versluys 2002, and on their "fantasy" element, Maderna 2005. For the broader category that art historians call the "sacro-idyllic" landscape, see Silberberg-Pierce 1980, Leach 1988: 197–260, and B. Bergmann 1992.

92. See above, n. 42.

93. Iacopi 1997, Versluys 2002: 69–71 and 358–59, and Van Aerde 2015: 83–91.

94. Van Aerde 2015: 143–63; and on "monstrous gods," Verg. *Aen.* 8.698: omnigenumque deum monstra et latrator Anubis.

95. On the Alexander mosaic, A. Cohen 1996; and on the Nilotic scene, Versluys 2002: 121–23. On the status of the Alexander mosaic as copy, A. Cohen 1996: 51–82: artists credited with the "original" include Philoxenus of Eretria (because of Plin. *HN* 35.110) and Aetion, Antiphilus, Protogenes, and Apelles.

96. Van Aerde 2015: 161.

97. A notable exception is the famous Nilotic mosaic from the nyphaeum floor of a public building in Palestrina, 120–110 BCE, National Museum of Praeneste, Palestrina, which Meyboom (1995: 90–95 and 360, n. 10) attributes to the same workshop as those from the House of the Faun. However, unlike the Alexander mosaic, the original of which "was undoubtedly a famous painting from the early Hellenistic period" (361), Meyboom (96–107) can speak in only rather vague terms about the possibility of the Palestrina mosaic being modeled on large scenes in preexisting works of art. A. Cohen too (1996: 61) thinks that the Alexander and Palestrina mosaics relate very differently to their purported models.

98. See above, ch. 2, n. 92.

99. Hellenistic Greek painter from Egypt and rival of Apelles: Plin. *HN* 35.114. Note also the Alexandrian "place painter" or "topographos" Demetrius (*DNO* 3566–67) as cited in Zevi and Bove 2008, and Petron. *Sat.* 2, which attributes the decline of Roman painting to Egyptian practice. See Gschwantler 2000: 18: "we read very little about artists who were attached to the court of the Ptolemies or who worked for it. The paucity of sources for the Hellenistic art of the third and second centuries BC is probably a reflection of the more classically oriented tastes of the writers from whom Pliny, for example, drew his information."

100. Winckelmann (1764) 2006 edn.: 128. See also Hartwig 2015: 39–40. Note, however, that even Winckelmann could see that some Egyptian art was beautiful (e.g., Winckelmann [1764] 2006 edn.: 145): Grimm and Schoske 2005.

101. W. M. Davis 1979.

102. Swetnam-Burland 2015: 60–63, who is interesting on the possibility of "Phidias" as a pseudonym and on Ammonius being less obviously Egyptian to a Roman reader than to us.

103. Swetnam-Burland 2015: 55. And, on the "grotesque," see Squire 2013b.

104. Although on whether or not the Apollo Sosianus sculpture blended in, see Cirucci 2010: 22–23.

105. Petron. *Sat.* 88. The *Satyrica* is usually dated to the Neronian period.

106. Mart. 9.59.12.

107. On the "art shops" of the Saepta Julia, Holleran 2012: 249–52.

108. Plin. *HN* 34.47: see Hallett (2005: 434), whose piece is helpful, on a more general level, on the differences between the Roman emulation and replication of Greek art.

109. Plin. (the younger) *Ep.* 4.28 and Vout 2018: 22.

110. On Timomachus and his Medea painting (*DNO* 3537–63), Gutzwiller 2004 and Vout 2012b.

111. Morales 2011.

112. Montel 2010.

113. Capasso 2010.

114. See Mattusch 2005: 276–77, Vout 2012a: 447–52, Neudecker 2014: 132, and Anguissola 2015: 240–42. On the Romans using paint to provide other kinds of "sophisticated visual experiences by combining duplication of form with variety of colour," see Østergaard 2015: 116.

115. Mattusch 2005: 155–56, and on its reception, Vout 2013a: 20–21 and 2013b and Fisher and Langlands 2016.

116. Bartman 1988 and Prioux 2008: 228–31. The display of "doubles" was a favored Roman strategy and one enjoyed liberally at Hadrian's Villa: see Ravasi 2015: 253.

117. Note that the body of the general has been linked to that of the Hermes Richelieu: Bartman 1988: n. 43.

118. Plin. *HN* 36.25, Paus 1.43.6, and Lattimore 1987 for the theory that the original figure was not alone but leaned on a companion.

119. The museum dates both as Hadrianic, as do Settis, Anguissola, and Gasparotto 2015: 217 and cat. nos. SC 29 and SC 30, who note that ancient restorations have misled some scholars. That said, see the seductive arguments of Bartman 1988: 216–17, who thinks the more complete statue Tiberian or early Claudian.

120. See Bartman 1992, Spinola 2015, and the "Great Small Bronzes" exhibition, National Archaeological Museum, Florence, 20 March to 31 August 2015.

121. Mart. 9.43 and 44 and Stat. *Silv.* 4.6. See, e.g., W. J. Schneider 2001, Mcnelis 2008, Miles 2008: 268–70, and Henriksén 2012: 187–201.

122. S. Stewart 1984: 55.

123. Cic. *Verr.* 2.4.12–14. For more on authenticity, see the final section of this chapter.

124. Beard 2013: 92 and W. V. Harris 2015: 398, n. 29.

125. Stat. *Silv.* 4.6.32–33: multo mea cepit amore/pectora nec longo satiauit lumina uisu.

126. Stat. *Silv.* 4.6.35–46. The statue type is now known as Hercules Epitrapezios after Statius, *Silv.* pref. 14–15, and is represented by a corpus that comprises a number of ancient miniature bronzes. In 1960, in excavations at Alba Fucens in Abruzzo, a colossal, fragmentary marble seated Hercules was found, which may or may not belong to this same "typology." Scholars have queried both the Lysippan attribution and the elaborate object biography: is it too a copy,

and which came first, the large-scale or small-scale versions? See Bartman 1986 and 1992: 71–88, 147–86, Ridgway 1997: 294–304, and Beard and Henderson 2001: 197–99.

127. Stat. *Silv.* 4.6.36–38: deus . . . paruusque uideri/ sentirique ingens.

128. Stat. *Silv.* 4.6.59–74.

129. Stat. *Silv.* 4.6.108–9: certe tu, muneris auctor,/ non aliis malles oculis, Lysippe, probari.

130. On Isabella d'Este, see below, ch. 5, and on Kedleston and its casts, Kenworthy-Browne 1993.

131. L. Harris 2004 (revised Baker), *Oxford Dictionary of National Biography*.

132. Coltman 2009: 144–45.

133. See, e.g., Stevens 2014.

134. See R. R. R. Smith 1987 and 2013. Not that all of the locals in Aphrodisias will have been convinced, nor necessarily sure of which side they were on.

135. Bianchi Bandinelli 1967 and also 1971. See Kampen 1981 and 1995, P. Zanker 1975, J. R. Clarke 2003.

136. Useful here are Henig 1995, Kampen 2006, and P. Stewart 2008: 155–166, 2009, and 2010.

137. E.g., Collingwood and Myres 1937: 250: "But on any Romano-British site the impression that constantly haunts the archeologist, like a bad smell or a stickiness on the fingers, is that of an ugliness which pervades the place like a London fog: not merely the common vulgar ugliness of the Roman empire, but a blundering, stupid ugliness that cannot even rise to the level of that vulgarity."

138. Especially Aldhouse-Green 2003 and Webster 2003. For a useful summary of the current state of play, see Croxford 2016. Collingwood (above) was rather more positive about pre-Roman Celtic art. The beauty of "Celtic" production is back in the spotlight: Farley 2014.

139. Particularly important here is Johann Gottfried Herder's criticism: see Harloe 2013: 231–37.

140. British Museum, inv. no. GR 1805.7-3.43. The head of this statue is alien and set to look forward instead of back: see M. Jones 1990: cat. no. 144 and I. Jenkins 2012: 33–47. Townley wanted it because of the fame of the Lancellotti Discobolus, found on the Esquiline in 1781, and because of the attribution of the type to Myron by Carlo Fea in 1783.

141. The Ribchester Helmet (British Museum, inv. no. 1814,0705.1) is the best known of this metalwork and the only antiquity that Townley ever published—*Vetusta Monumenta* 1815: 1–12: see B. J. N. Edwards 1982. On Townley's Indian

pieces, note Mitter 1977 and de Almeida and Gilpin 2005: 52–55, and on his Etruscan antiquities, the ongoing work of Dirk Booms.

142. First published in Latin and translated before the expanded edition of 1722: see Burn and Moore 2012. For more on it, and the founding of the Antiquaries, see ch. 7, "Locating the 'Classical.'"

143. Englefield 1792: 331 and Sweet 2004: 182.

144. There was no English edition of Winckelmann's *Geschichte* (the posthumous expanded edition of 1776) until the four-volume translation by Giles Henry Lodge, 1849–72, but Jansen's French edition, published in Paris in 1793, was already popular.

145. Vaux 1851: iii and iv, and, for a wider context, Hoselitz 2007.

146. De Bolla 2001.

147. See Camuset-Le Porzou 1985 and Bémont, Jeanlin, and Labanier 1993.

148. On her "lack of proportions," see, e.g., Wacher 1974: 402. Key now are Neal and Cosh 2002: 353–56, who still cannot resist calling her "a somewhat ungainly nude" (354) and the workmanship "generally poor" (356).

149. It is important to acknowledge here that gods' bodies do not necessarily conform to the same rules as those of mortals; that, in time, the Greek "solution" of how to represent godhead (anthropomorphism) risked making gods appear insufficiently divine and demanded that gods be given the sorts of human-shaped bodies that only gods could have. Helpful here is R. Osborne 2011: 185–215.

150. Also marble relief of women selling food from Ostia, Italy, second century CE, Ostia Museum, inv. no. 134, and Vout 2012a: 462–63.

151. Elsner 2006a.

152. See, e.g., the fresco of Daniel in the lion's den from the Catacomb of the Giordani, fourth century, in situ: Grabar 1967, cat. no. 239, and Mathews 1993, revised and expanded 1999.

153. See above, ch. 1, n. 49.

154. Perhaps too the display of the fourth-century Greek votive relief of Aphrodite and Eros (above, n. 74) with other reliefs in Pompeii's House of the Gilded Cupids, one of these neo-Attic and probably rescued from an earlier phase of decoration, asked visitors to compare and contrast.

155. Plin. *Ep.* 3.6. Other literary evidence for the production of "fakes" in Rome includes Phdr. 5, prol. 3–9.

156. Plin. *HN* 34.6: hoc casus miscuit Corintho.

157. The most famous of these images was that of Athena Polias: Paus. 1.26.6. See Gaifman 2012.

158. Suet. *Aug.* 70.2 and Mart. 9.59.11: consuluit nares an olerent aera Corinthon; Petron. *Sat.* 50.

159. Interestingly at Plut. *Mor.* 395A–396C, the foreign visitor being shown around Delphi by guides, a man learned enough to be considered something of an art expert, is struck less by the statues' form and technique than by their patina, an observation that again stimulates discussion of Corinthian bronze.

160. Plin. *HN* 34.6.

161. Mart. 9.59.21–22.

162. Pompeii, inv. no. P21803: Lazzarini and Zevi 1988–89 and 1992, and Cirucci 2009: 52–55 with bibliography. Against the booty idea are signs of intermediary use, perhaps in a tomb.

163. Luc. *Ind.* 13. On Stoic philosopher Epictetus (c. 50–125 CE), see Hershbell 1989.

164. See James Gillray, *A Cognocenti Contemplating ye Beauties of ye Antique*, 1801, print, handcolored etching, British Museum, inv. no. 1851,0901.1045: see Vout 2013a: 214–15.

165. Plin. *Ep.* 3.6: emi autem non ut haberem domi (neque enim ullum adhuc Corinthium domi habeo), uerum ut in patria nostra celebri loco ponerem, ac potissimum in Iovis templo.

166. Plin. *HN* 35.26 and 35.136.

167. Mattusch 2008: cat. no. 101. Another archaizing bronze, a kouros (Pompeii, inv. no. 22924) complete except for the wooden tray it would have carried, from the House of Gaius Julius Polybius (Mattusch 2008: cat. no. 48), is similar to a statue found in the sea off Piombino (Louvre, Br. 2) and once thought to be genuinely archaic (Settis and Catoni 2008: no. 56). See Ridgway 1967 and 1984: 20–21, M. Fuchs 1999: 23–28 and 40–41, W. V. Harris 2015: 406, and for the Piombino's possible Rhodian origin, made, initially, for display in a Rhodian sanctuary, Ruth Bielfeldt in the "Sacred Treasures: Collecting in Greek and Roman Sanctuaries" conference, Copenhagen, 9 December 2016. Interesting on archaism more broadly is Zagdoun 1989.

168. See, e.g., P. Stewart 1999: 172–81, Kristensen 2009, Leone 2013: 133–36. Systematic destruction of pagan temples, however, was not the state's intention; abandonment must be fed into the equation as must more positive attitudes toward the material culture of the pagan past: see below, ch. 4, and Saradi-Mendelovici 1990.

169. Even literary references to statues in villas decrease; Stirling 2014a: 143. On late antiquity's preference for "exquisite miniatures" over and above large-scale sculpture, Elsner 2004: 293–94.

1. La Grèce les céda; Rome les a perdus; leur sort changea deux fois, il ne changera plus (in Quynn 1945: 438). On this procession (part of the Fête de la Liberté), its celebration of the freedom brought by the Revolution, and its signaling of empire and of links soon increasingly made between Napoleon and Caesar, see Mainardi 1989 and Rowell 2012: 141–47, and for a broader context, Pommier 1991: 331–96. I presented some of the ideas in this chapter at the "Collecting and Empires" conference at the Istituto Lorenzo de' Medici in Florence in 2015. That paper is forthcoming (eds. Maia Wellington Gahtan and Eva-Maria Troelenberg).

2. Sandholtz 2007: 51.

3. Denon 1802. See A. H. Moore 2002 and Curl 1994: 116–20.

4. On bringing the Palladion from Constantinople to Rome, Malalas 13.7 (320 Bonn) and *Chron. Pasch.* s.a. 328 (528 Bonn).

5. Both of these belong to the later Lausus collection, discussed later in this chapter. For Constantinople's accumulation of Greek and Roman artifacts more broadly, see Bassett 2004 and 2014.

6. Jacoff 1993. Note that when brought into Paris, the horses were exceptional in not being in packing cases (Rowell 2012: 146). Their banner read (Mainardi 1989: 158) "Horses transported from Corinth to Rome and from Rome to Constantinople, from Constantinople to Venice, and from Venice to France. They are finally in a free land."

7. Artifacts that are seen to have suffered willful damage are often grouped, sometimes unhelpfully, under the heading "damnatio memoriae" as though all party to a single, officially sanctioned phenomenon. For various examples of, and approaches to, damnatio memoriae in ancient Rome, see Varner 2000 and 2004, Vout 2008, and, on late antiquity in particular, Hedrick 2000.

8. Kinney 1997: 134–37.

9. The bibliography on this monument is formidable and split between those who read its "spolia" as strongly ideological and those who are more reticent: compare, with a different emphasis on the relationship of past and present in each case, L'Orange and van Gerkan 1939, Peirce 1989, Elsner 2000, Varner 2014: 64–70, and Hughes 2014: esp. 107–8, with Kinney 1997: 142–43, Liverani 2011, and Greenhalgh 2011.

10. Ch. 3, "The Cult of Authenticity."

11. On Suetonius and the ninth century, see Innes 1997 and, on Pliny's dissemination and reception, M. Davies 1995, McHam 2013, and Fane-Sanders 2016.

12. See Curl 1994: 76 (even if, prior to the eighteenth century, the idea of the villa is admittedly more influential than the specifics of its architecture, which is largely restricted to those who knew the site firsthand), Macdonald and Pinto 1995, Pinto 2010, and Neverov 1999.

13. SHA *Hadr.* 1.5 and 14.8.

14. E. A. Smith 1999: 241–65, Sider 2010: 120, and Johns 1998: 160.

15. For Nero's afterlife in postclassical art more broadly, Marcos 2016.

16. On Getty as a self-styled Hadrian, see his lawyer and friend Robina Lund, 1977, as cited in Lapatin 2011: 283, on his defensiveness of Nero, Getty's short story "A Stroll along Minerva Street," in Le Vane and Getty 1955, and for the final quotation, Getty 1976: 338 and Duncan 1995: 79. He also had a lion called Nero on the grounds of his English mansion, editor's note in Getty 1976: 314. Very helpful on all of this are Lapatin 2011 and E. L. Thompson 2016a and 2016b.

17. Shapiro 1989.

18. For Catullus's poems against Julius Caesar's sidekick, Mamurra, under the name of "Mentula" or "dick" (nos. 94, 105, 114, and 115), Richlin 1983: 145, 148–49, and 153, McDermott 1983, Deuling 1999, and Pavlock 2013.

19. Plin. *HN* 36.48.

20. Suet. *Aug.* 70.2 where he is also criticized for his enthusiasm for costly furniture.

21. Suet. *Aug.* 72.1.

22. Suet. *Aug.* 72.3: ampla et operose praetoria grauabatur. His villas were decorated "non tam statuarum tabularumque pictarum ornatu quam xystis et nemoribus excoluit rebusque uetustate ac raritate notabilibus."

23. *HN* 35.81–83. None of this activity seems to qualify Augustus for the following assessment (Rutledge 2012: 70: "Augustus' private collection was an eclectic array of artistic, historic and natural objects that he kept in his house in Rome and his villa on Capri," the tone of which makes him a "Renaissance man." Similarly, "Tiberius' collection similarly inclined towards the Hellenistic, but also towards the erotic," and again (p. 71): "On the whole, everything points in Tiberius to a selective refinement of taste for the Hellenistic." For the artifacts in the Temple of Apollo Palatinus, Varner 2015a: 162, and, on

returning statues to sanctuaries, Miles 2008: 102–3.

24. Miles 2008: 100.

25. Suet. *Iul.* 47, a passage that also mentions his shameful penchant for slaves.

26. Cic. *Rosc. Am.* 133–35 (at 134): officina nequitiae et deuersorium flagitiorum omnium.

27. Cic. *Rosc. Am.* 135: ut hominem prae se neminem putet.

28. Suet. *Ner.* 31: quasi hominem tandem habitare coepisse.

29. Suet. *Tib.* 44.2 and Plin. *HN* 35.70. On the priests of Cybele in Roman visual culture, Hales 2002.

30. Supposedly written by the Alexandrian courtesan Elephantis: Suet. *Tib.* 43.2: ne cui in opera edenda exemplar imperatae schemae deesset.

31. D'Hancarville 1786: pl. 19 (British Library, PC 15.df.8), excluded from the earlier edition, which has less than half the number of engravings: Haskell 1987, H. King 1994: 37–38, Blanshard 2010: 66–68, and Pop 2015: 46.

32. Suet. *Calig.* 22.2, 52, and 57.1 and Dio Cass. 59.28.3.

33. On the return of statues by Claudius, see Arafat 1996: 86.

34. Plin. *HN* 35.94.

35. Above, ch. 3, "The Beginning of the End?"

36. In a letter to his sister, cited in Carroll 1982: 7. The inscription is IG II² 3277.

37. Ash 2006: 502.

38. Suet. *Ner.* 52.

39. Zenodorus: Plin. *HN* 34.45 and Famulus: Plin. *HN* 35.120.

40. On Alexander and his statuette, see Statius, as discussed in ch. 3, and for Nero, Plin. *HN* 34.63 (Alexander), 34.48, 34.82 (Amazon), and 34.84 (boy with goose and Gauls).

41. Varner 2015a: 164. Or was it always in the Portico of Octavia? Miles 2008: 254.

42. Plin. *HN* 34.84: in templo Pacis aliisque eius operibus.

43. Although note that his gilding of the Alexander statuette scars it: see Vout 2017: 181–82.

44. The phrase "living Greek art" is what E. P. Warren (below, ch. 8) and his fellow aesthetes thought they were doing: John Fothergill as cited in Sox 1991: 145. For Wilde, see Sherard 1916: 45.

45. Suet. *Ner.* 31 and Elsner 1994.

46. Squire 2013b. Squire's reservations aside (p. 445), Aldrovandi already understands that the site is Nero's Golden House in 1580: Biblioteca Universitaria Bologna, Aldrovandi MS 6/II, 97r–105v, "Lettera al Cardinale Paleotti sulle grottesche" (6 December 1580), fol. 102r as cited in Pugliano 2015: 359.

47. Sperlonga is discovered in 1957 (see Beard and Henderson 2001: 74–82 for a good introduction to the site and its problems) and Claudius's coastal villa at Punta Epitaffio in underwater excavations in the 1960s: Zevi and Andreae 1982 and, on both sites, Carey 2002.

48. Inscribed NERO. CLAVDIVS. CAESAR. AVGVSTVS. GERMANICVS. P. MAX. TR. P. IMP. PP. around 1428 and now in the National Archaeological Museum, Naples, inv. no. 26051. See Caglioti and Gasparotto 1997, Fusco and Corti 2006: 124–26, and Rambach 2011. Lorenzo was unusual in carving his "signature" into the stone in this way. Collectors such as Francesco Gonzaga and Pietro Barbo preferred to mount their gems on trays marked with their coat of arms: Fusco and Corti 2006: 155.

49. MacDonald and Pinto 1995.

50. MacDonald and Pinto 1995: 287–88 and fig. 376, and Christian 2010a: 341 and figs. 139 and 140. Christina of Sweden (1626–89), who displayed the muses in her palace in Rome, Palazzo Riario, acquired the core of her collection as war booty, and in 1648 some of the collections of Rudolf II were moved from Prague to Stockholm. See Leander Touati 1998: 23.

51. Artist and dealer Gavin Hamilton, who would excavate at the villa in the eighteenth century, supplying men such as Townley with ancient marbles, referred to Hadrian as "my old friend": 4 November 1773, TY7/554 as cited in Coltman 2009: 76.

52. Bignamini and Hornsby 2010.

53. Aur. Vict. *Caes.* 14.6: curare epulas signa tabulas pictas; postremo omnia satis anxie prospicere quae luxus lasciuiaeque essent.

54. SHA, *Hadr.* 26.5.

55. Above, ch. 3, "Managing the Legacy."

56. M. Jones 2012: 26–32 and M. Gleason 1994.

57. These "caryatids" were found in 1952; for a possible conflation with those on the Augustan Pantheon, see Broucke (abstract) 1999.

58. Morales 2005 and M. Jones 2012.

59. Sen. *Ep.* 51.3.

60. See Vout 2018: 33–35.

61. Vout 2006a.

62. See ch. 3, n. 16, and on the Egyptianizing sculpture from the recently excavated Antinoeion and "palaestra" regions of the villa, finds that query earlier attempts to position all such statues from the site in the canal area and thus the canal's "Canopus" designation, Mari and Sgalambro 2007 and Mari 2008.

63. Palagia 2010b: 433 and Spyropoulos 2001: 30–61. Also Tobin 1997: 333–54 and Spyropoulos 2006.

64. A seated statue of Antinous: Astros Museum: Spyropoulos and Spyropoulos 2003, fig. 12; Spyropoulos 2006, 131–32, fig. 24; a bust (Astros Museum 173: Meyer 1991: 28–29, cat. no. I 5; Datsouli-Stavridi 1993: 38, pl. 27α-δ), and an Egyptianizing head of Antinous as Osiris: Astros Museum 232: Datsouli-Stavridi 1993: 29–30, pl. 17α-ζ.

65. See Cirucci 2010: 50–51, who highlights how the villa of Herodes Atticus at Loukou is comparable only to the gardens of Rome in terms of its Greek sculpture yield.

66. Tobin 1997: 362–65 and Palagia 2016.

67. On Herodes's imperial pretensions, see Vout 2007: 85–88.

68. Burke 2009 (first published 1992): 136 and 144.

69. Humphreys 1840: 76.

70. On the Hadrianic *senatus* consultum, *Digest of Justinian* 30.1.41 as cited in Schnapp 2013: 168 and n. 38, and on the Arco di Portogallo, Varner 2014: 57 with bibliography. Arguing for a later, Honorian date, Liverani 2004. Note too the so-called "Trophies of Marius," incorporated into Alexander Severus's nymphaeum on the Esquiline, which, though not Republican as their name might suggest, are substantially earlier than the nymphaeum, possibly Domitianic or Trajanic.

71. On the Arcus Novus, previously dated to 303–4 CE, Varner 2014: 57 with bibliography, and on the problems of its dating and honorand(s), Buttrey 1983 and http://laststatues.classics.ox.ac.uk/database/discussion.php?id=3044. On the "Temple of Romulus," Varner 2014: 51.

72. Varner 2014: 54–56.

73. Varner 2014: 58–64 and, for a broader context, Prusac 2011.

74. Although note P. Zanker 2012, and the renewed emphasis on the arch as a senatorial monument.

75. Suet. *Aug.* 28.3: marmoream se relinquere, quam latericiam accepisset.

76. Aul. Gell. 16.13.9.

77. Jer. *Chron.* s.a. 334: dedicatur Constantinopolis omnium paene urbium nuditate.

78. *CTh.* 15.1.14: Praesumptionem iudicum ulterius prohibemus, qui in euersionem abditorum oppidorum metropoles uel splendidissimas ciuitates ornare se fingunt transferendorum signorum uel marmorum uel columnarum materiam requirentes. See Saradi-Mendelovici 1990: 50 and Alchermes 1994: 174–75.

79. See, e.g., the constitution by the emperors Gratian, Valentinian, and Theodosius of 382 which ordered that a temple in the eastern empire be kept open so that people could enjoy the statues for "the value of their art" rather than their divinity: *CTh.* 16.10.8: Aedem olim frequentiae dedicatam coetui et iam populo quoque communem, in qua simulacra feruntur posita artis pretio quam diuinitate metienda iugiter patere publici consilii auctoritate decernimus neque huic rei obreptiuum officere sinimus oraculum. Helpful here is Alchermes 1994: 171–72.

80. Prudent. *C. Symm.* 1.501–5 (see Alchermes 1994: 170–71 and P. Stewart 2003: 154–55): marmora tabenti respergine tincta lauate, o proceres: liceat statuas consistere puras, artificum magnorum opera: haec pulcherrima nostrae ornamenta fiant patriae, nec decolor usus in uitium uersae monumenta coinquinet artis.

81. La Regina 1991 and Liverani 2014: 74.

82. On the Augustan *curatores*, Beaujeu 1982, and for the *curator statuarum*, inscriptions and the *Notitia dignitarum* iv.12–14 (Chastagnol 1960: 469, P. Stewart 2003: 155, and Liverani 2014: 75). On moving statues, see Lepelley 1994 and 2000–2001, J. Curran 1994, and Witschel 2007: 121–24. Statues were "translatae de sordentibus locis" or "ex abditis locis" to "celeberrimum locum": Liverani 2014: 77. Also relevant here is Boin 2013 on "the late antique statuary collection" in the historic sanctuary of Magna Mater in Ostia and the importance of tradition, and Coates-Stephens 2016.

83. *CIL* VI 10040–42. See G. B. de Rossi 1874, J. Curran 1994: 46, Machado 2006: 181–85, Coates-Stephens 2007: 181 and 2016: 143. The date of these is unsettled and has ranged from the second century to the fourth century CE. Note too the Severan bases found in the Templum Pacis region, which again name famous sculptors, but in Greek, not Latin (above, ch. 3, n. 73).

84. *CIL* VI 10038: Gregori 1994 and Coates-Stephens 2016: 143–44. Also relevant here are *CIL* VI 10039 and VI 10043 and Kreikenbom 2013: 63–65.

85. Deichmann and Tschira 1939, Deichmann 1975, and Alchermes 1994: 169.

86. Although note Coates-Stephens 2016: 148 on the serious supernatural authority that was sometimes accorded to pagan statues.

87. *CTh.* 15.1.19 as discussed in Varner 2015b: 134 and by Alchermes 1994: 167, n. 2.

88. Compare Euseb. *Vit. Const.* 3.54 and *Patria* 1.62 (Preger 1907: 145; A. Berger 2013: 36): πάντα δὲ τὰ χαλκουργεύματα καὶ τὰ ξόανα ἐκ διαφόρων ναῶν καὶ πόλεων ἀθροίσας ἔστησεν αὐτὰ εἰς διακόσμησιν τῆς πόλεως, ὁμοίως δὲ καὶ τοὺς κίονας τῶν περιπάτων. See also *Patria* 2.73 (Preger 1907: 189; A. Berger 2013: 98), which, in connection with the Hippodrome, claims that Constantine brings statues from a vast range of cities east and west.

89. Colish 1985: 24–25. Compare Plutarch's use of Marcellus bringing "cosmos" to Rome, Plut. *Marc.* 21.1.

90. Liverani 2014: 76 and for the text itself, Valentini and Zucchetti 1940–53, vol. 1: 160–61.

91. Stirling 2014b: 98–101.

92. Vasari 1967–97, vol. 2: 15: "E se alcuna cosa mancava all'ultima rovina lora, venne lora data compiutamente dal partirsi Gostantino di Roma per andare a porre la sede dell'Imperio in Bisanzio, perciò che egli condusse in Grecia non solamente tutti I migliori scultori ed altri artefici di quella età, comunche fussero, ma ancora una infinità di statue e d'altre cose di scultura bellisime." For an easily accessible English edition of the *Lives*, see the 1996 Ekserdjian edition.

93. Malalas 319–20 (translation Jeffreys and Scott 1986: 173–74).

94. Yet scholars have bent over backward to make Constantine "curator" of a "museum city" and to itemize its exhibits and his "intention": e.g., Bassett 2004: passim and Martins de Jesus 2014.

95. Euseb. *Vit. Const.* 3.54 places them in the Palace and Zos. 5.24.6 in the Senate House. Were there two groups? See Bassett 2004: 73–74, 90–91, and 150–51, cat. no. 18, and for the link to Cephisodotus, Paus. 9.30.1 and Corso 2004: 76–77.

96. Bassett 2004: 224–27, and, on the Delphic tripods, Euseb. *Vit. Const.* 3.54 and Socrates, *Hist. eccl.* 1.16. Also relevant are Zos. 2.31 and Sozom. *Hist. eccl.* 2.5. The placement of the column in the Hippodrome by Constantine has not gone unquestioned: see Madden 1992: 112–16, who rehearses and rejects the arguments for a later installation. For a full biography of the column, see now Stephenson 2016, and, on its apotropaic function, Strootman 2014.

97. Hdt. 9.81 and Paus. 10.13.9. For the text, Meiggs and Lewis 1969: 27: το[ίδε τὸν] πόλεμον [ἐ]πολ[έ]μεον.

98. Chrysos 2010.

99. *Patria* 2.75 (Preger 1907: 190; A. Berger 2013: 100).

100. On the Palladion, see above, n. 4 and, on the column, itself supposed to have been brought from Rome, and its statue, perhaps from Troy, Bassett 2004: 192–204. On the relics at its base, see George Hamartolus 500, and Nicephoros Callistus 7.49 on the presence too of Noah's ax.

101. Bassett 2004: cat. nos. 116, 118, 124, and 147. On the importance of the she-wolf, see below, n. 153. Also important here is a sculptural group of an ass and its keeper (Nicetas Choniates, 650), which Suetonius (*Aug.* 96) tells us was set up by Augustus at Actium after his victory. On Choniates, Chatterjee 2012.

102. Bassett 2004: cat. no. 138 and for the obelisk in the context of Theodosian classicism, Kiilerich 1993.

103. Zos. 2.31.

104. On the Baths, see Stupperich 1982, Bassett 1996 and 2004: 51–58 and 160–85, Kaldellis 2007, and Martins de Jesus 2014, and on the sources behind Cedrenus, Mango, Vickers, and Francis 1992.

105. Two statue bases found in excavations confirm that there was at least an Aeschines and a Hecube at the site, although these are likely later than Constantine's reign: Casson, Talbot Rice, and Hudson 1929: 18–21.

106. E.g., *Greek Anthology* (edn. by Paton) 2.17–22: "And near him was Aristotle, the prince of wisdom: he stood with clasped hands, and not even in the voiceless bronze was his mind idle, but he was like one deliberating; his puckered face indicated that he was solving some doubtful problem, while his mobile eyes revealed his collected mind." See Kaldellis 2007: 363–64.

107. *Greek Anthology* (edn. by Paton) 2.228–33.

108. *Greek Anthology* (edn. by Paton) 2.59–60:
. . . ὁ δ᾽ ὑψόσε φαίνετο λεύσσων,
οἷά περ ἠνεμόεσσαν ἐς Ἴλιον ὄμμα τιταίνων.

109. Kaldellis 2007: 372. Note that Christodorus calls two statues "Homer," *Greek Anthology* (edn. by Paton) 2.311–50 and Ἵστατο δ᾽ ἄλλος Ὅμηρος (407ff). This second reference, to a Byzantine Homer, and the Virgil statue open the door to the idea of poetic succession.

110. *Greek Anthology* (edn. by Paton) 2.347–50:
ἐν δ᾽ ἄρα θυμῷ
σκεπτομένῳ μὲν ἔϊκτο . . .
. . . ἀρήϊον ἔργον ὑφαίνων.

111. On Christodorus as Homer, see Kaldellis 2007: 375–77 and Bär 2012 and on Constantine's initial plans, "βίος di Costantino," ed. Guidi 1907: 336. For a translation of the life, Beetham, "Constantine Byzantinus: The Anonymous *Life of Constantine* (*BHG* 364)," revised, Lieu and Montserrat 1996: 97–146.

112. *Greek Anthology* (edn. by Paton) 2.398–406. See Kaldellis 2007: 377–82.

113. *Greek Anthology* (edn. by Paton) 2.379.

114. See the Teubner texts by Preger 1901 and 1907, already cited, and the new editions by Cameron and Herrin 1984, and A. Berger 2013 respectively. Book 2 of the *Patria* is the book "on statues" and consists of 110 entries, over half of which are taken from the *Parastaseis*. On the problems of using the *Parastaseis* art historically, Cameron and Herrin 1984: 45–53: (53) "Its primary aim was not to record statues for any artistic reasons, but for their hidden potency, which for the compilers was of more immediate concern than their physical appearance or aesthetic quality"; L. James 1996 and A. Berger 2013: x. An exception, as Cameron and Herrin acknowledge, is chapter 82 of the *Parastaseis*, which does talk about the realism of the image and the skill of the artist. Also important here is Mango 1963: esp. 59–64 and Dragon 1985: 127–50, which unpacks the nature of the statues' agency, drawing attention, among other things, to the geographical spread of their supposed places of origin: (132) "les statues . . . contribuent à faire de Constantinople le centre de monde."

115. B. Anderson 2011: 7, who has argued strongly for the *Parastaseis* being an elite text.

116. *Parastaseis* 61, *Patria* 2.77 (Preger 1907: 190; A. Berger 2013: 100) and B. Anderson 2011: 7: "As most statues represent emperors, were erected by emperors, or both, the stories that they tell are primarily about the future of the imperial office."

117. Note here that as we found with Alexandrian artists in the last chapter, Byzantine artists are elusive: they have left few signatures and most of these postdate the twelfth century.

118. On Lausus, see Mango, Vickers, and Francis 1992 and Bassett 2000 and 2004: 232–38, and Miles 2008: 282–84, and on its Pheidian Zeus, Cedrenus 1.564. On Caligula's failed attempt to lay hands on the statue, Suet. *Cal.* 22, Dio Cass. 59.28.3, and Joseph. *AJ* 19.1.

119. On the location of the palace of Lausus, Bardill 1997.

120. Cedrenus 1.564 (Cedrenus A) and Zonar. 3.131.

121. On Skyllis and Dipoenus, Plin. *HN* 36.9 and on Amasis, Lindian Chronicle 29, Francis and Vickers 1984a and 1984b, and Higbie 2003: 7. Note that Cedrenus 1.564 confuses the pharaoh's name.

122. On Bupalus, see Heidenreich 1935 and, on his Graces, Paus. 9.35.6. Note now, however, Hedreen 2016: 110–15, who sees Bupalus as a fictional sculptor (infamous from Hipponax's poetry), to whom archaic sculptures are later attributed. On Lysippus's Kairos, referred to as "Chronus" by Cedrenus, Posidippus 142. See also Callistratus, *Stat.* 6 and, related to this, Auson. *Epigr.* 12, and the commentary by Kay 2001: 97–100. As in the *Patria*, geography is important—the statues are from some of the key sites in the ancient world, thereby speaking to Constantinople's imperialist agenda.

123. Mango 1963: 58.

124. See, e.g., Mango, Vickers and Francis 1992: 95–96.

125. Procop. *Goth.* 4.21.12–14. The question of whether Lausus's statues were copies is raised by Bassett 2000: 19–20.

126. See, e.g., R. Osborne 2011: 203–15 and Nasrallah 2010: 229–33.

127. Procop. *Goth.* 3.22.9–10: Ῥώμη μέντοι πόλεων ἁπασῶν, ὅσαι ὑφ᾽ ἡλίῳ τυγχάνουσιν οὖσαι, μεγίστη τε καὶ ἀξιολογωτάτη ὡμολόγηται εἶναι . . . τά τε ἄλλα πάντα ἐκ πάσης τῆς γῆς . . . ξυναγαγεῖν ἴσχυσαν.

128. Procop. *Goth.* 3.22.8: Πόλεως μὲν κάλλη οὐκ ὄντα ἐργάζεσθαι ἀνθρώπων ἂν φρονίμων εὑρήματα εἶεν καὶ πολιτικῶς βιοτεύειν ἐπισταμένων, ὄντα δὲ ἀφανίζειν τούς γε ἀξυνέτους εἰκὸς καὶ γνώρισμα τοῦτο τῆς αὑτῶν φύσεως οὐκ αἰσχυνομένους χρόνῳ τῷ ὑστέρῳ ἀπολιπεῖν.

129. This includes the decoration of the Baths of Leo the Wise, celebrated in an ecphrastic poem by Leo Choerosphactes, baths that Mango (1991) argues were merely restored by Leo, giving the decoration over to the emperor Arcadius's daughter Marina and to the fifth century. Note, however, Magdalino 1988.

130. The Panayia Domus, extensively renovated in the late third or early fourth century CE: Stirling 2008: cat. nos. 1, 3, and 5, and 2014b: 109–10.

131. The second stage of the villa dates from second century CE with habitation into the fourth century. For its sculpture, see Cazes 1999: 74–147, Balty and Cazes 2005 and 2008, and M. Bergmann 2007. Putting this villa's sculptures into context are Stirling 2005, Videbech 2015, and Fejfer 2008: 95–96.

132. Dandelet 2014: 34 and, more broadly, G. Clarke 2003: 237–38, Caglioti 2008, and Christian 2010b.

133. Vout 2012c.

134. This list is taken from the copy of a letter dated 25 May 1850, from Edmund Oldfield of the British Museum to W. C. Mathison of Trinity College, Cambridge, concerning the prospective

sale of these casts (Papers of the Fitzwilliam Museum Syndicate for 1850). In addition to the statues listed in my main text the letter also records a "male torso (unknown)," "Ganymede with eagle (the original I do not recollect)," nine busts (Hercules, Antinous, Minerva, Apollo, Jupiter, Apollo, Geta, Achilles, and an unknown male) and two bas-reliefs (Endymion and Perseus and Andromeda).

135. The "Weary Hercules" type, of which the Farnese Hercules is the most famous example, appears on Roman imperial coinage: see the bibliography above, ch. 1, n. 25, Moreno 1982, and Vermeule 1975. Also relevant here is the emperor Commodus's investment in Hercules, Hekster 2002.

136. Plin. *HN* 36.37.

137. Cecchetti 1886: doc. no. 60 as cited in P. F. Brown 1996: 29.

138. As cited in P. F. Brown 1996: 29: "Since our Church of San Marco has need of marbles in fine condition, and since we have heard reports that on the island of Mykonos and also other Roman islands, that there . . . are to be found the most beautiful marbles of every colour and type, we ask . . . that when you are in those parts . . . you make inquiries everywhere about those marbles which are whole shafts or pieces thereof, and about medium-sized columns—white, veined, green, porphyry, and every [other] type."

139. "Quartae partis et dimidiae totius imperii Romaniae Dominator," first assumed in 1205 by Marino Zeno but soon transferred to the doge: Nicol 1988: 153–54. On his death in 1229, Doge Pietro Ziani was praised as the equal of Caesar and Vespasian: Belozerskaya and Lapatin 2000: 84. It was early in the thirteenth century that the appearance of San Marco's facades changed radically, although some of these have changed radically since then. Still helpful here is Demus 1960: 109–15 and 120–23.

140. Giustinian 1484, cited in Cecchetti 1886: 2.232, is typical of a broader fifteenth-century cementing of the spoils' Constantinopolitan origins: allati ex Constantinopoli feruntur, sicut fere caetera precisa eius templo marmora. See F. Barry 2010a: 21.

141. See in particular Pincus 1992 and Belozerskaya and Lapatin 2000.

142. See the first edition of the *Chronicon Altinate*, probably written in the twelfth century, as cited by P. F. Brown 1991: 513. Also P. F. Brown 1996: 12–13.

143. "Quartine in dialetto veneziano," published by Gamba, *Raccolta di poesie* 3–4 as cited in P. F. Brown 2000: 28 and n. 7: "Io dico el vero io dico quell chio amo / Che Troya non fo mai sì posente / Ne Roma antichamente / Quanto e Veniexia e dezo chiaro el mostro."

144. Perocco 1984a: 67–68. For the contents of the Treasury based on extant inventories, see Pasini 1885–86 and Gallo 1967. Also, as was the case with Constantinople and the fourth century, *contemporary* evidence for the reception of any objects brought to the city in the thirteenth century is lacking (Belozerskaya and Lapatin 2000: 83).

145. Georgopoulou 2001.

146. See Nelson 2010: 79 and Perocco 1984b: 15.

147. Kleiner 2012: 317–18 and Krautheimer 1942.

148. F. Barry 2010a: 26, and on Charlemagne's motives, Brenk 1987: 108–9. Also relevant here is the burial, probably under the emperor Otto III (r. 983–1002), of Charlemagne's bones into an ancient Roman sarcophagus decorated with the myth of Persephone: see Grimme and Münchow 1994: 81.

149. On the statue from Ravenna (now lost), Hoffmann 1962, Frugoni 1984: 43–46, and, for responses to it, Greenhalgh 1989: 213. For the small bronze statue of Charlemagne or his grandson Charles the Bald, see Frugoni 1984: 46 and Gaborit-Chopin 1999: n. 13, and for the paradigm that is Marcus Aurelius, Fehl 1974, Krautheimer 1980: 192–99, and Haskell and Penny 1981: cat. no. 55. For Statius's poem about the equestrian statue of Domitian in the Forum, *Silv.* 1.1, and for other equestrian statues well known in the Middle Ages, Jacoff 1993: 62–70. Important on Carolingian use of the antique more broadly is Beutler 1964 and 1982.

150. Bober and Rubinstein 1986: cat. no. 91, Seidel 1975, Jacoff 1993: 70–73, and Settis and Catoni 2008: nos. 80 and 80a. The krater, which dates from the second century CE, is today in Pisa's Museo dell' Opera del Duomo.

151. Vasari 1967–97, vol. 2: 71: "questo è 'l talento che Cesare Imperadore diede a Pisa con lo quale si misurava lo censo che a lui era dato."

152. Kleinhenz 2004: 900. As well as Pisa's claims, Pincus (1992: 109) writes that in time "Venice, Florence, Milan, Padua—to name a number of centers—all become 'Second Romes.'" Also important here is Frederick II (r. 1220–50) and the revival of Roman imperium by the Hohenstaufen emperors: see, e.g., Alsop 1982: 302–3 and the 2008 exhibition "Exempla: The Rebirth of the Antique in Italian Art, from Frederick II

to Andrea Pisano" at Castel Sismondo, Rimini. Rightly, however, arguing against Frederick as collector is Settis 2008a: 20.

153. Herklotz 1985. On the she-wolf, now thought by many to be medieval rather than of ancient Etruscan origin, Capitoline Museums, Rome, inv. no. MC 1181: Presicce 2000a, Bartolini 2010, and Mazzoni 2010. A she-wolf was also central to Charlemagne's investment in the antique in his palace at Aachen: Krautheimer 1942: 35. On the Spinario, Haskell and Penny 1981: cat. no. 78; on the fragments of the colossal Constantine (head: Capitoline Museums, Rome, inv. no. MC 1072), and on their Christian nomenclature, Benjamin of Tudela, twelfth century (Asher edn., 1840–41, vol. 1: 41, for "lance," read "ball," and Borchardt 1936). Also on the Lateran bronzes, Krautheimer 1980: 192–97 and Kynan-Wilson 2013: 100–133.

154. Probably dated to the 1260s: Jacoff 1993: 1–2.

155. For the sculpture on the exterior of San Marco, see Demus, Tigler, Lazzarini, and Piana 1995.

156. Nagel and Wood 2010: 12 and 18.

157. Jacoff 1993: 91–93 and Greenhalgh 1989: 214–15. Note that the horses now on the facade are copies and the originals inside the Duomo. Nelson (2010: 77) writes: "the famed horses of San Marco stood metonymically for Venice and demonstrated the linkage of object, history, and political power during the period" and Jacoff 1993: 75: "There are good reasons, however, to think that the horses of San Marco assert a Venetian claim to the legacy of Imperial Rome as well as that of Byzantium," whether they evoked Roman triumphal arches at that time or not.

158. Jacoff 1993 and Freeman 2004.

159. On the identity of these sculptures, dating to c. 300 CE, see Laubscher 2000, Tigler 1995: 222–26, and Jacoff 2010: 134–35, esp. n. 28; on their place of origin and the discovery in Istanbul of a missing fragment of the right-hand figure, Naumann 1966: 209–11; on the changes to their setting in Venice, Maguire and Nelson 2010: 40; and on Byzantine views of porphyry, F. Barry 2010a: 39–40, esp. n. 98. Another porphyry head from Constantinople, known in Venice as the "Carmagnola" is set into the balustrade at the southwestern corner of the exterior balcony of the basilica (Marano for the Last Statues of Antiquity project, http://laststatues.classics.ox.ac.uk/database/discussion.php?id=826).

160. This motto is dated between the twelfth and fifteenth centuries (Tigler 1995: 221–22) and reads: L OM: PO FAR E/DIE : IN PENSAR/E UEGA QUEL/O CHE LI PO IN/CHONTRAR,

approximately, "L'uomo può fare e dire: nel pensare veda quello che gli può capitare." See F. Barry 2010a: 41 and Nelson 2007: 151.

161. P. F. Brown 1996: 21–23 and Belozerskaya and Lapatin 2000: 89–90.

162. E.g., the chalice of the emperor Romanos, Tesoro, no. 70: Buckton 1984: cat. no. 10. At its core is a classical bowl of first century BCE–first century CE, probably from Rome or Alexandria.

163. Buckton 1984: cat. no. 21. On the reuse of gems in Christian contexts of the period more broadly, see Sena Chiesa 2002.

164. On the mosaic of St. Mark's relics and its evocation of Byzantine models, see Dale 2010: 164.

165. See, e.g., Marino Sanudo, *Diario* iv col. 95 (as cited in Perocco 1984b: 5) on the visit of the queen of Hungary on 3 August 1502.

166. Nagel and Wood 2010: 18. Note Greenhalgh 1989: 217, who reminds his readers of just how much ancient sculpture must have been lost prior to the sack of Constantinople in 1204 and questions the extent to which Byzantine artists were familiar with it, just as Vasari questioned whether Venetian artists studied antiquities (a doubt refuted by Ridolfi—1996 edn.: 497).

167. Cutler 1995: 249. And if it was not undifferentiated, then Greek and Roman statuary was still seen as a sign of idolatry, its toppling celebrated in mosaics in San Marco itself: P. F. Brown 1996: 133–34.

168. Nagel and Wood 2010: 97.

169. Giard 1998 and Giuliani and Schmidt 2010.

170. As cited in Koortbojian 2011: 155. Also crucial is Tucci 2001. Also Miglio 1984: 104–5 and G. Clarke 2003: 229–30.

URBE ROMA IN PRISTINAM FORMA<*M R*>ENASCENTE LAUR(ENTIUS) MANLIUS KARITATE ERGA PATRI<*AM GENT(IS) A*>EDIS SUO / NOMINE MANLIAN(O) A S(OLO) PRO FORT<*UN*>AR(UM) MEDIOCRITATE AD FOR(UM) IUDEOR(UM) SIBI POSTERIS-Q(UE) <*SUIS IPSE*> P(OSUIT) / AB URB(E) CON(DITA) M M C C XXI L AN(NIS) M(ENSIBUS) III D(IEBUS) II P(OSUIT) XI CAL(ENDAS) AUG(USTAS).

See also the twelfth-century spolia and inscription built into the House of Niccolò di Crescenzio in the area toward the river between Rome's Theater of Marcellus and the Church of S. Maria in Cosmedin: "Nicolas, whose *domus* this is, was not unaware that the glory of this world means nothing in itself, so much so that he built this not out of vain glory, but to renew

Rome's ancient decorum" (translation, F. Barry 2010b: 154–55; also Krautheimer 1980: 197 and Christian 2010a: 65–67).

171. Manlio gained legitimacy by adopting Marcus Manlius Capitolinus, consul during the Gallic sack of Rome in 390 BCE, as his ancestor and renaming himself accordingly. See Christian 2010a: 74–76.

172. Cutler 1995: 239. Although note that in Venice too, the city's longstanding community ethos notwithstanding, noble and nonnoble families find their ancestry in ancient Rome: P. F. Brown 1996: 231–36.

173. "Quasi alterum Bysantium": Cardinal Bessarion in a letter dated 31 May 1468, and addressed to the Doge and the Venetian State on his donation of Greek manuscripts, cited in Omont 1894: 138.

174. Buckton 1984: 207–27.

175. The Gemma Augustea, traditionally but not uncontroversially dated to c. 10 CE, is now in the Kunsthistorisches Museum in Vienna, inv. no. IXa 79. For its supposed sighting in Venice, see Belozerskaya 2012: 169; for Rudolf II on precious stones, Bukovinská 2005: 218–20; and for Renaissance Venice and gems more broadly, de Maria 2013.

176. On notabilia and mirabilia, P. F. Brown 1996: 76.

177. P. F. Brown 1996: 74.

178. P. F. Brown 1996: 81–91 and Fane-Saunders 2016: 230–44. Cyriac produced copious notes about monuments seen on his journeys: see Ziebarth 1902 and Guarducci 1998 and for Polemon, above, ch. 2.

179. Mehus, *Kryiaci Anconitani Itinerarium* 33, cited in P. F. Brown 1996: 84: ad sacrum, et ornatissimam Leonidei Marci aedem perreximus. Aeneos primum illos, et arte conspicuos quadrijugales equos Phidiae nobile quidem opus, et insigne olim in Urbe belligeri Jani specimen Delubri non semel, sed dum placuerat, inspectare licuit. See Beschi 1986: 303–4. Also relevant here are the manuscripts of Stefano Magno (c. 1499–1572) as cited in Concina 1998: 50, which again give the horses documentary value by stressing their production in Asia, their transfer to Rome "as a sign of great triumph," and then to Constantinople by Constantine.

180. Muir 1979: 18 of Venice in the sixteenth century: "The Venetian republic appears to have been the most successful Italian example of a government that recognized and adapted to its own purpose the political potential of the arts."

Chapter 5: Reviving Antiquity in Renaissance Italy

1. On Cardinal Francesco Gonzaga (1444–83), see, e.g., C. M. Brown 1989 and D. Chambers 1992; on Lodovico Gonzaga (1460–1511), C. M. Brown 1983 and 1991; and on later members of the family, Brown and Lorenzoni 1993. On Lorenzo de' Medici, il Magnifico, whom Christian 2010a: 5 describes as "the paradigmatic Renaissance Maecenas whose antiquities collections back up his status as an avant-garde patron of the arts," e.g., Fusco and Corti 2006, Gombrich 1960, Dacos, Giuliano, and Pannuti 1973, Heikamp and Grotte 1974, and Kent 2004. Alsop 1982: 338–39 compares the Medici to the Attalids of Pergamum.

2. Haskell and Penny 1981 (above, ch. 1, n. 65).

3. Christian 2010a: 1–11.

4. McHam 2013: 9–10. By 1600, no fewer than fifty-five editions had rolled off the presses: see Findlen 2006: 439 and M. Davies 1995.

5. See, e.g., Christian 2010a: 20 and Settis 1986 and 2008a.

6. The words used are "ueteres statuas": see Chibnall 1986: 79–80, and for rather unconvincing attempts to tie these to objects listed in Henry's gifts to Winchester Cathedral, Bishop 1918: 396, no. 1 and 400, nos. 24 and 31. Useful here are Reynolds and Wilson 1974: 99–100, West 2008: 213–30, and Kynan-Wilson 2013: 3–7, who stresses the highly literary nature of the text in question. Note that Henry's activities are part of his religious ambition in relation to the pope, and of Winchester's boast to be, like Constantinople, a "second Rome."

7. Printing is obviously important for circulation but not perhaps as game-changing as some scholars have suggested: new educational establishments had already been founded from 1350 onward, texts circulated widely before printing, and several humanists had large manuscript collections of their own. See Grafton 1980.

8. Above, ch. 4, n. 153.

9. See Bodnar 1960 and Bodnar and Foss 2003.

10. Bodnar and Foss 2003: 196–97, October 1445 to M. Lepomagno: cum mihi Ioannes Delphin, ille Ναύαρχος diligens καὶ φιλοπονώτατος, apud eum per noctem praetoria sua in puppi moranti pleraque nomismata preciosasque gemmas ostentasset, alia inter eiusdem generis supellectilia nobile mihi de cristallo sigillum ostendit, quod policiaris digiti magnitudine galeati Alexandri Macedonis imagine pectore tenus miraque

Eutychetis artificis ope alta corporis concauitate insignitum erat. See P. F. Brown 1996: 85.

11. Bodnar and Foss 2003: 198: cum et ad lucem solidam gemmae partem obiectares, ubi cubica corporalitate intus sublucida et uitrea transparenti umbra mira pulchritudine membra quoque spirantia enitescere conspectantur, et tam conspicuae rei opificem suprascriptis inibi consculptis litteris Graecis atque uetustissimis intelligimus. The gem (P. F. Brown 1996: 85) is indeed inscribed with the name of its maker, "Eutyches, Son of Dioscurides," Dioscurides being the artist responsible for making Augustus's seal (Suet. *Aug.* 50).

12. Plin. *HN* 34.58–59, and on "diligentiores" or "diligentissimi" as "experts," 3.128, 4.83, 15.45, 19.126, and 32.26, and E. E. Perry 2000. On Cyriac and Pliny, Fane-Saunders 2016: 230–44.

13. Bettini 1984, and on the chapters on painting and sculpture in his *De remediis utriusque fortunae* in particular, Baxandall 1971: 53–58.

14. P. F. Brown 1996: 85.

15. Above, especially chs. 2 and 4.

16. [M]agis uiua creatura uideatur quam statua: erubescenti etenim nuditatem suam similis, faciem purpureo colore perfusam gerit. See J. Osborne 1987: viii (where he also calls Gregory "perhaps the first connoisseur of ancient art") and 26, and, for discussion, Carruthers 2013: 194–95 and Kynan-Wilson 2013: 133–47. On the possible link between Gregory's statue and the Capitoline Venus, disputed by Kynan-Wilson, J. Osborne 1987: 59–60 and Haskell and Penny 1981: 318.

17. Alsop 1982: 298 calls Forzetta the "first recognizably modern Western art collector." Also Christian 2010a: 32 and Favaretto 1988: 11.

18. Moved to the Church of Santa Maria dei Miracoli, they have been in the collection of the Archaeological Museum in Venice since 1811: P. F. Brown 1996: 60. They recently starred in the exhibition "La Primavera del Rinascimento: La scultura e le arti a Firenze 1400–1460," Palazzo Strozzi, 2013.

19. Poggio Bracciolini, funerary oration to Niccoli, *Opera* 1964–69 edn., vol. 1: 276: Delectabatur admodu tabulis ac signis ac uariis colaturis priscorum more. Also relevant here is Cyriac of Ancona, who compares Niccoli to Ptolemy Philadelphus (Scalamonti 1792: xcii). For Poggio to Pistoia, *Ep.* 3.7, written in Rome between October 1430 and January 1431 (Harth 1984–87, vol. 2: 105–6, lines 11–12 and 26–27): delector enim supra modum his sculpturis. . . . Si quod vero signum integrum posses reperire quod tecum afferres, triumpharem certe.

20. Christian 2010a: 15–16, 20, 52–53, and 77–84.

21. Narducci 1859 edn.: 137–38: "Capitolo delle vase antiche": "li conoscitori, quando le vedevano, per lo grandissimo diletto ratiento [*sic*], e vociferavano ad alti, e uscieno di sè, e diventavano quasi stupidi, e li non cognoscenti la voleano spezzare e gittare. E quando alcuni di questi pezzi venia a mano a scopitori o a disegnatori, o ad altri cognoscenti, tenienli in modo di cose santuarie."

22. P. F. Brown 1996: 134.

23. Nagel and Wood 2010.

24. See P. F. Brown 1996: 246. For "Man of Sorrows," compare Michele Giambono (active Venice, 1420–62), The Metropolitan Museum of Art, New York, Rogers Fund, 1906, inv. no. 06.180.

25. E.g., Leon Battista Alberti's undated "De statua," 1430s–60s (1972 edn.). Crucial, if controversial, on Poggio's profound influence on the world is Greenblatt 2011.

26. *Ep.* 3.7 (Harth 1984–87, vol. 2: 105–6, lines 19–21): Multi uariis morbis laborent; hic praecipue me tenet, ut nimium forsan, et ultra quam sit docto uiro satis. admirer haec marmora ab egregiis artificibus sculpta. Compare Cicero (*Att.* 1.8) and see Alsop 1982: 349. For Poggio and his copies of these letters, see Ullmann 1960: 43–44, and Canfora 2007: 57–58. For his discovery of several lost works by Cicero: Reynolds and Wilson 1974: 120–24.

27. Poggio Bracciolini to Niccolò Niccoli, *Ep.* 1.79, Rome, 23 September 1430 (Harth 1984–87, vol. 1: 195–96, lines 11–13): De nominibus sculptorum nescio quid dicam; Graeculi, ut nosti, sunt, uerbosiores et forsan ad uendendum carius haec finxerunt nomina. Perhaps the easiest edition to consult is Gordan (1974, reprinted 1991): 166–67, letter 84.

28. E.g., Cic. *De or.* 1.47, the first complete text of which was discovered in 1412, and SHA 1.5. Poggio had his own manuscript of the SHA, copied c. 1426 (I thank Gabriele Rota for this information).

29. Blosio Palladio, dedicatory epistle to Johann Goritz in the *Coryciana* (Ijsewijn 1997: 31), 1524: ut in tuis hortis medias Athenas emporiumque doctrinarum possis uideri illo die includere, et Musas de Helicone et Parnasso deductas in Tarpeium et Quirinalem tuis hortis imminentes transferre. Note that among his fellow humanists, Goritz was "Corycius" after Verg. *G.* 4.116–48.

30. Christian 2010a: 93 and Salomon 2003. This palazzo is now the Palazzo Venezia. See Uccella 1980.

31. Giant ancient bust of "Minerva" or "Madama Lucrezia" as she became known (now identified as a statue of Isis), still in the piazza outside the Palazzo Venezia, a basin from the Church of S. Giacomo del Colosseo, now in the Piazza Farnese, and the sarcophagus, probably of Constantia, from the Mausoleum of Santa Costanza adjacent to the Basilica of Sant' Agnese, now in the Pio-Clementino, Vatican Museums, inv. no. 237.

32. Letter from ambassador to the Gonzaga, Bartolomeo Marasca, to Barbara of Brandenburg, Marchesa of Mantua, 27 August 1467 (ASMn, *Fondo Gonzaga*, b. 843, cc. 465r–466v: 466r)— see Modigliani 2003: 127–28 and Christian 2010a: 98 and 264.

33. Compare Platina 1913–32 edn.: 288: "quippe qui et statuas ueterum undique ex tota Urbe conquisitas, in suas aedes, quas sub Capitolio extruebat, congereret" and Plin. *HN* 34.84: "And of all the objects I have noted, the most celebrated have now been dedicated by the emperor Vespasian in the Templum Pacis and his other public buildings; they had been been brought by Nero's violence into the Urbs and arranged in the sitting rooms of his Golden House."

34. Platina 1913–32 edn.: *Life of Paul II*: 388 and above, ch. 2, n. 7.

35. The bronze equestrian statue of Marcus Aurelius was not moved until 1538. On the transfer of the other bronzes, see Presicce 2000b.

36. See too Pope Pius II's description of Cardinal Rodrigo Borgia's collection, which is explicitly compared to the luxury of the Domus Aurea (Magnuson 1958: 230).

37. SIXTUS IIII. PONT: MAX: OB IMMENSAM BENIGNITATEM AENEAS INSINGNES [*sic*] STATUAS PRISCAE EXCELLENTIAE VIRTUTISQUE MONUMENTUM ROMANO POPULO UNDE EXORTE FUERE RESTITUENDAS CONDONANDASQUE CENSUIT (as cited in Christian 2010a: 233, n. 30).

38. On his descent from the Domitii Ahenobarbi, Salomon 2003: 1, and on Nero's descent, the early chapters of Suetonius's *Life of Nero*.

39. Platina 1913–32 edn.: 396–97: adire hominem die dormientem, ac noctu uigilantem, attrectantemque gemmas et margaritas difficile erat, nec nisi post multas uigilias.

40. Above, ch. 4, n. 25.

41. Platina 1913–32 edn.: 137: Cybeles quaedam Phrygia ac turrita, and on Julius Caesar as "Queen of Bithynia," Suet. *JC*. 49.1.

42. Cristoforo Landino, *Xandra* II, 30, c. 1446–47 (1939 edn.: 81–82).

43. Settis 2008b: 240.

44. Christian 2010a: 45.

45. For Ausonius's ecphrastic epigrams, including 63–71 on Myron's heifer (above, ch. 4, n. 125), see the edition by Kay 2001 and the article by Squire 2010b.

46. *Greek Anthology* (edn. by Paton) 16.167 and 204–6.

47. Christian 2010a: 47–48. Although note what she says (p. 52): "While it would be a mistake to brand Colonna as the 'first' collector of figural marbles in Rome, the display of a muscular torso and a group of Praxitelean nudes in the home of a cardinal at this date is striking."

48. Christian 2010a: 52 and 313.

49. The group was later transferred to the collection of Francesco Todeschini Piccolomini (1439–1503), Pope Pius III; see Genovese 2007.

50. Sen. *Ben*. 1.3.2–1.4.6 in a passage already recalled by Alberti in the 1430s, *De pictura* 3.54, and Christian 2010a: 55–56.

51. The poem inscribed, it would seem, on an antique base, opened: sunt nudae Charites niueo de marmore (Christian 2010a: 58 and 229). Helpful on this concept of covering a "Venus" in literary clothing is Didi-Huberman 2006: 39.

52. Filetico as cited in Christian 2010a: 229: sunt pariter nudae, sed stat conuersa duabus/ altera: quam duae nos bene conspiciunt. For more on Filetico's scholarship, see E. Lee 1978: 175–76.

53. Acquired by Julius II in 1512 and installed as a fountain on an ancient sarcophagus: Haskell and Penny 1981: no. 24 and Barkan 1993. On Alfonso V of Aragon and Naples and his Parthenope statue, Christian 2010a: 46–47 and, on the "sleeping nymph" phenomenon, 134–42.

54. Campbell 2004: 39.

55. See especially Biondo in his *Roma instaurata* (1444–46), 1953 edn.: 283: incolit ea hortorum Maecenatis aedificia et, quantum opes suppetunt, instaurat, alter nostri saeculi Maecenas summae humanitatis liberalitatisque uir et studiorum humanitatis apprime doctus, cultorumque amantissimus, Prosper Columnensis, and Christian 2010a: 48–49 and 313.

56. For the antiquities owned by Ghiberti and Donatello and seen by Cyriac of Ancona, see Scalamonti 1996 edn.: 132, and, on Ghiberti, Krautheimer 1953 and Medri 1978. On Squarcione and Bellini, B. L. Brown 2007: 284–86. And, for Bregno's collection, Christian 2010a: 177 and 278–80, and, for the Venus and Adonis sarcophagus, Ducal Palace, Mantua, inv. no. 6734, Bober and Rubenstein 1986: no. 21.

57. See, e.g., the tomb slab of Fra Angelico, who died in 1455, in the floor of Santa Maria Sopra Minerva in Rome, which commemorates him "uelut alter Apelles," and Bregno's tomb in the left transept of the same church, which compares him to Polyclitus. For a sense of artists learning from ancient sculpture, see Agostino dei Musi, called Agostino Veneziano (c. 1490–after 1536), after Baccio Bandinelli (1493–1560), *The Academy of Baccio Bandinelli in Rome*, Katrin Bellinger collection, inv. no. 1995–047 (Aymonino and Lauder 2015: cat. no. 1).

58. See Vout 2015b: 9 and Scrase 2011: no. 18.

59. Settis and Catoni 2008: no. 82a and Aymonino and Lauder 2015: 23. On the sexiness of the Spinario and his psychological as well as aesthetic quality within the context of a broader erotics of humanism, see Barkan 1999: 151–53, and on Narcissus, eroticism, and the gaze, Elsner 1996.

60. Settis 2008a: 27.

61. Also relevant here is Paolo Veronese's portrait of the same sculptor, oil on canvas, c. 1570, Metropolitan Museum of Art, New York, Gwynne Andrews Fund, 1946 (46.31).

62. And this, before the publication of Vincenzo Cartari's *Le imagini con la spositione de i dei degli antichi* (Venice, 1556) or Cesare Ripa's hugely influential *Iconologia* (1st edn., Rome, 1593).

63. Bronzino, *Portrait of a Young Man*, oil on canvas, 1550–55, on loan from a private collection, National Gallery, London. Also *Young Man with a Lute*, Uffizi, inv. no. 1575, with its statuette of Susanna based on an antique crouching Venus type, and *Portrait of a Man (Pierantonio Bandini?)*, National Gallery of Canada, Ottawa, inv. no. 3717, with its fragmented Venus sculpture to the right of the canvas, and its catalog entry in Falciani and Natali 2010: 268, which speaks of the eyes of the sitter looking "away from the viewer into space and extend[ing] the sculptural metaphor."

64. See Moreno and Stefani 2000: 332. Also relevant here is Bernardino Licinio, *A Sculptor and His Pupils*, c. 1533, Alnwick Castle.

65. The painting was once owned by Louis XIV. See Falciani and Natali 2010: 27–28 and 260. Sometimes, as with the portrait on loan to London's National Gallery, above, the sitter is identified as a sculptor. The nude is identified as "Fama," for which see Hardie 2012.

66. See above, ch. 4, n. 40 and Vout 2015a.

67. G. A. Johnson 2012: 183.

68. G. A. Johnson 2012: 183.

69. Freedman 1999.

70. See Christian 2015: 164–65 and 168, who notes, as others have done, similarities in the features of Odoni and the emperor, and 170, n. 1. Also important here is Brown, Humfrey, and Lucco 1997: no. 28. Christian also discusses other "collector portraits," e.g., Venetian-born artist and art writer Paolo Pino's *Portrait of a Collector*, 1534, oil on canvas, Musée Savoisien, Chambéry, in which the sitter is surrounded by sculpture and extends his hand toward the viewer to showcase a statuette. Also helpful is Franzoni 1984: 301–2.

71. Schmitter 2004. For this collection in its Venetian context, Favaretto 2002: 75–78.

72. Aretino I: 125 (letter dated 30 August 1538) as cited and translated in Schmitter 2004: 960: "Né so qual principe abbi sì ricchi letti, sì rari quadri e sì reali abigliamenti. De le scolture non parlo, con ciò sia che la Grecia terrebbe quasi il pregio de la forma antica, se ella non si avesse lasciato privare de le reliquie de le sue scolture." Also relevant here is Schmitter 2007.

73. Aretino I: 125 as cited and translated in Schmitter 2004: 949: "[N]on son prima costì guinto che l'animo piglia di quel piacere che soleva sentire nel giugner a Belvedere in Monte Cavallo in qualcuno dei luoghi dove si veggono di sì fatti torsi di colossi e di statue."

74. Schmitter 2004: 951–54. There were also small-scale sculptures on higher levels in the studiolo and bedroom.

75. Haskell and Penny 1981: 308 and Di Dio and Coppel 2013: 38. On Margaret, see Eichberger and Beaven 1995 and Eichberger 1996 (paintings), 2010, and 2013, and on Mary, van den Boogert 2010.

76. On the Jüngling statue (now lost) and its sixteenth-century bronze cast, Cupperi 2010.

77. C. M. Brown 1994 and 2002: 361.

78. The first Renaissance home of the statues that will become the Naples Tyrannicides: above, ch. 1.

79. Letter of Filippo Strozzi to Giovanni di Pioppi, September 1514, as cited in A. Stewart 2004: doc. RT1 and Gasparri 2009: 168: "circa 5 figure sì belle quante ne sian alter in Roma." These are immediately identified as the Horatii and Curiatii and are today in the National Archaeological Museum, Naples (inv. nos. 6012–5), the Louvre (Ma 324), and the Vatican (Galleria dei Candelabri 2794). See above, ch. 2, "Competitive Culture," Gasparri 2009: cat. nos. 78–81, and A. Stewart 2004: esp. 81–85. Note Christian 2010a: 199: "no women are known to have actively collected sculpture in Rome in the Quattrocento or

early Cinquecento. One could make the case that Alfonsina Orsini de' Medici was an exception."

80. Isabella d'Este to Nicolò Frisio, 2 January 1507, ASMn, Busta 2994, Libro 20, c. 8v (C. M. Brown 2002. doc. no. 380). ma per lo insaciabile desiderio nostro de cose antique.

81. Until the 1990s Isabella's interest in antiquity was often perceived by scholars as peculiarly feminine or aesthetic (as opposed to scholarly): so, Martindale 1964: 183: "Isabella herself was a determined collector and, in a typically feminine way, her enthusiasm was especially aroused by *objets d'art*." The nature of her correspondence, however, shows that this is not the case: see, e.g., San Juan 1991.

82. After Bourdieu 1968 (French original 1966), 1977, 1990, whose definition changes slightly over time.

83. Haskell and Penny 1981: 21 and Perrier 1638: 1 (Laocoon), 2–4 (Hercules), 81–83 (Medici Venus).

84. On Petrarch's coin collection, Favaretto 1988: 13.

85. Christian 2010a: 96 and D. Chambers 1992: 110, although there may have been such pieces in spaces beyond those covered by the inventories. See Salomon 2003: 3–4 and 14, who also notes the absence in Barbo's inventory of books, contemporary artworks, and bronze coins. Cesare Gonzaga, meanwhile, Isabella d'Este's grandson, seems not to have had any inscriptions, at least not in his *Galleria di Marmo*, the inventory of which dates to 1575 (C. M. Brown and Lorenzoni 1993: 26–27). It otherwise contained vases, a large number of portrait heads, some of them important enough for Jacopo da Strada to take casts of them, including a miniature set of the twelve Caesars, and statues, as well as two urns and five lamps.

86. Christian 2010a: 134–35.

87. On the word "cabinet," see Hooper-Greenhill 1992: 86–88, and on "ingenium," Christian 2010a: 42–44.

88. D. Chambers 1992: 79 and Christian 2010a: 94.

89. Actually Mexican. See Keating and Markey 2011: 288 for this, and for other objects from the Americas, India, Africa, China, Japan, and the Levant that were known as "Indian."

90. Also Heemskerck, *House of the Maffei*, Kupferstichkabinett, Berlin, inv. no. 79.D.2, vol. 1, fol. 3v, and his painting *Panorama with the Abduction of Helen Amidst the Wonders of the Ancient World*, 1535, The Walters Art Museum, Baltimore, inv. no. 37.656.

91. DiFuria 2010: 27 and 30–31.

92. Byzantine scholar Manuel Chrysoloras writing from Rome, where he lived from 1411 to 1413, to the Byzantine emperor, *PG* 156: cols. 57–58, discussed in Christian 2010a: 44. Also Baxandall 1971: 78–96.

93. Poliphilo in Francesco Colonna's *Hypnerotomachia Poliphili* (1964: 51, originally published 1499): "si gli fragmenti della sancta antiquitate et rupture et ruinamento . . . ne ducono in stupenda admiratione et ad tanto oblectamento di mirarle, quanto farebbe la sua integritate?" Crucial here is Barkan 1999: 119–207 on fragments, most famously the Belvedere Torso, and 210–31 on the ultimate "speaking statue," the mutilated Pasquino, which had, since 1501, been in public, not far from Rome's Piazza Navona.

94. See Rossi Pinelli 1986.

95. On Lorenzetto, Vasari 1967–97, vol. 4: 307: "la quale cosa fu cagione che altri signori hanno poi fatto il medesimo, e restaurato molte cose antiche; come il cardinal Cesis, Ferrara, Farnese, e, per dirlo in una parola, tutta Roma." See Barkan 1999: 188–89.

96. On the restoration of Cosimo's Marsyas, traditionally attributed to Donatello, and Lorenzo's Marsyas, Fusco and Corti 2006: 39–40. On Cosimo's collecting activity more broadly (for which there is no inventory), Alsop 1982: 357–60.

97. Christian 2010a: 175 and 361–62.

98. Gasparri 2015: 171.

99. For the restoration of François I's sculptures, see Cooper 2013: 136 and for Ribera's Casa de Pilatos, more on which below, Trunk 2002 and 2003.

100. See, e.g., Baglione 1935 (first published 1642): 151 on della Porta's restoration of the Hercules.

101. See Christian 2008 and 2010a: 174–75 and 383–88. Also relevant is Francisco de Holanda, *The Hanging Garden of Cardinal Andrea della Valle, Elevation of the East Wall*, pen and color wash, Biblioteca Reale, El Escorial, inv. no. 28-1-20, fol. 54. On the evolution of the collection, Paoluzzi 2007.

102. Christian 2008: 49–50.

103. Compare Lorenzo de' Medici's heavily mythologized sculpture garden in Florence as laboratory of sculptors as great as Michelangelo: Elam 1992.

104. For example, both the della Valle and Casa Sassi collections boasted statues of the Apollo Citharoedus type, complete with lyre: whereas the former was recognized as such in the fifteenth century, the latter, although restored between 1546 and 1552 when acquired by Odoardo Farnese, was known (Aldrovandi 1562: 152)

as a Hermaphrodite. See Barkan 1999: 182–87, Lodico 2007: 199–200, and Ainsworth 2010: cat. no. 99.

105. Note too Poggio's letter to Niccoli in which he admits that some of the heads he owns are still pleasing, even if damaged: Thornton 1997: 35.

106. Nofri Tornabuoni to Lorenzo de' Medici, 28 February 1489 (doc. 112, Fusco and Corti 2006: 309): "una fighura grande intera, che mostra che saettassi, che è tenuta chosa singhulare."

107. C. M. Brown 2002: 352–56, files 5 and 23 (ancient Cupid), 6, 22, and 28 (Michelangelo), and figs. 53 and 55.

108. C. M. Brown 2002: 348.

109. C. M. Brown 2002: 87.

110. C. M. Brown 2002: doc. no. 8a: Ludovici Agnello to Isabella d'Este, 28 March 1498: "certa cosa che è de le belle, non solum di Roma, ma dil mondo."

111. Mentioning both Pliny and Virgil is an account of the statue written the day after its discovery on the Esquiline and reported in a letter sent a few weeks later by Giovanni Sabadino degli Arienti to Isabella d'Este (cited in Koortbojian 2000: 200). For competition for the statue, C. M. Brown 2002: file 34 and Christian 2010a: 359.

112. C. M. Brown 2002: 122, 185, and file 31. Note too Barbo, who uses Maffeo Vallaresso, the archbishop of Zara in Dalmatia, to acquire engraved gems and coins from the East (Salomon 2003: 8).

113. De Divitiis 2012: 414 and 2015: 192.

114. G. Clarke 2003: 225–26. Rome's Casa Sassi (Christian 2010a: 374–79) would have served as another parallel, its niches' truncated torsos lending a different kind of wholeness by virtue of their replication series.

115. Ligorio (BNN Mss.B.VII, f. 124r) speaks of the palace's "diverse statue, vasi con figure fatte di marmo et lavorati di basso rilievo, et alter imagini simile, et dedication di statue, et epigraphii di morti." Note the coins too; Goltz 1563: 13. On the horse, which divided viewers as to its antiquity or modernity (now in the National Archaeological Museum, Naples, inv. no. 4887), see Diomede Carafa to Lorenzo de' Medici, 12 July 1471 (Fusco and Corti 2006: doc. 10) and de Divitiis 2007a: 26–29 and 98–99, de Divitiis 2010: 337–38, n. 9, and Fusco and Corti 2006: 35–39.

116. See, e.g., the index entry on "gifts" in Fusco and Corti 2006: 404.

117. De Divitiis 2007a: 106–23: "parte delle principal collezioni inglesi di antichità," and de Divitiis 2007b. For more on these men, see below, ch. 7.

118. De Divitiis 2007a: 106, from Hoby, *A Booke of the Travaile and Lief of Me Thomas Hoby, with Diverse Things Woorth the Notinge, 1547–1564*, Egerton ms. no. 2148; The British Library fol. 82v–83r: f. 50: "in this palatio are most part the fairest antiquities to be seen about Naples, which the owner settath great store by."

119. But even before that, almost every town in the Kingdom of Naples had one or more *seggio*, where leading families took decisions about the city's governance, many of these with public collections of ancient statuary and epigraphy, some inserted into the fabric of the building: Lenzo 2014.

120. Franzoni 1999: 43 as cited in Stenhouse 2014: 133 and n. 20: et collocari in aliquot publico loco, ita quod ab omnibus videri possint.

121. Biblioteca Angelica, Rome, MS 1729, fol. 12v as cited in Christian 2010a: 195–204 and 299: Julij S. Ang. diac. card. caes. Dietam hanc statuariam studiis suis et gentil. suor. uolup. honestae dicauit. Note too a third inscription in the della Valle hanging garden—"for the delight of friends and the delectation of citizens and strangers" (Christian 2008: 50).

122. Domenico's collection included copies of figures from the Attalid dedication on the Acropolis and sculptures from the pronaos of the Pantheon (Paschini 1926–27: 151–52) and was already in 1523 left in his will to the "virtuous people" of the Venetian Republic. A selection of these sculptures were restored and displayed in a room behind the Senate Chambers of the Doge's Palace. See M. Perry 1978 and Christian 2010a: 322–26.

123. M. Perry 1978, Favaretto 1997, Favaretto 2002: 89: "li forastieri dopo haver veduto et l'arsenale et l'altre cose meravigliose della città potessero anco per cosa notabile veder queste antiquità ridotte in luogo pubblico." The Statuario Pubblico opened in 1596. Also relevant here are R. W. Berger 1999: 221 and Stenhouse 2014: 138.

124. Note, however, that the Wrestlers, Knife Grinder, and Medici Venus are not sent here from Rome until 1677, and that the Dancing Faun does not join until 1688—see Findlen 2012.

125. For a reassessment of the connectedness of the cultural activities of husband and wife and of her spaces in San Giorgio and his in the Palazzo di San Sebastiano (home of Mantegna's *Triumphs of Caesar* (fig. 3. 4), below, ch. 6, "Iconic

Pieces in Context," and Cerati 1989), see Bourne 2001.

126. C. M. Brown 2005, and Furlotti and Rebecchini 2008: 96–110 on San Giorgio and 111–15 on the Corte Vecchia. Also B. Cohen 2003: 323–69. On the paintings in the "Studiolo," see Verheyen 1971 and Campbell 2004. Two paintings by Correggio, *Allegory of Virtue* and *Allegory of Vice*, are added on the move.

127. *Greek Anthology* (edn. by Paton) 16.210:
Ἄλσος δ᾽ ὡς ἱκόμεσθα βαθύσκιον, εὕρομεν ἔνδον πορφυρέοις μήλοισιν ἐοικότα παῖδα Κυθήρης . . . αὐτὸς δ᾽ ἐν καλύκεσσι ῥόδων πεπεδημένος ὕπνωι εὗδεν μειδιόων.

128. Philostr. *Imag.* 2.21.5:
Ὁρᾷς δὲ αὐτοὺς καὶ παλαίοντας, μᾶλλον δὲ πεπαλαικότας, καὶ τὸν Ἡρακλέα ἐν τῶι κρατεῖν. For other works by Antico (Pier Jacopo Alari Bonacolsi), c. 1455–1528, in Isabella's collection, see Furlotti and Rebecchini 2008: 107. For more on his oeuvre, Allison 1993–94 and Luciano, Kryza-Gersch, and Campbell 2011, and on Renaissance miniatures more broadly, Gasparotto 2015. For her vulgate version of Philostratus's *Imagines*, see Koortbojian and Webb 1993.

129. We focus on the Corte Vecchia and its adjacent Studiolo and Grotta because the inventory allows us to reconstruct the positioning of the objects in the space with "remarkable precision": C. M. Brown 2002: 319–62. For these rooms within the context of Isabella's Corte Vecchia apartments, C. M. Brown 1997.

130. C. M. Brown 2002: 321–28 and Furlotti and Rebecchini 2008: 112.

131. C. M. Brown 2002: 319–20 and 323.

132. Letter to Isabella d'Este, Rome, 7 March 1506, ASMn, Busta 857, c. 106 (C. M. Brown 2002: doc. 34b): "Alla quale [vostra signoria] significho nostro signore havere havuto el Lacheonte et ponerasse in Belvedere, in loco assai publico, che Dio volesse fusse in la Grotta de vostra signoria come di tale imagine più degna." On the reductions, C. M. Brown 1985: 63–64, nos. 157 and 169 and Campbell 2004: 239.

133. Compare Liebenwein 1977 (cited in Campbell 2004: 239), who sees the Grotta's assemblage as emulatory of the Belvedere Courtyard, and C. M. Brown 2002: 18: "Although the intent may have been purely decorative, the juxtaposition of several versions of the *Satyr, Hercules and Laocoon* statuettes . . . is suggestive of a refined sensibility and awareness of the uniqueness of styles of different craftsmen," and 325.

134. Both the wax and bronze are now lost. See Boucher 1991: cat. nos. 83–85, Maffei 1999:

229–30, and B. A. Curran 2012: 43. By the end of the sixteenth century, more ancient "Laocoons" had come to light in Rome. The discussion that the first of these elicits, however, is probably too late to have impacted from the outset on Isabella's display: see Koortbojian 2000: 204–6.

135. Vasari 1967–97, vol. 6: 178. The bronze was given in 1534 to Jean de Lorraine by the Signoria of Venice and disappeared into France.

136. Hochmann 2003: 91.

137. Campbell 2004: 92 and C. M. Brown 2002: 338, 340, and fig. 53.

138. Relevant here is Allison 1993–94: 126–27.

139. See Christian 2010a: 171–73, 317–20, and 357. The Bacchus is now in the Museo Nazionale del Bargello, Florence, inv. no. S 10, and the Risen Christ in the Monastery of San Vincenzo, Bassano.

140. Renaissance sources disagree as to the material of this second Cupid.

141. The piece is now lost: Fusco and Corti 2006: 41–52 and, for extensive bibliography, 225. For the relevant letter to Isabella from Antonio Maria Pico della Mirandola, 27 June 1496, see C. M. Brown 2002: 112, doc. 6a. Less than a month later, he writes again to confirm that it is modern.

142. See the correspondence in C. M. Brown 2002: 156–60 and 177–80 and Campbell 2004: 92.

143. De Thou 1823 edn.: 240–41: "c'étoit un Cupidon endormi, fait d'un riche marbre de Spezzia par Michel-Ange Buonarotti(. . .). Quand on les eut laissés quelque temps dans l'admiration, on leur fit voir un autre Cupidon qui étoit enveloppé d'une étoffe de soie. Ce monument antique, tel que nous le représentent tant d'ingénieuse épigrammes que la Grèce à l'envi fit autrefois à sa louange, étoit encore souillé de la terre d'où il avoit été tiré. Alors tout la compagnie comparant l'un avec l'autre, eut honte d'avoir jugé si avantageusement du premier, et convint que l'ancien paroissoit animé, et le nouveau un bloc de marbre sans expression. Quelques personnes de la maison assurèrent alors que Michel-Ange (. . .) avoit prié instamment la comtesse Isabella, après qu'il lui eut fait present de son Cupidon, et qu'il eut vu l'autre, qu'on ne montrât l'ancien que le dernier, afin que les connoisseurs pussent juger en les voyant, de combien, en ces sortes d'ouvrages, les ancients l'emportent sur les modernes."

144. In a letter written sixty years after the event by a man who was there at the Laocoon's discovery: Francesco da Sangallo to Vincenzio

Borghini, 28 February 1567, Settis 1999: 110–11, doc. III.

145. Fusco and Corti 2006: 120–30 (the Tazza Farnese was especially expensive with an estimate of 10,000 florins) and 201–2. The Tazza escapes being inscribed as Lorenzo's personal property and ends up in the Farnese collection upon Margaret of Parma's second marriage: Belozerskaya 2012.

146. Fusco and Corti 2006: 202.

147. Filarete 1965 edn.: 318–21.

148. Potts 1994: 118.

149. Indeed it was there already in Master Gregory's description of the Venus statue, above, even if in that instance it is some sort of "magicam persuasionem" (magical persuasion) that draws him back three times. For this and the fact that Rome as a site of sexual exploration was already live in the medieval period, see Kynan-Wilson 2013: 133–47.

150. Campbell 2004: 88 and, for the Italian, Rebecchini 2002: 56: "io son inamorato in Belvedere in uno giovine formosissimo nominato Apollo, di sorte che non è possibile che almen due volte il giorno per ordinario io resti di andar a contemplare le sue celeste bellezze, se vostra signoria mi vedesse so che rideresti de bon senno . . . ma lo ~~mio~~ Apollo mi farà venir matto, o non più, che è hora ch'io il vada a venere."

151. N. Schneider 2002: 70–71.

152. See Daston and Park 1998 and Evans and Marr 2006.

153. Fusco and Corti 2006: 189.

154. From the 1492 inventory as cited in Turpin 2006: 78. See also the inventory of Franciscan friar Franceschino da Cesena, who kept gesso casts, busts, and other pieces of marble in his bedroom with a snail, small devotional paintings, a portrait of himself, and an ostrich egg (Christian 2010a: 32). Important on "collecting nature" more broadly is Findlen 1996.

155. On this small, dark studiolo, accessible only from his bedroom (a door through to the Salone dei Cinquecento was not constructed until much later), see Schaefer 1976: 597, as cited in Sanger 2014: 78. Also important here are Feinberg 2002 and Conticelli 2007.

156. See Vasari's own account, 1976–97, vol. 6: 250–52 (although note that this was written before the room was completed and is thus an ideal vision), Gregg 2008: 112–22, and Cecchi and Pacetti 2008. And for contents most relevant for our study of classical art, Massinelli 1991.

157. Sanger 2014: 78 and Turpin 2013.

158. On the Casino, Beretta 2014.

159. Beretta 2014: 145 and Plin. *NH* 37.20: "Nero, however, as was proper for an emperor, outdid everyone by paying 1,000,000 sesterces for a single bowl."

160. Beretta 2014: 135.

161. Beretta 2014: 131.

162. Contrary, for example, to Sutton 2000: 34.

163. Olmi 1985: 6, n. 2, citing Neviani 1936: 257.

164. Laurencich-Minelli 1985: 19–20, based on the *Index alphabeticus rerum omnium naturalium in musaeo appensarum incipiendo a trabe prima* (1587; Biblioteca Universitaria, Bologna, MS 26).

165. For Calzolari's museum as "theater of nature," see Findlen 1996: 108, as "cornucopia," 64, and, as "spectacle," 117–18. On the "theatrical" metaphor more broadly, and the publication of Samuel von Quiccheberg's *Inscriptiones vel tituli theatri amplissimi* in 1565, Kuwakino 2013. When Aldrovandi put together his *Delle statue romane antiche* in 1550, his stated aim was already "to write and collect, as in a theatre" (scrivere e raccogliere, come in un Theatro) (Aldrovandi in a letter to his brother, Biblioteca Universitaria, Bologna, Aldrovandi, MS 21, III , c. 428r, as cited in Findlen 1989: 64).

166. Findlen 1996: 38.

167. Giganti 1595: 115 with reference to Aldrovandi's museum. Antonio Giganti's museum, also in Bologna, was conceived according to these same principles. See Laurencich-Minelli 1985: 19.

168. Olmi 1985: 11, based on Bellori's list (1664) of some 150 collections in Rome.

169. Kaliardos 2013: 7. Also Seelig 1985 and 1986, Marx 2007, and Diemer, Diemer, and Seelig 2008. The number of objects, excluding both the doll's house and more than 7,000 coins, comes from the 1598 inventory (Seelig 1985: 78). As was the case with the Medici collection, the Kunstkammer contained non-European "exotica."

170. Overbeeke 1994: 175–76.

171. Marx 2007: 208. And for Loredan's coins, Cunnally 2013.

172. For a catalog of its sculpture, see Weski, Frosien-Leinz, Grimm, and Fink 1987.

173. Kaufmann 1978.

174. Wünsche 2007: 82.

175. See Bredekamp 1995: 48, Lipińska 2014: 256 and, on the contents of the Kunstkammer more broadly, Bauer and Haupt 1976.

176. Note, e.g., that Cesare Gonzaga (1536–75) has two "Antinous" heads in his Galleria di Marmo (C. M. Brown and Lorenzoni 1993: 26) and Odoni, an Antinous and a Hadrian: Schmitter 2004: 948.

1. The sculpture commissioned in 1520 and completed in 1525 was first displayed in the courtyard of Florence's Palazzo Medici. On the commission, see Haskell and Penny 1981: 244, who emphasize the competing accounts of this story, and Barkan 1999: 10 and 276–79. And on the Spinario, commissioned for the cardinal by Benvenuto Cellini, Cooper 2013: 134. Ten years earlier, in 1530, François's lieutenant in Naples, Renzo da Ceri, had sent him an ancient marble of the Venus Genetrix type that was much praised by poets, suggesting perhaps that before this point he owned mainly fragments (see Bensoussan 2014: 177).

2. *CAF* IV, 82, no. 11374, 13 February 1540, 675 *livres*, as cited in Cooper 2013: 135: "(où nous l'envoyons) afin de pourtraire plusieurs medailles, tableaux, arcs triomphaux et autres anticailles exquises y estans que nous desirons veoir, aussi choisir et adviser celles que nous y pourrons recouvrer et achepter."

3. Cooper 2013: 137–48. The Aphrodite is first recognized as a potential Knidia early in the eighteenth century: see Haskell and Penny 1981: 331. On the della Valle satyrs (Bober and Rubinstein 1986: no. 75) and Spinoso's poem, see Christian 2010a: 384 and 386.

4. Vasari 1967–97, vol. 6: 144, and on the changing display of the bronzes at Fontainebleau, Bensoussan 2014. Primaticcio also obtained ancient marbles for the king (Maral and Milovanovic 2012: 16 and Cooper 2013: 135–36).

5. Nuancing Cooper (2013: 144), who notes only that these were not cast in bronze, Cupperi 2004 and 2010: 82–84.

6. Cupperi 2010: 85: "unlike the bronze casts made for Francis I, Mary's casts must have been esteemed not for their medium, but because of their fidelity to famous ancient statues."

7. Cooper 2013: 79–81. On the head, BnF, *ms. fr.* 5150, fᵒ 64, 24 June 1550; *Correspondance du Cardinal Jean du Bellay* (2008–12) V, 382–83, no. 1158: "les anticaires d'icy ont recontré que c'est *opus Phidie.*"

8. Louvre, Paris, inv. no. MR 152. Given in 1556 in the hope of securing the king's support in chasing the Spanish from Naples. See Haskell and Penny 1981: 196–97 and Maral and Milovanovic 2012: 34, cat. no. 20.

9. Charles I to the Treasurer, 25 May 1631, as cited in Avery 1980–82: doc. 56.

10. Kurtz 2008: 190. Although note too the influence of Spain: J. Brown 2002 and Howarth 2002: 78, who sees Charles's first visit to Madrid as "the decisive educational experience of his life" and claims that it was this that led to England's royal collection ranking in the European league for the first time. Also note the influence of the Habsburg courts: Brotton 2006: 175.

11. Pfeiffer 1976: 31–33 (Poggio) and Cooper 2013: 7: "uno belisimo Guliseo."

12. *CAF* VIII, 465, 5–6 and 13–16 August 1529 (Caesar), Poldo 1559: 59 (mosaic), and Cooper 2013: 128–29. On the king's subservience before the antique, Paradin 1542: 105: narrauit . . . Regem ipsum, quoties in tumulos illos altius humi defossos incidisset, crebro, ut legeret, procubuisse uelut regiae maiestatis fasces antiquitati submittens, seque telluri aduoluisse. And on Julius Caesar and mosaics, above, ch. 4, n. 25.

13. Cooper 2013: 130. Before being given to the pope and entering the Vatican collection, the telamons (Vatican, Museo Pio-Clementino, inv. no. 194) graced the entrance of Tivoli's Episcopal palace. See Guillaume 1979: 233–38.

14. Preface to Geoffroy Tory's edition of Alberti's *De re aedificatoria* (1512) fᵒ aii as cited in Cooper 2013: 11: ut non modo Italos, imo Dores et Iones, Italorum magistros, ipsi Galli vincere videantur et iudicentur manifestissime.

15. Tory (1529) fᵒ I, v vᵒ as cited in Cooper 2013: 13: "en destruyssant Loix, Costumes, Usages [. . .] et en demolissant Epitaphes, et Sepulchres."

16. On Vasari and the notion of decline, Marvin 2008: 21–25.

17. Kurtz 2008: 190, citing, for Nonsuch, William Camden. Although Kurtz follows centuries of viewers in identifying the Hampton Court roundels as Roman emperors, whether they were designed as such must remain open: see Kent Rawlinson in https://www.theguardian.com/culture/2011/sep/28/hampton-court-palace-roundels-restored (last accessed 4 December 2016). Note too the four coarse medallions, inscribed in Latin, of Hannibal, Julius Caesar, Nero, and Attila, in the garden loggia at Horton Court, Gloucestershire, built by William Knight sometime between 1519 and 1529. If these are original to the structure, they may date to c. 1527 when Knight went back to Rome to act for Henry VIII in his divorce case. See https://heritagerecords.nationaltrust.org.uk/HBSMR/MonRecord.aspx?uid=MNA165052 (last accessed 4 December 2016).

18. These are additions made under the twelfth Earl of Arundel, Henry Fitzalan, and his heir, John Lumley: see Kurtz 2008: 191–92 and 201, n. 25, and, in the context of Lumley's broader collecting, Barron 2003.

19. Thevet, *ms. La Description*, f° 77: "qu'il ne faut point aller ne en Grece ne en Egipthe et moings à Rome pour contenter les yeux et l'esprit de ceux qui sont amateurs de l'antiquité," as cited in Cooper 2013: 156.

20. Howarth 2002: 69. For a broader view of collecting in early modern England, see Swann 2001: 16–54 and Chaney 2003.

21. James Usher to John Selden, Drogheda 30 November 1627, Bodleian Library, Selden MS (Parr 1686: 386).

22. Speake 2003: 569. Note that Arundel's acquisition of the inscriptions, including the *Marmor Parium*, was itself a victory of the English over the French. The French antiquary Nicolas-Claude Fabri de Peiresc (see Schnapp 1996—first published in French in 1993—132–38) lost the inscriptions when his own agent was imprisoned: Stoneman 2010: 48.

23. This head has for a long time been known as the "Arundel Homer" but there is no evidence that Arundel called it this. It is now, more usually, identified as a poet or sometimes Sophocles: see Harding 2008. Petty also sent Arundel a few fragments of the Great Altar at Pergamum, Angelicoussis 2004: 149–50.

24. Harding 2008: 12–13, citing John Johnston's *Naturae constantia* 1632, which he notes (16, n. 11) was translated by Paul Quarrie.

25. The Vienna version is a copy, the original of which is in Arundel Castle: see Rambach 2013, Gilman 2000, and Weststeijn 2015: 53. On Aletheia's patronage, in particular with respect to her villa, Tart Hall, Howarth 1998, Chew 2003, and Rabe 2016.

26. Marble portrait statue, perhaps of Homer, Ashmolean Museum, inv. no. AN1984.45. See Vickers 2007: 66, Haynes 1974, and Weststeijn 2015: 53–61, Peter Paul Rubens, *The Arundel Homer*, c. 1605, black chalk on paper, 552 x 361 mm, Staatliche Museen Preussischer Kulturbesitz, Kupferstichkabinett, Berlin, inv. no. KdZ 10601, and de Bisschop 1668–69: pls. 71 and 72. For the Arundel marbles more broadly, see Haynes 1975.

27. For the inscription, Howarth 1985: 2 and for Peacham as Arundel's "protégé," Howarth 1985: 32. See Peacham's 1634 edn.: 107; he also talks of the threat to antiquities from "the barbarous religion of the Turks."

28. Above, ch. 3, "Managing the Legacy," and Camden 1610 (translated by Philomen Holland): 63: "the Romanes having brought over Colonies hither, and reduced the naturall inhabitants of the lland unto the society of civill life, by training them up in the liberall Arts . . . governed them with their laws, and framed them to good manners and behaviour." Note, however, that in the twelfth and thirteenth centuries, texts by William of Malmesbury and Gerald of Wales already attest to an interest in "mira Romanorum artificia" (wonderful Roman artifacts) on British soil—see Kynan-Wilson 2013: 49–69 and 73–77.

29. T. A. King 2008: 442. The first edition had appeared in 1622.

30. Peacham 1634: 109–10.

31. Peacham 1634: 105.

32. Junius 1638: 13.

33. Weststeijn 2015: 72.

34. Howarth 1997: 283–86.

35. Gilman 1994: 452.

36. Cooper 2013: 3–4.

37. Warr and Elliott 2010: 8.

38. Di Dio 2008: 259–62. And on Rubens as collector, Muller 1977 and 1989, Belkin and Healy 2004, and C. M. Anderson 2015: 89–92.

39. Arundel did receive a head of Jupiter from Carleton. On the relationship of Carleton and Rubens, see Hill and Bracken 2014, and Muller 1977. The stele, which later passed through the collection of Rotterdam brewer Reinier van der Wolff, is now in the Rijksmuseum van Oudheden, Leiden, no. AU. For Carleton's hype, *Correspondance de Rubens* II, 145, Carleton to Rubens, 7 May 1618: "la cosa la più cara et la più pretiosa in hoc genere che no ha nissun Principe ni particolare qual si voglia chi sia de di qua li monti."

40. Muller 1977: 573–74, Lockyer 1981, and Hille 2012.

41. Barkan 1999: 151 talks of "the grand industry of Renaissance *Spinarios*," including "(not surprisingly) the notable production of humanist-inspired statuettes."

42. Cooper 2013: 27: "un tireur d'espines de son pied."

43. Also attributed to Antonello Gagini, *Spinario*, c. 1507–9, inv. no. 32.121, *Spinario*, northern Italian, c. 1500–1520, inv. no. 68.141.9, Severo Calzetta da Ravenna, *Spinario*, late fifteenth century, inv. no. 41.100.76a, b, and possibly workshop of Severo Calzetta da Ravenna, *Spinario*, mid-sixteenth century, inv. no. 32.100.170.

44. Bentley-Cranch 1988 and McGowan 2000: 85.

45. Mayer and Bentley-Cranch 1983 and Kurtz 2008: 200, n. 18, who also notes Amboise's own marble roundels at Château de Gaillon.

46. Fulvio 1517, translated into French in 1524. See Haskell 1993: 28–30.

47. Wellington 2015: 22–23.

48. See, e.g., Stukeley 1776 (first published 1724): 135 on the collection of Thomas Herbert, eighth Earl of Pembroke (1656–1733), which contained sculptures formerly in the Arundel collection: "You, my Lord, by treading in the steps of the great Arundel, have brought old arts, Greece and Rome, nay Apollo and all his Muses, to Great Britain; Wilton is become tramontane Italy." On the Gonzaga gems, later acquired by George Spencer, fourth Duke of Marlborough (1738–1817), see Scarisbrick 1996 and Boardman 2009, and on Charles's acquisition in two installments, 1627–28, of the Gonzaga paintings and some antiquities, J. Brown 1995: 231, Arlt 2005: 52–56, Furlotti and Rebecchini 2008: 254–58, and Haskell 2013. The crouching Venus, known by some at the time as "Helen of Troy," on permanent loan to the British Museum from the Royal Collection (inv. no. 1963,1029.1), was later acquired by court painter Sir Peter Lely, and then reacquired by the Royal Collection. Four Cupids are recorded on an early seventeenth-century folio in an album of drawings in Windsor Castle (Royal Library, Windsor Castle, inv. no. 1914). For these and the other ancient sculptures in Charles's collection, see Scott-Elliot 1959 and the inventories and valuations of Charles's collection on its dispersal after his execution (Millar 1972 and Brotton 2006). For the dealer Daniel Nijs, himself a collector, C. M. Anderson 2015.

49. Haskell and Penny 1981: 32–33.

50. On the bronze Spinario and marble busts of the twelve Caesars presented to Philip II, probably all from the della Porta workshop, Di Dio 2008: 250–51, and on the later Spinario (Prado, Madrid, inv. no. E00163) and other casts, Haskell and Penny 1981: 33–35 and (for an additional Borghese Gladiator and Ludovisi Mars?) 221 and 260, and Di Dio and Coppel 2013: 50–52.

51. Pinatel 2000.

52. Haskell and Penny 1981: 37–41. They note that though the foundry had a mold of the Laocoon by 1701, a cast was not made for Versailles (though, p. 244, a marble copy was made by Jean-Baptiste Tuby in 1696). The resulting bronze was acquired by Sir Robert Walpole's eldest son, also Robert, and installed in Houghton Hall.

53. See Maral and Milovanovic 2012: 135–36.

54. Haskell and Penny 1981: 308. The relief was never installed. It was eventually put above the entrance of the Château of Anet.

55. Above, ch. 5, "From Ecphrasis to Art Appreciation," and on Angelo Colocci's Latin Academy devoted to the cult of the sleeping nymph, Christian 2010a: 308–13.

56. Cellini, saltcellar, 1540–43, gold, with ebony base, Kunsthistorisches Museum, Vienna, inv. no. 881.

57. Maral and Milovanovic 2012: 25, 50–52. The Meleager is now in the Vatican, Museo Pio-Clementino, inv. no. 490: see Haskell and Penny 1981: cat. no. 60.

58. Louis acquired these in 1685–86; Haskell and Penny 1981: 38 and cat. nos. 23 and 42 and Maral and Milovanovic 2012: 17, 25, 56–59, and cat. nos. 17 and 18.

59. Maral and Milovanovic 2012: 38, 51, and cat. nos. 4 and 5. On the Mazarin collection, Michel 1999. The statues from Smyrna included a Lycian Apollo, a Jupiter, and a Juno: Maral and Milovanovic 2012: 25 and cat. nos. 3 and 19.

60. Maral and Milovanovic 2012: 47, who also note the exceptions of Frenchman Jacob Spon (1647–85), who travels with Englishman Sir George Wheler (their *Voyage d'Italie, de Dalmatie, de Grèce et du Levant: Fait aux années 1675 et 1676* is published in 1678) and Charles François Olier, French ambassador to the Ottoman court.

61. Maral and Milovanovic 2012: 25, 30, fig. 6 (Benghazi statue), 25, 62, and cat. no. 22 (centaur), 25, 64, and cat. no. 16 (togate statue), and 25, 36, and cat. no. 21 (Venus of Arles).

62. Maral and Milovanovic 2012: 25: "qui vinrent affirmer à Versailles l'importance d'une Antiquité en quelque sorte gallicane," and 26. On the absence of "Cincinnatus," Haskell and Penny 1981: 182.

63. Guyonnet de Vertron 1686: iii: "Versailles est maintenant un Panthéon."

64. Maral and Milovanovic 2012: 36, 107, and cat. no. 21. On the rediscovery of the statue and its immediate and later reception, identification, and reconstruction, see Séréna-Allier 2013. Also relevant on the statue's reconstruction is Ridgway 1976.

65. Séréna-Allier 2013: 51, and, on the reception of the Venus de Milo, found in 1820, Prettejohn 2006. Note too the Louvre's Venus Genetrix, in Louis's collection: Pasquier 1985: 52.

66. Denis Dusault, in a letter dated 11 February 1695 to an unknown addressee, reporting the

opinion of the sculptor François Puget: "Il m'a assuré que la Diane d'Arles n'avoit rien de comparable à cette statue." See Lorenzatti 2013: 681. The statue was in the Louvre (inv. no. MR 245, Ma 1130) but, since 2004, has been returned to the Grand Galerie at Versailles.

67. Piganiol de la Force 1715: 114: "je ne suis pas du sentiment de ceux qui croyent que le vermillon des joues de cette Statue est naturel au marbre, très certainement il est ajoûté." Lorenzatti 2013: 688–89. The first edition of Piganiol's *Versailles* was printed in 1701 but included only a very brief notice of the statue.

68. Caylus 1759: 217: "on a été long-tems [sic] étonné de l'incarnat léger qu'on remarque sur les joues de cette Figure; mais les Mémoires de l'Académie des Belle-Lettres, pour l'année 1759, pourront faire évanouir cette surprise. On y verra que cette particularité, loin d'être l'effet du hazard, est une operation très simple de l'Art, sagement et modérément employé par les Anciens." On Quatremère and polychromy, see Luke 1996. Gibson's *Tinted Venus*, 1851–56 (Walker Art Gallery, Liverpool, inv. no. WAG7808), with its color-wash, golden hair, blue eyes, and red lips, proved very controversial when exhibited in London 1862.

69. Winckelmann (1764) 2006 edn.: 244. Although on the question of the statue's Greek- or Roman-ness in Winckelmann's eyes, Lorenzatti 2013: 691.

70. Lorenzatti 2013: 702–4 and Trimble 2011: 433–34.

71. D. de Rossi 1704: pl. 69. See Haskell and Penny 1981: 219.

72. Haskell and Penny 1981: 23. Also interesting, given that by the nineteenth century its ugliness was a problem, is the inclusion (pl. 103) of the ancient hellenistic-style Drunken Old Woman, now in the Munich Glyptothek, inv. no. 437.

73. D. de Rossi 1704: pl. 155 and Guardiola 2013.

74. D. de Rossi 1704: pl. 70: its caption gives its name and then beneath, "Fù nella Villa Montalto di dove è transportato nel Palazzo Regio di Versaglia"; the prior caption notes that "Germanicus" "oggi in Francia nel Palazzo Reale di Versaglia."

75. D. de Rossi 1704: pl. 121, and Haskell and Penny 1981: cat. no. 19. On Queen Christina's collection, see above, ch. 4, n. 50.

76. Haskell and Penny 1981: 23.

77. Thomassin 1723 edn. (first published in 1694): pls. 3–5 and 9–10. The only statue to come before the Venus is a Bacchus that is attested as being in the royal collection since at least 1609. Plate 1 is a frontispiece.

78. Formerly in the oval circus of the formal garden Wilton House, and now in Houghton Hall in Norfolk: Avery 1980–82: cat. no. 19A and Haskell and Penny 1981: 221–24. The engraving was part of Isaac de Caus's *Wilton Garden = Hortus Penbrochianus*, first published in 1645, and then the title page of the revised edition (1654). It proved very influential in English garden design. For author and garden designer de Caus, see L. Morgan 2009.

79. Philip Skippon (1641–91) 1732: 654 and John Northall (whose journey was in 1752) 1766: 351.

80. Haskell and Penny 1981: cat. no. 43 and, on Whitby and its seventeenth-century bronze version, installed by Sir Hugh Cholmley (1632–89), replaced in 2009 with a modern replica, Lea 2009.

81. Joseph Wright of Derby, *Three Persons Viewing the Gladiator by Candlelight*, 1765, now in a private collection. The statue also features in Henry Singleton, *The Royal Academicians in General Assembly*, 1795, oil on canvas, 1981 x 2590 mm, Royal Academy, London.

82. See Chard and Langdon 1996 and Chard 1999.

83. Gaze 1997: 39.

84. The picture of James dates to 1685 and is in the Royal Collection, inv. no. RCIN 403427.

85. Montfaucon 1722 (2nd edn.), vol. 1: preface. The work was hugely successful: its initial print-run of 1,800 sold out, leading to a second of 2,200 copies. It was translated into English (1721–22, London) and condensed into German (1757). See, e.g., Marvin 2008: 60–63, Haskell 1993: 131–33, Poulouin 1995, and Schnapp 1996: 234–37.

86. Richardson and Richardson 1728, vol. 3 (*Description de plusieurs des statues, tableaux, desseins &c. qui se trouvent en Italie*, in two parts; revised, expanded, and translated edition of 1722 text): 100–101, 581–85, and 592 and Haskell and Penny 1981: 99–100.

87. Richardson and Richardson 1728, vol. 3 (in two parts): 244: "En un mot, tout ce Groupe est grande et vaste; mais on y remarque quelquefois du sec, et surtout, peu du délicatesse. Les animaux sont d'un goût médiocre, et l'on trouve bien de la pauvreté dans la corde."

88. Note, however, that Richardson Sr. also never made it to Italy, helping his son to compile material gathered on his Grand Tour in 1720.

89. Richardson and Richardson 1728, vol. 3, part 1: epigraph, and Van Romburgh 2004: letter 114b. Sed quoniam Exempla illa Veterum Pictorum

fantasia tantum et pro cuiusque captu magis ad minus assequi possumus, uellem equidem eadem diligentia similem quandoque Tractatum excudi posse de Picturis Italorum, quorum Exemplaria siue Prototypa adhuc hodie public prostant, et digito possunt monstrari et diçier, "Haec sunt."

90. Marvin 2008: 41–54.

91. Haskell and Penny 1981: cat. nos. 43, 46, 42 ("Germanicus," signed by Cleomenes, an Athenian, son of Cleomenes), 80 (Torso, signed by Apollonius, an Athenian, son of Nestor), 88 (Medici Venus, signed by Cleomenes, an Athenian, son of Apollodorus), 71 (Orestes and Electra), and 20 (Furietti Centaurs). See Pollitt 1996: 4.

92. Richardson and Richardson 1728, vol. 3 (in two parts): 100 and 583.

93. Marvin 2008: 118.

94. As cited in Angelicoussis 2004: 149.

95. Angelicoussis 2004: 148–49.

96. Sir Edward Walker, one-time secretary of Thomas Howard in his life of Howard, 1705: 222. Also interesting, given Arundel's collection, is the apologia with which Walker opens his account (209): "Were I but as able to write Historical Observations as was that *Grecian* Statuary to form the exact Proportion of *Alcides'* Body by viewing only the Print of his Foot, I would not then despair."

97. Kennedy 1769: xiii.

98. Howarth 1985: 111–12, 136–38, and, on the obelisk of Domitian, now in the Piazza Navona, Chaney 2011.

99. Hille 2012: 26.

100. Junius 1638: 77. Note the 1991 edition by Aldrich, Fehl, and Fehl (under Junius in the bibliography).

101. See Gilman 2000: 296.

102. Novikova 2004: 322.

103. Novikova 2004.

104. See Marr 2010.

105. Howarth 2002. Not all of these pictures were bought. His Holbein portrait of Christina, Duchess of Milan (National Gallery, London, inv. no. NG2475), was inherited on the death of John Lumley in 1609 and formerly belonged to Arundel's great-grandfather, Henry Fitzalan (above, n. 18). For more on Lumley's paintings, see Evans 2010 and Stourton and Sebag Montefiore 2012: 42–43.

106. Ferrier 1970: 51.

107. See Cooper 2013 and McGowan 2000: 56–66. For the fake inscriptions attributed to Du Bellay's collection, see Pirro Ligorio and Jean-Jacques Boissard as discussed in Cooper 2013: 101–9.

108. Cooper 2013: 150 and 331–36.

109. Cooper 2013: 80–81.

110. Trunk 2002: 19.

111. Brown and Kagan 1987: 233, Trunk 2002, Di Dio 2008: 257, and, on the building, Lleó Cañal 1998.

112. The painting is now in the Vatican Museums.

113. Brown and Kagan 1987.

114. Antonio 1783: 366: "uerus alter Maecenas" as cited in Brown and Kagan 1987: 247; and for Arundel as Maecenas, Cust 1911: 97. On the Casa de Pilatos in the context of Seville as a "new Rome," Lleó Cañal 1979: 33–36, and on Philip II's collection of antiquities, some of them inherited from Mary of Hungary, Di Dio 2008: 248–53.

115. Trunk 2003: 259 and Trunk 2008. These reliefs, which are heavily restored, commemorate Augustus's decisive victory over Mark Antony at the Battle of Actium; see Szidat 1997 and La Rocca, Presicce, Lo Monaco, Giroire, and Roger 2013: 320–21.

116. Prideaux 1676 and Chandler 1763. See Haynes 1975 and Gadd, Eliot, and Louis 2013: 382–83.

117. Tradescant 1656: 179 and Scarisbrick 1996: 45.

118. MacGregor 1983a and 1983b.

119. C. J. Wright 1997, Hepple 2001 and 2003, and Hingley 2008.

120. Hepple 2003: 160.

121. Hepple 2001: 111.

122. On Cotton's library, see Tite 2003. Its shelves were crowned with busts of the twelve Caesars, Cleopatra, and Faustina: Christian 2010b: 165.

123. Hepple 2001: 118 and on Arundel's circle more broadly, Howarth 1985.

124. Maral and Milovanovic 2012: 106 and cat. nos. 125 and 126. One of two series acquired to adorn the Grand Appartement and la Grande Galerie at Versailles, and considered by early eighteenth-century visitors at least to be antique.

125. McNutt 1990: 159.

126. Kimball 1943: 241–42 and on collecting in early America more broadly, H. M. Gleason 2015.

127. Above, ch. 4, n. 44. And for "neoclassicism" as a phenomenon, e.g., Honour 1968, the exhibition catalog *The Age of Neo-classicism: Handlist to the Fourteenth Exhibition of the Council of Europe / The Royal Academy and the Victoria and Albert Museum, London, 9 September—19 November 1972*, and Coltman 2006.

1. Carlo Maratta, *Robert Spencer, Earl of Sunderland*, Collection of the Right Honorable the Earl Spencer, Althorp House, Northamptonshire.

2. Angelicoussis 2001: 17.

3. Pompeo Batoni, *Thomas Dundas, Later 1st Baron Dundas (1741–1820)*, 1763–64, oil on canvas, 298 x 196.8 cm, The Marquess of Zetland, Aske Hall, North Yorkshire. On the rarity of the Belvedere's ensemble in Batoni's work, perhaps for financial reasons, Bowron and Kerber 2007: 83–84.

4. On ennui and the arts in the eighteenth century, Saisselin 1992.

5. See Bowron and Kerber 2007: 60–61 and 188, n. 124. On the "Temple of the Sibyl," now more commonly referred to as the Temple of Vesta, M. Richardson 2003.

6. See Winckelmann (1764) 2006 edn.: 333–34. Helpful here are Potts 1994: 118–32 and Harloe 2007.

7. Prettejohn 2005: 29.

8. Bowron and Kerber 2007: 62. The marble bas-relief, dating to the first century CE, is now in the Capitoline Museums, inv. no. Albani, B 217.

9. Still classic on "homosociality" and its eroticism is Sedgwick 1985, and for David, Crow 1994.

10. Chard 1994: 148.

11. Solomon Godeau (1997: 63), whose work is particularly concerned with examining the attraction and potency of the androgynous male body in postrevolutionary French art.

12. Pascoe 2005: 84. On the eighteenth-century Uffizi, Findlen 2012.

13. Prettejohn 2005: 33, 38, and 40.

14. See, e.g., Pompeo Batoni, *Portrait of John Staples (1736–1820)*, 1773, oil on canvas, 264 x 198 cm, Museo di Roma, inv. no. MR1974. And *John Wodehouse, Later 1st Baron Wodehouse (1741–1834)*, 1763–64, oil on canvas, 136.5 x 99.1 cm, Allen Memorial Art Museum, Oberlin College, Ohio, inv. no. AMAM 1970.60. Also Bowron and Kerber 2007: 81 and 83.

15. Bowron and Kerber 2007: 76 (painting) and Haskell and Penny 1981: 288 (statue group).

16. Perrier 1638: pl. 41 (his identification is "fratres sese complectentes," "brothers embracing each other") and de Rossi 1704: pls. 62 and 63.

17. This was the only full-length standing portrait Batoni painted this year (Coltman 2009: 137) and the last one of this size to be painted entirely by the artist himself (Bowron and Kerber 2007: 76).

18. Dubos (first published in French in 1719) 1748, vol. 1: "The Author's Advertisement," although note that in the French, "beauty" is "plaisir."

19. Dubos 1748, vol. 1: 310 and 309 (Dubos 1719, vol. I: 361–63).

20. Published in its first edition in 1749 (although note that copies of this are rare compared to the 1756 edition). See Sweet 2012: 7–8 and Chard 1999: 14, n. 38.

21. Bowron and Kerber 2007: 48 and, on Albani and his villa on the Via Salaria, purpose-built to house his antiquities and celebrated as complete in 1763, Röttgen 1982.

22. Over four hundred of Albani's pieces go to the Capitoline Museum, among them the della Valle satyrs and Capitoline Antinous: see Paul 2012.

23. The Venus joins the Capitoline's collection in 1752 (Haskell and Penny 1981: no. 84).

24. On the Vatican's Museo Pio-Clementino, named after Pope Clement XIV and Pius VI, Collins 2012.

25. Bottari 1741–82 and E. Q. Visconti 1818–22 (the seven volumes were completed from 1782 to 1807 but reissued in a uniform edition) and Paul 2000: 79.

26. Bowron and Kerber 2007: 49.

27. See, e.g., Malgouyres 1999, Poulot 1997, and McClellan 2012.

28. The bibliography is formidable: see, e.g., the publications (on, among others, Holkham Hall, Woburn Abbey, Chatsworth, Petworth, Castle Howard, Newby Hall, the sculptures of Thomas Hope) in the Classical Sculpture in British Private Collections series of the Monumenta artis Romanae (MAR) and the essays in volume 27 of MAR, Boschung and Hesberg 2000. Also Wilton and Bignamini 1996, J. Scott 2003, Guilding 2001 and 2014, Coutu 2015, Stourton and Sebag Montefiore 2012, Coltman 2006 and 2009.

29. Above, ch. 4.

30. On the eight *Antichità* volumes (five of them on painting, two on bronzes, and one on lamps and candelabra), see Ciardiello 2006 and for the quotation, vol. 1 (1757): 278. On the limited circulation of its initial run, see Jenkins and Sloan 1996: 43 and Coltman 2006: 52–53. Cheaper editions appear from 1773.

31. Hamilton and d'Hancarville 1766 (actually 1767): ii and xxii. See Heringman 2013: 125–82.

32. Winckelmann (1764) 2006 edn.: 178, and discussion by Heringman 2013: 159.

33. Randall 2008: 221.
34. Habermas 1962 (English translation 1989), a key text for art historians of the eighteenth century (e.g., Poulot 2004 and M. Baker 2007).
35. E.g., Lake and Pincus 2006 and 2007, who argue that "'the public sphere' has been moving backwards in time."
36. On Habermas and the emergence of the modern museum, see Barrett 2011: 15–44.
37. M. Baker 2015: 13, 16, and passim.
38. So the terracotta bust of Francis Basset, attributed to Christopher Hewetson, c. 1778, Museo de la Real Academia de Bellas Artes de San Fernando, in Coltman 2009: 137 and pl. 10.
39. The term is first used of art in the mid-nineteenth century, and critically of Canova and friends: Watkin 2010: 630, with bibliography. Also helpful on the problems of the term is Griener 2008, and on the heterogeneity of English country-house collections, Coltman 2009: 234.
40. Vasari 1967–97, vol. 2: 95. Vaughan 2002, Fletcher 2012, esp. 75–77, and Collier 2013. Walker Art Gallery, Liverpool, inv. no. 2752 is certainly from the same fresco and perhaps a fragment owned by Townley.
41. T. Taylor 1853, vol. 1: 148.
42. Duggett 2010: 41 quoting from Hazlitt 1999 edn.: 281–88.
43. For the chalice (National Gallery of Art, Washington, inv. no. 1942.9.277), see Distelberger, Luchs, Verdier, and Wilson 1993: 4–12 and color fig. 4.
44. Tames 2004: 23–24. Note that Hugh Percy is formerly Hugh Smithson.
45. See Snodin 2009, "Horace Walpole's Strawberry Hill Collection," http://images.library.yale.edu/strawberryhill/index.html (last accessed 17 October 2016), and Vout 2015a: 244–46. The sculptures from Rome and Roman collections included a basalt head of Serapis, formerly from the Barberini collection, a basalt bust of Vespasian that had formerly belonged to Cardinal Ottoboni, and an eagle, recently excavated near the Baths of Caracalla and displayed on a Roman altar in the gothic gallery. Also note a small bronze bust of Caligula with silver eyes, acquired in Florence. For the relationship and broader network of Hamilton and Walpole, Jenkins and Sloan 1996.
46. J. Brown 2011: 314.
47. Vout 2015a: 243–44.
48. Sweet 2004: 81–87 and Nurse, Gaimster, and McCarthy 2007.
49. Although Walpole used the success of Samuel Foote's play *The Nabob*, and its parody of the antiquaries, as the main reason for terminating his membership: Sweet 2004: 100, Heringman 2013: 223, and, on Walpole's evolving relationship with the Antiquaries, Harney 2013: ch. 2.
50. D'Hancarville 1785–86 and Payne Knight 1786–87.
51. Bolter 1980: 84.
52. Markner and Veltri 1999: 61: "Es gab in alten Zeiten nur zwei Nationen, die eine höhere *Geistes-Cultur* erlangten, Griechen und Römer." Also Kelley 1998: 253–54 and Van Bommel 2015: 78. For similar sentiment from Wolf's alternative number at the Bibliothèque Nationale, Paris: Millin 1808: 1.51–52.
53. These date from the late 1760s and across the 1770s: see, as exemplary, his two-volume *Vasi candelabri, cippi* etc. and Vaughan 2015.
54. Advertisement (dated 1 October 1780) in Walpole 1771: vi, and this despite his increasing disenchantment with Adam's more elaborate, later "Etruscan" style, itself influenced by Piranesi: Wilton-Ely 2001 and 2002.
55. James Barry to Edmund Burke, 8 April 1769, in J. Barry 1809, vol. 1: 163.
56. Poniatowski, of the funerary monument inside the Church of Santa Maria del Priorato on the Aventine, diary entry 1 January 1786 as cited in Wilton-Ely 2002: n.119: "un Candelabre, compose de belles pièces de sculpture, qui sont assemblées avec peu de goût et placées meme hors de la perpendiculaire." Also relevant here is M. Jones 1990: 133.
57. Potts 1994: 13 calls it "the bible of late eighteenth-century Neoclassicism."
58. Dolce 1557: 32r–33r as cited in Ackerman 2000: 12. On Dolce's *L'Arentino*, see Roskill 1968.
59. Richardson (1st edn. 1715) 1725: 222–23.
60. On *Kunst und Leben* and national culture, see Brilliant 2000b: 270.
61. On the postantique myth of Greek art prior to Winckelmann, Beschi 1986.
62. See Soros 2006.
63. Brilliant 2000b: 270 and Coltman 2009: 140.
64. Scotsman, William Forbes, National Library of Scotland, MS 1544, 173–74 as cited in Coltman 2009: 140–41.
65. Piranesi 1769 (a trilingual publication in Italian, English, and French): 32–33.
66. Wilton-Ely 2002: 1.
67. Bignamini 2010: 8.
68. See, e.g., the rumors about Coke's acquisition of a famed Diana statue: Angelicoussis 2001: 23.
69. The antiquary Paciaudi to the Comte de Caylus 1862 edition of the letters: 119 as cited in Neverov 1984: 39, and dealer Thomas Jenkins

to Charles Townley, 29 January 1782 (TY 7/411) as cited in Bignamini and Hornsby 2010: 216. On the artfulness of dealers' correspondence, Coltman 2009: 234.

70. Angelicoussis 2001: 45. Also Winckelmann 1830–34, vol. 9: 633: "Who else but representatives of that nation have the means and the audacity to pay for objects worth so much?" cited in Neverov 1984: 39.

71. On the pragmatics of choosing statues, see, e.g., Penny 1991: 5, Angelicoussis 2001: 33, and Guilding 2014: 109, and on the "tolerably motley confusion" of marbles in the Pantheon at Ince in Merseyside, Michaelis 1882: 335.

72. See, e.g., Walter Pater's (1839–94) development of Winckelmann's thinking in Østermark-Johansen 2011: 94–101. Note, however, how scholarship has warped what Winckelmann thought about ancient sculpture, its whiteness, and its color: Brinkmann and Kunze 2011.

73. Winckelmann 1830–34, vol. 10: 84 and 91 as cited in Neverov 1984: 39.

74. J. Scott 2003: 307, n. 26 of a visitor in 1802, five years before the dining room was converted to a library.

75. Goethe 1993 edn.: 586 (English edn., 1983: 441): "Umgeben von antiken Statuen empfindet man sich in einem bewegten Naturleben, man wird die Mannichfaltigkeit der Menschengestaltung gewahr und durchaus auf den Menschen in seinem reinsten Zustande zurückgeführt, wodurch denn der Beschauer selbst lebendig und rein menschlich wird." See MacLeod 1998: 237. Also interesting here is De Bolla 2003: 171, on Robert Adam: "Antique Rome not only existed in the statues and monuments Adam was daily sketching; it was also becoming part of his 'real' lived experience, as if he were learning to project himself into a fantasized space midway between the historical period of antiquity and the contemporary moment of the invention of a new style. It was not for nothing that while in Rome he called himself 'Bob the Roman.'"

76. Lacan (1901–81) 1966: 95: "le *je* à la statue où l'homme se projette."

77. Letter from Goethe in Naples, 16 March 1787, Goethe 1993 edn.: 225–26 (English edn., 1983: 170–71) and recently, S. Blundell 2012: 657. The bibliography on Emma's "attitudes" is extensive: classic is Touchette 2000 and recently, Blundell (above), Pop 2015: 93–130, and Colville and Williams 2016.

78. W. S. Lewis 1937–83, vol. 11: 350.

79. My reading of Emma here is heavily influenced by K. Davies 2004.

80. See, e.g., *The Mirror of the Graces: Or, the English Lady's Costume* (London, 1811), 59–60.

81. K. Davies 2004 drawing on the work of Walter Benjamin.

82. Seen by some critics, Walpole included, as Chinese, gothic, and Indian: see Coltman 2006: 104–5, in a chapter on the influence of Pompeii and Herculaneum more broadly. Also Ramage 2013 and Hales and Leander Touati 2016; on the excavations themselves, Parslow 1995.

83. Jenkins and Sloan 1996: 43.

84. The letter from Isidore Justin Séverin Taylor (1789–1879) to Charles Nodier is included in Chateaubriand 1828: 421: "Herculanum [*sic*] et Pompéi sont des objets si importans pour l'histoire de l'antiquité, que pour bien les étudier, il faut y vivre, y demeurer" and 423: "Rome n'est qu'un vaste musée; *Pompéi est une antiquité vivante.*" Helpful here is Blix 2009: 69–88.

85. Plate xlii: Coltman 2006: 54–55 and 167 and Vaughan 1996: 34.

86. *Monthly Review* 52 (1775): 633.

87. Richard Cosway, *Charles Townley with a Group of Connoisseurs*, 1771–75, oil on canvas, 86.1 x 81 cm, Townley Hall Art Gallery and Museum, Burnley, England, and, for the Venus sculpture, British Museum, London, inv. no. 1805, 0708.17. Putting the painting in context are Coltman 2009: 159–90 and Vout 2013a: 204–37.

88. Haskell and Penny 1981: 178–79 (centaurs), 213–15 (faun), 60, 94 (Mercury, the most famous version of which is a fountain figure in Rome's Villa Medici).

89. The first volume of the final, multi-volumed product, *The Antiquities of Athens Measured and Delineated by James Stuart, F.R.S and F.S.A., and Nicholas Revett, Painters and Architects*, appeared in 1762.

90. Pressly 1999: 9.

91. Redford 2008.

92. Angelicoussis 2001: 61.

93. Frontispiece of 1765 edition. Spence 1747 was abridged by Tindal in six editions, published between 1764 and 1802. See, e.g., Robert Potter's panegyric of Holkham (1758), with its dedicatory inscription from Virgil's *Eclogues* and its rather vague reference to some of the statues within a pastoral context.

94. De Bolla 2003: 211.

95. De Bolla 2003: 65. Also critical here is Griener 2010.

96. Townley provided his guests with manuscript catalogs that were rewritten as the collection grew and the display shifted and gave his guests tours. His employment of d'Hancarville to

catalog his collection led to the *Recherches* being awash with references to artifacts in his possession. Walpole, Curzon at Kedleston, and Richard Worsley (of Appuldurcombe on the Isle of Wight) all printed catalogs, and Thomas Herbert had similar ambitions at Wilton, where a book of etchings of his marble antiquities "in imitation of Perrier" was made in 1731 (see Creed 1731) and a printed catalog of the statues, busts, and reliefs within twenty years of his death (Cowdry 1751). Two catalogs were produced of Lyde Browne's collection, one in 1768 and the other in 1779 well before his death. The first of these was in Latin, the second in Italian.

97. De Bolla 2003: 163 and Guilding 2014: 188.

98. H. Blundell 1803.

99. And to one day of the week at that, see H. Blundell 1809–10 (the year volume 1 of the *Specimens of Antient Sculpture* is published, from which Ince is omitted, although Blundell's "Theseus" does make it into volume 2), vol. 1: 1 and J. Moore 2010: 250. Note too that Strawberry Hill had strict rules of entry, including a ticketing system.

100. Hodson 2007: 181.

101. R. W. Jones 1998: 80–81, especially of female beauty.

102. Sloan 2003: 14 and 21 and R. G. W. Anderson 2012: 65–66. The need to acquire a ticket ceased in 1805 but systematic and scholarly publication of the collections does not start until 1810.

103. Ernst 1992: 156–57.

104. Ernst 1992: 167: "Il leur manque, toutefois, le trait essentiel: la présence du collectionneur, qui restituait un certain sens à ces compositions par sa propre *anticomanie,* son interprétation, sa mythologie individuelle." And this despite the hopes of the Museum's Trustees to Parliament who had argued that (Hansard 1803–5. HC Deb 05 June 1805 vol 5 cc170–2) Townley's sculptures far exceeded "any private collection in this country" and that "preserving and exhibiting" them "to the public view in the metropolis would be highly advantageous to the cultivation of the fine arts."

105. De Bolla 2003: 152.

106. Above, ch. 6, n. 59.

107. Above, ch. 6, n. 48, and *Public Advertiser,* 7 June 1785, as cited in MacGregor 2014: 79.

108. Cowdry 1751. Its first entry (p. 1) is to an obelisk from the Arundel collection. On p. 6, there is a statue of Apollo "out of the Justiniani Gallery."

109. *The London Chronicle,* vol. 1, from January to June 1757: 538.

110. On "curiosities," see Dietz and Nutz 2005 and Blix 2009: 19–21, and on the term "curiosity" in England, Benedict 2002.

111. On the Carafa, see above, ch. 5, "Taste and the Antique."

112. Walpole to Richard West, 7 May 1740, in J. Wright 1842, vol. 1: 153.

113. Ayres 1997.

114. Neverov 1984: 33.

115. Strickland was in Italy from 1778 to 1779. See Michaelis 1882: 216.

116. Coke purchased his copy of the *Raccolta* during his first stay in Rome in 1714: Angelicoussis 2001: 23. The Diana, previously owned by Ignazio Consiglieri, and the "Lucius Antonius," formerly in the Congregazione dell' Arciconfraternità della SS. Annunziata in Rome, are de Rossi 1704: pls. 145 and 147. See Angelicoussis 2001: cat. nos. 4 and 20.

117. The statue is much restored, perhaps even modern: see *The John Paul Getty Museum Journal* 16 (1988): cat. no. 82. Winckelmann 1767, vol. 2: 205, pl. 152, argues that it has been wrongly restored and that it is, in fact, a young priest.

118. Haskell and Penny 1981: 79–80, Fulton 2003, and Friedman 1974.

119. Kenworthy-Browne 1983: 42.

120. Kenworthy-Browne 1983: 43 and Coutu 1997: 176 and Coutu 2015: 93–126.

121. Elmes 1817: 367–68.

122. Robert Byron in a letter to the editor of *The Sunday Times,* 14 May 1939, as cited in I. Jenkins 2001: 10.

123. The constitution of the Metropolitan Museum in New York, written in 1870, as cited in http:// www.plastercastcollection.org/en/database .php?d=lire&id=172 (accessed 16 March 2016). On their integration into architecture, see W. Chambers 1862: 289–94.

124. At Holkham, there were casts in the Marble Hall of the Capitoline Antinous, Albani Apollo, St. Susanna, Capitoline Flora, Farnese Mercury, Medici Bacchus, Venus Callipyge, Albani Isis. At Kedleston (installed 1765), there was a Capitoline Antinous, Apollo Belvedere, a Meleager, Idolino, 2 x Medici Venus, 2 x Dancing Faun, Medici Apollo, Urania, Ganymede, Medici Mercury.

125. The four freestanding figures were installed in the Pillared Hall, and not the Marble Saloon where the niches contained marble versions of ancient sculptures by Rome's leading sculptors, including an Antinous by Cavaceppi (see Coutu 2015: 69–70, who, wrongly, thinks the Florentine casts to be of marble) and another

Medici Venus and Dancing Faun. In addition to the plaster Gauls that were later acquisitions (made for Rockingham's nephew), there was a "Dying Gladiator" in artificial stone. See Penny 1991, E. R. Mayor 1987, and with an emphasis on Rockingham's Whig politics, Coutu 2015: 49–92. I thank Wentworth Woodhouse's David Allott (pers. com.) for confirming the information about the casts.

126. On the Albani relief, see Haskell and Penny 1981: cat. no. 6 and Vout 2006b, and for its popularity, Pompeo Batoni, *Portrait of a Gentleman*, early 1760s, oil on canvas, 246.8 x 176 cm, The Metropolitan Museum of Art, New York, inv. no. 03.37.1. In discussing Winckelmann's investment in Antinous in 2006, I had not realized that the description of Antinous as "overseer of the hall" or "atriensis" as opposed to a simple "slave" comes from a Renaissance translation of Eusebius's Greek text. For the Antinous sculptures in Rockingham's collection, including the relief that is still in the entrance hall of the west front, E. R. Mayor 1987: 96–103 and appendixes. On a mold of the Albani relief acquired by Brettingham, Kenworthy-Browne 1983: 124 and Angelicoussis 2001: 41, n. 95.

127. By the sculptor Filippo della Valle: Haskell and Penny 1981: cat. no. 40 and E. R. Mayor 1987: 53.

128. Acquired by Nollekens from Bartolomeo Cavaceppi: Haskell and Penny 1981: 178. And on the importance of novelty for these collectors, Coltman 2006: 178.

129. H. Blundell 1803: 41.

130. Note too Rockingham's friend, the Duke of Northumberland, also acquires a marble Flora for his dining room at Syon House: E. R. Mayor 1987: 134.

131. Penny 1991: 12, Coltman 2009: 274, and, on the original, M. Jones 1990: 32–33.

132. Wilson 2003: 3.

133. Townley was odd in not wanting a designated sculpture gallery. On the possible influence of Newby Hall, via Yorkshire architect Thomas Harrison, who was a student in Rome 1769–76, Coltman 2009: 217–8 and Collins 2004: 157–59 and 2012: 121.

134. Angelicoussis 2001: 41.

135. Angelicoussis 2001: 106–7, cat. no. 16, and cat. no. 3.

136. Angelicoussis 2001: 56 and 113–14, cat. no. 20.

137. For the idea of statues conversing with the viewer, see Thomas Jenkins to Charles Townley, 20 April 1782, BM, TY7/413: "indeed the contemplation of such [i.e., the fine productions of the Ancients], seems a kind of conversing with the celebrated Genius's of those remote times."

138. Angelicoussis 2001: 62–64.

139. Brettingham Jr. 1773 (in an emended version of his father's plans, first published in 1761): VI as cited by Angelicoussis 2001: 64.

140. Richard Warner, who visited Newby in 1802, as cited in E. Harris 2001: 219.

141. On the emphasis on color, light, and motion in the new Pio-Clementino, see Collins 2012: 124–26.

142. Hope 1807: 21. Also in a letter to Matthew Boulton (1805), as cited in I. Jenkins 2008: 121: "Beauty consists not in ornament, it consists in outline—where this is elegant and well understood the simplest object will be pleasing: without a good outline, the richest and most decorated will only appear tawdry." On Hope's ancient sculpture collection, which included a Ganymede bought at Lord Bessborough's sale but formerly from the Albani collection, see Waywell 1986 and I. Jenkins 2008: 116–19.

143. Hope 1807: 22 and on his acquisition of Hamilton's vases, Jenkins and Sloan 1996: 58–59, I. Jenkins 2008: 119–25, and Watkin 2008a: 32–33. This room was one of four vase rooms at Duchess Street.

144. Hope continues (1807: 21): "The ceiling admits the light through three lanterns." Winckelmann 1765: 21 and 22–28.

145. On Flaxman in context, see Bindman 2013 and Wilton 2006: 6–8. For the engravings of Thorvaldsen's work, I thank Ernst Jonas Bencard and his paper "3D into 2D, Why?" at the "Bertel Thorvaldsen & Great Britain" conference, Rome, 19–20 January 2016. Also interesting here are J. Scott 2003: 134 and Fosbrooke's *The Outlines of Statues in the Possession of Mr Hope (never published) for which Illustrations by TD Fosbrooke,1813* as discussed by Waywell 1986: 37–38.

146. See above, ch. 4, "From Backdrop to Bricks and Mortar," and Knowles 1831, vol. 1: 390–91.

147. Siegel 2000: 192.

148. Jameson 1834: 124.

149. Penny 1991: 21–32, M. Baker 2000: 36–40, Coltman 2009: 273–80, and Coutu 2015: 82–86.

150. Penny 1991: 23 and 27.

151. Warner 1802: 220.

152. E. R. Mayor 1987: 92 and M. Baker 2000: 16.

153. See Vout 2013b: 211.

154. V. Lee 1881. See Dunstan 2014: 3, Evangelista 2009, and Siegel 2013.

155. For Foggini's Samson, 1749, Victoria and Albert Museum, London, inv. no. A.1–1991, Penny 1991: 6–7 and E. R. Mayor 1987: cat. no. A2, 1.

156. For Ince, see Southworth 1991, Fejfer and Southworth 1991, Fejfer 1997, and, on the 10 percent of the collection that was ash chests, G. Davies 2007; and for Woburn, Angelicoussis 1992. The Graces (Victoria and Albert Museum, London, inv. no. A.4–1994) were commissioned in 1814, and installed five years later on a base with a revolving top in the Temple of the Graces: M. Baker 2000: 159–68 and, on the politics of the group's arrival and removal from Woburn, Bush 1996.

157. Waywell 1986: 40.

158. Leander Touati 1998: 28, 39–40, and 111–55 (for the heavily restored group of Apollo and the Muses, which were among the first substantial ancient statues acquired by the king in 1784). Sergel's bronze statue of Gustav III adorning the Skeppsbron in Stockholm was dedicated in 1808.

159. Francisco de Miranda (1750–1816) as cited in Söderlind 1993: 80. For Endymion, found in 1783 and acquired 1785, four cipollino columns, also from Hadrian's Villa, and a cast of the Albani relief of Antinous, Leander Touati 1998: 28–29 and 99–110.

160. An unknown visitor in *Burton's Gentleman's Magazine and American Monthly Review*, 1840: 187. And on the royal museum, Olausson and Söderlind 2012.

161. Waywell 1986: 44: the exceptions were the copies of urns from the Albani and Barberini collections on either side of the door. The story was different in the Statue Gallery of Hope's country residence, The Deepdene in Surrey: see Waywell 1986: 52 and Watkin 2008b: 225–27.

162. The Star Room, also called the "Aurora" or "Flaxman" Room: Waywell 1986: 47, I. Jenkins 2008: 107, and Watkin 2008a: 37–38. The sculpture, made in 1790, is now in the Lady Lever Gallery, Liverpool, inv. no. LL713.

163. Hope 1807: 26 and 28.

164. Marble, h 54.2 cm, now in the Thorvaldsens Museum, Copenhagen, inv. no. G 271: Watkin and Hewat-Jaboor 2008: 274–75.

165. Hope to Matthew Boulton, 1805, cited in Waywell 1986: 48, n. 66: "it was owing to my having, not servilely imitated, but endeavoured to make myself master of *the spirit* of the Antique."

166. Yarrington 2009: 54. The Chatsworth Apollo, acquired from a dealer in Smyrna 1838 is, by the 1880s, in the library at Chatsworth (Michaelis 1882: 277) but is missing from the privately printed *Handbook of Chatsworth and Hardwick* 1845. Perhaps it was previously in Devonshire House in Chiswick? The ancient marbles, at least twenty of them from Canova's collection, were displayed in other areas of the house (e.g., the north and west corridors). See Furtwängler 1901.

167. Yarrington 2009 and Guilding 2014: 274–83.

168. The gallery also included copies after the antique, e.g., a Medici vase by Bartolini, later moved to the Orangery, and a double-headed Isis and Serapis copied from a sculpture found in the Villa Adriana. I thank Alison Yarrington for help with this and the preceding two notes. On the impact on Italy, and on display, of the return of its artworks from France, see the exhibition at Rome's Scuderie del Quirinale, 16 December 2016 to 12 March 2017, "Il Museo universale: Dal sogno di Napoleone a Canova."

169. *Monthly Supplement of the Penny Magazine of the Society for the Diffusion of Useful Knowledge*, October 31 to November 30 1837: 458. For Hope's influence on Soane, see I. Jenkins 2008: 108.

170. Middleton 1999: 26.

171. Furján 2011: 3.

172. Clérisseau: McCormick 1990, and the Venus de Milo: Prettejohn 2006. Note, however, that the Laocoon was de-restored during its requisition by the French and a competition staged to re-restore it: Bourgeois 2007.

173. Furján 2011: 4.

174. Fejfer 2003: 90.

175. One might also contrast Rockingham's Paris or indeed Gustav's Muses (above, n. 158), aggressively restored in the 1770s.

176. Vaughan 1991 and Coltman 2009: 84–116.

177. *The Farington Diary*, 5 December 1806, Greig edn., 1924, vol. 4: 56.

178. Leopoldo Cicognara (1767–1834) as cited in Le Grice 1843: 343.

179. Hope 1812, vol. 1: ix–x.

180. Redford 2008: 143–72. Also relevant here is Coltman 2009: 233–72.

181. Society of the Dilettanti 1809–35, vol. 1: 50.

182. Society of the Dilettanti 1809–35, vol. 1: pl. 29.

183. Society of the Dilettanti 1809–35, vol. 1: 103 and accompanying text to pl. 64.

184. Originally written in French, copied from the ms by Townley and translated for later record by Townley's uncle and heir, John (Townley Misc. Fo. 26, published by Cook 1977). See S. Walker 2000: 97. Also note Townley's view that the gallery at Newby Hall was overly ornamented: Coltman 2009: 198–99.

185. Acquired 1767: Penny 1991: 16–18 and E. R. Mayor 1987: 85. The use of the word "closet" reminds one of the later "secret cabinets" of the

Naples and British Museums, which made the illicit archaeologically interesting. On access to these cabinets, which was less restricted than often assumed, Fisher and Langlands 2011 and Beard 2012a.

186. Redford 2008: 164–65.
187. Society of the Dilettanti 1809: lxxvi.
188. Circulation was small: 200 for the first volume, 100 for the second: see *The British Critic for January, February, March, April, May, June 1811* (vol. 37): 609–10.
189. Worm's catalog is posthumously published in 1655.
190. Worsley 1824 (posthumous printed edn.), vol. 1: 1.
191. Worsley 1824: 3 and 7.
192. Whitley 2001: 34.
193. See Rozeik 2012.
194. Words of the American ambassador at the opening, *Reporter* 25 June 1884: 969 as cited in Beard 1994: 3 and 24, n. 5.
195. Vout 2015b.
196. Beard 1994.

Chapter 8: Seeing Anew in the Nineteenth Century

1. Supplement to *The Spectator*, 18 November 1899: 11.
2. Wherry 1898: vii.
3. Supplement to *The Spectator*, 18 November 1899: 11.
4. Wherry 1898: vii.
5. Wherry 1898: 110 and 179.
6. Wherry 1898 and Guralnick 1974, and, for the statuette of Zeus, National Museum, Athens, inv. no. X6440.
7. Furtwängler 1893: 3–45 as discussed by Hartswick 1983 and 1998, Palagia 1987a, and Wherry 1898: 117–18.
8. Phillips 1854: 46. Note that by 1879, the cast of the Venus de Milo in the center of the Greek court had been joined by a second cast of the same sculpture, taken after the original was reassembled for a second time in 1871 and the torso's angle adjusted (Nichols 2015: 101).
9. Wherry 1898: 197–200. The attribution to Praxiteles comes from Pausanias (5.17.3), who records that the statues in the Heraion at Olympia included a stone statue of Hermes carrying the infant Dionysus, a "techne" of Praxiteles. Note, however, that this attribution was not uncontentious (see the discussion by Fowler 1900) and

that its fourth-century dating remains contentious today.

10. See Beard 2004: 18. The House of the Tragic Poet is excavated in 1824 and the House of the Faun in 1830–32. The Odyssey Landscapes are found in 1848, the Esquiline Venus in 1874, and the paintings in the Villa Farnesina in 1879.
11. Moltesen 2004.
12. H. James, *A Roman Notebook*, 12 February 1873 (1993 edn.): 480.
13. The Antinous relief is returned after a brief sojourn in Paris under Napoleon and the villa bought by the Torlonia in 1866. See H. James, *A Roman Notebook*, 12 February 1873 (1993 edn.): 481.
14. Story was particularly influential on Henry James, who would later write his two-volume biography (see Powers 2008) and on Nathaniel Hawthorne and his novel *The Marble Faun*. Note, however, that not all influential sculptors of the period were based in Rome; the studio of Hiram Powers (1805–73), for example, was in Florence.
15. See, e.g., the poem by Margaret Sandbach on one of Gibson's reliefs, "The Hours Leading Forth the Horses for the Chariot of the Sun," in her *Aurora* collection, 1850: Vout in Droth, Edwards, and Hatt 2014: cat. no. 56.
16. Moltesen 2012.
17. Helbig 1868 (painting), 1884 (Homer and Mycenae), and 1891 (collections in Rome).
18. Matthews 1911: 99.
19. *Diario di Roma*, 18 November 1820, as cited in Johns 1998: 160.
20. Dyson 2006: 131.
21. Wherry 1898: 303.
22. Jeammet 2010.
23. Wherry 1898: 304 and 305.
24. Thorvaldsens Museum, Copenhagen, inv. no. A47. Also important is his self-portrait with the statue of Hope of 1839, inv. no. A771.
25. On the impact of the Aegina pediments, Prettejohn 2012: 181–93. Note too the impact, architecturally, of the temples at Paestum, Italy, in the eighteenth century already (de Jong 2015).
26. The "Apollo" of the Naxians and a similar statue from Thera are found in 1835 and 1836 and the "Apollo" of Tenea, in 1846. See A. Stewart 1986, and for the first doubts about their Apolline identity, Leonardos 1895: 75, n. 1. The Moscophoros is discovered in 1864, the torso of the Kritios Boy in 1865 and the head in 1888, and the korai in the 1880s. These Acropolis finds might have been compromised if Karl Friedrich Schinkel's 1834 plan to build Otto of Bavaria a

27. Robinson 1891: 45. By 1890, Boston could boast so many casts that it was surpassed only by German museums: Dyson 1998: 140.

28. Beulé 1868: 329: "La sculpture grecque avançait lentement parce qu'elle ne cherchait pas la nouveauté, elle cherchait le progrès," and for the Winckelmann quotation, Winckelmann (1764) 2006 edn.: 231.

29. Deonna 1909: 15, citing Lechat, "Comme les Corés sont des representations impersonnelles de la femme, ce sont 'des representations de l'homme.'"

30. Reinach 1899: 54: "Toujours élégante et jamais maniérée, toujours en marche et pourtant jamais pressée, la Tanagréene—ou plutôt la Tanagre—est vraiment la Parisienne de l'antiquité." See Mathieux 2010. For "New Sculpture," Getsy 2004.

31. Beulé 1868: 244: "une question moderne, qui date de notre siècle bien plus que de la génération qui nous précède."

32. See, e.g., Lechat 1890: 556 in his article on korai: "Pour des hommes à demi civilisés, la forme isolée, toute nue ne satisfait point les yeux; ils ne la comprennent que sous le vêtement de la couleur, L'idole, peinte et parée, produit sur eux une impression plus vive" (For half-civilised men, the isolated, completely naked form does not satisfy the eyes; they only understand under the garment of color. The idol, painted and adorned, makes a more lively impression on them).

33. Wherry 1898: 44. On color and the "classical" in the nineteenth century, see Grand-Clément 2005.

34. Wherry 1898: viii and, on Waldstein himself, the entry by Spivey in the Oxford Dictionary of National Biography.

35. Michaelis 1908 (first published in German in 1906): 336.

36. C. Lenormant 1844: 3: "La première condition pour devenir archéologue est donc de connaître les monuments: l'histoire de l'art est la base de toute archéologie."

37. Wherry 1898: 303.

38. Michaelis 1908: 302. This translation of the German edition contained photographs of its own: its frontispiece is an Assyrian relief from Nimrud in northern Iraq, brought to the British Museum by Austen Henry Layard, as archaeology begins to redeem the cultures that Wolf's Altertumswissenschaft, with its philological bias, had downgraded.

39. Fowler and Wheeler 1909: 26.

40. On Kopienkritik, Siapkas and Sjörgren 2014: 49–51, on Meisterforschung, Siapkas and Sjögren 2014: 45–48 and Marvin 2008: 144–67, and on dual slide projection, Nelson 2000.

41. Waterfield 2015: 18.

42. Kort and Hollein 2005, citing Wiese 1923: 83: "Ich haßte Rodin, der damals à la mode war. Seine Skulptur erinnerte mich an gekautes Brot, das man auf einen Sockel spuckt, oder an die verkrümmten Kadaver von Pompeji. Meine wahre Schule war der Louvre, den ich während einiger Jahre jeden Tag besuchte. Dort studierte ich hauptsächlich die archaische Kunst und alle die großen toten Stile."

43. Important here is Chevillot 2009.

44. For a photograph taken as a study for the painting, St. John's College, Cambridge, inv. no. IX/1/7.

45. Butler in His Rooms at Clifford's Inn, London, St. John's College, Cambridge, inv. no. IX/2/9.

46. As cited by Cavenagh 1922: 309.

47. Cavenagh 1922.

48. Garlick, Macintyre, Cave, and Newby 1978–98, vol. 5: 1819.

49. Poulot 1997, Stammers 2008, Swenson 2013: 30–31.

50. McClellan 1994 and 2012; on the Musée des Monuments français, Poulot 1986 and Bresc-Bautier and de Chancel-Bardelot 2016.

51. I. Jenkins 1992: 53 and B. Cohen 2015: 479.

52. Michaelis 1908: x. In the next breath, however, Gardner is sure to justify the taking of the Parthenon sculpture, something he sees as rescuing "what is really the property of the civilized world from certain injury and probable destruction." A useful summary of legislation as it impacted on Turkey is Kästner 2016.

53. See, in particular, Helbig and the Roman portraits supposedly all from the Licinian Tomb and now in the Ny Carlsberg Glyptotek, Copenhagen (Kragelund, Moltesen, and Stubbe Østergaard 2003; although note also Van Keuren 2003), and Helbig and the possible forgery of an inscription on the golden brooch known as the Praenestine fibula (key is Guarducci 1980).

54. Michaelis 1908: 25. On the original anxiety caused by Napoleon's plans to move objects from Rome to Paris, Quatremère de Quincy (1755–1849) and his letters to Miranda and Canova (Getty Research Institute edn., 2012). On "Nostoi," at the Quirinal Palace in Rome, and the New Acropolis Museum, Athens, see Marlowe 2013: 110–11.

55. The word is used of Odysseus's homecoming to Ithaca.

Top of left column continues from previous page:

palace on the Acropolis had been realized (see Carter 1979).

56. Swenson 2013.

57. For the antiquities' trade today, see Watson and Todeschini 2006 and Felch and Frammolino 2011.

58. Michaelis 1908: 25–26.

59. O. Jones 1854: 93.

60. Newton 1851: 206.

61. I. Jenkins 1992: 58 and Nichols 2015: 70.

62. Bilsel 2012: 71.

63. Burckhardt, letter to Robert Grüninger, Berlin, 17 August 1882, as cited in Bilsel 2012: 101.

64. Lessing 1766, the classic and controversial study of the distinction between the temporal and spatial arts that still impacts today. See, e.g., W. J. T. Mitchell 1984.

65. See, e.g., Prettejohn 2005, Nehamas 2007, and I. Jenkins (with the British Museum exhibition) 2015.

66. Moltesen 2004: 17.

67. Paul 2012: xiv.

68. Newton 1851: 227.

69. Newton 1851: 227.

70. Watkin 2006.

71. Pulszky 1852: 12. And on Pulszky, see Kabdebó 2015.

72. See http://www.louvre.fr/en/departments/greek-etruscan-and-roman-antiquities (last accessed 21 November 2016).

73. Pulszky 1852: 1.

74. Pulszky 1852: 1.

75. Pulszky 1852: 15.

76. Nichols 2015: 8.

77. In 1879, part of the East India Company's India Museum was absorbed by the British Museum. On global art or "world art" studies, see below, ch. 9, "Competing Values."

78. W. R. Hamilton, giving evidence to the National Gallery Parliamentary Commission in 1853, as cited in I. Jenkins 1992: 33–34.

79. Newton 1851: 226–27.

80. P. Connor 1989: 194 and Borbein 2000: 34.

81. I. Jenkins 1992: 35 and 65–66.

82. Walter C. Perry, *The Spectator*, 21 April 1877: 16. On Perry's *German University Education; or, the Professors and Students of Germany*, 1845, see J. R. Davis 2014: 44.

83. On the cast courts at Sydenham, see I. Jenkins 1992: 33–34 and Nichols 2015. Also note those of the Victoria and Albert Museum, first opened in 1873.

84. I. Jenkins 1992: 39.

85. See Swenson 2009.

86. On the ontology of casts, between art and science, see Beard 1994 and 2000.

87. Edmund Oldfield of the British Museum in a letter to Mr. Mathison of Trinity College, Cambridge, 25 May 1850, Papers of the Fitzwilliam Museum Syndicate for 1850, The Founder's Library, The Fitzwilliam Museum.

88. E. D. Clarke 1809: preface, i.

89. John Kirkpatrick in a letter to the Vice Chancellor, University of Cambridge, 11 July 1850, Papers of the Fitzwilliam Museum Syndicate for 1850, The Founder's Library, The Fitzwilliam Museum. On the history of the museum, see Burn 2015.

90. Beard 1994: 11. On the struggle of Roman art to extricate itself from Greek, below, ch. 9, "A Place for Roman Art."

91. In 1984, the Museum of Classical Archaeology, as it would become, moved again, to the Sidgwick Site in Cambridge.

92. Beard 2012b: 299.

93. Perry, *The Spectator*, 21 April 1877: 16.

94. P. Connor 1989: 194–95 and Swenson 2009: 210. Friederichs is appointed to the museum in 1854. For his identification of the Tyrannicides and Doryphorus, above, ch. 1.

95. Friederichs 1868 (revised by Wolters 1885) and Waldstein 1889.

96. Michaelis 1908: 303–12, Prettejohn 2012: 108–23, and on the Discobolus per se, Anguissola 2005.

97. Junker 2002: 129 and above, ch. 1.

98. P. Connor 1989: 195.

99. Robinson 1891: 96–97 (Myron), 111 (Diadumenoi), 109–10 (Doryphoroi), 229–35 (Praxiteles), and Dyson 2010: 564–65. For a history of the museum, see Whitehill 1970, for Boston in the context of other US collections, Dyson 1998 and 2010, and H. M. Gleason 2015, and for the controversy caused by the casts when the museum moved to its current site and subsequently, Beard 2000.

100. Robinson 1891: 232: "Hawthorne's description of the statue shows such keen appreciation of its qualities as a work of art that the visitor will be glad to read it with the figure before him."

101. Robinson 1891: 85–86, cat. nos. 63 and 64.

102. Robinson 1892: 4. Boston was not the first museum to do this; as Robinson notes (p. 6), Dresden had already been there, as indeed had the Crystal Palace (Nichols 2015: 74–77 and 103–4).

103. Cushing and Dearinger 2006: 357–59 and H. M. Gleason 2015: 50–51. The real Portland Vase was interesting, in part, because it had passed from the Barberini family to Sir William Hamilton to the Duchess and Dukes of Portland (hence

its name) to, in 1810 (on loan), the British Museum. In other words, its cast was perhaps initially illustrative of a collecting rather than an art genealogy. The original Portland Vase is later bought by the British Museum inv. no. 1945,0927.1.

104. Robinson 1891: 159, cat. no. 354. The cast escaped destruction and was returned to the Athenaeum in 1975.

105. Marchand 1997.

106. Waldstein 1880, reprinted 1885: 374.

107. See, e.g., "The Discoveries at Olympia," *The Times* 15 April 1876: 7 and its description of the pedimental sculpture: "Instead of drapery composed with consummate art, and combining in its execution breadth and force with richness and delicacy, we encounter great rolls and turgid lumps so coarsely executed that, if I had seen an isolated fragment of such drapery without knowing its *provenance*, I should never have suspected it to belong to the age of Pheidias, nor, indeed to any period but that of complete decadence. The treatment of the nude forms shows more style, . . . but there is an uncertainty in the modeling, a strange and perverse mixture of knowledge and ignorance, of dexterity and clumsiness."

108. Perkins 1880: 157, with line drawing of Apollo, fig. 5 on p. 158.

109. See, e.g., the work of John Addington Symonds (1840–93) and Walter Pater (1839–94) as discussed by Blanshard 2000, Evangelista 2007, Orrells 2015: 100–125, and Martindale, Evangelista, and Prettejohn 2017. Also relevant here is Goldhill 2011: 4–5 and passim.

110. Waldstein 1880, reprinted 1885: 393 (with a defense of this view in the reprint's first footnote).

111. Pound 1914: 67, as discussed by Antliff 2013: 108–9. On the Hermes as aesthetic icon, see Østermark-Johansen 2011: 247–49 and on Wilde's gift, Shand-Tucci 1995: 169.

112. On print culture, see P. J. Anderson 1991, on photography and antiquity, Lyons 2005, and on photography and archaeology, Downing 2006.

113. On photography and the Crystal Palace, Nichols 2015: 94, 97–98, and 119, and on MacPherson and Fenton, Lyons 2005: 63–64, Marvin 2008: 139–41, and McCauley 2011. Mention must be made here too of the important role played by William Henry Fox Talbot (1800–1877) and his "calotype" process, after the Greek *kalos*, meaning "beautiful," patented in 1841, and of James Anderson (above, fig. 5.5).

114. McCauley 2011: 100 and 115.

115. MacPherson 1863 and McCauley 2011: 102–3. For criticism of the Visconti catalogs, Murray's

Handbook of Rome and Its Environs 1858: 179: the "catalogues of the Vatican Museum are not worthy of the collection; their price is exorbitant, considering the information they convey."

116. See, e.g., MacPherson 1863: *Braccio Nuovo*, cat. no. II "A Colossal Bust of a Dacian Captive": "One of those frequently sculptured by order of the Emperor Trajan, in commemoration of his various victories. The bust is two feet five inches high."

117. MacPherson 1863: Introduction.

118. MacPherson 1863: title page. The quotation is taken from Goethe's introduction to the Propylaeum, Ward 1845: 20.

119. *The Spectator*, 5 March 1864: 21.

120. Maffioli 2003.

121. Conze 1875 and Brunn and Bruckmann 1888–1947 (the series continues to be published long after their deaths). Also important here is Lucy Mitchell's *History of Ancient Sculpture* 1883 with some photographs and others in an accompanying *Selections from Ancient Sculpture* portfolio. See Pollitt 1996: 12–13.

122. The first photograph is that of the Apollo of Tenea. The Parthenos Varvakeion (nos. 39 and 40) and Parthenos Lenormant (no. 38) are rare in having two photos (the second one, both on the same sheet).

123. Lyons 2005: 62.

124. See David Brewster 1856, a man often credited, wrongly, with inventing the stereoscope, in a section entitled "Application of stereoscope to sculpture" (p. 185): "When combined in the stereoscope, he may reproduce the statue in relief, in all its aspects, and of different sizes, and derive from its study the same advantages which the statue itself would have furnished. In one respect the creations of the stereoscope surpass the original." In contrast to the movement of the sun and the different play of light and shade, "in the stereoscopic statue, everything is fixed and invariable."

125. Wölfflin, "How One Should Photograph Sculpture," translated by G. A. Johnson 2013: 58. The article from which the extract is taken was originally published (1897) as "Wie man Skulpturen aufnehmen soll," *Zeitschrift für bildende Kunst*, n.s., 8: 294–97. "Painterly" is one of the key modes of vision in Wölfflin.

126. Rayet (former owner of the archaic Rayet head, Ny Carlsberg Glyptotek, Copenhagen, inv. no. 418) 1884, vol. 1 (first published 1881): ii: "Notre ouvrage est au contraire destiné surtout aux artistes curieux de savoir quelle route leurs

prédécesseurs ont suivie, aux hommes de goût, plus nombreux chaque jour, qu'attirent la beauté simple, le charme pénétrant de l'antique. Nous voulons faire passer sous leurs yeux, sans nous astreindre à un ordre méthodique, sans tenir compte de la chronologie, sans nous inquiéter des publications antérieures, les œuvres de ces heureuses époques où l'on cherchait avec un zèle si honnête à copier la nature."

127. Pollitt 1996: 12.

128. Rayet 1884, vol. 1 (first published 1881): no. 30: "Diadumène, statue en marbre trouvée à Vaison (British Muséum)"; "Le Diadumène": 8: "Telle est la manière dont la plus belle statue qui ait jamais été trouvée sur notre sol, et une des plus intéressantes qui existent de par le monde, passa en Angleterre pour le quart du prix qu'il eût fallu en donner" (This is how the most beautiful statue which has ever been found on our soil, and one of the most interesting to exist anywhere in the world, passed to England for a quarter of the price which it should have received).

129. Furtwängler 1893 (translated 1895) and Pollitt 1996: 13–14. Also important here are the Curtius and Adler Olympia volumes (1890–97).

130. Morelli, written in dialogue form under a pseudonym and first published in 1890, 1900: 11. Although there was not the squeamishness there is today about academics collecting, Morelli was not wealthy enough to own a large collection—Layard in the introduction to Morelli 1900: 11–12.

131. Rouet 2001: 63 and, on Beazley's method more broadly, Kurtz 1985 and Neer 1997.

132. Pottier 1896–1906. The British Museum's vase catalogs (1893–1923) also have some photographic plates.

133. Michaelis 1908: 302.

134. Lyons 2005: 24.

135. Venturi 1936: 233 as cited in Rouet 2001: 60.

136. De Grummond 1996: 834–35, *DNO*, and review by Osborne 2015.

137. Müller 1830, translated into English 1847: part 3, "On the subjects of the formative art," and Gerhard (1840–58), with Dyson 2006: 35 and Schnapp 2004. Also important for pottery studies is Jahn 1839 and 1854.

138. Klein 1886 (first published 1879) with Rouet 2001: 27–30.

139. Elsner 2002, 2003, 2006c, and 2010a and Hatt and Klonk 2006: 65–95.

140. Wölfflin (1915) 2015 edn.: 93.

141. Riegl 1985 (first published in German in 1901): 11. Also important here, on the Arch of Constantine, is Riegl 1985: 55: "As far as beauty goes, we do indeed miss the proportions which compare every part according to size and motion with other parts and with the whole; but in its place, we have found another form of beauty which is expressed in the strictest symmetrical conception and which we might call crystalline because it constitutes the first and eternal principal form for the inanimated raw material and because it comes comparatively closest to absolute beauty (material individuality)."

142. Riegl 1985: 8.

143. On Warren (whose best-known buy is his eponymous Warren Cup, now in the British Museum, inv. no. 1999,0426.1), see Sox 1991, Grove 2015, Vout 2015a, and the 2009 edition of the privately published *A Defence of Uranian Love*; and on Berenson, Elsner 1998a and 2003. Note that Berenson (born Bernhard Valvrojenski) was not American by birth but emigrated from Lithuania.

144. Goldhill 2011: 23.

145. A. Smith 1996: 126.

146. Edward Poynter, *Diadumenè*, 1885–93 (1893 is when the drapery is added), oil on canvas, private collection. A smaller painting, which remained nude, was exhibited in the Royal Academy in 1884, oil on canvas, Royal Albert Memorial Museum and Art Gallery, Exeter. See Goldhill 2011: 33–36, Liversidge and Edwards 1996: cat. no. 56, A. Smith 1999, Kear 1999: 26–27 and 72–76, and A. Smith 2001: cat. no. 33.

147. Old-fashioned, because Gibson's *Tinted Venus* (A. Smith 2001: 39–40 and 186–87) was courting controversy in 1862 already and Hiram Powers's *Greek Slave* (A. Smith 2001: cat. no. 46 and Droth, Edwards, and Hatt 2014: cat. nos. 80–83), which had been a sensation in the 1840s and 50s, beginning to be seen as anodyne. For *Hypatia*, see Liversidge and Edwards 1996: cat. no. 57 and A. Smith 2001: cat. no. 148, and, for *St. Eulalia*, Liversidge and Edwards 1996: cat. no. 58 and A. Smith 2001: cat. no. 149.

148. Mitchell's painting was exhibited with an excerpt from Charles Kingsley's historical novel *Hypatia, or New Foes with an Old Face* (1853).

149. Poynter, *Letters* (National Art Library, Victoria and Albert Museum, London) as cited in Kear 1999: 75.

150. *The Times*, 28 May 1885: 4.

151. Swenson 2013: 134. Note too the opening up of some of England's grandest country houses, which came to be viewed in the nineteenth

century as the common property of all classes: Mandler 1997.

152. On the Crystal Palace, Nichols 2015: 19, and on the numbers viewing *A Sculptor's Model* (oil on canvas, 1877, private collection) in Liverpool (Autumn Exhibition, Walker Art Gallery, no. 198), A. Smith 1996: 202–7. Earlier in the same year, the latter was exhibited in London at the Royal Academy (no. 255)—see *The Illustrated London News*, 4 May 1878: 410.

153. Relevant here is Dyson 1998: 149 and the ways in which historical and social aspects of ancient art were still in the 1920s relegated to a corridor exhibition at the Metropolitan Museum of Art, New York.

154. F. Lenormant 1877: 142: "une simple femme rajustant sa coiffure un sortent du bain" and 145: the statue "est trop chaste pour que l'on y voie un des statues-portraits de courtisanes . . . il me semble trop peu idéal pour être une déesse, mais, en même temps, on pourrait y trouver trop de gravité pour une simple representation tirée de la vie réelle."

155. F. Lenormant 1877: 147–52.

156. F. Lenormant 1877: 141 and 152: "un pendant féminin."

157. His sister was Clara Bell, the translator. She translated Maupassant among others.

158. Robinson 1891: cat no. 166.

159. See also Waldstein 1887: 12: "the body manifests a study of nature of a kind that, to my knowledge, is unexampled among extant works of classical art."

160. C. L. Visconti 1875.

161. Beard 1994: 1.

162. Museum of Classical Archaeology, Cambridge, inv. no. 464.

163. *Athenaeum*, 11 May 1867: 628.

164. See Verhoogt 2014: 497, Becker and Prettejohn 1996, Barrow 2001 and 2007.

165. As ventriloquized by an animated bronze statue of Rembrandt to a statue of Ary Scheffer in *De Kunstkronijk* (1869) as cited in Verhoogt 2014: 499.

166. *The Art Journal* as cited in Verhoogt 2014: 500.

167. Alma-Tadema, *The Sculpture Gallery*, oil on canvas, 1874, Hood Museum of Art, Dartmouth College, inv. no. P.961.125. See Barrow 2001: 79–80 and Mattusch 2008: 290–96. Note too the herm of Pericles to the far left, the seated marble statue, then identified as "Agrippina" (Haskell and Penny 1981: cat. no. 1) and, through the door, a lampstand from the House of Pansa at Pompeii.

168. Goldhill 2007: 2 and on art history as ecphrasis, Elsner 2010b.

169. Elis 1970 and "Lewis Dillwyn's 'Etruscan Ceramics'" on the "Classics and Class" website: http://www.classicsandclass.info/product/145 / (last accessed 24 May 2016).

170. P. J. Anderson 1987: 134–37. The magazine's discussion of the Dying Gaul also includes canto 4 of Byron's *Childe Harold's Pilgrimage*, published between 1812 and 1818. For the very different context that gave birth to Byron's poem and the relationship of poetry and sculptures such as the Apollo Belvedere and Parthenon marbles, see Yorimichi 2009.

171. Booth 1981: 18–19.

172. Maginn 1856: 87. Ducrow's circus show also toured.

173. An account of his act from 1828 cited in Nead 2007: 74.

174. Hood 1842: 43.

175. Hatt 2006.

176. Faulk 2004: 181.

177. See O'Mahony 2013: 706–7, and below, ch. 9. See also the official poster for the 1948 Olympic Games in London (British Museum, Greek and Roman, inv. no. 2007,5006.1), which set an image of the Townley Discobolus in front of the Houses of Parliament (I. Jenkins 2012: 53–55).

178. See, e.g., Malamud and McGuire on Caesar's Palace, 2001.

179. Montgomery-Massingberd and Sykes 1994: 17–26. Unsurprisingly, antiquities and works after the antique are also part of Victoria and Albert's collection; see Droth, Edwards, and Hatt 2014: cat. no. 76 and Marsden 2010.

180. These were commissioned in the 1840s: see Droth, Edwards, and Hatt 2014: 188–91.

181. This sculpture, 1901–4, was acquired by the Tate in 1953. See Butler 1993: 380–81.

182. Elsen 2003: 213, citing Alley 1959: 226.

183. Shippobottom 1992.

184. Waywell 1986, review by M. Robertson 1988, M. Robertson 1987, and, for Hope, above, ch. 7, "Staging the Antique."

185. Tatlock, Fry, Hobson, and Macquoid 1928: 7.

186. Lever 1927: 288.

187. Lever 1927: 288. Echoed by Grundy in the foreword to Tatlock, Fry, Hobson, and Macquoid 1928: 5.

188. *The Observer*, 17 December 1922: 6.

189. Lever 1927: 279–80.

190. Tatlock, Fry, Hobson, and Macquoid 1928: 159.

191. Lever 1927: 287. For Antinous, see Waywell 1986: 21–22, and for the altar (inv. no. LLAG 12), Waywell 1982 and 1986: 24–25.

192. The collection has Lawrence Alma-Tadema's *The Tepidarium*, 1881 (Liverpool Museums, inv. no. LL3130, and A. Smith 2001: 149), which Lever bought from the rival A. F. Pears's soap company for a massive £1150. Propriety perhaps prevented Pears from using it, though the publishers of the Lady Lever catalog (Tatlock, Fry, Hobson, and Macquoid 1928: 86, no. 2898, pl. 47) reproduce it for their readers.

193. Maurice Ferrary, *Salammbo*, 1899, Liverpool Museums, inv. no. LL205. Tatlock, Fry, Hobson, and Macquoid 1928: 13 says only that it is a "striking figure." It is not illustrated and all sculpture relegated to the final section.

194. Lever 1927: 288.

195. Tatlock, Fry, Hobson, and Macquoid 1928: 13–14.

196. Hope 1807.

197. Goldhill 2011: 3.

198. Vandiver 2013. From 1915 to 1918, Wherry herself served in the Women's Emergency Canteen beneath the Gare du Nord in Paris.

Chapter 9: The Death of Classical Art?

1. Thomas 1997.

2. On the Mostra, see Arthurs 2007 and Marcello 2011; on the Discobolus, Wünsche 2007: 205 and I. Jenkins 2012; and on Fascist appropriation of the classical more broadly, Prettejohn 2012: 219–20.

3. See above, ch. 7, "Locating the 'Classical.'"

4. Greek is scrapped in the wake of the First World War, and Latin at the end of the 1950s. Stray 1998: 110, 267–70, 282–83 for the introduction of the Cambridge English Tripos in 1917 and Philosophy, Politics, and Economics at Oxford in 1920, and passim for the gradually encroaching challenges to a classical education from the mid-nineteenth century onward.

5. Stray 1998: 277–81, citing one of the classics HMIs, G. C. Allen, 1948: "What do we mean by the Classics as really carried on in a secondary grammar school? Normally Latin only. . . . What of the Latin? That which I have seen in the last year is remarkably bad, though invariably diligent. It is dull, lifeless, 75% Grammar and Syntax and 25% often unrelated but wholly verbalistic translation" and 297: "The shift from culture to discipline belonged to a process of marginalization which led, in the end, to disestablishment."

6. Since revised again by Donald E. Sprague: Mountford 2006. See the review by Nodes 2006.

7. Higgins 2009.

8. Note, in particular, the defense of the canon mounted by Bloom 1994 and Kermode 2004. I thank Charles Martindale, Elizabeth Prettejohn, and Tania Demetriou for forcing me to think about this by inviting me to the symposium "Were We Right to Fire the Canon (If We Ever Did)?" in York on 19 May 2016.

9. Onians 1996.

10. Onians 1999: xiii. See also his *Bearers of Meaning: The Classical Orders in Antiquity, the Middle Ages, and the Renaissance* (1988).

11. Houghton 2009: 16.

12. Philippe de Montebello to Robin Pogrebin 2007: http://www.nytimes.com/2007/04/18/arts/design/18wing.html (last accessed 7 December 2016).

13. http://www.britishmuseum.org/about_us/news_and_press/press_releases/2014/record_visitor_figures.aspx (last accessed 21 June 2016).

14. For the exhibits of the Herculaneum exhibition, third only to "Tutankhamun" (1972) and "The First Emperor: China's Terracotta Army (2007)," see Roberts 2013, and for Pan and the Goat, Vout 2013c. For "Defining Beauty," I. Jenkins 2015, and for the Parthenon marbles, including the figure of Ilissos in St. Petersburg, http://www.britishmuseum.org/about_us/news_and_press/press_releases/2015/river_god_ilissos.aspx (last accessed 12 June 2016) and Smith and Muir in the *The Guardian*, 5 December 2014: https://www.theguardian.com/artanddesign/2014/dec/05/parthenon-marbles-greece-furious-british-museum-loan-russia-elgin and https://www.theguardian.com/commentisfree/2014/dec/05/british-museum-wrong-loan-elgin-marbles-russia-sanctions (last accessed 7 December 2016). The literature on their restitution (or not) is vast: see, e.g., St. Clair 1967 and 1999, D. King 2006, Hitchens 2008, Silverman 2010, van Gene-Saillet 2014, and T. Jenkins 2016b.

15. http://www.greece.org/parthenon/marbles/speech.htm (last accessed 21 June 2016).

16. Jones, in a piece that argues for their return, *The Guardian*, 18 August 2014: https://www.theguardian.com/artanddesign/jonathanjonesblog/2014/aug/18/parthenon-marbles-greece-return-acropolis-museum.

17. E.g., Christie's Classic Week," London (July 2016) sold a large Cycladic figurine from the Aegean islands, date c. 2500–400 BCE, for £1,202,500, a Roman marble head of Hadrian,

from the Hadrianic or early Antonine period, for £842,500, and a Wedgwood black "basaltes" decorated vase in Attic red-figure style, potted on the opening day of the Etruria Factory in Staffordshire on 13 June 1769, for £482,500.

18. Settis and Artistic Director Germano Celant in conversation with James Cahill: Cahill 2015. Also relevant here is the Benaki Museum's "Liquid Antiquity" exhibition, 4 April–17 September 2017.

19. Jeff Koons's *Gazing Ball (Farnese Hercules)*, plaster and glass (edition of 3 plus AP, 2013).

20. Vout 2015b, recording an interview with Darbyshire: 27.

21. In addition to those ancient artworks already discussed, Silenus with Baby Dionysus, Louvre, Paris, inv. no. Ma 922 (MR 346), and the Antinous Braschi (formerly in the Palazzo Braschi, hence its name), Vatican, cat. no. 256.

22. OCR "Greek art": http://www.ocr.org.uk/Images /315133-specification-accredited-a-level-classical -civilisation-h408.pdf and AQA "Greek architecture and sculpture": http://www.aqa.org.uk /subjects/classical-civilisation/as-and-a-level /classical-civilisation-2020/subject-content (last accessed 12 December 2016). AQA recently announced that it is to cut Classical Civilisation A-level.

23. Marathon Boy, 340–330 BCE, National Archaeological Museum, Athens, inv. no. X 15118.

24. Above, ch. 1, "What Is Classical Art?"

25. Also for the Riaces, Onatas and Alcamenes: see, e.g., Spivey 2013: 187–88. And for the Marathon Boy, Kaltsas 2002: cat. no. 509. On the difficulty of finding a frame of reference to make sense of the marble Motya Charioteer, 460–450 BCE, found in 1979 and now in the Joseph Whitaker Museum, Motya, Sicily, Marlowe 2013: 85–86.

26. Above, ch. 5, "Sculpture as Subject," and Cast 2009: 137.

27. Darbyshire has made four Doryphoros pieces; see also *CAPTCHA No. 15—Doryphoros*, 2014, multiwall polycarbonate, silicone, and steel armature, *CAPTCHA No. 21—Doryphoros*, 2015, multiwall polycarbonate, all 224 x 75 x 75 cm, and *CAPTCHA No. 40—Doryphoros*, 2015, multiwall polycarbonate and stainless steel armature, 220 x 70 x 70 cm.

28. Sui Jianguo's version of the Discobolus, 2012, bronze, painted white, h 172 cm, is now in the British Museum's collection, inv. no. 2012,5014.1.

29. I. Jenkins 2012: 57, http://www.britishmuseum .org/whats_on/past_exhibitions/2012/sui _jianguos_discus_thrower.aspx (last accessed 13 December 2016) and O'Mahony 2013: 713–15.

30. Ohly 1966: 515 as cited in Diebold 1995: 60.

31. Rave 1944: 71 as cited in Diebold 1995: 64.

32. The literature on looted antiquities is growing all the time: see above, ch. 8, n. 57, and Brodie 2012. On the Getty Kouros, see the papers of *The Getty Kouros Colloquium*, 1993. Note that the problem of "fakes" is not new: see, e.g., the antiquity of Isabella's Cupid, above, ch. 5.

33. For example, the late antique silver hoard known as the Sevso Treasure, acquired by the Marquess of Northampton and then caught up in legal wrangles until 2014 when some pieces were repatriated to Hungary: see, e.g., Kurzweil, Gagion, and de Walden 2005.

34. See Silver 2009, mainly on the Euphronios cup, but also, in part, on the krater, and Brodie at http://traffickingculture.org/encyclopedia /case-studies/euphronios-sarpedon-krater/ (last accessed 13 December 2016). On the krater's return to Cerveteri, http://roma .repubblica.it/cronaca/2015/11/07/news /franceschini_il_cratere_di_eufronio_resta_a _cerveteri_-126844061/ (last accessed 13 December 2016), and on the antiquities from the Shelby White and Leon Levy collection, Von Bothmer 1991.

35. Towne-Markus 1997.

36. Moreno 2003 and Corso 2004: 170, n. 309.

37. Former director of the Metropolitan Museum of Art Philippe de Montebello (2009: 55), opening his essay defensively titled "And What Do You Propose Should Be Done with These Objects?" with a quotation from a speech made in 1870.

38. Marlowe 2013: 2.

39. See Marlowe 2013: 9–11, and 127–28 on the suggestion that canonical but "ungrounded" works might be seen as "a separate branch of the discipline—and a separate chapter of the textbook—devoted to the reception of Roman art."

40. See Neer 2010: "Introduction: An Apology for Style" (1–19), referenced briefly in ch. 1.

41. I owe these points to Elizabeth Prettejohn's paper, "A New Connoisseurship?" in the "Were We Right to Fire the Canon (If We Ever Did)?" symposium in York.

42. Marlowe 2013: 40. On Sagalassos, see the Leuven and Brepols publications by Waelkens et al. and, beginning to think with some of its colossal imperial portrait sculpture, Vout 2012a.

43. Although note that Roman art has, at various points of our story, wrestled with Greek art

(though perhaps not in ways that credited it with a positive style of its own).

44. Fundamental here is Hölscher 1987, translated into English 2004.

45. Above, ch. 3, "Managing the Legacy."

46. Merrony 2011, and the press pack issued to celebrate the museum's opening, https://www.mouginsmusee.com/files/mougins-museum-press-pack.pdf (last accessed 13 December 2016).

47. Wickhoff 1900 (Strong's translation of Wickhoff's contribution to *Die Wiener Genesis*): vi.

48. Wickhoff 1900: 23.

49. Strong in Wickhoff 1900: vii and Wickhoff 1900: 48.

50. P. Gardner 1917: 5.

51. P. Gardner 1917: 6 and 15.

52. P. Gardner 1917: 5.

53. P. Gardner 1917: 1.

54. E. Strong 1907: vi.

55. E. Strong 1907: 9–10.

56. Strong 1907: 56. The reliefs of the "altar," end of the second century BCE, are split between the Louvre, inv. no. LL 399 (Ma 975), and the Munich Glyptothek, inv. no. 239. See Stilp 2001.

57. Strong 1907: 98–99.

58. See Kampen 1997.

59. Brendel 1979: 35.

60. On Schliemann's exhibition, see A. Baker 2015: 131–57, Duesterberg 2015: 99–116, and Nichols 2015: 110, and on Knossos, Gere 2009. And, on Evans's London exhibition, A. Baker 2015: 158–71.

61. Contemporary review cited in Duesterberg 2015: 316.

62. Brendel 1979: 6 and 9.

63. Brendel 1979: 137.

64. Kampen 1997.

65. Brendel 1979: 74.

66. Bianchi Bandinelli (translated from the French by Green) 1970: ix.

67. Above, ch. 3, "Managing the Legacy," and Kampen 1981, D'Ambra 1988, J. R. Clarke 2003, D'Ambra and Métraux 2006, Peterson 2006, and P. Stewart 2008.

68. Wallace-Hadrill 1989: 157.

69. P. Zanker 1988: v and Wallace-Hadrill 1989.

70. See, e.g., Elsner 1995 and 2007.

71. P. Zanker 1988: vi.

72. Seltman 1948: 111 in deference to Jocelyn Toynbee and her refutation of Wickhoff.

73. *The Arch of Constantine, or, the Decline of Form*, written in Italy at I Tatti, Settignano, in 1941, and translated into English in 1954. Helpful here is Elsner 1998a.

74. A. Baker 2015: 220. The Norwich show was seen by 48,557 visitors, including organized parties of Allied servicemen and Norwich schoolchildren.

75. Chittenden and Seltman 1947: cat. no. 154, pl. 70.

76. Chittenden and Seltman 1947: 5.

77. Fitzwilliam Archive envelope, 2487 (A. Baker 2015: fig. 19).

78. Seltman in an interview with *The Cambridge Daily News*, 17 May 1944, as cited in A. Baker 2015: 219.

79. Chittenden and Seltman 1947: 9 and Strong (first published 1903) 1904 illustrated edn.: Chatsworth Apollo, "Larger marbles and bronzes," cat. no. 8.

80. Chittenden and Seltman 1947: cat. no. 174 and pls. 62–65.

81. E. Strong (first published 1903) 1904 edn.: xv.

82. E. Strong (first published 1903) 1904 edn.: x and xiii–xiv. Note the inclusion of the emaciated "Sick Man Sitting on a Chair" from Gaul, Strong 1904: "Smaller Bronzes," cat. no. 50, pl. LII.

83. Note, in particular, E. Strong (first published 1903) 1904 edn.: "Vases," cat. nos. 47 and 50 (Gardner); and "Small Marbles," cat. no. 45 (head), pp. 129–38 (coins), pp. 164–81 (gems), and 257 (casts) (Evans).

84. See, e.g., Ridgway 1984, Bartman 1992, and Marvin 2008.

85. Until its final chapter, entitled "Museum." The Idolino (Seltman 1948: 71), in the National Archaeological Museum in Florence, inv. no. 1637, is now thought by the majority to be a Roman statue: see, e.g., Marvin 1997: 10.

86. On Myron's Discobolus, Richter 1929: 155–56 and Gardner (Yates Professor of Archaeology at the University of London) 1896–97, vol. 1: 236–40.

87. Richter 1929: 185. Compare E. A. Gardner 1896–97, vol. 1: 11–13, and vol. 2: 326, which bemoans how much is "lost in the translation" from Polyclitus's bronze original to the Naples Doryphorus statue.

88. Lullies, translated from the German by Bullock 1957: 9.

89. Ridgway 1970 and 1981, whose decisions make Roman copies worth studying in their own right as Roman, and Boardman 1985 (esp. 7–8 and 15–18) with review by Palagia 1987b, even if several of his photographs show casts of the objects.

90. R. Osborne 1998—a decision not, as far as I have found, picked up in any of the reviews.

91. Neer 2012: 198.

92. Neer 2012: 198. In stark contrast to this approach, see, e.g., Rolley 1999.

93. Compare, e.g., Stansbury-O'Donnell's "new history" of Greek art, 2015: 5, driven by questions like "who made something, who paid for it, what purpose did it serve, and what importance did it have in the lives of the ancient Greeks" and Spivey 2013: xx: "Readers must not be surprised, then, to find many works with Roman provenance included here as 'Greek sculpture'—and the category of 'Roman copy' virtually taboo throughout the book."

94. Beard and Henderson 2001: 5.

95. Beard and Henderson 2001: 4.

96. Whitley 2001: xxiii.

97. Ortiz (http://www.georgeortiz.com/downloads /The-George-Ortiz-Collection.pdf—last accessed 22 June 2016): ii. Also important here is Ortiz 2006.

98. Ortiz 1996: cat. no. 220 and p. 429.

99. Ortiz 1996: cat. no. 227 and p. 442.

100. Part of the text of an information panel that introduces one to the portrait gallery on the ground floor.

101. See Merrony 2011: 91, Vermeule 1955: 133 and 1981: 310, Wegner 1956: 95, and, on Louisiana, http://revmoore.blogspot.co.uk/2008/12 /landmark-is-lost.html. The Christie's catalog entry is available at http://www.christies.com /lotfinder/Lot/a-roman-marble-statue-of-the -emperor-5157992-details.aspx (both last accessed 14 December 2016).

102. Merrony 2011: 93–94. The collection also has a statue and a bronze "balsarium" or perfume-container, each identified as "Antinous," inv. nos. MMoCA.136 and MMoCA.291: Merrony 2011: 82 and 138.

103. http://www.christies.com/features/How-a -collector-of-Modern-and-Contemporary-Art -got-switched-on-to-Antiquities-7113-1.aspx (last accessed 14 December 2016).

104. Merrony 2011: 15. Aeschylus's portrait is actually, as the catalog later acknowledges (86), a Roman marble made in the first or second century CE.

105. Ortiz 1996: v.

106. Buitron-Oliver 1992: 6–7.

107. Buitron-Oliver 1992: 6, 7, and 9.

108. Buitron-Oliver 1992: 101, cat. no. 10.

109. Merrony 2011: 106 (Mougins, inv. no. MMoCA.702), illustrated in 1778 in Piranesi's *Vasi, candelabri, cippi* etc., 80 (inv. no. MMoCA.20), and 321 (inv. no. MMoCA.MA96).

110. Note that the cinerary urn has satyr heads as handles.

111. Merrony 2011: 336 (Mougins, inv. no. MMoCA. MA11), 338 (inv. no. MMoCA.MA1), and 84 (inv. no. MMoCA.29). Also relevant is https://www .theguardian.com/culture/2011/mar/27 /compulsive-art-collector-french-museum (last accessed 14 December 2016).

112. Especially given that "La Mort dans le Monde Romain" (Death in the Roman World) is the subject or theme of a subsequent section of the museum.

113. See the discussion of sanctuaries in ch. 2.

114. Merrony 2011: 305–11, 322, and 332.

115. https://www.mouginsmusee.com/en/2013/02 /european-museum-of-the-year-2013-nomination -for-the-macm (last accessed 22 June 2016).

116. Note too the two ancient marble portraits of Roman emperors Commodus and Septimius Severus, once in the Albani collection, allocated to the museum by Arts Council England in lieu of inheritance tax, but destined, normally, to remain in Houghton Hall, where they have been since they were gifted to Robert Walpole in the eighteenth century.

117. Antinous (inv. no. GR.100.1937) and pilasters (inv. no. GR.82.1850).

118. *Museums Journal* (May 2010: 52–53). The credit for the redisplay must go to the Fitzwilliam's keeper of antiquities, Lucilla Burn, and to Kate Cooper. Kate was the postdoctoral fellow on an AHRC-funded research project in which I and two other classics colleagues were also involved, entitled "Greece and Rome at the Fitzwilliam Museum."

119. Elsner 1998b: 170 in a chapter followed by "Classicism in the Late Empire."

120. Hallett 2015: 14. Also relevant here is Squire 2015.

121. https://www.nytimes.com/2014/08/18/arts /international/the-lure-of-antiquities.html?_r=0 (last accessed 14 December 2016).

122. http://www.metmuseum.org/about-the-met /curatorial-departments/greek-and-roman-art (last accessed 14 December 2016).

123. This gallery was curated by Ian Jenkins with contributions by several others, notable among them, Don Bailey.

Chapter 10: And the Moral of the Story . . .

1. Barolsky 2014: 2.

2. Theoc. 15.81–2. ὡς ἔτυμ' ἑστάκαντι, καὶ ὡς ἔτυμ' ἐνδινεῦντι,/ἔμψυχ', οὐκ ἐνυφαντά.

3. Squire 2010b: 601. Although treating artworks as living beings always also risked seeming excessive

4. For "agency," see Gell 1998 and, for a classics-specific response, Osborne and Tanner 2007. The idea of "affordances" originates from Gibson 1977 and 1979. Helpful in formulating this paragraph has been Van Eck, Versluys, and ter Keurs 2015.

5. Above, ch. 7, n. 172.

6. http://www.smb.museum/en/exhibitions /detail/kampf-um-troja.html (last accessed 19 December 2016), which also discusses the exhibition of the pieces, from 30 September 2015 to 16 May 2016, in the Altes Museum in Berlin.

7. De Bolla 2001: 31.

8. https://www.theguardian.com/artanddesign /2015/nov/09/jeff-koons-gazing-ball-paintings -its-not-about-copying (last accessed 19 December 2016).

BIBLIOGRAPHY

List of Abbreviations

Greek and Latin authors and their texts, collections of ancient inscriptions, and papyri in the notes are abbreviated as in S. Hornblower, A. Spawforth, and E. Eidinow, eds., 2012, *The Oxford Classical Dictionary*, 4th edition, http://classics.oxfordre.com/static files/images/ORECLA/OCD.ABBREVIA TIONS.pdf (last accessed 19 March 2017). For other abbreviated items, see below.

AQA Assessment and Qualifications Alliance (a UK body that compiles specifications and holds examinations in various subjects at GCSE, AS, and A Level and offers vocational qualifications)

BHG F. Halkin, ed. 1957. *Bibliotheca Hagiographica Graeca*, 3ʳᵈ edn., 3 vols. Brussels.

BnF Bibliothèque nationale de France (National Library of France)

BNN Biblioteca Nazionale di Napoli (National Library of Naples)

CAF P. Marichal, ed. 1887–1908. *Catalogue des Actes de François I*er, 10 vols. Paris.

DNO S. Kansteiner, K. Hallof, L. Lehmann, B. Seidensticker, and K. Stemmer, eds. 2014. *Der Neue Overbeck*. Berlin.

IPerg M. Frankel. 1890–95. *Die Inschriften von Pergamon (Altertümer von Pergamon* VIII), 2 vols. Berlin.

OCR Oxford, Cambridge, and RSA exams (a UK body that sets exams and awards qualifications, including GCSE and A Level)

The ensuing bibliography contains all of the works cited in the endnotes. Though inevitably missing what some readers will see as key items, it is extensive, overly anxious even, seeking both to function as an important scholarly tool and to enable the main text to make big claims lightly, without overgeneralizing. For anyone new to "classical art," I draw particular attention to the following: for the meaning of the "classical," Settis 2006; for classical art in classical antiquity, Beard and Henderson 2001; for the medieval period, Greenhalgh 1989; for the Renaissance, Barkan 1999; for the eighteenth century, Coltman 2006; and for "classicism" and "modernity," Prettejohn 2012. If there is a "bible" to accompany this book's exegesis, it is Haskell and Penny's groundbreaking *Taste and the Antique: The Lure of Classical Sculpture, 1500–1900* (1981) with its catalogue raisonné of nearly 100 influential works of classical sculpture. In the course of being revised as I write, it is still fundamental reading, even if—especially as—it has itself created a further canon.

Ackerman, J. 2000. "Imitation," in A. Payne, A. Kuttner, and R. Smick, eds., *Antiquity and Its Interpreters*. Cambridge: 9–16.

Acosta-Hughes, B., E. Kosmetatou, and M. Baumbach. 2004. *Labored in Papyrus Leaves: Perspectives on an Epigram Collection Attributed to Posidippus (P.Mil. Vogl. VIII 309)*. Washington, DC.

Adornato, G. 2008. "Delphic Enigmas? The Γέλας ἀνάσσων, Polyzalos, and the Charioteer Statue," *American Journal of Archaeology* 112(1): 29–55.

Ainsworth, M. W., ed. 2010. *Man, Myth, and Sensual Pleasures: Jan Gossart's Renaissance*. New York.

Ajootian, A. 1996. "Praxiteles," in O. Palagia and J. J. Pollitt, eds., *Personal Styles in Greek Sculpture*. Cambridge: 91–129.

———. 1998. "A Day at the Races: The Tyrannicides in the Fifth-Century Agora," in K. Hartswick and M. Sturgeon, eds., Στέφανος: *Studies in Honor of Brunilde Sismondo Ridgway*. Philadelphia: 1–13.

Alberti, L. B. 1972. "De statua: On Sculpture," in *On Painting and On Sculpture*, ed. and trans. C. Grayson. London: 117–42.

Alberti, L. B., and G. Tory. 1512. *Libri de re ædificatoria decem*. Paris.

Alchermes, J. 1994. "Spolia in Roman Cities of the Late Empire: Legislative Rationales and Architectural Reuse," *Dumbarton Oaks Papers* 48: 167–78.

Aldhouse-Green, M. J. 2003. "Alternative Iconographies: Metaphors of Resistance in Romano-British Cult Imagery," in P. Noelke, F. Naumann-Steckner, and B. Schneider, eds., *Romanisation und Resistenz in Plastik, Architektur und Inschriften des Imperium Romanum: Neue Funde und Forschungen.* Mainz: 39–48.

Aldrovandi, U. 1562. "Delle statue antiche, che per tutta Roma, in diversi luoghi, e case si veggono," in L. Mauro, *Le antíchità della città di Roma.* Venice: 115–315.

Aleshire, S. B. 1989. *The Athenian Asklepieion: The People, Their Dedications, and the Inventories.* Amsterdam.

Allen, R. E. 1971. "Attalos I and Aigina," *Annual of the British School at Athens* 66: 1–12.

Alley, R. 1959. *Tate Gallery: The Foreign Paintings, Drawings, and Sculptures.* London.

Allison, A. H. 1993–94. "The Bronzes of Pier Jacopo Alari-Bonacolsi," *Jahrbuch der Kunsthistorischen Sammlungen in Wien* 89–90: 35–310.

Alsop, J. 1982. *The Rare Art Traditions: The History of Art Collecting and Its Linked Phenomena Wherever These Have Appeared.* London.

Amelung, W. 1922. "Harmodios und Aristogeiton," *Studi romani* 3: 73–76.

Anderson, B. 2011. "Classified Knowledge: The Epistemology of Statuary in the *Parastaseis Syntomoi Chronikai,*" *Byzantine and Modern Greek Studies* 35(1): 1–19.

Anderson, C. M. 2015. *The Flemish Merchant of Venice: Daniel Nijs and the Sale of the Gonzaga Art Collection.* New Haven.

Anderson, M. 1987–88. "The Villa of P. Fannius Synistor at Boscoreale," *Metropolitan Museum of Art Bulletin,* n.s., 45(3): 17–36.

Anderson, P. J. 1987. "Pictures for the People: Knight's 'Penny Magazine', an Early Venture into Popular Art Education," *Studies in Art Education* 28(3): 133–40.

———. 1991. *The Printed Image and the Transformation of Popular Culture, 1790–1860.* Oxford.

Anderson, R. G. W. 2012. "British Museum, London: Institutionalizing Enlightenment," in C. Paul, ed., *The First Modern Museums of Art: The Birth of an Institution in 18th- and Early-19th-Century Europe.* Los Angeles: 47–72.

Andreae, B. 2009. *Der Tanzende Satyr Von Mazara Del Vallo und Praxiteles.* Oakville.

Angelicoussis, E. 1992. *The Woburn Abbey Collection of Classical Antiquities.* Mainz.

———. 2001. *The Holkham Collection of Classical Sculptures.* Mainz.

———. 2004. "The Collection of Classical Sculptures of the Earl of Arundel, 'Father of Vertu in England,'" *Journal of the History of Collections* 16(2): 143–59.

Angelucci, M. 2011. "Polemon's Contribution to the Periegetic Literature of the II C B.C.," Ὅρμος: *Ricerche di Storia Antica,* n.s, 3: 326–41.

Angiò, F. 2004. "Artisti 'vecchi' e 'nuovi' (Posidippo di Pella, P. Mil. Vogl. VIII 309, col. X 8–15)," *Museum Helveticum* 61: 65–71.

Anguissola, A. 2005. "Roman Copies of Myron's Discobolus," *Journal of Roman Archaeology* 18: 317–35.

———. 2012. *"Difficillima imitatio": Immagine e lessico delle copie tra Grecia e Roma.* Rome.

———. 2015. "'Idealplastik' and the Relationship between Greek and Roman Sculpture," in E. A. Friedland and M. G. Sobocinski, with E. K. Gazda, eds., *The Oxford Handbook of Roman Sculpture.* Oxford: 240–59.

Antliff, M. 2013. "Politicizing the New Sculpture," in M. Antliff and S. W. Klein, eds., *Vorticism: New Perspectives.* Oxford: 102–18.

Antonio, N. 1783. *Bibliotheca Hispania Nova.* Madrid.

Arafat, K. W. 1996. *Pausanias' Greece: Ancient Artists and Roman Rulers.* New York.

Arata, F. P. 2005. *Opere d'arte dal mare: Testimonianze archeologiche subacquee del trasporto e del commercio marittimo di prodotti artistici.* Rome.

Arias, P. E., ed. 1984. *Due bronzi da Riace: Rinvenimento, restauro, analisi ed ipotesi di Interpretazione,* 2 vols. Rome.

Arlt, T. 2005. *Andrea Mantegna, Triumph Caesars: Ein Meisterwerk der Renaissance in neuem Licht.* Vienna.

Arrington, N. T. 2015. *Ashes, Images, and Memories: The Presence of the War Dead in Fifth-Century Athens.* Oxford.

Arthurs, J. 2007. "(Re)presenting Roman History in Italy, 1911–1955," in C. Norton, ed., *Nationalism, Historiography and the (Re)construction of the Past.* Washington, DC: 27–41.

Ash, R. 2006. "Nero, 37–68," in N. G. Wilson, ed., *Encyclopedia of Ancient Greece.* New York: 501–3.

Asher, A. 1840–41. *The Itinerary of Rabbi Benjamin of Tudela,* 2 vols. New York.

Ashmole, B. 1972. *Architect and Sculptor in Classical Greece.* New York.

Ashton, S. 1999. "Ptolemaic Royal Sculpture from Egypt: The Greek and Egyptian Traditions and Their Interaction." Doctoral dissertation, King's College, London.

Ashworth, W. 1996. "Emblematic Natural History of the Renaissance," in N. Jardine, J. A. Secord, and E. C. Spary, eds., *Cultures of Natural History.* Cambridge: 17–37.

Aurigemma, S. 1961. *Villa Adriana.* Rome.

Austin, C., and G. Bastianini. 2002. *Posidippi Pellaei Quae Supersunt Omnia.* Milan.

Avery, C. 1980–82. "Hubert le Sueur: The 'Unworthy Praxiteles' of King Charles I," *The Walpole Society* 48: 135–209.

Aymonino, A., and A. V. Lauder, eds. 2015. *Drawn from the Antique: Artists and the Classical Ideal.* London.

Ayres, P. J. 1997. *Classical Culture and the Idea of Rome in Eighteenth-Century England.* Cambridge and New York.

Azoulay, V. 2014. *Les Tyrannicides d'Athènes: Vie et mort de deux statues.* Paris.

Baglione, G. [1642] 1935. *Le Vite de' pittori, scultori ed architetti*, ed. V. Mariani. Rome.

Bagnall, R. 2002. "Alexandria: Library of Dreams," *Proceedings of the American Philosophical Society* 146(4): 348–62.

Baker, A. 2015. "Ancient Narratives in the Modern Museum: Interpreting Classical Archaeology in British Museums." Doctoral dissertation, Birkbeck College, London.

Baker, M. 2000. *Figured in Marble: The Making and Viewing of Eighteenth-Century Sculpture.* London.

———. 2007. "Public Images for Private Spaces? The Place of Sculpture in the Georgian Domestic Interior," *Journal of Design History* 20: 309–23.

———. 2015. *The Marble Index: Roubiliac and Sculptural Portraiture in Eighteenth-Century Britain.* New Haven.

Balty, J.-C., and D. Cazes. 2005. *Sculptures antiques de Chiragans (Martres-Tolosane), 1.1. Les portraits romains. Les Julio-Claudiens.* Toulouse.

———. 2008. *Sculptures antiques de Chiragans (Martres-Tolosane), 1.2. Les portraits romains. La Tétrarchie.* Toulouse.

Bär, S. 2012. "Museum of Words: Christodorus, the Art of Ekphrasis and the Epyllic Genre," in M. Baumbach and S. Bär, eds., *Brill's Companion to Greek and Latin Epyllion and Its Reception.* Leiden and Boston: 447–71.

Bardill, J. 1997. "The Palace of Lausus and Nearby Monuments in Constantinople: A Topographical Study," *American Journal of Archaeology* 101(1): 69–75.

Barkan, L. 1993. "The Beholder's Tale: Ancient Sculpture, Renaissance Narratives," *Representations* 44: 133–66.

———. 1999. *Unearthing the Past: Archaeology and Aesthetics in the Making of Renaissance Culture.* New Haven and London.

Barolsky, P. 2014. "Winckelmann, Ovid, and the Transformation of the Apollo Belvedere," *Notes in the History of Art* 33(2): 2–4.

Barrett, J. 2011. *Museums and the Public Sphere.* Chichester and Malden, MA.

Barringer, J. M. 2014. *The Art and Archaeology of Ancient Greece.* Cambridge.

Barron, J. P. 1972. "New Light on Old Walls: Murals of the Theseion," *Journal of Hellenic Studies* 92: 20–45.

Barron, K. 2003. "The Collecting and Patronage of John, Lord Lumley (c. 1535–1609)," in E. Chaney, ed., *The Evolution of English Collecting: The Reception of Italian Art in the Tudor and Stuart Periods.* New Haven: 125–58.

Barrow, R. 2001. *Lawrence Alma-Tadema.* London and New York.

———. 2007. *The Use of Classical Art and Literature by Victorian Painters, 1860–1912: Creating Continuity with the Traditions of High Art.* Lewiston.

Barr-Sharrar, B. 2013. "The Dresden Maenad and Scopas of Paros," in D. Katsonopoulou and A. Stewart, eds., *Scopas and His World.* Athens: 321–38.

Barry, F. 2010a. "*Disiecta membra*: Ranieri Zeno, the Imitation of Constantinople, the *Spolia* Style, and Justice at San Marco," in H. Maguire and R. S. Nelson, eds., *San Marco, Byzantium, and the Myths of Venice.* Washington, DC: 7–62.

———. 2010b. "'Onward Christian Soldiers': Piranesi at S. Maria del Priorato," in M. Bevilacqua and D. Gallavotti Cavallero, eds., *L'Aventino in età moderna: Dal Rinascimento ai nostri giorni.* Rome: 140–60.

Barry, J. 1809. *The Works of James Barry*, 2 vols. London.

Bartman, E. 1986. "Lysippos' Huge God in Small Shape," *Bulletin of the Cleveland Museum of Art* 73: 298–311.

———. 1988. "Décor et Duplicatio: Pendants in Roman Sculptural Display," *American Journal of Archaeology* 92(2): 211–25.

———. 1992. *Ancient Sculptural Copies in Miniature.* Leiden and New York.

———. 2015. "Collecting in Premodern Europe," in E. A. Friedland and M. G. Sobocinski, with E. K. Gazda, eds., *The Oxford Handbook of Roman Sculpture.* Oxford: 13–26.

Bartolini, G., ed. 2010. *La Lupa Romana: Nuove prospettive di studio.* Rome.

Bassett, S. 1996. "Historiae custos: Sculpture and Tradition in the Baths of Zeuxippos," *American Journal of Archaeology* 100(3): 491–506.

———. 2000. "'Excellent Offerings': The Lausos Collection in Constantinople," *Art Bulletin* 82(1): 6–25.

———. 2004. *The Urban Image of Late Antique Constantinople.* Cambridge.

———. 2014. "Collecting and the Creation of History," in M. W. Gahtan and D. Pegazzano, eds., *Museum Archetypes and Collecting in the Ancient World.* Leiden: 146–55.

Bassi, K. 2014. "Croesus' Offerings and the Value of the Past," in J. Ker and C. Pieper, eds., *Valuing the Past in the Greco-Roman World.* Leiden: 173–96.

Bastianini, G., and C. Gallazzi. 2001. *Epigrammi (P. Mil. Vogl. VIII 309)*. Milan.

Bauchhenss, G. 1994. "Die klassischen Reliefs," in G. Hellenkemper Salies, ed., *Das Wrack: Der antike Schiffsfund von Mahdia*, vol. 1. Cologne: 375–80.

Bauer, R., and H. Haupt, eds. 1976. "Das Kunstkammerinventar Kaiser Rudolfs II, 1607–1611," *Jahrbuch der Kunsthistorischen Sammlungen in Wien* 72: vii–191.

Baumbach, M., I. Petrovic, and A. Petrovic. 2010. *Archaic and Classical Greek Epigram*. Cambridge.

Baxandall, M. 1971. *Giotto And the Orators: Humanist Observers of Painting in Italy and the Discovery of Pictorial Composition*. Oxford.

Bayliss, A. J. 2011. *After Demosthenes: The Politics of Early Hellenistic Athens*. London.

Beagon, M. 1992. *Roman Nature: The Thought of Pliny the Elder*. Oxford.

Beard, M. 1994. "Casts and Cast-Offs: The Origins of the Museum of Classical Archaeology," *Proceedings of the Cambridge Philological Society* 39: 1–29.

———. 2000. "Cast: Between Art and Science," in H. Lavagne and F. Queyrel, eds., *Les moulages de sculptures antiques et l'histoire de l'archéologie*. Geneva: 157–66.

———. 2003. "The Triumph of Flavius Josephus," in A. J. Boyle and W. Dominik, eds., *Flavian Rome: Culture, Image, Text*. Leiden: 543–58.

———. 2004. "Archaeology and Collecting in Late Nineteenth-Century Rome," in F. Friborg and M. Stevens, eds., *Ancient Art to Post-Impressionism: Masterpieces from the Ny Carlsberg Glyptotek, Copenhagen*. London: 18–21.

———. 2007. *The Roman Triumph*. Cambridge, MA.

———. 2008. "Art Collections on the Bay of Naples," in C. C. Mattusch, ed., *Pompeii and the Roman Villa: Art and Culture around the Bay of Naples*. Washington, DC: 71–84.

———. 2009. Review of M. M. Miles, *Art as Plunder: The Ancient Origins of Debate about Cultural Property*, *Times Literary Supplement* 30 September.

———. 2012a. "Dirty Little Secrets: Changing Displays of Pompeian 'Erotica,'" in V. C. Gardner Coates, K. Lapatin, and J. L. Sedyl, eds., *The Last Days of Pompeii*. Los Angeles: 60–69.

———. 2012b. "Cambridge's 'Shrine of the Muses': The Display of Classical Antiquities in the Fitzwilliam Museum, 1848–1898," *Journal of the History of Collections* 24(3): 289–308.

———. 2013. "Roman Art Thieves," in M. Beard, *Confronting the Classics: Traditions, Inventions and Innovations*. New York and London: 88–95.

Beard, M., and J. Henderson. 2001. *Classical Art from Greece to Rome*. Oxford.

Beaujeu, J. M. 1982. "A-t-il éxisté une direction des musées dans la Rome imperial," *Comptes rendus de l'Academie des Inscriptions et Belles Lettres* Nov–Dec: 671–88.

Becatti, G. 1956. "Letture Pliniane: Le opera d'arte nei monumenta Asini Pollionis e negli *Horti Serviliani*," in *Studi in onore di Aristide Calderini e Roberto Paribeni*, vol. 3. Milan: 199–210.

Beck, H., P. C. Bol, and M. Bückling, eds. 2005. *Ägypten – Griechenland – Rom: Abwehr und Berührung*. Tübingen.

Becker, E., and E. Prettejohn. 1996. *Sir Lawrence Alma-Tadema*. New York.

Belkin, K. L., and F. Healy. 2004. *A House of Art: Rubens as Collector*. Antwerp.

Bell, M. 1998. "Le stele greche dell'Esquilino e il cimitero di Mecenate," in M. Cima and E. La Rocca, eds., *Horti Romani*. Rome: 295–314.

Belozerskaya, M. 2012. *Medusa's Gaze: The Extraordinary Journey of the Tazza Farnese*. New York and Oxford.

Belozerskaya, M., and K. Lapatin. 2000. "Antiquity Consumed: Transformations at San Marco, Venice," in A. Payne, A. Kuttner, and R. Smick, eds., *Antiquity and Its Interpreters*. Cambridge: 83–98.

Bémont, C., M. Jeanlin, and C. Labanier, eds. 1993. *Les figures en terre cuite Gallo-Romaines*. Paris.

Benedict, B. 2002. *Curiosity: A Cultural History of Early Modern Inquiry*. Chicago.

Bensoussan, N. 2014. "From the French *Galerie* to the Italian Garden: Sixteenth-Century Displays of Primaticcio's Bronzes at Fontainebleau," *Journal of the History of Collections* 27(2): 175–98.

Bentley-Cranch, D. 1988. "A Sixteenth-Century Patron of the Arts: Florimond Robertet, Baron d'Alluye and His 'Vierge Ouvrante,'" *Bibliothèque d'Humanisme et Renaissance* 50(2): 317–33.

Beretta, M. 2014. "Material and Temporal Powers at the Casino di San Marco (1574–1621)," in S. Dupré, ed., *Laboratories of Art: Alchemy and Art Technology from Antiquity to the Eighteenth Century*. Dordrecht: 129–56.

Berger, A. 2013. *Accounts of Medieval Constantinople: The Patria*. Cambridge, MA and London.

Berger, R. W. 1999. *Public Access to Art in Paris: A Documentary History from the Middle Ages to 1800*. Philadelphia.

Bergmann, B. 1992. "Exploring the Grove: Pastoral Space on Roman Walls," in J. D. Hunt, ed., *The Pastoral Landscape*. Washington, DC: 21–46.

Bergmann, B., S. de Caro, J. R. Mertens, and R. Meyer. 2010. *Roman Frescoes from Boscoreale: The Villa of Publius Fannius Synistor in Reality and Virtual Reality*. New York.

Bergmann, M. 2007. "Die kaiserzeitlichen Porträts der Villa von Chiragan: Spätantike Sammlung oder gewachsenes Ensemble?" in F. A. Bauer and C. Witschel, eds., *Statuen in der Spätantike*. Wiesbaden: 323 39.

Beschi, L. 1986. "La scoperta dell'arte greca," in S. Settis, ed., *Memoria dell'antico nell'arte italiana*, vol. 3, *Dalla tradizione all'archeologia*. Turin: 295–372.

Bettini, M. 1984. "Francesco Petrarca sulle arti figurative," in S. Settis, ed., *Memoria dell'antico nell'arte italiana*, vol. 1, *L'uso dei classici*. Turin: 222–67.

Beulé, E. 1868. *Histoire de l'art grec avant périclès*. Paris.

Beutler, C. 1964. *Bildwerke zwischen Antike und Mittelalter: Unbekannte Skulpturen aus der Zeit Karls des Grossen*. Düsseldorf.

———. 1982. *Statua: Die Entstehung der nachantiken Statue und der europäische Individualismus*. Munich.

Bevan, E. 1927. *A History of Egypt under the Ptolemaic Dynasty*. London.

Bianchi Bandinelli, R. 1967. "Arte plebea," *Dialoghi di Archeologia* 1: 7–19.

———. 1970. *Rome, the Centre of Power: Roman Art to AD 200*, trans. P. Green. London.

———. 1971. *Rome, the Late Empire: Roman Art, AD 200–400*, trans. P. Green. New York.

Bieber, M. 1961. *The Sculpture of the Hellenistic Age*. New York.

Bielefeld, E. 1969. "Zu den Nereiden aus Formia," *Mitteilungen des Deutschen Archäologischen Instituts, Römische Abteilung* 76: 93–102.

Bignamini, I. 2010. "Introduction: The British Conquest of the Marbles of Ancient Rome: Aspects of the Material and Cultural Conquests," in I. Bignamini and C. Hornsby, *Digging and Dealing in Eighteenth-Century Rome*, vol. 1. New Haven and London: 1–16.

Bignamini, I., and C. Hornsby. 2010. *Digging and Dealing in Eighteenth-Century Rome*, 2 vols. New Haven and London.

Bilsel, C. 2012. *Antiquity on Display: Regimes of the Authentic in Berlin's Pergamon Museum*. Oxford.

Bindman, D. 2013. *John Flaxman from Line into Contour*. Birmingham.

Biondo, F. [1444–46] 1953. *Roma instaurata* (R. Valentini and G. Zucchetti, eds., vol. 4: 256–323).

Bishop, E. 1918. "Gifts of Henry of Blois, Abbat of Glastonbury, to Winchester Cathedral," *Downside Review* 1884, reprinted in E. Bishop, *Liturgica Historia*. Oxford: 392–401.

Blanshard, A. J. L. 2000. "Hellenic Fantasies: Aesthetics and Desire in John Addington Symonds," *Dialogos* 7: 99–123.

———. 2010. *Sex: Vice and Love from Antiquity to Modernity*. Oxford.

Blinkenberg, C. S. 1915. *Die lindische Tempelchronik*. Bonn.

———. 1941. *Lindos: Fouilles et recherches*. Berlin.

Blix, G. M. 2009. *From Paris to Pompeii: French Romanticism and the Cultural Politics of Archaeology*. Philadelphia.

Bloom, H. 1994. *The Western Canon: The Books and School of the Ages*. New York.

Blum, R. 1991. *Kallimachos: The Alexandrian Library and the Origins of Bibliography*, trans. H. H. Wellisch. Madison.

Blundell, H. 1803. *An Account of the Statues, Busts, Bass-Relieves, Cinerary Urns, and Other Ancient Marbles, and Paintings, at Ince*. Liverpool.

———. 1809–10. *Engravings and Etchings of the Principal Statues, Busts, Bass-Reliefs, Sepulchral Monuments, Cinerary Urns, &c. in the Collection of Henry Blundell, Esq. at Ince*, 2 vols. Liverpool.

Blundell, S. 2012. "Greek Art and the Grand Tour," in T. J. Smith and D. Plantzos, eds., *A Companion to Greek Art*, vol. 2. Oxford: 649–66.

Boardman, J. 1985. *Greek Sculpture: The Classical Period*. Oxford.

———. 1993. *The Oxford History of Classical Art*. Oxford.

———. 2004. "Greek Dedications," *Thesaurus Cultus et Rituum Antiquorum* 1: 269–318.

———. 2009. *The Marlborough Gems: Formerly at Blenheim Palace, Oxfordshire*. Oxford.

Bober, P., and R. Rubinstein. 1986. *Renaissance Artists and Antique Sculpture: A Handbook of Sources*. Oxford and New York.

Bodel, J. 2014. "Inventive Inscriptions: Afterward," *Journal of the History of Collections* 26(3): 439–45.

Bodnar, E. W. 1960. *Cyriacus of Ancona and Athens*. Brussels.

Bodnar, E. W., and C. Foss. 2003. *Cyriac of Ancona: Later Travels*. Cambridge, MA.

Boin, D. 2013. "A Late Antique Statuary Collection at Ostia's Sanctuary of Magna Mater: A Case-Study in Late Roman Religion and Tradition," *Papers of the British School at Rome* 81: 247–77.

Bol, P. C. 1972. *Die Skulpturen des Schiffsfundes von Antikythera*. Berlin.

Bolter, J. 1980. "Friedrich August Wolf and the Scientific Study of Antiquity," *Greek, Roman and Byzantine Studies* 21: 83–99.

Bonanno, A. 1976. *Portraits and Other Heads on Roman Historical Relief up to the Age of Septimius Severus*. Oxford.

Booth, M. R. 1981. *Victorian Spectacular Theatre, 1850–1910*. London.

Borbein, A. H. 1975. "Die Ara Pacis Augustae, geschichtliche Wirklichkeit und Programm," *Jahrbuch des Deutschen Archäologischen Instituts* 90: 242–66.

———. 2000. "Zur Geschichte der Wertschätzung und Verwendung von Gipsabgüssen antiker Skulpturen insbesondere in Deutschland und in Berlin," in H. Lavagne and F. Queyrel, eds., *Les moulages de sculptures antiques et l'histoire de l'archéologie.* Geneva: 29–44.

———. 2007. "Marmorstatue des Hermes mit dem Dionysosknaben," in S. Kansteiner, L. Lehmann, B. Seidensticker, and K. Stemmer, eds., *Text und Skulptur: Berühmte Bildhauer und Bronzegießer der Antike in Wort und Bild.* Berlin and New York: 94–97.

Borchardt, P. 1936. "The Sculpture in Front of the Lateran as Described by Benjamin of Tudela and Magister Gregorius," *Journal of Roman Studies* 26: 68–70.

Borda, M. 1953. *La Scuola di Pasiteles.* Bari.

Boschung, D., and H. von Hesberg, eds. 2000. *Antikensammlungen des Europäischen Adels im 18. Jahrhundert als Ausdruck einer Europäischen Identität.* Mainz.

Bottari, G. G. 1741–82. *Del Museo Capitolino,* 4 vols. Rome.

Boucher, B. 1991. *The Sculpture of Jacopo Sansovino,* 2 vols. New Haven and London.

Bounia, A. 2004. *The Nature of Classical Collecting: Collectors and Collections, 100 BCE–100 CE.* Farnham.

Bourdieu, P. 1968. "Intellectual Field and Creative Project," *Social Science Information* 8: 89–119.

———. 1977. *Outline of a Theory of Practice.* Cambridge.

———. 1990. *The Logic of Practice.* Stanford.

Bourgeois, B. 2007. "The French Laocoon," in P. Curtis and S. Feeke, eds., *Towards a New Laocoon.* Leeds: 25–28.

Bourne, M. 2001. "Renaissance Husbands and Wives as Patrons of Art: The *Camerini* of Isabella d'Este and Francesco II Gonzaga," in S. E. Reiss and D. G. Wilkins, eds., *Beyond Isabella.* Kirksville: 93–123.

Bowron, E. P., and P. B. Kerber. 2007. *Pompeo Batoni: Prince of Painters in Eighteenth-Century Rome.* New Haven and London.

Bravi, A. 2012. *Ornamenta urbis: Opere d'arte greche negli spazi romani.* Bari.

———. 2014. *Griechische Kunstwerke im politischen Leben Roms und Konstantinopels.* Berlin.

Bredekamp, H. 1995. *The Kunstkammer and the Evolution of Nature, Art and Technology,* trans. Allison Brown. Princeton.

Brendel, O. J. 1979. *Prolegomena to the Study of Roman Art.* New Haven and London.

Brenk, B. 1987. "Spolia from Constantine to Charlemagne: Aesthetics versus Ideology," *Dumbarton Oaks Papers* 41: 103–9.

Bresc-Bautier, G., and B. de Chancel-Badelot. 2016. *Un musée révolutionnaire: Le Musée des Monuments français d'Alexandre Lenoir.* Paris.

Bresson, A. 2006. "Relire la *Chronique de Lindos,*" *Topoi* 14: 527–51.

Brettingham, M. 1773. *The Plans, Elevations and Sections of Holkham Hall in Norfolk.* London.

Brewster, D. 1856. *The Stereoscope; Its History, Theory, and Construction.* London.

Brilliant, R. 2000a. *My Laocoön: Alternative Claims in the Interpretation of Artworks.* Berkeley and London.

———. 2000b. "Winckelmann and Warburg: Contrasting Attitudes toward the Instrumental Authority of Ancient Art," in A. Payne, A. Kuttner, and R. Smick, eds., *Antiquity and Its Interpreters.* Cambridge: 269–75.

Brinkmann, V., and M. Kunze, eds. 2011. *Die Artemis von Pompeji und die Entdeckung der Farbigkeit griechischer Plastik. Katalog einer Ausstellung im Winckelmann-Museum vom 2. Dezember 2011 bis 18. März 2012.* Wiesbaden.

Brodie, N. 2012. "Uncovering the Antiquities Market," in R. Skeates, C. McDavid, and J. Carman, eds., *The Oxford Handbook of Public Archaeology.* Oxford: 230–52.

Brotton, J. 2006. *The Sale of the Late King's Goods: Collecting Art in Seventeenth-Century Europe.* Basingstoke.

Broucke, P. B. F. J. 1999. "The Caryatids from Hadrian's Villa at Tivoli and the Pantheon of Agrippa," *American Journal of Archaeology* 103: 312.

Brown, A. B., P. Humfrey, and M. Lucco, eds. 1997. *Lorenzo Lotto: Rediscovered Master of the Renaissance.* New Haven and London.

Brown, B. L. 2007. "Seeing the Past: Titian's Imperial Adaptation of a Classical Relief," in D. Cooper and M. Leino, eds., *Depth of Field: Relief Sculpture in Renaissance Italy.* Bern: 275–304.

Brown, C. M. 1983. "I vasi di pietra dura dei Medici e Lodovico Gonzaga vescovo eletto di Mantova (1501–1502)," *Civiltà mantovana,* n.s., 1: 63–68.

———. 1985. *La Grotta di Isabella d'Este: Un simbolo di continuità dinastica per i duchy di Mantova.* Mantua.

———. 1989. "Lorenzo de' Medici and the Dispersal of the Antiquarian Collections of Cardinal Francesco Gonzaga," *Arte Lombarda* 90–91: 86–103.

———. 1991. "Nuovi documenti riguandanti la collezione di oggetti antichi di Lodovico Gonzaga," *Civiltà mantovana,* 3rd series, 1: 41–45.

———. 1994. "The Farnese Family and the Barbara Gonzaga Collection of Antique Cameos," *Journal of the History of Collections* 6(2): 145–51.

———. 1997. " 'Frustre e strache nel fabricare': Isabella D'Este's Apartments in the Corte Vecchia of the Ducal Palace in Mantua," in C. Mozzarelli,

R. Oresko, and L. Ventura, eds., *La corte di Mantova nell'età di Andrea Mantegna, 1450–1550*. Rome: 295–335.

———. 2002. *Per Dare Qualche Splendore a la Gloriosa Città di Mantua, Documents for the Antiquarian Collection of Isabella d'Este*. Rome.

———. 2005. *Isabella D'Este in the Ducal Palace at Mantua: A Guide to the Residential Rooms and the Studioli in the Castle and the Corte Vecchia*. Rome.

Brown, C. M., and A. M. Lorenzoni. 1993. *Our Accustomed Discourse on the Antique: Cesare Gonzaga and Geralamo Gerimberto, Two Renaissance Collectors of Greco-Roman Art*. New York.

Brown, J. 1995. *Kings and Connoisseurs: Collecting Art in Seventeenth-Century Europe*. New Haven and London.

———. 2002. "Artistic Relations between Spain and England 1604–1655," in J. Brown and J. Elliott, eds., *The Sale of the Century: Artistic Relations between Spain and Great Britain, 1604–1655*. New Haven: 41–68.

———. 2011. *The Omnipotent Magician: Lancelot "Capability" Brown, 1716–1783*. London.

Brown, J., and R. L. Kagan. 1987. "The Duke of Alcalá: His Collection and Its Evolution," *Art Bulletin* 69(2): 231–55.

Brown, P. F. 1991. "The Self-Definition of the Venetian Republic," in A. Molho, K. Raaflaub, and J. Emlen, eds., *City-States in Classical Antiquity and Medieval Italy*. Stuttgart: 511–48.

———. 1996. *Venice and Antiquity: The Venetian Sense of the Past*. New Haven and London.

———. 2000. "Acquiring a Classical Past: Historical Appropriation in Renaissance Venice," in A. Payne, A. Kuttner, and R. Smick, eds., *Antiquity and Its Interpreters*. Cambridge: 27–39.

Browne, L. 1768. *Catalogus Veteris Aevi Varii Generis Monumentorum quæ Cimeliarchio Lyde Browne, . . . Apud Wimbledon Asservantur*. London.

———. 1779. *Catologo [sic] dei piu scelti e preziosi marmi, che si conservano nella galleria del Sigr Lyde Browne*. London.

Brunn, H., and F. Bruckmann. 1888–1947. *Denkmäler griechischer und römischer Skulptur*. Munich.

Brunn, J. le, and R. Lullies. 1955. *Griechische Bildwerke in Rom*. Munich.

Brunnsåker, S. 1955. *The Tyrant-Slayers of Kritios and Nesiotes*. Lund.

———. 1971. *The Tyrant-Slayers of Kritios and Nesiotes: A Critical Study of the Sources and Restorations*. Stockholm.

Bruns-Özgan, C. 1987. *Lykische Grabreliefs des 5. und 4. Jahrhunderts v. Chr.* Tübingen.

Buckton, D., ed. 1984. *The Treasury of San Marco Venice*. New York.

Buitron-Oliver, D. 1992. *The Greek Miracle: Classical Sculpture from the Dawn of Democracy: The Fifth Century*. Washington, DC.

Bukovinská, B. 2005. "The Known and Unknown *Kunstkammer* of Rudolf II," in H. Schramm, L. Schwarte, and J. Lazardzig, eds., *Collection, Laboratory, Theater: Scenes of Knowledge in the 17th Century*. Berlin: 199–227.

Buranelli, F., P. Liverani, and A. Nesselrath, eds. 2006. *Laocoonte: Alle origini dei Musei Vaticani*. Rome.

Burke, P. 1990. "The Social History of Art," *Historical Journal* 33(4): 989–92.

———. 2009. *The Fabrication of Louis XIV*. New Haven and London.

Burn, L. 1997. "Sir William Hamilton and the Greekness of Greek Vases," *Journal of the History of Collections* 9(2): 241–52.

———. 2004. *Hellenistic Art: From Alexander the Great to Augustus*. London.

———. 2015. *The Fitzwilliam Museum: A History*. London.

Burn, L., and N. Moore. 2012. "The Dam Hill Bronzes," *Journal of the History of Collections* 24(3): 399–415.

Burton, J. B. 1995. *Theocritus's Urban Mimes: Mobility, Gender and Patronage*. Berkeley.

Bush, S. E. 1996. "The Protection of British Heritage: Woburn Abbey and the Three Graces," *International Journal of Cultural Property* 5(2): 269–90.

Butler, R. 1993. *Rodin: The Shape of Genius*. New Haven and London.

Buttrey, T. V. 1983. "The Dates of the Arches of 'Diocletian' and Constantine," *Historia* 32: 375–83.

Caglioti, F. 2008. "Fifteenth-Century Reliefs of Ancient Emperors and Empresses in Florence: Production and Collecting," in N. Penny and E. D. Schmidt, eds., *Collecting Sculpture in Early Modern Europe*. Washington, DC: 67–109.

Caglioti, F. and D. Gasparotto. 1997. "Lorenzo Ghiberti, il 'Sigillo di Nerone' e le origini della placchetta antiquaria," *Prospettiva* 82: 2–38.

Cahill, J. 2015. "Copying the Classical: Interview with Salvatore Settis," *Apollo*, 27 June, http://www.apollo-magazine.com/copying-the-classical-interview-with-salvatore-settis/ (last accessed 14 July 2016).

Calandra, E. 1996. *Oltre la Grecia: Alle origini del filellenismo di Adriano*. Naples.

Calandra, E., and B. Adembri. 2014. *Adriano e la Grecia: Villa Adriana tra classicità ed ellenismo*. Verona.

Calcani, G. 1989. *Cavalieri di Bronzo: La torma di Alessandro Opera di Lissipo*. Rome.

———. 2009. *Skopas of Paros*. Rome.

Caley, E. R., and J. F. C. Richards. 1956. *Theophrastus on Stones: Introduction, Greek Text, English Translation, and Commentary*. Columbus, OH.

Camden, W. 1610. *Britain, or A Chorographicall Description of the Most Flourishing Kingdomes, England, Scotland, and Ireland, and the Ilands Adioyning, Out of the Depth of Antiquitie: Beautified with Mappes of the Severall Shires of England*. London.

Cameron, A. 1993. *The Greek Anthology: From Meleager to Planudes*. Oxford.

Cameron, A., and J. Herrin. 1984. *Constantinople in the Early Eighth Century: The Parastaseis Syntomoi Chronikai: Introduction, Translation and Commentary*. Leiden.

Camp, J. M. 2001. *The Archaeology of Athens*. New Haven and London.

Campbell, S. J. 2004. *The Cabinet of Eros: Renaissance Mythological Painting and the Studiolo of Isabella d'Este*. New Haven.

Camuset-Le Porzou, F. 1985. *Figurines Gallo-Romains en Terre Cuite*. Paris.

Canfora, D. 2007. "Linguistic Unity and the Variety of Styles: The Latin of Poggio Bracciolini," *Latinitas Perennis* 1: 53–64.

Capasso, M. 2010. "Who Lived in the Villa of the Papyri?" in M. Zarmakoupi, ed., *The Villa of the Papyri at Herculaneum: Archaeology, Reception, and Digital Reconstruction*. Berlin and New York: 89–114.

Carey, S. 2002. "A Tradition of Adventures in the Imperial Grotto," *Greece and Rome* 49(1): 44–61.

———. 2003. *Pliny's Catalogue of Culture: Art and Empire in the* Natural History. Oxford.

Carpenter, R. 1960. *Greek Sculpture: A Critical Review*. Chicago.

Carpenter, T. 1997. "Harmodios and Apollo in Fifth-Century Athens: What's in a Pose?" in J. H. Oakley, W. D. E. Coulson, and O. Palagia, eds., *Athenian Potters and Painters: The Conference Proceedings*. Oxford: 171–79.

Carroll, K. K. 1982. *The Parthenon Inscription*. Durham.

Carruthers, M. 2013. *The Experience of Beauty in the Middle Ages*. Oxford.

Carter, R. 1979. "Karl Friedrich Schinkel's Project for a Royal Palace on the Acropolis," *Journal of the Society of Architectural Historians* 38(1): 34–46.

Casson, L. 2001. *Libraries in the Ancient World*. New Haven.

Casson, S., D. Talbot Rice, and D. F. Hudson. 1929. *Second Report upon the Excavations Carried Out in and near the Hippodrome of Constantinople in 1928*. London.

Cast, D. 2009. *The Delight of Art: Giorgio Vasari and the Traditions of Humanist Discourse*. Philadelphia.

Cavallaro, A. 2007. *Collezioni di antichità a Roma tra '400 e '500*. Rome.

Cavenagh, F. A. 1922. "Samuel Butler and Education," *The Monist* 32(2): 307–13.

Caylus, A. C. P. 1759. *Recueil d'antiquités égyptiennes, étrusques, grecques, romaines et gauloises*, vol. 3. Paris.

Cazes, D. 1999. *La musée Saint-Raymond, musée des antiquités de Toulouse*. Paris.

Cecchetti, B. 1886. *Documenti per la storia dell'augusta ducale basilica di San Marco in Venezia dal non secolo sino alla fine del decimo ottava*. Venice.

Cecchi, A., and P. Pacetti. 2008. *La sala delle carte geografiche in Palazzo Vecchio: Capriccio et invenzione nata dal Duca Cosimo*. Florence.

Cerati, C. 1989. *I Trionfi di Cesare di Andrea Mantegna e il palazzo di San Sebastiano in Mantova*. Mantua.

Ceruti, B., and A. Chiocco. 1622. *Musaeum Francesci Calceolari Iunioris Veronensis*. Verona.

Chambers, D. 1992. *A Renaissance Cardinal and His Worldly Goods: The Will and Inventory of Francesco Gonzaga (1444–1483)*. London.

Chambers, W. 1862. *A Treatise on the Decorative Part of Civil Architecture*. London.

Chamoux, F. 1955. *L'Aurige de Delphes*. Paris.

Chandler, R. 1763. *Marmora Oxoniensia*. Oxford.

Chaney, E. 2003. *The Evolution of English Collecting: The Reception of Italian Art in the Tudor and Stuart Periods*. New Haven.

———. 2011. "Roma Britannica and the Cultural Memory of Egypt: Lord Arundel and the Obelisk of Domitian," in D. Marshall, S. Russell, and K. Wolfe, eds., *Roma Britannica: Art, Patronage and Cultural Exchange in Eighteenth-Century Rome*. London: 147–70.

Chaniotis, A. 1988. *Historie und Historiker in den griechischen Inschriften: Epigraphische Beiträge zur griechischen Historiographie*. Stuttgart.

Charbonneaux, J. 1948. *L'art au siècle d'Auguste*. Paris.

———. 1961. "Bryaxis et le Sarapis d'Alexandrie," *Monuments et Mémoires de la Fondation Eugène Piot* 52(2): 15–26.

Chard, C. 1994. "Effeminacy, Pleasure and the Classical Body," in G. Perry and M. Rossington, eds., *Femininity and Masculinity in Eighteenth-Century Art and Culture*. Manchester: 142–61.

———. 1999. *Pleasure and Guilt on the Grand Tour: Travel Writing and Imaginative Geography, 1600–1830*. Manchester.

Chard, C., and H. Langdon, eds. 1996. *Transports: Travel, Pleasure, and Imaginative Geography, 1600–1830*. New Haven and London.

Chastagnol, A. 1960. *Le prefecture urbaine à Rome sous le Bas-Empire*. Paris.

Chateaubriand, F. R. de 1828. *Voyages en Amérique et en Italie*, vol. 2. Paris.

Chatterjee, P. 2012. "Sculpted Eloquence and Nicetas Choniates's *De Signis*," *Word and Image* 27(4): 396–406.

Chevillot, C. 2009. *Oublier Rodin? La sculpture à Paris, 1905–1914*. Paris.

Chew, E. 2003. "The Countess of Arundel and Tart Hall," in E. Chaney, ed., *The Evolution of English Collecting: The Reception of Italian Art in the Tudor and Stuart Periods*. New Haven: 285–314.

Chibnall, M., ed. 1986. *Historia Pontificalis*. Oxford.

Chippindale, C., and D. W. J. Gill. 1993. "Material and Intellectual Consequences of Esteem for Cycladic Figurines," *American Journal of Archaeology* 97(3): 601–59.

Chittenden, J., and C. Seltman. 1947. *Greek Art: A Commemorative Catalogue of an Exhibition Held in 1946 at the Royal Academy, Burlington House, London*. London.

Christian, K. W. 2008. "Instauratio and Pietas: The della Valle Collections of Ancient Sculpture," in N. Penny and E. D. Schmidt, eds., *Collecting Sculpture in Early Modern Europe*. Washington, DC: 33–65.

———. 2010a. *Empire without End: Antiquities Collections in Renaissance Rome, c. 1350–1527*. New Haven and London.

———. 2010b. "Caesars, Twelve," in A. Grafton, G. W. Most, and S. Settis, eds., *The Classical Tradition*. Cambridge, MA and London: 163–65.

———. 2015. "Between Reality and Representation: Portraits, Objects, and Collectors," in S. Settis, A. Anguissola, and D. Gasparotto, eds., *Serial/Portable Classic: The Greek Canon and Its Mutations*. Milan: 164–71.

Chrysos, E. 2010. "Hellenes," in A. Grafton, G. W. Most, and S. Settis, eds., *The Classical Tradition*. Cambridge, MA and London: 423.

Ciardiello, R. 2006. "Le antichità di Ercolano esposte: Contributi per la ricomposizione dei contesti pittorici antichi," *Papyrologica lupiensia* 15: 87–106.

Cirucci, G. 2009. "Antichità greche a Pompei: Tre esempi di reimpiego di antiche opere d'arte greca nelle abitazioni di Pompei," *Prospettiva* 134–35: 52–64.

———. 2010. "Sculture greche di VI–IV secolo a.C. reimpiegate nella Roma antica: Una proposta di sintesi," *Rivista dell'Istituto Nazionale D'Archeologia e Storia dell'Arte* 60: 9–58.

Clarke, E. D. 1809. *Greek Marbles Brought from the Shores of the Euxine, Archipelago, and Mediterranean, and Deposited in the Vestibule of the Public Library of the University of Cambridge*. Cambridge.

Clarke, G. 2003. *Roman House—Renaissance Palaces: Inventing Antiquity in Fifteenth-Century Italy*. Cambridge.

Clarke, J. R. 2003. *Art in the Lives of Ordinary Romans: Visual Representation and Non-Elite Viewers in Italy, 100 B.C.–A.D. 315*. Berkeley.

Cleland, L. 2005. *The Brauron Clothing Catalogues: Text, Analysis, Glossary and Translation*. Oxford.

Coates-Stephens, R. 2007. "The Re-Use of Roman Statues in Late Antique Rome and the End of the Statue Habit," in F. A. Bauer and C. Witschel, eds., *Statuen in der Spätantike*. Wiesbaden: 171–87.

———. 2016. "La Vita delle Statue nella Roma Tardantica," in M. Andaloro, G. Bordi, and G. Morganti, eds., *Santa Maria Antiqua tra Roma e Bisanzio*. Rome: 131–51.

Cohen, A. 1996. *The Alexander Mosaic: Stories of Victory and Defeat*. Cambridge.

Cohen, B. 2003. "The *Grotte* of Isabella d'Este Reconsidered," in J. Fejfer, T. Fischer-Hansen, and A. Rathje, eds., *The Rediscovery of Antiquity: The Role of the Artist*. Copenhagen: 323–69.

———. 2015. "Displaying Greek and Roman Art in Modern Museums," in C. Marconi, ed., *The Oxford Handbook of Greek and Roman Art and Architecture*. Oxford: 473–98.

Colini, A. M. 1938. "Zona dei Fori Olitorio e Boario," *Bullettino della Commissione Archeologica Comunale di Roma* 66: 281–82.

Colish, M. I. 1985. *The Stoic Tradition from Antiquity to the Early Middle Ages, 1*. Leiden.

Collier, C. 2013. "From 'Gothic Atrocities' to Objects of Aesthetic Appreciation: The Transition from Marginal to Mainstream of Early Italian Art in British Taste during the Long Eighteenth Century," in F. O'Gorman, ed., *The Centre and the Margins in Eighteenth-Century British and Italian Cultures*. Newcastle Upon Tyne: 117–39.

Collingwood, R. G., and J. N. L. Myres. 1937. *Roman Britain and English Settlements*. Oxford.

Collins, J. 2004. *Papacy and Politics in Eighteenth-Century Rome: Pius VI and the Arts*. New York.

———. 2012. "Museum Pio-Clementino, Vatican City: Ideology and Aesthetics in the Age of the Grand Tour," in C. Paul, ed., *The First Modern Museums of Art: The Birth of an Institution in 18th- and Early-19th-Century Europe*. Los Angeles: 112–43.

Colonna, F. 1964. *Hypnerotomachia Polyphili*, ed. G. Pozzi and L. A. Ciapponi, vol. 1. Padua.

Coltman, V. 2006. *Fabricating the Antique: Neoclassicism in Britain, 1760–1800*. Chicago.

———. 2009. *Classical Sculpture and the Culture of Collecting in Britain since 1760*. New York and Oxford.

Colville, Q., and K. Williams. 2016. *Emma Hamilton: Seduction and Celebrity*. London.

Comella, A. 2008a. "Sul riuso dei rilievi votivi greci in Italia in epoca Romana: Il caso di Pompei," in *Le perle e il filo: A Mario Torelli per i suoi settanta anni*. Venosa: 49–63.

———. 2008b. "I rilievi votivi greci dalla Campania," *Oebalus: Studi sulla Campania nell'antichità* 3: 148–201.

Concina, E. 1998. *A History of Venetian Architecture*. Cambridge.

Conlin, D. A. 1997. *The Artists of the Ara Pacis: The Process of Hellenization in Roman Relief Sculpture*. Chapel Hill.

Connor, P. 1989. "Cast Collecting in the Nineteenth Century: Scholarship, Aesthetics and Connoisseurship," in G. W. Clarke and J. C. Eade, eds., *Rediscovering Hellenism: The Hellenic Inheritance and the English Imagination*. Cambridge: 187–235.

Connor, W. R. 1970. "Theseus in Classical Athens," in A. G. Ward, ed., *The Quest for Theseus*. London: 143–74.

Conticelli, V. 2007. *"Guardaroba di cose rare et preziose": Lo studiolo di Francesco I de' Medici: arte, storia e significati*. Lugano.

Conway, R. S. 1897. *The Italic Dialects*. Cambridge.

Conze, A. C. L. 1875. *Archäologische Untersuchungen auf Samothrake*. Vienna.

Cook, B. F. 1977. "The Townley Marbles in Westminster and Bloomsbury," *British Museum Yearbook* 2: 34–78.

Cooper, R. 2013. *Roman Antiquities in Renaissance France, 1515–65*. London and New York.

Coqueugniot, G. 2013. "Where Was the Royal Library of Pergamum? An Institution Found and Lost Again," in J. König, K. Oikonomopolou, and G. Woolf, eds., *Ancient Libraries*. Cambridge: 109–23.

Cormack, R., and M. Vassilaki, eds. 2008. *Byzantium, 330–1453*. London.

Corso, A. 2004. *The Art of Praxiteles*. Rome.

Coutu, J. 1997. "William Chambers and Joseph Wilton," in J. Harris and M. Snodin, eds., *Sir William Chambers: Architect to George III*. New Haven and London: 175–85.

———. 2015. *Then and Now: Collecting and Classicism in Eighteenth-Century England*. Montreal, Kingston, Ithaca, and London.

Cowdry, R. 1751. *Description of the Pictures, Statues, Bustos, Basso-Relieuos, and Other Curiosities*. London.

Creed, C. 1731. *The Marble Antiquities, The Right Hon. the Earl of Pembroke's, at Wilton, &c.* London.

Crow, T. 1994. "A Masculine Republic: Bonds between Men in the Studio of Jacques-Louis David," in G. Perry and M. Rossington, eds., *Femininity and Masculinity in Eighteenth-Century Art and Culture*. Manchester: 204–18.

Croxford, B. 2016. "Art in Roman Britain," in M. Millett, L. Revell, and A. Moore, eds., *The Oxford Handbook of Roman Britain*. Oxford: 599–618.

Croz, J.-F. 2002. *Les portraits sculptés de Romains en Grèce et en Italie de Cynoscéphales à Actium (197–31 BC): Essai sur les perspectives ideologues de l'art du portrait*. Paris.

Cunnally, J. 2013. "The Mystery of the Missing Coin Cabinet: Andrea Loredan's Coin Collection and Its Fate," in U. Peter and B. Weisser, eds., *Translatio Nummorum: Römische Kaiser in Der Renaissance*. Ruhpolding: 141–48.

Cunningham, I. C. 1996. "Herodas IV," *Classical Quarterly* 16(1): 113–25.

Cupperi, W. 2004. "Un nuovo Laocoonte in gesso, i calchi dall'antico di Maria d'Ungheria e quelli della Casa degli Omenoni a Milano," *Prospettiva* 115–16: 159–76.

———. 2010. "'Giving Away the Moulds Will Cause No Damage to His Majesty's Casts'—New Documents on the Vienna *Jüngling* and the Sixteenth-Century Dissemination of Casts after the Antique in the Holy Roman Empire," in R. Frederiksen and E. Marchand, eds., *Plaster Casts: Making, Collecting, and Displaying from Classical Antiquity to the Present*. Berlin: 81–98.

Curl, J. S. 1994. *Egyptomania. The Egyptian Revival: A Recurring Theme in the History of Taste*. Manchester and New York.

Curran, B. A. 2012. "Teaching (and Thinking About) the High Renaissance: With Some Observations about Its Relationship to Classical Antiquity," in J. Burke, ed., *Rethinking the High Renaissance: The Culture of the Visual Arts in Early Sixteenth-Century Rome*. Farham and Burlington, VT: 27–56.

Curran, J. 1994. "Moving Statues in Late Antique Rome: Problems of Perspective," *Art History* 17(1): 46–58.

Curtius, E., and F. Adler, eds. 1890–97. *Die Ergebnisse der von dem Deutschen Reich veranstalteten Ausgrabung*, 5 vols. Berlin.

Cushing, S. E., and D. B. Dearinger, eds. 2006. *Acquired Tastes: 200 Years of Collecting for the Boston Athenæum*. Boston.

Cust, L. 1911. "Notes on the Collections Formed by Thomas Howard, Earl of Arundel and Surrey, K. G.-II," *Burlington Magazine for Connoisseurs* 20(104): 97–100.

Cutler, A. 1995. "From Loot to Scholarship: Changing Modes in the Italian Response to Byzantine Artifacts, ca. 1200–1750," *Dumbarton Oaks Papers* 49: 237–67.

Dacos, N., A. Giuliano, and U. Pannuti, eds. 1973. *Lorenzo il Magnifico: Le gemme*. Florence.

Dale, T. E. A. 2010. "Cultural Hybridity in Medieval Venice: Reinventing the East at San Marco in the Fourth Crusade," in H. Maguire and R. S. Nelson, eds., *San Marco, Byzantium, and the Myths of Venice*. Washington, DC: 151–92.

D'Ambra, E. 1988. "A Myth for a Smith: A Meleager Sarcophagus from a Tomb in Ostia," *American Journal of Archaeology* 92(1): 85–100.

D'Ambra, E., and G. P. R. Métraux, eds. 2006. *The Art of Citizens, Soldiers and Freedmen in the Roman World*. Oxford.

Dandelet, T. J. 2014. *The Renaissance of Empire in Early Modern Europe*. Berkeley.

Darbo-Peschanski, C., ed. 2004. *La citation dans l'antiquité*. Paris.

Daston, L., and K. Park. 1998. *Wonders and the Order of Nature, 1150–1750*. New York.

Datsouli-Stavridi, A. 1993. Γλυπτά από την Θυρεάτιδα Κυνουρίας. Athens.

Davies, G. 2007. *The Ince Blundell Collection of Classical Sculpture*, vol. 2, *The Ash Chests and Other Funerary Reliefs*. Mainz.

Davies, K. 2004. "Pantomime, Connoisseurship, Consumption: Emma Hamilton and the Politics of Embodiment," *CW3 Journal,* https://www2.shu.ac.uk/corvey/cw3journal/issue%20two/davies.html (last accessed 1 August 2016).

Davies, M. 1995. "Making Sense of Pliny in the Quattrocento," *Renaissance Quarterly* 9(2): 240–57.

Davies, P. J. E. 2011. "Aegyptiaca in Rome: *Aduentus* and *Romanitas*," in E. S. Gruen, ed., *Cultural Identity in the Ancient Mediterranean*. Los Angeles: 354–70.

Davis, J. R. 2014. "Higher Education Reform and the German Model: A Victorian Discourse," in H. Ellis and U. Kirchberger, eds., *Anglo-German Scholarly Networks in the Long Nineteenth Century*. Leiden: 39–62.

Davis, W. M. 1979. "Plato on Egyptian Art," *Journal of Egyptian Archaeology* 65: 121–27.

Davison, J. A. 1955. "Peisistratus and Homer," *Transactions of the American Philological Association* 86: 1–21.

De Almeida, H., and G. H. Gilpin. 2005. *Indian Renaissance: British Romantic Art and the Prospect of India*. Farnham.

De Bolla, P. 2001. *Art Matters*. Cambridge, MA.

———. 2003. *The Education of the Eye: Painting, Landscape, and Architecture in Eighteenth-Century Britain*. Stanford.

De Caro, S. 1996. *The National Archaeological Museum of Naples*. Naples.

De Caus, I. 1645. *Hortus Penbrochianus*. London.

De Divitiis, B. 2007a. *Architettura e committenza nella Napoli del Quattrocento*. Venice.

———. 2007b. "New Evidence for Sculptures from Diomede Carafa's Collection of Antiquities I," *Journal of the Warburg and Courtauld Institutes* 70: 99–107.

———. 2010. "New Evidence for Diomede Carafa's Collection of Antiquities II," *Journal of the Warburg and Courtauld Institutes* 73: 335–53.

———. 2012. "Antiquities as Gelatine: The Palace of Diomede Carafa in the Eyes of Costanza d'Avalos," in M. Israëls and L. A. Waldman, eds., *Renaissance Studies in Honour of Joseph Connors*. Florence: 412–21.

———. 2015. "Memories from the Subsoil: Discovering Antiquities in Fifteenth-Century Naples and Campania," in J. Hughes and C. Buongiovanni, eds., *Remembering Parthenope: The Reception of Classical Naples from Antiquity to the Present*. Oxford and New York: 189–216.

De Grummond, N. T., ed. 1996. *An Encyclopedia of the History of Classical Archaeology*. London.

Deichmann, F., and W. A. Tschira. 1939. "Die frühchristlichen Basen und Kapitelle von S.Paolo fuori le mura," *Mitteilungen des Deutschen Archäologischen Instituts, Römische Abteilung* 54: 99–111.

Deichmann, F. W. 1975. *Die Spolien in der spätantiken Architektur*. Munich.

De Jong, S. 2015. *Rediscovering Architecture: Paestum in Eighteenth-Century Architectural Experience and Theory*. New Haven and London.

De Jonge, C. C. 2013. "Longinus 36.3: The Faulty Colossus and Plato's *Phaedrus*," *Trends in Classics* 5(2): 318–40.

Delivorrias, A. 1990. "*Disiecta Membra:* The Remarkable History of Some Sculptures from an Unknown Temple," in M. True and J. Podany, eds., *Marble: Art Historical and Scientific Perspectives on Ancient Sculpture*. Los Angeles: 11–46.

De Maria, B. 2013. "Multifaceted Endeavors: Considerations on Gems and Jewelry in Early Modern Venice," in B. de Maria and M. E. Frank, eds., *Reflections on Renaissance Venice: A Celebration of Patricia Fortini Brown*. Milan: 119–31.

De Montebello, P. 2009. "And What Do You Propose Should be Done with These Objects?" in J. B. Cuno, ed., *Whose Culture? The Promise of Museums and the Debate over Antiquities*. Princeton and Oxford: 55–70.

Demus, O. 1960. *The Church of San Marco in Venice: History, Architecture, Sculpture*. Cambridge, MA.

Demus, O., G. Tigler, L. Lazzarini, and M. Piana, eds. 1995. *Le sculture esterne di San Marco*. Milan.

Denon, D. V. 1802. *Voyage dans la Basse et la Haute Égypte pendant les campagnes du général Bonaparte*. Paris.

Deonna, W. 1909. *Les "Apollons archaïques."* Geneva.

De Rossi, D., ed. 1704. *Raccolta di statue antiche e moderne . . .* Rome.

De Rossi, G. B. 1874. "La base d'una statua di Prassitele testé scoperta e la serie di simili basi quale essa appartiene," *Bullettino della Commissione Archeologica Comunale di Roma* 2: 174–81.

De Thou, J.-A. 1823. "Mémoires depuis 1553 jusqu'en 1601," in C. B. Petitot, ed., *Collection complète des mémoires relatifs à l'histoire de France* 37. Paris: 217–503.

Deuling, J. K. 1999. "Catullus and Mamurra," *Mnemosyne* 52: 188–94.

D'Hancarville, P. F. H. 1785–86. *Recherches sur l'origine, l'esprit et les progrès des arts de la Grèce*. London.

———. 1786. *Monumens [Monuments] de la vie privée des douze Césars, d'après une suite de pierres gravées sous leur règne*. Rome.

Didi-Huberman, G. 2006. "Opening Up Venus: Nudity, Cruelty and the Dream," in T. Frangenberg and R. Williams, eds., *The Beholder: The Experience of Art in Early Modern Europe*. Aldershot: 37–52.

Di Dio, K. H. 2008. "Sculpture in Spanish Collections from Philip II to Philip IV," in N. Penny and E. D. Schmidt, eds., *Collecting Sculpture in Early Modern Europe*. Washington, DC: 247–77.

Di Dio, K. H., and R. Coppel. 2013. *Sculpture Collections in Early Modern Spain*. Abingdon.

Diebold, W. J. 1995. "The Politics of Derestoration: The Aegina Pediments and the German Confrontation with the Past," *Art Journal* 54: 60–66.

Diemer, D., P. Diemer, and L. Seelig, eds. 2008. *Die Münchner Kunstkammer*, 3 vols. Munich.

Dietz, B., and T. Nutz. 2005. "Collections curieuses: The Aesthetics of Curiosity and Elite Lifestyle in Eighteenth-Century Paris," *Eighteenth-Century Life* 29(3): 44–75.

DiFuria, A. J. 2010. "Maerten van Heemskerck's Collection Imagery in the Netherlandish Pictorial Memory," *Intellectual History Review* 20(1): 27–51.

Dignas, B. 2002. "'Inventories' or 'Offering Lists'? Assessing the Wealth of Apollo Didymaeus," *Zeitschrift für Papyrologie und Epigraphik* 138: 235–44.

Dillon, S. 2006. *Ancient Greek Portrait Sculpture: Contexts, Subjects, and Styles*. Cambridge.

Di Nino, M. 2010. *I fiori campestri di Posidippo*. Göttingen.

Distelberger R., A. Luchs, P. Verdier, and T. H. Wilson. 1993. *Western Decorative Arts, Part I: Medieval, Renaissance, and Historicizing Styles Including Metalwork, Enamels, and Ceramics*. Washington, DC.

Dolce, L. 1557. *Dialogo della pittura*. Venice.

Doody, A. 2010. *Pliny's Encyclopedia: The Reception of the Natural History*. Cambridge and New York.

Downing, E. 2006. *After Images: Photography, Archaeology, and Psychoanalysis and the Tradition of Bildung*. Detroit.

Dragon, G. 1985. *Constantinople imaginaire: Études sur le recueil des Patria*. Paris.

Droth, M., J. Edwards, and M. Hatt, eds. 2014. *Sculpture Victorious: Art in an Age of Invention, 1837–1901*. New Haven.

Dubos, J.-B. 1719. *Réflexions critiques sur la poésie et sur la peinture*, 2 vols. Paris.

———. 1748. *Critical Reflections on Poetry, Painting and Music*, trans. T. Nugent, 2 vols. London.

Duesterberg, S. 2015. *Popular Receptions of Archaeology: Fictional and Factual Texts in 19th and Early 20th Century Britain*. Bielefeld.

Duffy, W. S. 2013. "The Necklace of Eriphyle and Pausanias," *Classical World* 107(1): 35–47.

Duggett, T. 2010. *Gothic Romanticism: Architecture, Politics, and Literary Form*. New York.

Duncan, C. 1995. *Civilizing Rituals: Inside Public Art Museums*. London and New York.

Duncan-Jones, R. 1994. *Money and Government in the Roman Empire*. Cambridge.

Dunstan, A. 2014. "Nineteenth-Century Sculpture and the Imprint of Authenticity," *19: Interdisciplinary Studies in the Long Nineteenth Century*, https://doaj.org/article/877725368b56440baff77695e2f8ad5c (last accessed 1 August 2016).

Dyson, S. L. 1998. *Ancient Marbles to American Shores: Classical Archaeology in the United States*. Philadelphia.

———. 2006. *In Pursuit of Ancient Pasts: A History of Classical Archaeology in the Eighteenth and Nineteenth Centuries*. New Haven and London.

———. 2010. "Cast Collecting in the United States," in R. Frederiksen and E. Marchand, eds., *Plaster Casts: Making, Collecting, and Displaying from Classical Antiquity to the Present*. Berlin: 557–75.

Edwards, B. J. N. 1982. "Charles Townley and the Ribchester Helmet," *Antiquaries Journal* 62(2): 358–59.

Edwards, C. 2003. "Incorporating the Alien: The Art of Conquest," in C. Edwards and G. Woolf, eds., *Rome the Cosmopolis*. Cambridge: 44–70.

Eichberger, D. 1996. "Margaret of Austria's Portrait Collection: Female Patronage in the Light of Dynastic Ambitions and Artistic Quality," *Renaissance Quarterly* 10(2): 259–79.

———. 2010. "Margaret of Austria and the Documentation of Her Collection in Mechelen," in F. C. Cremades, ed., *Los inventarios de Carlos V y la familia imperial/The Inventories of Charles V and the Imperial Family*, vol. 3. Madrid: 2351–63.

———. 2013. "Margaret of Austria's Treasures: An Early Habsburg Collection in the Burgundian Netherlands," in F. C. Cremades, ed., *El museo imperial: El coleccionismo artístico de los Austrias en el siglo XVI*. Madrid: 71–80.

Eichberger, D., and L. Beaven. 1995. "Family Members and Political Allies: The Portrait Collection of Margaret of Austria," *Art Bulletin* 77(2): 225–48.

El-Abbadi, M. 1990. *The Life and Fate of the Ancient Library at Alexandria*. Paris.

Elam, C. 1992. "Lorenzo de' Medici's Sculpture Garden," *Mitteilungen des Kunsthistorischen Instituts in Florenz* 36: 41–84.

Elis, J. 1970. "Dillwyn's 'Etruscan Ware,'" *Journal of the Gower Society*, December: 8–19.

Elmes, J. 1817. *Annals of the Fine Arts I, for 1816.* London.

Elsen, A. E. 2003. *Rodin's Art: The Rodin Collection of Iris & B. Gerald Cantor Center of Visual Arts at Stanford University.* Oxford.

Elsner, J. 1994. "Constructing Decadence: The Representation of Nero as Imperial Builder," in J. Elsner and J. Masters, eds., *Reflections of Nero: Culture, History, and Representation.* London: 112–27.

———. 1995. *Art and the Roman Viewer: The Transformation of Art from the Pagan World to Christianity.* Cambridge.

———. 1996. "Naturalism and the Erotics of the Gaze: Intimations of Narcissus," in N. B. Kampen, ed., *Sexuality in Ancient Art.* Cambridge: 247–61.

———. 1998a. "Berenson's Decline, or His Arch of Constantine Reconsidered," *Apollo* 148: 20–22.

———. 1998b. *Imperial Rome and Christian Triumph: The Art of the Roman Empire AD 100–450.* Oxford.

———. 2000. "From the Culture of Spolia to the Cult of Relics: The Arch of Constantine and the Genesis of Late Antique Forms," *Papers of the British School at Rome* 68: 149–84.

———. 2002. "The Birth of Late Antiquity: Riegl and Strzygowski in 1901," *Art History* 25(3): 358–79.

———. 2003. "Style," in R. S. Nelson and R. Schiff, eds., *Critical Terms for Art History.* Chicago: 98–109.

———. 2004. "Late Antique Art: The Problem of the Concept and the Cumulative Aesthetic," in S. Swain and M. Edwards, eds., *Approaching Late Antiquity: The Transformation from Early to Late Empire.* Oxford: 271–309.

———. 2006a. "Reflections on the Greek Revolution in Art: From Changes in Viewing to Changes in Subjectivity," in S. Goldhill and R. Osborne, eds., *Rethinking Revolutions through Ancient Greece.* Cambridge: 68–95.

———. 2006b. "Classicism in Roman Art," in J. I. Porter, ed., *Classical Pasts: The Classical Traditions of Greece and Rome.* Princeton: 270–97.

———. 2006c. "From Empirical Evidence to the Big Picture: Some Reflections on Riegl's Concept of Kunstwollen," *Critical Inquiry* 32(4): 741–66.

———. 2007. *Roman Eyes: Visuality and Subjectivity in Art and Text.* Princeton.

———. 2010a. "Alois Riegl and Classical Archaeology," in A. R. Noever and G. Vasold, eds., *Alois Riegl Revisited: Contributions to the Opus and Its Reception.* Vienna: 45–57.

———. 2010b. "Art History as Ekphrasis," *Art History* 33(1): 10–27.

———. 2014a. "Afterward. Framing Knowledge: Collecting Objects, Collecting Texts," in M. W. Gahtan and D. Pegazzano, eds., *Museum Archetypes and Collecting in the Ancient World.* Leiden: 156–62.

———. 2014b. "Lithic Poetics: Posidippus and His Stones," *Ramus* 43(2): 152–72.

Engels, D. 2014. "Polemon von Ilion: Antiquarische Periegese und hellenistische Identitätssuche," in K. Freitag and C. Michels, eds., *Athen und / oder Alexandreia? Aspekte von Identität und Ethnizität im hellenistischen Griechenland.* Cologne, Weimar, and Vienna: 65–98.

Englefield, H. 1792. "Account of Antiquities Discovered at Bath in 1790," *Archaeologica* 10: 325–33.

Ernst, W. 1992. "La transition des galeries privées au musée public et l'imagination muséale: L'exemple du British Museum," in A.-F. Laurens and K. Pomian, eds., *L'Anticomanie: La collection d'antiquités aux 18e et 19 e siècles.* Paris: 155–67.

Erskine, A. 1995. "Culture and Power in Ptolemaic Egypt: The Museum and Library of Alexandria," *Greece and Rome* 42(1): 38–48.

Evangelista, S. 2007. "Platonic Dons, Adolescent Bodies: Benjamin Jowett, John Addington Symonds, Walter Pater," in G. Rosseau, ed., *Children and Sexuality: From the Greeks to the Great War.* Basingstoke and New York: 206–30.

———. 2009. "Vernon Lee in the Vatican: The Uneasy Alliance of Aestheticism and Archaeology," *Victorian Studies* 52(1): 31–41.

Evans, M., ed. 2010. *The Lumley Inventory and Pedigree, Art Collecting and Lineage in the Elizabethan Age.* London.

Evans, R. J. W., and A. Marr. 2006. *Curiosity and Wonder from the Renaissance to the Enlightenment.* Aldershot.

Falciani, C., and A. Natali, eds. 2010. *Bronzino: Artist and Poet at the Court of the Medici.* Florence.

Fane-Saunders, P. 2016. *Pliny the Elder and the Emergence of Renaissance Humanism.* Cambridge.

Farley, J. 2014. *Celts: Art and Identity.* London.

Faulk, B. J. 2004. *Music Hall and Modernity: Late Victorian Discovery of Popular Culture.* Athens, OH.

Favaretto, I. 1988. *Collezioni di antichità a Venezia nei secoli della Repubblica.* Rome.

———. 1997. *Lo Statuario pubblico della Serenissima: Due secoli di collezionismo di antichità, 1596–1797.* Cittadella.

———. 2002. *Arte antica e cultura antiquaria nelle collezioni venete al tempo della serenissima.* Rome.

Fehl, P. 1974. "The Placement of the Equestrian Statue of Marcus Aurelius in the Middle Ages," *Journal of the Warburg and Courtauld Institutes* 37: 362–67.

Feinberg, L. J. 2002. "The Studiolo of Francesco I Reconsidered," in C. Acidini, ed., *The Medici, Michelangelo and the Art of Late Renaissance Florence.* New Haven: 47–66.

Fejfer, J. 1997. *The Ince Blundell Collection of Classical Sculpture,* vol. 1, *The Portraits, Part 2: The Male Portraits.* Liverpool.

———. 2003. "Restoration and Display of Classical Sculpture in English Country Houses," in J. B. Grossman, J. Podany, and M. True, eds., *History of Restoration of Ancient Stone Sculptures*. Los Angeles: 87–104.

———. 2008. *Roman Portraits in Context*. Berlin.

Fejfer, J., and E. Southworth. 1991. *The Ince Blundell Collection of Classical Sculpture*, vol. 1, *The Portraits, Part 1: Introduction, The Female Portraits, Concordances*. London.

Felch, J., and R. Frammolino. 2011. *Chasing Aphrodite: The Hunt for Looted Antiquities at the World's Richest Museum*. Boston and New York.

Ferrier, R. W. 1970. "Charles I and the Antiquities of Persia: The Mission of Nicholas Wilford," *Iran* 8: 51–56.

Fichard, J. (von). [1536–37] 1815. "Observationes antiquitatum et aliarum rerum memorabilium quae Romae videntur collectae per me J. Fichardum in aedem urbe mense VIIbri et VIIIbri anno MDXXXVI," *Frankfurtisches Archiv für ältere deutsche Litteratur und Geschichte* 3: 14–74.

Filarete. 1965. *Filarete's Treatise on Architecture* (Yale Publications in the History of Art 16), trans. with intro. by J. R. Spencer. New Haven and London.

Findlen, P. 1989. "The Museum: Its Classical Etymology and Renaissance Genealogy," *Journal of the History of Collections* 1(1): 59–78.

———. 1996 (first published 1994). *Possessing Nature: Museums, Collecting, and Scientific Culture in Early Modern Italy*. Berkeley, Los Angeles, and London.

———. 2006. "Natural History," in K. Park and L. Daston, eds., *The Cambridge History of Science*, vol. 3, *Early Modern Science*. Cambridge: 435–68.

———. 2012. "Uffizi Gallery, Florence: The Rebirth of a Museum in the Eighteenth Century," in C. Paul, ed., *The First Modern Museums of Art: The Birth of an Institution in 18th- and Early-19th-Century Europe*. Los Angeles: 73–112.

Finley, M. 1985. Foreword to P. E. Easterling and J. V. Muir, eds., *Greek Religion and Society*. Cambridge: xiii–xx.

Fiorelli, G. 1878–80. *Documenti inediti per servire alla storia dei musei d'Italia*, 4 vols. Florence and Rome.

Fisher, K., and R. Langlands. 2011. "The Censorship Myth and the Secret Museum," in S. Hales and J. Paul, eds., *Pompeii in the Public Imagination from Its Rediscovery to Today*. Oxford: 301–15.

———. 2016. "Bestiality in the Bay of Naples: The Herculaneum Pan and Goat Statue," in K. Fisher and R. Langlands, eds., *Sex, Knowledge, and Receptions of the Past*. Oxford: 86–110.

Fletcher, S. 2012. *Roscoe and Italy: The Reception of Italian Renaissance History and Culture in the Eighteenth and Nineteenth Centuries*. Farnham.

Fowler, H. N. 1900. "Pliny, Pausanias, and the Hermes of Praxiteles," *Transactions of the American Philological Society* 31: 37–45.

Fowler, H. N., and J. R. Wheeler. 1909. *A Handbook of Greek Archaeology*. New York.

Francis, E. D., and M. Vickers. 1984a. "Green Goddess: A Gift to Lindos from Amasis of Egypt," *American Journal of Archaeology* 88: 68–69.

———. 1984b. "Amasis and Lindos," *Bulletin of the Institute of Classical Studies* 31: 119–30.

Franzoni, C. 1984. "Le collezioni rinascimentali di antichità," in S. Settis, ed., *Memoria dell'antico nell'arte italiana*, vol. 1, *L'uso dei classici*. Turin: 301–60.

———. 1999. *Il 'portico dei marmi': Le prime collezioni a Reggio Emilia e la nascita del Museo Civico*. Reggio Emilia.

Fraser, P. M. 1972. *Ptolemaic Alexandria*, 2 vols. Oxford.

Frazer, J. G. 1898. *Pausanias's Description of Greece*, vols. 1 and 2. London.

Freedman, L. 1999. "Titian's Jacopo Strada: A Portrait of an 'Antiquario,'" *Renaissance Studies* 13(1): 15–39.

Freeman, C. 2004. *The Horses of St. Mark's: A Story of Triumph in Byzantium, Paris, and Venice*. New York.

Friederichs, C. 1859. "Harmodios und Aristogeiton," *Archäologische Zeitung* 17: 65–72.

———. 1863. *Der Doryphoros des Polyklet*. Berlin.

———. 1868. *Die Gipsabgüsse im Neuen Museum. Berlins antike Bildwerke*, vol. 1, *Bausteine zur Geschichte der griechisch-römischen Plastik*. Dusseldorf.

———. 1885. *Die Gipsabgüsse antiker Bildwerke in historischer Folge erklärt. Bausteine zur Geschichte der griechisch-römischen Plastik: neu bearbeitet von Paul Wolters*. Berlin.

Friedland, E. A., and M. G. Sobocinski, with E. K. Gazda, eds. 2015. *The Oxford Handbook of Roman Sculpture*. Oxford.

Friedländer, P. 1938. "Geschichtswende im Gedicht: Interpretationen historischer Epigramme," *Studi Italiani di Filologia Classica*, n.s., 15: 89–120.

———. 1948. *Epigrammata: Inscriptions in Verse from the Beginnings of the Persian Wars, with the Collaboration of H. B. Hoffleit*. Berkeley and Los Angeles.

Friedman, T. 1974. *The Man at Hyde Park Corner: Sculpture by John Cheere 1709–1787*. Leeds.

Frischer, B. 1982. *The Sculpted Word: Epicureanism and Philosophical Recruitment in Ancient Greece*. Berkeley and London.

Frugoni, C. 1984. "L'antichità: Dai *Mirabilia* alla propaganda politica," in S. Settis, ed., *Memoria dell'antico nell'arte Italiana*, vol. 1, *L'uso dei classici*. Turin: 5–72.

Fuchs, M. 1999. *In hoc etiam genere Graeciae nihil cedamus: Studien zur Romanisierung der späthellenistischen Kunst im 1. Jh. v. Chr.* Mainz.

Fuchs, W. 1969. *Die Skulptur der Griechen*. Munich.

Fulton, J. 2003. "John Cheere, the Eminent Statuary, His Workshop and Practice, 1737–1787," *Sculpture Journal* 10: 21–39.

Fulvio, A. 1517. *Illustrium imagines*. Rome.

———. 1524. *Illustrium imagines*. Lyons.

Furján, H. 2011. *Glorious Visions: John Soane's Spectacular Theater*. Abingdon.

Furlotti, B., and G. Rebecchini. 2008. *The Art of Mantua: Power and Patronage in the Renaissance*, trans. A. L. Jenkens. Los Angeles.

Furtwängler, A. 1880a. "Statue von der Akropolis," *Athenische Mitteilungen* 5: 20–42.

———. 1880b. *Der Satyr aus Pergamon*. Berlin.

———. 1893. *Meisterwerke der griechischen Plastik: Kunstgeschichtliche Untersuchungen*. Leipzig.

———. 1895. *Masterpieces of Greek Sculpture*. London.

———. 1901. "Ancient Sculptures at Chatsworth House," *Journal of Hellenic Studies* 21: 209–28.

Fusco, L., and G. Corti. 2006. *Lorenzo de' Medici, Collector of Antiquities*. Cambridge.

Gaborit-Chopin, D. 1999. *La statuette équestre de Charlemagne*. Paris.

Gadd, I., S. Eliot, and W. R. Louis. 2013. *The History of Oxford University Press*, vol. 1. Oxford.

Gaifman, M. 2012. *Aniconism in Greek Antiquity*. Oxford.

Galinsky, G. K. 1999. "*Aeneid* V and the *Aeneid*," in P. Hardie, ed., *Virgil: Critical Assessments of Classical Authors*, vol. 4. London and New York: 182–206.

Gallo, R. 1967. *Il Tesoro di San Marco e la sua storia*. Florence.

Gardner, E. A. 1896–97. *A Handbook of Greek Sculpture*, 2 vols. London and New York.

Gardner, P. 1917. "Professor Wickhoff on Roman Art," *Journal of Roman Studies* 7: 1–26.

Garlick, K., A. Macintyre, K. Cave, and E. Newby, eds. 1978–98. *The Diary of Joseph Farington*, 17 vols. New Haven and London.

Gasparotto, D. 2015. "The Pleasure of Littleness: The Allure of Antiquity in the Italian Renaissance," in S. Settis, A. Anguissola, and D. Gasparotto, eds., *Serial/Portable Classic: The Greek Canon and Its Mutations*. Milan: 81–88.

Gasparri, C. 2009. *Le sculture Farnese*, vol. 1, *Le sculture ideali*. Naples.

———. 2015. "The Making of an Icon: The Farnese Hercules and the Power of Place," in S. Settis, A. Anguissola, and D. Gasparotto, eds., *Serial/Portable Classic: The Greek Canon and Its Mutations*. Milan: 171–79.

Gazda, E. 1995a. "Roman Copies: The Unmaking of a Modern Myth," *Journal of Roman Archaeology* 8: 530–33.

———. 1995b. "Roman Sculpture and the Ethos of Emulation," *Harvard Studies in Classical Philology* 97: 121–56.

———, ed. 2002. *The Ancient Art of Emulation*. Rome.

Gaze, D., ed. 1997. *Dictionary of Female Artists*, vol. 1. London and Chicago.

Gell, A. 1992. "The Technology of Enchantment and the Enchantment of Technology," in J. Coote and A. Shelton, eds., *Anthropology, Art and Aesthetics*. Oxford: 40–67.

———. 1998. *Art and Agency: An Anthropological Theory*. Oxford.

Genovese, C. 2007. "La collezione del cardinal Francesco Piccolomini," in A. Cavallaro, ed., *Collezioni di antichità a Roma tra '400 e '500*. Rome: 33–37.

Georgopoulou, M. 2001. *Venice's Mediterranean Colonies: Architecture and Urbanism*. New York and Cambridge.

Gere, K. 2009. *Knossos and the Prophets of Modernism*. Chicago and London.

Gerhard, E. 1840–58. *Auserlesene griechische Vasenbilder*. Berlin.

Germini, B. 2008. *Statuen des Strengen Stils in Rom: Verwendung und Wertung eines griechischen Stils im Römischen Kontext*. Rome.

Getsy, D. 2004. *Body Doubles: Sculpture in Britain, 1877–1905*. New Haven and London.

Getty, J. P. 1955. "A Journey from Corinth," in E. Le Vane and J. P. Getty, eds., *Collector's Choice*. London: 286–329.

———. 1976. *As I See It: The Autobiography of J. Paul Getty*. London.

Giard, J. B. 1998. *Le Grand Camée de France*. Paris.

Gibson, J. J. 1977. "The Theory of Affordances," in R. Shaw and J. Bransford, eds., *Perceiving, Acting, and Knowing: Toward an Ecological Psychology*. Hillsdale, NJ: 67–82.

———. 1979. *The Ecological Approach to Visual Perception*. Boston.

Gibson, R. K., and R. Morello. 2011. *Pliny the Elder: Themes and Contexts*. Leiden.

Giganti, A. 1595. *Carmina Exametra, Elegiaca, Lyrica, et Hendecasyllaba*. Bologna.

Gilman, E. B. 1994. Review of F. Junius, K. Aldrich, P. Fehl, and R. Fehl, *The Literature of Classical Art*, vol. 1, *The Painting of the Ancients: De Pictura Veterum*; vol. 2, *A Lexicon of Artists and Their Works: Catalogus Architectorum*, *Renaissance Quarterly* 47(2): 451–54.

———. 2000. "Madagascar on My Mind: The Earl of Arundel and the Arts of Colonization," in P. Erickson and C. Hulse, eds., *Early Modern Visual Culture: Representation, Race, and Empire in Renaissance England*. Philadelphia: 284–314.

Giuliani, L. 1986. *Bildnis und Botschaft: Hermeneutische Untersuchungen zur Bildniskunst der römischen Republik*. Frankfurt am Main.

Giuliani, L., and G. Schmidt. 2010. *Ein Geschenk für den Kaiser: Das Geheimnis des grossen Kameo.* Munich.

Giustinian, B. 1484. *Die origine urbis venetiarum.* Venice.

Gjerstad, E., J. Lindros, E. Sjöqvist, and A. Westholm. 1935. *The Swedish Cyprus Expedition: Finds and Results of the Excavations in Cyprus 1927–1931,* vol. 2. Stockholm.

Gleason, H. M. 2015. "Collecting in Early America," in E. A. Friedland and M. G. Sobocinski, with E. K. Gazda, eds., *The Oxford Handbook of Roman Sculpture.* Oxford: 44–58.

Gleason, M. 1994. *Making Men: Sophists and Self-Representation in Ancient Rome.* Princeton.

Goddio, F., and A. Masson-Berghoff, eds. 2016. *Sunken Cities: Egypt's Lost Worlds.* London.

Goethe, J. W. von. 1983. *Italian Journey,* ed. T. P. Saine and J. L. Sammons, trans. R. R. Heitner. New York.

———. 1993. *Italienische Reise,* ed. C. Michel and H.-G. Dewitz, 2 vols. Frankfurt.

Goldhill, S. 1994. "The Naïve and Knowing Eye: Ecphrasis and the Culture of Viewing in the Hellenistic World," in S. Goldhill and R. Osborne, eds., *Art and Text in Greek Culture.* Cambridge: 197–223.

———. 2007. "What Is Ekphrasis For?" *Classical Philology* 102(1): 1–19.

———. 2011. *Victorian Culture and Classical Antiquity: Art, Opera, Fiction, and the Proclamation of Modernity.* Princeton.

Goltz, H. 1563. *Epistola ad eos, quorum opera et studio auctor se adiutum agnoscit, cum eorundem nomenclatura et catalogo, lettera nuncupatoria aggiunta in calce a Id., C. Iulii Caesaris numismata.* Bruges.

Gombrich, E. H. 1959, published 1960. *Art and Illusion: A Study in the Psychology of Pictorial Representation.* London.

———. 1960. "The Early Medici as Patrons of Art: A Survey of Primary Sources," in E. F. Jacob, ed., *Italian Renaissance Studies.* London: 279–311.

Gordan, P. W. G. 1974, reprinted 1991. *Two Renaissance Book Hunters: The Letters of Poggius Bracciolini to Nicolaus de Niccolis.* New York.

Gossman, L. 2006. "Imperial Icon: The Pergamon Altar in Wilhelminian Germany," *Journal of Modern History* 78(3): 551–87.

Grabar, A. 1967. *The Beginnings of Christian Art, 200–395,* trans. S. Gilbert and J. Emmons. London.

Graef, B., and E. Langlotz. 1925–33. *Die antiken Vasen von der Akropolis zu Athen.* Berlin.

Grafton, A. T. 1980. "The Importance of Being Printed," *Journal of Interdisciplinary History* 11(2): 265–86.

———. 2010. "Calendars, Chronicles, Chronology," in A. Grafton, G. W. Most, and S. Settis, eds., *The Classical Tradition.* Cambridge, MA and London: 165–68.

Grand-Clément, A. 2005. "Couleur et esthétique classique au XIXe siècle: L'art grec antique pouvait-il être polychrome?" *Ithaca: Quaderns Catalans de Cultura Clàssica* 21: 139–60.

Greenblatt, S. 2011. *The Swerve: How the World Became Modern.* New York.

Greenhalgh, M. 1989. *Survival of Roman Antiquities in the Middle Ages.* London.

———. 2011. "Spolia: A Definition in Ruins," in R. Brilliant and D. Kinney, eds., *Reuse Value: Spolia and Appropriation in Art and Architecture from Constantine to Sherrie Levine.* Farnham: 75–96.

Gregg, R. F. 2008. "Panorama, Power and History: Vasari and Stradano's City Views in the Palazzo Vecchio." Doctoral dissertation, Johns Hopkins University.

Gregori, G. 1994. "*Opus Phidiae, Opus Praxiteles,*" in L. Nista, ed., *Castores: L'immagine dei Dioscuri a Roma.* Rome: 209–14.

Greig, J., ed. 1924. *The Farington Diary by Joseph Farington,* vol. 4, *September 20 1806 to January 7 1808.* New York.

Griener, P. 2008. "La 'période' comme entrave: Le 'néo-classicisme' après Wölfflin," *Perspective: Actualités de la recherche en histoire de l'art* 4: 653–62.

———. 2010. *La République de l'oeil: L'expérience de l'art au siècle des Lumières.* Paris.

Grimme, A., and S. Schoske, eds. 2005. *Winckelmann and Ägypten: Die Wiederentdeckung der ägyptischen Kunst in 18. Jahrhundert.* Munich.

Grimme, E. G., and A. Münchow. 1994. *Der Dom zu Aachen: Architektur und Ausstattung.* Aachen.

Grosz, E. 2001. *Architecture from the Outside: Essays on Virtual and Real Space.* Cambridge, MA.

———. 2005. *Time Travels: Feminism, Nature, Power.* Durham and London.

Grove, J. 2015. "The Role of Roman Artefacts in E. P. Warren's Paederastic Evangel," in J. Ingleheart, ed., *Ancient Rome and the Construction of Modern Homosexual Identities.* Oxford: 214–31.

Gruen, E. S. 1990. *Studies in Greek Culture and Roman Policy.* Berkeley, Los Angeles, and London.

———. 1992. *Culture and National Identity in Republican Rome.* Ithaca.

———. 2011. *Rethinking the Other in Antiquity.* Princeton and Oxford.

Grüssinger, R., V. Kästner, and A. Scholl, eds. 2011. *Pergamon: Panorama der antiken Metropole.* Berlin.

Gschwantler, K. 2000. "Graeco-Roman Portraiture," in S. Walker, ed., *Ancient Faces: Mummy Portraits from Ancient Egypt.* New York: 14–22.

Gualandi, G. 1982. "Plinio e il collezionismo d'arte," in *Plinio il vecchio sotto il profile storico e letterario: Atti del Convegno di Romo 1979.* Como: 259–98.

Guardiola, R. R. 2013. "The Spell of Antinous in Renaissance Art: The Jonah Statue in Santa Maria del Popolo," in S. Knippschild and M. G. Morcillo, eds., *Seduction and Power: Antiquity in the Visual and Performing Arts.* London and New York: 263–78.

Guarducci, M. 1980. "La cosiddetta Fibula Prenestina: Antiquari, eruditi e falsari nella Roma dell'Ottocento," *Memorie. Atti dell' Accademia nazionale dei Lincei, Classe di scienze morali, storiche e filologiche.* 8(24): 415–574.

———. 1998. "Ciriaco e l'epigrafia," in G. Paci and S. Sconocchia, eds., *Ciraco d'Ancona e la cultura antiquaria dell'Umanesimo.* Reggio Emilia: 169–72.

Guidi, M. 1907. "Un βίος di Constantino," *Rendiconti della Reale Accademia di Lincei: Classe di scienze morali, storiche e filologiche V,* 16: 304–40 and 637–62.

Guilding, R. 2001. *Marble Mania: Sculpture Galleries in England 1640–1840.* London.

———. 2014. *Owning the Past: Why the English Collected Antique Sculpture, 1640–1840.* New Haven and London.

Guillaume, J. 1979. "Fontainebleau 1530: Le pavillon des Armes et sa porte égyptienne," *Bulletin monumental* 137(3): 225–40.

Guralnick, E. 1974. "The Chrysapha Relief and Its Connections with Egyptian Art," *Journal of Egyptian Archaeology* 60: 175–88.

Güthenke, C. 2008. *Placing Modern Greece: The Dynamics of Romantic Hellenism, 1770–1840.* Oxford.

Gutzwiller, K. 2002. "Posidippus on Statuary," in G. Bastianini and A. Casanova, eds., *Il Papiro di Posidippo un Anno Dopo: Atti del Convegno internazionale di Studi Firenze 13–14 Giugno 2002.* Florence: 41–60.

———. 2004. "Seeing Thought: Timomachus' Medea and Ecphrastic Epigram," *American Journal of Philology* 125(3): 339–86.

———. 2005a. "The Literariness of the Milan Papyrus, or 'What Difference a Book?'," in K. Gutzwiller, ed., *The New Posidippus: A Hellenistic Poetry Book.* Oxford: 287–319.

———, ed. 2005b. *The New Posidippus: A Hellenistic Poetry Book.* Oxford.

Guyonnet de Vertron, C. C. 1686. *Le Nouveau Panthéon, ou le Rapport des divinitez du paganisme, des héros de l'antiquité et des princes surnommez grands, aux vertus et aux actions de Louis-Le-Grand, avec des inscriptions latines et françoises en vers et en prose, pour l'histoire du Roy.* Paris.

Habermas, J. 1962. *Strukturwandel der Öffentlichkeit: Untersuchungen zu einer Kategorie der bürgerlichen Gesellschaft.* Frankfurt.

———. 1989. *The Structural Transformation of the Public Sphere: An Inquiry into a Category of Bourgeois Society,* trans. T. Burger. Cambridge.

Habicht, C. 1990. "Athens and the Attalids in the Second Century B.C.," *Hesperia* 59: 561–77.

———. 2006. "Athens and the Seleucids," in *The Hellenistic Monarchies: Selected Papers,* trans. P. Stevenson. Ann Arbor: 155–73.

Hafner, G. 1992. "Die beim Apollotempel in Rom gefundenen Griechischen Skupturen," *Jahrbuch des Deutschen Archäologischen Instituts* 107: 17–32.

Halbertsma, R. B. 2008. "From Distant Shores: Nineteenth-Century Dutch Archaeology in European Perspective," in N. Schlanger and J. Nordbladh, eds., *Archives, Ancestors, Practices: Archaeology in the Light of Its History.* New York and Oxford: 21–36.

Hales, S., and A. M. Leander Touati, eds. 2016. *Interior Space and Decoration Documented and Revived, 18th–20th Century.* Stockholm.

Hales, S. J. 2002. "Looking for Eunuchs: The Galli and Attis in Roman Art," in S. Tougher, ed., *Eunuchs in Antiquity and Beyond.* Cardiff: 87–102.

Hallett, C. H. 2005. "Emulation *versus* Replication: Redefining Roman Copying," *Journal of Roman Archaeology* 18: 419–35.

———. 2015. "Defining Roman Art," in B. E. Borg, ed., *A Companion to Roman Art.* Chichester: 11–33.

Hamilton, W., and P. F. H. d'Hancarville. 1766. *Collection of Etruscan, Greek, and Roman Antiquities from the Cabinet of the Hon. W. Hamilton his Brittanick Majesty's Envoy Extraordinary at the Court of Naples; Antiquités Etrusques, Grecques, et Romaines Tirées du Cabinet de M. Hamilton. . . .* vol. 1. Naples.

Handis, M. W. 2013. "Myth and History: Galen and the Alexandrian Library," in J. König, K. Oikonomopoulou, and G. Woolf, eds., *Ancient Libraries.* Cambridge: 364–76.

Hansen, E. V. 1971. *The Attalids of Pergamum.* Ithaca.

Hansen, S. 1996. "Weihegaben zwischen System und Lebenswelt," in H.-J. Gehrke and A. Möller, eds., *Vergangenheit und Lebenswelt: Soziale Kommunikation, Traditionsbildung und historisches Bewusstsein.* Tübingen: 257–76.

Hardie, P. 2012. *Rumour and Renown: Representations of "Fama" in Western Literature.* Cambridge.

Harding, R. J. D. 2008. "'The Head of a Certain Macedonian King': An Old Identity for the British Museum's 'Arundel Homer'," *British Art Journal* 9(2): 11–19.

Harloe, K. 2007. "Allusion and Ekphrasis in Winckelmann's Paris Description of the Apollo Belvedere," *Cambridge Classical Journal* 53: 229–52.

———. 2013. *Winckelmann and the Invention of Antiquity: History and Aesthetics in the Age of Altertumswissenschaft.* Oxford.

Harney, M. 2013. *Place-Making for the Imagination: Horace Walpole and Strawberry Hill*. Farham.

Harris, D. 1995. *The Treasures of the Parthenon and Erechtheion*. Oxford.

Harris, E. 2001. *The Genius of Robert Adam: His Interiors*. New Haven and London.

Harris, L. 2004. "Curzon, Nathaniel, first Baron Scarsdale (1726–1804)," rev. A. P. Baker. *Oxford Dictionary of National Biography*, http://dx.doi.org/10.1093/ref:odnb/37335 (last accessed 1 August 2016).

Harris, W. V. 2015. "Prolegomena to a Study of the Economics of Roman Art," *American Journal of Archaeology* 119(3): 395–417.

Harrison, E. B. 1972. "The South Frieze of the Nike Temple and the Marathon Painting in the Painted Stoa," *American Journal of Archaeology* 76: 353–78.

Harth, H., ed. 1984–87. *Poggio Bracciolini. Lettere*, 3 vols. Florence.

Hartswick, K. J. 1983. "The Athena Lemnia Reconsidered," *American Journal of Archaeology* 87(3): 335–46.

———. 1998. "The Athena Lemnia: A Response," in K. J. Hartswick and M. C. Sturgeon, eds., *Stephanos: Studies in Honor of Brunilde Sismondo Ridgway*. Philadelphia: 105-14.

———. 2004. *The Gardens of Sallust: A Changing Landscape*. Austin.

Hartwig, M. K. 2015. "Style," in M. K. Hartwig, ed., *A Companion to Ancient Egyptian Art*. Chichester: 39–59.

Haskell, F. 1987. "The Baron D'Hancarville," in F. Haskell, ed., *Past and Present in Art and Taste*. New Haven and London: 30–45.

———. 1993. *History and Its Images: Art and the Interpretation of the Past*. New Haven and London.

———. 2013. *The King's Pictures: The Formation and Dispersal of the Collections of Charles I and His Courtiers*. New Haven and London.

Haskell, F., and N. Penny. 1981. *Taste and the Antique: The Lure of Classical Sculpture, 1500–1900*. New Haven and London.

Hatt, M. 2006. "'A Great Sight': Henry Scott Tuke and His Models," in J. Desmarais, M. Postle, and W. Vaughn, eds., *Model and Supermodel: The Artist's Model in British Art and Culture*. Manchester: 89–104.

Hatt, M., and C. Klonk. 2006. *Art History: A Critical Introduction to Its Methods*. Manchester.

Hatzimichali, M. 2013. "Ashes to Ashes? The Library of Alexandria after 48 BC," in J. König, K. Oikonomopoulou, and G. Woolf, eds., *Ancient Libraries*. Cambridge: 167–82.

Haubold, J., G. B. Lanfranchi, R. Rollinger, and J. M. Steele, eds. 2013. *The World of Berossos: Proceedings of the 4th International Colloquium on "The Ancient Near East between Classical and Ancient Oriental Traditions," Hatfield College, Durham 7th-9th July 2010*. Classica et Orientalia 5. Wiesbaden.

Haynes, D. E. L. 1974. "The Arundel Homerus Rediscovered," *J. Paul Getty Museum Journal* 1: 73–80.

———. 1975. *The Arundel Marbles*. Oxford.

Hazlitt, W. 1999. *Selected Writings*, ed. John Cook. Oxford.

Head, B. V. 1897. *Catalogue of the Greek Coins in the British Museum of Caria, Cos, Rhodes etc.* London.

Hedreen, G. 2016. *The Image of the Artist in Archaic and Classical Greece: Art, Poetry, and Subjectivity*. Cambridge.

Hedrick, C. W. 2000. *History and Silence: Purge and Rehabilitation of Memory in Late Antiquity*. Austin.

Heidenreich, R. 1935. "Bupalos und Pergamon," *Archäologischer Anzeiger* 50: 668–701.

Heikamp, D., and A. Grotte. 1974. *Il Tesoro di Lorenzo il Magnifico*, 2 vols. Florence.

Heilmeyer, W. D. 2004. "Ancient Workshops and Ancient 'Art,'" *Oxford Journal of Archaeology* 23(4): 403–15.

Hekster, O. 2002. *Commodus: An Emperor at the Crossroads*. Amsterdam.

Helbig, W. 1868. *Wandgemälde der vom Vesuv verschütteten Städte Campaniens*. Leipzig.

———. 1884. *Das homerische Epos aus den Denkmälern erläutert*. Leipzig.

———. 1891. *Führer durch die öffentlichen Sammlungen klassischer Alterthümer in Rom*. Leipzig.

Hellenkemper Salies, G., ed. 1994. *Das Wrack: Der antike Schiffsfund von Mahdia*, 2 vols. Cologne.

Heller, A. 2014. Review of J. Haubold et al., eds., *The World of Berossos*, *Bryn Mawr Classical Review* 2014.05.50, http://bmcr.brynmawr.edu/2014/2014-05-50.html (last accessed 1 August 2016).

Hemingway, S. 2016. "Seafaring, Shipwrecks, and the Art Market in the Hellenistic Age," in C. A. Picón and S. Hemingway, eds., *Pergamon and the Hellenistic Kingdoms of the Ancient World*. New York: 92–99.

Henig, M. 1995. *The Art of Roman Britain*. London.

Henriksén, C. 2012. *A Commentary on Martial, Epigrams Book 9*. Oxford.

Hepple, L. W. 2001. "The Museum in the Garden: Displaying Classical Antiquities in Elizabethan and Jacobean England," *Garden History* 29(2): 109–20.

———. 2003. "William Camden and Early Collections of Roman Antiquities in Britain," *Journal of the History of Collections* 15(2): 159–73.

Heringman, N. 2013. *Sciences of Antiquity: Romantic Antiquarianism, Natural History, and Knowledge Work*. Oxford.

Herklotz, I. 1985. "Der Campus Lateranensis im Mittelalter," *Römisches Jahrbuch für Kunstgeschichte* 22: 1–43.

Hershbell, J. 1989. "The Stoicism of Epictetus," *Aufstieg und Niedergang der römischen Welt* II 36(3): 2148–63.

Hervey, M. F. S. 1921. *The Life, Correspondence, and Collections of Thomas Howard, Earl of Arundel.* Cambridge.

Higbie, C. 1999. "Craterus and the Use of Inscriptions in Ancient Scholarship," *Transactions of the American Philological Association* 129: 43–83.

———. 2003. *The Lindian Chronicle and the Greek Creation of Their Past.* Oxford.

———. 2017. *Collectors, Scholars, and Forgers in the Ancient World: Object Lessons.* Oxford.

Higgins, C. 2009. "Why Study Latin?" *The Guardian*, 24 May, https://www.theguardian.com/culture/charlottehigginsblog/2009/may/24/latin-in-schools (last accessed 1 August 2016).

Hill, R., and S. Bracken. 2014. "The Ambassador and the Artist. Sir Dudley Carleton's Relationship with Peter Paul Rubens: Connoisseurship and Art Collecting at the Court of the Early Stuarts," *Journal of the History of Collections* 26(2): 171–91.

Hille, C. 2012. *Visions of the Courtly Body: The Patronage of George Villiers, First Duke of Buckingham, and the Triumph of Painting at the Stuart Court.* Berlin.

Himmelmann, N. 1994. "Mahdia und Antikythera," in G. Hellenkemper Salies, ed., *Das Wrack: Der antike Schiffsfund von Mahdia*, vol. 2. Cologne: 849–55.

Hingley, R. 2008. *The Recovery of Roman Britain, 1586–1906: A Colony So Fertile.* Oxford.

Hitchens, C. 2008. *The Parthenon Marbles: The Case for Reunification.* London and New York.

Hochmann, M. 2003. "Laocoon à Venise," *Revue Germanique Internationale* 19: 91–103.

Hodder, I. 2012. *Entangled: An Archaeology of the Relationships between Humans and Things.* Chichester.

Hodson, J. 2007. *Language and Revolution in Burke, Wollstonecraft, Paine, and Godwin.* Aldershot and Burlington, VT.

Hoffmann, H. 1962. "Die aachener Theodorichstatue," in V. Elbern, ed., *Das Erste Jahrtausend: Kunst und Kultur am werdenen Abendland am Rhein und Ruhr*, vol. 1. Dusseldorf: 318–33.

Holleran, C. 2012. *Shopping in Ancient Rome: The Retail Trade in the Late Republic and the Principate.* Oxford.

Hölscher, T. 1987. *Römische Bildsprache als semantisches System.* Heidelberg.

———. 2004a. *The Language of Images in Roman Art*, trans. A. Snodgrass and A.-M. Künzl-Snodgrass. Cambridge.

———. 2004b. "Provokation and Transgression als politischer Habitus in der späten römischen Republik," *Mitteilungen des Deutschen Archäologischen Instituts, Römische Abteilung* 111: 83–104.

———. 2006a. "Transformation of Victory into Power: From Event to Structure," in S. Dillon and K. E. Welch, eds., *Representations of War in Ancient Rome.* Cambridge: 27–48.

———. 2006b. "Greek Styles and Greek Art in Augustan Rome: Issues of the Present Versus the Records of the Past," in J. I. Porter, ed., *Classical Pasts: The Classical Traditions of Greece and Rome.* Princeton: 237–69.

———. 2015. "Wandering Penelope: Multiple Originals in Classical Greece," in S. Settis, A. Anguissola, and D. Gasparotto, eds., *Serial/Portable Classic: The Greek Canon and Its Mutations.* Milan: 119–24.

Holz, S. 2009. "*Praeda* und Prestige–Kriegsbeute und Beutekunst im (spät-) republikanischen Rom," in M. Coudry and M. Humm, eds., *Praeda: Butin de guerre et société dans la Rome républicaine/Kriegsbeute und Gesellschaft im republikanischen Rom.* Stuttgart: 187–206.

Homolle, T. 1897. "L'Aurige de Delphes," *Monuments et Mémoires de la Fondation Eugène Piot* 4(2): 169–208.

Honour, H. 1968. *Neoclassicism.* London.

Hood, T. 1842. "The Late Andrew Ducrow," *Coburn's New Monthly Magazine; the new Monthly magazine and Humorist*, part II: 41–48.

Hooper-Greenhill, E. 1992. *Museums and the Shaping of Knowledge.* London and New York.

Hope, T. 1807. *Household Furniture and Interior Decoration Executed from Designs by Thomas Hope.* London.

———. 1812. *Costumes of the Ancients*, 2 vols. London.

Höpfner, W. 1996. "L'architettura di Pergamo," in *L'altare di Pergamo: Il fregio di Telefo.* Milan: 74–106.

Hornblower, S. 1982. *Mausolus.* Oxford.

———. 1983. *The Greek World 479–323 BC.* London.

Hoselitz, V. 2007. *Imagining Roman Britain: Victorian Responses to a Roman Past.* Woodbridge.

Houghton, J. R. 2009. *Philippe de Montebello and the Metropolitan Museum of Art, 1977–2008.* New York.

Houser, C. 1987. "Silver Teeth: Documentation and Significance," *American Journal of Archaeology* 91: 300–301.

Howard, S. 1983. "The Dying Gaul, Aigina Warriors, and Pergamene Academicism," *American Journal of Archaeology* 87: 483–87.

———. 1986. "Pergamene Art Collecting and Its Aftermath," *Akten des XXV Internationalen Kongresses für Kunstgeschichte* 4: 25–36.

Howarth, D. 1985. *Lord Arundel and His Circle.* New Haven and London.

———. 1997. *Images of Rule: Art and Politics in the English Renaissance, 1485–1649.* Berkeley.

———. 1998. "The Patronage and Collecting of Ale-theia, Countess of Arundel, 1606–54," *Journal of the History of Collections* 10(2): 125–37.

———. 2002. "The Arundel Collection: Collecting and Patronage in England in the Reigns of Philip III and Philip IV," in J. Brown and J. Elliott, eds., *The Sale of the Century: Artistic Relations between Spain and Great Britain, 1604–1655*. New Haven: 69–86.

Hughes, J. 2008. "Fragmentation as Metaphor in the Classical Greek Sanctuary," *Social History of Medicine* 21(2): 217–36.

———. 2014. "Memory and the Roman Viewer: Looking at the Arch of Constantine," in K. Galinsky, ed., *Memoria Romana: Memory in Rome and Rome in Memory*. Supplements to the Memoirs of the American Academy in Rome 10. Ann Arbor: 103–16.

Humphreys, H. N. 1840. *Rome and Its Surrounding Scenery*. London.

Hunt, A. 1996. *Governance of the Consuming Passions: A History of Sumptuary Law*. Basingstoke and London.

Hunter, R. 1996. *Theocritus and the Archaeology of Greek Poetry*. Cambridge.

———. 2009. *Critical Moments in Classical Literature: Studies in the Ancient View of Literature and Its Uses*. Cambridge.

Hurwit, J. M. 1989. "The Kritios Boy: Discovery, Reconstruction, and Date," *American Journal of Archaeology* 93: 41–80.

Hutchinson, G. 1988. *Hellenistic Poetry*. Oxford.

Iacopi, I. 1997. *La decorazione pittorica dell'aula Isiaca*. Milan.

Ijsewijn, J., ed. 1997. *Coryciana*. Rome.

Innes, M. 1997. "The Classical Tradition in the Carolingian Renaissance: Ninth-Century Encounters with Suetonius," *International Journal of the Classical Tradition* 3: 265–82.

Iverson, E. 1968. *Obelisks in Exile*, vol. 1, *The Obelisks of Ancient Rome*. Copenhagen.

Jackson, D. 1987. "Verism and the Ancestral Portrait," *Greece and Rome* 34(1): 32–47.

Jacoby, F. 1904. *Das Marmor Parium*. Berlin.

Jacoff, M. 1993. *The Horses of San Marco & the Quadriga of the Lord*. Princeton.

———. 2010. "Fashioning a Façade: The Construction of Venetian Identity on the Exterior of San Marco," in H. Maguire and R. S. Nelson, eds., *San Marco, Byzantium, and the Myths of Venice*. Washington, DC: 113–50.

Jacquemin, A. 1999. *Offrandes monumentales à Delphes*. Paris.

Jahn, O. 1839. *Vasenbilder*. Hamburg.

———. 1854. *Beschreibung der Vasensammlung König Ludwigs in der Pinakothek zu München*. Munich.

James, H. 1993. *Collected Travel Writings: The Continent*. New York.

James, L. 1996. "'Pray Not to Fall into Temptation and Be on Your Guard': Pagan Statues in Christian Constantinople," *Gesta* 35(1): 12–20.

Jameson, A. B. 1834. *Visits and Sketches at Home and Abroad*, vol. 1. New York.

Jeammet, V., ed. 2010. *Tanagras: Figurines for Life and Eternity*. Paris.

Jeffreys, E. M., and R. Scott. 1986. *The Chronicle of John Malalas: A Translation*. Melbourne.

Jenkins, I. 1992. *Archaeologists and Aesthetes in the Sculpture Galleries of the British Museum 1800–1939*. London.

———. 2001. "Cleaning and Controversy: The Parthenon Sculptures 1811–1939," British Museum Occasional paper number 146, http://www.british museum.org/research/publications/research _publications_series/2001/cleaning_and_contro versy.aspx (last accessed 2 August 2016).

———. 2006. *Greek Architecture and Its Sculpture*. Cambridge, MA.

———. 2008. "The Past as a Foreign Country: Thomas Hope's Collection of Antiquities," in D. Watkin and P. Hewat-Jaboor, eds., *Thomas Hope: Regency Designer*. New Haven and London: 107–29.

———. 2012. *The Discobolus*. London.

———. 2015. *Defining Beauty: The Body in Ancient Greek Art*. London.

Jenkins, I., and K. Sloan, eds. 1996. *Vases and Volcanoes: Sir William Hamilton and His Collection*. London.

Jenkins, T. 2016a. "Mad for Marble (review of E. L. Thompson, *Possession: The Curious History of Private Collectors from Antiquity to the Present*)," *Literary Review* 444: 13.

———. 2016b. *Keeping Their Marbles: How the Treasures of the Past Ended Up in Museums . . . And Why They Should Stay There*. Oxford and New York.

Jex-Blake, K., and E. Sellers. 1968. *The Elder Pliny's Chapters on the History of Art*. Chicago.

Johns, C. M. S. 1998. *Antonio Canova and the Politics of Patronage in Revolutionary and Napoleonic Europe*. Berkeley and Los Angeles.

Johnson, G. A. 2012. "In the Hand of the Beholder: Isabella d'Este and the Sensual Allure of Sculpture," in A. Sanger and S. T. Kulbrandstad Walker, eds., *Sense and the Senses in Early Modern Art and Cultural Practice*. Aldershot: 183–97.

———. 2013. "How One Should Photograph Sculpture," *Art History* 36(1): 52–71.

Johnson, L. L. 1984. "The Hellenistic and Roman Library." Doctoral dissertation, Duke University.

Johnson, R. R. 1970. "Ancient and Medieval Accounts of the 'Invention' of Parchment," *California Studies in Classical Antiquity* 3: 115–22.

Jones, A. 2007. *Memory and Material Culture.* Cambridge.

Jones, M. 1990. *Fake? The Art of Deception.* Berkeley.

———. 2012. *Playing the Man: Performing Masculinities in the Ancient Greek Novel.* Oxford.

Jones, O. 1854. *The Greek Court Erected in the Crystal Palace.* London.

Jones, R. W. 1998. *Gender and the Formation of Taste in Eighteenth-Century Britain: The Analysis of Beauty.* Cambridge.

Junius, F. 1638. *The Painting of the Ancients.* London.

———. 1991. *The Literature of Classical Art,* vol. 1, *The Painting of the Ancients,* ed. K. Aldrich, P. Fehl, and R. Fehl. Berkeley, Los Angeles, and Oxford.

Junker, K. 2002. "Die Athena-Marsyas-Gruppe des Myron," *Jahrbuch des Deutschen Archäologischen Instituts* 117: 127–84.

Junker, K., and A. Stähli, eds. 2008. *Original und Kopie: Formen und Konzepte der Nachamung in der antiken Kunst. Akten des Kolloquiums in Berlin, 17.–19. Februar 2005.* Wiesbaden.

Kabdebó, T. 2015. "Ferenc Pulszky," *Hungarian Review* 6(2): 94–100.

Kaldellis, A. 2007. "Christodorus on the Statues of the Zeuxippos Baths: A New Reading of the Ekphrasis," *Greek, Roman and Byzantine Studies* 47: 361–83.

Kaliardos, K. P. 2013. *The Munich Kunstkammer: Art, Nature, and the Representation of Knowledge in Courtly Contexts.* Tübingen.

Kaltsas, N. 2002. *Sculpture in the National Archaeological Museum, Athens.* Los Angeles.

Kampen, N. 1981. *Image and Status: Roman Working Women in Ostia.* Berlin.

———. 1995. "On Not Writing the History of Roman Art," *Art Bulletin* 77(3): 375–78.

———. 1997. "Democracy and Debate: Otto Brendel's 'Prolegomena to a Book on Roman Art,'" *Transactions of the American Philological Association* 127: 381–88.

———. 2006. "The Art of Soldiers on a Roman Frontier: Style and the Antonine Wall," in E. D'Ambra and G. P. R. Métraux, eds., *The Art of Citizens, Soldiers and Freedmen in the Roman World.* Oxford: 125–34.

Kästner, U. 2016. "The German Excavations at Pergamon: A Chronology," in C. A. Picón and S. Hemingway, eds., *Pergamon and the Hellenistic Kingdoms of the Ancient World.* New York: 27–31.

Kaufmann, T. D. 1978. "Remarks on the Collections of Rudolf II: The *Kunstkammer* as a Form of *Representatio,*" *Art Journal* 38(1): 22–8.

Kay, N. M. 2001. *Ausonius: Epigrams.* London.

Kear, J. M. 1999. "Victorian Classicism in Context: Sir E. J. Poynter (1836–1919) and the Classical Heritage." Doctoral dissertation, University of Bristol.

Keating, J., and L. Markey. 2011. "'Indian' Objects in Medici and Austrian-Habsburg Inventories: A Case-Study of the Sixteenth-Century Term," *Journal of the History of Collections* 23(2): 283–300.

Keesling, C. M. 2003. *The Votive Statues of the Athenian Acropolis.* Cambridge.

———. 2015. Review of V. Azoulay, *Les Tyrannicides d'Athènes: Vie et mort de deux statues. L'Univers historique, Bryn Mawr Classical Review* 2015.01.23, http://bmcr.brynmawr.edu/2015/2015-01-23.html (last accessed 2 August 2016).

Kelley, D. R. 1998. *Faces of History: Historical Inquiry from Herodotus to Herder.* New Haven and London.

Kennedy, J. 1769. *A Description of the Antiquities and Curiosities in Wilton-House.* Salisbury.

Kent, F. W. 2004. *Lorenzo de' Medici and the Art of Magnificence.* Baltimore.

Kenworthy-Browne, J. 1983. "Matthew Brettingham's Rome Account Book 1747–1754," *The Walpole Society* 49: 37–132.

———. 1993. "Designing Around the Statues: Matthew Brettingham's Casts at Kedleston," *Apollo* 137: 248–50.

Kermode, F. 2004. *Pleasure and Change: The Aesthetics of Canon.* Oxford.

Kiilerich, B. 1993. *Late Fourth Century Classicism in the So-Called Theodosian Renaissance.* Copenhagen.

Kimball, F. 1943. "Jefferson and the Arts," *Proceedings of the American Philosophical Society* 87(3): 238–45.

King, D. 2006. *The Elgin Marbles.* London.

King, H. 1994. "Sowing the Field: Greek and Roman Sexology," in R. Porter and M. Teich, eds., *Sexual Knowledge, Sexual Science: The History of Attitudes to Sexuality.* Cambridge: 29–46.

King, T. A. 2008. *The Gendering of Men, 1600–1750,* vol. 2, *Queer Articulations.* Wisconsin.

Kinney, D. 1997. "*Spolia, Damnatio,* and *Renovatio Memoriae,*" *Memoirs of the American Academy in Rome* 42: 117–48.

Klein, W. 1886. *Euphronios: Eine Studie zur Geschichte der griechischen Malerei.* Vienna.

Kleiner, F. S. 2012. *Gardner's Art through the Ages: A Concise Global History.* Boston.

Kleinhenz, C. 2004. *Medieval Italy: An Encyclopedia.* Abingdon.

Knowles, J. 1831. *The Life and Writing of Henry Fuseli,* vol. 1. London.

Koortbojian, M. 2000. "Pliny's Laocoon?" in A. Payne, A. Kuttner, and R. Smick, eds., *Antiquity and Its Interpreters.* Cambridge: 199–216.

———. 2011. "Renaissance *Spolia* and Renaissance Antiquity (One Neighborhood, Three Cases)," in R. Brilliant and D. Kinney, eds., *Reuse Value: Spolia and Appropriation in Art and Architecture from Constantine to Sherrie Levine.* Farnham: 149–65.

Koortbojian, M., and R. Webb. 1993. "Isabella D'Este's Philostratos," *Journal of the Warburg and Courtauld Institutes* 56: 260–67.

Kort, P., and M. Hollein. 2005. *Rodin, Beuys*. Düsseldorf.

Kosmetatou, E. 2004. "'Persian' Objects in Classical and Early Hellenistic Inventory Lists," *Museum Helveticum* 61: 139–70.

Kosmin, P. J. 2014. *The Land of the Elephant Kings: Space, Territory, and Ideology in the Seleucid Empire*. Cambridge, MA and London.

Kousser, R. M. 2008. *Hellenistic and Roman Ideal Sculpture: The Allure of the Classical*. Cambridge.

Kragelund, P., M. Moltesen, and J. Stubbe Østergaard. 2003. *The Licinian Tomb: Fact or Fiction?* Meddelelser fra Ny Carlsberg Glyptotek 5. Copenhagen.

Krautheimer, R. 1942. "The Carolingian Revival of Early Christian Architecture," *Art Bulletin* 24(1): 1–38.

———. 1953. "Ghiberti and the Antique," *Renaissance News* 6(2): 24–26.

———. 1980. *Rome: Profile of a City, 312–1308*. Princeton.

Kreikenbom, D. 1990. *Bildwerke nach Polyklet. Kopienkritische Untersuchungen zu den männlichen statuarischen Typen nach polykletischen Vorbildern. "Diskophoros", Hermes, Doryphoros, Herakles, Diadumenos*. Berlin.

———. 2013. "Originale und Kopien: Signaturen an späthellenistischen und kaiserzeitlichen Skulpturen," in N. Hegener, ed., *Künstlersignaturen von der Antike bis zur Gegenwart*. Petersberg: 60–73.

Krevans, N. 2004. "Callimachus and the Pedestrian Muse," in A. Harder et al., eds., *Callimachus II*. Hellenistic Groningana 6. Groningen: 173–84.

Kristeller, P. O. 1951. "The Modern System of the Arts: A Study in the History of Aesthetics Part I," *Journal of the History of Ideas* 12(4): 496–527.

Kristensen, T. M. 2009. "Religious Conflict in Late Antique Alexandria: Christian Responses to 'Pagan' Statues in the Fourth and Fifth Centuries AD," in G. Hinge and J. Krasilnikoff, eds., *Alexandria: A Cultural and Religious Melting Pot*. Aarhus: 158–75.

Kristensen, T. M., and B. Poulsen, eds. 2012. *Ateliers and Artisans in Roman Art and Archaeology*. Journal of Roman Archaeology Supplement 92. Portsmouth, RI.

Krumeich, R. 2007. "Kritios und Nesiotes," in S. Kansteiner, L. Lehmann, B. Seidensticker, and K. Stemmer, eds., *Text und Skulptur: Berühmte Bildhauer und Bronzegießer der Antike in Wort und Bild*. Berlin and New York: 8–14.

Kuntz, U. S. 1994. "Griechische Reliefs aus Rom und Umgebung," in G. Hellenkemper Salies, ed., *Das Wrack: Der antike Schiffsfund von Mahdia*, vol. 2. Cologne: 889–900.

Kunze, C. 1991. "Dall'originale Greco all copia romana," in E. Pozzi, ed., *Il Toro Farnese; La 'montagna di marmo' tra Roma e Napoli*. Naples: 13–42.

———. 1998. *Der Farnesische Stier und die Dirkegruppe des Apollonios und Tauriskos*. Berlin.

Kurtz, D. 1985. "Beazley and the Connoisseurship of Greek Vases," *Greek Vases in the J. Paul Getty Museum* 2: 237–50.

———. 2008. "The Concept of the Classical Past in Tudor and Early Stuart England," *Journal of the History of Collections* 20(2): 189–204.

Kurzweil, H., L. V. Gagion, and L. De Walden. 2005. "The Trial of the Sevso Treasure," in K. F. Gibbon, ed., *Who Owns the Past? Cultural Policy, Cultural Property and the Law*. New Brunswick: 83–96.

Kuttner, A. 1995. "Republican Rome Looks at Pergamon," *Harvard Studies in Classical Philology* 97: 157–78.

———. 1999. "Culture and History at Pompey's Museum," *Transactions of the American Philological Society* 129: 343–73.

———. 2005. "Cabinet Fit for a Queen: The Λιθικά as Posidippus' Gem Museum," in K. Gutzwiller, ed., *The New Posidippus: A Hellenistic Poetry Book*. Oxford: 141–63.

———. 2014. "Hellenistic Court Collecting from Alexandros to the Attalids," in M. W. Gahtan and D. Pegazzano, eds., *Museum Archetypes and Collecting in the Ancient World*. Leiden: 45–53.

Kuwakino, K. 2013. "The Great Theatre of Creative Thought: The *Inscriptiones vel tituli theatri amplissimi . . .* (1565) by Samuel von Quiccheberg," *Journal of the History of Collections* 25(3): 303–24.

Kynan-Wilson, W. 2013. "Rome and Romanitas in Anglo-Norman Text and Image (circa 1100–circa 1250)." Doctoral dissertation, Cambridge.

Lacan, J. 1966. *Écrits*. Paris.

Lake, P., and S. Pincus. 2006. "Rethinking the Early Modern Public Sphere," *Journal of British Studies* 45(2): 270–92.

———, eds. 2007. *The Politics of the Public Sphere in Early Modern England*. Manchester.

Landino, C. [c. 1446–47] 1939. *Christophori Landini carmina Omnia*, ed. A. Perosa. Florence.

Landwehr, C. 1982. *Griechische Meisterwerke in römischen Abgüssen: Der Fund von Baia*. Frankfurt.

———. 1985. *Die antiken Gipsabgüsse aus Baiae: Griechische Bronzestatuen in Abgüssen römischer Zeit*. Berlin.

Lapatin, K. D. S. 2001. *Chryselephantine Statuary in the Ancient Mediterranean World*. Oxford.

———. 2011. "The Getty Villa: Art, Architecture, and Aristocratic Self-Fashioning in the Mid-Twentieth

Century," in S. Hales and J. Paul, eds., *Pompeii in the Public Imagination from Its Rediscovery to Today*. Oxford: 270–85.

La Regina, A. 1991. "Tabulae Signorum Urbis Romae," in M. R. di Mino, ed., *Rotunda Diocletiani: Sculture decorative delle terme nel Museo Nazionale Romano*. Rome: 3–8.

La Rocca, E. 1985. *Amazzonomachia: Le sculture frontale del Tempio di Apollo Sosiano*. Rome.

———. 1988. "Der Apollo-Sosianus-Tempel," in W. D. Heilmeyer, E. La Rocca, and H. G. Martin, eds., *Kaiser Augustus und die verlorene Republik*. Mainz am Rhein: 121–36.

———. 2001. "La nuova imagine dei fori Imperiali," *Mitteilungen des Deutschen Archäologischen Instituts, Römische Abteilung* 108: 171–203.

La Rocca, E., C. P. Presicce, A. Lo Monaco, C. Giroire, and D. Roger, eds. 2013. *Augusto*. Milan.

Lattimore, S. 1987. "Skopas and the Pothos," *American Journal of Archaeology* 91(3): 411–20.

Laubscher, H. P. 2000. "Beobachtungen zu tetrarchischen Kaiserbildnissen aus Porphyr," *Jahrbuch des Deutschen Archäologischen Instituts* 114: 207–52.

Laurencich-Minelli, L. 1985. "Museology and Ethnographical Collections in Bologna during the Sixteenth and Seventeenth Centuries," in O. Impey and A. MacGregor, eds., *The Origins of Museums: The Cabinet of Curiosities in Sixteenth- and Seventeenth-Century Europe*. Oxford: 17–23.

Lavin, I. 1998. "Ex Uno Lapide: The Renaissance Sculptor's Tour de Force," in M. Winner, B. Andreae, and C. Pietrangeli, eds., *Il Cortile delle Statue: Der Statuenhof des Belvedere im Vatikan*. Mainz: 191–210.

Lazzarini, M. L., and F. Zevi. 1988–89. "Necrocorinthia a Pompei: Una idria bronzea per le gare di Argo," *Prospettiva* 53–56: 33–48.

———. 1992. "Hydria bronzea da Pompei," *Atti e Memorie della Società Magna Grecia* 3: 91–97.

Lazzeretti, A. 2014. "Verres, Cicero and Other Collectoris in Late Republican Rome," in M. W. Gahtan and D. Pegazzano, eds., *Museum Archetypes and Collecting in the Ancient World*. Leiden: 91–101.

Lea, R. 2009. "The Whitby Gladiator," *English Heritage Historical Review* 4(1): 84–97.

Leach, E. W. 1988. *The Rhetoric of Space: Literary and Artistic Representations of Landscape in Republican and Augustan Rome*. Princeton.

Leander Touati, A.-M. 1998. *Ancient Sculptures in the Royal Museum: The Eighteenth-Century Collection in Stockholm*. Stockholm.

Lechat, H. 1890. "Observations sur les statues archaïques de type feminine du Musée de l'Acropole," *Bulletin de Correspondance Hellénique* 14: 301–62 and 552–86.

Lee, E. 1978. *Sixtus IV and Men of Letters*. Rome.

Lee, V. 1881. *Belcaro, Being Essays on Sundry Aesthetical Questions*. London.

Le Grice, H. 1843. "An Essay on Sculpture (continued)," *The Artist and Amateur's Magazine* 1: 343–44.

Lendle, O. 1992. *Einführung in die griechische Geschichtsschreibung: Von Hekataios bis Zosimos*. Darmstadt.

Lenormant, C. 1844. "Archéologie," *Revue Archéologique: Revue des Musées Nationaux* 1: 1–17.

Lenormant, F. 1877. "La Vénus de l'Esquilin et le Diadumène de Polyclète," *Gazette Archéologique* 3: 138–52.

Lenzo, F. 2014. *Memoria e identità civica: L'architettura dei seggi nel regno di Napoli XIII–XVIII secolo*. Rome.

Leonardos, B. I. 1895. "Κοῦρος ἐξ Ἀττικῆς," *Archaiologike Ephemeris*: 75–83.

Leone, A. 2013. *The End of the Pagan City: Religion, Economy and Urbanism in Late Antique North Africa*. Oxford.

Lepelley, C. 1994. "Le musée des statues divines: La volonté de sauvegarder le patrimoine artistique païen à l'époque théodosienne," *Cahiers Archéologiques* 42: 5–15.

———. 2000–2001. "Recherches sur le paganism au temps de l'empire chrétien," *Annaire de l'École Pratique des Hautes Etudes, Section des Sciences Religieuses* 109: 339–44.

Lessing, G. E. [1766] 2007. *Laokoon / Briefe, antiquarischen Inhalts: Text und Kommentar*, ed. W. Barner. Frankfurt am Main.

Le Vane, E., and J. P. Getty, eds. 1955. *Collector's Choice*. London.

Lever, W. H. 1927. *Viscount Lever, by His Son*. London.

Lewis, W. S. 1937–83. *The Yale Edition of Horace Walpole's Correspondence*, 48 vols. New Haven and Oxford.

Liddel, P. 2014. "From Chronography to Liberal Imperialism: Greek Inscriptions, the History of Greece, and Historiography from Selden to Grote," *Journal of the History of Collections* 26(3): 387–98.

Liebenwein, W. 1977. *Studiolo: Die Entstehung eines Raumtyps und seine Entwicklung bis zum 1600*. Berlin.

Lieu, S. N. C., and D. Montserrat. 1996. *From Constantine to Julian: Pagan and Byzantine Views: A Source History*. London and New York.

Lightfoot, C. S. 2016. "Royal Patronage and the Luxury Arts," in C. Picòn and S. Hemingway, eds., *Pergamon and the Hellenistic Kingdoms of the Ancient World*. New York: 77–83.

Linders, T. 1972. *Studies in the Treasure Records of Artemis at Brauronia Found in Athens*. Stockholm.

———. 1988. "The Purpose of Inventories: A Close Reading of the Delian Inventories of the Indepen-

dence," in D. Knoefler, ed., *Comptes et inventaires dans la cité grecque*. Neuchâtel: 37–47.

Lipińska, A. 2014. *Moving Sculptures: Southern Netherlandish Alabasters from the 16th to 17th Centuries in Central and Northern Europe*. Leiden and Boston.

Lissarrague, F. 2004. "Comment citer en image? Quelques variations grecques," in C. Darbo-Peschanski, ed., *La citation dans l'antiquité*. Grenoble: 103–8.

———. 2009. "Les temps des boucliers," in G. Careri, F. Lissarrague, J. C. Schmitt, and C. Severi, eds., *Tradition et temporalité des images*. Paris: 25–35.

Liverani, P. 2004. "Arco di onorio, Arco di portogallo," *Bullettino della Commissione Archeologica Comunale di Roma* 105: 351–70.

———. 2011. "Reading *Spolia* in Late Antiquity and Contemporary Perception," in R. Brilliant and D. Kinney, eds., *Reuse Value: Spolia and Appropriation in Art and Architecture from Constantine to Sherrie Levine*. Farnham: 33–51.

———. 2014. "The Culture of Collecting in Roma: Between Politics and Administration," in M. W. Gahtan and D. Pegazzano, eds., *Museum Archetypes and Collecting in the Ancient World*. Leiden: 72–77.

Liversidge, M., and C. Edwards. 1996. *Imagining Rome: British Artists and Rome in the Nineteenth Century*. London.

Lleó Cañal, V. 1979. *Nueva Roma: Mitología y humanism en el renacimiento sevillano*. Seville.

———. 1998. *La Casa de Pilatos*. Madrid.

Lockyer, R. 1981. *The Life and Political Career of George Villiers, First Duke of Buckingham, 1592–1628*. London.

Lodico, D. 2007. "La collezione della famiglia Sassi," in A. Cavallaro, ed., *Collezioni di antichità a Roma tra '400 e '500*. Rome: 187–204.

Loewy, E. 1885. *Inschriften griechischer Bildhauer*. Leipzig.

Lollio Barberi, O., G. Parola, and M. P. Toti. 1995. *Le antichità egiziane di Roma imperiale*. Rome.

L'Orange, H. P., and A. van Gerkan. 1939. *Der Spätantike Bildschmuck des Konstantinsbogens*. Berlin.

Lorenzatti, S. 2013. "De Benghazi a Versailles: Histoire et réception d'une statue entre XVIIe et XXe siècles," *Archeologia Classica* 64: 677–718.

Luciano, E., C. Kryza-Gersch, and S. Campbell. 2011. *Antico: The Golden Age of Renaissance Bronzes*. Washington.

Luke, Y. 1996. *Quatremère de Quincy's Role in the Revival of Polychromy in Sculpture*. Leeds.

Lullies, R. 1957. *Greek Sculpture*, trans. M. Bullock. London.

———. 1979. *Griechische Plastik: Von den Anfängen bis zum Beginn der römischen Kaiserzeit*. Munich.

Lyons, C. L. 2005. "The Art and Science of Antiquity in Nineteenth-Century Photography," in C. L. Lyons, J. Papadopoulos, L. S. Stewart, and A. Szegedy-Maszak, eds., *Antiquity and Photography: Early Views of Ancient Mediterranean Sites*. Los Angeles: 22–65.

Ma, J. 2013. *Statues and Cities: Honorific Portraits and Civic Identity in the Hellenistic World*. Oxford Studies in Ancient Culture and Representation. Oxford.

MacDonald, W. L., and J. A. Pinto. 1995. *Hadrian's Villa and Its Legacy*. New Haven and London.

MacGregor, A. 1983a. *Ark to Ashmolean: The Story of the Tradescants, Ashmole and the Ashmolean Museum*. Oxford.

———, ed. 1983b. *Tradescant's Rarities: Essays on the Foundation of the Ashmolean Museum, 1683, with a Catalogue of the Surviving Early Collections*. Oxford.

———. 2014. "Aristocrats and Others: Collectors of Influence in Eighteenth-Century England," in I. Reist, ed., *British Models of Art Collecting and the American Response: Reflections across the Pond*. Farnham and Burlington, VT: 73–86.

Machado, R. 2006. "Building the Past: Monuments and Memory in the Forum Romanum," in W. Bowden, A. Gutteridge, and C. Marchado, *Social and Political Life in Late Antiquity*. Late Antique Archaeology 3.1. Leiden: 157–92.

MacLeod, C. 1998. *Embodying Antiquity: Androgyny and Aesthetics from Winckelmann to Keller*. Michigan.

MacPherson, R. 1863. *Vatican Sculptures, Selected and Arranged in the Order in which they are Found in the Galleries*. London.

Madden, T. F. 1992. "The Serpent Column of Delphi in Constantinople: Placement, Purposes, and Mutilations," *Byzantine and Modern Greek Studies* 16: 111–45.

Maderna, C. 2005. "Ägypten—phantastische 'römische' Welt," in H. Beck, P. C. Bol, and M. Bückling, eds., *Ägypten – Griechenland – Rom: Abwehr und Berührung*. Tübingen: 434–45.

Maffei, S. 1999. "La fama di Laocoonte nei testi dei cinquecento," in S. Settis and S. Maffei, *Laocoonte: Fama e stile*. Rome: 98–230.

Maffioli, M. 2003. "Fratelli Alinari: A Family of Photographers. 1852–1920," in C.-H. Favrod, M. Maffioli, Z. Ciuffoletti, and E. Sesti, eds., *Fratelli Alinari: Photographers in Florence*. Florence: 11–30.

Magdalino, P. 1988. "The Bath of Leo the Wise and the Macedonian Renaissance Revisited," *Dumbarton Oaks Papers* 42: 97–118.

Maginn, W. 1856. *The Shakespeare Papers of the Late William Maginn, LL.D.*, ed. S. MacKenzie. New York.

Magnuson, T. 1958. *Studies in Roman Quattrocento Architecture*. Stockholm.

Maguire, E. D., and H. Maguire. 2007. *Other Icons: Art and Power in Byzantine Secular Culture*. Princeton.

Maguire, H., and R. S. Nelson, eds. 2010. *San Marco, Byzantium, and the Myths of Venice*. Washington, DC.

Mainardi, P. 1989. "Assuring the Empire of the Future: The 1768 Fête de la Liberté," *Art Journal* 48: 155–63.

Malamud, M., and D. T. McGuire, Jr. 2001. "Living Like the Romans in Las Vegas: The Roman World at Caesar's Palace, 1966," in S. Joshel, M. Malamud, and D. T. McGuire, eds., *Imperial Projections: Ancient Rome in Modern Popular Culture*. Baltimore: 249–69.

Malgouyres, P. 1999. *Le musée Napoléon*. Paris.

Mandler, P. 1997. *The Fall and Rise of the Stately Home*. New Haven and London.

Mango, C. 1963. "Antique Statuary and the Byzantine Beholder," *Dumbarton Oaks Papers* 17: 53–75.

———. 1991. "The Palace of Marina, the Poet Palladas and the Bath of Leo VI," Ευφρόσυνον: Αφιέρωμα στον Μανώλη Χατζηδάκη 1: 321–30.

Mango, C., M. Vickers, and E. D. Francis. 1992. "The Palace of Lausus at Constantinople and Its Collection of Ancient Statues," *Journal of the History of Collections* 4(1): 89–98.

Maral, A., and N. Milovanovic, eds. 2012. *Versailles et l'antique*. Paris.

Marcello, F. 2011. "Mussolini and the Idealisation of Empire: The Augustan Exhibition of Romanità," *Modern Italy* 16(3): 223–47.

Marchand, S. 1997. "The Excavations at Olympia: An Episode in German-Greek Cultural Relations," in P. Carabott, ed., *Greek Society in the Making, 1863–1913*. London: 73–85.

Marcos, D. 2016. "Vom Monster zur Marke—Neros Karriere in der Kunst," in J. Merten, ed., *Nero: Kaiser, Künstler und Tyrann*. Darmstadt: 354–68.

Mari, Z. 2008. "The 'Egyptian Places' of Hadrian's Villa," in A. Lo Sardo, ed., *The She-Wolf and the Sphinx: Rome and Egypt from History to Myth*. Milan: 122–31.

Mari, Z., and S. Sgalambro. 2007. "The Antinoeion of Hadrian's Villa: Interpretation and Architectural Reconstruction," *American Journal of Archaeology* 111(1): 83–104.

Markner, R., and G. Veltri, eds. 1999. *Friedrich August Wolf: Studien, Dokumente, Bibliographie*. Stuttgart.

Marlowe, E. 2013. *Shaky Ground: Context, Connoisseurship and the History of Roman Art*. London.

Marr, A. 2010. "The Flemish 'Pictures of Collections' Genre, an Overview," *Intellectual History Review* 20(1): 5–25.

Marsden, J. 2010. *Victoria and Albert in Love*. London.

Martelli, A. 2002. "Per una nuova lettura dell'inscrizione Vetter 61 nel contesto del Santuario di Apollo a Pompei," *Eutopia* 2(2): 71–81.

Martindale, A. 1964. "The Patronage of Isabella d'Este at Mantua," *Apollo* 79: 183–91.

Martindale, C., S. Evangelista, and E. Prettejohn, eds. 2017. *Pater the Classicist*. Oxford.

Martins de Jesus, C. 2014. "The Statuary Collection Held at the Baths of Zeuxippus (*AP* 2) and the Search for Constantine's Museological Intentions," *Synthesis* 21, http://www.synthesis.fahce.unlp.edu.ar/article/view/SYNv21a02/html_12 (last accessed 3 August 2016).

Marvin, M. 1989. "Copying in Roman Sculpture," in K. Precidado, ed., *Retaining the Original: Multiple Originals, Copies, and Reproductions*. Washington, DC: 29–45.

———. 1993. "Copying in Roman Sculpture: The Replica Series," in E. D'Ambra, ed., *Roman Art in Context: An Anthology*. Englewood Cliffs, NJ: 161–88.

———. 1997. "Roman Sculptural Reproductions, or Polykleitos the Sequel," in A. Hughes and E. Ranfft, eds., *Sculpture and Its Reproductions*. London: 7–28.

———. 2008. *The Language of the Muses: The Dialogue between Roman and Greek Sculpture*. Los Angeles.

Marx, B. 2007. "Wandering Objects, Migrating Artists: The Appropriation of Italian Renaissance Art by German Courts in the Sixteenth Century," in H. Roodenburg, ed., *Forging European Identities, 1400–1700*. Cultural Exchange in Early Modern Europe 4. Cambridge: 178–226.

Marzano, A. 2007. *Roman Villas in Central Italy: A Social and Economic History*. Columbia Studies in the Classical Tradition 30. Leiden.

Massinelli, A. M. 1991. *Bronzetti e anticaglie dalla Guardaroba di Cosimo I*. Florence.

Masson-Berghoff, A., and F. Goddio. 2016. "Greek Kings and Egyptian Gods," in F. Goddio and A. Masson-Berghoff, *Sunken Cities: Egypt's Lost Worlds*. London: 73–137.

Mathews, T. F. 1993. *The Clash of Gods: A Reinterpretation of Early Christian Art*. Princeton.

———. 1999. *The Clash of Gods: A Reinterpretation of Early Christian Art*, revised and expanded edition. Princeton.

Mathieux, N. 2010. "Tanagras in Paris: A Bourgeois Dream," in V. Jeammet, ed., *Tanagras: Figurines for Life and Eternity*. Paris: 17–19.

Matthews, T. 1911. *The Biography of John Gibson, RA, Sculptor, Rome*. London.

Mattusch, C. C. 1988. *Greek Bronze Statuary: From the Beginnings through the Fifth Century B.C.* Ithaca.

———. 1997. *The Victorious Youth*. Malibu.

———. 2005. *The Villa dei Papiri at Herculaneum: Life and Afterlife of a Sculpture Collection.* Los Angeles.

———. 2008. *Pompeii and the Roman Villa: Art and Culture around the Bay of Naples.* Washington, DC.

Matusova, E. 2015. *The Meaning of the Letter of Aristeas.* Göttingen.

Mauro, L. 1562. *Le antichità della città di Roma.* Venice.

Mayer, C. A., and D. Bentley-Cranch. 1983. "Florimond Robertet: Italianisme et Renaissance française," in *Mélanges à la mémoire de Franco Simone,* vol. 4. Geneva: 135–49.

Mayor, A. 2000. *The First Fossil Hunters: Paleontology in Greek and Roman Times.* Princeton.

Mayor, E. R. 1987. "The Sculpture Collection of the Second Marquis of Rockingham at Wentworth Woodhouse." Masters thesis, Sheffield City Polytecnic, now Sheffield Hallam University.

Mazzoni, C. 2010. *She-Wolf: The Story of a Roman Icon.* Cambridge.

McCauley, E. A. 2011. "Fauning Over Marbles: Robert and Gerardine Macpherson's Vatican Sculptures and the Role of Photographs in the Reception of the Antique," *Studies in the History of Art* 77: 91–122.

McClellan, A. 1994. *Inventing the Louvre: Art, Politics and the Origins of the Modern Museum in Eighteenth-Century Paris.* Cambridge.

———. 2012. "Musée du Louvre, Paris: Palace of the People, Art for All," in C. Paul, ed., *The First Modern Museums of Art: The Birth of an Institution in 18th- and Early-19th-Century Europe.* Los Angeles: 213–36.

McCormick, T. J. 1990. *Charles-Louis Clérisseau and the Genesis of Neo-Classicism.* New York.

McDermott, W. C. 1983. "Mamurra, Eques Formianus," *Rheinisches Museum für Philologie* 126: 292–307.

McDonnell, M. 2006. "Roman Aesthetics and the Spoils of Syracuse," in S. Dillon and K. E. Welch, eds., *Representations of War in Ancient Rome.* Cambridge: 68–90.

McGowan, M. 2000. *The Vision of Rome in Late Renaissance France.* New Haven and London.

McHam, S. B. 2013. *Pliny and the Artistic Culture of the Italian Renaissance: The Legacy of the Natural History.* New Haven.

Mcnelis, C. 2008. "*Ut Sculptura Poesis*: Statius, Martial, and the Hercules *Epitrapezios* of Novius Vindex," *American Journal of Philology* 129: 255–76.

McNutt, J. 1990. "Plaster Casts after Antique Sculpture: Their Role in the Elevation of Public Taste and in American Art Instruction," *Studies in Art Education* 31(3): 158–67.

Medri, L. 1978. "Ghiberti e gli umanisti: La collezione di Lorenzo Ghiberti," in *L. Ghiberti: Materia e ragionamenti.* Florence: 559–67.

Meiggs, R., and D. M. Lewis. 1969. *A Selection of Greek Historical Inscriptions to the End of the Fifth Century B.C.* Oxford.

Meister, K. 2004. "Duris of Samos," in *New Pauly: Brill's Encyclopaedia of the Ancient World,* vol. 4. Leiden: 747.

Merker, G. S. 2000. *The Sanctuary of Demeter and Kore: Terracotta Figurines of the Classical, Hellenistic, and Roman Periods.* Princeton.

Merrony, M., ed. 2011. *Mougins Museum of Classical Art.* Mougins.

Meyboom, P. G. P. 1995. *The Nile Mosaic of Palestrina: Early Evidence of Egyptian Religion in Italy.* Leiden and New York.

Meyer, H. 1991. *Antinoos: Die archäologischen Denkmäler unter Einbeziehung des numismatischen und epigraphischen Materials sowie der literarischen Nahrichten.* Munich.

Michaelis, A. 1882. *Ancient Marbles in Great Britain,* trans. C. A. M. Fennell. Cambridge.

———. 1906. *Die archäologischen Entdeckungen des neunzehnten Jahrhunderts.* Leipzig.

———. 1908. *A Century of Archaeological Discoveries.* London.

Michel, P. 1999. *Mazarin, prince des collectionneurs: Les collections et l'ameublement du Cardinal Mazarin (1602–1661): histoire et analyse.* Paris.

Middleton, R. 1999. "Soane's Spaces and the Matter of Fragmentation," in M. Richardson and M. A. Stevens, eds., *John Soane Architecture: Master of Light and Space.* London: 26–37.

Mielsch, H. 1995. "Die Bibliothek und die Kunstsammlung der Könige von Pergamon," *Archäologischer Anzeiger*: 765–79.

Miglio, M. 1984. "Roma dopo Avignone: La rinascita politica dell'antico," in S. Settis, ed., *Memoria dell'antico nell'arte italiana,* vol. 1, *L'uso dei classici.* Turin: 77–111.

Miles, M. M. 2008. *Art as Plunder: The Ancient Origins of Debate about Cultural Property.* Cambridge.

———. 2011. "Still in the Aftermath of Waterloo: A Brief History of Decisions about Restitution," in P. G. Stone, ed., *Cultural Heritage, Ethics and the Military.* Chippenham and Eastbourne: 29–42.

———. 2014. "Collecting the Past, Creating the Future: Art Displays in the Hellenistic Mediterranean," in M. W. Gahtan and D. Pegazzano, eds., *Museum Archetypes and Collecting in the Ancient World.* Leiden: 33–44.

Millar, O. 1972. *The Inventories and Valuations of the King's Goods 1649–1651.* The Walpole Society 43. London.

Miller, M. M. 1997. *Athens and Persia in the Fifth Century B.C.: A Study in Cultural Receptivity.* New York.

Millin, A.-L. 1808. *Dictionnaire des Beaux-Arts*, 3 vols. Paris.

Mitchell, L. M. 1883. *History of Ancient Sculpture*. London.

Mitchell, W. J. T. 1984. "The Politics of Genre: Space and Time in Lessing's Laocoon," *Representations* 6: 98–115.

Mitter, P. 1977. *Much Maligned Monsters: A History of European Reactions to Indian Art*. Oxford.

Modigliani, A. 2003. "Paolo II e il sogno abbandonato di una piazza imperial," in *Antiquaria a Roma: Intorno a Pomponio Leto e Paolo II*. Rome: 125–61.

Moggi, M. 1973. "I furti di statue attribuiti a Serse e le relative restituzioni," *Annali della Scuola Normale di Pisa* 3(3): 1–42.

Mol, E. M. 2015. "Egypt in Material and Mind: The Use and Perception of Aegyptiaca in Roman Domestic Contexts of Pompeii." Doctoral dissertation, Leiden.

Moltesen, M. 2004. "Carl Jacobsen and W. Helbig: Perfect Partners in Ancient Art," in *Ancient Art to Post-Impressionism: Masterpieces from the Ny Carlsberg Glyptotek, Copenhagen*. London: 14–17.

———. 2012. *Perfect Partners: The Collaboration between Carl Jacobsen and His Agent in Rome Wolfgang Helbig in the Formation of the Ny Carlsberg Glyptotek 1887–1914*. Copenhagen.

Montanari, F. 2002. "Apollodorus of Athens," in *New Pauly: Brill's Encyclopaedia of the Ancient World*, vol. 1. Leiden: 859.

Montel, S. 2010. "The Architectural Setting of the Aphrodite of Knidos," in A. C. Smith and S. Pickup, eds., *Brill's Companion to Aphrodite*. Leiden: 251–68.

Montfaucon. B. de. 1722. *L'antiquité expliquée et représentée en figures*, 2ⁿᵈ edn. Paris.

Montgomery-Massingberd, H., and C. S. Sykes. 1994. *Great Houses of England and Wales*. London.

Moore, A. H. 2002. "Voyage: Dominique-Vivant Denon and the Transference of Images of Egypt," *Art History* 25(4): 531–49.

Moore, J. 2010. "'Marble Mad and Very Extravagant': Henry Ince Blundell and the Politics of Cultural Reputation in Britain and Italy," in R. Loretelli and F. O'Gorman, eds., *Britain and Italy in the Long Eighteenth Century: Literary and Art Theories*. Newcastle Upon Tyne: 238–56.

Morales, H. 2005. *Vision and Narrative in Achilles Tatius' Leucippe and Clitophon*. Cambridge.

———. 2011. "Fantasising Phryne: The Psychology and Ethics of Ekphrasis," *Cambridge Classical Journal* 57: 71–104.

Morelli, G. [1890] 1900. *Italian Painters: Critical Studies of Their Work*, trans. C. J. Ffoulkes. London.

Moreno, P. 1982. "Il Farnese ritrovato ed altri tipi di Eracle in riposo," *Mélanges de l'Ecole Française de Rome et d'Athènes* 94: 379–526.

———. 1995. *Lisippo: L'arte e la fortuna*. Rome.

———. 2003. "Satiro di Prassitele," in R. Petriaggi, ed., *Il Satiro danzante*. Milan: 102–13.

Moreno, P., and C. Stefani. 2000. *The Borghese Gallery*. Milan.

Morgan, K. 2015. *Pindar and the Construction of Syracusan Monarchy in the Fifth Century B.C.* Oxford.

Morgan, L. 2009. "Isaac de Caus invenit," *Studies in the History of Gardens & Designed Landscapes* 29(3): 141–51.

Mountford, J. F., ed. 2006. *Bradley's Arnold Latin Prose Composition: Foreword and Updates by Donald E. Sprague*. Wauconda, IL.

Muir, E. 1979. "Images of Power: Art and Pageantry in Renaissance Venice," *American Historical Review* 84(1): 16–52.

Muller, J. M. 1977. "Rubens's Museum of Antique Sculpture: An Introduction," *Art Bulletin* 59(4): 571–82.

———. 1989. *Rubens, the Artist as Collector*. Princeton.

Müller, K. O. 1830. *Handbuch der Archäologie der Kunst*. Breslau.

———. 1847. *Ancient Art And Its Remains: Or A Manual of the Archaeology of Art*, trans. J. Leitch. London.

Murray, J. 1858. *A Handbook of Rome and Its Environs; Forming Part II of the Handbook for Travellers in Central Italy*. London.

Mylonopoulos, I. 2006. "Greek Sanctuaries as Places of Communication through Rituals: An Archaeological Perspective," in E. Stavrianopoulou, ed., *Ritual and Communication in the Graeco-Roman World*. Kernos supplement 16. Liège: 69–110.

Nagel, A., and C. Wood. 2010. *Anachronic Renaissance*. Brooklyn.

Nagy, G. 1998. "The Library of Pergamon as a Classical Model," in H. Köster, ed., *Pergamon: Citadel of the Gods*. Cambridge, MA: 185–232.

Narducci, E. 1859. *La Composizione del Mondo di Ristoro d'Arezzo: Testo Italiano del 1282*. Rome.

Nasrallah, L. S. 2010. *Christian Responses to Roman Art and Architecture: The Second-Century Church Amid the Spaces of Empire*. New York and Cambridge.

Naumann, R. 1966. "Die antike Rundbau beim Myrelaion und der Palast Romanos I Lekpenos," *Istanbuler Mitteilungen* 16: 209–11.

Nead, L. 2007. *The Haunted Gallery: Painting, Photography, Film c. 1900*. New Haven and London.

Neal, D. S., and S. R. Cosh. 2002. *The Roman Mosaics of Britain*, vol. 1. London.

Neer, R. T. 1997. "Beazley and the Language of Connoisseurship," *Hephaistos* 15: 7–30.

———. 2010. *The Emergence of the Classical Style in Greek Sculpture*. Chicago.

———. 2012. *Art and Archaeology of the Greek World: A New History, c. 2500–c. 150 BCE*. London.

Nehamas, A. 2007. *Only a Promise of Happiness: The Place of Beauty in a World of Art*. Princeton and Oxford.

Nelson, R. S. 2000. "The Slide Lecture, or the Work of Art 'History' in the Age of Mechanical Reproduction," *Critical Inquiry* 26(3): 414–34.

———. 2007. "High Justice: Venice, San Marco, and the Spoils of 1204," in P. Vokotopoulos, ed., *Art in the Aftermath of the Fourth Crusade*. Athens: 143–51.

———. 2010. "The History of Legends and the Legends of History: The Pilastri Acritani in Venice," in H. Maguire and R. S. Nelson, eds., *San Marco, Byzantium, and the Myths of Venice*. Washington, DC: 63–90.

Neudecker, R. 2014. "Collecting Culture: Statues and Fragments in Roman Gardens," in M. W. Gahtan and D. Pegazzano, eds., *Museum Archetypes and Collecting in the Ancient World*. Leiden: 129–36.

Neverov, O. 1984. "The Lyde Browne Collection and the History of Ancient Sculpture at the Hermitage Museum," *American Journal of Archaeology* 88(1): 33–42.

———. 1999. "Catherine II émule de l'empereur Hadrien," in J. Charles and H. Lavagne, eds., *Hadrien: Trésors d'une villa impériale*. Paris: 101–6.

Neviani, A. 1936. "Ferrante Imperato speziale e naturalista napoletano con documenti inediti," *Atti e Memorie dell'Accademia di Storia dell'Arte Sanitaria* 2(2): 57–74, 124–45, 191–210, 243–67.

Newby, Z. 2007. "Reading the Archelaos Relief," in Z. Newby and R. Leader- Newby, eds., *Art and Inscriptions in the Ancient World*. Cambridge: 156–78.

Newton, C. T. 1851. "Remarks on the Collections of Ancient Art in the Museums of Italy, the Glyptothek at Munich and the British Museum," *Museum of Classical Antiquities* 1: 205–27.

Nichols, K. 2015. *Greece and Rome at the Crystal Palace: Classical Sculpture and Modern Britain, 1854–1936*. Oxford.

Nicol, D. M. 1988. *Byzantium and Venice: A Study in Diplomatic and Cultural Relations*. Cambridge.

Niemeier, J. P. 1985. *Kopien und Nachahmungen im Hellenismus: Ein Beitrag zum Klassizismus des 2. und frührn 1. Jhs. V. Chr*. Bonn.

Nodelmann, S. 1993. "How to Read a Roman Portrait," in E. D'Ambra, ed., *Roman Art in Context: An Anthology*. Eaglewood Cliffs, NJ: 10–26.

Nodes, D. J. 2006. Review of J. F. Mountford, ed., *Bradley's Arnold Latin Prose Composition. Foreword and Updates by Donald E. Sprague, Bryn Mawr Classical Review* 2006.06.26, http://bmcr.brynmawr .edu/2006/2006-06-26.html (last accessed 7 August 2016).

Noreña, C. 2003. "Medium and Message in Vespasian's *Templum Pacis*," *Memoirs of the American Academy in Rome* 48: 25–43.

Norman, N. J. 1984. "The Temple of Athena Alea at Tegea," *American Journal of Archaeology* 88(2): 169–94.

Northall, J. 1766. *Travels through Italy, Containing New and Curious Observations on that Country*. London.

Novikova, A. 2004. "Virtuosity and Declensions of Virtue: Thomas Arundel and Alethea Talbot Seen by Virtue of a Portrait Pair by Daniel Mytens and a Treatise by Franciscus Junius," in J. de Jong, ed., *Virtus: Virtuositeit en kunstliefhebbers in de Nederlanden, 1500–1700*. Zwolle: 308–33.

Nurse, B., D. Gaimster, and S. McCarthy. 2007. *Making History: Antiquaries in Britain, 1707–2007*. London.

Ohly, D. 1966. "Die Neuaufstellung de Ägineten," *Archäologischer Anzeiger* 4: 515–28.

Olausson, M., and S. Söderlind. 2012. "Nationalmuseum/Royal Museum, Stockholm: Connecting North and South," in C. Paul, ed., *The First Modern Museums of Art: The Birth of an Institution in 18th- and Early-19th-Century Europe*. Los Angeles: 191–211.

Olmi, G. 1985. "Science—Honour—Metaphor: Italian Cabinets of the Sixteenth and Seventeenth Centuries," in O. Impey and A. MacGregor, eds., *The Origins of Museums: The Cabinet of Curiosities in Sixteenth- and Seventeenth-Century Europe*. Oxford: 1–16.

O'Mahony, M. 2014. "In the Shadow of Myron: The Impact of the Discobolos on Representations of Olympic Sport from Victorian Britain to Contemporary China," in T. Terret, ed., *London, Europe and the Olympic Games: Historical Perspectives*. Abingdon = O'Mahony 2013 *International Journal of the History of Sport* 30(7): 693–718.

Omont, H. 1894. "Inventaire des manuscrits grecs et latins donnés à Saint-Marc de Venise par le cardinal Bessarion en 1468," *Revue des Bibliothèques* 4: 129–87.

Onians, J. 1988. *Bearers of Meaning: The Classical Orders in Antiquity, the Middle Ages, and the Renaissance*. Princeton.

———. 1996. "World Art Studies and the Need for a New Natural History of Art," *Art Bulletin* 78(2): 206–9.

———. 1999. *Classical Art and the Cultures of Greece and Rome*. New Haven and London.

Orrells, D. 2015. *Sex: Antiquity and Its Legacy*. London.

Ortiz, G. 1996. *In Pursuit of the Absolute: Art of the Ancient World. From the George Ortiz Collection*. Bern.

———. 2006. "Overview and Assessment after Fifty Years of Collecting in a Changing World," in E. Robson, L. Treadell, and C. Gosden, eds., *Who Owns Objects? The Ethics and Politics of Collecting Cultural Artefacts*. Oxford: 15–32.

Osborne, J. 1987. *Master Gregorius: The Marvels of Rome*. Toronto.

Osborne, R. 1998. *Archaic and Classical Greek Art*. Oxford.

———. 2010. "The Art of Signing in Ancient Greece," *Arethusa* 43(2): 231–51.

———. 2011. *The History Written on the Classical Greek Body*. Cambridge.

———. 2015. Review of S. Kansteiner et al., eds., *Der Neue Overbeck (DNO): Die antiken Schriftquellen zu den bildenen Künsten der Griechen, Journal of Hellenic Studies* 135: 283–84.

———. 2017. "How the Gauls Broke the Frame: The Political and Theological Impact of Taking Battle Scenes off Greek Temples," in V. Platt and M. Squire, eds., *The Frame in Classical Art: A Cultural History*. Cambridge: 425–56.

Osborne, R., and J. Tanner. 2007. *Art's Agency and Art History*. Malden, MA.

Osborne, R., and C. Vout. 2010. "A Revolution in Roman History?" *Journal of Roman Studies* 100: 233–45.

Östenberg, I. 2009. *Staging the World: Spoils, Captives, and Representations in the Roman Triumphal Procession*. Oxford.

Østergaard, J. S. 2015. "Identical Roman Copies? Diversification through Colour," in S. Settis, A. Anguissola, and D. Gasparotto, eds., *Serial/Portable Classic: The Greek Canon and Its Mutations*. Milan: 113–18.

Østermark-Johansen, L. 2011. *Walter Pater and the Language of Sculpture*. Aldershot and Burlington, VT.

O'Sullivan, P. 2005. "Victory Statue, Victory Song: Pindar's Agonistic Poetics and Its Legacy," in D. Phillips and D. Pritchard, eds., *Sport and Festival in the Ancient World*. Swansea: 75–100.

Overbeck, J. 1868. *Die antiken Schriftquellen zur Geschichte der bildenden Künste bei den Griechen*. Leipzig.

Overbeeke, N. M. 1994. "Cardinal Otto Truchsess von Waldburg and His Role as Art Dealer for Albrecht V of Bavaria (1568–73)," *Journal of the History of Collections* 6(2): 173–79.

Paciaudi, P. M. 1862. *Lettres de Paciaudi au comte de Caylus*. Paris.

Palagia, P. 1987a. "In Defense of Furtwangler's Athena Lemnia," *American Journal of Archaeology* 91(1): 81–84.

———. 1987b. Review of J. Boardman, *Greek Sculpture: The Classical Period, a Handbook* and *The Parthenon and Its Sculptures, Classical Review* 37(2): 269–71.

———. 2008. "The Marble of the Penelope from Persepolis and Its Historical Implications," in S. M. R. Darbandi and A. Zournatzi, eds., *Ancient Greece and Ancient Iran: Cross-Cultural Encounters*. Athens: 223–37.

———. 2010a. "Pheidias Epoisen: Attribution as Value Judgement," in F. Macfarlane and C. Morgan, eds., *Exploring Ancient Sculpture: Essays in Honour of Geoffrey Waywell*. BICS Supplement 104: 97–107.

———. 2010b. "Sculptures from the Peloponnese in the Roman Imperial Period," in A. D. Rizakis and C. E. Lepenioti, eds., *Roman Peloponnese III: Society, Economy and Culture under the Roman Empire: Continuity and Innovation*. Athens: 431–45.

———. 2016. "Herodes Atticus' Athenian Caryatids," in C. Zambas, ed., *ΑΡΧΙΤΕΚΤΩΝ, Honorary Volume for Professor Manolis Korres*. Athens: 217–24.

Paoletti, M. 2003. "Verre, gli argenti e la *cupiditas* del collezionista," in A. Corretti, *Quarte Giornate Internazionali di Studi Sull' Area Elima: Atti II*. Pisa: 999–1028.

Paoluzzi, M. C. 2007. "La famiglia della Valle e l'origine della collezione di antichità," in A. Cavallaro, ed., *Collezioni di antichità a Roma tra '400 e '500*. Rome: 147–86.

Papazarkadas, N. 2014. "Two New Epigrams from Thebes," in N. Papazarkadas, ed., *The Epigraphy and History of Boeotia: New Finds, New Perspectives*. Leiden: 223–51.

Papini, M. 2004. *Antichi volti della repubblica: La ritrattistica in Italia Centrale tra IV e II secolo A. C.*, 2 vols. Rome.

———. 2011. "Della maschera al ritratto," in E. La Rocca and C. Parisi Presicce, eds., *Ritratti: Le tante face del potere*. Rome: 33–49.

Paradin, G. 1542. *De antique Statu Burgundiae liber*. Lyon, S. Dolet [BL, g.4222(4); BnF, Rés. 4° LK² 327].

Paribeni, E. 1969. "Considerazioni sulle sculture originali greche di Roma," in *La Magna Grecia e Roma nell'età arcaica*. Naples: 83–89.

Parr, R. 1686. *The Life of James Usher Lord Arch-Bishop of Armagh, Primate and Metropolitan of All Ireland*. London.

Parry, G. 1989. *The Golden Age Restor'd: The Culture of the Stewart Court, 1603–42*. London.

Parslow, C. C. 1995. *Rediscovering Antiquity: Karl Weber and the Excavation of Herculaneum, Pompeii, and Stabiae*. Cambridge.

Parsons, E. A. 1952. *The Alexandrian Library, Glory of the Hellenic World: Its Rise, Antiquities and Destruction*. New York.

Paschini, P. 1926–27. "Le collezioni archeologiche dei prelati Grimani nel cinquecento," *Rendiconti Pontificia Accademia Romana di Archeologia* 5: 149–90.

Pascoe, J. 2005. *The Hummingbird Cabinet: A Rare and Curious History of Romantic Collectors*. Ithaca.

Pasini, A. 1885–86. *Il Tesoro di San Marco in Venezia illustrato da Antonio Pasini, canonico della Marciana*, ed. F. Organia. Venice.

Pasquier, A. 1985. *La Vénus de Milo et les Aphrodites du Louvre*. Paris.

Paton, W. R. 1916–18. *The Greek Anthology*, 5 vols. New York and London.

Paul, C. 2000. *Making a Prince's Museum: Drawings for the Late-Eighteenth-Century Redecoration of the Villa Borghese*. Los Angeles.

———. 2012. "Capitoline Museum, Rome: Civic Identity and Personal Cultivation," in C. Paul, ed., *The First Modern Museums of Art: The Birth of an Institution in 18th- and Early-19th-Century Europe*. Los Angeles: 21–45.

Pavlock, B. 2013. "Mentula in Catullus 114 and 115," *Classical World* 106(4): 595–607.

Payne Knight, R. 1786–87. *The Discourse on the Worship of Priapus, and Its Connexion with the Mystic Theology of the Ancients*. London.

Peacham, H. 1634. *The Compleat Gentleman*. London.

Pedley, J. G. 1993. *Greek Art and Archaeology*. London.

Peirce, P. 1989. "The Arch of Constantine: Propaganda and Ideology in Late Roman Art," *Art History* 12(4): 387–418.

Penny, N. 1991. "Lord Rockingham's Sculpture Collection and *The Judgement of Paris* by Nollekens," *J. Paul Getty Museum Journal* 19: 5–34.

Perkins, C. C. 1880. "Olympia as it was and as it is: The Temple of Zeus (Continued)," *American Art Review* 1(4): 152–59.

Perocco, G. 1984a. "History of the Treasury of San Marco," in D. Buckton, ed., *The Treasury of San Marco Venice*. New York: 65–68.

———. 1984b. "Venice and the Treasury of San Marco," in D. Buckton, ed., *The Treasury of San Marco Venice*. New York: 5–34.

Perrier, F. 1638. *Segmenta nobilium signorum e[t] statuaru[m]*. Rome and Paris.

Perry, E. E. 2000. "Notes on Diligentia as a Technical Term," *Classical Philology* 95(4): 445–58.

———. 2005. *The Aesthetics of Emulation in the Visual Arts of Ancient Rome*. Cambridge.

Perry, M. 1978. "Cardinal Domenico Grimani's Legacy of Ancient Art to Venice," *Journal of the Warburg and Courtauld Institutes* 41: 215–44.

Perry, W. C. 1877. "The Great Artistic Want of England," *The Spectator*, 21 April: 16.

Peterson, L. H. 2006. *The Freedman in Roman Art and Art History*. Cambridge.

Pfeiffer, R. 1968. *History of Classical Scholarship from the Beginnings to the End of the Hellenistic Age*. Oxford.

———. 1976. *History of Classical Scholarship from 1300 to 1850*. Oxford.

Phillips, S. 1854. *Guide to the Crystal Palace and Park*. London.

Picón, C. A., and S. Hemingway, eds. 2016. *Pergamon and the Hellenistic Kingdoms of the Ancient World*. New York.

Piganiol de la Force, J.-A. 1715. *Description des Chateaux et Parcs de Versailles, de Trianon, et de Marly*, vol. 1. Paris.

Pinatel, C. 2000. "Les envois de moulages d'antiques à l'École des Beaux-Arts de Paris par l'Académie de France à Rome," in H. Lavagne and F. Queyrel, eds., *Les moulages de sculptures antiques et l'histoire de l'archéologie*. Geneva: 75–120.

Pincus, D. 1992. "Venice and the Two Romes: Byzantium and Rome as a Double Heritage in Venetian Cultural Politics," *Artibus et historiae* 26: 101–14.

Pinto, J. 2010. "Hadrian's Villa," in A. Grafton, G. W. Most, and S. Settis, eds., *The Classical Tradition*. Cambridge, MA and London: 418–19.

Piranesi, G. B. 1769. *Diverse maniere d'adornare i cammini = Divers Manners of Ornamenting Chimneys = Différentes manières d'orner les cheminées*. Rome.

———. 1778. *Vasi, candelabri, cippi, sarcophagi, tripodi, lucerne, ed ornamenti antichi disegnati ed incisi dal Cav. Gio. Batta. Piranesi*. Rome.

Pirson, F., and A. Scholl, eds. 2014. *Pergamon: Anadolu'da Hellenistik Bir Başkent/A Hellenistic Capital in Anatolia*. Istanbul.

Platina, B. S. 1913–32. *Platynae historici: Liber de uita Christi et omnium pontificum*, ed. G. Gaida. Rerum Italicarum Scriptores 3.1. Città di Castello.

Platt, V. J. 2010. "Art History in the Temple," *Arethusa* 43(2): 197–213.

———. 2011. *Facing the Gods: Epiphany and Representation in Graeco-Roman Art, Literature and Religion*. Cambridge.

Pocock, J. G. A. 1999. *Barbarism and Religion*, vol. 1, *The Enlightenments of Edward Gibbon, 1747–1764*. Cambridge, New York, and Melbourne.

Poggio Bracciolini. 1964–69. *Opera Omnia*, ed. R. Fubini, 4. vols. Turin.

Pogrebin, R. 2007. "Redesigning the Met's Home for Greek and Roman Art," *New York Times*, http://www.nytimes.com/2007/04/18/arts/design/18wing.html?_r=0 (last accessed 8 August 2016).

Poldo d'Albernas, J. 1559. *Discours historial de l'antique cite de Nismes*. Lyon [G. Roville, fol. BnF, Rés. Lk⁷ 5652(A)].

Pollini, J. 2012. *From Republic to Empire: Rhetoric, Religion, and Power in the Visual Culture of Ancient Rome*. Norman, OK.

Pollitt, J. J. 1974. *The Ancient View of Greek Art: Criticism, History, and Terminology*. New Haven and London.

———. 1978. "The Impact of Greek Art on Rome," *Transactions of the American Philological Society* 108: 155–74.

———. 1986. *Art in the Hellenistic Age*. Cambridge.

———. 1996. "Introduction: Masters and Master-works in the Study of Classical Sculpture," in O. Palagia and J. J. Pollitt, eds., *Personal Styles in Greek Sculpture*. Cambridge: 1–15.

Pommier, E. 1991. *L'art de la liberté: Doctrines et débuts de la Révolution Française*. Paris.

Pop, A. 2015. *Antiquity, Theatre and the Painting of Henry Fuseli*. Oxford.

Popkin, M. L. 2016. *The Architecture of the Roman Triumph: Monuments, Memory, and Identity*. Cambridge.

Porter, J. I. 2006. "What Is 'Classical' about Classical Antiquity?" in J. I. Porter, ed., *Classical Pasts: The Classical Traditions of Greece and Rome*. Princeton: 1–68.

———. 2009a. "Is Art Modern? Kristeller's 'Modern System of the Arts' Reconsidered," *British Journal of Aesthetics* 49(1): 1–24.

———. 2009b. "Reply to Shiner," *British Journal of Aesthetics* 49(2): 171–78.

———. 2010. *The Origins of Aesthetic Thought in Ancient Greece: Matter, Sensation, and Experience*. Cambridge.

Potter, R. 1758. *Holkham: A Poem to the Right Honourable The Earl of Leicester*. London.

Pottier, E. 1896–1906. *Catalogue des vases antiques de terre cuite*. Paris.

Potts, A. 1980. "Greek Sculpture and Roman Copies: Anton Rafael Mengs and the Eighteenth Century," *Journal of the Warburg and Courtauld Institutes* 43: 150–73.

———. 1994. *Flesh and the Ideal: Winckelmann and the Origins of the History of Art*. New Haven and London.

Poulot, D. 1986. "Alexandre Lenoir et la musée des monuments français," in P. Nora, ed., *Les lieux de mémoire*, vol. 2, *La nation*. Paris: 497–531.

———. 1997. *Musée, nation, patrimoine, 1789–1815*. Paris.

———. 2004. "Pantheons in Eighteenth-Century France: Temple, Museum, Pyramid," in R. Wrigley and M. Craske, eds., *Pantheons: Transformations of a Monumental Idea*. Aldershot and Burlington, VT: 124–45.

Poulouin, C. 1995. "L'antiquité expliquée et représentée en figures (1719–1724) par Bernard de Montfaucon," *Dix-huitième Siècle* 27(1): 43–60.

Pound, E. 1914. "The New Sculpture," *The Egoist* 4(1): 67–68.

Powers, E. 2008. "Interrogation of the Past: Henry James and William Wetmore Story," *Arion* 16(2): 51–70.

Preger, T. 1901. *Scriptores originum Constantinopolitanarum*, vol. 1. Leipzig.

———. 1907. *Scriptores originum Constantinopolitanarum*, vol. 2. Leipzig.

Preller, L. [1838] 1964. *Polemonis Periegetae Fragmenta*. Amsterdam.

Presicce, C. P. 2000a. *La Lupa Capitolina*. Milan.

———. 2000b. "I grandi bronzi di Sisto IV dal Laterano al Campidoglio," in F. Benzi et al., eds., *Sisto IV: Le arti a Roma nel primo Rinascimento*. Rome: 189–200.

Pressly, W. L. 1999. *The French Revolution as Blasphemy: Johan Zoffany's Paintings of the Massacre of Paris, August 10, 1792*. Berkeley and London.

Prettejohn, E. 2005. *Beauty and Art 1750–2000*. Oxford.

———. 2006. "Reception and Ancient Art: The Case of the Venus de Milo," in C. Martindale and R. Thomas, eds., *Classics and the Uses of Reception*. Oxford: 227–49.

———. 2012. *The Modernity of Ancient Sculpture: Greek Sculpture and Modern Art from Winckelmann to Picasso*. London.

Prideaux, H. 1676. *Marmora Oxoniensia, ex Arundellianis Seldenianis, alisque conflata*, 3 parts in 1 vol. Oxford.

Prioux, E. 2008. *Petits musées en vers: Épigramme et discours sur les collections antiques*. Paris.

———. 2014. "Poetic Depictions of Ancient Dactyliothecae," in M. W. Gahtan and D. Pegazzano, eds., *Museum Archetypes and Collecting in the Ancient World*. Leiden: 54–71.

Prusac, M. 2011. *From Face to Face: Recarving Roman Portraits and the Late Antique Portrait Arts*. Leiden.

Pugliano, V. 2015. "Ulisse Aldrovandi's Color Sensibility: Natural History, Language and the Lay Color Practices of Renaissance Virtuosi," *Early Science and Medicine* 20: 358–96.

Pulszky, F. 1852. "On the Progress and Decay of Art and on the Arrangement of a National Museum," *Museum of Classical Antiquities* 2: 1–15.

Purcell, N. 1993. "Atrium Libertatis," *Papers of the British School at Rome* 61: 125–55.

Quatremère de Quincy, A.-C. 1814. *Le Jupiter Olympien ou l'art de la sculpture antique considéré sous un nouveau point de vue; ouvrage qui comprend un essai sur le gout de la sculpture polychrome*. Paris.

———. 2012. *Letters to Miranda and Canova on the Abduction of Antiquities from Rome and Athens*, trans. C. Miller and D. Gilks. Los Angeles.

Queyrel, F. 2005. *L'Autel de Pergame: Images et pouvoir en Grèce d'Asie. Antiqua*, vol. 9. Paris.

Quiccheberg, S. (von). 1565. *Inscriptiones vel tituli theatri amplissimi*. Munich.

Quynn, D. M. 1945. "The Art Confiscations of the Napoleonic Wars," *American Historical Review* 50(3): 437–60.

Rabe, J. 2016. "Mediating between Art and Nature: The Countess of Arundel at Tart Hall," in S. Burghartz,

L. Burkart, and C. Göttler, eds., *Sites of Mediation: Connected Histories of Places, Processes, and Objects in Europe and Beyond, 1450–1650.* Leiden. 183–210.

Raeder, J. 1983. *Die statuarische Ausstattung der Villa Hadriana bei Tivoli.* Frankfurt am Main.

Ramage, N. H. 2013. "Flying Maenads and Cupids: Pompeii, Herculaneum, and Eighteenth-Century Decorative Arts," in C. C. Mattusch, ed., *Rediscovering the Ancient World on the Bay of Naples, 1710–1890.* New Haven: 161–70.

Rambach, H. J. 2011. "Apollo and Marsyas on Engraved Gems and Medals," *Jahrbuch für Numismatik und Geldgeschichte* 61: 131–57.

———. 2013. "Van Dyck's Project for a Family Portrait of Lord Arundel," *British Art Journal* 14(1): 1–14.

Randall, D. 2008. "Ethos, Poetics, and the Literary Sphere," *Modern Language Quarterly* 69(2): 221–43.

Raubitschek, A. E. 1949. *Dedications from the Athenian Acropolis.* Cambridge, MA.

Rausa, F. 2007. "Le collezioni farnesiane di sculture antiche: Stria e formazione," in C. Gasparri, ed., *Le sculture Farnese: Storia e documenti.* Naples: 15–80.

Ravasi, T. 2015. "Displaying Sculpture in Rome," in P. Destrée and P. Murray, eds., *A Companion to Ancient Aesthetics.* Chichester: 248–61.

Rave, P. O. 1944. "Bertel Thorvaldsen zu seinem hundertsten Todestag am 24 März 1944," *Die Kunst im Deutschen Reich* 8: 62–72.

Rayet, O. 1884. *Monuments de l'art antique.* Paris.

Rebecchini, G. 2002. *Private Collectors in Mantua 1500–1630.* Rome.

Redford, B. 2008. *Dilettanti: The Antic and the Antique in Eighteenth-Century England.* Los Angeles.

Reiman, D. H., and N. Fraistat, eds. 2002. *Shelley's Poetry and Prose*, 2nd edn. New York and London.

Reinach, T. 1899. "Un temple élevé par les femmes de Tanagra," *Revue des Études Grecques* 12: 53–115.

Reynolds, L. D., and N. G. Wilson. 1974. *Scribes and Scholars: A Guide to the Transmission of Greek and Latin Literature.* Oxford.

Rhodes, P. J., and R. Osborne. 2017. *Greek Historical Inscriptions 478–404 B.C.* Oxford.

Rice, E. E. 1983. *The Grand Procession of Ptolemy Philadelphus.* Oxford.

Richardson, J. 1725. *An Essay on the Theory of Painting*, 2nd edn. London.

Richardson, J., Sr., and J. Richardson Jr. 1722. *An Account of Some of the Statues, Bas-Reliefs, Drawings, and Pictures in Italy, etc. With Remarks.* London.

———. 1728. *Traité de la peinture et de la sculpture*, 3 vols. Amsterdam.

Richardson, M. 2003. "John Soane and the Temple of Vesta at Tivoli," *Architectural History* 46: 127–46.

Richlin, A. 1983. *The Garden of Priapus: Sexuality and Aggression in Roman Humor.* New Haven and London.

Richter, G. M. A. R. 1929. *The Sculpture and Sculptors of the Greeks.* New Haven.

Ridgway, B. S. 1967. "The Bronze Apollo from Piombino in the Louvre," *Antike Plastik* 7: 43–76.

———. 1970. *The Severe Style in Greek Sculpture.* Princeton.

———. 1974. "A Story of Five Amazons," *American Journal of Archaeology* 78: 1–17.

———. 1976. "The Aphrodite of Arles," *American Journal of Archaeology* 80: 147–54.

———. 1981. *Fifth-Century Styles in Greek Sculpture.* Princeton.

———. 1984. *Roman Copies of Greek Sculpture: The Problem of the Originals.* Jerome Lectures 15. Ann Arbor.

———. 1987. Review of J.-P. Niemeier, *Kopien und Nachahmungen im Hellenismus. Ein Beitrag zum Klassizismus des 2. und frühern 1. Jhs. v. Chr., American Journal of Archaeology* 91: 624–26.

———. 1991. "The Bronze Granikos Group of Alexander and the Companions at the Porticus Octaviae (review of G. Calcani, *Cavalieri di Bronzo*)," *Journal of Roman Archaeology* 4: 206–9.

———. 1995. "The Wreck of Mahdia, Tunisia, and the Art Market in the Early First Century BC," *Journal of Roman Archaeology* 8: 340–47.

———. 1997. *Fourth-Century Styles in Greek Sculpture.* Madison, WI.

———. 2000. *Hellenistic Sculpture II: The Styles of ca. 200–100 B.C.* Madison, WI.

———. 2002a. *Hellenistic Sculpture III: The Styles of ca. 100–31 B.C.* Madison, WI.

———. 2002b. "The Riace Bronzes: A Minority Viewpoint," in L. V. Borelli and P. Pelagatti, eds., *Due bronzi da Riace: Rinvenimento, restauro, analisi ed ipotesi di interpretazione*, vol. 1. Rome: 313–26.

———. 2006. "The Boy Strangling the Goose: Genre Figure or Mythological Symbol?" *American Journal of Archaeology* 110: 643–48.

Ridolfi, C. 1996. *The Life of Titian*, ed. J. Bondanella, B. Cole, J. R. Shiffman, and P. Bondanella. Philadelphia.

Riebesell, C. 1989. *Die Sammlung des Kardinal Alessandro Farnese: Ein "Studio" für Künstler und Gelehrte.* Weinheim.

Rieche, A. 2010. "Verweigerte Rezeption: Zur Wirkungsgeschichte der 'Leda des Timotheos,'" in T. Bartsch, M. Becker, and H. Bredekamp, eds., *Das Originale der Kopie: Kopien als Produkte und Medien der Transformation von Antike.* Berlin and New York: 117–38.

Riegl, A. 1901. *Die Spätrömische Kunstindustrie nach den Funden in Österreich-Ungarn I.* Vienna.

———. 1985. *Late Roman Art Industry*, trans. R. Winkes. Rome.

Roberts, P. 2013. *Life and Death in Pompeii and Herculaneum*. London.

Robertson, J. 2001. "The Enlightenments of J. G. A. Pocock," *Storia della Storiografia—History of Historiography* 39: 140–51.

———. 2005. *The Case for the Enlightenment: Scotland and Naples 1680–1760*. Cambridge.

Robertson, M. 1987. *Greek, Etruscan and Roman Vases in the Lady Lever Art Gallery, Port Sunlight*. Liverpool.

———. 1988. Review of Geoffrey B. Waywell, *The Lever and Hope Sculptures: Ancient Sculptures in the Lady Lever Art Gallery, Port Sunlight and a Catalogue of the Ancient Sculptures Formerly in the Hope Collection, London and Deepdene*, *Classical Review* 38(1): 183.

Robinson, E. 1891. *Museum of Fine Arts Boston: Catalogue of Casts*. Boston.

———. 1892. *The Hermes of Praxiteles and the Venus Genetrix: Experiments in Restoring the Color of Greek Sculpture*. Boston.

Rolley, C. 1990. "En regardant l'Aurige," *Bulletin de Correspondance Hellénique* 114: 285–97.

———. 1999. *La sculpture grecque*, vol. 2. Paris.

Roskill, M. 1968. *Dolce's Aretino and Venetian Art Theory of the Cinquecento*. New York.

Rossi Pinelli, O. 1986. "Chirurgia della memoria: scultura antica e restauri storici," in S. Settis, ed., *Memoria dell'antico nell'arte italiana*, vol. 3. Turin: 179–250.

Röttgen, S. 1982. "Die Villa Albani und Ihre Bauten," in H. Beck and P. C. Bol, eds., *Forschungen zur Villa Albani: Antike Kunst und die Epoche der Aufklärung*. Berlin: 59–123.

Rouet, P. 2001. *Approaches to the Study of Attic Vases: Beazley and Pottier*. Oxford.

Rouveret, A. 1987. "'Tout la mémoire du monde': La notion de collection dans la NH de Pline," *Helmantica* 38: 115–33.

Rowell, D. 2012. *Paris: The "New Rome" of Napoleon I*. London and New York.

Rozeik, C. 2012. "'A Maddening Temptation': The Ricketts and Shannon Collection of Greek and Roman Antiquities," *Journal of the History of Collections* 24(3): 369–78.

Rumscheid, F. 2006. *Die figürlichen Terrakotten von Priene: Fundkontexte, Ikonographie und Funktion in Wohnhäusern und Heiligtümern im Licht antiker Parallelbefunde*. Wiesbaden.

Russell, A. 2012. "Aemilius Paullus Sees Greece: Travel, Vision, and Power in Polybius," in C. Smith and L. M. Yarrow, eds., *Imperialism, Cultural Politics, and Polybius*. Oxford: 152–67.

———. 2016. *The Politics of Public Space in Republican Rome*. Cambridge.

Rusten, J., and I. C. Cunningham. 2002. *Theophrastus: Characters; Herodas: Mimes; Sophron and Other Mimes*. Cambridge, MA and London.

Rutledge, S. H. 2012. *Ancient Rome as a Museum: Power, Identity, and the Culture of Collecting*. Oxford.

Saisselin, R. G. 1992. *The Enlightenment against the Baroque: Economics and Aesthetics in the Eighteenth Century*. Berkeley.

Salomon, X. F. 2003. "Cardinal Pietro Barbo's Collection and Its Inventory Reconsidered," *Journal of the History of Collections* 15(1): 1–18.

Sandbach, Mrs. H. R. 1850. *Aurora and Other Poems*. London.

Sandholtz, W. 2007. *Prohibiting Plunder: How Norms Change*. Oxford.

Sanger, A. E. 2014. *Art, Gender and Religious Devotion in Grand Ducal Tuscany*. Farnham.

San Juan, R. M. 1991. "The Court Lady's Dilemma: Isabella d'Este and Art Collecting in the Renaissance," *Oxford Art Journal* 14(1): 67–78.

Saradi-Mendelovici, H. 1990. "Christian Attitudes toward Pagan Monuments in Late Antiquity and Their Legacy in Later Byzantine Centuries," *Dumbarton Oaks Papers* 44: 47–61.

Sarnelli, P. 1685. *Guida de' forestieri curiosi di vedere, e d'intendere le cose più notabili della regal città di Napoli, e del suo amenissimo distretto*. Naples.

Savvopoulos, K. 2010. "Alexandria in Aegypto: The Use and Meaning of Egyptian Elements in Hellenistic and Roman Alexandria," in L. Bricault and M.-J. Versluys, eds., *Isis on the Nile: Egyptian Gods in Hellenistic and Roman Egypt. Proceedings of the Fourth International Conference of Isis Studies*. Liège: 75–86.

Savvopoulos, K., and R. S. Bianchi. 2012. *Alexandrian Sculpture in the Graeco-Roman Museum*. Alexandria.

Scalamonti, F. 1792. "Commentario permesso alla vita di Ciriaco Antonitano," in G. Colucci, ed., *Delle Antichitè Picene* 15: 45–155.

———. 1996. *Vita viri clarissimi et famosissimi Kyriaci Anconitani*, trans. and ed. C. Mitchell and E. W. Bodnar. *Transactions of the American Philosophical Society*. Philadelphia.

Scarisbrick, D. 1996. "The Arundel Gem Cabinet," *Apollo* 144(141): 45–48.

Schaefer, S. J. 1976. "The Studiolo of Francesco I De'Medici in the Palazzo Vecchio in Florence." Doctoral dissertation, Bryn Mawr College.

Schalles, H.-J. 1990. "Die Kunstsammlung der pergamenischen Herrscher: Ein Bestandsaufnahme," *Akten des XIII Internationalen Kongresses für klassiches Archäologie*. Mainz: 598–650.

Schapiro, M. 1953. "Style," in A. L. Kroeber, ed., *Ar-chaeology Today*. Chicago: 287–312.

Schmidt, S. 2009. "Images of Statues on Attic Vases: The Case of the Tyrannicides," in V. Noerskov, L. Hannestad, C. Isler-Kerenyi, and S. Lewis, eds., *The World of Greek Vases. Analecta Romana Instituti Danesi*, supplement 41: 219–37.

Schmitter, M. 2004. "Virtuous Riches: The Bricolage of Cittadini Identities in Early Sixteenth-Century Venice," *Renaissance Quarterly* 57(3): 908–69.

———. 2007. "Odoni's Façade: The House as Portrait in Renaissance Venice," *Journal of the Society of Architectural Historians* 66(3): 294–315.

Schnapp, A. 1996. *The Discovery of the Past: The Origins of Archaeology*, trans. I. Kinnes and G. Varndell. London.

———. 2004. "Eduard Gerhard: Founder of Classical Archaeology?" *Modernism/Modernity* 11(1): 169–71.

———. 2013. "Conservation of Objects and Monuments and the Sense of the Past during the Greco-Roman Era," in A. Schnapp, ed., *World Antiquarianism: Comparative Perspectives*. Los Angeles: 159–75.

Schneider, N. 2002. *The Art of the Portrait*. Cologne.

Schneider, W. J. 2001. "*Phidiae Putavi*: Martial und der Hercules *Epitrapezios* des Novius Vindex," *Mnemosyne* 54: 697–720.

Scholl, A. 2014. "Pergamon Sunağı—Homeros' tan İlham Alan Bir Zeus Sarayi mi?/The Pergamon Altar—A Palace of Zeus with Homeric Traits?" in F. Pirson and A. Scholl, eds., *Pergamon, Anadolu'da Hellenistik Bir Başkent/A Hellenistic Capital in Anatolia*. Istanbul: 480–91.

———. 2016. "The Pergamon Altar: Architecture, Sculpture, and Meaning," in C. A. Picón and S. Hemingway, eds., *Pergamon and the Hellenistic Kingdoms of the Ancient World*. New York: 44–53.

Schuchhardt, W., and C. Landwehr. 1986. "Statuen-kopien der Tyrannenmörder-Gruppe," *Jahrbuch des Deutschen Archäologischen Instituts* 101: 85–126.

Schweitzer, B. 1948. *Die Bildniskunst der römischen Republik*. Leipzig.

Scott, J. 2003. *The Pleasures of Antiquity: British Collectors of Greece and Rome*. New Haven.

Scott, M. C. 2010. *Delphi and Olympia: The Spatial Politics of Panhellenism in the Archaic and Classical Period*. Cambridge.

———. 2014. *Delphi: A History of the Centre of the Ancient World*. Princeton.

Scott, S. 2006. "Art and the Archaeologist," *World Archaeology* 38(4): 628–43.

Scott-Elliot, A. H. 1959. "The Statues from Mantua in the Collection of Charles I," *The Burlington Magazine* 101(675): 218–27.

Scrase, D. 2011. *Italian Drawings at the Fitzwilliam Museum, Cambridge*. Cambridge.

Sedgwick, E. K. 1985. *Between Men: English Literature and Male Homosocial Desire*. New York.

Seelig, L. 1985. "The Munich Kunstkammer, 1565–1807," in O. Impey and A. MacGregor, eds., *The Origins of Museums: The Cabinet of Curiosities in Sixteenth- and Seventeenth-Century Europe*. Oxford: 76–89.

———. 1986. "Die Münchner Kunstkammer," *Jahrbuch der Bayerischen Denkmalpflege* 40: 101–38.

Seidel, M. 1975. "Studien zur Antikenrezeption Nicola Pisanos," *Mitteilungen des Kunsthistorischen Institutes in Florenz* 19: 307–92.

Seiler, F. 1992. *La Casa degli Amorini Dorati (VI 16, 7.38)*. Munich.

Selden, J. 1628–29. *Marmora Arundelliana*. London.

Seltman, C. T. 1948. *Approach to Greek Art*. London and New York.

Sena Chiesa, G. 2002. *Gemme dalla corte imperial alla corte celeste*. Milan.

Sens, A. 2005. "The Art of Poetry and the Poetry of Art: The Unity and Poetics of Posidippus' Statue Poems," in K. Gutzwiller, ed., *The New Posidippus: A Hellenistic Poetry Book*. Oxford: 206–28.

Séréna-Allier, D. 2013. *Louis XIV et la Vénus d'Arles*. Paris.

Settis, S. 1986. "Continuità, distanza, conoscenza: Tre usi dell'antico," in S. Settis, ed., *Memoria dell'antico nell'arte italiana*, vol. 3, *Dalla tradizione all'archeologia*. Turin: 375–486.

———. 1999. *Laocoonte: Fama e stile*. Rome.

———. 2006. *The Future of the "Classical,"* trans. A. Cameron. Cambridge and Malden, MA.

———. 2008a. "Collecting Ancient Sculpture: The Beginnings," in N. Penny and E. D. Schmidt, eds., *Collecting Sculpture in Early Modern Europe*. Washington, DC: 13–31.

———. 2008b. "Nostalgia dell'arte greca," in S. Settis and M. L. Catoni, eds., *La forza del bello: L'arte greca conquista l'Italia*. Milan: 235–303.

———. 2010. "Classical," in A. Grafton, G. W. Most, and S. Settis, eds., *The Classical Tradition*. Cambridge, MA and London: 205–6.

———. 2015. "Supremely Original: Classical Art as Serial, Iterative, Portable," in S. Settis, A. Anguissola, and D. Gasparotto, eds., *Serial/Portable Classic: The Greek Canon and Its Mutations*. Milan: 51–72.

Settis, S., A. Anguissola, and D. Gasparotto, eds. 2015. *Serial/Portable Classic: The Greek Canon and Its Mutations*. Milan.

Settis, S., and M. L. Catoni, eds. 2008. *La forza del bello: L'arte greca conquista l'Italia*. Milan.

Shand-Tucci, D. 1995. *Boston Bohemia, 1881–1900*. Amherst.

Shanks, M. 1996. *Classical Archaeology of Greece: Experiences of a Discipline*. London.

Shapiro, H. A. 1989. *Art and Cult under the Tyrants.* Mainz.

Sharples, R. W. 2010. *Peripatetic Philosophy, 200 BC to AD 200: An Introduction and Collection of Sources in Translation.* Cambridge.

Shaya, J. 2005. "The Greek Temple as Museum: The Case of the Legendary Treasure of Athena from Lindos," *American Journal of Archaeology* 109(3): 423–42.

———. 2014. "Greek Temple Treasures and the Invention of Collecting," in M. W. Gahtan and D. Pegazzano, eds., *Museum Archetypes and Collecting in the Ancient World.* Leiden: 24–32.

Shear, J. L. 2007. "Cultural Change, Space, and the Politics of Commemoration in Athens," in R. Osborne, ed., *Debating the Athenian Cultural Revolution: Art, Literature, Philosophy, and Politics 430–380 BC.* Cambridge: 91–115.

———. 2012a. "The Tyrannicides, Their Cult and the Panathenaia: A Note," *Journal of Hellenic Studies* 132: 107–19.

———. 2012b. "Religion and the Polis: The Cult of the Tyrannicides at Athens," *Kernos* 25: 27–56.

Shear, T. L. 1994. "They Made Athens a City of Equal Rights: The Agora and Democracy," in W. D. E. Coulson, T. L. Shear, H. A. Shapiro, and F. J. Frost, eds., *The Archaeology of Athens and Attica under the Democracy.* Athens: 225–48.

Shefton, B. B. 1960. "Some Iconographic Remarks on the Tyrannicides," *American Journal of Archaeology* 64: 173–79.

Sherard, R. H. 1916. *The Real Oscar Wilde. With Numerous Unpublished Letters, Facsims, Ports. and Illus.* Philadelphia.

Shiner, L. 2001. *The Invention of Art: A Cultural History.* Chicago.

Shippobottom, M. 1992. "The Building of the Lady Lever Art Gallery," *Journal of the History of Collections* 4(2): 175–93.

Siapkas, J., and L. Sjögren. 2014. *Displaying the Ideals of Antiquity: The Petrified Gaze.* Routledge Monographs in Classical Studies 15. London and New York.

Sider, D. 2010. "The Books of the Villa of the Papyri," in M. Zarmakoupi, ed., *The Villa of the Papyri at Herculaneum: Archaeology, Reception, and Digital Reconstruction.* Berlin and New York: 115–27.

Siegel, J. 2000. *Desire and Excess: The Nineteenth-Century Culture of Art.* Princeton.

———. 2013. "The Material of Form: Vernon Lee at the Vatican and Out of It," *Victorian Studies* 55(2): 189–201.

Silberberg-Pierce, S. 1980. "Politics and Private Imagery: The Sacral-Idyllic Landscapes in Augustan Art," *Art History* 3(3): 241–51.

Silver, V. 2009. *The Lost Chalice: The Epic Hunt for a Priceless Masterpiece.* New York.

Silverman, H., ed. 2010. *Contested Cultural Heritage: Religion, Erasure, and Exclusion in a Gobal World.* New York.

Simon, E. 1975. *Pergamon und Hesiod.* Mainz.

Skinner, M. B. 2001. "Ladies' Day at the Art Institute: Theocritus, Herodas, and the Gendered Gaze," in A. Lardinois and L. McClure, eds., *Making Silence Speak: Women's Voices in Greek Literature and Society.* Princeton: 201–22.

Skippon, P. 1732. "An Account of a Journey Made thro' part of the Low Countries, Germany, Italy and France," in *A Collection of Voyages and Travels, Some Now Printed from Original Manuscripts, Others Now First Published in English in Six Volumes with a General Preface Giving an Account of the Progress of Navigation from its Beginning,* vol. 6. London: 359–736.

Slavazzi, F. 2002. "Imagini riflesse: Copie et doppi nelle sculture di Villa Adriana," in A. M. Reggiani, ed., *Villa Adriana: Paesaggio antico e ambiente moderno. Elementi novità e ricerche in corso. Atti del convegno Roma 2000.* Milan: 52–61.

Sloan, K. 2003. "'Aimed at Universality and Belonging to the Nation': The Enlightenment and the British Museum," in K. Sloan and A. Burnett, eds., *Enlightenment: Discovering the World in the Eighteenth Century.* London: 12–25.

Smith, A. 1996. *The Victorian Nude: Sexuality, Morality, and Art.* Manchester.

———. 1999. "'The British Matron' and the Body Beautiful: The Nude Debate of 1885," in E. Prettejohn, ed., *After the Pre-Raphaelites: Art and Aestheticism in Victorian England.* Manchester: 217–39.

———, ed. 2001. *Exposed: The Victorian Nude.* London.

Smith, A. H. 1916. "Lord Elgin and His Collection," *Journal of Hellenic Studies* 36: 163–372.

Smith, E. A. 1999. *George IV.* New Haven and London.

Smith, R. R. R. 1981. "Greeks, Foreigners, and Roman Republican Portraits," *Journal of Roman Studies* 71: 24–38.

———. 1987. "The Imperial Reliefs from the Sebasteion at Aphrodisias," *Journal of Roman Studies* 77: 88–138.

———. 1996. "Typology and Diversity in the Portraits of Augustus," *Journal of Roman Archaeology* 9: 31–47.

———. 2013. *The Marble Reliefs from the Julio-Claudian Sebasteion.* Aphrodisias 6. Mainz.

Snodgrass, A. 2012. "Greek Archaeology," in S. E. Alcock and R. Osborne, eds., *Classical Archaeology,* 2nd edn. Chichester and Malden, MA: 13–29.

Snodin, M., ed. 2009. *Horace Walpole's Strawberry Hill.* New Haven and London.

Society of the Dilettanti. 1809–35. *Specimens of Antient Sculpture: Ægyptian, Etruscan, Greek, and Roman*, 2 vols. London.

Söderlind, S. 1993. *Kongl. Museum: Rum för ideal och bildning*. Stockholm.

Solomon Godeau, A. 1997. *Male Trouble: A Crisis in Representation*. London.

Soros, S. W., ed. 2006. *James "Athenian" Stuart, 1713–1788: The Rediscovery of Antiquity*. New Haven.

Sourvinou-Inwood, C. 1995. *"Reading" Greek Death: To the End of the Classical Period*. Oxford.

Southworth, E. 1991. "The Ince Blundell Collection: Collecting Behaviour in the Eighteenth Century," *Journal of the History of Collections* 3(2): 219–34.

Sox, D. 1991. *Bachelors of Art: Edward Perry Warren & the Lewes House Brotherhood*. London.

Sparkes, B. A. 1996. *The Red and the Black: Studies in Greek Pottery*. London and New York.

Speake, J. 2003. *Literature of Travel and Exploration: G to P*. New York and London.

Spence, J. 1747. *Polymetis*. London.

———. 1765. *A Guide to Classical Learning; or Polymetis Abridged*. London.

Spencer, J. R. 1965. *Filarete's Treatise on Architecture*, 2 vols. New Haven.

Spinola, G. 2015. "Miniaturizing Greek Masterpieces: Small Size Copies and Their Purpose," in S. Settis, A. Anguissola, and D. Gasparotto, eds., *Serial/Portable Classic: The Greek Canon and Its Mutations*. Milan: 145–52.

Spivey, N. J. 1991. "Greek Vases in Etruria," in T. Rasmussen and N. J. Spivey, eds., *Looking at Greek Vases*. Cambridge: 131–50.

———. 2013. *Greek Sculpture*. Cambridge.

Spon, J., and G. Wheler. 1678. *Voyage d'Italie, de Dalmatie, de Grèce et du Levant: Fait aux années 1675 et 1676*, 3 vols. Lyons.

Spyropoulos, G. 2001. *Drei Meisterwerke der griechischen Plastik aus der Villa des Herodes Atticus zu Eva/Loukou*. Frankfurt.

———. 2006. *Η έπαυλη του Ηρώδη Αττικού στην Εύα/Λουκού Κυνουρίας*. Athens.

Spyropoulos, G., and T. Spyropoulos. 2003. "Prächtige Villa, Refugium und Musenstätte," *Antike Welt* 34: 463–70.

Squire, M. 2010a. "Introduction: The Art of Art History in Graeco-Roman Antiquity," *Arethusa* 43(2): 133–63.

———. 2010b. "Making Myron's Cow Moo? Ecphrastic Epigram and the Poetics of Stimulation," *American Journal of Philology* 131(4): 589–634.

———. 2012. "Classical Archaeology and the Contexts of Art History," in S. E. Alcock and R. Osborne, eds., *Classical Archaeology*, 2nd edn. Chichester and Malden, MA: 468–500.

———. 2013a. "Embodied Ambiguities on the Prima Porta Augustus," *Art History* 36(2): 242–79.

———. 2013b. "'Fantasies So Varied and Bizarre': The Domus Aurea, the Renaissance, and the 'Grotesque,'" in E. Buckley and M. Dinter, eds., *A Companion to the Neronian Age*. Chichester: 444–64.

———. 2015. "Roman Art and the Artist," in B. E. Borg, ed., *A Companion to Roman Art*. Chichester: 172–94.

Stähli, A., and A. Wessels. 2015. *Die neue Poseidipp: Text, Übersetzung, Kommentar*. Darmstadt.

Stammers, T. 2008. "The Bric-à-Brac of the Old Regime: Collecting and Cultural History in Post-Revolutionary France," *French History* 22: 295–315.

Stansbury-O'Donnell, M. 2015. *A History of Greek Art*. Hoboken.

Stanwick, P. E. 2002. *Portraits of the Ptolemies: Greek Kings as Egyptian Pharaohs*. Austin.

St. Clair, W. 1967. *Lord Elgin and the Marbles*. London.

———. 1999. *The Elgin Marbles: Questions of Stewardship and Accountability*. Oxford.

Steiner, D. 1998. "Moving Images: Fifth-Century Victory Monuments and the Athlete's Allure," *Classical Antiquity* 17(1): 123–50.

Stenhouse, W. 2014. "Roman Antiquities and the Emergence of Renaissance Civic Collections," *Journal of the History of Collections* 26(2): 131–44.

Stephens, S. A. 2003. *Seeing Double: Intercultural Poetics in Ptolemaic Alexandria*. Berkeley.

Stephenson, P. 2016. *The Serpent Column: A Cultural Biography*. Oxford and New York.

Stevens, J. 2014. "Louvre Abu Dhabi Scoops Up 300 Masterpieces from France," *The Guardian*, 13 October, https://www.theguardian.com/culture/2014/oct/13/300-french-masterpieces-to-be-loaned-to-the-louvre-abu-dhabi (last accessed 8 August 2016).

Stewart, A. 1979. *Attika: Studies in Athenian Sculpture of the Hellenistic Age*. London.

———. 1986. "When Is a Kouros Not an Apollo? The Tenea 'Apollo' Revisited," in M. A. del Chiaro and W. R. Biers, eds., *Corinthiaca: Studies in Honor of Darrell A. Amyx*. Columbia, MO: 54–70.

———. 1990. *Greek Sculpture: An Exploration*, vol. 1. New Haven and London.

———. 1993. "Narration and Allusion in the Hellenistic Baroque," in P. J. Holliday, ed., *Narrative and Event in Ancient Art*. Cambridge: 130–74.

———. 1997. *Art, Desire and the Body in Ancient Greece*. Cambridge.

———. 2001. "David's 'Oath of the Horatii' and the Tyrannicides," *The Burlington Magazine* 143(1177): 212–19.

———. 2004. *Attalos, Athens, and the Akropolis: The Pergamene "Little Barbarians" and Their Roman and Renaissance Legacy*. Cambridge.

———. 2005. "Posidippus and the Truth in Sculpture," in K. Gutzwiller, ed., *The New Posidippus: A Hellenistic Poetry Book*. Oxford: 183–205.

———. 2006. "Hellenistic Art: Two Dozen Innovations," in G. R. Bugh, ed., *The Cambridge Companion to the Hellenistic World*. Cambridge: 158–85.

———. 2008. *Classical Greece and the Birth of Western Art*. Cambridge.

———. 2014. *Art in the Hellenistic World: An Introduction*. Cambridge.

Stewart, A. F. 1977. *Scopas of Paros*. Park Ridge, NJ.

Stewart, P. 1999. "The Destruction of Statues in Late Antiquity," in R. Miles, ed., *Constructing Identities in Late Antiquity*. London and New York: 159–89.

———. 2003. *Statues in Roman Society: Representation and Response*. Oxford.

———. 2008. *The Social History of Roman Art*. Cambridge.

———. 2009. "Totenmahl Reliefs in the Northern Provinces: A Case-Study in Imperial Sculpture," *Journal of Roman Archaeology* 22: 253–274.

———. 2010. "Geographies of Provincialism in Roman Sculpture," *Research Institutes in the History of Art Journal*, http://www.riha-journal.org/articles/2010 (last accessed 8 August 2016).

Stewart, S. 1984. *On Longing: Narratives of the Miniature, the Gigantic, the Souvenir, the Collection*. Baltimore.

Stieber, M. 2004. *The Poetics of Appearance in the Attic Korai*. Texas.

Stilp, F. 2001. *Mariage et Suovetaurilia: Étude sur le Soidisant "Autel de Domitius Ahenobarbus."* Rome.

Stirling, L. 2005. *The Learned Collector: Mythological Statuettes and Classical Taste in Late Antique Gaul*. Ann Arbor.

———. 2008. "Statuary from the Late Roman Panayia Villa at Corinth," *Hesperia* 77: 89–161.

———. 2014a. "The Opportunistic Collector: Sources of Statuary Décor and the Nature of Late Antique Collection," in M. W. Gahtan and D. Pegazzano, eds., *Museum Archetypes and Collecting in the Ancient World*. Leiden: 137–45.

———. 2014b. "Collections, Canons, and Context: The Afterlife of Greek Masterpieces in Late Antiquity," in S. Birk, T. M. Kristensen, and B. Poulsen, eds., *Using Images in Late Antiquity*. Oxford and Philadelphia: 96–114.

Stoneman, R. 2010. *Land of Lost Gods: The Search for Classical Greece*. London and New York.

Stourton, J., and C. Sebag Montefiore. 2012. *The British as Art Collectors: From the Tudors to the Present*. London.

Stray, C. 1998. *Classics Transformed: Schools, Universities and Society in England, 1830–1960*. Oxford.

Strocka, V. 2000. "Noch einmal zur Bibliothek von Pergamon," *Archäologischer Anzeiger*: 155–68.

Strong, D. E. 1973. "Roman Museums," in D. E. Strong, *Archaeology, Theory and Practice: Essays Presented to W. F. Grimes*. London and New Haven: 247–64.

Strong, E. 1904. *Exhibition of Ancient Greek Art*. London.

———. 1907. *Roman Sculpture from Augustus to Constantine*. London.

Strootman, R. 2007. "The Hellenistic Royal Courts: Court Culture, Ceremonial and Ideology in Greece, Egypt and the Near East, 336–30 BCE." Doctoral dissertation, Utrecht.

———. 2014. "The Serpent Column: The Persistent Meanings of a Pagan Relic in Christian and Islamic Constantinople," *Material Religion* 10(4): 432–51.

Stuart, J., and N. Revett. 1762–1816. *The Antiquities of Athens*, 4 vols. London.

Stukeley, W. 1776. *Itinerarium Curiosum; or, An Account of the Antiquities, and Remarkable Curiosities in Nature or Art, Observed in Travels through Great Britain*. London.

Stupperich, R. 1982. "Das Statuenprogramm in der Zeuxippos-Thermen. Uberlegungen zur Beschreibung der Christodorus von Koptos," *Istanbuler Mitteilungen* 32: 210–35.

Sutton, T. 2000. *The Classification of Visual Art: A Philosophical Myth and Its History*. Cambridge.

Swann, M. 2001. *Curiosities and Texts: The Culture of Collecting in Early Modern England*. Philadelphia.

Sweet, R. H. 2004. *Antiquaries: The Study of the Past in Eighteenth-Century Britain*. London and New York.

———. 2012. *Cities and the Grand Tour: The British in Italy, c. 1690–1820*. Cambridge.

Swenson, A. 2009. "Musées de moulages et protection du patrimonie," in A. S. Rolland and H. Murauskaya, eds., *Les musées de la nation: Creations, transpositions, renouveau. Europe XIXe-XXe siècles*. Paris: 205–19.

———. 2013. *The Rise of Heritage: Preserving the Past in France, Germany and England, 1789–1914*. Cambridge.

Swetnam-Burland, M. 2015. *Egypt in Italy: Visions of Egypt in Roman Imperial Culture*. New York.

Szidat, S. G. 1997. *Teile eines historischen Frieses in der Casa de Pilatos*. Munich.

Talamo, E. 1998. "Gli *horti* di Sallustio a Porta Collina," in M. Cima and E. La Rocca, eds., *Horti Romani*. Rome: 113–69.

Tames, R. 2004. *Robert Adam: An Illustrated Life of Robert Adam, 1728–92*. London.

Tanner, J. 2000. "Portraits, Power, and Patronage in the Late Roman Republic," *Journal of Roman Studies* 90: 18–50.

———. 2006. *The Invention of Art History in Ancient Greece: Religion, Society and Artistic Rationalisation.* Cambridge.

Tatlock, R., R. R. Fry, R. L. Hobson, and P. Macquoid, eds. 1928. *A Record of the Collections in the Lady Lever Art Gallery, Port Sunlight, Cheshire.* London.

Taylor, M. W. 1981. *The Tyrant Slayers: The Heroic Image in Fifth Century B.C. Athenian Art and Politics.* New York.

Taylor, T. 1853. *The Life of Benjamin Robert Taylor, Historical Painter, from his Autobiography and Journals,* 3 vols. London.

Thomas, K. 1997. "Hugh Dalton to the Rescue," *London Review of Books* 19(22): 7–8.

Thomassin, S. [1694] 1723. *Recueil des statues, groupes, fontaines, termes, vases et autres magnifiques ornemens du chateau et parc de Versailles.* Paris.

Thompson, D. B. 1956. "The Persian Spoils of Athens," in *The Aegean and the Near East: Studies Presented to Hetty Goldman.* New York: 281–91.

Thompson, D. J. 2000. "Philadelphus' Procession: Dynastic Power in a Mediterranean Context," in L. Mooren, ed., *Politics, Administration and Society in the Hellenistic and Roman World: Proceedings of the International Colloquium, Bertinoro 19–24 July 1997.* Studia Hellenistica 36. Leuven: 365–88.

Thompson, E. L. 2016a. *Possession: The Curious History of Private Collectors from Antiquity to the Present.* New Haven and London.

———. 2016b. "J. Paul Getty's Motivations for Collecting Antiquities," *Adalya* 19: 351–68.

Thompson, H. A. 1952. "The Altar of Pity in the Athenian Agora," *Hesperia* 21: 47–82.

Thompson, H. A., and R. E. Wycherley. 1972. *The Agora of Athens: The History, Shape and Uses of an Ancient City Center.* Athenian Agora 14. Princeton.

Thornton, D. 1997. *The Scholar in His Study: Ownership and Experience in Renaissance Italy.* New Haven and London.

Tigler, G. 1995. "Catalogo delle sculture," in O. Demus, G. Tigler, L. Lazzarini, and M. Piana, eds., *Le sculture esterne di San Marco.* Milan: 25–227.

Tite, C. G. C. 2003. *The Early Records of Sir Robert Cotton's Library.* London.

Tobin, J. 1997. *Herodes Attikos and the City of Athens: Patronage and Conflict under the Antonines.* Amsterdam.

Too, Y. L. 2010. *The Idea of the Library in the Ancient World.* Oxford.

Touchette, L. A. 2000. "Sir William Hamilton's 'Pantomime Mistress': Emma Hamilton and Her Attitudes," in C. Hornsby, ed., *The Impact of Italy: The Grand Tour and Beyond.* London: 123–46.

———. 2015. "Archaism and Eclecticism," in E. A. Friedland and M. G. Sobocinski, with E. K. Gazda, eds., *The Oxford Handbook of Roman Sculpture.* Oxford: 292–306.

Towne-Markus, E. 1997. *Masterpieces of the J. Paul Getty Museum: Antiquities.* Los Angeles.

Toynbee, J. M. C. 1934. *The Hadrianic School: A Chapter in the History of Greek Art.* Cambridge.

———. 1953. *The Ara Pacis Reconsidered and Historical Art in Roman Italy.* Proceedings of the British Academy 39. London.

Tradescant, J. 1656. *Musaeum Tradescantianum, or A Collection of Rarities Preserved at South-Lambert Neer London.* London.

Treu, G. 1897. *Olympia III: Die Bildwerke von Olympia in Stein und Thon.* Berlin.

Trimble, J. 2007. "Pharaonic Egypt and the Ara Pacis in Augustan Rome," *Working Papers in Classics,* Stanford University, https://www.princeton.edu/~pswpc/pdfs/trimble/090701.pdf (last accessed 9 August 2016).

———. 2011. *Women and Visual Replication in Roman Imperial Art and Culture.* Oxford.

Trimble, J., and J. Elsner, eds. 2006. *Art and Replication: Greece, Rome and Beyond.* Art History 29.2. London.

True, M., and J. Silvetti. 2005. *The Getty Villa.* Los Angeles.

Trunk, M. 2002. *Die 'Casa de Pilatos' in Sevilla: Studien zu Sammlung, Aufstellung und Rezeption antiker Skulpturen im Spanien des 16. Jahrhunderts.* Mainz.

———. 2003. "Early Restorations of Ancient Sculptures in the Casa de Pilatos, Seville: Sources and Evidence," in J. B. Grossman, J. Podany, and M. True, eds., *History of Restoration of Ancient Stone Sculptures.* Los Angeles: 255–64.

———. 2008. "Batalla y triunfo: Los relieves históricos de colección del primer Duque de Alcalá," in J. M. Abascal and R. Cebrián, eds., *Escultura romana en Hispania VI: Homenaje a Eva Koppel.* Murcia: 27–44.

Tucci, P. L. 2001. *Laurentius Manlius: La riscoperta dell'antica Roma, la nuova Roma di Sisto IV.* Rome.

Turpin, A. 2006. "The New World Collections of Duke Cosimo I de' Medici and Their Rome in the *Kunst-* and *Wunderkammer* in the Palazzo Vecchio," in R. J. W. Evans and A. Marr, eds., *Curiosity and Wonder from the Renaissance to the Enlightenment.* Aldershot: 63–86.

———. 2013. "The Display of Exotica in the Uffizi Tribuna," in S. Bracken, A. M. Gáldy, and A. Turpin, eds., *Collecting East and West.* Newcastle Upon Tyne: 83–118.

Uccella, M. L. C. 1980. *Palazzo Venezia: Paolo II e le fabbriche di S. Marco.* Rome.

Ullmann, B. L. 1960. *The Origin and Development of the Humanistic Script*. Rome.

Valentini, R., and G. Zucchetti, eds. 1940–53. *Codice topografico della città di Roma*, 4 vols. Rome.

Van Aerde, M. E. J. J. 2015. "Egypt and the Augustan Cultural Revolution: An Interpretative Archaeological Overview." Doctoral dissertation, Leiden.

Van Bommel, B. 2015. *Classical Humanism and the Challenge of Modernity: Debates on Classical Education in 19th-Century Germany*. Berlin, Munich, and Boston.

Van den Boogert, B. C. 2010. "María de Hungría, mecenas de las artes—Mary of Hungary as a Patron of the Arts," in F. Checa Cremades, ed., *Los inventarios de Carlos V y la familia imperial//The Inventories of Charles V and the Imperial Family*, vol. 3. Madrid: 2807–22.

Vandiver, E. 2013. *Stand in the Trench, Achilles: Classical Receptions in British Poetry of the Great War*. Oxford.

Van Eck, C., M.-J. Versluys, and P. ter Keurs. 2015. "The Biography of Cultures: Style, Objects and Agency: Proposal for an Interdisciplinary Approach," *Les Cahiers de l'École du Louvre* 7: http://cel.revues.org/275 (last accessed 19 December 2016).

Van Gene-Saillet, P., ed. 2014. *The Reunification of the Parthenon Marbles: A European Concern*. Geneva.

Van Keuren, F. 2003. "Unpublished Documents Shed New Light on the Licinian Tomb, Discovered in 1884–1885," *Memoirs of the American Academy in Rome* 48: 53–139.

Van Romburgh, S. 2004. *For My Worthy Friend Mr Franciscus Junius: An Edition of the Correspondence of Franciscus Junius, F. F. (1591–1677)*. Leiden.

Varner, E. R., ed. 2000. *From Caligula to Constantine: Tyranny and Transformation in Roman Portraiture*. Atlanta.

———. 2004. *Mutilation and Transformation: Damnatio Memoriae and Roman Imperial Portraiture*. Leiden.

———. 2014. "Maxentius, Constantine, and Hadrian: Images and the Expropriation of Imperial Identity," in S. Birk, T. M. Kristensen, and B. Poulsen, eds., *Using Images in Late Antiquity*. Oxford and Philadelphia: 48–77.

———. 2015a. "Patronage of Greek and Roman Art," in C. Marconi, ed., *The Oxford Handbook of Greek and Roman Art and Architecture*. Oxford: 152–75.

———. 2015b. "Reuse and Recarving: Technical Evidence," in E. A. Friedland and M. G. Sobocinski, with E. K. Gazda, eds., *The Oxford Handbook of Roman Sculpture*. Oxford: 123–38.

Vasari, G. 1967–97. *Le vite de' più eccellenti pittori, scultori e architettori nelle redazioni del 1550 e 1568*, ed. R. Bettarini and P. Barocchi, 9 vols. Florence.

———. 1996. *Lives of the Painters, Sculptors and Architects*, trans. Gaston du C. de Vere; with an introduction and notes by David Ekserdjian, 2 vols. London.

Vaughan, G. 1991. "Albacini and His English Patrons," *Journal of the History of Collections* 3(2): 183–97.

———. 1996. "The Townley Zoffany: Reflections on Charles Townley and His Friends," *Apollo* 144: 32–35.

———. 2002. "An Eighteenth-Century Classicist's Medievalism: The Case of Charles Townley," in B. J. Muir, ed., *Reading Texts and Images: Essays on Medieval and Renaissance Art Patronage in Honour of Margaret M. Manion*. Exeter: 297–314.

———. 2015. "Piranesi's Last Decade: A Reappraisal of the *Vasi*," in K. Stone and G. Vaughan, eds., *The Piranesi Effect*. Sydney: 278–302.

Vaux, W. S. W. 1851. *Handbook to the Antiquities in the British Museum*. London.

Venturi, L. 1936. *History of Art Criticism*, trans. C. Marriott. New York.

Verheyen, E. 1971. *The Paintings in the "Studiolo" of Isabella d'Este at Mantua*. New York.

Verhoogt, R. 2014. *Art in Reproduction: Nineteenth-Century Prints after Lawrence Alma Tadema, Jozef Israëls and Ary Scheffer*. Amsterdam.

Vermeule, C. 1955. "Notes on a New Edition of Michaelis: Ancient Marbles in Great Britain," *American Journal of Archaeology* 59(2): 129–50.

———. 1975. "The Weary Herakles of Lysippos," *American Journal of Archaeology* 79(4): 323–32.

———. 1981. *Greek and Roman Sculpture in America*. Malibu.

Versluys, M.-J. 2002. *Aegyptiaca Romana: Nilotic Scenes and the Roman Views of Egypt*. Leiden.

———. 2007. "Aegyptiaca Romana: The Widening Debate," in L. Bricault, M.-J. Versluys, and P. B. P. Meyboom, eds., *Nile into Tiber: Egypt in the Roman World*. Proceedings of the IIIrd International Conference of Isis Studies. Leiden and Boston: 1–14.

———. 2012. "Making Meaning with Egypt: Hadrian, Antinous and Rome's Cultural Renaissance," in M.-J. Versluys and L. Bricault, eds., *Egyptian Gods in the Hellenistic and Roman Mediterranean: Image and Reality between Local and Global*. Caltanissetta: 25–40.

———. 2015. "Roman Visual Culture as Globalising Koine," in M. Pitts and M. J. Versluys, eds., *Globalisation and the Roman World: World History, Connectivity and Material Culture*. Cambridge and New York: 141–74.

Vickers, M. 2007. *The Arundel and Pomfret Marbles*. Oxford.

Vickers, M., and D. Gill. 1994. *Artful Crafts: Ancient Greek Silverware and Pottery*. Oxford.

Videbech, C. 2015. "Private Collections of Sculpture in Late Antiquity: An Overview of the Form, Function and Tradition," in J, Fejfer, M. Moltesen, and A. Rathje, eds., *Tradition: Transmission of Culture in the Ancient World*. Acta Hyperborea 15. Copenhagen: 451–80.

Visconti, C. L. 1875. "Di una statua di Venere rinvenuta sull'Esquilino," *Bullettino della Commissione Archeologica comunale di Roma* 3: 16–23.

Visconti, E. Q. 1818–22. *Il Museo Pio-Clementino*. Milan.

Vlachogianni, E. 2012. "Sculpture," in N. Kaltsas, E. Vlachogianni, and P. Bouyia, *The Antikythera Shipwreck: The Ship, the Treasures, the Mechanism*. Athens: 62–115.

Vlassopoulos, K. 2013. *Greeks and Barbarians*. Cambridge.

Von Bothmer, D. 1991. *Glories of the Past: Ancient Art from the Shelby White and Leon Levy Collection*. New York.

Von Stackelberg, O. M. 1837. *Die Gräber der Hellenen*. Berlin.

Vout, C. 2006a. "What's in a Beard? Rethinking Hadrian's Hellenism," in S. Goldhill and R. Osborne, eds., *Rethinking Revolutions through Ancient Greece*. Cambridge: 96–123.

———. 2006b. "Winckelmann and Antinous," *Cambridge Classical Journal* 52: 139–62.

———. 2007. *Power and Eroticism in Imperial Rome*. Cambridge.

———. 2008. "The Art of Damnatio Memoriae," in S. Benoist, ed., *Un discours en images*. Metz: 153–72.

———. 2009. "Domination and Liberation (review of S. Dillon and K. Welch, eds., *Representations of War in Ancient Rome* and L. H. Peterson, *The Freedman in Roman Art and Art History*)," *Art History* 32(1): 186–92.

———. 2012a. "Putting the Art into Artefact," in S. E. Alcock and R. Osborne, eds., *Classical Archaeology*, 2nd edn. Chichester and Malden, MA: 442–64.

———. 2012b. "Unfinished Business: Re-viewing Medea in Roman Painting," *Ramus* 41(1–2): 119–43.

———. 2012c. "Treasure, Not Trash: The Disney Sculpture and Its Place in the History of Collecting," *Journal of the History of Collections* 24(3): 309–26.

———. 2013a. *Sex on Show: Seeing the Erotic in Greece and Rome*. Berkeley and London.

———. 2013b. "Epic in the Round," in H. Lovatt and C. Vout, eds., *Epic Visions: Visuality in Greek and Latin Epic and Its Reception*. Cambridge: 191–217.

———. 2013c. "The Shock of the Old: What the Sculpture of Pan Reveals about Sex and the Romans," *The Guardian*, 23 March, https://www.theguardian.com/profile/carrie-vout (last accessed 9 August 2016).

———. 2014. "The End of the 'Greek Revolution'?" *Perspective: La Revue de l'INHA*: 246–52.

———. 2015a. "Romantic Visions: Collecting, Display and Homosexual Self-Fashioning," in J. Ingleheart, ed., *Ancient Rome and the Construction of Modern Homosexual Identities*. Oxford: 232–51.

———. 2015b. *Following Hercules: The Story of Classical Art*. Cambridge.

———. 2017. "Art and the Decadent City," in S. Bartsch, K. Freudenburg, and C. Littlewood, eds., *The Cambridge Companion to the Age of Nero*. Cambridge: 179–94.

———. 2018. "The Aesthetics of Roman Error," in B. Dufallo, ed., *Roman Error: Classical Reception and the Problem of Rome's Flaws*. Oxford: 15–36.

———. Forthcoming. "The Stuff of Crowded Sanctuaries," in M. Haysom, M. Milli, and J. Wallensten, eds., *The Stuff of the Gods: The Material Aspects of Religion in Ancient Greece*. Athens.

Wacher, J. S. 1974. *The Towns of Roman Britain*. Berkeley.

Walbank, F. W. 1984. "Monarchies and Monarchic Ideas," in F. W. Walbank and A. E. Astin, eds., *The Cambridge Ancient History*, 2nd edn., vol. 2, part 1. Cambridge: 62–100.

Waldstein, C. 1880. "Praxiteles and the Hermes with the Infant Dionysos," *Transactions of the Royal Society of Literature* 12(2), reprinted in C. Waldstein, 1885. *Essays on the Art of Pheidias*. Cambridge: 373–93.

———. 1887. "Pasiteles and Arkesilaos, the Venus Genetrix and the Venus of the Esquiline," *American Journal of Archaeology and of the History of the Fine Arts* 3(1–2): 1–13.

———. 1889. *Catalogue of Casts in the Museum of Classical Archaeology*. London.

Walker, A. 2008. "Meaningful Mingling: Classicizing Imagery and Islamicizing Script in a Byzantine Bowl," *Art Bulletin* 90(1): 33–53.

Walker, E. 1705. *Historical Discourses Upon Several Occasions Relating to Charles I*. London.

Walker, S. 2000. "Tenez le vraye," in D. Boschung and H. von Hesberg, eds., *Antikensammlungen des europäischen Adels in 18. Jahrhundert*. Mainz am Rhein: 93–98.

Wallace-Hadrill, A. 1989. "Rome's Cultural Revolution" (review of P. Zanker, *The Power of Images in the Age of Augustus* and the German original), *Journal of Roman Studies* 79: 157–64.

———. 2008. *Rome's Cultural Revolution*. Cambridge.

Walpole, H. 1771. *Anecdotes of Painting in England, with Some Account of the Principal Artists*, vol. 4. London.

Ward, S. G. 1845. *Essays on Art by Goethe*. Boston.

Warner, R. 1802. *A Tour through the Northern Counties of England, and the Borders of Scotland*, vol. 1. Bath.

Warr, C., and J. Elliott, eds. 2010. *Art and Architecture in Naples, 1266–1713: New Approaches*. Chichester.

Warren, E. P. 2009. *A Defence of Uranian Love*, ed. M. M. Kaylor and M. R. Miner. Kansas City.

Waterfield, G. 2015. *The People's Galleries: Art Museums and Exhibitions in Britain, 1800–1914*. New Haven and London.

Watkin, D. 2006. "The Transformation of Munich by Maximilian I Joseph and Ludwig I," *The Court Historian* 11(1): 1–14.

———. 2008a. "The Reform of Taste in London: Hope's House in Duchess Street," in D. Watkin and P. Hewat-Jaboor, eds., *Thomas Hope: Regency Designer*. New Haven and London: 23–43.

———. 2008b. "The Reform of Taste in the Country: The Deepdene," in D. Watkin and P. Hewat-Jaboor, eds., *Thomas Hope: Regency Designer*. New Haven and London: 219–35.

———. 2010. "Neoclassicism," in A. Grafton, G. W. Most, and S. Settis, eds., *The Classical Tradition*. Cambridge, MA and London: 629–32.

Watkin, D., and P. Hewat-Jaboor, eds. 2008. *Thomas Hope: Regency Designer*. New Haven and London.

Watson, P., and C. Todeschini. 2006. *"The Medici Conspiracy": The Illicit Journey of Looted Italy's Tomb Raiders to the World's Greatest Museums*. New York.

Waywell, G. B. 1978. *The Freestanding Sculptures of the Mausoleum at Halicarnassus in the British Museum*. London.

———. 1986. *The Lever and Hope Sculptures: Ancient Sculptures in the Lady Lever Art Gallery, Port Sunlight and a Catalogue of the Ancient Sculptures Formerly in the Hope Collection, London and Deepdene*. Berlin.

———. 1988. "The Mausoleum at Halicarnassus," in P. A. Clayton and M. J. Price, eds., *The Seven Wonders of the Ancient World*. New York: 100–123.

———. 1989. "Further Thoughts on the Placing and Interpretation of the Freestanding Sculptures from the Mausoleum," in T. Linders and P. Hellström, eds., *Architecture and Society in Hecatomnid Caria*. Uppsala: 23–30.

Webb, P. A. 1996. *Hellenistic Architectural Sculpture*. Madison, WI.

Webster, J. 2003. "Art as Resistance and Negotiation," in S. Scott and J. Webster, eds., *Roman Imperialism and Provincial Art*. Cambridge: 24–51.

Wegner, M. 1956. *Hadrian, Plotina, Marciana, Matidia, Sabina*. Berlin.

Welch, K. E. 2006. "Domi Militiaeque: Roman Domestic Aesthetics and War Booty in the Republic," in S. Dillon and K. E. Welch, eds., *Representations of War in Ancient Rome*. Cambridge: 91–161.

Wellington, R. 2015. *Antiquarianism and the Visual Histories of Louis XIV: Artifacts for a Future Past*. Farnham.

Weski, E., H. Frosien-Leinz, W.-D. Grimm, and P. Fink, eds. 1987. *Das Antiquarium der Munchner Residenz: Katalog der Skulpturen*. Munich.

West, J. 2008. "A Taste for the Antique? Henry of Blois and the Arts," in C. Lewis, ed., *Anglo-Norman Studies XXX: Proceedings of the Battle Conference 2007*. Woodbridge: 213–30.

Weststeijn, T. 2015. *Art and Antiquity in the Netherlands and Britain: The Vernacular Arcadia of Franciscus Junius (1591–1677)*. Leiden.

Wherry, A. 1898. *Greek Sculpture, with Story and Song*. London.

White, C. 1995. *Anthony van Dyck: Thomas Howard, the Earl of Arundel*. Los Angeles.

Whitehill, W. M. 1970. *Boston Museum of Fine Arts: A Centennial History*, 2 vols. Boston.

Whitley, J. 2001. *The Archaeology of Classical Greece*. Cambridge.

———. 2013. "Agency in Greek Art," in T. J. Smith and D. Plantzos, eds., *A Companion to Greek Art*, vol. 2. Oxford: 579–95.

Wickhoff, F. 1900. *Roman Art: Some of Its Principles and Their Application to Early Christian Painting*, trans. and ed. E. Strong. London.

Wilson, K. 2003. *The Island Race: Englishness, Empire and Gender in the Eighteenth Century*. London.

Wilton, A. 2006. *Turner in His Time*. London.

Wilton, A., and I. Bignamini. 1996. *Grand Tour: Lure of Italy in the Eighteenth Century*. London.

Wilton-Ely, J. 2001. "'Gingerbread and Sippets of Embroidery': Horace Walpole and Robert Adam," *Eighteenth-Century Life* 25(2): 147–69.

———. 2002. Introduction to G. B. Piranesi, *Observations on the Letter of Monsieur Mariette*. Los Angeles: 1–83.

Winckelmann, J. J. 1764. *Geschichte der Kunst des Alterthums*. Dresden.

———. 1765. *Reflections on the Painting and Sculpture of the Greeks*, trans. H. Fuseli. London.

———. 1767. *Monumenti antichi inediti*, 2 vols. Rome.

———. 1830–34. *Opere di G. G. Winckelmann*, 12 vols. and atlas. Prato.

———. 1952–57. *Briefe*, ed. W. Rehm and H. Diepolder, 4 vols. Berlin.

———. 2003. *Ville e Palazzi di Roma: Antiken in den römischen Sammlungen. Text und Kommentar*, ed. S. Kansteiner, B. Kuhn Forte, and M. Kunze. Mainz.

———. 2006. *History of the Art of Antiquity*, intro. by Alex Potts; trans. H. F. Mallgrave. Los Angeles.

Winner, M., B. Andreae, and C. Pietrangeli, eds. 1998. *Il Cortile delle Statue: Der Statuenhof des Belvedere im Vatikan*. Mainz.

Winnicki, J. K. 1994. "Carrying Off and Bringing Home the Statues of the Gods: On an Aspect of the Religious Policy of the Ptolemies Towards the Egyptians," *Journal of Juristic Papyrology* 24: 149–90.

Winter, F. 1908. *Altertümer von Pergamon (Band VII, 1 and 2): Die Skulpturen mit Ausnahme der Altarreliefs*. Berlin.

Witschel, C. 2007. "Statuen auf Spätantiken Platzanlagen in Italien und Afrika," in F. A. Bauer and C. Witschel, eds., *Statuen in der Spätantike*. Wiesbaden: 113–69.

Witty, F. J. 1958. "The Pinakes of Callimachus," *Library Quarterly* 28(1–4): 132–36.

Wölfflin, H. 1915. *Kunstgeschichtliche Grundbegriffe: Das Problem der Stilentwickelung in der neueren Kunst*. Munich.

———. 2015. *Principles of Art History: Heinrich Wölfflin: a New Translation by Jonathan Blower*, eds. E. Levy and T. Weddigen. Los Angeles.

Woodford, S. 1986. *An Introduction to Greek Art*. London.

Worm, O. 1655. *Musei Wormiani Historia*. Leiden.

Worsley, R. 1824. *Museum Worsleyanum; or, a Collection of Antique Basso Relievos, Bustos, Statues and Gems, with Views of Places in the Levant Taken on the Spot in the Year MDCCLXXXV, VI and VII*. London.

Wright, B. G. 2015. *The Letter of Aristeas: "Aristeas to Philocrates" or "On the Translation of the Law of the Jews."* Berlin and Boston.

Wright, C. J., ed. 1997. *Sir Robert Cotton as Collector: Essays on an Early Stuart Courtier and His Legacy*. London and Toronto.

Wright, J. 1842. *The Letters of Horace Walpole, Earl of Orford*, 4 vols. Philadelphia.

Wünsche, R. 2007. *Glyptothek, Munich: Masterpieces of Greek and Roman Sculpture*, trans. R. Batstone. Munich.

Wyke, M. 1997. "Herculean Muscle! The Classicizing Rhetoric of Bodybuilding," *Arion* 4 (3): 51–79, reprinted in J. I. Porter, ed. 1999. *Constructions of the Classical Body*. Michigan: 355–79.

Yarrington, A. 2009. "'Under Italian Skies': The Sixth Duke of Devonshire, Canova and the Formation of the Sculpture Gallery at Chatsworth House," *Journal of Anglo-Italian Studies* 10: 41–62.

Yarrow, L. M. 2006. "Lucius Mummius and the Spoils of War," *Scripta Classica Israelica* 25: 57–70.

Yorimichi, K. 2009. "Byron's Dying Gladiator in Context," *The Wordsworth Circle* 40(1): 44–51.

Zagdoun, M.-A. 1989. *La sculpture archaïsante dans l'art hellénistique et dans l'art romain du Haut-Empire*. Athens.

Zanker, G. 2004. *Modes of Viewing in Hellenistic Poetry and Art*. Madison, WI.

———. 2009. *Herodas: Mimiambs*. Oxford.

Zanker, P. 1974. *Klassizistische Statuen: Studien zur Veränderung des Kunstgeschmacks in der römischen Kaiserzeit*. Mainz.

———. 1975. "Grabreliefs römischer Freigelassener," *Jahrbuch des Deutschen Archäologischen Instituts* 90: 267–315.

———. 1987. *Augustus und die Macht der Bilder*. Munich.

———. 1988. *The Power of Images in the Age of Augustus*, trans. A. Shapiro. Ann Arbor.

———. 2012. "Der Konstantinsbogen als Monument des Senates," *Acta ad Archaeologiam et Artium Historiam Pertinentia*, n.s., 11(25): 77–105.

Zevi, F., and B. Andreae. 1982. "Gli scavi sottomarini di Baia," *La Parola del Passato* 37: 114–56.

Zevi, F., and E. V. Bove. 2008. "The Nile Mosaic of Palestrina," in A. Lo Sardo, ed., *The She-Wolf and the Sphinx: Rome and Egypt from History to Myth*. Milan: 78–87.

Ziebarth, E. 1902. "Cyriacus von Ancona als Begründer der Inschriftenforschung," *Neue Jahrbücher für das Klassische Altertum* 9: 214–26.

INDEX

Johnston, John, 280n24
Jonah, 138
Julia, Basilica, Rome, 81
Julius II, Pope, 5, 273n53
Junius, Francis, 131, 140–41, 143, 168
Justinian II, 85

Kairos, statue of, 86
Keats, John, 241
Kedleston Hall, Derbyshire, 169–71, 173
Killigrew, Anne, 140, 144, 151
Kingsley, Charles, 294n148
Kirkpatrick, John, 292n89
kitsch, 64, 222–23
Kitzinger, Ernst, 211
Klein, Wilhelm, 210
Klein, Yves, 238
Knatchbull-Wyndham, Wyndham, 151
Knidos: Battle of, 17. *See also* Aphrodite of Knidos
Knight, William, 279n17
Knole House, Kent, 139
Knossos. *See* Evans, Arthur
Koons, Jeff, 222–26, 241, 245
Kopienkritik, 192, 203
korai, 18–19, 189, 191. *See also* Phrasikleia
kouroi, 69, 225, 228
Krautheimer, Richard, 211
Kristeller, Paul Oskar, 12
Kritios Boy, 3–4, 189, 203, 225
Kunstkammern. *See* curiosity, cabinets of

Labraunda, sanctuary of, 26
Lacan, Jacques, 140, 165
Lafreri, Antonio, 131
Laius, king of Thebes, 23
Landino, Cristoforo, 102
Langres, France, 137
Lansdowne Hercules, 53–54
Lansdowne House, London, 234, 240
Laocoon, 115, 124–25, 260n67, 289n172; casts and copies of the, 88, 112, 124, 135, 161, 185; demoting of the, 188, 197; as described by Pliny, 51, 115–16; engravings and paintings of the, 138, 145, 149, 171–72; entry into Paris, 50, 71, 244; rediscovery of the, 112, 118, 120
Laodamas, king of Thebes, 23
lares, 63
Lateran Palace, Rome, 90, 97, 102, 117
Laterculi Alexandrini, 52
Latin, learning of, 220–21
Lausus, Palace of, Constantinople, 84–87
Layard, Austen Henry, 197, 291n38
Lee, Vernon, 178
Leiden, Dutch National Museum in, 132
Leighton, Frederic, 214

Lely, Peter, 281n48
Lenormant, Charles, 191
Lenormant, François, 213
Leo Choerosphactes, 268n129
Leo the Wise, 268n129
Leo X, Pope, 77, 125
Leochares, ancient Athenian sculptor, 27, 260n73
Leoni, Pompeo, 132
Lessing, Gotthold Ephraim, 131, 197
Leto, Giulio Pomponio, 112, 135
Levant, the, 116, 136
Lever, William Hesketh, 218
Levett, Christian, 230–38
Levy, Leon, 236
Lewes, 217–18
Lewis, Edonia, 187
Licinii, Tomb of the, 291n53
Licinio, Bernardino, 107, 109
Ligorio, Pirro, 77
Limyra, Shrine of king Pericles of, 25, 252n42
Lindos, and the Temple of Athena Lindia, 25, 38–39, 85
Longinus, *On the Sublime*, 257n174
Loredan, Andrea, 123
Lorenzetto (Lorenzo Lotti), 138
Lorraine, Jean de, 277n135
Lotto, Lorenzo, 107–8, 111
Louis XIV of France, 79, 135–39, 274n65. *See also* Versailles
Louis XVI of France, 195
Loukou. *See* Herodes Atticus
Louvre, the, Paris, 79, 158, 193–96, 198, 244
Lucian, 10, 26, 68, 102; or Pseudo-Lucian, 166
Ludovisi, family and collection, 4, 136, 142, 197–98
Ludovisi Mars, 155
Ludwig I of Bavaria, 198
Lullies, Reinhard, and Max Hirmer, 3–4, 234, 248n16
Lumley, John, 280n18, 283n105
luxury, 45–49
Lysimachus, general of Alexander and ruler of Thrace, 18
Lysippus, 40, 57, 59, 63, 86; and Lysippan form, 67; statuette of Alexander by, 77. *See also* Apoxyomenos; Farnese Hercules; Hercules; Kairos; Granicus group

Macedon, Roman victory over, 50; royal court of, 35
MacPherson, Robert, 174, 205–7, 244
Madagascar, 130
Madama, Villa, Rome, 77
Madrid, Alcázar Palace, 135
Maecenas, 104, 147, 271n1, 283n114
Maenad(s): at Hadrian's Villa, 79, 90; after Scopas, 27, 252n53
Maffei, family and collection of, 112

Myron, 40, 52, 59, 63, 82, 234, 254n78; Athena by, 87; heifer by, 86; Marsyas after, 33, 202–3; other statues ascribed to, 30, 225. *See also* Discobolus

myrrhine vessels, 121

Mytens, Daniel, 143–46, 151

mythographies, hellenistic, 29

Nagel, Alexander, and Christopher Wood, 90

Naples, 88, 104, 116, 122, 132, 147

Napoleon, 139, 236; and Egypt, 71, 185; and the entry of sculpture into Paris, 50, 52, 70–71, 244; and the looting of Venice, 89; the Musée, Paris, 158, 195–97; and the "Napoleon Room," Lady Lever, 219; and the return of sculpture to Rome, 180–81

Narcissus, 105

naturalia (natural specimens), 118, 121–24

Naucratis, Egypt, 236

Neer, Richard, 2–4, 39, 235

Negroni, Villa, Rome, 172

neoclassicism, 150, 153, 160

Neoptolemus, 85

Nero, 20, 53, 104; as art collector, 76–77, 88, 107, 121; Domus Aurea (Golden House) of, 76–77, 79, 102; images of, 65, 72, 279n17; as negative paradigm, 75, 79, 102; Seal of, 101

New Iberia, Louisiana, 236

New Sculpture, 191

New York, 84

Newby Hall, North Yorkshire, 164–65, 169–70, 175, 284n28, 289n184

Newton, Charles, 199–200, 252n41

Niccoli, Niccolò, 99, 276n105

Nijs, Daniel, 281n48

Nile, 199; landscapes of the, 55–59, 261n97; personifications of the, 79, 125, 135

Niobids, sculptures of, 52, 260n77

Nizzola, Jacopo da Trezzo, 132

Nodier, Charles, 286n84

Nollekens, Joseph, 160, 177–81, 288n128

Nolli, Giambattista, 156

Nonsuch Palace, Surrey, 127

Northall, John, 282n79

Nossis, poetry of, 40

nostos (homecoming), 196, 291n55

Novus, Arcus, Rome, 80

Nucci, Giuseppe, 217

Nugent, Thomas, 156

nymphs, sleeping, 104, 112, 135, 147

obelisks: in Constantinople, 83–84; in England, 127; in Rome, 46, 59, 143, 258n25

Odescalchi, Livio, 138

Odoni, Andrea, 104, 107–8, 111, 119, 143

Odyssey Landscapes, 187

Oedipus, king of Thebes, 23

Oldfield, Edmund, 292n87

Olympia: ancient tourism to, 49; casts after sculpture found at, 201, 204–5; dedications at, 22, 37; excavations at, 43, 184, 188, 196; film entitled, 216; and the Nike of Paeonius, 27; pediments from the Temple of Zeus at, 204, 225; statuette of Zeus from, 186; Treasury of the Metapontians, 37. *See also* Pheidias

Olympus, Lycian city, 49

Onatas, ancient sculptor, 297n25

Orestes and Electra group, 142, 156–57

Ortiz, George, 235–37

Osborne, Robin, 235

Ostrogoths, 86. *See also* Theodoric

otium, 45, 63

Otto, king of Greece, 290–91n26

Ottoboni, Pietro, 171, 285n45

Ottoman empire, 89, 94

outline, 176–77

Overbeck, Johannes, 131, 209–10, 234

Ovid, 98, 131

Oxford: the Union in, 222; University of, 201, 220, 231. *See also* Ashmolean Museum

Paestum, 290n25

Palatine Hill, Rome, 55, 75–76

Palladio, Blosio, 101

Palladion, 71, 83, 89

Palmyra, 245

Pan, 119; and goat statue, 60–61, 166; 221; or satyrs from the della Valle collection, 125

Pandarus, 39

Panini, Giovanni Paolo, 145, 149, 181

Panofsky, Erwin, 211

Pantheon, 276n122; the Augustan phase of the, 78, 265n57; as a model for later galleries, 136, 162

Papirius, 156

Parastaseis Syntomoi Chronikai, 85

parchment, invention of, 35

Paris, France, 84, 195; Musée des Monuments français in, 195; treasury of Sainte-Chapelle in, 93. *See also* Napoleon

Paris, Trojan prince: judgment of, 61–62, 98; statue identified as, 171–72, 177–78

Parium, Marmor (Parian Chronicle), 3, 5, 128, 148, 248nn13, 29, 280n22

Parnassus, 101

Paros, Greece, 98

Parrhasius, ancient painter, 23, 41, 76, 225

Parthenocles, ancient sculptor, 260n73

Parthenon: casts of sculpture from the, 185, 188, 200; construction of the, 27–28; frieze from the, 161, 200; horse from the east pediment of the, 216–17; influence of the, 44, 189; metopes from the, 29–30, 179; Neronian inscription on the, 76–77; restitution of sculptures from, 221–22; restoration of sculptures of the, 182;